ASIA'S CULTURAL MOSAIC

ASIA'S CULTURAL MOSAIC

AN ANTHROPOLOGICAL INTRODUCTION

GRANT EVANS
EDITOR

PRENTICE HALL

New York London Toronto Sydney Tokyo Singapore

First published 1993 by
Prentice Hall
Simon & Schuster (Asia) Pte Ltd
Alexandra Distripark
Block 4, #04-31
Pasir Panjang Road
Singapore 0511

Cover photograph: Courtesy of Jean Berlia.

Printed in Singapore

1 2 3 4 5 97 96 95 94 93

ISBN 0-13-052812-9

Prentice-Hall International (UK) Limited, *London*
Prentice-Hall of Australia Pty. Limited, *Sydney*
Prentice-Hall Canada Inc., *Toronto*
Prentice-Hall Hispanoamericana, S.A., *Mexico*
Prentice-Hall of India Private Limited, *New Delhi*
Prentice-Hall of Japan, Inc., *Tokyo*
Editora Prentice-Hall do Brasil, Ltda., *Rio de Janeiro*
Prentice-Hall, Inc., *Englewood Cliffs, New Jersey*

PREFACE

This book is for students of Asia. It takes mainsteam anthropological themes on kinship, the economy or gender and examines them through the available empirical material on Asian cultures and societies provided by anthropologists, sociologists, and others. It ranges from India to Japan, from Mongolia to Indonesia; and despite the fact that some places and some specific topics are treated in greater depth than others, anyone who reads this book from cover to cover will learn a lot about the cultures of Asia. To be comprehensive would have meant being encyclopedic, but that would have defeated the purpose of *Asia's Cultural Mosaic* which is to *introduce* readers to Asia from an anthropological point of view.

While this book provides a core text for any course on Asia or anthropology each teacher will want to supplement its coverage with extra reading on particular regions and areas and groups, and in-depth readings on specific topics, probably in accordance with their own interests and expertise. In other words, through their teaching and suggestions for further reading teachers will enhance what has already been provided in the pages of *Asia's Cultural Mosaic*.

Hopefully non-academics interested in Asia will find the information and analyses contained in these pages useful and informative as well.

In producing this book a number of debts have been incurred: thanks is due to Professor Wong Siu-lun at the University of Hong Kong for his support of the project and Dr Christopher Hutton for advice. One of my students, Ms Yang Yueng, provided research assistance. Professor James L. Watson of Harvard University offered critical comments and encouragement. Dr Geoffrey Benjamin of the University of Singapore read the whole manuscript with great care and gave many suggestions for improvement. The staff at the *Far Eastern Economic Review* kindly allowed me to ransack their photo library, while various individuals generously contributed photographs. At Prentice Hall, Jerene Tan and Helene D'Cruz have offered expert editorial advice.

Grant Evans

CONTENTS

1 INTRODUCTION

Asia and the Anthropological Imagination

Grant Evans

What is "Asia"? This may seem a strange question to ask at the beginning of a book whose intention is to provide an anthropological introduction to "Asian" cultures. But it is a necessary question, because while "Asia" probably conjures up in people's minds the same broad geographical area, one stretching from India to Japan and from Mongolia to the southernmost point of Indonesia, in other respects it means different things to different people. We can ask, does "Asia" share anything more than geography? Is there a common "Asian culture"? A common "Oriental disposition" or "Asian mind"? Shared religious or political values? The answer, surprisingly perhaps, is no.

So how did the notion of "Asia" or the "Orient" or the "East" come about? *The East* is the clue, for we must ask, East from where? "The West", naturally, and the West is Europe, which in modern times includes North America. The idea of Asia or the Orient is an artifact of the European imagination. For a long time Asia or the Orient meant the countries known today as the Middle East, but after Marco Polo's travels to China in the thirteenth century European conceptions of Asia gradually expanded as European states extended their political and economic activities into Asia from the fifteenth century onwards.

But only in the late eighteenth century did Western perceptions of the East begin to crystallize as "Orientalism". In his study of this phenomenon, which focuses on the Middle East, Edward Said argues that Orientalism was a mode of thinking and teaching and writing about the East which propagated a number of general stereotypes concerning the supposed typical ways of thinking of "Orientals": such as, the "Inscrutable", "Oriental Mind", often linked with an idea of the "Mystical East" or a supposed preoccupation with spiritual values; and "Oriental Despotism" was reckoned to be Asia's natural form of political rule, along with social and economic stagnation. The ability of Europe to propagate this view was closely tied to the growth of European power following the emergence of capitalism, the industrial revolution in Europe in the late eighteenth century, and then the rapid expansion of capitalism globally through trade and colonialism throughout the nineteenth and early twentieth centuries. Large parts of Asia were colonized, and those areas which were not – China, Japan and Thailand – were either dominated by European powers indirectly as was China, or rapidly transformed themselves in order to resist, which was Japan's response following the Meiji restoration in 1868. "Orientalism," writes Said, was "a Western style for

dominating, restructuring, and having authority over the Orient" (Said, 1985: 3). That *authority* was the ability to say what was and was not "Asian".

Of course, it is fairly easy to see that Europe's version of Asia was an inversion of what it claimed were its own central values: democracy, scientific rationality, economic and social dynamism, and that watchword of the nineteenth century, *progress*. This stereotype *of itself* that Europe projected served to rationalize colonial expansion and Europe's "civilizing mission" in the world. It also concealed the violence, brutality and plain cultural arrogance that accompanied many colonial and neo-colonial endeavours. Amid wide indignation about the international drug trade today it is salutary to remember that the mid-nineteenth century opium wars between Britain and China were over the right of British and American traders to sell opium to Chinese drug addicts. The Emperor, faced by blazing British cannons, was forced to concede.

Europe's stereotype of itself as a force for enlightenment was no more accurate than its stereotype of Asia. A stagnant Asia was not simply waiting for a dynamic Europe to come and roughly wake it from its slumber. Had the Portuguese maritime explorer Vasco da Gama rounded the Cape in Southern Africa in the early rather than the late fifteenth century he might have encountered the enormous treasure ships of the famous Chinese admiral Zheng He which travelled throughout the Indian Ocean and Southeast Asian region. As we shall see in the following chapters, even some of the apparently most remote peoples in Asia were linked into trans-Asian trade networks along which travelled knowledge and cultural artifacts well before European penetration.

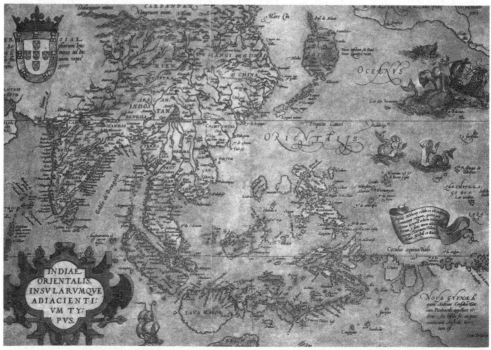

Ways of seeing: an old European map of Asia.
Courtesy of Maritime Museum Macau.

The exploratory endeavours of Zheng He were cut short by social and political changes taking place in China which led that state to become insular once again. A nascent Chinese mercantilism which perhaps could have led in the direction of capitalism was cut short, whereas the mercantilist forces which Vasco da Gama represented, would play an important role in the final emergence of capitalism in Europe. There was nothing inevitable about these two historical trajectories; Chinese merchants just may have appeared on the European horizon rather than the latter on Asian shorelines. But they did not, and therefore the last two centuries have seen the spread of technology, ideas, and capitalist forms of social organization from Europe to Asia and elsewhere. This major shift in the direction of world history initiated from Europe was not because Europeans were super-human, it was an "accident of history". But in the first flush of burgeoning European power Europeans were inclined to assert that it was a result of their "racial" superiority.

"Race" and "racism" became, therefore, a central component of colonial expansion. There was the European "race" and the Asian "race" or sometimes "races" who were allegedly biologically different in some profound, though usually unspecified, way. "Race", a highly problematic notion according to modern social scientists and biologists (see Chapters 2 and 9), was an especially powerful idea because it *naturalized* the inequalities between those who held power, the colonialists, and those who did not, the colonized or dominated. It also naturalized cultural differences. Various ideas culled, often incorrectly, from the emerging natural sciences of the nineteenth century in Europe were used to legitimize the idea of race. Most notoriously, ideas were co-opted from Charles Darwin's revolutionary theory of natural evolution and applied to "social evolution" to prove why some societies or cultures were superior to others and therefore should rule over them. It was an early lesson in how theories can be swayed by broader social and political influences.

The biological idea of race, however, was largely absent from Asia. The Chinese, for instance, clearly asserted their cultural superiority over "barbarians", but "barbarians" could become Chinese by adopting the appropriate Chinese cultural norms and values. Barriers between the two were not absolute as with racism. It is true, however, that this was a product of cultural isolation. As the outside world burst in on China and the Chinese had to deal increasingly with physically different people, so the idea of race grew (Dikotter, 1990). By and large, the biological idea of race is something Europe gave to Asia where, unfortunately, it has often been adopted enthusiastically. As we shall see in Chapter 9 by Ananda Rajah and Lian Kwen Fee, ethnic or "racial" tensions are rife in many Asian countries today.

Despite Zheng He's travels, or the transfer of Hinduism from India to Java and Bali by traders, or of Islam to what is now the southern Philippines, no sense of "Asia" emerged prior to European expansion in the region. Just as Asia was largely a political creation of Europeans, so it would become a political invention for people in the different countries of Asia who, usually following failed "traditionalist" revolts, would join nationalist movements in the twentieth century to struggle against European domination of "Asians". For Asians, therefore, the concept of Asia emerged in reaction to European power, and often they embraced a version of Orientalist ideas concerning, for example, "Asian spirituality" to assert their allegedly common "Asianess" in this struggle. Japanese imperialism was able to capitalize on this sentiment during its attempt to create an "Asian

Co-prosperity Sphere" during World War II, and many Asian nationalists initially saw the Japanese as liberators from colonialism. The exchange of European for Asian domination, however, was not what these nationalists had expected. The post Second World War anti-colonial wars and political movements saw the flowering of pan-Asian sentiment, and newly independent states often played on the ideology of "Asianness" as they began the wholly new task of conducting international relations with neighbours.

Nationalism is a highly potent idea. It entails the construction of an "imagined community", to use Ben Anderson's evocative concept. "In an anthropological spirit," he writes, "I propose the following definition of the nation: It is an imagined political community – and imagined as both inherently limited and sovereign. It is *imagined* because the members of even the smallest nation will never know most of their fellow-members, meet them, or even hear them, yet in the minds of each lives the image of their communion" (Anderson, 1983:15). Pan-national "Asianness" never achieved the same imagined community. Nationalism is a modern idea whose history goes back no more than two hundred years, yet the *idea* of nationalism claims to represent units of great antiquity. The idea of the "nation" is so firmly established in modern discourse that it is almost impossible for people today to imagine a world without nations. The idea of nationalism, however, is notoriously difficult to pin down. Ernest Gellner has argued that "Nationalism is primarily a political principle, which holds that the political and national unit should be congruent" (1983:1). The idea of a state ruling over a fixed territory is not so hard to grasp, but the elusive idea of the nation is. Gellner offers the following definitions: "1. Two men are of the same nation if and only if they share the same culture, where culture in turn means a system of ideas and signs and associations and ways of behaving and communicating. 2. Two men are of the same nation if and only when they *recognize* each other as belonging to the same nation...nations are the artifacts of men's convictions and loyalties and solidarities" (1983:7). Pre-modern European states and pre-modern Asian states did not view the regions over which they ruled through the lens of nationalism. The Middle Kingdom, writes Anderson, "imagined itself not as Chinese, but as central" (1983:20). In all pre-modern states boundaries blurred as one travelled further, and downwards, from hierarchical divine centres of power until one shaded off into another divinely ordained region where a new ascent began to the divine centre ruled by a King, a Son of Heaven or a *Devaraja*. "The fundamental conceptions about "social groups" were centripetal and hierarchical, rather than boundary-oriented and horizontal" (Anderson, 1983:22). The world views of Europe and Asia had much in common in, say, the fourteenth century. And a modern Englishman is more culturally distant from an Englishman of the fourteenth century than he is from a modern Japanese, and the latter is equally distant from his fourteenth century Japanese counterpart.

The idea of nationalism came to Asia through imperialist expansion, and colonial powers created nations where none existed beforehand. Even the language deployed by colonial powers towards the different groups that made up these societies created uniformities where previously they did not exist. The people being ruled were the "natives" to the English, the *indigenes* to the French or the *inlanders* to the Dutch. Through this process Balinese, Javanese, Torajas, Ambonese and so on, suddenly emerged as "the spectacular butterfly called 'Indonesian'" (Anderson, 1983:112). The construction of a modern state administrative apparatus and a

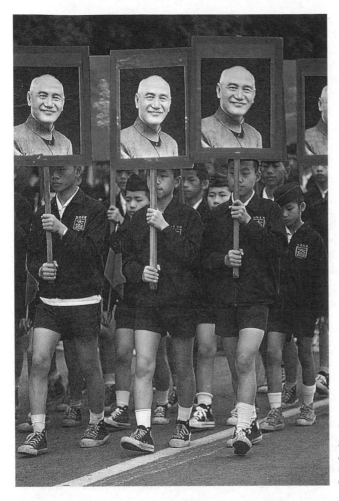

The iconography of modern nationalism. Chinese students with portraits of Chiang Kai Shek. Courtesy of Frank Fischbeck.

centralized education system gave rise to political aspirations by Asian nationalists to re-take the territory ruled by colonial states. Few called for the dissolving of colonial borders.

New elites in charge of states promoted the search for national identity, and this saw the invention of traditions or the revival of those associated with a particular group in a new context. These inventions have sometimes involved vague assertions about fundamental Asian values. But by the late twentieth century "Asianess" was thoroughly nationalised, from the most underdeveloped states like Laos to the most modern like Japan. Japan in fact has seen one of the most intense explorations of so-called national character, *nihonjinron*, which has produced stereotypes of Japanese society equal to the most ardent Western Orientalist. Japanologist and culture critic Ian Buruma writes:

The Japanese spirit. It is a subject of almost obsessive anxiety. The national soul – how it must be revived, defended, even held up as a model to the outside world – this nebulous soul is endlessly discussed by politicians, journalists, and scholars. Nihonjinron, or defining Japaneseness, has grown

into a huge intellectual enterprise, responsible for hundreds of books, thousands of articles, TV programs and radio shows. The key word is "uniqueness"; the uniqueness of Japaneseness which is beyond understanding in terms of Western logic, even though it can serve as the premise for scientific research. A neurologist made a name for himself by writing a book about the uniqueness of the Japanese brain, which was uniquely sensitive to the sounds of temple bells, waterfalls, cicadas and other natural vibrations. (1989:238–9)

In reaction to Japan's rapid emergence as a major industrial power there has also been a flood of books in English which attempt to explain Japanese "uniqueness". What these studies have in common, as Sugimoto and Mouer argue, is that "all Japanese are uniform in size, shape, behaviour and thought. Much of the literature tends to deal with the Japanese personality as though it emerges from a single cultural mold; the popular image suggests that Japanese behaviour arises out of a common mental frame without individual idiosyncrasies" (Mouer and Sugimoto, 1986:10). This tendency is particularly acute in Japanology, but it can be found elsewhere in Asia with Thais attempting to articulate Thai uniqueness, or Javanese the essence of Indonesian culture, or take the following account by a Vietnamese ethnographer concerning the "fundamental features of the Vietnamese mentality" which are alleged to include "unyielding valour, traditional love of learning, respect of letters and scholars, patience and tenaciousness in endeavours, endurance in the face of hardships, love or refinement and delicacy in daily life... aesthetic aptitude, ability for artistic creation" (Le Van Hao, 1972:31). Ronald Inden in *Imagining India* (1990) argues that both Europeans and Indians participated enthusiastically in the creation of timeless "collective essences" for Indian culture. This creation of national stereotypes by Asians themselves – a new form of Orientalism – usually tells us more about the imperatives of modern nationalism than about these various "unique" cultures, and is a subject that demands further investigation.

Given the nationalist stress on "uniqueness" it may seem strange that the general idea of "Asia" even survives. But "Asianness" retains its original political appeal in trade negotiations with the West, or when Singapore's Prime Minister wishes to defend his government's restrictions on press freedom against supposedly Western critics. In late 1990 Lee Kuan Yew nonchalantly asserted that: "Asians are in little doubt that a society with communitarian values where the interests of society take precedence over that of the individual suits them better than the individualism of America." This contrast invokes two stereotypes, the allegedly communal East and the supposedly individualistic West. Both are equally faulty. Asia itself is just as easily disaggregated. When Japanese businessmen encounter "argumentative" and "rigid" Indians they are inclined to see them as "Occidentals" and to argue that Asia stops at the borders of Burma. So Asia is as much a political as a cultural idea, which does not mean it has no significance for anthropologists.

The use of the term Asia can be extremely misleading if it is used to denote some sort of cultural uniformity throughout the geographic area. There is no doubt that China has influenced Vietnamese culture more than French culture, that India has influenced Bali, or Sri Lanka Thai Buddhism. But the survey of Asian societies and cultures provided by this book should make it clear just how diverse and complex Asia really is. Asia, of course, has been broken down into smaller regional units, such as South Asia overshadowed by Indian civilization,

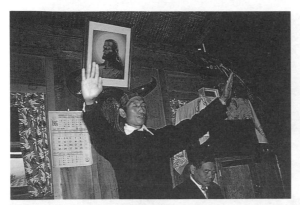

A Kachin Christian preacher in Burma.
Courtesy of Hseng Noung Lintner.

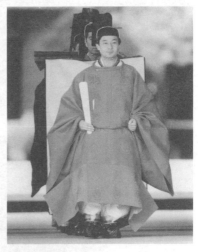

Japan's Prince Naruhito is installed as
heir apparent at a Shinto ritual.
Courtesy of Japan Information Service.

Head Mahayana
Buddhist monk,
Ho Chi Minh City,
Vietnam.
Courtesy of Sarah Lock.

A Theravada Buddhist monk
in the Dai region of
Southern China "indulges"
in a pipe.
Courtesy of Jean Berlie.

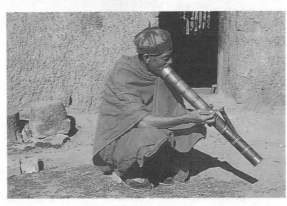

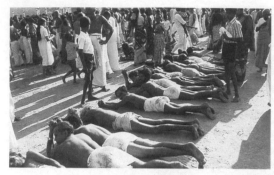

Tamils in Hindu festival in Jaffna.
Courtesy of Rodney Tasker.

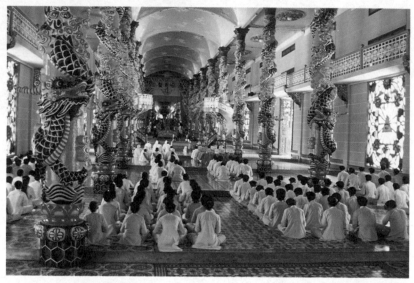

Cao Dai Temple, Vietnam.
Courtesy of Kelvin Rowley.

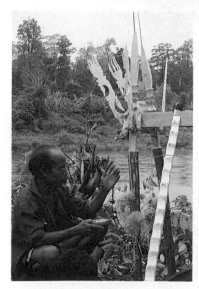

The Sedang people of the Annamite Cordillera worship local spirits.
Courtesy of Grant Evans.

East Asia by Chinese civilization, and Southeast Asia which is seen to accommodate mainly Indian influences but on a basically independent cultural complex built, among other things, on a proto-Austronesian linguistic base, a similar material culture, and a higher status for women compared with the other two areas (Reid, 1988). These broad **Culture Areas** have some intellectual attractions, and they will be used throughout the book. But it will become clear that these are large generalizations whose value for understanding the details of individual societies and cultures are limited. We strike similar problems with generalizations even when we deal with individual countries for all of them are culturally and linguistically diverse. To speak of "the Chinese", "Filipinos", "Indonesians" or "Burmese" is always a simplification. This fact alone throws up important questions concerning the very idea of culture which has been a central anthropological concept to date.

Our discussion of what "Asia" is has been our first lesson in anthropological understanding. It has shown us how what is an apparently familiar and clear idea, namely Asia, is not what it seems. It has shown us that much of what we take for granted and eternal are human creations, including the idea of natural nations. Our reflections should make us wary of all generalizations, whether they are about "Asians" or about "Thais", or indeed about even smaller groups found within individual countries, such as the Punan of Borneo. They should also make us wary about generalizations concerning "The West".

What is Anthropology?

Above all else anthropology is interested in the diversity of humankind. It studies the evolution of humans, the various societies and cultures created by humans throughout history, and the diversity of human societies in the world today. Anthropologists, therefore, are a species of **comparative sociologist**. In pursuit of diversity anthropologists, most of whom are from comfortable social backgrounds, sometimes go to remote areas such as the hills of northern Thailand to live with peoples whose language and customs are radically different from their own, and in conditions which are rudimentary in almost every material respect. Others, however, stay at home and investigate the various groups and cultures which make up their own society. Still others, whose major interest is human evolution, may find themselves cooperating with archaeologists in excavating and interpreting the remains of defunct societies, or spend their time in the wild observing primates, such as orangutans in Borneo, in an attempt to understand what is unique about *Homo sapiens*.

Because of anthropology's concern with comparison and diversity all modern anthropologists are on guard against what is called **ethnocentrism**. Ethnocentrism is the belief that the organization and cultural practices and assumptions of one's own society are not only "normal" but also the best. At its most extreme ethnocentrism sees the practices or beliefs of other people as not only strange, but as repulsive and "inhuman" or "barbarian". Where people with ethnocentric beliefs hold power they have often tried to stamp out the practices of other cultures and force them to accept their own beliefs and practices. This regularly happened during the colonial era, and it still occurs in modern states where ethnic or

religious majorities attempt to convert minorities, often while claiming that they are simply trying to "civilize" them. Indian administrators, for example, are likely to refer to the subcontinent's tribal minorities as "innocent children" who require paternal direction.

A working assumption of anthropologists, therefore, is that no culture or social organization is automatically superior to another. This approach, often called **cultural relativism**, has the virtue of trying to evaluate each culture on its own terms. It attempts to understand the internal logic of particular societies and their cultural ways of thinking. Each culture, in other words, has its own rationality and anthropology argues that this must be grasped if we are to understand the workings of that society.

The major strength of this approach is its emphasis on field research and the gathering of a wide array of empirical data from individual societies, which in turn allows an accumulation of possible sources for comparison. But it also throws up dilemmas.

The first is, does cultural relativism translate into moral relativism? For example, when anthropologists analyze headhunting and the brutality which often accompanies it should they be aloof? Or, when they analyze the current indignities inflicted on humans by the caste system in India, should they ignore them? Or, when **feminist** anthropologists examine gender inequalities or the binding of womens' feet in pre-modern China, can they be indifferent? The dilemma can be seen clearly in the clash of cultures brought about by colonialism. The British colonial administration in India, for example, attempted to suppress the practice of *suttee*, that is the immolation of a widow after her husband had died. A British colonial officer in the 1840s responded to a high-caste Brahman's argument that *suttee* was a national custom: "My nation also has a custom. When men burn women alive, we hang them....Let us all act according to national customs!"

Most modern anthropologists would reply that understanding does not add up to an endorsement of, for instance, foot-binding or *suttee*. They would argue that the stance of relativism is a *methodological* one essential to fieldwork. It is also essential if one is to grasp the logic of culturally strange practices. Dorothy Stein, for instance, examines *suttee* in the context of the low status of widows in traditional India (1978). In Chapter 10 Christine Helliwell brings the analysis forward to look at the phenomena of "dowry murders" by immolation in India. In these cases it is clear that intellectual understanding does not commit the anthropologist to moral relativism, although some anthropologists would maintain that it does.

Fortunately, most anthropologists are not faced with such stark moral choices as with *suttee* or foot-binding. Often, however, they are confronted with state policies which amount to a form of "ethnocide", that is the destruction of a minority peoples' way of life either directly or indirectly through the political, cultural, or economic policies of particular states. Indiscriminate logging in Borneo which destroys the forest ecology, accompanied by state policies to settle "nomadic" hunter-gatherers has had a devastating impact on the Punan way of life. What are the moral issues here? Should anthropologists become advocates for these people, or just observe their disintegration? On the other hand, should they work with the states carrying out "development" projects, if only to ease the trauma of development for peasants or marginalised peoples? Some of these difficult issues are tackled by Jesucita Sodusta in Chapter 13 on applied anthropology.

Anthropology as Social Science

The issue of relativism is a difficult one because it often seems to imply that humans are so locked within their cultural values that they are unable to understand another culture. If this is true then anthropology is impossible as a science. Some anthropologists in fact reject scientific explanation as the aim of anthropology and argue that its practice is closer to a form of fictional literature which can, of course, convey understanding of humans even if it does not aim to explain them (Clifford and Marcus, 1986). Clifford Geertz (1984) rejects a simple-minded relativism, yet at the same time resists what he views as the *absolutist* claims of science. He sees instead the continual discovery of new anthropological data spurring on the supercession of previously useful theoretical **paradigms**. His argument, at the very least, is a strong defence of methodological relativism, yet it does not necessarily commit the anthropologist to epistemological relativism.

Many social scientists have difficulty with the idea of science because it conjures up in their minds a picture of a chemist working with test tubes or a physicist with complicated equations. Social scientists therefore assume that if they are to be scientists then they should be doing something similar. Social scientists also live in the shadow of the greater prestige of the "hard sciences", as they are sometimes called, and perhaps this is to be expected as the achievements of *some* fields of physical science in the twentieth century have been spectacular. It is unlikely that the social sciences can ever deliver similar results. But it is also worth remembering that much physics is no more than highly abstract theoretical speculation.

Science is not a set of techniques, as many people seem to imagine, it is a commitment to a certain way of thinking about the world. And its history is as messy and as complicated as any. Jarvie writes: "There is the historical fact that science is a living tradition, a set of customs, social institutions and personnel, sets of books, papers, documents and apparatus, and a great many errors, side-tracks, complete nonsense. This is real science and this is also rational science..." (1984:52). The Modern World, perhaps, tends to idealise science because for many people it is a new Messiah which promises absolute certainty and a solution to all of humanity's problems.

Science, in principle, is an open system of thought which rejects circular belief systems. It holds that knowledge can be accumulated because the various features which make up our world are related in some systematic way. If there is no system, or no order then there can be no science. Some relativists argue for idiosyncratic explanations, but these are scientifically untenable because they deny the principle that cumulative knowledge must be orderly and comparable. As Gellner writes: "If like conditions did *not* produce like effects, then the experimental accumulation of knowledge would have no point and would not be feasible. Only theories built on the assumption of symmetry and orderliness can be negotiated and applied" (1985:90). Some anthropologists have been wary of this idea of science because it emerged first in the West and they feel that its spread is a form of ethnocentrism. This is an understandable suspicion, not only by anthropologists but also by people in Asia who have experienced European racism, for example, under the guise of science.

It is important to understand, however, that the growth of scientific thought in

the West is as accidental as the emergence of capitalism in the West which carried the culture of science around the globe with it. A commitment to scientific reasoning could have emerged first in China or India for these societies at one time possessed more impressive bodies of knowledge than in Europe. But the fortuitous coming together of the various requisite elements did not happen there as in Europe. Nevertheless, the culture of science has been easily adopted elsewhere, though some would argue that it has been easier to export the products of science, such as television, than its rationality. Science, unlike many previous bodies of thought, is not exclusive. "Scientists are not priests administering mysteries, despite occasional resemblances in their guild organization and enigmatic style of utterance. Science is an activity open to all who will master it, not surrounded in any essential way by initiation ritual, and taking pride in exposing all of its ideas and their backing to public scrutiny, both expert and lay...the mission of science is consciously democratic and egalitarian" (Jarvie, 1984:107).

This, however, presents a far too rosy view of science today. As sociologists of science have pointed out science does not occur in a vacuum and it is subject to many social, economic and political constraints in the modern world, not unlike the ancient world. Imperial China, for example, made major advances in astronomy, but its main social function was astrological in a world in which things on earth were believed to have a counterpart in the heavens. Able to foresee dangers to the emperor court astrologers were in a politically strategic position, and for this reason the findings of these astrologers were treated by many emperors as state secrets. "Leaks, which might get into the hands of the opposition, were regarded with as much concern as official secrets are by contemporary governments." (Merson, 1989:39) The mechanical clock, so fundamental to later technological and industrial developments in Europe, remained similarly constrained, and finally fell into disuse until reintroduced to China by European Jesuit missionaries in the sixteenth century.

As for modern science, a recent anthropological study of one of Australia's leading medical research institutes discovered that the institute had its own distinctive rituals, heroic stories and sustaining myths. "It certainly has its own way of forming and educating (socializing) its members and its own strict rules for deciding who are 'good' scientists and who are 'bad', who are 'in' and who are 'out', who are worthy of being funded and who are not. In other words, it is a small sub-culture all of its own. Or, one can say that it is a distinctive 'life-world' – a complex set of beliefs, attitudes, practices, relationships, and networks which make science possible" (Charlesworth *et al.*, 1989:3). What these researchers discovered in their study of the institute was that science was not a simple impersonal process, but one that involved considerable politicking not only for funding from governments or private industry, but also among scientists themselves. Their study, however, aimed to *demystify* science rather than debunk it. That is, their demonstration that science is also a social process may challenge modern myths about "cold", "hard" science, but it does not thereby, reject the achievements of science.

Modern science and technology may be constrained by funding, by secrecy and by profitability, and some of its practitioners may choose to act like a priesthood. But these observations do not disprove the aims or claims of modern science – they simply make it imperative that all claims to accuracy or authority be scrutinised not only for logical consistency but also for biases resulting from

social, political or economic influences. It is important to recognise, however, that even questioning the social relativity of claims by scientists only makes sense within a framework that already accepts scientific forms of rationality. As anthropologists and historians have shown, other forms of rationality, some religious ones for example, assert pre-ordained truths which may prescribe serious punishments for any questioning of those truths; or an acceptance of the complete relativity of truth, such as among many stateless societies where there are no central arbiters of "truth". Maurice Godelier has argued that different societies structure perception differently because of the arrangement of institutions and functions within them. For example, there is a close intermeshing of kinship or religious relations and the economic structure of society in so-called tribal societies. "In some societies, including our own, there are distinct institutions corresponding to these distinct functions. But this is an exception rather than the rule – an exception that has enabled Western thought [historically] to perceive with greater clarity the role of material activities and economic relations in social evolution, that is, the material and social relations which men enter into in their active appropriation of nature" (1986: 141–2). It is therefore more possible for science to be a generalized body of thought in complex modern societies. Anthropology is an offspring of this belief in a scientific culture.

Anthropological Comparison

Humans spontaneously compare their own cultures and societies with those of others. It is one way awareness of one's own cultural practices is produced. Arguably, international tourism and travel is expanding human points of comparison (Chapter 15). But awareness of difference is also a basis for prejudice, as we are reminded everyday by ethnic jokes retailed around the world.

Anthropologists, in a sense, make a science or at least a profession out of what most people do unreflexively. That is, they have tried to develop concepts not only for understanding the differences between cultures, but also their similarities.

The trademark of early British evolutionary anthropology was broad ranging global comparisons. These anthropologists were familiar with an astonishing variety of ethnographic data, mostly derived from books rather than fieldwork. The long-running anthropological best-seller, *The Golden Bough* (1922) by Sir James Frazer, is in this genre. Unfortunately the technique employed by these anthropologists consisted of collating superficially similar beliefs and practices in accordance with an *a priori* theory they already held about "primitive" societies. These social evolutionists simply selected the facts that were most convenient to their theories, regardless of context. A consideration of context, however, would often show that superficial similarities in symbolism, for example, signified different meanings in different societies.

This was one reason why later anthropologists rejected social evolutionism, and its theory that all societies pass through inevitable "stages" of evolution. They criticised the evolutionists for ripping facts out of context in order to make evolutionary comparisons. In America the revolt was led by Franz Boas who popularised the idea of cultural relativism, whereas in England rejection took the form of **functionalism** under the leadership of Bronislaw Malinowski and A.R.

Radcliffe-Brown. These streams were united by their claim that aspects of cultures must be understood in their social context and cannot be deduced from grand evolutionary themes.

This reaction to evolutionism led, as often happens during major theoretical shifts, to an over-correction so that in the case of British social anthropology historical explanations were neglected, or sometimes dismissed. If there were elements of the past in the present, they argued, then it must be because they still have a function in the present and therefore can be explained by reference to the existing social structure. As for Boasian inspired cultural anthropology emphasis on cultural context and meaning reigned supreme and gave birth to some of the strongest versions of cultural relativist epistemology.

Both approaches placed obstacles in the path of comparison, for if features of cultures and societies were explicable exclusively by context then features from other social and cultural contexts were, strictly, incomparable. Social anthropologists got around this problem by using the abstract idea of social function, that is by explaining, for example, the presence of similar kinship structures in different societies with reference to the political or economic functions they fulfilled. But the stress by cultural anthropologists on context bound meaning, on inter-subjectivity, meant there has generally been a strong resistance to comparison in this tradition. Interestingly, however, most anthropologists engage in comparison regardless of their stated theoretical position – which in itself attests to the importance of comparison for anthropological work and human understanding.

There are, nevertheless, very real theoretical problems involved in cross-cultural comparisons. The key issues are: first, establishing the level of abstraction at which an analysis will operate, and second, attempting to ensure that one does not fall into the old trap of indiscriminate comparison. By paying attention to the first problem one can normally avoid the second.

For example, anthropologists and other social scientists talk about "the economy". At first sight such an idea seems straightforward. But "the economy" is a high level of abstraction by which we normally mean something like how people produce their livelihood, yet societies do this in many ways. Some anthropologists have adopted the conceptual abstractions developed by marxist theory in their attempts to talk about the economy at different levels of abstraction. For example, they use the terms **means of production** to refer to the raw materials and technology of production – such as land, hoes or machines – and **relations of production** to refer to how these means are distributed among particular groups of people. One can only operationalize these concepts at lower levels of abstraction. So, for example, if we decide to study a group of Hmong hillpeople in northern Laos we will find that their economy is based on no fixed ownership of land because they practice shifting cultivation using hoes, that rights over land are held by large households of kin, and that the village domain is usually dominated by one or two clans. The interpenetration of "the economy" and kinship is so close that it is almost impossible to talk about the economy without also discussing kinship because kinship here defines relations of production. This is not true for an analysis of modern economies where there is often private, or privately incorporated ownership of means of production – factories and finance companies, for example – accompanied by large scale lack of ownership of these means. One can largely analyze modern economies without discussing kinship. Yet we can still use the abstraction "the economy" to compare the similarities and differences

in modes of economic organization, so long as we pay attention to the level of abstraction at which we discuss economic issues. We may, for example, compare productivity in economies with similar levels of technology but discern that the social organization of the economy leads to the production of surpluses in one whereas in the other a different form of social organization does not require surplus production.

There are other conceptual approaches to the economy used by anthropologists and these are discussed by John Clammer in Chapter 6. As can be seen there, one of the main ongoing disagreements among economic anthropologists is the extent to which concepts developed for analyzing modern capitalist economies can be used to understand tribal or peasant economies, and to what degree economies are "embedded" in social organization and influenced by cultural values.

Similar problems of comparison and formulation of conceptual abstractions apply across the spectrum of anthropological inquiry. It is clear that abstract concepts like the economy or religion are necessary, but researchers also have to be aware of the need to add caveats and qualifications to these concepts as they move from one level of abstraction to another.

It has been suggested that anthropology is most persuasive when it attempts "intermediate level" comparisons. By this is meant comparisons between societies and cultures which are in a similar Culture Area, or influenced in important ways by similar forces such as, for example, Buddhism or Hinduism or Confucianism. In this way cultural content is not likely to be eclipsed by cultural form (Kuper, 1980). That is, there is more likely to be a similarity in cultural meaning for the peoples being studied if one looks at spirit mediumship among Burmese speaking Buddhists and Lao speaking Buddhists, than if one considers spirit mediums among Burmese Buddhists and Filipino Catholics. The problem of comparing religious practices in Asia is tackled by Nicholas Tapp in Chapter 11.

Insiders and Outsiders

A fundamental assumption of anthropology, therefore, is that cross-cultural communication is possible, and that human cultures are mutually intelligible. Opening his classic study *The Political Systems of Highland Burma*, Edmund Leach writes:

> *I assume that all human beings, whatever their culture and whatever their degree of mental sophistication, tend to construct symbols and make associations in the same general sort of way. This is a very large assumption, though all anthropologists make it. The situation amounts to this: I assume that with patience I, an Englishman, can learn to speak any other verbal language – e.g. Kachin. Furthermore, I assume that I will then be able to give an approximate translation in English of any ordinary verbal statement made by a Kachin....I assume that I can, with patience, come to understand approximately even the poetry of a foreign culture and that I can communicate that understanding to others. In the same way I assume that I can give an·approximate interpretation of even non-verbal symbolic actions such as items of ritual. It is difficult entirely to justify this kind of assumption,*

but without it all the activities of anthropologists become meaningless.
(Leach, 1970: 14–15)

This statement is equally true for an Indonesian, a Thai, a Chinese or any other person wishing to practice anthropology among people belonging to a different culture.

In recent times, however, there has been considerable discussion about whether "indigenous anthropologists" are better able to study their own societies than outsiders. The "outsiders" in this discussion are usually thought to be Westerners. The reason for this is that anthropology historically has been mostly practised by Westerners, and this continues to be true. But in the last two to three decades there has been an important growth in anthropology and sociology in Asia, and we have seen the establishment of anthropology/sociology departments in most Asian countries, and the training of a significant number of students. This has led, not surprisingly, to a growing number of anthropological studies of Asian societies by indigenous scholars. Few of these scholars, for reasons of finance mainly, have studied other Asian societies or turned their attention to the West, although there have been some important examples of both.

The argument for indigenization runs along the lines that, for example, a Sri Lankan scholar is better able to study Sri Lankan culture than say an Australian scholar. This is because the Sri Lankan anthropologist already understands the language and having been brought up in the culture better understands many of its aspects. Some suggest that indigenous anthropologists will be treated as insiders more easily and comfortably than non-indigenous researchers (assumed to be Western). Counter arguments have run along the lines that language proficiency can be acquired by outsiders, that because they have not been raised in the culture they will therefore be less likely to take at face value many common sense assumptions and therefore be able to ask more penetrating questions about the culture, and less afraid to pose them. Furthermore, ethnic or class differences within societies may create important barriers to communication between indigenous scholars and ordinary people, compared with a more socially neutral outsider. Some aspects of this discussion have become quite complex, but it is important to understand that there appears to be no pure solution to the problem. This can be seen in the following opinions of indigenous Asian anthropologists about their research.

Koentjaraningrat is Indonesia's oldest and probably best known anthropologist. He is unusual inasmuch as he has done research in several culturally distinct locations: his home culture in Java, in West Papua (part of the Indonesian state), and in Holland. He writes of his fieldwork in Java:

I can consider myself to have a sufficient comprehension of Javanese culture; however, except for the language, which is of course my native tongue, that knowledge was almost totally irrelevant for an understanding of the community life of rural peasants...I experienced my study of those two Javanese peasant communities almost as if studying an unfamiliar environment in which I could not even take the basic cultural elements and value orientation for granted...By members of both communities I was placed as an outsider because, although I am a Javanese, I was considered to be one of a different and higher social class...I was part of my own subject

*matter but remained a stranger, and I was caught in this situation during
the greater part of my fieldwork. (1982:178)*

His work among Papuans was constrained by different factors, related this time
to him being a member of a dominant ethnic group within Indonesia. "I was
considered not only a genuine stranger but one who belonged to another nation
of colonizers, similar to the Dutch or Japanese. Throughout the whole period of
my fieldwork I felt an atmosphere of suspicion" (1982:180). Yet when he came to
study a Dutch fishing community in Holland he "succeeded in developing an
extremely good rapport with my respondents and informants" (1982:182).

Indian anthropologists have written at length on their experiences in the field.
Some have found themselves restrained by caste barriers, in particular those
erected around *harijans* or "untouchables", in a way, perhaps, that a non-Hindu
anthropologist would not experience. I say *perhaps* because veteran Japanese
anthropologist Chie Nakane felt herself so inhibited when she carried out fieldwork
in India. She writes of her experience there: "I felt that it was not wise to study
the family among lower castes in a village with the same degree of concentration
as I had bestowed on the upper caste. I was completely caught within a family in
which I worked, so that I dared not have contacts of a similar intensity with
another family of lower caste. In this respect I can very well see the difficulty
which Indian anthropologists must experience in the study of intercaste relations"
(1975:23).

Indian women anthropologists have sometimes found themselves constrained
by caste, class and gender. As Khadija Ansari Gupta explains (1979), her whole
family had to come together to decide whether she could carry out her research
among socially "undesirable" lower caste people. Happily she was allowed to
because of the strong support of her husband. M.N Srinivas, who among Asian
anthropologists was one of the first to examine the issues surrounding the study
of one's own society, remarks on how difficult it is for an urban middle class
Indian to get used to living among the unusual smells of the village, its discomforts
and its intrusiveness: "My worst complaint, however, was that I was never left
alone" (1979:23). Maybe one can think of this as the villagers unconscious revenge
on the anthropologist for the latter's intrusion into their lives!

Nakane was one of the first Asian anthropologists to study another Asian society.
In more recent times Indians like S. Seshaiah have reciprocated and gone to Japan.
He makes the interesting observation that, because of the importance of the English
intellectual tradition in India, he has little trouble understanding Western culture.
His encounter with other parts of Asia, however, is experienced as foreign. "Indians
who, influenced by fuzzy Indian travellers, imagine that since Buddhism was
adopted by these countries centuries ago, the culture of these countries has been
Indianized and is therefore easy to understand. This illusion has to be shed before
understanding can begin" (1979:233). Intriguingly he comments that he found
Japanese social structure confusing because of the *absence* of caste. "It took me
sometime to realize that I was reading too much of my Indianess into Japanese
society. At the same time, I also became aware that I would not make headway
with my work without bringing my Indianess into continuous comparison with
everything I studied. This operated at the conscious as well as at the unconscious
level. In fact I could not carry on interviews with villagers without their asking
me at some point in the interview, 'How is it in India?'" (1979:244) This, he says,
led to a sharper understanding not only of Japan but also India.

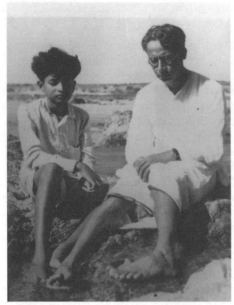

M. N. Srinivas during fieldwork in the village of Rampura, India, in 1948. With him is the headman's son.
Courtesy of M. N. Srinivas.

Chie Nakane, Japan's best-known anthropologist.
Courtesy of Current Anthropology.

Koentjaraningrat found research in his native Java more difficult than in Holland.
Courtesy of Current Anthropology.

Korean anthropologist Choong Soon Kim contrasts his experience of working in Korea with his fieldwork in the United States. In Korea he was forced to conform to Korean customs: "When I was allowed to talk to a young female, her parents would hang a curtain between us and an elder family member would remain in the room" (1990:197). In the United States where he studied relations between blacks and whites in the South he found that he had fewer problems than white American anthropologists. "My own access to each racial group in the South as a neutral person was, in contrast, tolerated and relatively tension-free, since I am neither black nor white" (1990:197). One can compare this with the experience of Indian anthropologist Triloki Nath Pandey among the Pueblo Indians in North America where the fact that he was an "Indian" and non-white assisted his research. Nevertheless, even after two years, he says he still felt himself to be a stranger.

This very brief survey of the experience of Asian anthropologists demonstrates that the anthropologists' relationship to the field is very complex and cannot be encompassed by ideas of "indigenous" versus "outside" anthropologists. Furthermore, just what constitutes inside and outside is problematic as Koentjaraningrat discovered among the "Indonesian" Papuans. Outsiders and insiders each have their characteristic strengths and weaknesses. Emiko Ohnuki-Tierney, a Japanese-American and therefore both insider and outsider when in Japan, summarizes aspects of these strengths and weaknesses:

> On the one hand, native anthropologists are in a far more advantageous position in understanding the emotive dimensions of behavior – psychological dimensions of behavior are hard for outsiders to understand. However, the intensity with which native anthropologists recognize and even identify the emotive dimension can be an obstacle for discerning patterns of emotion. As an endeavor to arrive at abstractions for "the native's point of view," if nonnative anthropologists have difficulty in avoiding the superimposition of their own cultural categories and meanings, native anthropologists have the task of somehow "distancing" themselves, both intellectually and emotively. (1984b:584)

As Kim suggests, the ideal situation is more-or-less one where both insiders and outsiders collaborate to cross-check each others findings.

Christine Helliwell points out in Chapter 10 that a similar debate has taken place among feminist anthropologists concerning the place of "insiders" (Asian women) and "outsiders" (Western women) with respect to the study of gender, and it has been equally vexed and inconclusive. She tries to set out different terms for the discussion of gender in Asia. While culture clearly affects the work of anthropologists they are probably, as a group, as deeply divided by theoretical differences as they are by cultural differences.

Emics/Etics

Emics and etics refer in a different way to the issue of insiders and outsiders. An emic statement is one made from the point of view of a social actor giving either their world-view or their opinion about a particular feature of their world. It is an insider's, or "native's" point of view. An etic statement observes the behaviour of

individuals or groups, and in a sense compares what actors say they do or believe with what they actually do. It has often been found that people say one thing and do another. The etic is an outsider's point of view.

These concepts have what theorists call a **heuristic** value. That is, they stimulate and help organize further investigation by anthropologists into, in this case, the relationship between thought and social action. Their use is premised on the fact that there are patterns in human action which are not conscious, and are done because people have been socialized into acting or thinking that way. Grammar is analogous. People use their own languages everyday and in inventive ways, but few of them can explain the grammar of their language. There are, however, some patterns about which people are more or less conscious, a fact which can blur the boundaries between emic and etic statements.

Barbara Ward, an anthropologist who worked among Chinese Tanka fishing people in Hong Kong, found she needed to construct a variety of what she called "conscious models" in order to understand the people she studied. Often when she asked the people in the village of Kau Sai why they follow a particular custom they answered: "Because we are Chinese". This she says was their conscious model of the social system which they carried in their minds in order to explain, predict or justify their behaviour as "Chinese". The problem begins, however, upon the investigator's realization that people in different locations of China have different ideas about what it means to be "Chinese". While these Tanka would often tell Ward that she was mistaken when she told them of customs in other parts of China because what the Tanka did was *really* Chinese, the surrounding Cantonese were loathe to recognize the Tanka as Chinese. There are, therefore, a variety of conscious models "a number of different Chinese ideal patterns varying

A fisherman in Hong Kong. For a long time other Chinese did not consider them to be Chinese.
Courtesy of Hong Kong Museum of History.

in time and space with varying historical development and the demands of particular occupations and environments" (1985:42).

The overarching model is a rather idealised version of Chineseness promoted by the traditional literati. This ideal, always incompletely known by ordinary Chinese, was what they aspired to but fell short of. Yet each group believed that the way they lived more closely approximated the ideal than any other neighbouring group which they observed. They constructed an observer's model of these other groups as distinct from the model they had of their own way of doing things which Ward called their immediate model. The Tanka were aware of the ways of the Cantonese, the Hoklo, the Hakka and Shanghainese, so when they gave up water-living the Tanka had at hand fairly useful working models of non-Tanka Chinese ways of doing things. Thus they carried in their minds several models. There is the ideal or ideological model of Chineseness, their observer models of other Chinese groups, and their immediate model of themselves which may vary considerably from other groups and from the ideal model. "Strictly speaking," writes Ward, "the only people who can observe differences between immediate models are outsiders (or social scientists); what a Chinese layman compares is his own immediate model of his own social arrangements with his own 'observer's' model of the other fellow's" (1985:51). Stated in another way, emically what the Tanka said was Chinese about their way of life was only related tangentially to what others (Cantonese, Hakka, etc.) emically believed to be Chinese. That this is so can only be constructed from an etic perspective.

But this heuristic strategy must be used carefully lest the anthropologist begin to believe that emic = subjective, while etic = objective. In practice, there is often substantial interpenetration of emic and etic perspectives. Thus, in the case of Ward's Tanka people it can be argued, as she does, that despite all the differences between various Chinese groups "they are undoubtedly all variations on one easily recognisable theme" (1985:42) and it is this which allows Tanka, for example, to blend fairly easily into Cantonese society. So there is considerable overlap between what is emically Chinese for the Tanka and what is etically Chinese.

Culture and Its Reproduction

It has often been thought that individual cultures are homogenous. Or at least many people speak as though they are, many academics write as if they are, and many states act as if they are. It is common for people to speak about "Chinese Culture" or "Filipino Culture" as if all the people in those societies think and act in the same way, when clearly they do not. We have already seen from our brief discussion of Ward's work the kind of confusions that can be generated by the use of a unitary or simple idea of "Chinese Culture". Other cultures are equally complex. It is hard to imagine how one could speak simply of Indian Culture given the ethnic and linguistic divisions in that country as well as the elaborate hierarchical ones of caste. Culture, at its most abstract level, refers to the human ability to use complex linguistic and non-linguistic symbols to transmit shared traditions and patterns of social interaction through time and space. Or as Sandra Bowdler writes in Chapter 2, it refers to those things which enable survival which

are not genetically inherited. But the abstraction, culture, is only manifest in empirical cultures.

Most modern anthropologists are aware that broad generalizations are of little use in understanding the workings of a particular society and prefer to see cultures as complex and often containing sub-cultures, the latter term usually being reserved for minority cultures within a larger dominant culture. Modern anthropology is alert to the fact that while people may participate in a culture which shares a broad set of symbols for communication, various groups and individuals in a society may interpret those symbols differently according to where they stand in a system of social stratification, for example, or their gender or ethnicity. But a major reservation that must be made about the use of a general concept of culture is that it can assume firm boundaries where they are in fact fuzzy or fluid, and it may divert analytic attention away from important relationships which cut across cultural boundaries. This problem is especially acute in the analysis of ethnicity for, as Leach pointed out many years ago in his study of Burma, people often participate in several ethnic cultures simultaneously. A related point is made by Barbara Ward in her analysis of "Chineseness".

Anthropology cannot do without the concept of culture, but modern anthropologists must beware of **reifying** it. That is, of allowing the concept to take the place of the empirical reality for which it is designed as an explanatory device. Culture can be used at different levels of abstraction, but these always need to be specified; and the detailed description and analysis of specific peoples and their cultures has always been anthropology's strength.

But at whatever level of generality the concept of culture is used we are always faced with two theoretical problems:

1. How do cultures reproduce themselves over time?
2. How can we explain cultural change?

For continuity anthropologists and sociologists have used the concepts of **enculturation** or **socialization** to explain the acquisition of culture, usually by infants and children. Family members in all societies play a key role in this process, teaching their children how to speak and how to adopt the manners and roles considered appropriate to their age and gender. It is clear, however, that socialization is something which occurs throughout life. The Fried's, whose original fieldwork was in Taiwan, in their book *Transitions* (1980) compare the rituals associated with birth, puberty/adolescence, marriage and death in several cultures. All known human societies observe these "rites of passage", but there are significant variations between cultures in the importance or the attention given to each. For example, some have elaborate funerals, some simple ones. But each transition sanctions new modes of behaviour and new statuses for individuals at different stages of their lives. Juniors become seniors, and instead of giving deference receive it, young women become wives and then mothers, and so on. Socialization is sometimes also carried out by peers or age-groups, by religious organizations or by armies, or increasingly by schools, where, in the modern world, children are sometimes taught ideas which conflict with those of their families. These institutions – families, armies, religions, schools – are bearers of cultural "traditions" and they attempt to pass these on to each succeeding generation. Thus it often seems that societies are machines for reproducing human and cultural replicas of the past.

Chinese parents teach their children to worship at their local temple.
Courtesy of South China Morning Post.

Socialization naturally opens up the debate concerning **culture and personality**. That is, the extent to which human personality varies between cultures, and how personality is viewed in different cultures. The theoretical problem in this discussion is, how much does culture determine personality, or conversely how much does human personality or psychology determine the features of a culture? It also raises a subsidiary problem, whether people in particular cultures can be said to have a general personality disposition, especially given that we have already questioned simplistic ideas of unitary cultures.

It is sometimes said that villages are more culturally homogenous than modern, urban, complex societies. It is tempting to jump from this assumption to say that people in villages are also psychologically more uniform. But certainly in my experience, and I know this holds for most anthropologists, one cannot help but be struck by the range of personalities one finds in a village context. Some individuals are quieter than others, some more boisterous, some more surly, some more friendly, some more funny, some more depressed, and so on. But, of course, each of these tendencies may be more or less culturally valued. In some cultures it is more valued to be self-effacing, in some more boastful. The latter type of person in the former society will be disliked by many people there, and vice versa.

Anthropologists who have tried to use concepts derived from psychology, or psychologists who have attempted to delve into anthropology have often been tempted to talk of "modal personalities", or the most prevalent personality types to be found in a particular culture. Herbert Phillips attempts to do this in his *Thai Peasant Personality* (1965). But Phillips criticises those approaches which assume what he calls "psychological *unimodality*; that is, an assumption that the culture being investigated has such a high degree of psychological homogeneity that it can be portrayed as having a *single* personality pattern, with perhaps a few deviant

sub-types" (1965:140). He also rejects the idea that there are no prevailing personality traits in a society. He argues that there are likely to be specific aspects of personality which have a high degree of homogeneity because they are surrounded by strong cultural sanctions, and are associated with the greatest cultural conditioning. In Thai society, he finds, these are closely associated with authority in what has been a strongly hierarchical society. Thai attention to social deference to superiors in language and etiquette, and their concern, indeed anxiety, about public performance is symptomatic of this. Here one is reminded of Geertz's comments on Balinese fear of "stage fright" lest they botch their performance when interacting with others. (Geertz, 1973:402) Such concern with "face" is also considered typical of the Chinese. But where cultural sanctions are not so concentrated, as among friends with the Thais, one finds greater spontaneous variation.

Anthropological arguments concerning personality tend to be "culturalist" rather than "psychologistic", as can be seen by Phillip's argument. What is modal in Thai personality is determined by a social structural emphasis on authority. Barbara Ward exemplifies this style of argument in her analysis of temper tantrums among boys aged five to ten in Kau Sai. She was struck by the way they were left to scream themselves out and given no comfort. She relates this pattern of socialization to the need to play down aggressiveness among people who have to live in extremely crowded conditions. (1985:173–86) De-emphasis of aggression is therefore adaptive to the social structure. Margery Wolf makes a similar point in her discussion of "Child Training and the Chinese Family", but places it in the context of the extremely complex tensions which exist in Chinese rural families in Taiwan. These revolve around different interests in maintaining a unified joint family by the various brothers and their in-marrying wives. "If the brothers and their wives are on good terms, they do not want to endanger these good relations by disciplining one another's children; and if, as is more common, their relationship is brittle but still operative, nothing could more quickly open (or re-open) hostilities than a fracas between the wives over the misbehaviour of a child" (1978:236). Also, the fact that males tend to stay at home whereas females marry out influences interpersonal relations between the parents and the children. Fathers became distant and stern with their sons, whereas warmer relations were had with the daughter who would leave and therefore not impinge on his authority. Conversely, mothers who are outsiders attempt to consolidate their position in the family by establishing a special emotional relationship with their sons.

In this way anthropologists have emphasized the impact of social structure, kinship and other aspects of social organization, on socialization and personality formation. Obviously, one implication of such an approach is that a culture's "modal personality" will change as that society changes. But the nature and speed of this change is obviously highly complex, and is still under-researched. Margery Wolf, for example, asserted that "as long as power is vested in the senior generations of a family (i.e. the grandparents) child-training practices will change more slowly than other aspects of culture" (1978:223). But we have few examples of research into the impact of modernization on the cultures and personalities of the people of Asia, and the work on cross-cultural psychology in Asia has made little progress. A volume on Chinese psychology (Bond, 1986), for example, is puzzled to the point of intellectual immobility by the fact that it cannot find an invariant psychology among the vastness of the Chinese people.

Earlier I remarked that anthropologists need to beware of reifying cultures, and perhaps it is this tendency which has meant that we have so few studies of the process of change. One of the most celebrated and subtle analyses of the cultural context of personality in Asia, Clifford Geertz's essay, "Person, Time and Conduct in Bali", can be said to be guilty of such reification. He set out to examine "the cultural apparatus in terms of which the people of Bali define, perceive, and react to – that is think about – individual persons" (1973:360). Through an examination of cultural symbolism he argues that there is a tendency towards the "immobilisation of time", the depersonalisation of the individual, and the theatricalisation of everyday intercourse. Geertz's discovery of a "timeless" culture largely results from his emphasis on the ritual aspects of Balinese culture. As Maurice Bloch writes, it is "a recurrent professional malpractice of anthropologists to exaggerate the exotic character of other cultures. Only concentrating on the picture of the world apparent in ritual communication may well be due to this tendency, and it obscures the fact of the universal nature of the part of the cognitive system available in all cultures" (1977:285). Bloch is referring to a universal awareness of change because of human biological growth, decay and final death. All humans are acutely aware of the latter however much they may care to "deny" it in the realm of cosmology. Of course Geertz knows this, but he does not emphasize it, thus he leaves the impression of a totally unique Balinese way of perceiving humans. And the picture of cultural and personal timelessness that he paints cannot help but shift the anthropologist's attention from change to continuity.

The transmission of culture, however, is problematic and is neither simple nor painless. There are many tensions within the process which, given certain conditions, may even generate rapid social change. Historical sociologist Barrington Moore, with the chilling realism born of his wide knowledge of human societies in the past and the present, observes:

> The assumption that cultural and social continuity do not require explanation obliterates the fact that both have to be created anew in each generation, often with great pain and suffering. To maintain and transmit a value-system, human beings are punched, sent to jail, thrown into concentration camps, cajoled, bribed, made into heroes, encouraged to read newspapers, stood up against a wall and shot, and sometimes even taught sociology [and anthropology]. To speak of cultural inertia is to overlook the concrete interests and privileges that are served by indoctrination, education, and the entire complicated process of communicating culture from one generation to the next....(Moore, 1967:486)

In this sober overview Moore highlights the coercive aspects of culture and the fact that people do not voluntaristically choose their cultural values.

Values and beliefs are often intimately bound up with particular social and political structures and **legitimize** those structures – whether they are chieftain-ships, imperial bureaucracies, or modern states as Paul Cohen demonstrates in Chapter 7, or as Grant Evans shows with reference to caste and class in Chapter 8. When these structures change either through some process of internal evolution or revolution, or due to intervention by a more powerful society, these values and beliefs also undergo transformation. The broader processes which cause cultural change are usually ecological, economic or political.

The Anthropological Imagination

The inventiveness demanded by the anthropological imagination requires not only a flexible and creative use of concepts, but often demands imaginative leaps by anthropologists when attempting to understand other cultures and societies. This striving to grasp the rationality of other cultures or sub-cultures and to understand the working of various social structures is a defining feature of anthropology.

More than any other discipline in the social sciences, anthropology continually wrestles with how to reconcile the universal aspects of humankind with its multifarious cultural manifestations. One result has been a more continuous dialogue between anthropology and biology than one will find among sociologists. It entails a greater interest in human evolution, as can be seen in Sandra Bowdler's chapter for example, or the cultural consequences of the physical differences between men and women. There has also been an ongoing dialogue with linguists who are equally pre-occupied with the universality of language alongside the bewildering array of specific languages they find distributed among human populations, as Amara Prasithrathsint demonstrates in Chapter 3.

The scope of anthropology, therefore, is vast – perhaps too vast. Edmund Leach, for example, argues that anthropologists have been misled into assuming "that the object of anthropological enquiry was to understand the nature of man rather than the nature of human society" (1982:29). Others disagree. Robin Fox, standing at the opposite pole from Leach, argues for a "biosocial anthropology" which is a branch of evolutionary biology. (Fox, 1975a). These theoretical divergences are almost inevitable in a field which continuously tacks back and forth between universal and particularistic propositions. Different anthropologists are likely to take their bearings from any point across this spectrum, partly depending on their own biography and theoretical training, the people they study and the problems they wish to solve. It is hardly surprising that there are periods in anthropology when much debate is organized around a specific set of problems which are partly a result of fashion and the requirements of academe (the arena in which most anthropological theorising goes on), as well as being an outcome of the problems thrown up by fieldwork and broader political and social developments in the world. The Vietnam War, for example, generated an intense debate among anthropologists concerning the ethics of research. Theoretical developments, as we have already observed, do not take place in a social vacuum, and perhaps one could even argue that these shifts in emphasis are an indispensable part of the growth and renewal of knowledge.

One of anthropology's main concerns in the past few decades has been to re-orient its historical evolution away from being predominantly a study of "primitive societies". This was an outcome of its initial growth in the West. European colonialism in Africa and Asia, and American "internal colonialism", opened up new fields for investigation, and evolutionary theory caused attention to be focused on "primitive" or pre-state societies (Kuper, 1988). The major early pioneering works of anthropology were, therefore, on Adaman islanders (Radcliffe-Brown), on Trobriand islanders in New Guinea (Malinowski), on the Nuer in Africa (Evans-Pritchard), on the Tikopians in the Pacific (Firth), and on American Indians or Eskimos (Boas and Kroeber). Just how much anthropology was caught up in the process of colonial domination is debateable (Asad, 1973), but the history of

colonialism clearly had an important impact on the evolution of anthropology as a discipline.

Most importantly, perhaps, it led to a clear division of labour between anthropology and sociology in the West: the former studied pre-modern societies, the latter industrial societies. Often this meant separate departments of anthropology and sociology, and out of this grew different intellectual traditions. But as Ernest Gellner observes, "The distinction between sociology and social anthropology is itself a social rather than a logical one" (1987:107). It is hard, he says, to find neat distinctions between subject or method, so that the boundary can only be sought "in the actual social structure, ethos and history of the two disciplines, and this moreover will vary from country to country" (1987:110).

Perhaps the most immediate difference between anthropology and sociology as it is practised in Asia compared with the West is that in Asia sociologists and anthropologists have often worked in tandem, and this is reflected in the fact that one finds many joint anthropology and sociology departments in the region. This has a certain logic as well. If sociologists in the West were the ones who stayed home to study industrial society and anthropologists were the ones who went out to study "primitive" societies, this hardly made sense in most of Asia. All of them, excepting Japan, until very recently were developing countries whose populations were predominantly rural peasants, with some hunter gatherers in the interior. Anthropologists and sociologists confronted largely the same reality.

There were differences between countries because of their colonial backgrounds. So, for instance, Indians studied English textbooks and went to English universities as postgraduates, Filipinos studied American textbooks and went to America for higher degree studies, while the Vietnamese looked to French ethnography and Indonesians looked to the Dutch. Consequently the colonial connection influenced the future evolution of the disciplines of sociology and anthropology in these countries. For countries like Thailand the strong political connections between Thai military rulers and the United States during the post World War II period meant that American intellectual influences were strong there.

Many of these students, quite naturally, imbibed the priorities and the prejudices of the traditions they were exposed to. Thus differences in the way Asian anthropologists or sociologists approached research partly grew out of the quantitative and macro stress one finds in Western sociology and the qualitative micro studies stressed by anthropologists in the West. Interestingly, the communist countries of Asia, primarily Vietnam and China, insist on a clear division between anthropology (usually termed ethnography) and sociology. This is partly a consequence of communist dogmatic adherence to nineteenth century evolutionary assumptions derived from Engels which commits anthropology to a study of primitive society.

Asian anthropology is also distinguished from Western anthropology by its greater interest in the sociology of development and applied anthropology. Koentjaraningrat, for instance, writes: "The study of problems of nation-building forces Indonesian anthropologists to cooperate closely with related disciplines such as sociology....the two sciences are now indistinguishable in Indonesia.... they share practically the same knowledge, concepts and theories; are interested in similar national as well as local problems; are concerned with urban as well as rural areas; and both utilize similar qualitative as well as quantitative methods" (1982:187). This convergence of interest, despite the different intellectual traditions

of sociology and anthropology in the West, springs from the fact that the pace of change in Asia makes the idea of studying a community or an ethnic group in isolation from broader developments even more untenable than it was in the colonial heyday of Western anthropology.

Evidence for convergence can be found elsewhere as well. Urban anthropology, as Patrick McGuinness shows in Chapter 12, attempts to deploy many of the methodological techniques that ethnographers have developed within a setting which has historically been considered the preserve of the sociologist; and as Joy Hendry shows in Chapter 14, the anthropological tradition can throw new light on the nature of social and cultural development in apparently hyper-modern societies like Japan. The differences between the disciplines will no doubt be sustained by all kinds of sociological forces, such as already established departments and the career interests which go with them, specialist journals and professional associations, and so on, which only goes to show that anthropologists and sociologists are as human as the people they study. And one could argue in a similar vein to what has already been suggested earlier, diversity may be a vital precondition for the growth of social scientific knowledge.

Anthropologists in the world today have many different and sometimes conflicting interests (Ortner, 1984). They, like the rest of the world, appear to be splitting up into smaller and smaller specialisms. Robin Fox, for one, laments this fact calling it "frantic fragmentation...*not* healthy specialization: that can only take place in a science that already has a central theory within which to specialize" (1985:30). But a peculiarity of the social sciences compared with the physical sciences (from where Fox derives his paradigm of scientific practice) is that anthropologists are part of what they study, and therefore their work is subject to even greater social and historical "interference" than other sciences. What is cumulative in it can rarely be arbitrated once and for all, but must be continually contested. This, of course, is frustrating for those who want final solutions, but it is doubtful that any science can offer them. On the other hand, one may want to argue that the forces of convergence referred to above are pulling against those pressing towards fragmentation.

For anthropologists and sociologists in Asian countries who are surrounded by poverty and who face the steep ascent of economic development some of the preoccupations of Western anthropologists probably look like the frivolous activities indulged in by the affluent everywhere, and ones they cannot afford. In some cases they are undoubtedly correct. But for as long as there is no royal road of science along which all thought must travel then what may now look like sidepaths may in the future produce important insights into human cultures and societies in Asia and elsewhere.

Anthropology remains marked by its Western genesis, but this is rapidly fading. The strong contrast between primitive and modern, or East and West, which organized much earlier thought is being bypassed by modern researchers. Even the study of kinship, long considered the hallmark of anthropology's contribution to modern knowledge, has not escaped unscathed. A recent major work by Jack Goody, *The Oriental, the Ancient and the Primitive* (1990), is devoted to demonstrating that the basic structures of domestic groups in the East and the West are much more similar than presumed in the past. This re-orientation in kinship studies is carefully surveyed by Clark Sorensen in Chapters 4 and 5. Other contrasts are also collapsing: reports in 1990 of mass exorcisms in San Francisco

during Halloween led by "Prayer Warriors", underline the fact that there is a "mystic West", just as Singapore's sometimes austere modernism demonstrates there is a "rational capitalist" East. The expectations of simplistic modernization theory have been confounded by developments both in the West and in the East and the cold "disenchanted" world expected by Max Weber has not emerged. In the interstices of large complex societies, the favourite haunts of anthropologists, people attempt to construct meaningful lives with whatever material they have available to them. It is the task of anthropologists to try to understand this human ingenuity wherever it is found, East or West, in the cities or in the countryside.

Asia's Cultural Mosaic introduces readers to the various human lifeways of Asia. Readers will notice some divergences among anthropologists in the following chapters. This is deliberate, for while *Asia's Cultural Mosaic* is designed as a textbook, and although each author is aware of what other contributors have written and tried to adapt accordingly, each has retained an idiosyncratic emphasis. This range, we believe, is healthy as it provides an accurate introduction to anthropology as it is practised in Asia today.

2 ASIAN ORIGINS

Archaeology and Anthropology

Sandra Bowdler

One hundred years ago in Java, a young Dutch scientist who had given up a post at Leiden University to sail to the East Indies, discovered a human thigh bone with a pathological disfigurement. This was one of the most important discoveries ever made for the understanding of human evolution. The man was named Eugene Dubois, and he had arrived in Sumatra in 1887, with the specific hope of discovering the "missing link" between the mutual ancestors of apes and humans. The thigh bone found at Trinil on the Solo River joined a skull cap and molar which Dubois had attributed to a human precursor. The significance of the thigh bone was that it showed that this creature walked upright like a human, and thus Dubois named it *Pithecanthropus erectus:* the ape-human which walked erect.

In 1859, Charles Darwin published *The Origin of Species*. He argued that species came into being by a process of change called evolution, which worked by natural selection. This theory is quite simple, although it has been much misunderstood. Darwin argued that in any given species, individuals vary in many, often small, ways. More individuals are born than survive; but those that survive, do so because of their particular characteristics. The survivors are thus those which are best adapted to their particular surroundings, and they pass their particular characteristics on to their offspring. Thus over time new species emerge, with characteristics best adapted to their environment.

Darwin scandalized his Victorian contemporaries, in two ways. On the one hand, he challenged the teachings of the Christian church, that all species were originally created by God and were subsequently unchanging. On the other hand, he dared to hint that the human species itself was not the pinnacle of divine creation, but a species like any other, which had evolved from an ancestor shared in common with our closest relatives, the great apes: gorillas, orang-utans, chimpanzees.

Alfred Russel Wallace was Darwin's contemporary, and he had also arrived at a very similar theory about the evolution of species. Indeed, it was Wallace writing to Darwin about his own ideas which galvanized Darwin into publishing his great work. Wallace travelled extensively in the islands of Southeast Asia, and described the "man-like orang-utan", which inhabited exclusively the islands of Sumatra and Borneo. Dubois, inspired apparently by Wallace's observations, travelled to Sumatra as a colonial surgeon, with the dream of discovering the "missing link". His success in achieving this is, in retrospect, astonishing. That the meaning of his discoveries is still in dispute in no way detracts from their significance.

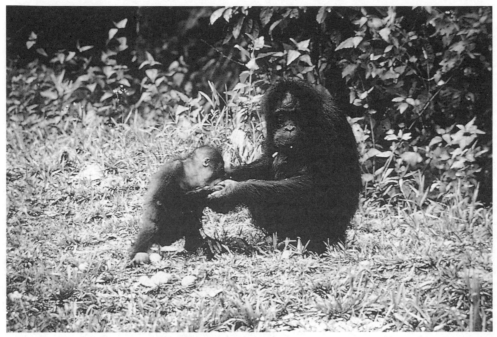

Orang-utans in Malaysia.
Courtesy of Malaysian Tourist Development Corporation.

Human Evolution: Biological Evidence and Argument

Shortly before the publication of *The Origin of Species* in 1856, some apparently human fossil remains were dug out of a cave in Germany, in the valley of the Neander River. Some anatomists at the time pointed out that characteristics of the skull, such as its thickness and a ridge of bone over the eye sockets, were not those of contemporary Germans. These oddities were however explained away as characterizing "inferior races" – the remains, it was said, belonged to a Dutchman, or a Cossack – or as being pathological. Some however clung to the idea that they might be human, but somehow primitive. The science of archaeological excavation and dating was then in its infancy, and there was no way of suggesting exactly how old such remains might be. Further finds of human remains were made in Europe in the latter part of the nineteenth century, some of which were more "modern" in form than those of what came to be called Neanderthal Man; these more modern kind were named Cro-Magnon, after the place in France where they were first found.

By the 1890s, gradual acceptance of Darwin's ideas by the scientific world led also to the beginning of a recognition of a human evolutionary history. Neanderthal fossils were seen as representing an earlier form of human, possibly an earlier species, *Homo neanderthalensis*, which had, some many thousands of years ago, evolved into the modern form, represented in Europe by Cro-Magnon fossils.

Dubois's discoveries in the 1890s were controversial, but by this time, a large number of people were prepared to recognize that they were a genuine human ancestor. Dubois himself had, as we have seen, proposed a scientific name which classified his fossil type as not only a different species to humans, but a completely different genus: not *homo* at all, but *Pithecanthropus*. His view was that this was a very ancient ancestor, a genuine link in the sense of being a precursor of both apes and humans. Other scientists disagreed, and thought it was not on the ape line at all, but entirely human, even if it was older and more primitive than any known human fossils. The fact that it walked upright seemed a distinctly human characteristic.

By the turn of the century, a reasonable case could be made for a human evolutionary lineage which began with Dubois *Pithecanthropus erectus* in Java, which on geological grounds he thought must be some 500,000 years old. *P. erectus*

Eugene Dubois, number two from the top.
Courtesy of National Museum of Natural History, The Netherlands.

was followed in an evolutionary sense by *Homo neanderthalensis*, probably somewhere between 100,000 and 200,000 years old and found by now in various parts of Europe, who became *Homo sapiens* of the Cro-Magnon type sometime during the last Ice Age. The physical characteristics which define humanity are still to some extent open to debate. The evolutionary pattern shown by these fossils, however, seemed to indicate that walking upright occurred early on and was evident in the Java specimens, as were recognizably human dental characteristics. On the other hand, the skull proper retained primitive characteristics, such as very thick bone and a heavy brow ridge, well into the Neanderthal stage. The size of the brain case was much smaller in the Java sample, while it was as large as a modern person's in the Neanderthal case.

In 1924, a new type of fossil was found in South Africa, and, like its predecessors, was greeted with suspicion and skepticism. This was the skull of a baby, a six-year-old, which was embedded in the limestone of a cave being quarried as a limeworks at a place called Taung. But a baby what? Anatomist Raymond Dart thought it could not be a baboon or any other ape or monkey, because of the shape of its skull and its lack of pointed canine teeth. On the other hand, as a human fossil, it was more primitive than anything yet seen; its brain was tiny. It did however preserve enough of its foramen magnum, the hole at the back of the skull through which the spinal cord passes, to indicate that it had walked erect. Dart announced that a small human ancestor with a brain not much bigger than an ape's, but which had walked upright, had been found in South Africa, and named it *Australopithecus africanus*: the southern ape of Africa.

It was many years before the new species was accepted as representing a human ancestor. One of the factors hastening acceptance was the discovery of adult examples, also in South African cave sites, in the 1930s. A complicating factor however was the discovery that there seemed to be two kinds of South African fossil. One was comparatively fine-boned, or "gracile", with more humanlike features; the other was more thick-boned, or "robust", with more ape-like characteristics, such as a crest of bone on the top of the skull. This latter kind was named by its discoverer, Robert Broom, *Paranthropus robustus*: meaning, robust, parallel but not quite human species. This species is now recognized as also an Australopithecine, *Australopithecus robustus*.

The evolutionary ball was now in Africa's court. For those who accepted the new Australopithecine fossils as being human ancestors, they were very clearly more primitive, and presumably much older than Dubois's *Pithecanthropus*. New evidence was however being found in China which, while not as old or as primitive as the South African finds, nevertheless was of great significance.

In a limestone hill not far from Beijing at a place called Zhoukoudian a collection of scholars from Sweden, Canada, Austria, France, the USA and China carried out palaeontological investigations, culminating in the announcement of a discovery of a hominid molar in 1927. In 1928, what Gunnar Anderson (1934:109) called "a whole nest" of fossil remains was found: more than a score of teeth, of different ages and degrees of wear, as well as parts of skulls of both young and adult individuals. By the 1930s, five almost complete skulls and many pieces of cranial bone, jaws and teeth had been uncovered. Furthermore, the remains had come from sediment deposits within an ancient cave, in which these individuals had camped, leaving behind other evidence of their presence, to which we will return. These fossils were given the specific name of *Sinanthropus pekinensis*: Chinese

man from Peking (Beijing). They were thus seen as sufficiently different from *Pithecanthropus* to merit a different genus, but today both *Sinanthropus* and *Pithecanthropus* are classified together as *Homo erectus*. Unfortunately, the Chinese specimens were all lost during World War II, but casts were made of them which still survive.

During the 1930s, further remains of Dubois's *Pithecanthropus* were found in Java, at Ngandong, Sangiran and Mojokerto. Many of the new finds were made under the direction of Ralph von Koenigswald, who, like Dubois, worked for the Dutch Colonial Government. The new fossils showed a wide range of variation. The Ngandong specimens looked considerably more modern than the original skull, while some of the others had distinctly more primitive (in an evolutionary sense) features. Two specimens were considered so primitive that they were given a new generic name, *Meganthropus* (very large human), and there has been speculation that they might represent a form of Australopithecine.

Since 1945, much research has been carried out in Africa, particularly by members of the Leakey family. Major discoveries have been made in east Africa, in the large geological structure known as the Great Rift Valley, which extends through the modern nations of Kenya, Tanzania, and Ethiopia. Australopithecine fossils are now known from several sites in east Africa, some of the robust kind, others which appear to be older, and more primitive, than both the *A. robustus* and *A. africanus* fossils from South Africa.

Today the *Pithecanthropus/Sinanthropus* group is defined as a single genus, indeed a single species, *Homo erectus*. This name reflects the view that the species is more human-like than Dubois and the others had recognized, and should be classed in the same genus as modern humans. It also recognizes that the group displays sufficiently similar characteristics to be classed as a single species, which (according to international rules of biological nomenclature) preserves the original species name bestowed by Dubois. It does not however imply that *Homo erectus* was the first species in the human line to walk upright; *Australopithecus* fossils from east Africa, and even some preserved footprints, show that walking upright came very early on in the human evolutionary story.

Homo erectus fossils have also been found in East Africa, in very well-dated sites such as Olduvai Gorge, and we now know that the species appeared here about 1.6 million years ago. The new evidence has complicated the story considerably.

Based largely on the Olduvai Gorge evidence, a new species of *Homo* has been proposed, which is held by some to represent the stage between the Australopithecines, and *Homo erectus*. This species is named *Homo habilis*, the "handy man", and to consider this evidence, we now need to take into account evidence which is not purely biological.

Cultural Evidence

The evidence of skeletal remains tells us about the biology of evolving humans. There is however another dimension to human evolution, the development of culture. Culture has been variously defined; for archaeologists, the most useful definitions are: (1) culture is patterned behaviour learnt by human beings as

members of their society and (2) culture is the human species' non-genetic means of adaptation. The first definition tells us more or less simply what culture *is*, the second suggests what culture *does*. Cultural things are not inherited biologically, they are passed on socially; culture is the way that humans adapt to changing environments without themselves changing biologically. While culture may or may not be exclusive to humans (this depends on exactly how it is defined), it is one of the things that defines the species. In identifying the emergence of the human species therefore, we look for some form of evidence of culture.

For archaeologists and palaeoanthropologists, the earliest evidence of culture is usually thought to be in the form of stone tools. This is a fairly pragmatic view, based very largely on the fact that stone is a material with a good archaeological survival potential. The manufacture of ad hoc tools has been observed amongst chimpanzees. The kind of evidence we are looking for to define humanity is repetitive patterns of stone tool making, which suggest that the makers are teaching each other these skills, and passing them on within and beyond the immediate social group.

Such evidence has been found at sites in east Africa, at Hadar and the Lower Omo in Ethiopia, and at Olduvai Gorge and Koobi Fora in the rift valley. It consists of stone artifacts produced by percussion, that is, striking one stone against another to produce a piece of stone called a "flake" with a sharp edge, which has been detached from a "core", which might itself also be a tool. The important thing about the various collections of artefacts from these sites is that they are similar to one another, thus providing evidence for repetitive patterning in manufacture, and hence culture. The collective name for these early tools is "Oldowan", after Olduvai Gorge. The oldest sites appear to be those in Ethiopia, where Oldowan tools are dated to between 2.0 and 2.5 million years. The Oldowan industries at the Kenyan sites are dated to between 1.9 and 2.0 million years. The question is, which species was making them?

Ever since the recognition of the Australopithecines being in the human line, there has been debate about their level of capability. Although at some sites the remains of Australopithecines appear to be contemporary stone artefact assemblages, there is no good evidence that they made or used stone tools. At Olduvai Gorge, for instance, stone artefacts are contemporary with *Australopithecus robustus* (also called here *A. boisei*). But there is also another, more advanced specimen from Olduvai Gorge, and it is this specimen which has been called *Homo habilis*, not only because it appears more advanced than the Australopithecines biologically, but also because it is believed to have been responsible for the stone tools. Similarly, at Koobi Fora, stone tools appear to date from the same period as another advanced specimen, known by its museum number of "1470", also often classified as *Homo habilis*.

For Africa overall, despite continuing confusion and controversy, we have a general consensus that the first appearance of humans can be identified between about 2.5 and 2.0 million years ago. The biological evidence is that there were three or four species of *Australopithecus* present between about 5 and 6 million years ago until perhaps 1 million years ago. One of these was probably ancestral to *Homo*, while some or all of the others lived alongside the emergent human genus until they died out. Between 2.5 and 2.0 million years ago, the first *Homo* appeared, whom we might refer to as *Homo habilis*. Also dating to this period is

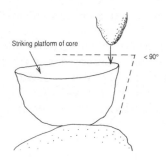

Striking platform of core

< 90°

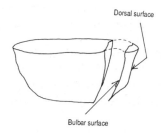

Dorsal surface

Bulbar surface

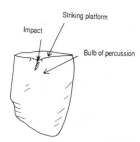

Striking platform

Impact

Bulb of percussion

Figure 2.1
Stone Artifacts Produced by Percussion

the first appearance of patterned stone tools, evidence of the possession of culture. About 1.6 million years ago, the species *Homo erectus* appears in Africa, having evolved from the earlier *Homo habilis*.

The appearance of *Homo erectus* in Africa is accompanied by a new kind of stone tool industry. These tools were in fact first recognized during the nineteenth

century in France, and so have a French name: the *Acheulian* industry. Acheulian industries are characterized by large core tools called "handaxes" and "clearers", although they are usually accompanied by other, smaller flake tools, and kinds which also appeared in the Oldowan industries. Acheulian industries, which appear in Africa along with *Homo erectus*, are found over a very wide area: most of Africa, most of Europe, some of India and in the Middle East. They persisted in time until *c.*100,000 years ago, with surprisingly little change. It is assumed that they are associated with *Homo erectus*, but most Acheulian sites do not in fact have associated fossil remains.

Conversely, the distribution of *Homo erectus* is wider than the distribution of Acheulian tools. *Homo erectus*, as we have seen, includes Dubois's *Pithecanthropus* and the Chinese *Sinanthropus*, but Acheulian industries are not found in China or Southeast Asia, a fact to which we shall return.

It is unlikely that anyone would argue, at the present time, that the genus *Homo* did not evolve in Africa. The only possible evidence to the contrary is the two or three primitive fossil specimens from central Java, which some have suggested may be Australopithecines. Their fragmentary nature and the lack of firm dating controls however makes such an argument difficult to sustain. For the present, it can be asserted with some confidence that early human ancestors, with evidence of culture, appeared in Africa 2.5 to 2.0 million years ago.

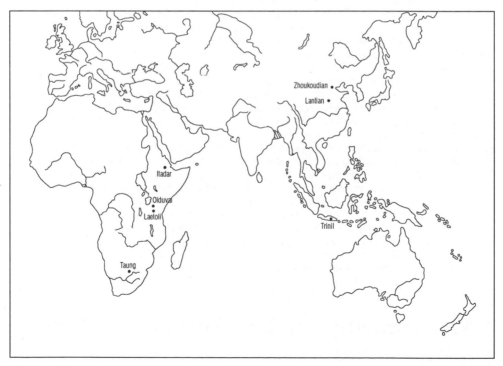

Figure 2.2
The Major Sites where Homo erectus Remains have been Discovered

STONE TOOLS

Stone tools are, generally speaking, of two kinds. One kind comprises *ground stone tools*, where a sharp edge is produced by grinding it on another stone. Ground tools are a relatively late invention. The oldest examples known from Japan and Australia, are of the order of 40,000 years old.

More ancient, and more common, are *flaked stone tools* which are formed by percussion, that is, by the action of forcibly striking one stone against another. This produces a sharp edge, which may be further modified to make it suitable for one or more tasks. Flaked stone tools are usually made out of a fine grained stone, such as chert, quartzite, quartz or flint. The last was most commonly used in Europe; in most parts of Asia, cherts, quartzites and quartzes are more common.

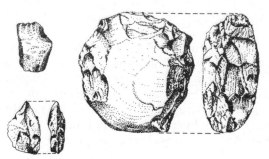

Stone Choppers from Zhoukoudian

Flaked stone tools are recognized by specific characteristics. Striking a fine-grained piece of stone produces an effect called *conchoidal fracturing*. The stone which is fractured will then be in two pieces, one generally larger than the other. The smaller piece is termed a *flake*, and is recognized by a convexity on its newly formed surface called a *bulb of percussion*, and a flat surface where it was struck called a *striking platform*. The larger piece is called a *core*, and on its newly formed surface will be found a concavity, a *negative* bulb of percussion. It is usual for a core to have had several flakes detached from it before it is discarded. This process produces a lot of unused material called *waste* or *debitage*. Those flaked pieces which are assumed to have been actually used as tools may, be either flakes or cores.

A core, therefore, may be either a by-product which has served only a quarry for flakes; or it may have functioned as a tool in its own right. "Choppers" and "chopping tools" are usually core tools, often made on water-worn pebbles.

A flake, similarly, may simply have been removed in order to produce a core of a particular shape. On the other hand, the desired end product may have been a flake of a particular shape. In the course of producing such a flake several other flakes may be rejected as not quite right. A flake with no further sign of modification is called a *primary flake*, and usually considered as debitage. A flake tool may be recognized as such because it has visible signs of use on one of its edges. A flake may also be modified by having small flakes removed from it: this process is called *secondary working*. A flake with secondary working is assumed to have been a tool. The term "scraper" is used for a flake with a modified margin of secondary working. A "point" is generally taken to be a flake with two margins of secondary working converging to a point. A "blade" is a flake more than twice as long as it is wide, where "length" is measured perpendicular to the striking platform.

"Anatomically Modern Humans": *Homo sapiens sapiens*

The evolution of the modern human species, that is, us, is currently the subject of much greater debate. What is the relationship between *Homo erectus* and *Homo*

sapiens? What of Neanderthal? What is the origin of modern biological differences, of the kind generally referred to as "races"? Recent research has sharpened our interest in these questions, and provided material for what has become a surprisingly contentious debate.

In China, a German anatomist named Franz Weidenreich had been directing the excavations at Zhoukoudian between 1935 and 1937. He also made close studies of many other human fossils, from Asia and elsewhere and, in the 1940s, expressed the view that there was "an almost continuous line leading from *Pithecanthropus* through *Homo soloensis* and fossil Australian forms to certain modern primitive Australian types" (Weidenreich 1943:226). This argument was taken up by many others, including Carleton Coon, who used it, controversially, as a general model to derive modern "racial" types from distinctive fossil forebears.

This general model was until recently gaining considerable ground as the preferred interpretation for the emergence of modern humans as the result of a process of regional continuity. According to this model, there was an early radiation of *Homo erectus* out of Africa to the many parts of the Old World where they were found, and evolutionary change then proceeded in place, with distinctive human lineages at a regional level. Thus, for example, the Zhoukoudian *H. erectus* type evolved through later forms known from later Chinese fossils to become the Mongoloid, or Asian, racial type. The Javanese *H. erectus* form on the other hand evolved through the later Ngandong form to become Australoids, found in recent times mainly in Australia. In Java and the rest of Southeast Asia, Mongoloid types had become established more recently, presumably at the expense of the pre-existing Australoids. In Europe, *Homo erectus* passed through the Neanderthal stage to become the ancestors of Europeans, modern "Cro-Magnon" *Homo sapiens*.

Objections had been raised to this model, particularly to Coon's version, as early as the 1960s. One of the difficulties it raises is the idea that one species, *Homo erectus*, independently evolved into another species, *Homo sapiens*, in different places, and with different characteristics. This places considerable stress on the idea of *H. erectus* as a distinct species, and one response was to argue that it was not indeed sufficiently different from *H. sapiens* to maintain its specific status. Another response has been to argue for considerable gene flow between the different *H. erectus* groups, which seems somewhat to contradict the idea of distinctive regional lineages. The alternative hypothesis is that modern humans

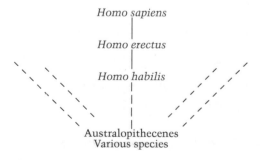

Figure 2.3
Generalized Model for Human Evolution

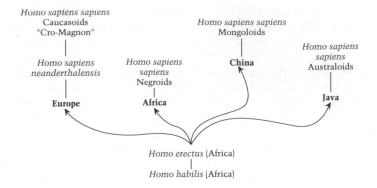

(a) Regional Continuity Model

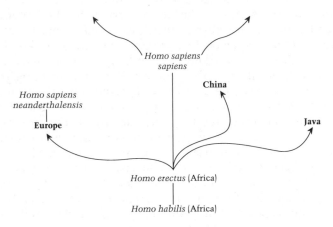

(b) Replacement Model

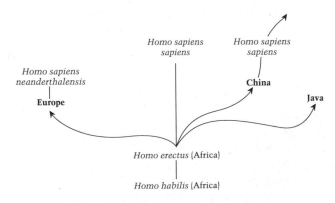

(c) Possible Compromise Model

Figure 2.4
Emergence of Homo sapiens sapiens

evolved in one place, and radiated throughout the Old World (and also some of the Newer) to displace the less evolved forms already there. This is known as the *replacement* hypothesis.

The real challenge to the regional continuity model has come, not from new fossil finds, nor the work of archaeologists or palaeoanthropologists, but from research in molecular biology. Biologists studying DNA, the genetic material which determines biological inheritance, argue that it mutates at a constant rate, and that this rate can be assessed, providing a molecular "clock". By comparing DNA from members of different populations, the amount which one has diverged from another can be determined, and a time depth for the divergence calculated. For assessing human evolution, biologists have used DNA taken from the mitochondria, which is inherited in the female line only, rather than from the chromosomes.

The results of research of this kind carried out by Rebecca Cann and her colleagues have been startling. They argue that it shows that modern human beings are all descended from a common ancestor in Africa, within the last 200,000 years. There has been strenuous criticism of this line of research and its results. It has been argued that the samples used by Cann and her colleagues have not been appropriate, and that the mutation rate is either much slower than they would have it, or else that it cannot be assumed to be constant, which is necessary for the argument. In other ways however, it has been argued that this does fit the evidence from the fossil and archaeological record, and supports the replacement model for the evolution of modern humans.

Proponents of the two hypotheses, the regional continuity model and the replacement model, tend to argue that one or the other must be correct, and that there is no possibility of a "middle ground". When we look at the Asian archaeological and human fossil record, however, we can see that there is a case to be made for something very like a compromise between these two positions.

China: Archaeological and Hominid Fossil Record

Fossil Hominids

We have already discussed the discovery of *Sinanthropus* (now *Homo erectus*) at Zhoukoudian, near Beijing. Work has resumed at that site since the Revolution, and many other sites have been examined by Chinese scholars. The application of modern dating techniques shows a long and continuous sequence of occupation of China by the genus *Homo* (Table 2.1).

The fossil remains of over forty individuals have now been found at Zhoukoudian. Several modern dating techniques have been applied, and they have provided a reasonably consistent range of dates between 600,000 and 220,000 B.P. [years Before Present]. Older specimens have been found at sites at the Lantian localities of Chenjiawo and Gongwangling in Shaanxi Province, north China. At the former locality, a mandible of *Homo erectus* was found, in a context dated to between 650,000 and 530,000 B.P. At the other locality, a *Homo erectus* skull cap and some teeth were recovered from contexts variously dated to over 1 million years ago, to

Table 2.1
Chinese Hominid Fossil Sites

	Sites	Year B.P.
H. erectus	Gongwangling	1000000
	Chenjiawo	650000
	Zhoukoudian	610000
	Yuanmou	600000
	Hexian	200000
H. erectus/ archaic H. sapiens	Jinniushan	300000
	Dali	230000
	Tongzi	214000
	Xujiayao	131000
Homo sapiens	Changyang	220000
	Dingcun	210000
	Xindong	200000
	Chaohu	200000
	Maba	140000
	Wugui Cave	117000
H. sapiens sapiens	Liujiang	67000
	Salawusu	50000
	Ziyang	39000
	Shiyu	29000
	Upper Cave	23000

500,000 B.P. While some Chinese scholars prefer a younger date, there is archaeological evidence from China which appears to date to c.1 my [million years B.P].

Homo erectus is also known from southern China, from the site of Yuanmou in Yunnan province. The fossils consist only of a few teeth, and there are problems with their exact provenance (that is, exactly where they came from) and with the dating of their context. Dates of up to 750,000 B.P. and even 1.7 my have been obtained, but generally a palaeomagnetic dating of between 600,000 and 500,000 B.P. seems to be preferred. A much younger site has produced what may be a more advanced H. erectus form. This is the cave of Longtandong at Hexian in Anhui Province in northern China. Part of a skull and some teeth here have been dated to between 200,000 and 150,000 B.P.

This last site poses a particularly interesting problem, since it is younger than sites with what may be forms transitional between H. erectus and H. sapiens, and also sites with fossils considered to represent Homo sapiens.

The oldest site with fossils considered to be of a form transitional between H. erectus and H. sapiens is Jinniushan, in Liaoning Province in north China, dated to 300,000 B.P. Others are Dali in Shaanxi in the north, dated to 230,000 B.P.; Xujiayao in Shanxi dated to 131,000 B.P.; and, in the south, Tongzi in Guizhou province, dated to 214,000 B.P. The oldest site with remains considered to be Homo sapiens is Changyang in Hebei province. A jaw fragment and a tooth were

found in contexts dated to between 220,000 and 170,000 B.P. Other sites (see Table 2.1) with apparent early *Homo sapiens* remains also overlap the sites with presumed transitional forms.

A skull and post-cranial fragments from Liujiang in Guangxi Zhuang Autonomous Region have been dated to 67,000 B.P. Several fossil remains from Salawusu in the Nei Mongol Autonomous Region have been dated by both radiocarbon dating and the uranium method. The uranium dates range from 50,000 to 37,000 B.P., and the carbon-14 dates fall between 53,000 and 44,000 B.P. A skull from the Ziyang site in Sichuan has been dated by radiocarbon to between 39,000 and 36,000 B.P. These are the oldest fossils generally recognized as *Homo sapiens sapiens*. The dating is in general conformity with the dating of fully anatomically modern human fossils from other places, as we shall see.

The overlapping dating of these fossil sites present problems, but they are problems for both, or even any, interpretation of human evolution. On the one hand, the regional continuity model would not predict that *Homo sapiens* would overlap in time with *Homo erectus*. On the other hand, the replacement model would not predict that there would be fossils transitional between *Homo erectus* and *Homo sapiens*. There are of course possible problems with the interpretation of the fossil forms on the one hand, and potential difficulties with dating on the other.

To take the more obvious question first, many of the various dating techniques used are regarded as still being experimental, or as not particularly reliable without very stringent environmental controls. The dating of Zhoukoudian is considered to be reasonably secure, because of the consistent results of the different techniques used there. Even where the dating results may be accurate in themselves, there may be doubts raised about the actual *association* between the phenomenon being dated, and the object whose age we wish to know. This may arise because what is being dated may be, for example, the age of a cave, rather than the time when an object was deposited within it; or it may be due to an object being dislodged from its original resting place, and coming into association with other objects or sediments which are either older or younger. These are all problems faced by archaeologists and palaeontologists everywhere.

With respect to the interpretation of the fossils themselves, this may depend very much on the expertise of the scholars who study them, and also on the particular models they start off with. This is of course another way of saying that all interpretations may have a subjective element. The way the fossils have been assigned here, to one species or group or another, is just one of many ways they have, or could be, assigned.

Proponents of the regional continuity model may argue that the difference between *Homo erectus* and *H. sapiens* is arbitrary anyway, and the perceived variations are simply part of the expected range to be found within an evolving species. Proponents of the replacement model may take a similar view to a different end, and argue that the range within *Homo erectus* is wide, but the real quantum difference is between *Homo erectus* and *Homo sapiens sapiens*. In this model, all the fossils classified as *H. erectus*, transitional *H. sapiens* and early *H. sapiens* are really *H. erectus*, or at any rate, all to be distinguished from *Homo sapiens sapiens*. In this case, of all the fossils we have considered, only those from Liujiang (and it has been suggested that this fossil is not fully modern), Salawusu and Ziyang are considered to be *Homo sapiens sapiens*, and they are clearly younger than all

the others, and appear at approximately the same time as *H. sapiens sapiens* elsewhere. The regional continuity proponents would defend this by arguing that they are not that especially different from many of the earlier ones. As to how this all relates to questions of modern "racial" characteristics, we shall consider later.

DATING

Dating of archaeological and palaeontological sites is of two kinds. On the one hand, we have *relative* dating, where we are able to say that one thing is older, or younger, than another, but not how old it is in calendar years. On the other hand, we have absolute dating, when we can attach a number indicating a calendar year. This may however not be very accurate; for instance, something may be said to be "about 300,000 years old".

Relative dating is often based on the use of *stratigraphy*. This term derives from the geological word *stratum*, meaning a layer. The basic principle of stratigraphy is the assumption that older layers are found beneath younger layers. There is also an assumption of *association*, in that certain kinds of fossil occur together in strata of a particular *age*, and when such a group of fossils is found, the context is attributed to the period which they are known to represent elsewhere. This is often extended to archaeological contexts, where certain kinds of artefact are held to indicate a certain period.

Absolute dating for periods before the existence of written records or calendars is generally carried out by a range of modern techniques which may be characterized as radiometric dating. *Radiocarbon dating*, is perhaps the best known of the modern radiometric dating techniques. It is based on the knowledge that all living organisms (both plant and animal) absorb during their lives a mildly radioactive substance from the atmosphere, an isotope of carbon called carbon-14 (C14, or C^{14}). The normal stable isotope of carbon is carbon-12 (C12, C^{12}), which is present in living organisms in a constant proportion to C14. When the organism dies, it ceases to absorb C14, and the C14 remaining in the remains of the dead organism, being radioactive, continues to decay at a constant rate. The time of death is ascertained by measuring the ratio of C14 to C12 in the remains of the organism. The actual techniques used are too complicated to describe here, and are carried out in special radiocarbon dating laboratories by trained specialized personnel. It is however important to note that C14 has a relatively short half-life (about 5730 years), which limits the range of this technique's applicability; it is only effective for the last 50,000 to 40,000 years. A recent refinement, which allows older dates to be obtained with more precision from smaller samples than was previously the case, is the use of *Accelerator Mass Spectrometry* (*AMS*), a different way of measuring the carbon ratios. Radiocarbon dating may in theory be used to date any organic substance (wood, bone, shell, hair and so on), but is most successfully used on charcoal, and so on which is both chemically inert, and which commonly occurs in archaeological sites.

It should be noticed with respect to this, and most other dating techniques, that the principle of association is important: if one wants to date stone tools, for instance, one must use charcoal that is clearly in, association with those tools, that is, which resulted, from fires lit at the same time as the tools were used and discarded. Thus, the principles of stratigraphy continue to be just as important in obtaining absolute dates, as in assigning relative dates.

Other kinds of radiometric dating also rely on radioactive decay of isotopes. These include potassium argon dating and uranium-series dating. The *potassium argon* (*K-Ar*) technique is based on the decay of radioactive potassium-40 (K40) into the inert gas argon in volcanic rocks after their initial formation. This technique may thus only be useful where volcanic activity has occurred, and where, for instance, archaeological or palaeontological deposits are covered with a layer of volcanic ash which has formed into a kind of rock called a tuff. It has been much used in dating the early hominid sites of East Africa. Potassium-40 has an extremely long half-life (over 1 billion years), and the effective range of this technique is for events older than between 100,000 years.

Uranium-series dates work on a similar principle, based on the decay of radioactive isotopes of uranium. In this case, the decay begins when the isotopes, which are soluble in water, are precipitated into a solid state. This commonly occurs in flowstone deposited in limestone caves, and limestone caves are often important archaeological sites. The technique works for a time range between 50,000 and 500,000 years.

Fission track dating also involves a uranium isotope found in certain glassy rocks like obsidian and tektites, which fall from outer space. This isotope does not just decay, but divides itself in half: a process of "fission", at the molecular level. This produces tracks in the rock which can be seen under a microscope, and counted, to provide an estimate of time since the rock formed. It is best used to obtain dates older than 300,000 years.

Palaeomagnetic (or *archaeomagnetic*) dating is a combination of relative and absolute dating techniques. It is based on the fact that, every so often over long periods of time, the earth's magnetic field reverses itself, so that the north pole becomes the south. This is reflected in the orientation of iron particles in burnt rooks and sediments. By using any of the above absolute dating techniques, a history of such reversals over long periods of time can be constructed, and when sequences of reversals are found in archaeological or palaeontological sites, they can be matched up with the known sequences from other places.

The application of different kinds of dating techniques may not always result in agreement. Sometimes archaeologists and paleontologists do not agree amongst themselves as to what is the "correct" date. Sometimes an individual researcher will opt for a "long chronology": the maximum amount of time over which an event or a sequence of events occurs, represented by different dating techniques, or a "short chronology".

Cultural Record

So far we have considered only the biological evidence of the actual hominid remains. The cultural evidence must also be considered, in the form of the archaeological record. Many of the sites we have considered so far contain only fossil evidence, and no other archaeological materials are present. Some of them however do contain cultural materials in the form of stone tools, and sometimes of bone also, and there are also archaeological sites which do not contain fossil hominid remains.

Most of the archaeological, that is, cultural, evidence from Pleistocene sites in China and Southeast Asia, as in Africa, consists of stone tools. Stone tools are good for archaeologists because they survive well. They have drawbacks also however for archaeologists, in that they are made of a rigid material, unlike pottery, and hence there are limiting physical factors to the shapes they may take. Another problem is that we have relatively little understanding of how stone tools were actually made and more particularly used. There were peoples in the world, and especially in Australia, who were using stone tools until relatively recently. When these people came into contact with Europeans (usually in the form of conquerors or at least appropriators of land), they quickly adopted the use of other materials such as glass and metal. We thus have very few first-hand and informed observations of how stone tools were made and used in recent times. Furthermore, many of the types found in Pleistocene sites were not in use or manufacture in more recent times.

A further complication in interpreting the archaeological record of Asia is the fact that the study of the Pleistocene archaeological record began in western Europe. The stone age peoples of France in particular made very nicely patterned stone tools which archaeologists could use to construct detailed sequences based on changes in these patterns. There has been a consistent tendency to try and apply these "Eurocentric" models to other parts of the world but, not surprisingly,

they fail to make much sense. One reaction to this has been to describe the stone tool industries of Asia as "amorphous", or even "backward and primitive". Other approaches have been to argue that stone tools were less important in this part of the world than artifacts of more perishable materials. Even this line can however be seen as a failure to come to terms with non-European stone tool industries. What we must do is try and look at these industries without a Eurocentric bias.

Archaeological sites in China dated to the Pleistocene are listed in Figure 2.5. The artefact assemblages found at these sites may be seen as amorphous, but there are in fact consistent patternings observable. Furthermore, there are definite continuities over what is clearly a very long period of time. The oldest site currently appears to be Xihoudu, an open site in Shanxi Province which *may* be 1.8 my old. The dating was described some time ago (Jia, 1985) as preliminary, but no further information is available. If this site does indeed demonstrate a tool-making hominid in China nearly 2 million years ago, contemporary with the oldest evidence from Olduvai Gorge, it must indicate a very rapid spread from Africa, or we must revise our ideas about an African origin. There are no associated hominid fossil remains. The artifacts are said not to resemble other assemblages from Pleistocene China, but they are not all that different either. They include flake scrapers, utilized flakes, chopper tools made on pebbles and large core tools called points, which were clearly never intended as projectile points, but resemble more nearly a pointed chopper. The use of the bipolar technique, that is, striking flakes off a core supported on a stone anvil, is possibly evident. There is also a suggestion that fire was known here.

Two sites, Xiaochangliang and Dongutuo, are known from the Nihewan basin in Hebei which have been dated to one million years B.P. Both consist of stratified

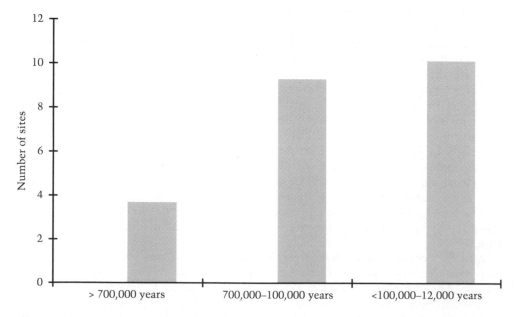

Figure 2.5
Pleistocene Archaeological Sites in China

open sites containing stone artifacts. These include small flake scrapers, small core tools, and there is evidence of the use of the bipolar technique. As Chinese scholars have observed, the assemblages at these sites are an early manifestation of a cultural tradition which continues throughout the Pleistocene archaeological record.

The Gongwangling site at Lantian has yielded stone artifacts as well as fossil material. The sample is not very large, three flake scrapers and one core tool have been identified. The Yuanmou site has also yielded a few artifacts (three scrapers), but it is unclear whether they are in any real association with the fossil teeth found here.

Zhoukoudian is not only one of the most important hominid fossil sites in China, and indeed the world, it is also one of the most important archaeological sites. At Zhoukoudian we get a window on the activities of *Homo erectus* which is almost unique. There has also been recent controversy about the interpretation of this site. It is one of the oldest known cave sites with human occupation. Such sites are valuable to the archaeologist, and the palaeontologist, because they represent a self-contained unit with natural boundaries which contain and define evidence of past activities. Deposits are often laid down within them in an orderly fashion with protection from the elements, and, if the rock of which they are formed is limestone, also actively preserves organic materials such as bone.

As we have seen, investigations at Zhoukoudian (locality 1) have continued on and off since the 1920s. Several dating techniques have been used to provide a chronology for the site. The range of dates is between 610,000 and 230,000 B.P., and the deposits are divided into three stages, Early (>600,000–400,000 B.P.), Middle (400,000–300,000 B.P.) and Late (300,000–200,000 B.P.).

Within the deposits, as well as the hominid material, are found stone artifacts, animal bones, and evidence for the use of fire in the form of layers of ash, and hearths or fireplaces. The animal bones suggest that large animals were being hunted for food. The stone artifacts are abundant. Evidence for bipolar flaking is common. Tools made on flakes predominate, and most are smaller than 4 cm in length. Larger chopper tools are also present however. There is evidence for tools made of bone also. Based on the way some of the hominid remains had been broken up, it has often been argued that *Homo erectus* practiced cannibalism at this site.

Recently, the American archaeologist Binford has questioned previous interpretations of the evidence from Zhoukoudian (Binford and Ho, 1985; Binford and Stone, 1986). He and his various co-authors have argued that the evidence does not support the use of fire, the practice of cannibalism, the manufacture of bone tools, and that the cave was used by hyenas and wolves as much as hominids. They argue that much of the non-hominid bone was not brought there by *Homo erectus*, but by the other animals who lived there. The general thrust of the argument is that the cultural achievements of *Homo erectus* have been overstated. Chinese scholars have rejected most of these arguments (e.g. Jia, 1989).

The other sites listed in Figure 2.5 contain, generally speaking, variations on the cultural themes so far established. Most assemblages are dominated by small flakes, and small scrapers. Small end scrapers, sometimes called thumbnail scrapers, are found at several sites. The bipolar technique is common to many. Large core tools do occur, but not at the majority of sites, and when they do, do not dominate the assemblages. Spheroids, or stone balls, occur at some sites.

Digging at the roof of the middle part of the deposits at the Zhoukoudian site.

Fossils of small mammalian species such as bats and rodents were found in the ash layer at the Zhoukoudian site.

One of the skullcaps unearthed at the Zhoukoudian site.

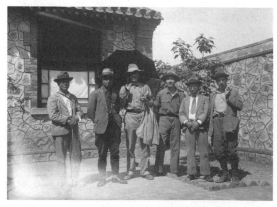

At the office of the Zhoukoudian Project. Left to right: Pei Wenzhong, Li Siguang,Teilhard de Chardin, Bian Meinian, Yang Zhongjian, G. B. Barbour.

Photographs courtesy of Jia Lan-po.

Dingcun is distinguished by a range of large core implements, some of which resemble European or African bifaces of the Acheulian tradition, but even here, smaller flake tools are in the numerical majority.

From a Eurocentric, or even African, perspective, this is not exactly what would be expected. In the West, it is generally thought that Lower Pleistocene assemblages are dominated by larger, heavier tools, such as handaxes, and there is decreasing size and increasing fineness of manufacture through time, culminating in the small and finely worked tools of the Upper and terminal Pleistocene. In China, small tools are dominant at many sites from earliest times. While some evidence of greater delicacy of manufacture is evident in upper to terminal Pleistocene assemblages, it is not as noticeable a trend as in Europe. Also in the West, there is a rough (but far from exact) correlation between changing cultural assemblages and biological changes, such that *Homo erectus* is generally associated with Acheulian industries (Lower Palaeolithic), *Homo sapiens neanderthalensis* is generally associated with Mousterian industries (Middle Palaeolithic) and *Homo sapiens sapiens* is associated with a variety of industries characterized by finely worked long thin flake tools, called blade implements, grouped under the heading of Upper Palaeolithic. In China, there are no neat chronological divisions like this, nor geographical ones, and the different physical types are associated with the general range of cultural evidence described above.

In short, the cultural evidence from Pleistocene sites in China shows continuity in both space and time, throughout a period of something like a million years.

Southeast Asia: Archaeological and Hominid Fossil Record

Southeast Asia is of course a modern construct, and there is no particular reason to assume that south China was a separate entity from northern Vietnam, Laos and Burma in prehistoric times. It does appear however as though they may have been somewhat separate entities, as the archaeological record tells a quite different story in all the Southeast Asian countries, at least for the Lower and Middle Pleistocene. Southeast Asia is here defined as the geographical area which includes the modern nation states of Vietnam, Burma, Laos, Cambodia, Thailand, Malaysia, Indonesia, and the Philippines. In terms of the prehistoric past, we also need to recognize the distinctive area of Australasia, which includes modern Australia, Papua New Guinea and also Irian Jaya. This region has an important role in our story, as we shall see. It was however always separated from Southeast Asia by a deep water barrier, even during times of lowered world sea levels.

Fossil Hominids

Our story began with Dubois's discovery of *Pithecanthropus erectus* in Java, a fossil form which we have now come to recognize as *Homo erectus*. Despite continuing research over the last hundred years, the dating of the *Homo erectus* fossils from Java is still extremely fraught. As we have seen, there are now several localities

known in central Java where hominid fossils have been found, including Dubois's Trinil site, von Koenigswald's Sangiran, Mojokerto and Ngandong sites, and several others such as Sambungmacan and Ngawi. These are all open sites associated with river valleys, in particular that of the Solo River and its tributaries. Originally, dating was based on a relative assessment of different layers of sediment containing different faunal assemblages: the more extinct species of animals in an assemblage, the older it was assumed to be. There was, and indeed still is, considerable argument about the identification and ordering of these assemblages, about the actual associations of different fossils with faunal assemblages and identified geological layers, and also about the accuracy and relevance of modern dating techniques as they have been brought to bear on the problem. Not surprisingly, there also continues to be disagreement about the fossils themselves and their interpretation in terms of human evolutionary trends and models.

Table 2.2
Java: Dating of Fossil Sites

Stratigraphic Unit	SHORT CHRONOLOGY	LONG CHRONOLOGY
Notopuro	[0.15 my KAr]	
Kabuh	[0.51–0.47 my fission track]	
	H. erectus <0.7 my	1.2 my
	0.7–0.95 my	1.2–1.4 my
Pucangan	[0.67–0.56 my fission track]	
	H. erectus 1.3–1.7 my	0.9–1.3 my
	1.9–2.1 my	2.5–3.0 my
Kalibeng	[2.99–0.47 my KAr]	

The most generally accepted view is that there are two stratigraphic units associated with the Solo River which contain hominid fossils, the Pucangan beds (the oldest), and the Kabuh beds, and the deposits at the Ngandong locality represent a younger period than these.

At Sangiran, the sequence appears to be as follows. The lowest stratigraphic unit, which contains no hominids, comprise the Kalibeng beds which are estuarine silts with marine fauna. They are considered to date to the Pliocene age (the one before the Pleistocene) and to be older than 2 million years. It is possible that at this time Java was a series of separate small islands beginning to coalesce into its present shape.

The Pleistocene levels begin with the Pucangan beds which contains the *Jetis* fauna, with 80 percent extinct species of animal, and which includes some hominids. One school of thought ("long chronology") puts the base of this unit at 2.5–3.0 my, which would be Pliocene not Pleistocene. Another school of thought ("short chronology") dates the bottom of the unit to 1.9–2.1 my; this does not represent the age of the hominids. Pollen preserved here suggests the emergence

of land, with decreasing mangroves, increasing rainforest, and also more open forest. The hominid fossils found here include Sangiran 4, characterized as very "primitive", because of its small brain size (900 cc), general robustness, and possession of a diastema – a gap between incisors to accommodate the canine from the opposing jaw protruding beyond the other teeth. This is a characteristic thought to be limited to apes rather than shared with hominids. There is also a *Meganthropus* from this layer – another primitive form sometimes suggested as an Australopithecine rather than a member of the genus *Homo*. The age of these hominids is generally put at *either* 1.3–1.7 my *or* 0.9–1.3 my. There is a fission track date of 0.67–0.56 my which is thought to provide a ceiling date.

The next unit is the Kabuh beds with a *Trinil fauna*, comprising 50 percent extinct species. The age of the unit itself is put at between 1.2 and 1.4 my according to the long chronology, or between 0.7 and 0.95 my. Associated pollen suggests an open grassy environment, but with rainforest. Most of the *Homo erectus* material comes from this unit. They are more robust than the Chinese fossils, but less so than the Pucangan specimens. The mean cranial capacity is 929 cc. Another *Meganthropus* occurs here. A fission track date supplies a ceiling of 0.51–0.47 my. The age of the fossils is put at either about 1.2 my or less than 700,000 B.P. Overlying the Kabuh beds is a layer of volcanic ashes, the Notopuro unit, which contains no fossils.

Ngandong is the name of a locality, and also a faunal assemblage which consists of modern species, with the exception of one (a Stegodon). The associated hominid fossils are generally assigned to *Homo erectus*, but there is some debate about this. They used to be known as "Solo man", and are sometimes considered a sub-species of modern humans, *Homo sapiens soloensis*. Their cranial capacity is larger than the earlier fossils, with a mean of 1500 cc, which is still considerably less than most fossils assigned to *Homo sapiens*. The dating of these specimens is, if anything, even more controversial than the others: anything from 900,000 to 20,000 B.P. has been suggested. There is a date of 0.25 my, and a date of about 300,000 B.P. is probably the most favoured, with another school of thought leaning towards 60,000 B.P.

There is, given even the latter dating, a gap between "Solo man" and fossils in Southeast Asia which are considered to be *Homo sapiens*, indeed *Homo sapiens sapiens*. The latter consist of a skull of a juvenile from the Niah Cave in Sarawak, east Malaysia, once thought to date to about 40,000 B.P. but probably much younger, and a mandible from the Tabon Cave on Palawan Island in the Philippines, dated to about 30,000 B.P.

Anthropological Record

Turning from the biological to the cultural record, we find a very noticeable contrast with the Chinese evidence . There is absolutely no evidence whatsoever for any cultural manifestation of any kind in association with, or even contemporary with, the *Homo erectus* fossil material in Java, indeed anywhere in Southeast Asia. Various claims have been made for surface scatters of stone artifacts, but none have ever been found in a datable context of the requisite antiquity. There are no cave sites like Zhoukoudian, nor open sites like Xihoudu or Dingcun, which contain artifacts or any other cultural evidence plausibly dating to the period of any of the *Homo erectus* (including Ngandong) fossil material.

Various arguments have been advanced to account for this. One is that such material has simply not been found yet. It has to be said however that the attempt has been going on for over 100 years. Another argument is that the geological formations do not favour the preservation of such material. There are however abundant limestone caves in Southeast Asia. Yet another argument is that *Homo erectus* in this part of the world used tools made of perishable materials, such as bamboo; this is not an easy proposition to subject to testing, and it would seem that something would be needed to cut the bamboo. A further line of reasoning is to query the significance of stone tools. If they are seen as important indicators of humanity in Africa, however, surely similar arguments must be applied elsewhere. If we are left with the proposition that *Homo erectus* in Southeast Asia was bereft of culture, what does this imply for our models of human evolution? We will come back to this important question.

The archaeological record in Southeast Asia begins with the Niah Cave where, as we have seen, a human skull was found in a context considered to be about 40,000 years old. The cave contains a long dated sequence of human occupation, including stone tools, animals bones, and pottery in the upper layers. There have been some problems with the site's excavation, analysis and interpretation, but recent research has clarified much of the site's significance. Artifacts from the lowest levels include small scrapers, thumbnail-type scrapers, notched scrapers and pointed flakes, and some pebble implements.

Several other sites are listed in Figure 2.6, which have produced dated cultural evidence for Southeast Asia in the late Upper Pleistocene. Most of the dating of these sites is by the relatively reliable radiocarbon method. For some of these sites, little detailed evidence has yet been published. Some are very well documented however. Lang Rongrien, a rockshelter in Thailand recently excavated, has produced stone artifacts dated to between *c.*27,000 and 31,000 B.P. They include predominantly small flake tools, mostly rather irregular scrapers. The cave site

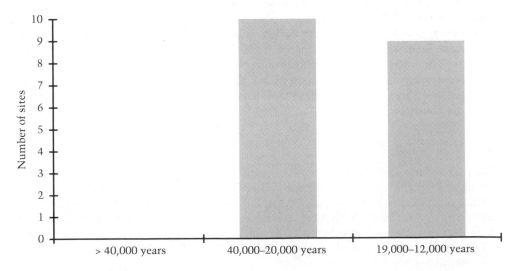

Figure 2.6
Pleistocene Archaeological Sites in S.E. Asia

Leang Burung 2, in Sulawesi, has yielded artifacts dated to between 20,000 and 31,000 B.P. which include steep edge scrapers, small multi-platform cores, and also blade-like forms. Kota Tampan is unusual in that it is a stone artefact workshop site dated to 31,000 B.P.; we would not therefore necessarily expect to find at it many finished implements. The artefact categories recognized at the site included anvils, cores, hammerstones, flake blanks and debitage, but also included some flake and pebble tools. Tabon Cave is another site with a rather problematic history. Artifacts from the lower levels consist largely of rather large (over 5 cm) flakes, with less than one per cent consisting of small scrapers.

Tingkayu is a series of open sites on the shores of a defunct lake. The date of the lake's formation is "probably indicated" by the dating of a lava flow which dammed the river course thus creating the lake. This does not necessarily indicate such a date for the sites themselves. A further complication is the fact that at least one of the sites was disturbed by a bulldozer. Artifacts include large pebble tools, horsehoof-type cores, some bifacial types, and flake tools, including at least one thumbnail scraper.

Generally speaking, it may be said that there is a resemblance between the stone tool assemblages of Southeast Asia which are represented at the earliest cultural sites there, and the industries of China which span almost the entire Pleistocene period. Before drawing any further conclusions however it will be useful to consider briefly the Australasian archaeological and human fossil record.

Australasia: Archaeological and Hominid Fossil Record

Australasia is important in the formulation of the regional continuity model for the evolution of modern humans; it has also been invoked with respect to the replacement model. As discussed above, Weidenreich's original continuity argument was that there was an evolutionary lineage from the Javanese *Homo erectus* through to modern day Australoids, that is, Australian Aborigines. In China, another lineage involved an evolution from the Zhoukoudian *Homo erectus* through to modern mongoloids. In Southeast Asia itself, Australoids were in more recent times supplanted by Mongoloids from (ultimately) China. We will come back to these notions of racial lineages. For now, the important point is the connection between *Homo erectus* in Java and Australian Aborigines.

Fossil Hominids

There are two main Pleistocene sites for fossil humans in Australia, one of which is only just Pleistocene in age. The oldest human Australian fossils are from Lake Mungo, in western New South Wales. One is the cremation burial of a female, known as Mungo 1, and dated to between 24,500 and 26,500 B.P. by a series of radiocarbon dates, including one on the bone itself. The other firmly dated example is Mungo 3, the extended inhumation burial of a male, which is dated to between 24,000 and 26,000 B.P. on the basis of radiocarbon samples from sediment and other material in close association with the burial. Several other human remains

AUSTRALIAN ABORIGINAL PEOPLE AND THE STUDY OF FOSSILS

In Australia, there has been considerable debate over the last twenty years between researchers, such as archaeologists and physical anthropologists, and Aboriginal people about the study of human skeletal material. The debate has at times become extremely heated.

Aboriginal people have expressed the view that it is inappropriate for scientists to study the physical remains of their immediate and past ancestors, of whatever antiquity. Researchers, who have been of mostly European descent, have tended to feel that the scientific pursuit of knowledge was sufficiently important to override other considerations. Aboriginal people, who view themselves as an oppressed indigenous minority, have accused researchers of being insensitive, and of being cultural imperialists. Researchers have responded by accusing Aboriginal people of being politically motivated.

Of recent years, however, most researchers have recognized that Aboriginal people may have the right to determine what should be done with their own heritage. A more conciliatory approach by archaeologists and physical anthropologists has led to much better communication between these groups, and leaves us with the hope that research in this sensitive area may continue in the future, so long as Aboriginal people are properly consulted.

are known from the Willandra Lakes complex, but few have been dated or described. One specimen, WLH [Willandra Lakes hominid] 50, has attracted considerable attention. It was found as an unstratified specimen, and consists of a heavily mineralized calvarium. An attempt has been made to date this fossil by electron spin resonance, with a resulting suggested date of 29,000 B.P.

One of the largest human fossil assemblages from Australia comes from the Kow Swamp burial site, on the Murray River in southeastern Australia. Over 40 individuals were buried here between 9300 and 14,000 B.P. There are several other sites which have produced individual specimens, or larger collections, but they are mostly not well dated (Table 2.3).

All known Australian human remains are definitely anatomically modern humans, *Homo sapiens sapiens*. There is however variation between them, which has led to different interpretations. The Lake Mungo 1 and 3 specimens have been

Table 2.3
Human Fossil Sites in Australia

	Sites	Years B.P.
Gracile	Mungo I–III	32–25,000
	King Island	4,300
	Keilor	?12,000
	Cohuna	?14–9,000
Robust	Kow Swamp	14–9,000
	WL50	?29,000
	Lake Nitchie	?15–7,000
	Talgai	?12,000
	Coobool Creek	?12,000
	Mossgiel	?11–5,000
	Cossack	?<6,000

said to be especially gracile, that is, fine-boned. They are, as it were, very modern in appearance. The Kow Swamp individuals, on the other hand, are said to be extremely *robust*, and to retain archaic features, in particular, foreheads which slope back. This characteristic is referred to as "frontal recession". Various other remains have been referred to either a "gracile" group, being similar to the Mungo examples, or to a robust group, similar to those from Kow Swamp (see Table 2.3). These two groups are both said to exceed the range for modern Aboriginal people, the gracile group being more gracile, and the robust group being more robust. There are two main interpretations of this.

One school of thought follows Weidenreich and the regional continuity model. In this view, the Kow Swamp fossils retain characteristics which link them to the Ngandong (Solo) hominids, and through them to the early Javanese *Homo erectus* fossils . The gracile group, on the other hand, is seen as showing more modern characteristics. This is of course extremely problematic, given the relative dating of the two groups; the oldest fossils are the most modern, and none of the supposedly archaic ones have been convincingly shown to be older than 15,000 B.P. at the very most, and, indeed, most of them seem to be post-Pleistocene in age. To support this view, it is necessary to argue that the Kow Swamp group is a lingering remnant of a very much older population, but one for which there is currently no evidence. Furthermore, the Mungo group are seen as "intrusive" in this view, and they have indeed been compared to such Chinese fossils as Liujang.

Another view is that the differences between the robust and gracile groups have been overemphasized. One scholar in particular has shown good evidence to support the idea that many of the robust group's significant features, particularly frontal recession, was due to a cultural practice, that of moulding the soft skulls of infants. In support of this view is the fact that many of the robust specimens come from the Murray River Valley in southeastern Australia. This region was characterized by high population densities and specific cultural practices during the Holocene, and it is very likely that it was a group which was more genetically self-contained than many other Aboriginal populations.

There is further support for the view that the robust group was not so much a population retaining archaic features, as a population which developed its own unique features in terminal Pleistocene times. The Tasmanian Aboriginal people were, on the basis of the archaeological evidence, isolated from mainland and Australia, and the rest of the world, since the formation of Bass Strait at the end of the Pleistocene, about 12,000 years ago. The Tasmanian Aborigines were however morphologically extremely similar to the coastal populations of mainland Australia, and showed features more in common with the Mungo-Keilor group, than the Kow Swamp group. This is further supported by the inclusion in this group of the fossil human from King Island dated to 14,000 B.P.

Archaeological Record

The archaeological record for Australia during the Pleistocene is abundant and comparatively well researched. The oldest dates are similar to those for Southeast Asia, between 40,000 and 30,000 B.P. Some evidence has been argued to represent earlier dates, but it has not been verified as yet. Stone artefact assemblages from these sites, with few exceptions, comprise a repertoire of small flake tools, scrapers including thumbnail scrapers, with a small proportion of core tools, including

pebble choppers, with the use of bipolar techniques in evidence. In short, they bear marked resemblances to the earliest assemblages of Southeast Asia, and to the Pleistocene industries of China.

The Australian archaeological record has been used to support the replacement model of human evolution, in that it shows a significant colonization of an empty land mass by *Homo sapiens sapiens* well after their presumed emergence in Africa. The fact that a major water barrier had to be crossed to effect this colonizing process is argued to be evidence of skill possessed only by fully anatomically modern humans.

The Coming of Humans to Asia

In China, the weight of the evidence, both biological and cultural, appears to favour the regional continuity model of human evolution. While it may be possible that *Homo sapiens sapiens* spread out from Africa 200 to 100,000 years ago as far as the Far East, there is little evidence for a total replacement in the cultural record, and neither does the fossil evidence show a marked change of the kind the replacement model appears to demand. The situation in Southeast Asia is rather different however.

There is no doubt that the first hominid occupant of Southeast Asia was *Homo erectus*. This *H. erectus* had certain primitive morphological features, and also appears to have been, compared with the populations in Africa, Europe and China, virtually bereft of culture. This population appears to have evolved to some extent, as shown in the Ngandong fossils, but sometime, perhaps in the Middle Pleistocene or even early Upper Pleistocene, became extinct. The first human occupation of

Table 2.4
An Outline of Human Evolution

0.004 my	Beginning of Chinese civilization
0.007 my	Agriculture in China and S.E. Asia
0.01 my	Appearance of pottery in S.E. Asia = agriculture?
0.04 my	*Homo sapiens sapiens* plus tools in S.E. Asia and Australia
0.50 my	Zhoukoudian: *Homo erectus* and tools
1.00 my	*Homo erectus* in Java. *Homo erectus* in China
1.50 my	*Homo erectus* and Achevlian in Africa
2.00 my	
2.50 my	*Homo habilis* and tools in Africa

Southeast Asia took place about 50,000 years ago, by *Homo sapiens sapiens*. This fully modern human was probably coastally adapted and equipped with highly functional watercraft. At a time of lowered sea level, water crossings of up to 65 km appear to have been negotiated across Wallacea into Australia and to oceanic islands of Melanesia. This was also a time of major dispersion of mammals into Southeast Asia. Whatever the reason, whether due to climatic change, and whether there is indeed any connection between human and beast, the major human dispersal took place at about the same time. The animals were however stopped by the larger water barriers; the humans on the other hand seem to have found them to be no barrier at all. Thus we may see mainland Southeast Asia and Australasia colonized virtually simultaneously by modern human beings some 40,000 to 50,000 years ago. The general characteristics of the cultural record in these areas suggests the most reasonable place to look for their origin is to the north rather than the west, that is, to look to China for the origins of the early modern human populations of Southeast Asia and Australasia. It appears that ultimately modern humans came to Asia from Asia.

The Coming of Asians to Asia

It has been argued here that the early archaeological evidence from Southeast Asia and Australia both show a relationship to the Pleistocene archaeological record of China. The fossil evidence may also be interpreted this way, although this is extremely controversial. Scholars have perceived resemblances between the Chinese early *H. sapiens sapiens* fossils such as Liujiang and Ziyang, and the skull from the Niah Cave, and the Australian fossils Mungo 1 and Mungo 3. There is of course a disparity between the latter and the robust Kow Swamp type fossils from Australia, but they may be explained as an indigenous variation. Even so, we are still left with a problem. Modern Asians bear little resemblance to modern Australian Aboriginal people. Where, therefore, did this "racial" difference come from? Is it possible that it could have occurred as a natural process of genetic divergence within the last 40,000 years?

The notion of "race" amongst the human species is an old one, and has often and notoriously been used to distinguish one group of humans from another for rather less than benign purposes (see Chapter 9). While it is one thing to classify people into groups according to purely physical characteristics, it is quite another to impute levels of "superiority" or "inferiority" to one group or another; but this has always tended to be the case, and often with appeals to "evolutionary" justification. The question as to whether there can be a proper, objective and scientific division of humankind into races is still a vexed one, and many people now believe it to be inappropriate. Others see this as an unfortunate reaction against the improper uses to which the concept has often been put.

Emmanual Kant, the philosopher, divided humanity up into races as long ago as 1775, in a classification similar to the one still in general currency. *Caucasoids* include the white skinned Europeans as well as darker skinned Indians; *Mongoloids* are the more pigmented peoples of Asia and the Americas; and *Negroids* are the deeply pigmented peoples of Africa. Some racial schemes have further major races, such as the *Veddoids* of Peninsular India, and the *Australoids* of Australia.

WHAT IS A SPECIES?

A botanist called Karl Linnaeus (1787–1778) published a book called *Systema Natura* in an attempt to classify all the plants and animals in the world. This book was in its thirteenth edition when Linnaeus died in 1778, and many more editions were produced by his students on his death. By the tenth (1758) edition, Linnaeus had refined his system of classification to that which we still use: the *binomial system of nomenclature*, governed now by the *International Rules of Nomenclature*. In this edition, it was used to name 4236 species.

In this system, each kind of organism has two names, a *Genus* name (e.g. *Homo*) followed by a *species* name (e.g. *sapiens*) – note emphasis and capitalization. Linnaeus also grouped genera into Orders, and Orders were grouped into Classes. Now we have Families inserted between order and genus, and classes sorted into higher groups – Phyla. We also have over-arching kingdoms, plant and animal. This is an hierarchical classification, which means there is no cross-cutting between the groups.

The main criterion for a species is that all its members may interbreed with each other (if they are of the appropriate sexes, of course!), and produce fertile offspring. Thus, lions cannot interbreed with tigers; and horses and donkeys may produce offspring in the form of mules, but they are not fertile, and hence horses and donkeys are classified as separate species.

All human beings alive today, and in the last 40,000 years or so, are classified as a single species, *Homo sapiens*. All humans are able to breed with all other humans, wherever they come from. The Aboriginal people of Tasmania, who seem to have been quite isolated from the rest of the human species for at least 12,000 years, were nonetheless able to interbreed with the Europeans who invaded Tasmania 200 years ago. Indeed, there are some four thousand people in Tasmania today who identify themselves as Tasmanian Aboriginal people, who mostly also share some degree of European ancestry.

Sometimes species are sub-divided into sub-species, to indicate differences between groups which are not sufficient to render them as separate species. Sometimes, these sub-species are referred to as *races*.

In the past, it was common to classify different groups of human beings as races. To some extent, these differences were considered to be sub-specific. This is not now the case, as the usual classification of all humans is as a single sub-species, *Homo sapiens sapiens*. There is still, however, some recognition of differences between human groups, which may be discussed in terms of "race". The traditional human races are of courser Caucasoids (people of Europe and India), Negroids (people of Africa), Mongoloids (people of Asia and America) and Australoids (people of Australia and Melanesia). Generally, however, it is recognized that it is too simplistic to draw really firm distinctions of this kind.

These are the major divisions usually recognized, but it leaves many human groups unclassified, or difficult to locate. The Hottentots of southern Africa, the Tasmanian Aborigines, the so-called Negritoes of Southeast Asia, for instance, have always been seen as anomalous, and the tendency has always been to classify such groups as more "primitive" than their numerically dominant neighbours.

By and large the classification of races has always relied on what the palaeontologist at least sees as superficial differences: soft tissue characteristics of hair and skin which are not reflected in the skeleton. Mongoloids are classified as having a sallow skin colour, straight black hair, black eyes, an epicanthic fold in the eyelid, and very little body hair. The only characteristic with potential fossil value is the possession of shovel-shaped incisors, and perhaps a general gracility compared with other groups. This of course raises two problems. Most obviously, fossils simply do not display most of the characteristics which have been used to define races. It also means that we do not really know how long such characteristics take to become established as the norm in a given population.

The Tasmanian Aborigines provide an instructive example. They were considered for many years, from the time of their first encounter with Europeans in the eighteenth century to be different from mainland Aboriginal peoples. This is indeed

one of the most persistent of myths about Tasmanians: that they were totally unrelated to other Australian Aborigines, were a "lost race" of some sort, had drifted down from Melanesia, or were a surviving remnant of primitive antiquity. There is no doubt however that the Tasmanians were *Homo sapiens sapiens*; quite apart from anything else, they were demonstrably able to interbreed with Caucasoids. The major physical reason for considering the Tasmanians as "different" appears to have been their hair: instead of being loosely wavy like that of mainland Aboriginal people, it was tightly curled, like that of Negroid peoples. We now know however that Tasmanian Aborigines shared a common ancestry with mainland Aboriginal peoples, and such differences as there were, were due to 12,000 years of isolation. And, as we have seen, at a skeletal level, there was very little difference between Tasmanian populations, and those of the neighbouring coastal areas of mainland southeast Australia.

Returning to our primary interest, that is, where Asians came from, that is, people of Asian appearance, or Mongoloids, it is clear that the fossil record is not going to be as helpful as we would like. There are two possibilities.

1. There is the old Weidenreich idea that Asians evolved from Chinese *Homo erectus (Sinanthropus)*, with a lineage from Lantian and Zhoukoudian through Dali, Maba, Liujiang and the Upper Cave fossils, and Australoids evolved from Javanese *Homo erectus (Pithecanthropus)* from Trinil and Sangiran, with a lineage through Ngandong (Solo man) leading to modern Australian Aboriginal populations. This has been perpetuated within the context of the regional continuity model for the emergence of modern humans. The main problems with this model lie in the lack of evidence of continuity in Southeast Asia, either physical or cultural, and the Australian fossil record, as discussed above.

2. There is the full replacement model, given impetus in recent times by studies of mitochondrial DNA. In this model, *Homo sapiens sapiens* spread out of Africa probably within the last 100,000 years, and replaced previous *Homo erectus* populations all over the Old World, and spread into previously unoccupied areas like Australia. The problem with this model lies in the evident continuity in China both physical and cultural.

3. There is the modified replacement model, which sees regional continuity in China with *Homo erectus* evolving into *Homo sapiens*, then *Homo sapiens sapiens* (not excluding the possibility of genetic input from elsewhere), which spreads out and replaces the *Homo erectus* populations of Java, if they are not indeed already extinct. Chinese fossils from the Pleistocene show consistent shovelling of incisors. This may be taken as a sign of early "Mongoloidization", but early fossils from other areas also show this characteristic, so it may be one that is retained by Asians and lost by other groups, rather than being distinctive of the modern group. Some scholars see considerable resemblances between Australian human fossils and Chinese fossils from the upper Pleistocene.

In both the last two cases, we must infer that the evident physical differences between Mongoloids and Australoids developed within the last 40,000 years. This presents some difficulties, but not insuperable ones. On the one hand, the fossil record is ambivalent on this issue. On the other hand, the really crucial area is

Southeast Asia. Was this area occupied by a common ancestor of Mongoloids and Australoids who diverged in the direction of Mongoloids from an early period? Or was it perhaps occupied by an Australoid population which was supplanted in recent times by Mongoloids?

After the Pleistocene

The fossil record for the last 10,000 years is scanty and suffers from dating problems. It presents a range of characteristics which have been interpreted both ways, to show either regional continuity (or replacement at this relatively localized level). I have referred above to the Niah Cave in Sarawak and the Tabon Cave on Palawan in the Philippines. The so-called "deep skull" from Niah may be up to 40,000 years old, although many now prefer to see it as younger. This site also contains burials in later contexts, one group dating to terminal Pleistocene times (from perhaps 14,000 to 4000 years ago), and a more recent group, about 2000 years old. One school of thought characterizes the "deep skull" as having "Australoid" rather than "Mongoloid" characteristics, and the older group of burials as having non-Mongoloid affinities. The younger burials, on the other hand, are suggested to have Mongoloid characteristics, and thus, in this sequence, we may see a replacement of a non-Mongoloid population by a Mongoloid one within the last 2000 to 3000 years. A similar interpretation has been suggested for the Tabon

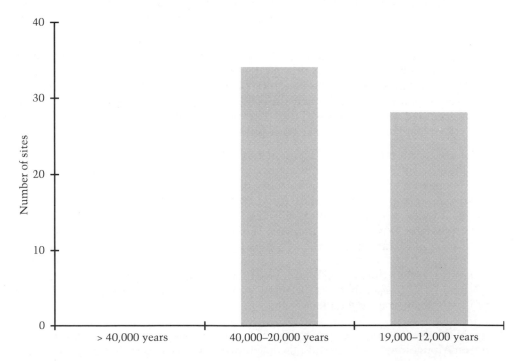

Figure 2.7
Pleistocene Archaeological Sites in Australasia

material, where the early human remains dated to about 30,000 years ago have been seen by some as Australoid, but burials younger than 3000 B.P. have Mongoloid characteristics, particularly shovelled incisors. On the other hand, some researchers do not agree at all with these racial characterizations, and other sites do not show such (real or apparent) differences over this time span.

The archaeological record provides some further clues, but they are, as always, open to differing interpretations. The archaeological record in Australia shows considerable continuity from 40,000 until mid-Holocene times (c.4000 B.P.), when a new range of stone artefact types is added to the preexisting repertoire. Changes of the kind seen in other parts of the world are not however evident in Australia, where Aboriginal people maintained a successful lifestyle as hunter-gatherers, without it seems needing to take up agricultural practices, metallurgy nor elaborate social stratification.

In China, we see new socio-economic structures emerging during the early Holocene. The use and manufacture of ceramics is usually taken as indicating a more settled way of life than that of the hunter-gatherer, and suggests the beginning of agricultural practices. At three cave sites in south China, some fragments of pottery has been found. Dates have been obtained from each site of the order of c.11,000 B.P. – this is highly controversial. If accurate, it indicates either a ceramic tradition independent of farming, or a very early date indeed for the beginnings of agriculture.

More widely accepted dates for the origins of agriculture in China, north and south, are around 7000 years ago. Such a dating has been obtained from settled village sites, with evidence for agriculture in the form of actual remnants of cultivated plants, and the bones of domesticated pigs and dogs. These settlements increase in size through time, and by perhaps 4500 years ago, we find the earliest evidence for Chinese writing, in the form of incisions on the shoulder blades of oxen, used in divination practices. At about this time also, it is believed that the cultivation of rice became firmly established. By about 4000 years ago, the Shang Bronze Age brings us firmly into the age of metallurgy, and over the threshold of recorded history. Throughout this early post-Pleistocene period in China, despite various economic and stylistic changes, we see remarkable overall cultural continuity in the archaeological record, which indeed continues to this day.

The archaeological record of Southeast Asia, on the other hand, shows considerably more change through time during the Holocene than that of Australia, and less cultural continuity than that seen in China. It is possible that some of the major social and economic changes we see here were accompanied, indeed accomplished, by new groups of people.

The stone artefact industry known as the Hoabinhian was once considered to be of considerable antiquity. Recent research however suggests that it is of terminal Pleistocene age, c.12,000 B.P. at the oldest. It is found mainly on mainland Southeast Asia – in Vietnam, Thailand, and Peninsular Malaysia – and on the north coast of Sumatra. While it does have resemblances to the earlier industries, it is different in that it contains fewer flake tools and has a much greater emphasis on pebble choppers. Of particular interest is the fact that the beginnings of agricultural practices appear to occur within the context of the Hoabinhian without any great noticeable accompanying cultural changes. This change is indicated by the appearance of pottery and also *ground* stone axes in archaeological sites, alongside Hoabinhian flaked stone tools types, about 5000 years ago.

What is usually regarded as one of the most significant changes in the archaeological record of the region is the appearance of a range of pottery types across island Southeast Asia and beyond, into Oceania, about 5000 years ago. This is usually correlated with the widespread expansion of agricultural Austronesian-speaking peoples.

The Austronesian family is a related group of languages spoken by peoples in Indonesia, Malaysia, the Philippines and Taiwan, that is, island Southeast Asia, as well as parts of Vietnam. It is also the language of the Polynesian found in the Micronesian Islands, and some Melanesian groups. The furthest example is Madagascar. Historical linguists suggest that the initial development of Austronesian began between 6000 and 4000 years ago. Some, but far from all, linguists believe the original affiliations of it to have been with the Thai-Kadai languages of Thailand and South China. The issue is an extremely complex one, which cannot be properly explored here. It may be said however that the spread of Austronesian-speaking peoples is often taken to represent the expansion of Mongoloid peoples from the north, across those areas. In this model, the so-called "Negrito" or "Aboriginal" peoples of Malaysia and the Philippines are taken to be surviving remnants of non-Mongoloid, indeed Australoid, peoples who preceded Mongoloid in all these areas. They are usually said to be hunter-gatherers, but in fact many of them have been observed to practise a form of agriculture and, conversely, some hunter-gatherer groups are in fact Austronesian speakers.

Sometime in the last 2000 years, we see archaeological (and linguistic) evidence for trading connections between Southeast Asia and India, and the subsequent development of Indianised courts and temples, both Hindu and Buddhist, by 1500 years ago (A.D. 500). It is doubtful that this had much effect on the ordinary village farming communities. During this time, there is also evidence for trading connections with China. By about A.D. 1200, Islamic influences, again from India, began to make themselves felt, and a number of Islamic sultanates were established in several parts of the islands. Not long after this, of course, western European powers began to manifest an interest and a presence in Asia, leading to the cultural mosaic of modern historical times.

It should be clear by now that the archaeological record, and the human fossil record, both present problems of interpretation and analysis which will always resist clear and unequivocal answers. Perhaps the greatest advance of recent research is to point the way towards interpretations which are not Eurocentric, nor Afrocentric for that matter, but which allow data from Asia and Australasia to be considered in their own right. We may thus hope to avoid the pitfalls of imputing "primitiveness" to "otherness", and rather concentrate on the ability of the human species to colonize and adapt to a wide range of environments in space and time, while retaining a common humanity, but with distinctive regional identities.

3 THE LINGUISTIC MOSAIC

Amara Prasithrathsint

Humans communicate by using language, but does language only belong to humans? Animals communicate with one another and humans communicate with animals too. In some Asian languages, there are expressions suggesting that people believe animals have "language". For example, in Mandarin Chinese one says /neng2 dong3 ren2 yu3/[1] (can-understand-man-language), when describing any animal that is intelligent or understands quickly what is said to it. In Thai when describing any animal as clever, one says that the animal /ru:3 pha:sa:4/[2] (know-language), meaning it understands what is said to it. But these expressions do not necessarily imply that humans regard animals as having a "language" with which to communicate among themselves just as we, human beings do. It probably simultaneously reflects the continuing human fascination with how we differ from other animals, as well as a recognition of the fundamental connection between language and culture.

Anthropologists agree that language is a part of culture. It shares all the significant characteristics of other parts of culture; it belongs to human beings living together in society; it is patterned behaviour that they learn and pass down from generation to generation; it changes through time and in accordance with changes in other aspects of culture. Most regard language as the most symbolic and most abstract part of culture. Language is essential to culture, for it is through it that humans create, accumulate, adapt, expand and transmit other aspects of culture. Yet some anthropologists treat language as if it stands to one side of "culture" as a whole. Thus they use the word "culture" to mean non-linguistic culture, or all aspects of culture except language. For instance, Beals and Hoijer (1971:471) say, "Just as each human society has its own culture, distinct in its entirety from every other cultures, so every human society has its own language." This approach to language as a distinct sphere of human cultural activity arises from the fact that it is universal, rooted in our biological nature.

Design-features of Human Language

Hockett (1960) proposed thirteen design-features all shared by the human languages

1. There are four distinctive tones in Mandarin: high, rising, low, and falling. They are marked here as 1, 2, 3, 4, respectively.
2. There are five distinctive tones in Thai: mid, low, falling, high, and rising. The mid tone is usually unmarked, and the other four tones are marked here as 1, 2, 3, 4, respectively.

of the world. They are as follows:

1. *Vocal-auditory channel.* This means using vocal apparatus including the mouth and the ears.
2. *Broadcast transmission and directional reception.* This means that while our speech travels in all directions at once, we can usually distinguish the direction that a spoken message is coming from (Stross, 1976: 55).
3. *Rapid fading.* This means lasting for only a short time. Our speech fades away immediately.
4. *Interchangeability.* According to Hockett this means a speaker of a language can reproduce any linguistic message he can understand.
5. *Total feedback.* The speaker of a language hears everything of linguistic relevance in what he himself says. Hockett says, "Feedback is important since it makes possible the so-called internalization of communicative behaviour that constitutes at least a major portion of 'thinking'." Also it makes learning faster and easier.
6. *Specialization.* This refers to the fact that "the bodily effort and spreading sound waves of speech serve no function except as signals" (Hockett, 1960: 6).
7. *Semanticity.* This means "language is meaning" (Stross, 1976: 55). When we say something we always mean something, although we must remember there are many kinds of meaning.
8. *Arbitrariness.* "Most speech signals share no characteristics of sound or form with the object or events that they refer to" (Stross, 1976: 55). For example, the word /nam3taan/ in Thai or *sugar* in English is not sweet. The word for 'elephant' in Thai,/cha:ng3/, does not sound or look bigger than the word /nO:n4/ 'worm' in Thai. The same sound in different languages does not mean the same thing, *me* /mi:/ in English compared with /mi:/ 'have' in Thai.
9. *Discreteness.* Speech is made up of distinct parts that are contrastive. The smallest units, sounds, that constitute speech make distinctions of meaning. For example, in Thai /paj/ and /phaj/ mean 'go' and 'danger', respectively. The discrete sounds that cause difference in meaning in the two words are the unaspirated /p/ and the aspirated /ph/.
10. *Displacement.* This means that in using language, humans are able to talk about things that are not present, e.g. events in the past or something that might happen in the future or in the speaker's imagination.
11. *Productivity.* This means "openness". Human language is open because it can be used to talk about things that have never been said before and can produce an infinite number of messages.
12. *Traditional transmission.* This means that language is passed on from one generation to another by teaching and learning, not through genes. Like other aspects of culture, language has to be acquired: it is not instinctive; however linguist Noam Chomsky has argued that there is an inherent "language faculty" in humans.
13. *Duality of patterning.* This means that meaningless elements are combined into meaningful units. For example, the meaningless sounds /p/, /l/ and /a:/ are put together into /pla:/ and this means 'fish' in Thai. Every human language has a limited number of meaningless individual sounds. These sounds are put together into a large number of combinations called words.

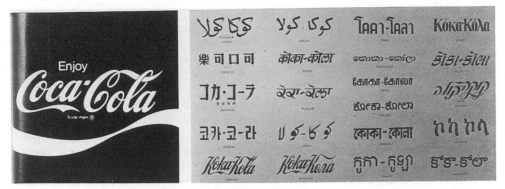

From The Illustrated Encyclopedia of Mankind, Vol. 17, (new edition edited by Yvonne Deutch), Marshall Cavendish: New York (1984).
Courtesy of Coca-Cola Europe Ltd.

According to Hockett, only human language possesses all the thirteen features. From an anthropological point of view it could be said that points 8, 10, and 11 are the most important. For it is the combination of these elements which generates the complex meanings of human communication.

Human language, as Edmund Leach (1971:141) put it, is "true language". With it, each individual is capable of making an indefinitely large number of brand-new utterances. Ordinary animal communication systems may be complicated but are highly repetitive. They make use of signals. Unlike humans, animals normally do not create new combinations and permutations from items in their communication systems. In short, we could say that human language is an abstract or symbolic system, whereas animal communication is a signal-response system.

But is the contrast between humans and animals so clear? It has been one of the achievements of modern biology to show how close we are to primates like chimpanzees and this has led to a series of experiments in which humans have tried to teach them human language. Premack and Premack (1972) report that over the past forty years several efforts have been made to teach a chimpanzee human language. In the early 1930s Winthrop and Luella Kellog raised a female chimpanzee named Gua along with their infant son. At the age of 16 months, Gua could understand about 100 words, but she never tried to speak them. In the 1940s Keith and Cathy Hayes raised a chimpanzee named Vicki in their home. She learned a large number of words and finally was able to pronounce the words "mama", "papa" and "cup" but with some difficulty. In the early 1960s, Allen and Beatrice Gardner (Gardner and Gardner, 1969) taught their chimpanzee, Washoe, to communicate in American Sign Language with her fingers and hands. In 1966, the Premacks started to teach Sarah, a young chimpanzee to read and write with variously shaped and colored pieces of plastic, each of which represented a word, such as "Sarah", "Mary", "chocolate", "banana", "give", "take", "same", "different", and so forth. Sarah had about one hundred and thirty terms that she used with a reliability between 75 and 80 percent.

Premack and Premack asked, "Was Sarah able to think in the plastic-word language? Could she store information using the plastic word or use them to solve certain kinds of problems that she could not solve otherwise?" (1972:31) The authors suggested that the answer to these questions may be a qualified yes.

The test also suggests that Sarah was able to understand words in the absence of their external referents. This implies that her linguistic system has displacement, which as we have seen is one of the significant features of human language. Indeed, the authors concluded that "Sarah had managed to learn a code, a simple language that nevertheless included some of the characteristic features of natural language" (1972:33).

To state definitely whether Sarah's linguistic system is language or not is difficult and debatable. What is important to bear in mind, however, is that it is the humans who create and teach language, and the chimpanzees who learn from them. And even then their level of competence falls well below that of a human infant. Most anthropologists would argue that there is a *qualitative* difference between human and animal communication. Tim Ingold (1988) has argued that language is primarily "an instrument of thought":

> *Hence, the crucial difference between natives of another culture and animals of another species is this: the former possess a language which enables them to think, the latter do not. To grasp the natives' thoughts we have but to learn their language, and...one of the specific features of human language is that speakers of one language can learn and speak and understand one another. However we cannot grasp the animals' thoughts simply by learning and practising their communicatory mode, because the animals have no thoughts, as such, to grasp. (Ingold, 1988:94)*

Genetically, he says, we may differ only a little from other animals, but those differences have "mighty consequences for the world we inhabit" (Ingold, 1988:97).

The Content of Language

Some scholars regard language as composed of two dimensions: *form* and *substance* or *form* and *content* (see Grace, 1981:24–5 for a modification of this in terms of "lexification" and "content form"). Others talk about three major components or levels of language: **phonology**, dealing with speech sounds; **vocabulary**, dealing with words and their meanings; and **grammar**, dealing with rules for putting words together to form meaningful sentences. Greenberg (1977:10–21) emphasizes the fact that language is "structured"; rules and relationships exist at every level of language. The structure in language is governed by two kinds of relationship: **syntagmatic** and **paradigmatic relationships**. The syntagmatic dimension is the relation of successive items to each other. It varies from language to language. In Thai a modifier is placed after the modified item, e.g. /dek1 di:/ (child-good), whereas in Mandarin the modifier comes before the noun: /hao3 hai2-zi3/ (good-child). In short the syntagmatic dimension controls the order and agreement between words in a sentence, between sounds in a word or between features that comprise the meaning of a word.

In Thai we do not say a sentence like */chan4 kha:w2 kin/ (I-rice-eat), because it violates rules in the syntagmatic dimension of Thai,[3] which states that the word

3. The sign * in front of a sentence signifies that the sentence is ungrammatical.

order in a sentence should be Subject-Verb-Object (SVO), whereas such a word order, SOV, is perfectly correct in Japanese, Burmese, and Tibetan.

In phonology, a sequence of consonant sounds or cluster like /st/, as in the English word *star*, does not occur in Thai and therefore would violate the syntagmatic rules in Thai phonology, which does not allow a cluster beginning with a fricative sound, as the *s, sh, f,* and *th* sounds in English. Therefore, such English loanwords in Thai from original English words as *stamp, steak, swim,* are pronounced with the vowel /a/ inserted between the two consonants in the cluster as /satE:m/, /sate:k3/, and /sawim/, respectively.

A parallel phenomenon can be seen in the pronunciation of English loan words in Japanese. The syntagmatic rule in Japanese phonology does not allow a cluster and a word ending in a consonant, except nasal sounds. Therefore such English words as *bus, glass, milk,* and *hotel* are Japanized as /basu/, /gurasu/, /miruku/, and /hoteru/, respectively. It should also be noted that the English /l/ becomes /r/ in Japanese because /l/ is not a significant speech sound in Japanese.

The paradigmatic relationship is the relation between members of a class, where the members in each class share certain common characteristics. In syntax, we group words into parts of speech or word classes, as nouns, verbs, adjectives, and so forth. In phonology, we classify sounds like /i, a, o, u/ as "vowels" and /p, t, k, b, d, g, m, n, s, z/ as "consonants", which may be sub-grouped as "**stops**" (p,t,k,b,d,g), "**nasals**" (m,n), and "**fricatives**" (s,z).

We have seen how the two dimensions of relationship play their roles in various levels of language. Now we will have a look at the so-called "levels" of language. Goodenough (1981:5–11) divides language into five levels or systems: the phonological, morphological, syntactic, semantic and symbolic.

In the **phonological system**, we deal with **phonemes**. Phonemes are significant speech sounds in a particular language. They comprise words. For example, in Thai, the word for 'take' is /pha:/ composed of two phonemes /ph/ and /a:/. This word is in contrast with /pa:/ 'throw' and /ba:/ "bar." Thus, the consonant sounds /ph/, /p/ and /b/ in Thai are significant sounds; the meaning of the words depend on them.

Different languages choose different features to distinguish significant sounds. Indian languages discriminate retroflex /d/, pronounced with the tongue bent backward, from non-retroflex /d/. Mandarin differentiates palatalized /s/, pronounced with the front of the tongue against the hard palate, from the alvelolar /s/, pronounced with the tip of the tongue against the alveolar ridge. It is the task of phonologists to find significant sounds and explain the phonetic context of variants of those sounds.

The study of the **morphological system** – morphology – deals with the distribution of the minimal meaningful units in a particular language, which we term **morphemes**. A morpheme is composed of phonemes; for example, /khon/ "person" in Thai is a morpheme composed of three phonemes: /kh/, /o/ and /n/. Morphology also has to do with how morphemes are combined into a "smallest meaningful unit that can stand in isolation" called **word**. In Thai /khon/ "person", /khap1/ "drive" and /rot3/ "car" are put together to form a word – /khon-khap1-rot3/ meaning "driver" or "chauffer". However, /khon/, /khap1/ and /rot3/ are themselves words too, because each of them can stand alone. Topics like affixation,

derivation, word formation and compounding, etc. are also the concern of morphologists.

When we put words together to form a larger linguistic unit, we are stepping into the area of **syntax**. It is understood that the **syntactic system** deals with principles of ordering words into sentences. Different languages have different syntactic rules. Thai and Mandarin, although very similar in many ways in terms of syntactic characteristics, still have different ways of placing the modifier. The sentences /la:j my: khO:ng4 khaw4 suaj4 ma:k2/ (pattern-hand-of-he-beautiful-very) in Thai and /ta1 de zi4 ti3 hen3 mei3/(he-of-hand-pattern-very-beautiful) in Mandarin mean the same thing – "His hand-writing is very beautiful" – but in Thai the modifier comes after the word it modifies, whereas in Mandarin it is the opposite, as shown below (Figure 3.1).[4]

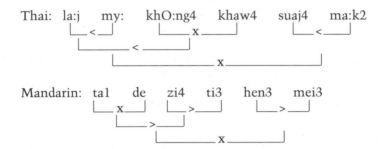

Figure 3.1

When we talk, our talk has to mean something, otherwise language would not be useful or worthwhile at all. The system that deals with meaning is the **semantic system**, which, according to Goodenough (1981:9), has to do with the standards by which people select particular words and expressions to convey particular meanings. It also relates us to the real world; it contains concepts that represent real entities.

The **symbolic system** is another system that constitutes language. Goodenough (1981:10) uses this term to mean the system that "comprises the principles governing the expressive and evocative uses of linguistic forms. *That's my father* and *That's my pop* denote the same kin relationship but express quite different attitudes of the speaker toward it". In brief, what this system deals with is **connotation** whereas the semantic system deals with **denotation** of the liguistic forms. Some people use the term "figurative meaning" versus "literal meaning" to mean similar things to connotation and denotation, respectively. In Thai, the words /ti:n/ and /tha:w3/ both denote "foot" or "feet", but /tha:w3/ connotes politeness, whereas /ti:n/ sounds impolite; it is used only by low-class people, people from rural areas, and in expletives.

It should be noted that social conditions play a very important role in the symbolic system. Hymes (1962), recognizing this fact, emphasizes that utterances

4. Note that the sign ⌊x⌋ signifies an exocentric construction in which the two constituents are both heads, whereas ⌊>⌋ marks an endocentric construction in which one constituent is the head (the end of the arrow) and the other is the modifier (the beginning of the arrow).

may be grammatical and semantically meaningful but can be inappropriate due to social conditions. Thus, a sentence like /kuu cep1 ti:n/ (I-hurt-feet/ "My feet hurt" in Thai, although perfectly grammatical, is inappropriate if used by a student when talking to his/her teacher because /kuu/ "I" and /ti:n/ sound very impolite.

The fact that the use of any linguistic item depends on social factors has led to the development of sub-disciplines within linguistics such as sociolinguistics, the sociology of language, discourse analysis, and the ethnography of communication. These disciplines deal with different aspects of the relation of language to society (for a survey see Fasold, 1984 and 1990).

Language, Thought and Culture: The Sapir-Whorf Hypothesis

The relation between language and thought was talked about very much in the 1950s and 1960s. In America it was Edward Sapir who, in 1929, launched the idea about the influence of language on all non-linguistic behaviour. He claimed: "Language is a guide to 'social reality.' Though language is not ordinarily thought of as of essential interest to the students of social science, it powerfully conditions all our thinking about social problems and processes" (Sapir, 1929; cited in Beals and Hoijer, 1971: 495).

Later, Benjamin Lee Whorf, a distinguished student of Sapir, tried to find evidence from American Indian languages that he had studied all his life to support Sapir's ideas. He proposed a hypothesis, which has been known as "the Sapir-Whorf Hypothesis", "the Whorfian Hypothesis", or "the Linguistic Relativity Hypothesis". Some also call it "the Linguistic Determinism Hypothesis" due to its suggestion that language governs or controls the behaviour of its speaker.

Whorf claimed that language shapes our ideas and confines the way people think and perceive their world. He cited examples from the grammar of some American Indian languages, but mostly from Hopi and Shawnee to demonstrate that there was a great discrepancy between these languages and European languages, which he called Standard Average European (SAE). The examples he gave do not lead to a definite conclusion that language governs our thought and behaviour. Therefore, his hypothesis has been controversial and become the subject of much debate and research among linguists, philosophers, anthropologists and psychologists since the publication of his writings.

Based on plenty of data from American Indian languages, which he compared to several European languages, Whorf drew our attention to grammatical categories, which he divided into two types: the overt categories or *phenotype*, such as the plural marking of nouns in English, and the covert categories or *cryptotype*, such as gender in English (compared to strict overt gender marking in Latin). He emphasized that anthropologists should not pay attention to only the overt type because "linguistic meaning results from the interplay of phenotype and cryptotype, not from the phenotype alone" (Whorf, 1956: 72). However, when Whorf cited evidence from the grammars of American Indian languages and the English language to argue for his hypothesis, he usually referred to the overtly marked categories.

For instance, he argued that Hopi verbs are not marked for tense, so he labelled Hopi "a timeless language" (1956:213), and tried to cite evidence in Hopi culture to support the idea of timelessness in Hopi culture. On the other hand, he labelled English "a temporal language" because of its overt tense marking. Another example he gave to show that Hopi is different from English is that Hopi does not use cardinal numbers with temporal words, such as "day", "month", in English. One does not say "in ten days" in Hopi, but would say something like "until the eleventh day". Moreover, there is no metaphorical use of words in Hopi as in English, but Hopi has a special class of words called "tensors" to express the same thing as metaphor in English. Whorf claimed that Hopi grammar or "fashions of talking", control the way the Hopi perceive the universe. Since Hopi grammar and English grammar are different, as shown above, the speaker of Hopi and the speaker of English have different pictures of reality, which, as Whorf suggested, lead to different patterns of behaviour or culture.

In one of his papers, entitled "Science and linguistics", Whorf put forward his idea clearly:

> It was found that the background linguistic system (in other words, the grammar) of each language is not merely a reproducing instrument for voicing ideas but rather is itself the shaper of ideas, the program and guide for the individual's mental activity, for his analysis of impressions, for his synthesis of his mental stock in trade. Formulation of ideas is not an independent process...but is part of a particular grammar, and differs, from slightly to greatly, between different grammars.
>
> ...no individual is free to describe nature with absolute impartiality but is constrained to certain modes of interpretation even while he thinks himself most free. The person most nearly free in such respects would be a linguist familiar with very many widely different linguistic systems....We are thus introduced to a new principle of relativity, which holds that all observers are not led by the same physical evidence to the same picture of the universe, unless their linguistic backgrounds are similar.... (Whorf, 1956:212–4)

The content of Whorf's assertion can be summarized as follows:

1. Our thought and perception of the environment depend on the language we speak.
2. The larger discrepancy between any two languages, the more different the world views of the speakers of these languages.

The Sapir-Whorf Hypothesis Applied to Asia

Taking evidence from Indian languages, Chinese, Tibetan and Japanese, Nakamura (1964) asserts many points describing what he calls "Eastern ways of thinking." He believes that language is basic to the cultural life of a people, and that it is necessary to inquire into forms of linguistic expressions to get insight into ways of thinking. Nakamura's (1964) claims for four Asian languages are briefly summarized below.

India

Nakamura says that Indians are more likely to think in terms of abstract than concrete things. In Sanskrit, there is excessive use of abstract nouns, which can be derived without limit by adding /-ta/ /-tva/ suffix to adjectives. In European languages abstract nouns are not often used except in scientific essays or formal sentences. "The fruit is soft" in English becomes "The fruit is softness" in Sanskrit – /phalam mrdutam yati/.

A remarkable characteristic of Indian thought, Nakamura suggests, is what he calls "the subjective comprehension of personality". Nakamura cites evidence from Indian grammar. He states that Indian languages do not use the accusative case as the subject of a sentence where it is required in Western classical languages. Even in classical Sanskrit this Indo-European characteristic has been lost. For example, in the sentence /na tvam socitum arhasi/ (You need not be sad), the subject "you" is expressed in the nominative case, while it is in the objective case in Greek and Latin. In other words, in classical Sanskrit, the grammatical subject of an instransitive sentence is in the same case form as that of a transitive sentence – the nominative case form, whereas in Greek and Latin, the subject of an intranstive sentence is in the accusative case form but the subject of a transitive sentence is nominative. In short, Indian languages are accusative languages, whereas Greek and Latin are more like ergative languages. The use of nominative case in intransitive sentences, Nakamura claims, reflects the preference for subjective interpretation, or the absence of impersonal judgements.

China

He then argues that Chinese, unlike Indians, tend to perceive things as concrete entities. Chinese characters, which are mostly pictographs, indicate that Chinese ways of expressing concepts are concrete. The term "epigraphy" would be expressed by Chinese characters meaning "writing on metal and stone". The term for "clairvoyance" would be in Chinese /qian1-li3-yan3/ "thousand li vision" (one li = 1890 feet).

The Chinese preference for concreteness may, Nakamura claims be related to their lack of consciousness of universals. In Chinese one finds many different words used to denote subtly shaded varieties of the same thing or action. The English word "carry" may be /dan1/, /song4/, /na2/, /yun4/, /ban1/, /bao4/, /dai4/, or /chou1/ in Chinese. This may correspond to Chinese emphasis on particular, vivid and complicated details reflected in other aspects of culture, as art and literature.

Another characteristic is esteem for hierarchy. In ancient times, Chinese society was based on an order based upon class discrimination. This was reinforced by Confucianism, which emphasizes the superiority of the governing class in society. In Chinese, there are many kinds of personal pronouns and each of them is used according to the social class of the person addressed.

Tibet

Tibetans, he characterizes as religious people. Their absolute submission to a religiously charismatic individual is reflected in the word for "monarchs" – /lha-

Tibetan with prayer leaf. Some writers stress the Tibetans' absolute submission to a religiously charismatic individual.
Courtesy of Grant Evans.

sras/ meaning "sons of god". They have belief in */bla-ma/* "personality of the lamas" – literally meaning "a high *(bla)* person *(ma)*". The word for "teacher" is a borrowed word from Sanskrit */kalyana-mitra/* "a friend of virtue".

The Tibetan language honorific forms demonstrate adherance to social order. Personal pronouns differ according to the speaker's attitude towards the person spoken of. Some nouns and verbs have their honorific forms besides the usual one. For example, words used in addressing a person vary according to the addressee: */kye/* to a king, */ka-ye/* to a friend, */kva/* to an employee, */baye/* to a servant. When talking to their fathers, Tibetans use */lha/* "Oh! God!" instead of "you", */sku/* "honored body" instead of */lus/* "body", */yab/* "respected father" and */yum/* "respected mother" instead of */pha/* and */ma/* "father" and "mother" respectively. Verbs are also changed to show respect. When conversing with or referring to an honored person, one uses */bgyid-pa/* instead of */byed-pa/* "to do" and */mchis-pa/* instead of */yin-pa/* "to be".

Japan

Japanese emphasize human group relations. A reply to an interrogation in Japanese is the converse of a Western reply. The question like "Aren't you going?" would be replied in Japanese "Yes, I am not" whereas in English it would be "No, I am not". The Japanese reply refers to the opinion or intention of the interrogator, whereas the Western reply refers to the objective fact involved in the question. Greetings in Japanese also make the point. Japanese greetings are elaborate. Forms

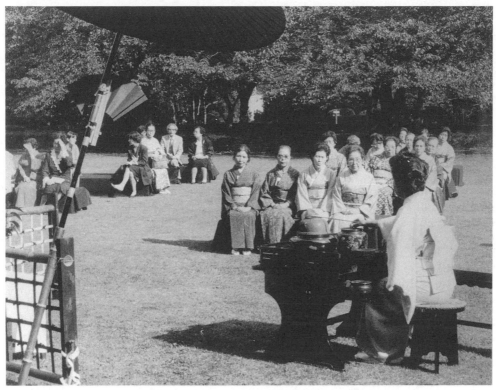

Some people argue that the Japanese emphasize human group relations and this is claimed to be epitomized by the Japanese tea ceremony, being studied here by older Japanese women.
Courtesy of Japan Information Service.

of politeness have to be observed not only among strangers but also among family members of the upper class.

Japanese subordinate the individual, and this is shown by the omission of the first-person pronoun. The Japanese prefer a harmonious social atmosphere in human relationships. They do not attribute actions to an independent individual performance of actions, which is why we see Japanese acting in groups rather than as individual, as in Western society.

Unlike Indians, who are inclined to attach importance to abstract complex ideas, Japanese emphasize simple and concrete ideas. In Sanskrit, "cloud" is often called /jalada/ or /ambuda/ "water giver", the bird /vihamga/ "flyer in the air", the elephant /matamga/ "meditative walker", and the lotus /ambuja/ "the flower which grows out of water". In Japanese, the same things would be expressed simply as: /kumo/ "cloud", /tori/ "bird", /zo/ "elephant", and /hasu/ "lotus".

The evidence cited above may lead to another conclusion that Japanese prefer simple symbolic expressions. The words are simple and clear. In art, this tendency can be discerned clearly. The Japanese are very fond of the impromptu short verse, like the *haiku* and *tanka*. In Japanese literature lyric poems and scenery sketches have been highly developed, but poems of grand style, with dramatic plots full of twists and turns have not been as popular.

Summary

To summarize, according to the Sapir-Whorf Hypothesis, language and culture are closely related and language shapes the world view of its speakers.

The points asserted above about Indian, Chinese, Tibetan and Japanese ways of thinking should not be taken as conclusive, and they are certainly open to further discussion or study. There have been many strong critiques written of the Sapir-Whorf hypothesis (Haugen, 1977). Furthermore, as mentioned in the introduction, modern anthropologists no longer view culture as a simple totality, as implied by the Sapir-Whorf argument. They recognize that cultures may share symbols but that individuals will interpret these differently according to where they stand in the society; according to their class, caste, gender or ethnicity. Also, in the latest meeting concerning the Sapir-Whorf hypothesis – a Wenner-Gren Foundation International Symposium entitled "Rethinking Linguistic Relativity" (reported in Gumperz and Levinson, 1991: 613) – it seems that instead of trying to settle the controversy of the hypothesis, the organizers attempted to "show that 'meaning' is not fully encapsulated in lexicon and grammar" which means that interpretation has to focus on language use. While some principles of language use are universal, others are culturally specific:

> In that case, aspects of meaning and interpretation are determined by culture-specific activities and practices. Those activities and practices are interconnected in turn with the larger sociopolitical systems that govern and are in turn in part constituted by them: particular divisions of labor and social networks provide differential access to such activities and the associated patterns of language use. (ibid.: 614)

Grace (1987: 56) proposed a new way of looking at the relation between language and thought or world view – "the reality construction view". In this view, we do not have direct access to the real world itself. We construct models of realities. These constructed realities are reflected in the language we speak. His view of the relation between language and culture seems to be a moderate interpretation of the Sapir-Whorf Hypothesis. He maintains that "a language is shaped by its culture, and a culture is given expression in its language, to such an extent that it is impossible to say where one ends and the other begins, i.e. what belongs to language and what to culture" (1987: 10).

Roy Harris in his study *The Language Makers* (1980) gives culturalist interpretations like Grace's a firmer political emphasis. He shows how in Europe the creation of standard dictionaries to provide a "correct" interpretation of the language meant that the "new orthology became an integral part of an equation between linguistic unity and socio-political unity..." (ibid.: 132). In Asia, the Thai language, for example has been strongly influenced by the most important and powerful institutions in Thai society: the state, buddhism and the monarchy. The idea of "the nation" and Thai nationalism gives rise to the policy of Thai monolingualism. Although implicit, this policy has vast influence on language choice, language use and even the structure of Thai itself. In terms of language choice, Thai is used in almost all functions: as the standard language, official language, national language, educational language and even a religious language in some monastries. With regard to language use, all Thais are supposed to be able to understand and/or speak Standard Thai. Switching to a foreign language or a

regional dialect and mixing foreign elements into Thai sentences is not tolerated in formal style. Finally, the phonology, lexicon and even the grammar of Thai is affected by this institution since the Thai language is one of the characteristics that mark the Thai identity. The Royal Institute of Scholars and other language authorities work hard to cultivate Thai. They advise or suggest "correct" pronunciation or grammatical usage and coin new words to be used instead of foreign words.

The institution of religion has influence on the lexicon. Words like /bun/ "merit", /kam/ "karma", /tratlsaru:3/ "enlightened", /nip3pa:n/ "nirvana" in Thai reflect the Buddhist world view. These words in turn also shape Thai people's world view. They tend to see and explain things in terms of the law of karma, merit and demerit, and the like.

The institution of monarchy has brought about a special variety or register of Standard Thai – the Royal language or "*Rachasap*". This variety is, in turn, used and manipulated to maintain this institution. "Cultivated" Thais are supposed to learn how to use this cultivated variety of language. In an address or report to the royal family, most of the expressions used are of the frozen style. However, the Royal family uses the normal variety when talking to common people.

Linguistic Diversity in Asia

Asia is rich in languages. In India alone it is said that more than eight hundred and forty-five languages are spoken. In Indonesia, one estimate is that there are at least three hundred distinct languages spoken by the various peoples of Indonesia. Most of these languages belong to the Austronesian family. Therefore, we may estimate that not less than one thousand five hundred languages are spoken in Asia.

There are many criteria used by linguists to classify languages. First, they may group them according to their genetic relationship, or their belonging to the same language family, e.g. Vietnamese, and Cambodian belong to the Austroasiatic family. Secondly, languages may be classified into "type". This kind of classification is known as "typology". For example, Thai, Cambodian and Malay are SVO languages (the word order of the sentence is Subject-Verb-Object). Tibetan, Burmese, Japanese and Korean are all SOV languages, whereas Philippine languages belong to the VSO type. Thirdly, languages may be classified into areal groups. Languages in the same areal group share the same part of the world and certain linguistic features. This way of classifying languages is called "areal classification". Thai, Vietnamese, Lao and Cambodian are grouped together into "Southeast Asian languages", which share some features, such as the SVO word order. Japanese, Chinese and Korean are usually grouped collectively as "East Asian languages" – all these languages have a large number of common lexical items borrowed from Chinese and some common syntactic features, such as putting the modifier in front of the modified. Besides, languages may be classified functionally into such groups as standard languages, official languages, and so forth. Finally, some people group languages politically into such classes as "minority languages," such as hill tribe languages in Thailand.

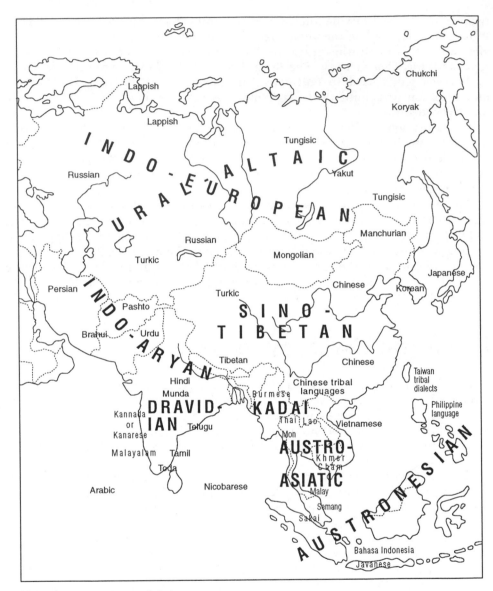

Major language groups of Asia.

Language Families in Asia

If we organize all Asian languages into language families, we end up with about seven families. To say that two languages belong to the same family means the same thing as saying that they are genetically related. **Genetic classification** of languages is based on the assumption that when languages share some sets of features in common, these features are to be attributed to their common ancestor. Philippine languages and Malay belong to a common family called the Austronesian

family, and the ancestor language of these languages is called "Proto-Austronesian". A proto-language is not an attested language; it is a hypothetical construct. Its postulation is useful when we hypothesize how sounds in daughter languages have changed through time from the past.

Linguists have proposed families for all the languages spoken in Asia. The following languages are ordered from the family with the largest number to the one with the smallest number:

Indo-European
Austroasiatic
Ural-Altaic
Sino-Tibetan
Austronesian
Dravidian
Tai-Kadai

South Asia has the largest number of languages in Asia. There are more than eight hundred languages spoken there. Some belong to the Indo-Aryan group, which is a branch of the Indo-European family, such as Marathi and Hindi. Others, such as Telegu and Tamil, belong to the Dravidian family. The others belong to the Sino-Tibetan, Tai-Kadai, and Austroasiatic families.

In mainland Southeast Asia, there are three main families: Austroasiatic, Tai-Kadai and Sino-Tibetan. Austroasiatic languages are scattered from central India eastwards to Vietnam. The languages belonging to this family spoken in this part of Asia are Vietnamese in Vietnam and Cambodian (Khmer) in Cambodia and also in some areas of Northeast Thailand. The Tai-Kadai family includes Thai (the

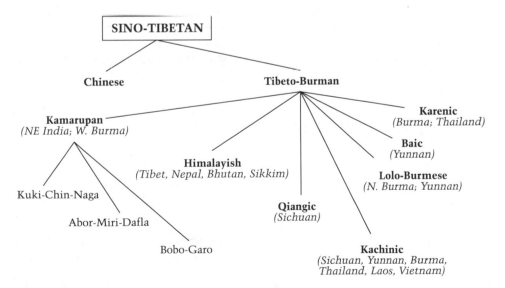

Figure 3.2
Sub-groups of Tibeto-Burman

(Source: J. A. Matisoff, "Sino-Tibetan linguistics: Present state and future prospects", in *Annu. Rev. Anthropol.* (1991) **20**, pp. 469–504)

language of Thailand) and Lao. This family used to be considered a branch of Sino-Tibetan, but this view is no longer accepted because of lack of convincing evidence and because of Paul Benedict's Austro-Tai Hypothesis. According to his proposed family tree, the Tai family is a sub-branch of the Kadai family, which is under Austro-Kadai, in contrast with Miao-Yao. Both Austro-Kadai and Miao-Yao are the two main sub-branches of Austro-Tai. (Benedict, 1942, 1972; cited in Thurgood, 1985:2) The Tai-Kadai languages are found spoken in Thailand, Laos, Southern China and in parts of Burma and Vietnam. Sino-Tibetan languages include all Chinese languages, Tibetan and Burmese. Some people also consider Miao-Yao languages spoken in Southern China and Northern Thailand to belong to this family but this remains controversial.

In East Asia, apart from Chinese languages there are Japanese and Korean which do not belong to the Sino-Tibetan family. The genetic relationship between Korean and Japanese, and between these two languages and other languages remain the subject of debate. Some scholars (Martin, 1966; Miller, 1967) proposed a genetic relationship between Korean and Japanese but this has been argued against by Benedict (1942, 1972). Korean is considered by some linguists as belonging to the Altaic branch of Ural-Altaic family. Languages in the Ural Branch are mostly spoken in Europe like Hungarian. Those belonging to the Altaic branch, apart from Korean, are Turkish, Mongolian and Manchu spoken in Northern Asia.

Another significant family in Asia is the Austronesian family which was formerly called Malayo-Polynesian. It includes almost all the languages of Indonesia and the Pacific, Malay spoken in Malaysia, Cham spoken in Cambodia and Vietnam, Philippine languages, Malagasy and also the indigenous languages of Taiwan. The term "Malayo-Polynesian" is still used in the literature, to refer to all Austronesian languages except those of Taiwan.

It should be noted that a language family need not be found only in one country. Diversity in language family is found all over Asia, especially in Southeast Asia. Thailand is a good example of diversity; all the languages found in the country belong to five families: Tai-Kadai, Austroasiatic, Austronesian, Sino-Tibetan, and Indo-European in the form of Pali.

Language Typology of Asian Languages

Besides genetic relationship, we may classify languages according to their "universal types". This classification is called **typological classification**. The oldest criterion used to classify languages into "types" is the ways morphemes are arranged and held together in a word. Based on this we have three groups of languages: isolating, agglutinating and inflectional languages.

Isolating languages are languages in which words consist mostly of single meaningful morphemes. There is no inflection, no derivational affixation. Thai and Chinese belong to this group. For example, in Thai /ba:n2 khO:ng4 chan4/ (house-of-I) means "my house"; /chan4 klap1 ba:n2/ (I-return-home) "I return/ returned home". The words /chan4/ "I", /ba:n2/ "house", /khO:ng4/ "of", and /klap1/ "return" are each composed of a single morpheme.

Agglutinating languages are languages in which a word is composed of a root and prefixes and suffixes, which are added to it to modify its meaning. However,

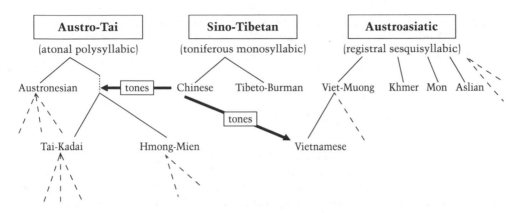

Figure 3.3
Chinese Tonal Influence on Tai-Kadai, Hmong-Mien, and Vietnamese

(Source: J. A. Matisoff, "Sino-Tibetan linguistics: Present state and future prospects", in *Annu. Rev. Anthropol.* (1991) **20**, pp. 469–504)

these parts do not fuse into one another. They are recognizable. Most Austronesian and Austroasiatic languages are agglutinating languages. For example, in Malay, an Austronesian language, /pindah/ means "to move", /berpindah/ means "to move oneself", /kelahi/ "to quarrel", /berkelahi/ "to quarrel with one another", /churi/ "to steal", /penchuri/ "thief", /gali/ "dig", /penggali/ "spade". Other examples of this type of language are Burmese, Japanese, Korean and Altaic languages like Mongolian and Manchu.

Inflectional languages, like Pali and Sanskrit, are languages in which a word is composed of a root and inflectional morphemes, which fuse into one another. The inflectional morphemes signify the number, gender, person, and case of nouns and tense or aspect of verbs. In Sanskrit, the stem /deva/ "god" changes to /devas/, /devam/, /devasya/, and /deve/ in nominative, accusative, genitive and locative, respectively. Languages in India are mostly inflectional languages.

According to Greenberg (1971:291), a typological classification of languages refers to similarities which may arise without any necessary implication of historical connection through either contact or common origin. He cites tone languages as an example: Ewe in West Africa, Chinese in East Asia and Zapotecan in Mexico make use of pitch distinctions in their phonological systems although the languages have had no historical connection and are not in the same continent.

In Asia, Chinese, Thai, Vietnamese and some hill-tribe languages are tone languages. Others are non-tone languages, as those in South Asia, the Middle East and all Oceanic languages. Studies show that non-tonal languages may become tonal. Haudricourt (1954) showed that Vietnamese was originally non-tonal but was developed into a tonal language through a variety of phonological processes. Matisoff (1973, 1983) attributed development of tones in non-tonal languages in Southeast Asia to areal diffusion. Through contact with Chinese, Tai-Kadai languages and Miao-Yao have become tonal.

Besides the way morphemes are arranged and tones as mentioned above, word order is another criterion that may be used to classify languages into types. Chinese and most languages in mainland Southeast Asia, like Thai, Cambodian and

Vietnamese, are SVO languages. Japanese, Korean, Burmese and most languages in India, as Hindi, Telegu and Tamil, are SOV languages. Most Philippine languages belong to the VSO type.

Language Contact in Asia

Study of languages influenced by an unrelated language spoken in the same area is called **areal linguistics** (Fraenkel, 1967: 52). Languages can thus be grouped according to area when they stay close to one another. This is called **areal classification**. Evidence shows that languages that are close in an area share common areal features due to their borrowing of linguistic features from each other. Southeast Asian languages, such as Thai, Cambodian, Malay, no matter what family they belong to, share many characteristics; for example, they are isolating and SVO languages. Lexically, they share many words borrowed from each other. Borrowing among languages causes them to converge or become similar. This may be regarded as a result of "language contact".

According to Weinreich (1953: 1), two or more languages are said to be in contact if they are used alternately by the same person. Language contact is similar to **linguistic convergence**, which presupposes a situation in which speakers of different languages live in close proximity for centuries. People living in such areas are bilingual or multilingual. Their languages share common features even though they may be related only remotely or not at all. In such cases linguists talk of a *Sprachbund* "linguistic area" (Emeneau, 1965/80: 127). Some linguists distinguish between bi- and multi-lingualism on the one hand and diglossia on the other (see Fasold, 1984: 34–60). Bi- or multi-lingualism usually means a person's ability to understand and/or speak more than one language alternately. Diglossia means a situation in which two or more varieties of one language or two languages coexisting in a community have specific and clear-cut functions. The variety or language used at home or in informal situations is called the "Low" variety and the one used in public or formal situations is called the "High" variety. Members of a multilingual community may switch varieties or languages freely, such as in Chiang Mai, a northern city in Thailand, where people switch back and forth between Chiang Mai Dialect and Standard Thai. In a diglossic community every member knows when to use which variety such as the use of the Royal language variety when speaking to the Royalty and the normal variety when talking to others.

In Asia, the classic example of "linguistic area" in the continent seems to be India. Emeneau's paper on "India as a Linguistic Area" (1956/1980) illustrates in detail how languages of different families could have come in contact and change so that they become alike in many ways. The three major language families in India – Indo-Aryan, Dravidian and Munda – have been in contact for three millennia. The study of the non-Indo-European element in the Sanskrit lexicon shows that at the time of the earliest Sanskrit records there were already a few Dravidian words in Sanskrit. Dravidian has also adopted Indo-Aryan words. Emeneau says a similar relationship must have existed between Indo-Aryan and Munda and between Dravidian and Munda.

Multi-lingualism. These two women from Hong Kong use English as their medium of communication rather than their native tongues.
Courtesy of Grant Evans.

Besides vocabulary, most of the languages of India, no matter which family they belong to, share certain phonological features. They have a set of retroflex consonants (especially stops and nasals) in contrast with dentals. Even the earliest Sanskrit records already show phonemes of this class, which are, on the whole unknown elsewhere in the Indo-European field, and which are certainly not Proto-Indo-European (Emeneau, 1956/1980: 110).

As for morphology and syntax, evidence shows that Dravidian and Indo-Aryan have more traits in common than Munda has with Indo-European. Emeneau (1954/1980: 90) attributes the absolutive or the non-finite verb form and its syntactic use to Dravidian influence because this feature is parallel to a feature of Dravidian and unlike what is found in the other old Indo-European languages.

The existence of classifiers in Modern Indo-Aryan languages, such as Bengali, Assamese, Oriya and some dialects of Bihari, is another piece of evidence cited by Emeneau (1965/1980: 131) as supporting the assertion that the Indian languages have been in contact with Southeast and East Asian languages. Indo-European does not have classifiers, but Tibetan, Burmese, Thai, Khmer, Vietnamese, Chinese, Japanese and Austronesian languages like Malay and Indonesian, have classifiers.

In Southeast Asia, there are many examples of languages in contact. Thai spoken in Thailand has been in contact with several languages of other families: Austroasiatic, Indo-Aryan, Chinese, Austronesian and also some European languages. Loanwords from Khmer, Indian, and Chinese are easily found in the Thai vocabulary, e.g. /dI:n/ "walk", /camu:k/ "nose" from Khmer, /a:ha:n4/ "food",

/sat1/ "animal", /pha:sa:/ "language" from Sanskrit, and /kuaj4tiaw4/ "noodle" and /suaj/ "unlucky" from Chinese. Shan language, which is closely related to Thai, is now hardly comprehensible with Thai because Shan has been in contact with Burmese for a very long time. The situation is parallel to Zhuang in Southern China. Zhuang is a Tai language related to Thai, but now Thai and Zhuang in most cases are mutually incomprehensible because Zhuang has been in contact with Chinese whereas Thai itself has been influenced by so many languages that it has changed a great deal.

The Philippines is another example that can demonstrate languages in contact. Many languages in the Philippines, the major ones of which are Tagalog, Ilocano, Cebuano and Panay-Hiligaynon, had been in contact with one another before the Spanish. Romanization of the Philippine languages was introduced by the Spanish conquerors, and later Philippine languages came in contact with English during the American colonial period.

Besides being close to one another, languages may come into contact because of several other factors, including colonization and modernization. Colonization brought Asia in contact with the West. Regardless of whether one perceives this contact as an advantage or disadvantage, French culture in Vietnam, Cambodia and Lao, English ways in India, Burma and Malaysia, Spanish traits in the Philippines and Dutch influence in Indonesia are still discernible today.

However, it should be noted that Western influence is not confined to colonized states only. Some countries underwent Westernization at their own choosing. Japan and Thailand under the "open country" policy during the Meiji period and the reign of King Chulalongkorn, respectively (around the end of the nineteenth century), modernized by taking the West as a model. They adopted many systems from the West, from material culture to abstract ways of thinking, which come along with the adoption of the Western languages, especially English. Japanese and Thai have been strongly affected by modernization. English loanwords in the languages are numerous. However, there seem to be differences in the way Japanese and Thai adopt English influences. In Japan, English words are Japanized and unrecognizable as English by new generations. Thai is somewhat different from Japanese in its treatment of English borrowings. In my study of Thai linguistic acculturation (Prasithrathsint, 1981) I found that when concepts representing cultural items from other cultures are imported into Thai, they are absorbed in various forms. In the case of borrowings from English, if the items adopted are accessible, agreeable and familiar concrete things, such as computers, football, soda, battery, cream, plastic, shirts, and the like, the concepts are represented in Thai by loanwords, the pronunciation of which is assimilated to the Thai phonology, but still recognizable as having English origin. When the items imported are abstract, and not very accessible, agreeable and familiar, the Thais use words that are loan translations from English, such as "standpoint", "right arm", "black sheep", and "first lady". It was also found that attitudes towards the foreign culture also played an important part in linguistic acculturation. Indeed, most borrowed items are given newly coined Thai words signifying that they are new cultural items. The main reason is to preserve Thai identity.

Modernization of Asian countries also seems to have effected the syntax of their languages. Studies of Japanese syntax have shown that some constructions came into use after the period of modernization. My research on the change in passive constructions in Thai (Prasithrathsint, 1988) also shows that the neutral

/*thuuk1*/ passive in Thai emerged around the time Thailand underwent of modernization.

Languages and Their Functions in Society

Generally, languages in each society do not have an equal function. Some languages may be raised to the status of *standard languages*. A standard language is a language variety that has been accepted by a society as the most correct. It has become institutionalized and is usually accepted as representative of all the languages in the society. Normally, the standard language is the variety that has a long history. It has become a code consisting of norms. It is prestigious, and other varieties are regarded as lower than it. As it is widely accepted, the standard language usually plays an important role in the most important domains in the community, such as the government, school and mass media. Smalley (1988: 248) defines Standard Thai as "the language used by the government, promoted in the schools and overwhelmingly predominant in the mass media throughout the country".

Every nation has at least one *national language*. A national language is a language that is formally accepted and known among all other nations as the language of a particular nation. Usually, in any country, it is the standard language that is generally accepted as the national language. For example, Thai, the standard language of Thailand is also the national language of the country, in which approximately sixty languages of various language families are spoken.

Yao minority children learning the national language, Chinese.
Courtesy of Chinese University of Hong Kong, Department of Anthropology.

Well-known languages in Asia are mostly national languages of Asian countries; for example, Filipino (based on Tagalog) of the Philippines, Bahasa Indonesia of Indonesia, Japanese of Japan, Mandarin Chinese of China, Korean of Korea, Urdu `of Pakistan and Turkish of Turkey.

Some nations have more than one national language. India, the most multilingual society in Asia, has been cited as a classic example of this. Fourteen languages are given the status of national languages by the Constitution of India. Out of these, four belong to the Dravidian Group of languages spoken and used in South India and ten, spoken and used in North India, belong to the Indo-Aryan group of languages (Carlisle *et al.*, 1978).

A language may function as an *official language* – a language assigned or accepted for use by the government. The official language is used in the courts, parliament, official announcements, the mass media and by leaders or elite of the country. Generally, it is natural for any nation to use its national language as its official language; for example, Japanese, Korean, Mandarin, Thai, and Turkish, are both national and official languages of Japan, Korean, China, Thailand, and Turkey, respectively.

However, in some countries in Asia the languages that are recognized as national languages are not used officially. In India, English is still used as the official language because of conflict concerning the use of the national languages. Although Hindi is constitutionally the national language (Fasold, 1984:20), English is the more practical medium. In the Philippines, there are three official languages: English, Spanish and Filipino. Malaysia, though moving toward monolingualism, still uses English in Parliament and the courts. Singapore is officially quadrilingual; English, Mandarin, Malay and Tamil are official languages (Noss, 1984:48,49,70).

Another important function of a language in any society is as the medium of instruction. A language used as a medium of instruction is called an *educational language*. It is natural that the national language plays this role. In Thailand, for example, Standard Thai, which is the national language, is also the educational language in the country. It is used as the medium of instruction in schools and universities all over the country except in a few international schools and private universities where English is used as the medium of instruction. The situation is the same as in China, Japan and Korea, where Mandarin, Japanese and Korean are educational languages.

In some countries, however, selecting the languages which will be used as the medium of instruction is not an easy job. In India, regional languages are used as the medium of instruction at primary and secondary levels. At higher levels, Hindi is used as the medium of instruction of every subject except science, which is taught in English. In the Philippines, Filipino is used as medium of instruction in primary and secondary schools, but in the university, both Filipino and English are used. Indonesia allows eight provincial languages to be used in the first three years of primary school as media of instruction in the provinces along with Bahasa Indonesia. They are Achehnese, Balinese, Batak, Buginese, Javanese, Madurese, Makassarese and Sundanese.

Languages can function as *religious languages*. Every country has a religious language. In some countries, religious languages may be the same languages that play the role of national languages or official languages, but in others they may

not, depending on the history of those countries. In Thailand, for example, Pali has been used predominantly as the religious language of the country – it is used in Buddhist ceremonies. However, nowadays Standard Thai is used in some temples. At funeral rites, for example, monks chant in Thai instead of Pali. Also, among muslims in Thailand, Koranic Arabic is used as a religious language. In Indonesia, Arabic is also used among muslims, whereas in the Philippines, Christianity was closely tied with Spanish.

Every country needs an *international language* or a *lingua franca* for communicating with another country. In Asia, English has played the role of an international language. Mandarin plays some part as a lingua franca too among Chinese in many countries. International meetings organized in any Asian country nowadays use English as the conference language.

Languages and Politics in Asia

From the political point of view, languages in Asia raise complicated issues. Politics has influence on the linguistic situation in Asia. Take China as an example, we can see that the present linguistic situation is a result of the Chinese government's policy after the 1948 Revolution. China has a Standard language – Mandarin, which is widely used and has made mass literacy possible. The first thing the government did was to choose Mandarin from among the many languages in China as a standard. The next step was the teaching of Mandarin throughout the country.

In Indonesia, independence from the Dutch led to the policy of "one nation, one language." Bahasa Indonesia, originally a Malay dialect from around the area of Srivijaya, which had been used as the lingua franca for trade, was accepted as the national language. However, in modern Indonesia many other languages are still used: Arabic, Chinese, Dutch, many different Austronesian languages, and English.

India has also been affected linguistically by political change in the country. After the achievement of independence it was intended that Hindi (or Hindustani), related to Sanskrit, and written in Devanagari characters, should become the common tongue among the diverse linguistic stocks of this vast country. However, India never achieved such a plan. According to Girsdansky (1967), the original deadline for the transfer of state business to Hindi was 1965, but that date was set back due to linguistic rivalries. Other Indo-European tongues spoken by substantial portions of the population are Punjabi, Bengali, Gujarati, Sindhi and Marathi. Also, there are non-Indo-European languages spoken by the peoples who regard Indo-European speakers as invaders because the latter came to India when those people were there already. So the Kanarese, Telegu, Tamil and Malayalam speakers do not want to adopt Hindi as the official language. They regard the language as alien to them as English. English which was imposed on the Indian population during the period of British colonial rule, has been used as the lingua franca among educated people and the official language since then. Also, to avoid linguistic conflict, Indians resort to English.

According to Lehiste (1988:57), the choice of English as the official language in India appears to be closely connected with the question of social mobility.

Language is seen as a fundamental marker of identity for minority independence movements. Here young Jing-paw children learn their own language in the Golden Triangle area of Burma.
Courtesy of Hseng Noung Lintner.

Malaysian schoolgirls with a poster calling for one language.
Courtesy of Bernama.

Government jobs have been the chief avenue for upward mobility in India and competition for them is sharp. The elite that had administered India under the British colonial regime was generally bilingual in English and a regional language. The less educated masses were excluded from government jobs then and are excluded now, except insofar as the locus of power has shifted to regional centres. Attempts have been made to replace English with Hindi, but these attempts have met with strong opposition from speakers of other languages, since this would automatically give the Hindi-speaking people preferential access to political office. Thus, English is less divisive because all groups are more or less equally handicapped.

Smalley (1988) analyzes the linguistic situation in Thailand. He points out that unlike most Asian nations, Thailand has experienced very little or no linguistic conflict in spite of the linguistic diversity in the country. On the contrary, there is unity in the linguistic diversity, and Smalley attributes this to the hierarchy of multilingualism, at the top of which is Standard Thai. Second to Standard Thai are the four regional languages: Kamuang (Northern Thai), Thaiklang (Central Thai), Lao (Northeastern Thai) and Paktay (Southern Thai). Next to these and ordered from the most to the least important are what Smalley calls "marginal regional languages", such as Northern Khmer and Pattani Malay, "displaced languages", such as Phu thai, Lue, Song, "languages of towns and cities", such as Teochiu, Hakka, Cantonese, "marginal languages", such as hill tribe languages, and "enclave languages", such as Lavua, Urak lawoi, and Nyah Kur.

Smalley explains that whether widespread or localized, every language has its place in the system and no language threatens the place of the national language, Standard Thai. This linguistic hierarchy also masks the diversity of languages in use because people communicate with outsiders on a higher level of the system than their base level. Those with native languages at or near the top of the hierarchy, such as people born in the capital city of Bangkok or high-ranking government officials who work upcountry, do not necessarily realize how much diversity lies around them. It is the responsibility of speakers of languages at lower levels to adjust themselves so that they are able to communicate with people of a higher status in the latter's language or dialect.

Smalley concludes that "the hierarchy of multilingualism in Thailand serves to reduce the divisiveness of language difference because it provides an established place for each language and the people who speak it. So long as people accept that place, language is removed as a cause of contention". Moreover, he explains how language hierarchy supports social mobility in Thailand as follows:

> The language hierarchy helps to make upward mobility possible for those who can learn the behavior of people above them and who can manage the resource required. In Thailand's hierarchy of multilingualism, with its assumption of multiple linguistic identities, many people not only add identities by learning behaviors above where they started, but may also shed identities, if they chose to do so, and if they do not betray the identity they are leaving off through their accent or other behaviors which carry over. Often the identity is not consciously hidden or discarded, but is simply not exercised because it is not relevant to a new situation (like when people are living and working in a different region). If disuse continues long enough an original identity may, in effect, cease to exist. (Smalley, 1988:257)

Summary

This chapter is an attempt to show what human language is like, how it distinguishes humans from other creatures, and how language and culture are related. It also gives a picture of linguistic diversity and linguistic convergence in Asia.

Language is a part of culture. It has all the significant characteristics shared by all other aspects of culture. However, language is a special property of human beings. It is one of the key features that distinguish man from other creatures. It is uniquely human in the sense that it is only possible if the brain and vocal tract are ready for it; i.e. when they are exactly like the human brain and vocal tract. Besides, evidence shows that no system of communication in any other species is comparable to human language in its productivity and patterning.

Language is a vehicle of culture. It makes the accumulation and transmission of all aspects of culture possible. It enables us to think and rationalize. Also, perception and conceptualization of all the things around us depend on our language. It has been generally accepted that language and thought are related. However, some scholars have gone as far as asserting that a language controls thought and governs all the behaviour of its speaker. Thus, from this point of view, speakers of different languages see the universe differently.

Languages in Asia are very diverse. There are at least one thousand five hundred languages spoken all over the region. From the genetic point of view, there are at least six main linguistic families in Asia. Asian languages are also of diverse types. This makes them a rich source of phonological and syntactic data. However, these languages have converged considerably and share certain common features as a result of language contact. This enables us to group them into linguistic areas, such as South Asia, Southeast Asia, East Asia. Finally, looking from the functional and political points of view, languages in Asia reflect complexity and variety in Asian society and also remarkable changes in Asian history.

4 ASIAN FAMILIES

Domestic Group Formation

Clark W. Sorensen

The family seems natural. Everybody has a mother and father. Mothers and fathers marry each other to have children. Parents must nurture and educate their children for many years until they are capable of caring for themselves. It seems natural, then, that parents should live together with their children and maintain a common budget. The American anthropologist George Peter Murdock has argued that this nuclear family of parents and unmarried children who live together and share a common budget is the most functional family form, and is a universal building block of all societies (Murdock, 1949: 2). In many Asian countries, however, families care not only for children, but for aged parents as well, and are often more complex than simple nuclear families. Classic works of Chinese literature, such as *Dream of the Red Chamber*, or Ba Chin's novel of social criticism, *Family*, describe huge families including aunts, uncles and cousins all living under the same roof.

Complex families as described in traditional literature are indeed found in East and South Asia, but for practical reasons they tend to be a minority even where they are a cultural ideal. The nuclear family described by Murdock is statistically the most commonly found family form in Asia (Coale, 1965). Murdock explained the frequency of nuclear families by arguing that domestic groups of co-resident kin that include a sexually cohabiting couple must universally fulfil four functions that are best met by families of co-resident parents and children. These functions are: (1) regulation of sexual relations, (2) maintenance of a common budget, (3) giving birth to children, and (4) socializing children through training and education. Since Murdock wrote, however, anthropologists have documented numerous societies in Asia and elsewhere that meet these functions very well through non-family institutions. In Tibet, sexual relations are not necessarily limited to those who are married, nor are married couples necessarily required to limit their sexual activities to their marriage partner (Dargyay, 1982). Up until the late nineteenth century amongst wealthy members of the Nayar caste of the present-day Indian state of Kerala, women were not necessarily supposed to have sexual relations with their "husband" but to receive at night a series of lovers who were discouraged from forming close emotional ties to any children they might father. Mother's brothers, rather than fathers, were the figures of authority in the families of these matrilineal Nayar (Gough, 1961). In the corporate families of east and south Asia, family members who share a common budget may not all live together, while kin living in the same house do not necessarily share a common budget if partition has already taken place. Among the Minangkabau, boys from the age of six or seven receive much of their socialization outside their family, and they usually move at this time from their mother's house to a prayer house to sleep and receive

their education. In Tibet, much socialization takes place within a neighbourhood of cooperating families rather than within a single family per se.

The nuclear family proves to be neither universal nor as fundamental as it seems at first glance. No family form, in fact, can be deemed universal or "natural" because the form and function of families are defined by the norms and values of each society, rather than by biology, and in some cases even these culturally defined family members do not reside together. Asian families reveal a striking range of diversity from the simple families of the hunting and gathering Semang to the large corporate families of east and south Asia; from the small, flexible families of southeast Asia to the families of the Himalayas where adaptation to an extremely difficult environment has led to special developments. Asian families often do manage Murdock's four functions, but sometimes other institutions take care of these functions, too. Asian families commonly also take on other tasks not mentioned by Murdock such as agricultural or craft production, control and management of property, care of the aged, holding of important religious rites, or social control of family members.

Because of the diversity of social and economic environments in Asia, there is no single institution (whether a family or not) that best manages all these functions. There is also no function, apart from the birth of children, that all family systems manage. Each society, however, has a culturally defined group that meets some of these functions. Asian families thus can be studied in relation to those tasks, whatever they may be, that families are supposed to accomplish in each society. We can interpret each family system as an expression of the values and culture of the society and of the creative ways human beings have adapted to their natural and social environments.

Anthropological Vocabulary for Discussing Families

One reason why discussing the family in cross-cultural contexts can be confusing is that the word for "family" in most languages is polysemous; it has more than one meaning. In English the term "family" can mean the "group of kin with whom I live and share a budget", but it can also refer simply to "my close relatives", (some of whom I live with now, some of whom I used to live with, and some of whom I may never have lived with). This ambiguity in the meaning of the word for family is not confined to English. In Korea, where vocabulary to describe kinship is much more highly developed than in English, the colloquial term for family, *chiban*, can also refer either to the members of a delimited corporate family (known legally as the *ka*), to a minimal lineage, or to one's close relatives generally. The reason for this ambiguity lies in the nature of human life cycles. The family in which one is born and raised, or birth family, is commonly different from the new family created upon adulthood and marriage, or marital family. As an adult, one may call both one's birth and marital families simply as "family" even though one may no longer reside with, or even legally belong to, one's birth family. Because the culturally specific, or emic, definition of the family varies from society to society, these ambiguities multiply when we try to compare families

cross-culturally. To reduce the potential for misunderstanding in cross-cultural comparison and facilitate scientific, or etic, description, anthropologists have restricted the definition of some terms and have invented a number of technical terms.

Family and Household

A common-sense definition of the family is "a social group characterized by common residence, economic cooperation, and reproduction" (Murdock, 1949: 1) but as we noted above, the people who live together and cooperate economically may not all be family members (as when servants live in the house), while some family members may live separately (as when children live away from home to go to school, or when individual family members have jobs in a different place from the main family residence). Anthropologists call task-oriented residential groups households, reserving the term family for groups defined by marriage and descent (Netting, Wilk, and Arnould, 1984: xx). Distinguishing family and household is useful for understanding some family systems, but it must be remembered that when dealing with specific societies, the unit to which both of these terms refer is culturally defined; each society has its own definition of family and/or household.

Family and Biology

Biologically, of course, it is true that every child must have a father and mother, but fatherhood and motherhood (as well as other kinship relations) are social, rather than simply biological, relations. That is, who is a father, or mother, and the behaviour expected to follow from that fact, is culturally defined. As biological parents are sometimes different from the culturally defined parents, anthropologists use special terms to distinguish the social from the biological roles. The biological father is termed the *genitor* and the biological mother the *genetrix*. The person who plays the socially recognized role of the father is called the *pater*, and the socially recognized mother the *mater*. Biological and social roles most commonly diverge in adoption – the adoptive parents play the roles of pater and mater even though they are neither genitor nor genetrix – but other less obvious cases are also found. It is common in patrilineal societies, as among the Kachin for example, for the pater to be defined as a woman's husband even if he is known not to be the genitor (Leach, 1970: 75).

Culture and Strategies

When we say family and kinship roles are culturally defined, we mean that each society has distinct ways of categorizing kinship relationships, defining kinship roles, and has rules for forming families and other kinship-based groups. These methods of categorizing, defining and organizing family and kinship relations in a society may be called its kinship culture. Culture in this sense exists in the heads of people, but the rules and categories of kinship culture are never so rigid and specific that they determine all by themselves the kinship organization we can observe in concrete societies. For one thing, no culture can account for all the vicissitudes of life. If, for example, the eldest son is culturally recognized as the proper person to continue the family line, it is inevitable that some families will

lack eldest sons. Societies, thus, always recognize a range of alternatives so that people may adjust their actions in light of their concrete circumstances. In addition, however, people are rarely passive in relation to their culture. They frequently manipulate cultural possibilities so as to enhance their status, wealth, or legitimacy. For this reason, the behaviour anthropologists observe in their field studies can often be thought of as strategic: designed to attain goals through the manipulation of cultural possibilities. The anthropologist can rarely predict which strategies people will use, but by revealing the cultural premises on which they are based, he or she can often show the logic that governs variations in social behaviour.

The Family Cycle

Individuals as they are born, grow up, marry and die, pass through various culturally defined stages: childhood, adulthood, old age, and so forth. Families, too, grow, develop and pass through phases. Three overlapping phases of the family developmental cycle have been characterized by Fortes as expansion, fission, and replacement. The phase of expansion lasts from the marriage of a couple until the completion of their childbearing. Fission (or dispersion) lasts from the marriage of the first sibling and continues until all the children are married. Replacement ends with the death of the parents (Fortes, 1958: 4–5). No matter what a society's cultural ideals, then, families are never static. A good deal of variation in family size and structure will be due to the stage at which various families stand in their family cycle.

Types of Family

Families are classified in a number of ways, but the most useful for comparative anthropological purposes is based on number and type of marriages. Simple families are composed of no more than a single married couple (or a widow or widower) and their unmarried children. Sometimes known as nuclear families, or conjugal families, simple families may be extended by the addition of other unmarried kinsmen (grandparents, grandchildren, aunts, uncles), but they remain simple so long as only one currently active marriage is involved (Laslett, 1972: 28–31). Complex families include more than one marriage and can be further divided into three types: stem, joint, and polygamous. Stem families include two or more married couples, no two of whom are of the same generation. The most common example is a married couple and one married child, though it is possible for a stem family to include in addition one married grandchild. Like stem families, joint families are also composed of two or more married couples, but in this case at least two of the couples must be of the same generation. The most usual example is the family of married siblings, but it is also common for a large family to be composed of married parents and two or more married children. This, too, is a form of joint family. Polygamous families are those in which at least one of the married persons has more than one spouse. There are two types of polygamy: polygyny, in which an individual man marries more than one woman, and polyandry in which a woman marries more than one man. Both types of marriage are found in Asia – sometimes even in the same family – but in Asian societies, polygyny and/or polyandry are usually options taken up by a small proportion of the wealthy or childless in complex family systems rather than separate systems in their own

right. Each of these types of family may be further subdivided by the type of kinship reckoning, post-marital residence, inheritance, and succession. These further distinctions will be explained in more detail as we discuss concrete cases below.

Observers sometimes have tried to characterize whole family systems based on the statistical frequency of the various family forms. Since a family often changes its form through the phases of the family cycle, however, this by itself is an unsatisfactory procedure. A host of circumstantial factors, too, can affect the form a family takes at any particular time including: (1) demographic considerations, such as how long people live and how many children they have, (2) how much property they have, (3) how much labour they need on a family farm or for a family business, and (4) what level of status they are trying to maintain. These considerations make the classification of family form, and assessment of the significance of that form, more complicated than is sometimes recognized. Because studies of pre-revolutionary Chinese villages found simple families to be statistically most common, for example, some have questioned the characterization of the ordinary Chinese peasant family as complex (Levy, 1949: 59–60). When one studies Chinese families in terms of their family cycle, however, it turns out that even if the majority of peasant families at any one time are simple, most families go through a complex phase for at least part of their family cycle (Wolf, 1984: 281), so it is correct to consider the Chinese family cycle as a whole a complex one.

The Lineal, Corporate Families of East and South Asia

The civilizations of Asia, like those of traditional Europe, have been founded on plough culture, a highly productive type of cropping system using ploughs and draft animals on permanent fields. The basic unit of production has usually been the peasant household. In these complex civilizations, differential access to limited land is correlated with great variation in wealth and status. Acquiring and transmitting control over property, and maintaining efficient productive households have been central family concerns. Corporate families have proved to be resilient and successful adaptations to these circumstances.

As Fortes has noted (1978: 17), the notion of "corporateness" has sometimes been used to designate any bounded group. Here, however, we shall use a strict definition with four criteria that apply not simply to corporate families, but to any type of corporation (including modern industrial enterprises): (1) defined membership boundaries, (2) corporate property or an estate, (3) a head, and (4) succession.

Unlike the ambiguous Anglo-American notion of "family" alluded to above, corporate families have defined boundaries. One can say precisely which corporate family each person belongs to, and one may belong to one and only one corporate family. In Taiwan and South Korea the state even maintains family registers that list precisely who is, and who is not, a member of each corporate family. One reason the boundaries of corporate families are carefully maintained is that family membership usually confers property rights. In Maharashtra in central India, for example, the residents of a household are classified into "owners" and "guests".

Only the "owners" are full members of the corporate family with claims on the family estate (Carter, 1984: 46).

Each corporate family has a head with specific rights and duties. Frequently, though not always, the head is the father of the family, but headship is a social role rather than a personal attribute of an individual. This can be seen in the practice of succession, that is, taking on a social role at the retirement or death of the former incumbent of that role. When succession takes place the person exercising the rights and duties of a role changes, but the role itself (conceived of as a bundle of rights and duties) stays the same. Just as when a king dies, a new king succeeds to the office of kingship, when a house head dies or retires in a corporate family, a new person succeeds to the position. The family as a social institution can thus be maintained forever, in theory at least, so long as successors to the most important family roles – especially family head – can be found. Individual family members are born, married, and die, but the family itself goes on.

All Asian families are not corporate in this full sense. The Javanese, for example, have families that, though corporate in the sense of a property-holding group, lack clear boundaries, headship and succession to family roles. The Javanese recognize kinship through both the mother and father, so their system of kinship reckoning is *bilateral*. Children often live with the wife's parents for several months until a marriage is seen as stable, but there is no formulated rule for residence with kin after marriage, and each child is expected to quickly set up a household separate from that of his or her parents. Anthropologists call this *neolocal* (neo = new, local = place) post-marital residence. According to Islamic Law, sons are supposed to

A Javanese wedding. These two people will set up a separate household and live neolocally.
Courtesy of Patrick Guinness.

inherit twice what daughters do, but the folk idea among Islamic Javanese is for equality between sons and daughters. Inheritance thus can be said to be equal and partible among all children, though anthropologists have found great flexibility in inheritance arrangements (H. Geertz, 1961:47). Divorce is quite common – ending nearly half of all marriages – and non-nuclear kin often *foster* (care for without adopting) children, especially those of sisters. Household composition thus tends to show a great deal of flux over the family cycle without affecting formal family membership. Complex households are not uncommon in Java, comprising almost 9 percent of one sample (H. Geertz, 1961:32), but because of the non-corporate character of the Javanese family system, these complex families tend to be created because of economic convenience rather than to preserve a particular family cycle.

Such non-corporate family systems are widespread in insular Southeast Asia, being found among the Christian Ilocano of the Philippines as well as the Muslim Javanese. They are also found among the peninsular Malays (except for matrilineal Malays of the state of Negri Sembilan mentioned below). The nuclear families of the peninsular Malays are often extended to include unmarried, divorced, or widowed kin – particularly kin on the wife's side – but two or more intact couples rarely share the same budget (Firth, 1943:9) even if they live in the same house. What look like complex households made up of more than one married couple often turn out to be economically separate families who merely share living quarters. As in Java, complex households are agglomerations of convenience rather than regular creations of a corporate family cycle with succession to household roles.

The typical family cycle of non-corporate families, then, involves the formation, and eventual dissolution with death of the parents, of each family in each generation. Widowed parents can be brought into children's houses for care in old age, but since they enter their child's family after it has already created an independent existence through neolocal residence, parents lack the authority they would have in corporate families in which they may not yet have passed family headship on to the next generation. The careful maintenance of family boundaries and concern with maintaining continuity over time through succession characteristic of corporate family systems is also absent. Property and social roles tend to be held by individuals rather than the family as a unit, and children do not succeed to roles in their birth family, but form new families when they reach adulthood. When parents die, then, their families die with them. Their legacy may be maintained through the families of their children, but these are new families rather than continuations of the parents' original family. A non-corporate family cycle, then, consists of the dying out of old families and creation of new families in each generation, whereas in corporate family cycles, although new families die out or are created in each generation, most families are continued through succession.

Joint Family Systems

China has one of the best studied and understood of the Asian corporate family systems. The Chinese corporate family, called the *jia*, is a bounded group of members related by descent, marriage, or adoption. The corporate nature of the *jia*

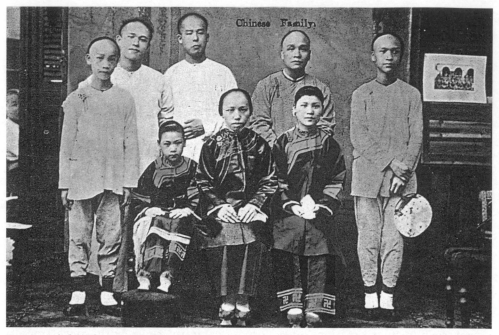

Portrait of the Chinese patrilineal family.
Courtesy of Dr Tong Cheuk Man and the Museums Section Regional Services, Hong Kong.

can be seen in the fact that each member belongs to one and only one *jia*, the property of the *jia* belongs to the members in common, and the income of all *jia* members is pooled to meet family needs. The *jia* is normally headed by the eldest male member, known as the *jiazhang*, who represents the family to the outside (in contracts, for example). In most cases the family head also manages the pooled assets of the family. In extremely complex families, however, another male or female member talented in economic matters might, as *dangjia*, manage family financial affairs. The *jia* can be large or small, and whether it takes nuclear, stem, joint or some other form depends upon how the family has managed its developmental cycle. This corporate family characterized pre-revolutionary China (changes since 1949 will be dealt with later) and continues today as an important form in Taiwan, Hong Kong and Singapore. Let us turn, then, to a hypothetical *jia* as it develops over time. (See accompanying diagrams.)

We can begin our hypothetical *jia* with a newly married couple in an independent family. As children are born, this couple develop a nuclear family. The family remains nuclear until the children are ready to marry. As succession in the Chinese family is normally patrilineal (from father to son along the male line), the favoured form of marriage for the Chinese is patrilocal (pater = father, local = place), that is, the bride leaves her natal family and joins the family of her husband who usually has not yet partitioned from his birth family. This move is both a physical move from one house to another and a legal change of membership from one corporate family to another. From the point of view of their birth family, then, marriage of daughters involves their legal and physical departure. Though daughters visit and maintain other contacts with their birth family, they are now members

of their husband's *jia* and, having received a dowry, have no further claim on the property of their birth *jia*. The marriage of sons, on the other hand, brings daughters-in-law into the *jia*. With the marriage of the first son, the family assumes stem form. From the marriage of the second son, the family attains joint form.

1. Nuclear stage

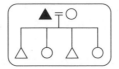

2. Stem stage after marriage of eldest son and daughter

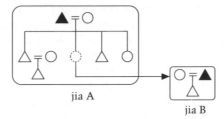

3. Joint stage after marriage of second son

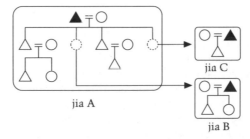

4. Beginning of new cycle after fēn jīa

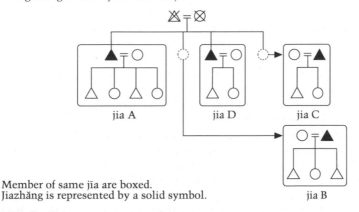

Member of same jīa are boxed.
Jiazhǎng is represented by a solid symbol.

Figure 4.1
Chinese Patrilineal Joint Family Cycle

Chinese joint families often have a true division of labour with the common economy being maintained even if all family members do not live in the same place. Sons work together in the fields under the direction of their father. Daughters-in-law living in a joint agricultural household might, under the direction of their mother-in-law, rotate among themselves the responsibility for cooking for the whole joint family so that the other daughters-in-law can be freed for agricultural labour, or even factory work (Cohen, 1976: 139–48). Sometimes these joint families diversify, with one son using family assets to open a business in town, but the family economy remains joint. As Yang noted of a village in pre-revolutionary Shandong Province:

> *In an old fashioned family, the kind which predominates in Taitou, everyone works or produces for the family as a whole, be he a farmer, a mason, a cloth weaver, a merchant or what not. It goes without saying that those who work on the family's farm work for the whole family. Any earning made in special trades also belongs to the family. If someone keeps a part of his wages, he will be condemned by the family head and suspected by all the other members of the family as being untrustworthy. A merchant who has to do his business outside may spend what he has made for his living expenses and according to his own judgement, but he must turn over all the rest and report what he has spent to the family head. If some of his expenses are found to have been unnecessary, he will be questioned about them in detail. Only when satisfactory reasons are given will his account be closed. (1945: 76)*

Brothers should theoretically remain together in the Chinese joint family until the death of their father, at which time the family and its estate is supposed to be partitioned into equal parts for each of the sons who, together with his wife and children, forms successor *jia*. Because of the strains inherent in joint family organization, however, early partition is quite common. Unlike in the stem family systems described below where the house head owns the family estate until he transfers it to his successor, in joint family systems such as that of China all heirs are co-owners of the family estate from the time of their birth (Freedman, 1966: 49). Though it is discouraged, a son can demand partition and set up a separate *jia* at any time. The new bride coming into a joint family where she will be under the authority of her husband's mother is often depicted as a powerless victim, but as the potential mistress of a separate *jia*, she, too, has more influence than is sometimes recognized. A new room for her and her husband's exclusive use is usually prepared before the wedding. "Room", in fact, is used in Chinese to designate the nuclear family formed by her, her husband, and their children within the joint family. The new bride normally brings a substantial dowry of both goods and cash with her at the time of her marriage, and this dowry (the cash portion of which is known in Mandarin as "private room money"), remains separate from the joint family estate. It is managed by her until she and her husband set up a separate *jia*. It often happens that when the interests of the "rooms" of a joint family diverge, some or all of the sons demand partition even if the parents are still alive. In such cases, ad hoc provisions are made for the care of parents – a portion of the estate being reserved for their subsistence, or, perhaps, an arrangement by which they rotate eating their meals at the *jia* of their various sons.

Though Chinese joint families have proved to be very successful, because of the strains between the various "rooms", they can succeed only with determined effort. Some *jia* with amicable brothers may remain in joint form for long periods – even after the death of the father – but others may go through a very short period of joint operation before splitting into smaller nuclear-family *jia*. Chinese informants often blame such early splits on women, who they say are quarrelsome and small-minded. From the etic point of view, however, we can see that even if quarrels between daughters-in-law are the proximate causes of early partition, daughters-in-law quarrel not simply as individual women, but as the representatives of potential independent *jia* within the joint family (Freedman, 1966: 46). In this sense they are structural representatives of their husbands as well as themselves. In families that diversify into several lines of business the economic incentives for maintaining joint family organization are very strong. In peasant farming where there are few economies of scale, on the other hand, the strains of joint family organization usually lead to fairly early partition. Those who have surveyed Chinese peasant villages, for this reason, find that joint families are usually no more than 20 percent of the families, even though the Chinese family system can be accurately characterized as a joint one in the sense that joint families are the most complex families regularly produced.

Depending upon the timing of births, marriages, and partitions the forms of the Chinese *jia* vary between nuclear, stem and joint over the course of the family cycle. This variation depends, of course, on a married couple successfully raising sons. Especially in pre-modern times when death rates were high and subsistence precarious, however, Chinese families have commonly had to deal with the problem of sonlessness or even childlessness. In such cases, families have to maintain their continuity through some means other than patrilineal succession. Common alternatives are uxorilocal marriage, or adoption of a relative. In an uxorilocal marriage (uxor = wife) a family that has daughters but no son brings in a husband. The frequency of such marriages can be as high as 20 percent of the marriages in a village, but because it is non-standard such marriages are normally made by contract. Contracts fix who will be the house head, whether the married-in husband will have rights in family property, and which surname the children will take. The rights of the husband are often fixed to be analogous to those of a wife in a patrilocal marriage – his income will support the family members, he will have the right to support from family funds, his children will take his wife's surname to continue the family line, and his children will have rights in his father-in-law's *jia* estate. Sometimes a man will stipulate that some of his children take his own surname to continue his family line. Because of the awkward position of uxorilocally married husbands who have fewer rights in their marital *jia* than patrilocally married husbands, however, only poor men usually make this sort of marriage, and they end up in divorce much more frequently than patrilocal marriages. Sometimes a widow will make an uxorilocal marriage to provide enough labour to manage the family farm until such time as her son by her first husband, to whom she was patrilocally married, is old enough to take over. In such cases the uxorilocally married husband may be forced out when her son reaches majority.

The Chinese type of corporate joint family system with preferred patrilineal succession and patrilocal post-marital residence is also found among the Hmong,

a hill-tribe of southern China and the northern areas of Vietnam, Laos and Thailand. It is the most common family system in South Asia among both Hindus and Muslims, but due to the high degree of ethnic diversity in India several other types of family are also found. The higher age of marriage in South India compared to North India also makes for the less frequent formation of joint families there than in the north (Goody, 1990: 274).

In some parts of south India, too, succession is in the female rather than male line. The most famous group with a matrilineal corporate joint family system are the Nayar caste of southwest India, but a similar family system is also found in Indonesia among the Muslim Minangkabau who formed matrilineal joint families with duolocal or uxorilocal post-marital residence. The Minangkabau are the dominant ethnic group of the province of West Sumatra in Indonesia, and the state of Negri Sembilan on the Malay Peninsula. Numbering in all some three million persons, in recent years they have migrated to most parts of Indonesia with major population clusters in the cities of Sumatra and in Djakarta, in addition to the two million, or so, who continue to reside in their traditional homeland of highland West Sumatra.

The matrilineal Minangkabau family centres on a group of sisters and their brothers. According to Minangkabau custom, or *adat*, one remains for life a member of the family into which one is born, that is, of one's mother. Sisters and their young children traditionally lived together in a large "tradition house" (*rumah adat*) with a high peaked roof said to resemble buffalo horns. This house was divided

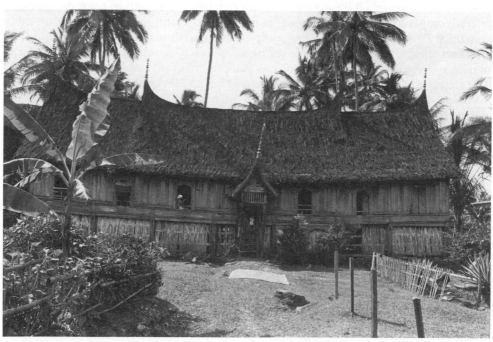

Minangkabau house at Balimbing, near Bukit-tinggi, West Sumatra. The house is said to be over two hundred and fifty years old and would formerly have housed a group of matrilineally related women and their families.
Courtesy of Roxana Waterson.

into apartments known as *bilek*. As each sister reached marriageable age, she would be allocated an apartment for herself and her children where she could receive her husband at night. From the age of six, or so, boys usually slept in village prayer houses, though they would continue to take meals at their mother's house. Life in the house was corporate and communal: brothers and sisters worked the house land and stored the produce in common granaries built in front of the house. The oldest mother's brother of the house would play the male political roles – primarily representing the house to the outside and partaking in councils in which disputes would be settled according to custom – while the eldest female headed the day-to-day activities of the house that were mostly taken care of by the women. We lack detailed data on the developmental cycle of these communal houses, but when the number of married sisters (or cousins) became too large, the house would be partitioned, and a group of sisters (most likely the descendants of a single mother or grandmother) would hive off to form a new tradition house junior to the original one. Most tradition houses then would be inhabited by joint matrilineal corporate families, the possession of their own house being the chief sign of their separate, corporate existence.

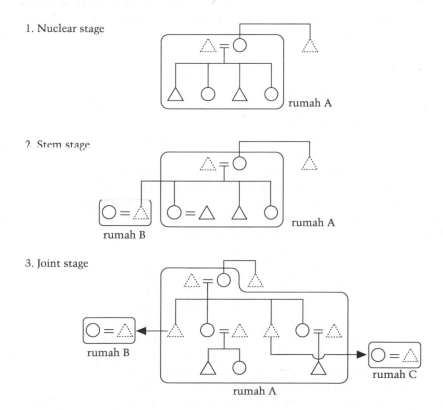

Men are represented by dotted symbols as they "belong to mother's house but don't live there, and live in wife's house but don't belong there".

Figure 4.2
Minangkabau Matrilineal Joint Family System

Josselin de Jong (1952:11) characterizes the traditional Minangkabau residence pattern as duolocal, that is, husband and wife each belonged to their natal family and never formed a separate marital family. As Kato notes, "Adult male house members belong to the *adat* house but do not live there. The husbands of the female house members stay at night at the *adat* house but do not belong to it" (1982:44). This residence pattern becomes explicable when rights in property are understood. Property among Minangkabau is of two types: ancestral property (*harta pusaka*) that belongs to lineages but is managed by families, and personal property that has been earned by individual effort (*harta pancarian*). Ancestral property is in principle inalienable (cannot be bought or sold) and must be passed down matrilineally (that is through the female line from a woman to her own children, or from a man to his sister's children, since his own children belong to his wife's family). Irrigated riceland, the basis of traditional subsistence, is mostly ancestral property owned by matrilineages who grant the various corporate families of their lineage usufruct, or use rights, to the land. Each corporate family may cultivate that land, but must pass it on only to lineage members – to children of sisters, but not to brothers, since brothers' children belong to their wives' lineage. Membership in a Minangkabau corporate family, then, gives one use rights to the family house and family riceland and these rights are not affected by residence. Ancestral property brought by a man in marriage to his wife's house reverts to the man's natal family at his death. Although a man might love his wife and children, his chief economic responsibility lay with his sisters and their children, and he was supposed to work hard to enlarge their and his family estate. In addition to ancestral property, however, men and women also sometimes obtained personal property through their own efforts in crafts, trading, or through earnings gotten while sojourning outside the Minangkabau heartland. Such personal property is interpreted as subject to Islamic Law, rather than custom, and is accordingly passed by bequest, usually from fathers to sons, and mothers to daughters.

One can see, then, that the traditional Minangkabau family was female-centred and self-sufficient. Most agricultural and domestic tasks were managed through the cooperative effort of the women of the house, and whether each woman's husband was resident or not had little impact on household affairs. Male socialization of boys went on, to a large extent, at Islamic prayer houses outside the family so that even in this domain the husbands presence was not necessarily required at home. This made temporary migration (*merantau*) out of villages to make money a simple affair. Minangkabau, in fact, are known for their propensity to move to cities and engage in commercial occupations. This picture of female-centred households contradicts, to an extent, the picture of matrilineal households gleaned from studies of the Nayar and matrilineal African groups, among whom males have authority over women and children, and succession goes from mother's brother to sister's son (Schneider, 1961). For the Minangkabau, it is clear that a wide variety of arrangements and roles are available to both sexes and that women are central in day-to-day decision making (Tanner, 1985).

In recent years few new communal tradition houses have been constructed, and the duolocal residence pattern seems to have evolved into an uxorilocal one. This seems mostly to be a result of the reduced access of corporate families to ancestral land which, with population growth, is no longer sufficient to support most people. Landlessness is not unusual now. As male earnings, rather than cooperative female agriculture, have become more important for subsistence, the economic role of

the husband has become more central, and since his earnings usually do not come from the cultivation of ancestral land, they are personal property that he is able to pass in significant amounts down to his biological children rather than to the children of his birth family (that is, his sister's children). Some commentators have seen this development as evidence of a break-down of matrilineal family organization. Uxorilocal residence, though often found as an alternative form of residence in patrilineal societies such as China, is usually a predominant practice only in matrilineal societies. Once a man's personal property has been inherited it becomes ancestral property that again follows matrilineal inheritance rules. Houses, whether built with husbands' or brothers' money, seem still to be owned by females, and to be passed down the female line. Sisters now live in neighbouring clusters of houses where they can easily cooperate with each other. As we saw for the Chinese, in any society the frequency of joint family households is heavily influenced by the timing of partition. Although we lack details, it seems likely that the decline of cooperative agriculture among the Minangkabau may have encouraged earlier partition of joint households and a consequent simplification of joint family structures rather than abandonment of matrilineal family organization per se. For their part, the Minangkabau see their customary family law as a fundamentally unchanging entity and do not concede that basic rules by which households are structured are different from the past, though they of course are aware that society today is different from the past (Kato, 1982:27). Perhaps new field workers investigating the family cycle in more detail in relationship to land tenure and other economic processes will be able to give detailed answers to these questions.

Bilateral Systems

Though not common, bilateral joint family systems are also known in Asia. Corporate families are unusual in societies with bilateral kinship because in such systems family membership is ambiguous if defined by kinship alone. In bilateral kinship systems one can claim membership in one's mother's and one's father's family, so the system makes it difficult to maintain the condition necessary for corporate family organization of belonging to one and only one family. An example of a bilateral joint family system, however, is that of the Ibans, a swiddening group living in the interior of the Malaysian state of Sarawak on the island of Borneo. The Ibans, who live by cultivating hill rice and keeping orchards, reside in large long-houses divided into apartments. Each apartment of the long-house is individually owned by a ritually and economically autonomous corporate family. For those who are not yet married, their parents' residence choice determines family membership. If their parents live patrilocally the children belong only to the corporate family of the father and his parents; if they live uxorilocally the children belong only to the corporate family of the mother. Kinship ties of affection, of course, are maintained between grandparents and grandchildren regardless of corporate family affiliation. Any child by birth or adoption has an equal right to inheritance in his or her birth family, but marriage is utrolocal (utro = either) – a child may choose virilocal or uxorilocal residence, but must choose one or the other. The person, either male or female, who marries out eventually becomes

Longhouses with bilaterally related families are common in Borneo.
Courtesy of Dennis Lau.

fully incorporated in his or her marital family. Inheritance is equal and partible among all sons and daughters of the family, but those who marry out thereby lose membership and inheritance rights in their birth family and gain them in their marital family. The important point to note, however, is that because of the ambiguity of bilateral kinship some criterion besides descent – in this case residence – must be used to determine who belongs to the corporate family. Whether a particular child chooses uxorilocal or virilocal residence depends upon pragmatic considerations – how much land the respective families have, whether there is already a married couple in one of the families, and so forth. Freeman (1970), who studied a long-house village in the late forties, found that uxorilocal and virilocal residence were equally popular (49 percent uxorilocal, 51 percent virilocal). If there are only two children, then, one child brings a spouse into the house while the other marries out. With more children, however, joint families generally develop. As in all joint family systems, joint family organization tends to favour the older sibling. Older siblings will have begun their families earlier so that they are typically larger than the families of younger siblings during the early years of joint family organization. More house resources tend to go toward the children of the older than younger sibling. Because of this tensions tend to build up between married-in spouses in a manner similar to the way they build up in Chinese families. Younger siblings typically demand partition a few years after their marriage by which time their families have become well established, and married siblings

almost never remain together after the death of their parents. When partition takes place the younger sibling and spouse takes his or her share of the family possessions and uses it to form a new family. Because of this early partition and the fact that only families with three or more siblings are demographically capable of forming joint families, joint families tend to comprise fewer than 10 percent of the families of a long-house village, with another 15 percent in stem form.

Stem Family Systems

Joint family systems may be based on patrilineal kinship as among the Chinese, Indians, and Hmong, on matrilineal kinship as among the Minangkabau, or on bilateral kinship as among the Iban. All, however, are based on partible inheritance, a form of inheritance in which all children – all those of a particular sex in lineal systems, or of both sexes in bilateral systems – inherit approximately equal shares of productive property from their parents, and in which their rights to property begin in principle at birth. This system has the disadvantage of making it difficult to preserve wealth over time, since family property is partitioned in each generation among a number of heirs. Yang, for example, noting that few Chinese farm families maintain wealth for several generations, suggests that the well-being of families rises and falls over the family cycle (Yang, 1945: 132–42), and a similar effect has been noted by Greenhalgh (1985) for urban Taiwan. Another disadvantage of joint family systems from the point of view of parents is that house heads' authority tends to recede as they age. Access to joint property is a right of all heirs and does not depend upon parental whim. Children dissatisfied with house heads' decisions can always agitate for partition – a demand that in the long run must be met – and this possibility limits house heads' arbitrary authority.

It is common in corporate family systems, thus, for a single child to be favoured over others in the amount of inheritance and for that person to be the one upon whom the family headship will devolve. In extreme cases, inheritance is impartible: the family estate is passed intact, along with the family headship, to only one person in the succeeding generation. In either case a stem family system is created: only the child who is the successor to the family headship is allowed to bring permanently a spouse into their birth family, and the most complex form normally attained in the family cycle is a stem family. As stem family systems create a strong distinction between the social position of successors and non-successors, they tend to exist in societies with strong hierarchical status distinctions. In contrast to joint family systems, moreover, in stem family systems the senior generation maintains full control over the family and property until either their death or retirement.

Korea and Vietnam are two interesting examples of patrilineal stem family systems. In both of these countries bordering on China strong Chinese cultural influence led originally bilateral family systems to become patrilineal when local elites appropriated aspects of Chinese ancestor worship and lineage organization. Both systems seem at first glance so similar to that of China that observers have sometimes seen them as minor variants of the Chinese model, but succession and inheritance in Korea and Vietnam are quite different from China and from each other. Although joint families are occasionally found in both systems, neither

system produces the true joint family with a full division of labour and heirs with rights to property from birth.

The Korean family, or *chip*, has the usual corporate characteristics: a person belongs to one and only one corporate family whose membership is clearly defined, and each family has a head maintained by succession who manages the family estate. The family cycle on the surface, looks similar to that of China. Except in cases of sonlessness, daughters make patrilocal marriages in which they transfer membership from their corporate birth family to their husband's corporate family bringing with them a small dowry. Unlike China, however, the position of the eldest son in inheritance and succession is distinguished from that of all others. The eldest son must succeed to the position of house headship on the death of his father, and consequently, only he is allowed to make a patrilocal marriage and bring a wife into his father's house. All other sons must make neolocal marriages, that is, they must partition from their birth family and form a new corporate family at the time of their marriage. This marriage pattern corresponds with a system of partible, but unequal, inheritance. Parents may divide their property among their children however they see fit, so it is possible for them to give all their property to their eldest son – the successor who will care for them in their old age – and this sometimes actually happens. In intestate inheritances, however, the right of all children, male and female, to a portion of the family estate is recognized, and inheritances in general tend to follow an approximation of these rules. Females lose all but a negligible portion of their inheritance right when they transfer to another corporate family at marriage (which is well-nigh universal), so for practical purposes inheritance is confined to sons. The successor to the family headship, who must be the eldest son in all cases where an eldest son exists, receives twice the portion of non-successors. A family with two sons, thus, will reserve two-thirds for the eldest son and bestow one-third on the younger son; with three sons, the eldest gets half and each of the younger sons a quarter, and so forth. In folk practice the eldest son's portion rarely falls below half even when sons are more numerous than two. Koreans justify unequal inheritance by noting that eldest sons, unlike younger sons, inherit the responsibility for ancestor worship.

In a stem family system like that of Korea families of oldest and younger sons have different family cycles. An eldest son remains a member of his birth family which, with his marriage, assumes stem form. This main family of parents and married eldest son retains the bulk of the family property, and is known as the "big house" (*k'ùn chip*). Younger sons partition from the big house at the time of their marriage, and on the basis of their smaller inheritances create conjugal branch families known as "little houses" (*chagùn chip*). With the death of the parents, the main family may well revert to nuclear form until the marriage of the next eldest son, while in the following generation the conjugal families of the "little houses" may also raise more than one son, in which case they, too, in addition to developing stem form, may create their own branch families. Over time in rural villages, a nested structure of relatively prosperous main, and less prosperous branch, families tends to be created, perpetuating in following generations the status distinction between eldest and younger brothers. This is reflected in the kin terms for fathers' brothers and their wives who, if they were successors in a main house will be known as "big father" (*k'ùn abòji*) and "big mother" (*k'ùn òmòni*), but if they formed a branch family will be known as "little father" (*chagùn abòji*) and "little mother" (*chagùn òmòni*).

1. Nuclear big house

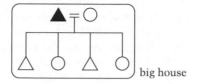

big house

2. Stem big house

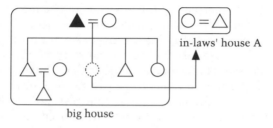

in-laws' house A

big house

3.

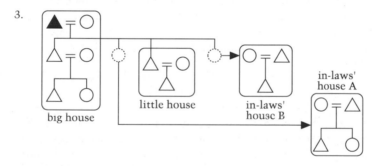

big house

little house

in-laws' house B

in-laws' house A

Figure 4.3
Korean Patrilineal Stem Family Cycle

Fathers in Korea retain more authority than in Chinese joint families since they can, in fact, divide the property between heirs however they please. Partition for non-successors in stem family systems, thus, is different from partition in joint family systems. In joint family systems, as among the Chinese or Iban, partition is precipitated by quarrels among the incipient nuclear families of the joint household that reflect underlying economic tensions. Based as they are on partible inheritance, joint families partition by recognizing and making concrete the rights that the various heirs inherently have in family property. This allows heirs to force partition whenever they feel that joint family organization is no longer in the interest of their nuclear family. In stem family systems, on the other hand, formal rights to the family estate do not begin even for successors until actual succession to the headship upon the death of the father. Rather than being forced by heirs, then, the timing of younger sons' partition and how much they get depends solely on the house head – who may be the father, but can be an older

brother if succession has already taken place. From an etic point of view the estate can be considered family rather than individual property, but since heirs do not have inherent parcenary rights in the same sense that they do in China, house heads can in fact treat family property as a personal possession.

In Vietnam, hierarchical and corporate features are less developed than in Korea, but again stem rather than joint family formation is encouraged despite strong Chinese cultural influence. In Vietnam, as in Korea, kinship is patrilineal and marriage is normally patrilocal. Succession, at least in the south, goes to the youngest, rather than oldest son, however. Each older son may bring a wife into his birth family for a short time, but he is expected to partition and set up neolocal residence before the marriage of the next son and he may, in fact, partition at the time of his marriage. Only the youngest son is expected to remain in his birth family on a permanent basis after his marriage. As in Korea, then, two types of family – neolocal nuclear families, and patrilocal stem families – are regularly formed. Because the successor is the youngest rather than the oldest son, however, the phase of stem family formation tends to be shorter in Vietnam than in Korea simply because parents are older when their youngest rather than oldest son marries so that the number of years during which married parents and children live together is shorter. Statistically, then, while in Korean villages 20 to 40 percent of the families tend to be in stem form at any particular time (Sorensen, 1988: 43), in Vietnam the proportion is closer to 10 percent (Hickey, 1964: 92; Rambo, 1970: 29; Houtart and Lemercinier, 1984: 102). This again illustrates how demographic factors interact with the phases of the family cycle to create a variety of family forms.

Because of differences between the formal legal code and folk practices, and because of the political fragmentation of Vietnam from the colonial period until unification in 1975, inheritance practices were not uniform over the whole country. Most contentious has been the question of female inheritance. The traditional Vietnamese legal code followed Chinese precedents in confining inheritance to sons, but folk practice included daughters in inheritance. In Cochin China (the southern third of colonial Vietnam) the folk practice of equal inheritance among all sons and daughters was legally recognized, whereas in the more densely populated north it was not. The capability of women to inherit that has been retained in Vietnamese folk practice reflects the more powerful position of women in the Vietnamese family, where they have more significant decision-making powers than is typical for East Asia. In both north and south Vietnam, one twentieth of the family estate was supposed to devolve on the eldest son (who resided neolocally) to support ancestor worship responsibilities. As in Korea, desire to conform to Chinese ancestor worship practices favours males over females and eldest over younger sons, but in Vietnam succession to family ancestor worship which goes to the eldest son, and succession to the family household, which goes to the youngest son, are split so that hierarchical distinctions between sons are more muted than in Korea where inheritance, succession, and ancestor worship are all concentrated on the eldest son.

The Kachin, a swiddening tribe of the India-Burma border also has patrilocal residence with youngest son succession, and Leach argues that these rules are "inconsistent" because it is hard for a younger son to maintain authority when his older brother is nearby (1970: 167). In fact, the tension brought about by this is one of the chief structural features of Kachin society. We know little about the

1. Nuclear stage

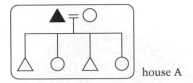

house A

2. Stem stage after marriage of eldest son and daughter

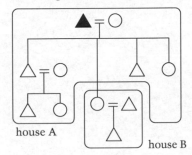

house A

house B

3. Stem stage after marriage of all sons and daughters

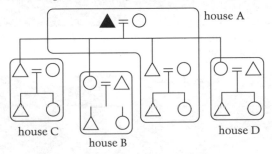

house A

house C

house B

house D

Figure 4.4
Vietnamese Patrilineal Stem Family System

relationship of brothers in Vietnam, but it seems likely that further investigation of this relationship would be revealing.

Many of the family systems of Southeast Asia are similar to the Vietnamese or Kachin in that each child in turn may bring in a spouse before establishing neolocal residence, but only the youngest will marry and reside permanently with their birth family. Most Southeast Asian ethnic groups, however, do not follow a patrilocal residence rule. (The Hmong, having patrilocal marriage, are an exception.) Among the Burmese, the Karen, the Northern Thai and Lao (but not the Central Thai), and currently among the matrilineal Malay of the state of Negri Sembilan in Malaysia, the post-marital residence rule is uxorilocal with only one married child at a time allowed to live in their birth family. Grooms usually move in with their wife's family, where they live for a couple of years until they can establish a neolocal residence – most often close to the wife's family. The youngest daughter is supposed to remain in her birth family to care for her parents in their old age.

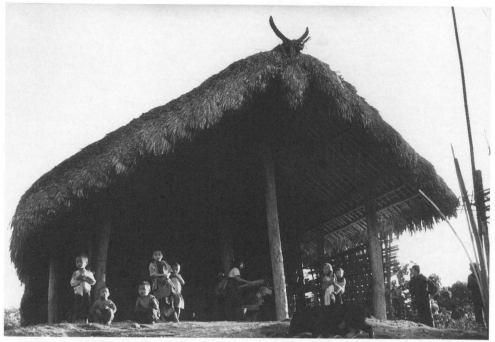

Traditional Kachin house in the Golden Triangle area of Burma.
Courtesy of Hseng Noung Lintner.

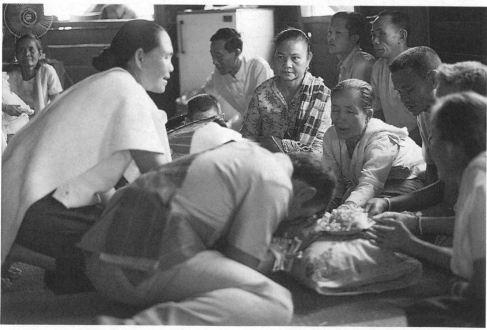

A Lao wedding. The married couple bow before her parents, initially they will be expected to live uxorilocally.
Courtesy of Grant Evans.

Inheritance – which occurs at the death of the parents – in these societies is partible among all children, male and female, but the youngest daughters who care for their parents in old age, just like the youngest son in Vietnam, are supposed to inherit the house. As in all stem family systems, then, two residence rules (uxorilocal and neolocal) are in operation with the birth order and sex of children determining which rules comes into play. At any particular time, most families are nuclear, but some families are matrilineal stem families.

Most Southeast Asian kinship systems, and some South Asian ones such as that of the Singhalese, are bilateral with weak or no development of corporate

1. Nuclear stage

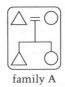

family A

2. After marriage of eldest son

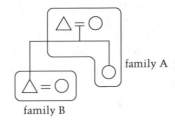

family A

family B

3. After marriage of all children

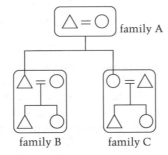

family A

family B family C

4. Extinction of family A after death of parents

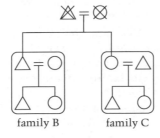

family B family C

Figure 4.5
Non-corporate Family Cycle

lineages. Both lineality and corporateness are weakly developed among families as well. Inheritance tends to be equal and partible among all children, so the development of stem families in most of these societies functions primarily to facilitate mother-daughter cooperation in domestic labour and provide for care of parents in their old age rather than to maintain social status by consolidating lineal control of family property. Succession in the female line, however, usually has support derived from ancestor worship practices. Among the Karen, swidden cultivators of the hills between Burma and Thailand, matrilineal ancestors are the chief objects of worship, and for this reason it is thought impossible for the husband's mother (but not father, if widowed) to reside in the same house (Mischung, 1984:75). The uxorilocal residence rule, thus, is strongly maintained by the Karen who in some regions develop matrilineages. Among the Northern Thai and Burmese, on the other hand, rule-based family formation is less of a preoccupation than in the societies mentioned so far, so that pragmatic circumstances such as the wealth of parents' households, whether co-residence will allow access to scarce land and so forth have a strong effect on whether uxorilocal, patrilocal, or neolocal residence will be chosen. Uxorilocal residence is preferred, and household spirits are passed along the female line. When pragmatic considerations become foremost, as among the Central Thai, a basically bilateral stem system can emerge. Thus, although the Central Thai, when asked, will say that uxorilocal marriage and stem family formation based on the youngest daughter are the preferred forms, investigation of actual families reveals that the sex and sibling order of the child around which the stem family is organized is not strongly stereotyped. One statistical study of four villages, for example, found that 80 percent of the marriages resulted in stem family formation and of these 64 percent were matrilocal with the remaining 36 percent patrilocal (Foster, 1977:309), giving the Central Thai system a bilateral flavour.

Where inheritance is impartible, however, even bilateral systems can be strongly corporate. This can be seen in the pre-war Japanese corporate family, known as the *ie*. Because the Meiji Civil Code implemented between 1896 and 1898 instituted primogeniture, a system in which the family estate together with the headship normally passed on intact to the eldest son, the prewar Japanese *ie* system is sometimes treated as a flexible patrilineal system (Befu, 1963). True patrilineages are absent from Japan, however, and anthropologists and folklorists who have investigated folk customs have found a variety of succession practices. In some areas if the eldest child was a male a patrilocal marriage was made, while if female an uxorilocal marriage in which the son-in-law succeeded to the headship was made. In others, the youngest child succeeded (Befu, 1971:41). In many ways this makes the Japanese system look like that of the Central Thai. As Nakane points out, however, the most fundamental basis of the Japanese system was impartible inheritance – that the family patrimony be passed on intact to succeeding generations and that only one child was consequently allowed to bring a spouse into their birth house (1967:5). Stem families were regularly created, then, but joint families in principle were avoided.

Japanese *ie* display a kind of lineality – a succession of house heads and their spouses – but whether succession was matrilateral, patrilateral, or by some other means was not important in the folk system, and could be affected by individual desires and other pragmatic considerations. Succession practices, in fact, are reminiscent of the utrolateral filiation of the bilateral Iban (Nakane, 1967:168).

Before modern times commoners did not have surnames, but rather each house had a nickname. People were known by their house name and their role in the house ("daughter-in-law of such and such a house", for example). When surnames were introduced for commoners in the nineteenth century, their inheritance tended to follow this house name system, so that whoever marries into a house – whether male or female – takes the surname of that house (Nakane, 1967: 4, 30). This differs from a true patrilineal system such as that of Korea where surnames represent not a corporate house, but a patriline, and are inherited for life by both males and females from the father and do not change regardless of corporate family membership.

Both patrilocal and uxorilocal marriage were common in pre-war Japan, but unlike among the Ibans – another example of a bilateral corporate family system – virilocal marriage was statistically much more common than uxorilocal, usually accounting for three quarters or so of the marriages in a village. This is because male succession took precedence over female succession in most parts of Japan, though females could succeed to house headships in some situations. Uxorilocal marriage in Japan is not stigmatized the way it is in true patrilineal systems such as those of China or Korea, where it is considered a disagreeable expedient only for cases of sonlessness. The married-in husband in Japan takes the name of his new house. His wife may succeed to the house headship, but it is equally likely that he will succeed to the house headship as an adopted son-in-law (*muko yôshi*). Younger sons who have no prospects in their birth house, then, are likely to make uxorilocal marriages, and prominent families without sons, or who have sons they deem unworthy, often deliberately search for talented and ambitious younger sons from good families to marry into their families and continue the line and fortunes of the house. Even prime ministers, thus, have been known to be married-in husbands. Because family systems such as that of Japan cannot be described in terms of lineality and a simple residence rule, and seem to focus on a house line rather than a blood line, they are sometimes called house systems (Lévi-Strauss, 1982).

In the normal Japanese family cycle, then, one child remained in the house, brought in the spouse and continued the family line while all other children had to marry into other houses. Partition was, however, an option. Non-successors did not have an inherent parcenary right to family property, but a house that had more land than it could manage by itself could choose to grant a small portion of the property to any house member (including servants) who could then partition and form a branch house. When this happened, a hierarchical relationship between the main and branch house was maintained. A series of houses linked to a main house in this way was known in Japan as a *dôzoku*. Branch houses had to provide services to main houses when asked, and participated in ancestor worship at the main house. Unlike Korea and China, however, where the ancestors worshiped represented a known genealogical patriline, the Japanese main house worshiped generalized house ancestors whose genealogical relationship to one another was of little concern. This lack of concern about the genealogical relationships of house heads to one another again shows the bilateral nature of the Japanese house system. *Dôzoku* have sometimes been termed "lineages". Since genealogical links did not structure the internal organization of the *dôzoku*, and by themselves were not sufficient to establish main-branch house relationships, and since main-branch relationships could, if desired, be established between unrelated households, *dôzoku* were clearly not true lineages.

A final and very interesting variant of a corporate stem family system is that of the tax-paying serfs of Tibet. Before wholesale reforms were implemented by the Chinese in Tibet in the late fifties, heritable land was held in large estates by three groups of people: (1) aristocrats whose estates were managed by stewards and cultivated by tenants, (2) corporate monasteries whose land was also cultivated by tenants, and (3) tax-paying serfs (*treba*) who cultivated their land with the help of numerous dependent families. The tax-paying serfs in theory held their land as tenants of the government, but they paid tax and could pass their land freely down to heirs. Most Tibetans did not have heritable land, did not pay tax, and had to work for landowners. Landowners were organized as named corporate families. Among them inheritance was partible: all male members of the named corporate family from birth had rights to a portion of the family's land. We have already noted that this type of inheritance, which resembles that of China, is associated with joint family systems, but in order to preserve landed estates the landowning Tibetans maintained corporate stem families. The institution that allowed them to do this was polyandry, a type of marriage in which a woman takes more than one husband.

Landowning Tibetans felt that since each son had a right to a portion of the estate upon partition of the family, fragmentation of the estate upon which family status depended would be inevitable if each brother married. Like the Japanese, then, the landowning Tibetans tried to limit marriages to one in each generation. The rice-growing Japanese are content to force non-successors to marry outside the family, but the complex high-altitude cropping and herding economy of the Tibetans required much labour. It has been estimated, for example, that a medium-size farm required a family of about ten adults (Dargyay, 1982:33). Through fraternal polyandry, a group of brothers marrying the same woman with all the children being regarded as the children of all the brothers, a labour force could be retained without forcing partition of the house in each generation. Only one woman would be brought into the house in marriage, but her services would be extended to all the brothers so as to encourage their remaining in the house. Almost any marriage variant that kept the sexually active males happy without inducing partition was acceptable. A widower and his sons, for example, could all marry the same woman. Or, if a woman in a polyandrous marriage was barren, another wife could be brought in, adding polygyny to polyandry. In polyandrous families, the job of the common wife was to create feelings of satisfaction and harmony among all her husbands and so prevent partition of the family (Dargyay, 1982:33). It was always possible for a discontented brother to become a monk, or make a separate marriage and demand partition – though in such cases he usually either had to find another landowning family to take him in an uxorilocal marriage, or to renounce his landowner status.

A woman who could skilfully keep all the brothers contented was greatly admired. Even if one of the brothers was too young to marry jointly with the others, a skilful older brother's wife was expected to initiate the younger brother into sexual relations at the appropriate time so as to convince him to join the polyandrous ménage. If all went well, in each generation some daughters would marry out with the rest remaining at home. A single wife would be brought in to marry all the brothers, and her children – no matter who the genitor – would be considered the children of all the brothers. Families would alternate between polyandrous "nuclear" (one wife married to a group of brothers) and polyandrous

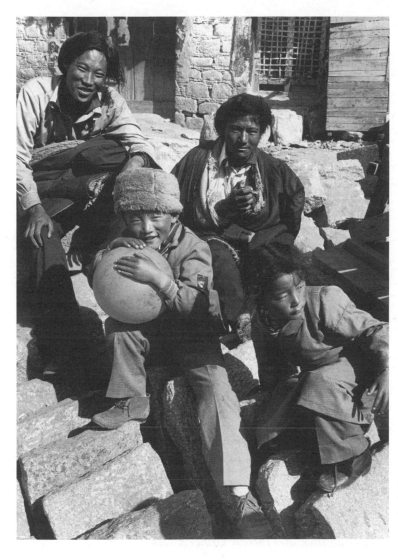

In Tibet there is institutionalized polyandry.
Courtesy of Adrian Bradshaw.

"stem" (a mother married to a group of uncles and a wife to a group of brothers). Since a wide range of marriage practices were allowed – including uxorilocal marriages in cases of sonlessness – many other variants were also possible.

Institutionalized polyandry has been documented only for societies in the Himalayan region, parts of South India, and the Polynesian Marquesans. The explanation for this lies in its connection with highly stratified agrarian systems using plough agriculture, having restricted land tenure, and having high labour needs – conditions found only in areas of Old World Civilization. The Tibetan tax-paying serfs lived in large farm houses that acted as sub-centres around which the cottages of the hired workers, servants, and tenants clustered. They valued polyandry explicitly because it preserved their landed estates. The tenants, craftsmen, herders and servants who clustered around these estates, who were

1. Polyandrous nuclear

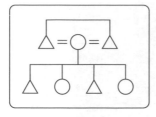

2. Polyandrous stem

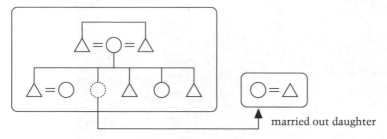

3. Polyandrous stem

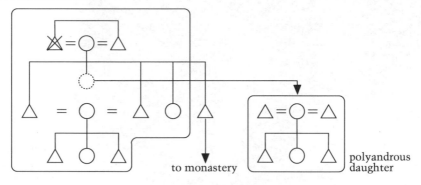

Figure 4.6
Polyandrous Stem Families of Tibetan Upper Class

actually a majority of the Tibetan population, did not practice polyandry. They lived in non-corporate, nuclear families formed through informal unions with neolocal or uxorilocal residence. This illustrates an important point about Asian corporate families. Corporateness is not simply a cultural trait, but develops where social status can be maintained through keeping control of productive resources within family lines. Corporate families are not a feature of simple, classless societies, but are common in Asia precisely because of the complex, stratified nature of Asian societies. Because of the link of corporateness with control of resources, corporate features are often more strongly developed among those classes who control the most resources, a point we will come back to later in Chapter 5.

Further Research

In older studies, family, household, and lineage were not always kept distinct. Anthropologists tended to focus on large-scale kinship units, such as lineages, and view small residential families as of less interest. Consequently, they often treated lineages as automatic, or "natural" developments of the family, and we often lack detailed knowledge of family cycles of even well-studied groups, such as the Minangkabau. Much room, thus, remains for the study of domestic groups, their size, structure, relationship to production and consumption, and how these change in response to changing circumstances.

5 ANCESTORS AND IN-LAWS

Kinship Beyond the Family

Clark W. Sorensen

Asian families have various types of organization, but like all human families they cannot live in isolation. All societies have an incest tabu in which some kin are prohibited as marriage partners, though the precise categories of prohibited kin vary from society to society. Many reasons – biological, psychological, and sociological – have been given for the universality of the incest tabu. Sociologically speaking, however, marriage can be seen as a means by which strangers can become kin. The incest tabu, by prohibiting marriage among family members, forces families to forge alliances with other families through marriage. Two types of kinship relations are thus created: biological kinship, or consanguinity, and kinship created through marriage, or affinity. Relations of consanguinity are modeled in all societies on biological relations, but as noted for pater and mater in the chapter on domestic groups, what is biological is still socially defined. In the Trobriand Islands of Papua New Guinea, for example, because men are held to have no substantive biological role in procreation, a child's genitor is thought to be related to him by affinity (because of his being married to the child's mother) rather than consanguinity (because of his being genitor). Anthropologists divide consanguineal relatives into two types: lineal relatives – those such as parents or children who are direct ancestors of, or direct descendants of a person; and collateral relatives – those such as nieces and nephews, who are descendants of one's lineal relatives, but who are not themselves either ancestors or descendants of oneself. Whether the lineal/collateral distinction is important or not depends upon a society's system of kinship reckoning.

If one starts with oneself, and traces consanguineal links as if on a kinship chart to parents, grandparents, and their descendants on both one's mother's and father's side, one can define a group that anthropologists call a bilateral kindred. Bilateral (or cognatic) kinship reckoning involves recognizing equally all consanguineal links through both males and females, and is the traditional Anglo-American system of kinship reckoning. Koreans also have a bilateral system of kinship reckoning called "inch reckoning" (*ch'onsu*) that they use to determine degrees of consanguinity. Each link is termed one inch, and the number of links it takes on a kinship chart to trace the relationship of one person to another defines their degree of consanguinity. A mother's brother, for example, is called "outside three inch" (*woe samch'on*) – "outside", because on the mother's side, and "three inch"

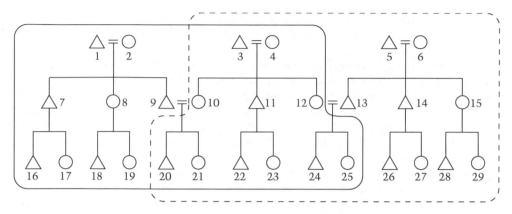

Bilateral kindreds are ego-centred and overlapping. Each person begins calculating his personal kindred starting with himself (ego). For each number of degrees only the kindred of full-blooded siblings will be the same. In the above figure the bilateral kindred up to four degrees of 20 and 21 (siblings) is marked by a solid enclosure. The bilateral kindred up to four degrees of 24 and 25 (also siblings) is marked by a dotted enclosure. The kindreds of these two sets of cousins overlap, but are different.

Figure 5.1
Bilateral Kindred

because three links (self-mother, mother-maternal grandfather, grandfather-son) are involved. Cousins are called "four inch" (*sach'on*).

All societies recognize the existence of bilateral kindreds, and in those lacking corporate descent groups, such as Java, kinship reckoning may be no more elaborate than this. Kindreds are ego-centred and overlapping. Each person begins calculating his personal kindred starting with himself (ego). For each number of degrees only the kindred of full-blooded siblings will be the same. If relatives similarly calculate their kindreds, it is clear that any person belongs to numerous overlapping kindreds. The overlapping ego-centred nature of kindreds make them a poor basis for the organization of corporate kinship groups, since they provide no easy means of maintaining discrete boundaries.

Societies that have corporate kinship groups, thus, in addition to bilateral reckoning of general consanguinity make use of unilineal ("single-line") kinship reckoning to determine kin group membership. The two most common types of unilineal kinship are patrilineal and matrilineal. In patrilineal kinship only descent in the male line confers kin group membership: I belong to my father's kin group and not to my mother's. In matrilineal kinship, the opposite is true: I belong to my mother's kin group and not to my father's. Two other types of kinship system are less frequently found: double descent (sometimes termed "bilineal"), and ambilineal descent. In double descent systems both matrilineal and patrilineal kinship groups are formed. These two types of kinship group normally serve different purposes, and each person belongs both to a matrilineal and patrilineal group. Ambilineal systems result when corporate kinship groups are formed in bilateral societies that allow affiliation to either the mother's or the father's group. In ambilineal systems, both male and female links are appropriate for determining

kin group membership, but an additional criterion for affiliation is used, such as residence among the Iban, to unambiguously determine which link is operative in each specific case.

Clans and lineages are defined by unilineal descent from a common ancestor. Unlike for ego-centred kindreds, group boundaries are the same for all clan or lineage members. Because in each generation a person is filiated either to the male or the female line but not both, clans and lineages do not have overlapping membership. Unilineal kinship, thus, is convenient for defining bounded, corporate groups beyond the family. Unilineal kinship groups whose members can trace their genealogical connections through known persons back to a founding ancestor are called lineages. Lineages can be deep or shallow depending upon the number of generations between living members and the ancestor from whom they trace common descent. In many cases, however, people cannot trace their specific genealogical links. This commonly happens, for example, when a kin name is passed on unilineally but elaborate genealogies are not kept. People may assume that anybody with the same kin name must have inherited it from a common ancestor, but they might not be able to specify the ancestor or the precise genealogical ties that link them. Anthropologists call such groups clans. Clans and lineages are not mutually exclusive, and both may segment. Segmentation takes place when, within a clan or lineage, descendants from an ancestor intermediate between living group members and the common ancestor of the whole group set themselves apart while still recognizing common group membership. Among the Hmong, for example, patrilineal kin defined by descent from a common grandfather are recognized as segments of larger lineages defined by descent from a common great grandfather. These larger lineages, in turn, are recognized to be segments of clans united by patrilineal descent, the details of which people do not precisely reconstruct.

It is important to note that although many societies use unilineal kinship reckoning to define a special class of relatives – lineage or clan members – members of these societies normally also recognize bilateral relatedness. In classical Hindu kinship, for example, Brahmins belong to exogamous patrilineages known as *gotra*. In addition, however, marriage is prohibited within a person's bilateral kindred, or *sapinda* (Trautman, 1981: 246). The situation is similar in Korea where bilateral relatives calculated by inch reckoning are recognized as *ch'inch'ok* ("relatives"), while those *ch'inch'ok* descended in the male line from a common ancestor are further differentiated as *ilga* ("one house"). The founding ancestor of *ilga* often lived twenty-five to thirty generations back (500–800 years ago), but members know each other by possession of the same surname and clan origin (*tongsòng tongbon*). Koreans explain that bones come from the father, and flesh from the mother. Both provide kinship, but bones last longer than flesh so that kinship in the male line is long-lasting, while kinship in the female line fades more quickly with time and genealogical distance. Marriage with patrikin (*ilga*) however distant was prohibited until a few years ago, but marriage with matrilateral kin past eight degrees of kinship was allowed.

Societies that have clans and lineages are usually like Hindus or Koreans in that they require marriage outside the lineage, or lineage exogamy (exo = outside, gamos = marriage). This rule prevents the formation of marital alliances within the kinship group that might hinder overall group solidarity. The major exception to this generalization is among South Asian and Middle Eastern Muslims who

Patrilineal Descent

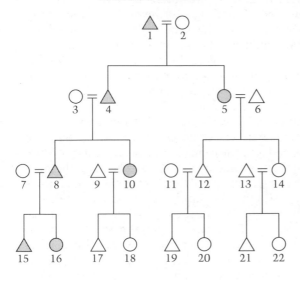

Individuals 4 and 5, who are the children of 1 and 2, affiliate with their father's patrilineal kin group, represented by the shaded symbols. In the next generation, the children of 3 and 4 also belong to the shaded kin group, since they take their descent from their father, who is a member of that group. However, the children of 5 and 6 do not belong to this patrilineal group, since they take their descent from their father, who is a member of a different group. That is, although the mother of 12 and 14 belongs to the shaded patrilineal group, she cannot pass on her descent affiliation to her children, and since her husband (6) does not belong to her patrilineage, her children (12 and 14) belong to their father's group. In the fourth generation, only 15 and 16 belong to the shaded patrilineal group, since their father is the only male member of the preceding generation who belongs to the shaded patrilineal group. In this diagram, then, 1, 4, 5, 8, 10, 15, and 16 are affiliated by patrilineal descent; all the other individuals belong to other patrilineal groups.

Individuals 4 and 5, who are the children of 1 and 2, affiliate with their mother's kin group, represented by the shaded symbols. In the next generation, the children of 5 and 6 also belong to the shaded kin group, since they take their descent from their mother, who is a member of that group. However, the children of 3 and 4 do not belong to this matrilineal group, since they take their descent from their mother, who is a member of a different group; their father, although a member of the shaded matrilineal group, cannot pass his affiliation on to them under the rule of matrilineal descent. In the fourth generation, only 21 and 22 belong to the shaded matrilineal group, since their mother is the only female member of the preceding generation who belongs. Thus, individuals 2, 4, 5, 12, 14, 21, and 22 belong to the same matrilineal group. This rule of descent generates a group that is almost a mirror image of the group generated by a patrilineal rule.

Matrilineal Descent

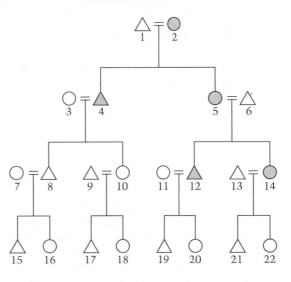

Figure 5.2
Patrilateral and Matrilateral Cross-Cousin Marriage Patterns

often favour marriage within the lineage, or lineage endogamy (endon = within, gamos = marriage). Ambilineal kinship groups, called ra*mages*, are also often not exogamous. Common in Oceania, *ramages* are relatively unimportant in Asia.

Clans and lineages, unlike domestic groups, are rarely units of residence or production. In addition to the regulation of marriage, however, clans and lineages typically have a variety of functions that mostly have to do with politics, religion, or social status. Thus among the Minangkabau, land is owned not by individuals, or even families, but by matriclans, and the heads of the matriclans of each village form councils that make decisions on the interpretation of Minangkabau customary law, while families remain the basic units of co-residence, production, and reproduction.

In our classification of domestic groups the Chinese, Muslims and high-caste Hindus of south Asia, and the Hmong were classed together as having patrilineal joint systems while the Vietnamese and Kachin were classed together as patrilineal stem systems with youngest son succession, and so forth. The Kachin and Hmong, however, have much less complex societies than the Vietnamese or Chinese, while Indian and Chinese societies, though of similar complexity, have quite different systems of social stratification. Even setting aside the significant matrilineal groups in India, moreover, social stratification and kinship patterns are different among patrilineal Hindus and Muslims, and between patrilineal groups in North and South India. Societies with the same type of family cycle, in fact, can have quite different kinship systems when we look beyond the domestic group. This can be seen if we consider aspects of marriage beyond type of post-marital residence, and explore the link between kinship and social status.

Marriage and Alliance in Highland Southeast Asia

The Hmong, a relatively unstratified patrilineal people with a joint family system have been introduced before. Members of corporate Hmong families clear plots, or swiddens, in the highland forests of south China and Southeast Asia. After being cultivated for a few years, the swiddens become unproductive, so Hmong families then create new clearings, leaving the old ones to regrow to forest so that the soil may be rejuvenated. According to the Hmong family developmental cycle patrilocally married brothers eventually partition to form separate corporate households, but they try to live close to each other. Over time, groups of households whose heads are patrilineal descendants of a common ancestor congregate in villages to form shallow lineages of three to four generations' depth. The members of a corporate family have a right to whatever family members produce on land they have cleared themselves, but the clans of which lineages are said to be segments regulate where families are allowed to clear land. Periodically it becomes clear that adequate land to clear is no longer available within a village, so some or all of the families must migrate to new areas. If the new area is controlled by a lineage of the same clan, then lineage members will be granted land to clear regardless of whether a known relationship of descent unites the two lineages.

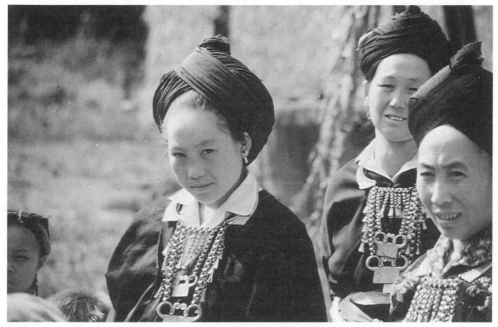

The Hmong highlanders have a relatively unstratified patrilineal joint family system.
Courtesy of Grant Evans.

Otherwise, they have to find some other tie to the clan that controls the land. One of the best ways of doing this is to make an alliance through marriage.

Marriage among the Hmong must be lineage exogamous, and the preferred residence pattern is patrilocal. For the woman and her children to be transferred from her birth family to her marital family, however, a substantial brideprice must be paid in Burmese silver rupees. Brideprice is a marriage payment that goes from the groom's family to the bride's family (but not the bride herself). In the case of the Hmong, it is collected among the patrikin of the groom, and distributed among the patrikin of the bride. Hmong men talk of "buying a wife" (Cooper, 1984: 139), but the brideprice payment does not actually represent a commercial purchase: the woman retains a relationship to her birth family; she can leave her husband to return home or remarry, and if he has mistreated her, brideprice does not have to be repaid; and in any case the compensation her family receives does not equal the value of her lost labour.

Two analytic traditions in anthropology – descent theory and alliance theory – have emphasized two different aspects of brideprice. Descent theorists such as A. R. Radcliffe-Brown have emphasized the role of brideprice in effecting the transfer of rights to filiate offspring to the groom's descent group (rights in genitricum), and rights to the domestic services of a woman as wife (rights in uxorem). Alliance theorists such as Claude Lévi-Strauss, on the other hand, have emphasized that brideprice payments are part of a comprehensive relationship of reciprocity between kinship groups – an alliance – that is created by exchange of both women and goods through marriage. Evidence from the Hmong supports both descent and alliance theory. It is clear that payment of brideprice is a condition for the filiation

of children to the lineage of the pater. If a woman remarries and takes her children, the new husband through the payment of brideprice filiates the children to his lineage. But it is clear that social status and maintenance of relations between affines is also a consideration. Hmong talk about the honour of high brideprice payments. Geddes has noted, moreover, that village exogamous marriages are valued because "they increase the range of social relationships for the marriage partners and their relatives. Not only do the new connections provide occasions for inter-visiting, thereby adding to the interest and variety of life, but more importantly they promise greater possible opportunities for resettlement, an important asset to the Miao [Hmong] who are constantly seeking more productive land. Communities which are largely endogamous are often poorer communities to begin with, and their endogamy tends to perpetuate their relative poverty" (Geddes, 1976: 82).

The Hmong show a concern with maintaining marriage alliances once formed. Brideprice payments sometimes are not given in a lump sum, but paid in bits and pieces over time. If a married man dies, his younger brother can marry the widow without paying brideprice, thus maintaining the alliance between clans. A third way lineage alliances can be maintained is through cross-cousin marriage. Cross-cousins are cousins descended from parents' siblings of the opposite sex – father's sisters' children and mother's brothers' children – while parallel cousins are descended from parents' siblings of the same sex – father's brother's children and mother's sister's children. In patrilineal kinship systems, father's brothers' children belong to one's same lineage, while in matrilineal systems mother's sisters' children fall in the same category. These parallel cousins, then, usually fall within the range of kin prohibited by the incest tabu. Cross-cousins, on the other hand, belong to different lineages and are often preferred marriage partners because marrying them reinforces an alliance between lineages created in previous generations. A boy in a patrilineal system, for example, by marrying his father's sister's daughter (his patrilateral cross-cousin) would be bringing a bride from the group that the generation before had received a bride from the boy's group, thus completing and making symmetrical an exchange begun a generation before. By marrying his mother's brother's daughter (matrilateral cross-cousin), on the other hand, he would be getting a wife from the same group from which his father got a wife, and sending his daughters to the same group into which his sisters married. This form of marriage, which can be done without brideprice payments and is accomplished by childhood betrothal among the Hmong, continues in the following generation the same relationship of bride-givers and bride-takers set up by the parents in the preceding generation. Notice here that the system operates to prohibit marriage with one set of cousins, but not with another. This illustrates that, although considerations of biological closeness and fears of incest may be involved in marriage, prohibitions must also be understood in terms of the way they structure marriage alliances.

Among the Kachin, another highland swiddening people of Southeast Asia, matrilateral cross-cousin marriage is a fundamental aspect of social structure. As among the Hmong, Kachin marriage is patrilocal and is accompanied by a substantial brideprice that legitimizes offspring. Cohabitation without marriage is not considered a particular disgrace, but unless brideprice is paid, the children will be filiated to their mother's rather than their father's lineage. With matrilateral cross-cousin marriage, one gets wives from the same clans from which wives have

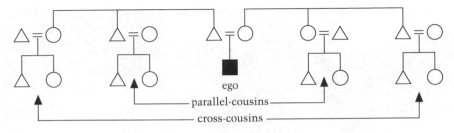

(a) Parallel- and cross-cousins

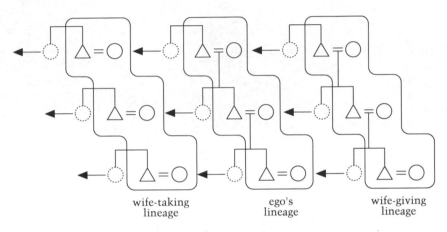

(b) Matrilateral cross-cousin marriage

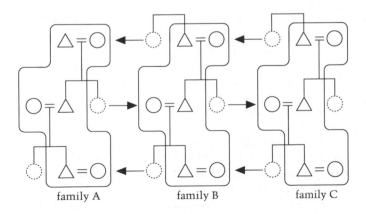

(c) Patrilateral cross-cousin marriage
(notice change of direction of exchange in each generation)

Figure 5.3
Patrilateral and Matrilateral Cross-Cousin Marriage Patterns

A woman, Jingpaw-Kachin, marrying a Haur Chinese in the Golden Triangle area of Burma.
Courtesy of Hseng Noung Lintner.

come in the past, and sends daughters to the same clans in which clan sisters have been married. From the male point of view, then, lineages can be classified into four types: (1) lineages belonging to the same clan (with whom marriages cannot be contracted because of the rule of clan exogamy), (2) wife-giving lineages (*mayu ni*) from which wives are taken, (3) wife-taking lineages (*dama ni*) to which wives are sent, (4) other lineages with which no particular relationship has been set up. All women in wife-giving lineages are classified as cross-cousins and potential spouses, so that many classificatory cross-cousins are biologically much more distant than one's own real mother's brother's daughter. Not all marriages conform to this cross-cousin model, but a certain number of marriages of politically prominent people each generation that are ratified through brideprice payment do. Once brideprice is paid, moreover, the relationship of the two lineages as wife-givers and wife-takers is thought to be permanent; the wife-givers (*mayu ni*) must continue to give wives, and wife-takers (*dama ni*) must continue to take wives.

Neither the Hmong nor the Kachin have classes in the sense of people who accumulate, or fail to accumulate, large amounts of wealth, but the Kachin rank their lineages in terms of status, political importance, and influence. This ranking is intimately related to the system of marriage alliances. Wife-givers (*mayu ni*), because they receive the very substantial brideprice payments, are considered higher than wife-takers (*dama ni*). So long as each lineage contracts patrilocal marriages and pays the same level of brideprice, this may not lead to area-wide rank differences; each lineage will be wife-givers to some, but wife-takers to others. A poor man, or one who cannot get along with his lineage mates, however, might make an uxorilocal marriage with a reduced bride price on the condition of a given

number of years bride service. In this case, his patrilineal descendants will become a subordinate lineage to that of his wife. Even more radically, in the past a poor man could become a voluntary "slave" of a prominent man, who would pay his bride price for him. The master in return would have a claim on the labour of the man and his children, and be entitled to a share of the produce of his livestock and of the brideprice for his daughters.

This system left great scope for political manipulation of marriage alliances. For example, when marriages took place between lineages of different rank, the system was usually one of hypogamy (marriage down, from the point of view of the bride). Brideprice, though in theory determined by the rank of the bride, was actually determined by the rank of the groom (Leach, 1970: 151). By accepting reduced brideprice from men of slightly lower rank, then, a chief could recruit subordinate followers. On the other hand, if the chief wanted to make an alliance with another chief, he would have to pay especially high brideprice. By these means, an enterprising man might, by paying a high brideprice and marrying into a prominent family, ratify higher rank than the prominence of his ancestors would otherwise allow.

As among the Hmong, both descent and alliance principles are at work among the Kachin. Rank is in principle hereditary, and brideprice seems to transfer rights in genitricum to the husband's lineage as would be expected in an analysis of the Kachin that assumes descent to be the most important principle in operation. In practice, however, we can see that marriage alliances are a fundamental foundation for the ranking system, and that brideprice payments are probably of most fundamental importance for linking and ranking lineages – that is, for expressing and creating ranked marital alliances. Among the Kachin and other highland groups that do not keep elaborate written genealogies, lineages are shallow, being only a few generations deep. Memories of ancestry get vague after a few generations so that the ancestral background of an upwardly mobile person might be raised by reinterpretation, or discovery of "forgotten" prominent relatives. It is possible, in fact, to see lineages among these highland people less as groups defined by descent from a common ancestor, than as groups defined by common bride-giving and bride-taking alliances. In other words, marital alliances rather than descent might be the defining features of the Kachin kinship system.

Marriage and Alliance in South India

Alliance models such as have been effectively used to analyze highland systems of Southeast Asia have been widely used to explain kinship in South India, too. The south, even for India, is ethnically extremely complex. The most common family type is patrilineal and patrilocal, but many groups are matrilineal matrilocal, especially in the state of Kerala where the famous matrilineal caste, the Nayars, live. Double descent is found among several groups. As in the north, in the four states of South India – Tamil Nadu, Andhra Pradesh, Karnataka, and Kerala – most people are Hindu, but they speak Dravidian rather than Indo-European languages related to Sanskrit. Hindu Indians are divided into hereditary regional castes (*jati*) whose relative rank is based on the purity of their occupation and lifestyle. Castes are corporate groups with common rituals, traditional occupations, and a council

Indian wedding.
Courtesy of Veronica Garbutt.

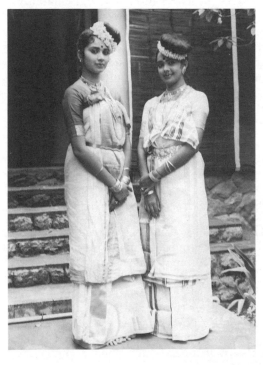

Two Nayar women of South India, members of one of the most anthropologically famous matrilineal systems.
Courtesy of K. Kunhikrishnan.

that adjudicates infringement on caste tradition. They are, in principle, endogamous. Since rules of marriage and kinship are regulated at the caste level, castes form a marriage circle with common kinship organization and constitute categories similar to ethnic groups. If the caste marks the largest group within which marriage takes place, the clan, for both matrilineal and patrilineal groups, marks the group within which marriage is prohibited. Throughout South India, however, true cross-cousin marriage is favoured, and marriages tend to be village endogamous, so that villages tend to consist of small groups of intermarrying affines, known in Tamil as *chutram*, who renew marital alliances in each generation. This does not lead to a ranking of clans as among the Kachin, however, for two reasons: (1) true rather than classificatory cross-cousin marriage means that affinal relations between families from different clans apply only to the families involved and not to the whole clan, (2) both patrilateral and matrilateral cross-cousin marriage is allowed in most castes so that women are both married into and taken from the same families, and affines therefore cannot be unambiguously classified as wife-givers or wife-takers, (3) status in South India depends much more on control of landed wealth than among the ranked, but classless, Kachin.

The evidence is not conclusive, but Goody argues that the close marriage practices of South India are probably related to greater female rights in landed property (1990:257–8) than in north India, where Hindus do not allow cousin marriage. Logically, where females have rights to landed property through dowry or inheritance, cousin marriage would have the advantage of bringing back in the children's generation properties of brother and sister dispersed in their own generation (Tambiah, 1973:119). The evidence for this proposition, however, is stronger for the bilateral kinship systems of both Tamil and Singhalese-speaking Sri Lankans, among whom women inherit landed property, than for South India itself.

Cousin Marriage among South Asian Muslims

Considerations similar to those for South India can be used to analyze the different sort of cousin marriage among South Asian Muslims. In India and Pakistan, Muslims are commonly organized in patrilineages, but these patrilineages are not exogamous. On the contrary, the favoured form of marriage is with parallel cousins (especially one's father's brother's daughter), though cross-cousin marriage is also considered desirable. In a patrilineal system, of course, one's patrilateral cross-cousin belongs to one's own lineage. This is considered an advantage among Muslims for two reasons: (1) the unstained purity and character of daughters is highly valued, and one can best be sure of this purity and character among close kin with whom one already has an intimate relationship of visiting and cooperation, and (2) parallel cousin marriage keeps landed property in the same family line in a society where this is considered important. Both these considerations have been explicitly mentioned by informants (Donnan, 1988:126–9). This concern with property is related to the way women are endowed at marriage through dowry and dower.

Dowry and Social Stratification

Dowry is a transfer of property from the bride's family that results in the endowment of the new conjugal family created by the marriage. This property may continue to be controlled by the woman after her marriage, or it may be controlled by her husband, but it is part of a process termed "diverging devolution" in which property is passed down to both male and female heirs (most typically by inheritance for males, and dowry for females) (Goody, 1973). It is often found in societies that also have brideprice. Thus among the Hmong, though the most important marriage transaction is the brideprice paid in silver rupees to the family of the bride, the bride is also supposed to be given a dowry of an ox, a pig, some silver neck rings, and a new embroidered costume to start out her married life.

Because dowry comes most often from the bride's family, it is sometimes seen as the opposite of brideprice, which typically is paid by the groom's family. As we have seen, however, brideprice is a transaction between lineages, and the money or goods involved go to the parents of the bride and more distant kin rather than to the bride and groom themselves. True dowry always goes to the married couple even if they live in a joint family. Similar transfers of wealth to the newly married couple sometimes come from the groom's side. The European marriage portion that a husband or his family pledged to his wife, sometimes known as dower, thus can be considered a form of dowry, as can the *sabong*, an endowment of land given to a son at the time of his marriage among the Ilocano of northern Luzon in the Philippines. Other wealth transfers that look at first glance like brideprice can also be considered a form of indirect dowry, if they end up with the married couple.

Among Muslim groups, both dower and dowry are usually exchanged at marriage. According to Islamic marriage law of Pakistan, for example, a bridegroom must pledge a money dower known as *mehr* to his bride at the time of marriage. In most cases this money is not given directly to the bride at the time of marriage, but rather is a pledge redeemable only upon her husband's death, or if she should be divorced. The size of this pledge is an important indication of social status, and it protects the position of the woman where divorce is fairly easily obtainable by men. Although not mentioned in the marriage law, in addition to the dower, a substantial dowry in goods and jewels, known as *jâhez*, is usually also given to a woman at marriage by her father and brothers and remains her property. Brothers contribute to sisters' dowries partly as a way of solidifying brother-sister ties, but also because the dowry is recognized as a woman's share of the inheritance and, according to Islamic Law, justifies her exclusion from inheritance of land (Donnan, 1988: 113–114). Parallel cousin marriage, then, not only reaffirms ties between patrilineage members, but also keeps the dowry within the lineage.

Substantial dowry payments are most characteristic of class societies in which wealth varies greatly among families, and in which social status depends upon the control of wealth. In such circumstances the social status of daughters and their children can be assured only if their access to property is assured, and this depends greatly on how property is transferred from one generation to the next. In these societies we tend to find not a single system of brideprice or dowry with standard payment levels, but rather a good deal of variation in the nature and timing of the transmission of wealth that is systematically related to strategies of family status

reproduction (Papanek, 1979). Thus among the Islamic groups mentioned above, marriage is isogamic (iso = same level, gamy = marriage): most people marry with families of the same level. Close marriage with known persons (especially agnatic kin) is favoured by most people because they can more easily assess affines' economic level, and can trust them so that a more modest dowry – or even help with the dowry – can be obtained. Among wealthier people, however, the ability to transfer large sums at marriage through a dowry gives them more options. On the one hand, wealthy persons who live at a distance may become interested in a woman who comes with a large dowry, and on the other, a family that is able to well endow their daughter can risk a distant marriage since they know their daughter's dowry will support her should their information about the son-in-law and his prospects be faulty.

Bridewealth and Dowry in North India

The above social status considerations figure prominently among North Indian Hindus. Most North Indian Hindus are patrilineal, and, unlike among Muslims, may not marry a member of the same patriclan, or *gotra*. This rule, however, eliminates only patrilateral cross-cousins, and is equally true of South India where close marriage is common. North Indians, however, either also forbid marriage among one's bilateral kindred, or *sapinda* – usually up to the seventh degree on the male side and the fifth degree on the female side – or prohibit marriage with the clans of each of one's four grandparents. Either rule prohibits cousin marriage of any sort, so that alliances between families or clans cannot be maintained through repeated intermarriage as they are in South India. Thus descent and transmission of property are more important than in the alliance systems we have been considering so far.

North Indian clans are non-corporate groups that neither own property nor organize clan-wide activities. They function most importantly to regulate exogamy, though clan members from a single village may also gather annually to worship the clan goddess. Illiteracy used to be widespread in India, so most clan members do not themselves keep written genealogies. Each clan does, however, have a professional genealogist whose task it is to keep written records of such things (Mayer, 1960: 194–201). Eight to ten generations of records are usually maintained. Beyond that only clan names, origin myths, and rituals are remembered. Etically, lineages in which people can trace their descent as recorded by their genealogists can be distinguished within the clan as a whole, for which a myth of clan origin and record of the clan goddess unites patrilineal relatives whose genealogical ties cannot be specified. These distinctions are not emically made among Hindi speakers, however. North Indian genealogies, then, though not so deep as those kept by the Chinese and Koreans, have considerably more precision and scope than those kept by non-literate peoples such the Hmong and Kachin, and even South Indians, where detailed knowledge of kinship among most groups goes back only so far as living memory.

As in South India, castes in North India are endogamous, but whereas in South India marriages, as they tend to be with close kin, are most commonly village endogamous, in North India most fellow villagers are prohibited because of clan

or caste endogamy, so village exogamy is most common. In some areas village exogamy is explicitly required. As among the Hmong, both brideprice and dowry are found in North India, but whether brideprice or dowry is paid, and the size of the payments depends upon the position of castes in the caste hierarchy, and the position of a family within the caste. Sanskritic, or Hindu, norms emphasize that proper marriage should involve the free gift of a daughter without any expectation of return. Upper caste groups, then, avoid brideprice transactions. Dowry, known classically as *stridhana*, is usually part of such marriages, and is usually deemed to represent the daughter's share of the family estate, since she receives nothing in inheritance. Members of lower castes, however, can rarely afford to give daughters significant dowries, and among them brideprice is common. According to Hindu notions, this is one of the justifications of the caste hierarchy: lower castes demonstrate impurity by asking for brideprice in exchange for daughters, and by allowing remarriage or inheritance of widows by brothers; upper castes demonstrate greater purity by giving daughters and dowries as a pure gift, and by avoiding remarriage or inheritance of widows. The extreme expression of this purity is the upper caste custom of *sati* in which a widow might immolate herself on her husband's funeral pyre as a demonstration of the indissolubility of her marriage to her husband. Cases of *sati* were never common, however, and widows who did this were often worshipped as minor deities.

In addition to the emic Hindu interpretation of these marital transactions, an etic interpretation is also possible. As noted for the Kachin and Hmong, payments in unilineal kinship systems usually ratify the transferral of rights in genitricum and rights in uxorem to the wife-taking lineage. Where substantial brideprice payments are demanded – as among some North India castes – the groom's lineage, among whom the brideprice payment would have been collected, may want to continue to maintain control of a widow's reproductive rights and domestic labour for which they have paid by giving her to a brother of a deceased husband, or they may allow her to remarry, using the brideprice they receive to obtain new spouses for lineage members. Where substantial dowry is involved, however, considerations of control of property rather than of a woman's reproductive rights come into play. Dowry, as we have seen, endows a new conjugal family with property so that, in a class society in which status depends on wealth, children will be able to maintain their social status. A widow who remarries might take her dowry – and even some of her deceased husband's property – into her second marriage, thus alienating from her first marital family property crucial for the maintenance of their social status. In the case of a poor, low status brideprice-paying caste, then, widow inheritance does not threaten the affinal alliances created through marriage. Neither does remarriage with repayment of the brideprice threaten the ability of the lineage to reproduce. Both practices are allowed. In rich, high status dowry-transferring castes, on the other hand, both widow inheritance and remarriage threaten the integrity and social status of the property holding family line and are not allowed.

Questions of brideprice and dowry in India are related to stratification within castes, as well as status relations between castes, and are especially important when brides and grooms are of different social status – either because of caste differences, or because of wealth differences. Whether among matrilineal or patrilineal groups, intra-caste hypergamy (marriage of women into richer families

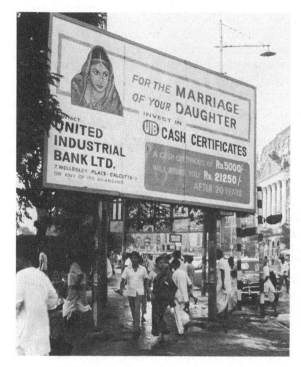

A bank in Calcutta, India, offers the possibility of investing the equivalent of US$700 to make a dowry twenty years later of over US$3000. An average worker would have to work 500 days to earn enough for the initial investment.
Courtesy of Carol R. Ember/Melvin Ember, *Cultural Anthropology*, 6th ed., © 1990, p. 181. Reprinted by permission of Prentice Hall, Englewood Cliffs, New Jersey.

of the same caste) and hypogamy (marriage of a woman into poorer families of the same caste) are closely related to transfers of wealth at marriage. A high dowry, for example, can make up for less-than-perfect family background, or looks, in a woman, or a brideprice payment can, to an extent, make up for similar defects in a man.

Since women move to their husband's house and take his status upon marriage in most of North India this phenomenon reinforces the notion that dowry is high status and brideprice low status. In some parts of India, in fact, systematic hypergamy is found where families try to take brides from slightly lower groups and give brides to slightly higher groups. The more substantial the dowry, of course, the more successfully a family can play this game, but systematic hypergamy creates problems in the lowest and highest social groups. At the bottom of the system, poor men may have difficulty finding wives, since most women marry up. Informal polyandry sometimes develops when brothers find they can get together only enough brideprice for a single marriage (Karve, 1953:132). High status families, on the other hand, may find it difficult to find a husband for all their daughters, since most males of their class find wives from slightly lower groups. This sometimes leads to high rates of celibacy, as among Nambudiri Brahmin females of Kerala, or even to high rates of female infanticide as among high-status Rajputs in the nineteenth century who did not want the family property to be dissipated by numerous female marriages requiring high dowry payments (Goody, 1990:306).

With greater commercialization of the Indian economy, questions of dowry have become more acute than in the past. "Dowry evil" has become a regular

topic of discussion in the Indian mass media, but what is called "dowry" here does not always precisely conform to anthropological definitions of the term. As mentioned above, one of the defining features of dower and dowry is that the wealth involved ultimately devolves upon the new conjugal family created by marriage (Goody, 1990:15). "Brideprice" payments that do not remain with the bride's family, but return with the bride into her marital family, thus, are really forms of indirect dowry provided by the groom's family. Conversely, "dowry" payments that come from the bride's family, but go to the groom's family rather than the bride or the groom themselves, do not strictly constitute dowry, but rather must be considered a form of "bridegroom price". The existence of bridegroom price has been best documented for India by Caplan (1984). Among upper class families in urban India, men with highly desirable occupational prospects (doctors, high civil servants) who also belong to one's own caste, are scarcer than the supply of women who wish to marry them. Because of this, highly desirable grooms can ask for and get very large dowry settlements. In many cases part of this dowry comes with the wife and may be considered a form of *strîdhana*, but much of it goes directly to the groom. Most interesting, however, is that a very large proportion may go neither to the bride nor groom, but the groom's family which in turn uses the money to make good marriages for their own daughters. This kind of payment which forms a revolving conjugal fund that does not devolve on the couple actually getting married is precisely analogous to brideprice.

Although inflation of "dowry" and bridegroom price has been pointed to as a social evil and been the object of legislative reform in India, where the 1961 Prohibition of Dowry Act forbade giving property between families directly or indirectly "as a consideration for marriage" (Caplan, 1984:219), it is not clear that "dowry evil" is an entirely new phenomenon in India where high caste Hindus have always looked with contempt at those who "sell their daughters" (i.e. accept brideprice). In parts of Bengal, high status Brahmins who called themselves *kulîn* used to be able to demand very high bridegroom prices for their sons from girl's families whose *kulîn* status was not universally acknowledged. It is said that some families with many sons practised this form of marriage, known as *kulînism*, as a virtual business by marrying a large number of wives, and that sometimes these wives would remain at their birth family's house and their husbands would demand money for each visit (Karve, 1968:116–7). A similar form of bridegroom price may also be implicated in the "dowry deaths" that have received publicity in recent years. "Dowry deaths" are cases when young wives have died in their marital family's house under suspicious circumstances – often from kitchen burns. In many of these cases, which number several hundred each year, the media have inferred that desire for more "dowry" has been the motivation. Though it is not clear whether it is dowry in the strict sense or bridegroom price that is the culprit, two factors seem to be involved: (1) in many cases in India "dowry" is not paid in a lump sum at the time of marriage, but in instalments beginning with the marriage, and (2) the bride herself often does not control this "dowry" after her incorporation into a joint family, despite norms which indicate that at least some of it should be considered her personal property. This opens the door for bride-taking families to make continuous demands for "dowry" from bride-giving families even years after the marriage has been arranged. It is suspected that brides' unexplained deaths are in some cases a result of the inability, or unwillingness, of bride-giving families to meet these continuous "dowry" demands.

Bridewealth and Dowry in China

The link between dowry and the social status of wives noted for India, is common to all dowry systems and is also found in China. There, as in India, both brideprice and dowry are found. Brideprice is the more ancient practice, being the only marriage gift mentioned in ancient ritual texts, but dowry has also been an important part of the Chinese marriage system for at least a thousand years (Ebrey, 1991). Though the size of the brideprice varies with the relative desirability of bride and groom and the social status of the families involved, some sort of brideprice and dowry is part of true marriages among all classes. Traditional Chinese marriages were arranged by the parents with little consultation with the potential bride and groom. Perhaps for this reason, "objective" considerations such as the contacts possible through particular marriage alliances, the relative wealth of the households, the career prospects of the husband, the diligence and level of education of the female, all outranked the personal compatibility of the couple as marriage considerations.

In the Chinese patrilocal marriage – the preferred and most prestigious type – a go-between contacted the relevant houses and negotiated levels of brideprice and dowry. Once the brideprice (called betrothal gifts in Chinese), was transferred to the bride's house, the marriage was considered valid. Out of concern for the post-marital welfare of their daughters, however, most families did not retain the brideprice for themselves. Rather, they used part of it to finance wedding rituals, and gave the rest to their daughter, along with as substantial a dowry in goods and money as they could afford. This dowry could be equivalent to a years' family income or more. Since the brideprice returned with the bride to the groom's house in such cases, brideprice functioned as a form of indirect dowry, an endowment to the newly married couple paid by the groom's side through the bride's father. So long as the bride and groom remained in a joint family, the money and goods brought in marriage by the bride – whatever their ultimate source – were supposed to remain under her personal control. Only after partition was her dowry combined with the inheritance of her husband into a common family fund.

The common phrase for an appropriate marriage "the gate is appropriate, the house matches" (*méndāng hùduì*), implies that marriage was isogamous in China, but in a patrilineal, patrilocal society a woman's post-marital social status follows that of her husband's family, and marriage strategies for sons and daughters can differ. A bride-taking family can easily incorporate a bride from somewhat lower status family, especially if she has brought a substantial dowry (hypergamy). If a bride's birth family could provide important contacts, however, a high brideprice might be justified to solidify an alliance with powerful affines, especially since in such cases the brideprice and more would come back to the groom's family in the bride's dowry (hypogamy). For families with daughters other considerations might also come into play. Though dowry could be used to transmit property through daughters to their offspring to maintain their social status, poor families might consider minimizing marriage expenses by sending daughters to their marital home with the barest minimum of a dowry and using most of her brideprice to acquire a daughter-in-law for their son, who will maintain the family line.

Anthropologists usually emphasize that brideprice payments do not represent "sales" of women, because most societies don't have a market for women, and

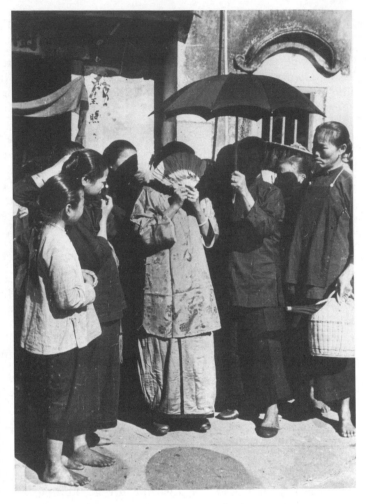

The women in black on either side of the bride holding the fan are the go-betweens who conduct the bride on her wedding day.
Courtesy of South China Morning Post.

because brideprice payments result in the transfer of certain rights in women from her birth to her marital house, but married women cannot be "resold" and usually continue to maintain significant ties with their birth family even after marriage. These points have to be modified for China, however, because before 1949 it had a highly commercialized economy in which women were sometimes treated as commodities. A woman's guardians, usually due to dire poverty, might, instead of marrying her with dowry, sell or mortgage her on the regular market for maids, concubines, or prostitutes, and this could even be done by husbands. Women, then, might enter a household in statuses other than wife. A Chinese man could have only one wife (*qī*) at a time, but he could also bring in concubines (*qiè*) if he wished and could afford it. The main difference between wives and concubines – both of whom were recognized sexual consorts of their husband and who provided legitimate children to him – were that wives were brought in with ceremony and always brought some dowry, however small, while concubines were brought in without ceremony and without dowry (Ebrey, 1986; R. Watson, 1991). This point

is not lost on Chinese women who are apt to point to having arrived in appropriate fashion bringing dowry as justifying their position in their marital house.

Being sent away in something other than marriage was a fate endured by only a small minority of poor daughters, but this possibility illustrates the importance of dowry as an statement on the part of the bride-giving family of a degree of social equality with the bride-taking family. As R. Watson points out: "The entry of wives, concubines, and maids into a [Chinese] household was marked by a transfer of money. The way people thought about and discussed these transfers, however, differed significantly. The language of gifts and reciprocity was used for wives; the idiom of the marketplace was used for concubines and maids" (1991: 239). Wives who came in with dowry were not cut off from their birth families, but provided affinal ties for their husband's family and their offspring. They also had access to "private room money" out of their dowry to provide advantages to their children in a joint household. Concubines who came in without dowry, however, were "bought" and completely cut off from their birth families who did not provide affinal ties for husband or offspring. The children of concubines were considered fully legitimate, so their genitor was recognized as their pater, but it is not clear that they had a mater at all. Their father's wife (rather than their birth mother) was their formally recognized mother and thus filled the role somewhat, but even she did not provide them with affinal ties a full mother would or shower part of her private room money on them.

The creation of affinal alliances, then, is a key to understanding Chinese brideprice and dowry. The more substantial the brideprice, the more substantial the bride-taking family's acknowledgement of the importance of the bride-giving family; the more substantial the dowry, the more substantial the bride-giving family's assertion of ties and social equality with the bride-taking family. It is because an affinal alliance is forged in marriage that the "language of gifts" is appropriate in such transactions, and brideprice is not a commercial transaction in spite of the commoditization of women in pre-1949 China.

The Corporate Lineages of East Asia

The lineages and clans we have dealt with so far – Hmong, Kachin, North Indian – have been mostly shallow, non-corporate institutions that we have been able to treat as an aspect of marriage regulation and alliances. Similar lineages are also found in East Asia, but due to strong Chinese cultural influence East Asians (with the exception of the bilateral Japanese) have elaborated principles of patrilineal descent to a greater degree than elsewhere in Asia, and have made ancestor worship a central ritual activity. In addition, in the countries of East Asia, endogamous, corporate castes as found in South Asia do not regulate social stratification. Instead, East Asians have based their stratification systems partly on control of wealth, and partly on access to bureaucratic offices obtained through success in state examinations. Because East Asian lineages have been able to aid the attainment and maintenance of social status in such systems, their role in social stratification has been much more important than elsewhere in Asia. Like their counterparts in North India, East Asian lineages are exogamous foci of ritual activity, but crucial innovations made in China between the eleventh and fourteenth centuries and

later borrowed in Korea and Vietnam have facilitated lineage solidarity and provided techniques by which occasional lineages have been able to develop some of the most elaborate corporate kinship structures known to ethnography.

Three levels of complexity can be distinguished in East Asian lineages, each with its corresponding structural characteristics: (1) non-corporate genealogical lineages, (2) minimally segmented corporate lineages with modest amounts of property, and (3) assymetically segmented corporate lineages with multiple corporate estates. Non-corporate lineages are common all over mainland East Asia. Minimally segmented corporate lineages are also found in at least small numbers in most areas of East Asia, though they are most common in China's Yangtse River basin, Korea, and the northern and central parts of Vietnam. The highly segmented corporate lineages with multiple estates are hardly found outside the two southeastern Chinese provinces of Guangdong and Fujian. In addition, corporate same-name fraternal associations are often organized among urbanized and/or emigrated Chinese, Koreans and Vietnamese, though these, strictly speaking, are not lineages.

The mere fact of descent is not sufficient to create a corporate lineage. All East Asians have a family and ancestors, but not everybody belongs to a corporate lineage. Descendants of a person must engage in some sort of collective activity for a lineage to exist. The most fundamental activity that accounts for the development of lineages in East Asia is ancestor worship. The details of how ancestor worship is done vary from country to country in East Asia, but in each case ancestor worship can been seen of as two types: household level, and lineage level. Household ancestor worship commemorates near ancestors on the anniversary of each ancestor's death, and is done at a permanent or temporary altar set up within the house. Lineage level ancestor worship commemorates more distant ancestors on major holidays and is done either at the ancestors' tombs, or, in the case of some corporate lineages, in specially built ancestor halls. This latter type of ancestor worship, since it provides an occasion for the patrilineal descendants of common ancestors to gather together and celebrate their solidarity, leads to the consolidation of lineages.

Lineages Based on Fixed Genealogies

In pre-revolutionary North China, though elaborate corporate lineages were rare, neighbourhoods tended to be dominated by and named after lineage segments (Yang, 1945:6, 135). Relations of descent used to be celebrated each lunar new year, when families got out their genealogical scrolls and held ancestor worship ceremonies. These ceremonies were done in the house, but because scrolls, unlike the other property that was divided equally among all sons, were inherited in the senior male line, the senior lines had more prestige than the junior ones. When the joint family partitioned, younger brothers would make their own scroll, but they would only record a couple of generations of lineal ancestors. The eldest brothers' scrolls had more complete genealogies. Thus, informants from a village near Beijing noted that one lineage was divided into three genealogical segments descended from three brothers who came to the village many generations ago. The senior successor in each line had the most complete genealogy and was

known as the "successor son", while the successor son in the senior line was known as the "eldest of the senior branch". Each of these genealogical positions involved a considerable amount of prestige and was independent of wealth (Cohen, 1990: 515–19).

Maintenance of scrolls preserves genealogical records, but a surer sign of lineage organization is the maintenance of lineage-level ancestor worship. Separately built lineage halls were rare in North China, but lineages often kept a common graveyard. Each spring on the early April holiday known as Qīngmíng ("clear and bright") the patrilineal descendants of this ancestor in the village would gather at the graveyard, clean the graves, celebrate ancestor worship, and have a banquet. Such gatherings, which might also be replicated at lunar New Year, the Hungry Ghost Festival (lunar 15 July) and the Winter Clothes Festival (lunar 1 October), were powerful expressions of lineage solidarity. Lineage solidarity provided people with a sense of social orientation and, if strong enough, inspired lineage mates to provide political protection, charity, and education for each other.

Because of the unequal inheritance system of Korea, fixed genealogical lineages were even more ubiquitous and powerful there than in North China. In Korea, only the eldest son – "the big house" – could hold household ancestor worship ceremonies. Younger sons would have to gather in their older brother's house on the death day of their father. This system was continued up to the great-great-grandfather, so that all patrikin within eight degrees of kinship according to inch reckoning would have to gather at the senior descendant for his ancestor worship. In addition, at major holidays – especially lunar New Year and the Harvest Moon Festival (on lunar 15 August) – all patrikin within eight degrees were supposed to get together for ancestor worship at the senior-most "big house". Because of the unequal inheritance system, this big house was normally also one of the wealthier houses of the lineage, and could well afford to provide a banquet for lineage members. Because junior lines were ritually (and usually economically) dependent on senior lines, and because ancestor worship brought lineage members together several times a year for ritual celebrations, household ancestor worship was a powerful means of creating and reinforcing lineage solidarity.

Minimally Segmented Corporate Lineages

For those who were wealthy enough, setting aside some land as a lineage estate to finance ancestor worship allowed the creation of minimally segmented corporate lineages. In Korea those of gentry (yangban) status often set aside modest tracts of land, known as wit'o to support annual ancestor worship ceremonies for patrilineal ancestors more distant than the great-great-grandfather. The land was usually rented out to a poor, hereditary tenant known as a myojigi, or grave keeper. It was the responsibility of this tenant (who was treated as a servant and addressed in low language by lineage members) to use the income from cultivating the wit'o to prepare an elaborate ancestral sacrifice to be held at the ancestral tombs in the tenth lunar month. Ancestral tombs in Korea are usually scattered all over the mountains surrounding the village, and aristocratic Koreans would often spend the greater part of the tenth lunar month trekking over these mountains from tomb to tomb, accompanied by their grave keepers carrying the sacrificial

The Chinese lineage hall of the Liu clan in Hong Kong's New Territories.
Courtesy of Grant Evans.

paraphernalia, to hold ancestor worship ceremonies starting with the earliest ancestor to arrive in the village and working backward genealogically to the great-great-grandfather. Such ancestor worship ceremonies were an assertion of high status and genealogical background – since in principle only legitimate descendants of high government officials could hold them – but they also replicated in ritual form the genealogical structure of the lineage.

Similar phenomena are known from China and Vietnam, though since the ruling class in those two countries was more fluid than in Korea, the status differential between grave keeper and lineage member was not so strongly expressed. In Vietnam, for example, a family often set aside "incense land" (*hoang hoa*) to finance ancestor worship rituals. In this case, however, management of the land did not always have to remain with the house of the eldest brother, and such estates were often partitioned among the descendant families with ancestor worship discontinued after three generations or so. In the Yangtse River valley of China, similar lineages were maintained through land set aside to finance ancestor worship (*jìtián*), or land set aside to finance lineage charitable activities (*yìzhuāng*) such as schools. Often in these wealthier lineages of China, a separate hall was built to enshrine the tablets of distant ancestors and facilitate gathering together for seasonal ancestor worship rituals. As among the Korean gentry who only occasionally built separate ancestral halls or had charitable estates, such Chinese lineages kept written genealogies and maintained lineages of startling genealogical depth. Written genealogies, often published, recording founding ancestors going back twenty-five or thirty generations are not uncommon among such Chinese or Korean lineages.

This contrasts with the fixed genealogical lineages of North China whose genealogical depth, like that of their counterparts in North India, rarely exceeds ten generations.

Asymmetrically Segmented Lineages

The maximal complexity attained by East Asian corporate lineages was reached in the Chinese provinces of Guǎngdōng and Fújiàn. Here lineage estates could become very large – encompassing more than half the land of entire villages in some cases, and unlike among the less complex corporate lineages of the Yangtse valley, segments within the lineage as a whole were often separately endowed with their own estates and ancestral halls. Power and prestige within households and segments within the lineage did not depend upon genealogical seniority as in North China or Korea, but on household wealth and prominence. The descendants of a younger brother who became prominent, for example, might form a segment within a lineage because an estate had been created in this ancestor's name, even though, since a comparable estate was not created in the name of his elder brother, the potential segment of this elder brother's descendants did not exist as a corporate entity. Due to their large land holdings and complex, nested, asymmetrically segmented structure, these Cantonese and Fujianese lineages could become very large and powerful. If a lineage owned most of the land in a village, it might be feasible for them to support irrigation improvements that would benefit the whole village. They might use lineage resources to record and publish genealogies, buy weapons and support militias, keep elaborate social controls within the lineage – for example, expelling members who make uxorilocal marriages (J. Watson, 1975) – run schools for lineage members, maintain very elaborate ancestor worship that would give them very high local status, and intervene on the behalf of lineage members with local government officials.

Lineages and Social Stratification

Looking back on the various lineages we have considered – Hmong, Kachin, North Indian, Chinese, Korean – we can see that their functions are mainly political and are closely related to systems of social stratification. In societies where control of landed property is not a determinant of social status, lineages may, in fact, be the primary determinant of social status and the main ingredient of the political system. Here brideprice payments reach their greatest importance. Thus, among the Kachin marital relations among bride-giving and bride-taking lineages, combined with brideprice payments, are the primary determinants of the lineage and family status.

In economically stratified societies, such as China or India, however, lineages interact with control of property and other institutions in complex ways. Both brideprice and dowry become important for social status and three different models, the North Indian, Chinese and Korean can be identified. In North India, where the endogamous occupational groupings known as caste are important, the functions

of lineages are limited, and their depth shallow. Dowry is more important than brideprice. In southeast China where castes were absent, on the other hand, complex lineages became corporate institutions for political action, and the control of endowed wealth gave lineage members advantages others might not share in political competition and upward mobility through the examination system. Here both brideprice and dowry were important. In Korea membership in corporate lineages with seasonal tombside ancestor worship was considered to be an attribute of an endogamous ruling elite, called the *yangban*. In this case ancestor worship and lineage organization – most of which was modelled after Chinese precedents – could be considered conspicuous consumption of Chinese culture in order to ratify position in a ruling group steeped in the Chinese culture tested in state examinations. Since control of property was less important for social status than demonstration of membership in the endogamous *yangban* status group, interchange of gifts between affines rather than strict brideprice or dowry were the most important marital exchanges.

Lineages come out of domestic groups and the operation of the domestic cycle, but they are analytically distinct from either. Families are units of everyday economic and sexual life – of production and reproduction – but lineages are political entities that may or may or may not develop depending upon potential lineage members' political and economic circumstances. Lineage membership – especially of the corporate sort – is not an automatic development of the family cycle, then, but rather something that is deliberately created, or not created, through acts of filiation, payment and organization. Though everybody has ancestors and belongs to a potential lineage, even in societies that have corporate lineages, not everybody belongs to one, and much scope is left for strategic manipulation of cultural possibilities.

Kinship and Social Change

Though families and other kinship-based institutions are thought of as a separate field of study in anthropology, it is clear that they are best understood in relationship to other social institutions – the organization of production, land tenure, religion, social stratification, political organization – in other words the total production and reproduction of society. As is inevitable in a short text, however, we have not been able to cover all topics of interest, nor deal with social institutions in the full richness of their historical specificity. For purposes of simplification we have also downplayed the constant development and change of family and kinship institutions as societies themselves have been in constant flux. Here, however, we will touch on some contemporary issues of change in Asian family systems.

Social change can be thought of as of two main types: cultural and strategic. If we consider a society's kinship and family culture as made up of their categories for thinking about family and kinship, and their rules for forming proper family and kinship institutions, then cultural change – change in categories and rules – can be seen to take place at the ideational level. Changes in methods of kinship reckoning, in ideas about proper family structure and role relations, or in the legal or customary rules that regulate marriage, the family, and kinship can all be thought of as "cultural" in the sense used here. Cultural change can be

planned and deliberate – as when legal reforms in family and kinship law are introduced – but it also can be brought about by gradual changes in values and modes of thinking about family and kinship introduced through education, urbanization, or other sources. This last sort of cultural change, of course, is the most nebulous and difficult to study. Strategies can be thought of as ways of manipulating categories and rules to attain concrete ends. Strategic change has an intellectual component, since strategies must be formulated on the basis of an understanding of culture, but strategies can also be seen as adaptive behavioural responses to changes in material and other circumstances that affect family organization.

The idea of strategic thinking has been introduced in earlier sections: that is, we have not assumed that culturally appropriate behaviour is an automatic response to stereotyped circumstances, but rather have emphasized that people manipulate cultural possibilities – post-marital residence possibilities, or brideprice and dowry payments – for social ends. If the political or material conditions under which decisions have to be made change, we may notice changes in the frequency with which certain strategic choices are made, or changes in the use of strategic resources. Increasing power of children in choosing their spouses may lead to a decline in types of marriage that are more advantageous from the parents' rather than children's point of view. This seems to have happened with adopted daughter-in-law marriages in Taiwan in the thirties (Wolf, 1970). Changes in fertility and mortality, as we have noted in our discussion of the family developmental cycle, can increase or decrease the frequency of complex family organization by making the creation of stem or joint families more or less demographically feasible. Changes in economic variables that condition family structure such as patterns of land tenure, industrialization, urbanization, or commercialization may encourage changes in family formation and kinship behaviour as well. Response to such changes may be considered primarily strategic if the behaviours involved do not require new ways of categorizing family and kinship relations, or rules for organizing families and kinship groups.

Cultural and strategic change are not mutually exclusive. Members of a society normally experience change as a holistic, lived experience, rather than something that happens in two distinct realms. Any cultural change will require adaptive adjustments and responses to the concrete situations in which individuals find themselves, yet a short term adaptive response to changing circumstances may in the long run lead people to think about their family and kinship relations in different ways than in the past, and so lead to cultural change. The distinction between cultural and strategic change, then, is an analytical one made by the anthropologist. It is useful, however, because it helps us keep the nature and extent of contemporary social change in perspective.

Social critics sometimes write as if all social change is the result of changes in norms and values (i.e. "culture") and as if the social change people experience today is unique in world history. Much of what is perceived of as social change, however, is simply strategic adaptation to changing circumstances rather than fundamental shifts in values. We have noted above for the Minangkabau that reduction in the complexity of family organization is quite as likely to be caused by strategic changes in the timing of partition as in the decline of matriliny as an organizing principle (cultural change), and other cases could be cited. One should be wary of underestimating the amount of change in the past, or overestimating

its amount in the present. Strategic thinking and manipulation of cultural norms are as fully characteristic of the past as the present; social change in this sense is a condition of all societies, and not something we should think of as peculiar to the modern era.

Nevertheless, change is taking place all over Asia, and one of the most pervasive circumstances requiring strategic response has been the commercialization, industrialization, and urbanization of economies. Urbanization makes the maintenance of large families problematic: birth rates tend to be lower in urban areas, housing is too crowded and expensive for large families to live together, expectations of inheritance of productive property no longer keep sons at home, and the extensive labour requirements of traditional agriculture no longer are a motivating factor. One expects, then, a reduction in family size to accompany the commercialization and urbanization of Asian economies. It is sometimes forgotten, however, that other factors in addition to the ones mentioned above in commercial urban economies, continue to encourage complex families even in industrial countries: a large number of family workers may have to pool incomes to make ends meet in poor countries, lack of social services means family members must continue to care for parents in their old age or support each other between jobs, and improving health conditions cause parents to live longer than in the past. Thus in rural South Korea, in spite of the fact that the economy has become thoroughly urban and industrial and the average size of rural families has contracted due to urban migration, their degree of complexity has remained fairly static: there are fewer family members, but families are more likely to include aged parents than in the past. In this case, changes in rural family organization can be seen as primarily strategic, and explanations for change do not require the analyst to make an assumption of far-reaching cultural change (Sorensen, 1988).

Another interesting strategic change found in capitalist countries has been dowry inflation. Dowry inflation was mentioned in our discussion of India, where it is considered a social evil, but it is not confined to that country. Dowry inflation has been noted in Japan, South Korea, Taiwan and even among the Hmong. Successful capitalist development, of course, should result in increases in wealth that would be reflected in increases in the size of dowries, but dowry inflation is more than a simple response to changing levels of wealth. It also reflects changing stratification systems. In capitalist societies, social status comes more and more to reflect differences in wealth and to be expressed by differences in consumption standards. One way a girl's birth family can assure her social status after marriage in societies with this sort of social stratification is by transferring as much wealth as possible to her or her marital family through dowry. Dowry becomes more important as societies develop because wealth is socially more significant.

The fact that dowry inflation has tended to outstrip inflation in brideprice and indirect dowry, leaving a larger and larger proportion of the expenses for setting up a new family the responsibility of the bride's family, rather than the groom, on the other hand, probably reflects asymmetry in gender roles. It has been argued for India, for example, that rising "dowry" is in fact a form of "bridegroom price" to catch a husband who will earn a high income in societies where males, rather than females, are the breadwinners. Similar arguments have been made for South Korea (Kendall, 1985, 1989) where affluent females repeat – half-joking and half in horror – the new folklore: "If you want to marry one of the three professionals [doctor, lawyer, PhD], you have to bring [as dowry] the three keys: an apartment

key, an office key, and a car key" (Kendall, 1989: 196). For a bride to bring a trousseau with her in a patrilocal marriage is traditional, but even among the elite high dowries such as mentioned above are a strategic innovation of the seventies and eighties.

An interesting variant on this theme of strategic changes in marriage payments has been argued for the People's Republic of China (PRC) by Parish and Whyte (1978: 180–92). With land reform and collectivization in the 1950s, family status no longer was based on wealth, but rather on family land reform classification (heritable in the male line), and whether any family members were cadres or activists. The basis for the large traditional dowry payments – maintenance of daughter's status through transfers of wealth – no longer existed. Women, on the other hand, became more valuable, since they now worked in the fields and contributed greatly to family work points and thus income. The brideprice payments under these conditions, seem to have inflated. As will be recalled, Chinese brideprice for all but the poorest families usually became indirect dowry because most or all of it returned with the bride to her marital home, but in the parts of Guǎngdōng studied by Parish and Whyte, girl's families, rather than returning brideprice payments, used them to obtain wives for their sons. This seems to be the reverse of the problem of dowry inflation in capitalist countries.

We must be cautious in generalizing Parish and Whyte's conclusions, however, for subsequent work has not confirmed a China-wide increase in brideprice at the expense of dowry. Rather, as Lavely has pointed out (1991), controls on migration during the period of collectivization have made it extremely difficult for men to change their place of residence, but allows women to gain upward mobility by making patrilocal marriages into more prosperous, or better located, collectives. Brideprice and dowry in the PRC, then, reflect complex calculations as to the personal qualifications of brides, and the desirability of moving to various collectives. Well-educated women with good dowries can marry into more prosperous collectives, and their families are willing to settle in such cases for modest brideprices. Men living in poor collectives, on the other hand, find it difficult to attract women from the outside and may have to pay high brideprices, and accept women with smaller dowries and less education.

The case of the PRC is interesting also as one of deliberate cultural change. The Marriage Law of 1950 and its implementation campaign by local cadres and women's associations was one of the most far-reaching attempts at reform of family and kinship systems. The Chinese communists, when they took over in 1949, had definite ideas about aspects of Chinese marriage and the family they considered "feudal" and that required abolition as inappropriate to the modern society they were trying to build. Among the "feudal" elements were marriage at too young an age, forced marriages arranged by parents without obtaining the consent of the bride and groom, adopted child daughters-in-law, concubinage, prohibitions on the remarriage of widows, and exaction of money or gifts as a condition for marriage (which was considered "marriage by purchase"). Some of these changes have been fully implemented, but other changes – because they prohibit marriage strategies that continue to be useful in the new society – have been only partially implemented. Childhood betrothal has died out, and age at marriage has continuously risen in the PRC as too youthful marriage has been discouraged by the party and cadres. Obtaining the consent of the bride and the groom is now a universal condition of marriage (though cases of coercion of brides

A wedding in the Chinese countryside. On the third day of the wedding, the bride (second from left) is escorted to her new home with some delicious food to entertain the guests. On the left is an escort sent by her parents. The other women in the picture are her female companions sent by her mother-in-law.
Courtesy of Yue Guofang.

are occasionally reported in the newspapers), but arranged marriages are still most common in rural areas, mostly because young men and women in these areas where the sexes are rigidly separated lack opportunities to meet and socialize. In urban areas arranged marriages are less common, but even here prospective brides and grooms usually rely on friends and acquaintances to make introductions, rather than taking the initiative themselves, and many marriages are a compromise between arranged and "love matches" – after suitable consideration of qualifications a couple are introduced through acquaintances, and if they like each other they will ask a go-between to formally arrange the match. In urban areas of the PRC, since many social services such as housing, child care, and pensions are available primarily through work units, one's living standard depends more on the services provided by the work place than anything else, so brideprice and dowry payments have become relatively unimportant there. Despite official disapproval of brideprice and dowry, however, because such payments aid in strategies of social mobility for women, they continue in rural areas where they are tolerated so long as they are freely given "gifts" rather than "a condition for marriage".

The example of marriage payments in the rural parts of the PRC illustrate how official attempts at cultural change do not always succeed when their implementation would hinder strategic options important to the people at large. In Japan, for example, the corporate family (*ie*) was legally abolished in the Constitution of 1947, and inheritance made partible among all sons and daughters. In rural areas, however, all but one of the sons or daughters normally forgoes their

inheritance right so that impartible inheritance of the family farm continues de facto (Nakane, 1967: 6). In many parts of the world, dowry has been the object of legal reform, but just as often it has continued in society at large. It has been illegal in India since 1950, but large dowries continue to be transferred in certain classes. High dowries and wedding expenses have also been discouraged in South Korea, where the government has published "Standard Rules for Family Ceremonies" that encourage frugality in weddings and funerals, but with only moderate success. What family with means would willingly forgo the chance to ensure the social status of their daughter and solidify an affinal alliance with another powerful family no matter what government ministers promote? When reforms in family law provide clear advantages, on the other hand, they have been more successful. Thus in South Korea in the late fifties and early sixties when the civil code was amended to limit the number of relatives who have the right of support if they cannot make a living, and to make partition automatic upon the marriage of second sons (thus making joint family formation impossible), implementation was no problem, since these changes confirmed tendencies already present in the Korean family system where the eldest son was always the successor, and the joint phase of the family cycle short, temporary, and often skipped anyway.

Many of the changes in family law in Asia have been designed to create conjugal families more similar to those of the developed West. It has sometimes been argued that, as the West was the first part of the world to industrialize, the family and kinship organization characteristic of much of Western Europe and North America – bilateral nuclear families based on love marriages with neolocal residence and a severe limitation on the elaboration and importance of kinship units beyond the family – must be either a cause or effect of industrialization (Goode, 1963). If this is true, then as countries industrialize, their family and kinship systems ought to converge on a single model, and emulation of Western European or North American family institutions might shorten the route to industrialization for Third World nations.

To some extent, this notion of the convergence of families on a single type in industrial countries is justified. It is clear, for example, that in the long run very high rates of fertility cannot be supported, and some institutions that encourage high fertility (marriage of women at a very young age, for example) are likely to disappear almost everywhere. It seems likely, too, that in industrial countries where job prospects require education until relatively late in life and a competitive attitude toward work, marriage is most conveniently delayed until after a child's education is complete, and when children at the time of marriage are already income-earning adults, parents cannot maintain control of the marriage of their children in the same ways they could when children married young and remained economically dependent until middle age. In capitalist societies where many kin have rights in family resources, those who may want to work hard and acquire wealth may be discouraged by the possibility of having to dissipate the earned wealth to support impecunious kin, so small families may be more functional in encouraging hard work and capital accumulation, too.

All of the above may be true, but the conclusion that bilateral nuclear families based on love marriages with neolocal residence are uniquely adapted to industrial societies can still be questioned. Recent work on European families has shown the association between bilateral nuclear family developmental cycles and industrialization is not as strong as once had been thought. Bilateral nuclear

families long preceded industrialization in most parts of Europe where they are found today (Laslett, 1972), and in those parts of Europe traditionally characterized by other family patterns – particularly stem family patterns in southwestern Europe – these family patterns have persisted in spite of industrialization and law codes designed to break them up (Rogers, 1991). It is also not clear that the various developmental cycles found in Asia hinder industrialization and commercialization. Anthropologists working in Asia have found that complex family systems often can persist quite well in commercial, capitalist economies. The Minangkabau, who have maintained matrilineal family organization for several hundred years, are known within Indonesia as a highly successful ethnic group in business. Kato has argued, in fact, that their matriliny has facilitated the migration strategies that have allowed men to maintain contacts with their homeland while succeeding in big cities such as Jakarta (Kato, 1982). The Chinese joint family, is alive and well in industrial Hong Kong and Taiwan (Salaff, 1981; Gallin, 1982). Pooling of resources by adult Chinese brothers seems to facilitate the accumulation of capital for housing and/or small business ventures. The corporate organization of these families with their sharp definition of family membership boundaries combined with the fact that brothers can demand partition if they feel their interests are not being met seems to counteract disincentives for capital accumulation that might follow from the large number of people who have rights in family property.

There are disadvantages of the conjugal family systems of the West, moreover, that some of the Asian family systems may avoid. Socialization of children is not easy in isolated conjugal families that need to independently finance housing, education for their children, and, if both parents work, child care. High rates of divorce only exacerbate these problems, as single parents try to manage the entire burden of family wage earning and domestic labour. Right now in the United States, for example, high rates of single parenthood have led to children experiencing higher rates of poverty than found in the society as a whole. As aged parents and their adult, married children are members of different households in nuclear family systems, moreover, care for their aged becomes problematic. Although various solutions – such as special homes for the aged – are possible, their cost is very substantial. The developed Western societies with nuclear family systems have had to shoulder very heavy social welfare expenses in terms of old age pensions, unemployment insurance, child care expenses, scholarships for higher education, and so forth.

In societies with complex family systems most of these welfare functions are taken care of by family members who pool their resources. Grandparents care for the children of working parents. Housing costs can be shared among a large number of income-earning family members. The aged can be cared for at home. Such complex families are not idyllic. Maintaining complex family organization requires forbearance and effort among all members, and, as we have noticed for Chinese joint families, serious strains can be detected in most complex families. Even complex families must often strain to meet child care needs, housing needs, and needs for the care of the aged.

The issue of the adaptive value of various family systems is complex, and, as much more research needs to be done, must here remain unresolved. Some commentators see the necessity for complex families to attend to child care, housing, and care of the aged as a backward trait related to poverty and the inability of the state in poor countries to provide desirable social services at a

sufficiently high level. These commentators tend to see the forbearance and adjustment of goals necessary to maintain complex family organization as oppressive restrictions on the individual freedom necessary and desirable for vibrant, progressive social organization, or as mechanisms that perpetuate undesirable class divisions. The government of Singapore has thus actively endeavoured to promote smaller and less class differentiated families by expanding on an egalitarian basis state-provided social services such as education, health services, housing, and job training. With the expansion of these services, the functional value of corporate family organization has been reduced among the Chinese population, coresidence has become less common, and maintenance of corporate family boundaries – something that in any case has tended to become blurred as the economy gets more complex – has become less crucial than in the past (Salaff, 1988).

All people do not react so positively to the development of less complex families with fewer functions, however. In many countries, distinctive family organization is considered a sign of ethnicity and an important part of national identity that must be protected from social change. This tendency is especially prominent in Islamic countries, though not confined to them. Even apart from ethnicity, however, many wonder if high state welfare expenses do not strain the taxation system of even the wealthiest countries. They wonder if too high taxes do not become a disincentive for work, and whether, if welfare expenses consume too much of a nation's income, accumulation of capital necessary for investment and economic growth might be harmed. Such commentators point to such economically successful countries as Japan, Taiwan and South Korea and wonder if their lower welfare expenses and success in education might not be related to their family systems. Here we have begun to enter the realm of speculation, but the remarks with which we introduced this chapter should be kept in mind: Asian forms of family and kinship are various, the functions they manage are various, and there is no single institution that can best manage all these functions in all societies. Whether the family and kinship institutions presently found in various countries are "backward" or "ideal" cannot be solved on theoretical grounds, but empirical research on this topic might well yield important insights.

Further Research

Family and kinship are staples of anthropological enquiry. It may come as a surprise, then, that much further research needs to be done. As different ideas and perspectives on the analysis of family and kinship emerge, however, new questions must be posed and new research initiated. Past research on kinship has tended to focus on two areas that have been touched lightly here: kinship terminology, and unilineal kinship organization. It was hoped that in the past by classifying societies in terms of kinship terminology, rules of marriage and residence, and type of kinship reckoning a good baseline for comparative research would emerge. This approach has proved to be problematic because people tend to manipulate cultural possibilities. It is impossible to characterize most societies by simple rubrics such as "patrilineal, patrilocal" because a variety of possibilities are usually available, and people take advantage of different ones depending upon their goals and circumstances. Now that anthropologists have become aware of strategic

manipulation of culture, however, endless opportunities for good research on the interaction between cultural possibilities, social circumstances, and family strategies of marriage, heirship, reproduction and the like have opened up. Some of these opportunities are discussed in the sub-sections below.

Families, Households, and Lineages

In older studies, family, household, and lineage were not always kept distinct. Anthropologists tended to focus on large-scale kinship units, such as lineages, and view small residential families as of less interest. They often treated lineages as automatic, or "natural" developments of the family. We consequently often lack detailed knowledge of family cycles of even well-studied groups, such as the Minangkabau. Much room, thus, remains for the study of domestic groups, their size, structure, relationship to production and consumption, and how these change in response to changing circumstances.

Social Stratification

Anthropology cuts its teeth on small-scale, unstratified societies, and it has only been in recent years that the main focus has been on complex, stratified societies. Anthropologists are still developing concepts and methods that allow them to deal with questions of social stratification. Two issues come to the fore: (1) questions of brideprice and dowry, and (2) the relationship of lineages to social stratification. Jack Goody in recent work has emphasized the fundamental difference between transfers of wealth that end up with the conjugal family newly constituted in marriage (dowry, dower) and transfers between families that do not go to the newly married couple (brideprice, bridegroom price). These distinctions have not always been made in the past so it is often not certain whether older works that talk about brideprice are referring to brideprice or indirect dowry. Similarly, payments from the bride's side have often been termed dowry, but may in fact be bridegroom price. Much new work needs to be done to clarify such transfers of wealth at marriage and their relationship to social stratification. In addition, of course, we need to continue to study larger kinship units such as the lineage in closer relationship to other political institutions and patterns of social stratification.

Gender

Feminist anthropologists have, in recent years, directed anthropologists' attention to the fact that family and kinship systems may look different when analyzed from a female rather than a male perspective. Interesting work has been done showing that strategies within particular kinship systems may be differentiated by gender. One result of looking more closely at female roles in patrilineal systems, for example, has been a realization that male-centred principles of descent are usually complemented by principles of affinity in which patrilocally married women link together their birth and marital families. The idea that people in a society may be working with more than one set of categories and attitudes toward kinship and the family enormously complicates the anthropological notion of culture, but also opens a wide field for research.

Psychology

Related to questions of point of view, gender, and various family strategies, are psychological issues. Since the structures of families differ, the stresses and strains of families also differ. Interesting research has been, and continues to be done, on distinctive psychological stresses found in various family systems. In patrilineal joint family systems, relations between mothers-in-law and daughter-in-law have often been treated as being especially problematic, but the positions of married-in husband and father in a matrilineal household, of wife in a household of married cousins, all have their psychological dynamics, and much work could be done to explain them in more detail.

6 FISHERMEN, FOREST-EATERS, PEDDLERS, PEASANTS, AND PASTORALISTS

Economic Anthropology

John Clammer

Economic and Social Life

Economic anthropology is the study of the material dimension of life in its social and cultural context. It studies the way in which the production, distribution and consumption of things enters into the whole fabric of social life, and comprises a vital part of the seamless totality that constitutes a living society. For anthropologists economic concepts are also social ones that reveal in a profound way the basic values, worldview and moral orientations of a society. The fundamental economic ideas of credit, saving, capital, exchange or entrepreneurship, although capable of abstract, general definitions applicable across a range of human societies are at bottom socio-cultural notions. This is true even in modern capitalist societies, or in the context of the predominant **neo-classical** paradigm in economics which has given many of these concepts their standard textbook definitions. Exchange, for example, at least since the classic work of Marcel Mauss (1954), is widely known to be deeply embedded in social relationships, and is often an expression of them. The example of gift-giving beautifully illustrates these social dimensions, but culture enters into almost any exchange, even the seemingly most "economic".

In a world in which everything seems to have its price anthropologists draw attention to systems where not everything can be swapped, bartered or exchanged for anything else: some things may not be exchangeable at all (e.g. an heirloom or

piece of ancestral land) or can only be exchanged for certain other things, bark-cloth for a canoe or cattle for a bride for instance, but never batik-cloth (however much and however valuable) for a bride – a notion known as *spheres of exchange* (Barth, 1970). Even in a fully monetized economy social relationships and cultural factors enter into exchange. This is evident in a Japan where gift giving remains a very important custom and is, in fact, a complex social institution (Befu, 1974). Economic anthropology is thus about the role of things in animating and structuring social and ecological relationships.

There is no richer field for exploring this interaction of the material and socio-cultural than Asia. Peasants and fishermen, swidden-agriculturalists and forest gatherers, pastoralists and factory workers, traders and plantation labourers interact with one another in all sorts of complex ways and all are caught up in varying degrees with the process of "development", including urbanization and the spread of a money economy. Despite this vast ecological, geographical and sociological range some preliminary attempt at classification of social types is necessary (for purposes of comparison if for no other reason) provided that we recognize that such general classifications are heuristic – they serve a theoretical purpose, but are not absolute.

So perhaps initially a four-fold classification is helpful. First we can classify economic systems on a *social basis* – for example peasants, entrepreneurs, family-owned and run businesses, or where a particular social group, usually ethnic and/or religious, dominates a particular economic activity. A second principle of classification is *ecological* – fishermen, hunter-gatherers, and rice farmers, for instance. A third is the Marxist-derived concept of *modes of production*: economic formations defined by the relationship of their participants to the process of production – peasants and landlords, rural plantation or agribusiness labourers and the owners of the establishments, or urban factory workers and capitalist proprietors. The fourth is what we might call *cultural-thematic*, i.e. a classification of socio-economic types based primarily on the presence of certain conspicuous activities of an economic or quasi-economic nature, which might include extensive gift-giving, competitive feasting or conspicuous consumption, which empirically might include Japan, many Indonesian societies and the "big man" phenomenon (where men compete for social status and community power through the accumulation and display of possessions), usually identified with New Guinea, but actually extensive throughout Asia. In the light of these categories, what are the main socio-economic types that we need to deal with, and what is their relationship to the theoretical questions that economic anthropology has raised about the interpretation of economic practices in their socio-cultural settings?

Theoretical Issues

Modern economic anthropology has up till now been dominated by two main theoretical controversies, between the "formalists" who argue that the basic theoretical apparatus of neo-classical economics is applicable to all human societies, and the "substantivists" who argue that, on the contrary, every society operates according to different systems of economic rationality which arise from each one's specific cultural logic. Alongside this debate is one between Marxist and

non-Marxist anthropologists. A more recent development has been the analysis of economic systems through the use of concepts drawn from developments in contemporary cultural theory, including ideas about the consumer society and commoditization, in which the objects of exchange are analyzed as being part of a semiotic system, i.e. systems of signs, rather than just material "things". And some have focused on the emergence of a "global system" which allegedly is progressively incorporating more and more of the world's cultures (e.g. Featherstone, 1991).

Most economic anthropologists would agree that economic activity is about social relationships – about the creation, preservation and enhancing of them, and they are also, when necessary, about their termination. Material things, whatever their practical utility, mediate these relationships, even with the supernatural (sacrifice, for instance, nearly always involves a physical or material medium). The distinction, beloved of an earlier generation of anthropologists, between "modern" and "primitive" societies is totally irrelevant here: they all share this fundamental characteristic, and as we will see below the range of economies present in contemporary Asia transcends all such patronizing divisions of humanity.

Thus economics, properly understood, is a *social* science rooted in social behaviour, belief, valuation and ideology, but this foundation does not destroy the relatively autonomous logic of economic activities. Otherwise, it would not be possible to conceive of the "economic" as a distinct category at all. So although economists often *talk* as if their subject is purely abstract, even mathematical, the reality is that economics is as embedded in socio-cultural and historical contexts as any other social science or branch of the humanities for that matter (McCloskey, 1985). If we see the problem in this way, we can recognize that both "formalism" and "substantivism", formulated as mutually exclusive and antagonistic positions, are both false. Each grasps an aspect of the truth and represents it as the totality. Where each has been most useful in fact has been in generating concepts that help to isolate concrete and discussable elements of real economies – such as "markets" and "entrepreneurs", to name but two of the most useful. Whether the term "market" is meant to apply to a physical location for exchange and trade (as in anthropological studies of "market places" or "market towns") or to the abstract and impersonal "market forces" of capitalism, the presence of entrepreneurs (individuals who seize or create economic and technological opportunities to enhance their own material and social standing) is implied.

And here interesting empirical questions for students of anthropology begin: Where are these market places? Who are the merchants and entrepreneurs? Are they women – of one ethnic group or of one caste? What are the sources of capital? How does the activity of exchange in the market place relate back to the social structure and productive capacities of the villages? Is the system monetized or are non-monetary media being used in the exchanges? Can everything be exchanged for everything else, or are there "spheres of exchange" in which only certain items can be traded for certain others? How do entrepreneurs innovate, and how do they manage what they innovate? What is their social role? How are localized markets related to the wider political and economic structures of the society? And as anthropologists begin to answer these questions they see some interesting social patterns emerge. Entrepreneurs and operators (indeed even manipulators) of market forces are often women. Hawkers in the cities of China and the Chinese-dominated cities of Southeast Asia are often women, and in the Muslim areas of Southeast

Asia, for example Indonesia and the east coast states of Peninsular Malaysia, small traders, market stall keepers and shopkeepers are often women, although in the Muslim areas of South Asia this is less likely to be so. Entrepreneurs and traders are also rarely socially isolated individuals, but are actually much more likely to be backed by strong ethnic and/or kin networks: as members of a distinct religious community such as the Southeast Asian Arab communities, famous for their business acumen, or the Indian spice traders of urban Southeast Asia, who are all Muslim (although of different sects), or they belong to a strong kinship group, as with Chinese merchants all over Asia, or belong to a specific caste, as in the case of the South Indian Chettiars, famous as money lenders.

Markets and the Division of Labour

Markets, the nexus of exchange, are an important subject in themselves and have attracted a great deal of historical and contemporary attention from economic anthropologists (Firth, 1970; Belshaw, 1965; Polanyi, 1957; Geertz, 1963; Alexander, 1987). Most attention in Asian anthropology has focused on physical markets – market places, small market towns and the social organization of these markets – and the questions of who sells to whom, what ritual or religious activities are involved, how the market is related to the social structure of the town (e.g. the Chinese middlemen in small Malaysian market towns) or of the countryside. A

Women are often prominent in Asian markets. Here women sell rice in a market in Cambodia. Courtesy of Grant Evans.

classic case study is by Clifford Geertz (1963) where he explores a small Javanese market town with its social make-up of peddlers and store-keepers, of unskilled workers, and of civil servants and white collar workers (the local elite). The central economic divide in the town was between the "firm centred" (i.e. commercial) trading enterprises and the "bazaar" or flexible and individualized hawking sector. He examined the flows of perishable and imperishable commodities, large and small objects, bulk goods and trickles of small items, and the service, techniques of bargaining, credit and business relationships. What he does not examine in detail, however, is the role of gender in marketing. Throughout Asian markets women often dominate marketing, and this is especially visible in Southeast Asia. Throughout Thailand, Malaysia and Indonesia, and in the Chinese hawker centres of Singapore and Hong Kong, women are often dominant. This is a source of both real economic power and social independence for Southeast Asian women, and this should force us to re-examine the stereotypes of women's role in Islamic and "Confucian" societies. Interestingly, this is very apparent in exactly the context that Geertz explored, the Javanese market where Muslim women play a leading role (Alexander, 1987).

While marketing flows obviously differ from culture to culture (the business culture of Chinese shopkeepers being very different in many respects from that of an Indonesian bazaar trader for instance) and depend very much on the scale of the market (the small-town, or rural cross-roads market being different from big-scale marketing in the large cities, and both differ from the markets that spring up around temples or pilgrimage sites), the central significance of market places of the kind that Geertz describes as the focal point of exchange, credit, entrepreneurship and of social and cultural contact, is very great. To revert for a moment to the language of the old formalist/substantivist and Marxist/non-Marxist paradigms – markets are a major location of *exchange*, although not the location of *production*, the two phases of the economic cycle that precede *consumption*. And in the larger sense of the term "market" that we earlier identified, local markets often provide the point of contact between a traditional economy and a monetized one. They are where nomads and peasants discover the logic of money and a taste for goods, such as watches, radios or bicycles that their own technology cannot produce.

The important concept of "division of labour" is only a small step from this, and raises some further interesting theoretical questions. We have mentioned examples of economic divisions along the lines of race, religion, caste and sex. But are these a real system of hierarchy, or simply convenient ways of dividing up tasks? In the case of the caste system we see a fairly clear instance of a real hierarchy: a system where occupations are ranked in status by caste and sub-caste – potters, leather workers, weavers, sweepers, and so on. The basis of caste is religious, and particularly related to Hindu notions of purity (see Chapters 8 and 11), but it also entails a complex linking of economic and religious status. In the case of ethnic stratification there is a different linkage. It may be that in general terms the Chinese in Malaysia dominate urban trades, the Malays the peasant sector and Indians the plantations, but in reality there are Chinese peasants and plantation workers, Malay entrepreneurs, and Indians are statistically over-represented in some high status primarily urban occupations like medicine and law. In certain respects the middle class Malay doctor has more in common with his Indian and Chinese colleagues than with his ethnic cousins and co-religionists

in the *kampung* (village), yet ethnicity (including its important religious component) still divides, or seems to (see Chapter 9).

In opening up the issue of the linkage between social stratification and economic inequality, fundamental questions about social justice, the distribution of resources and the need for socio-economic reform, or even revolution, are posed. Economic anthropology then turns out not to be a purely "academic" discipline, but one with practical implications (see Chapter 13).

Systems of Economic Organization

Despite variations in details from place to place, we can make a working list of cases which includes the cases outlined below.

Hunters and Gatherers

Although they have attracted a great deal of anthropological attention, hunters and gatherers are actually fairly rare. Hunter-gatherers do not plant crops on a systematic basis and do not breed domestic animals, but live by collecting forest produce, fish and game. They are often nomadic, building simple shelters from the materials at hand and characteristically are found in the few remaining deep jungles of Southeast Asia. Well-documented examples include the Batak of Kentan in West Malaysia (Endicott, 1979), the Punan of East Malaysia, the Mlabr and the Tasadays of the Philippines and some boat and shore-dwelling Orang Laut of Malaysia. Interestingly the Batak are what might be called a "primary" hunter-gatherer group in that, as far as is known, they have always maintained this way of life. There is evidence however that the other groups just mentioned had previously more complex social and economic arrangements, from which they have moved away, because of the social and economic pressure to which they were historically subjected, and of the special advantages that this form of life affords.

True hunter-gatherers then live nomadic lives in the rainforests, living in simple temporary shelters, and exist by hunting small game, collecting wild honey, birds eggs and edible plants, and fishing in the jungle streams for fresh water fish and crustaceans. The Orang Laut gatherers similarly forage for marine products, catch or trap fish and collect plants from the seashore. The Punan (actually a collective name for a group of Boreno hunter-gatherers) also collect rattan, resin and other forest products for barter for useful goods (tools, cloth and medicine) from the outside world. Gatherers are small scale societies entirely, or almost entirely, self-sufficient and with a close and often benevolent relationship to their ecological setting. Today such groups are coming under great pressure to abandon their life-style as a result of government policies (bureaucrats generally dislike peoples of no fixed abode who cannot be counted, controlled or taxed), the logging of the tropical hardwood forests of Southeast Asia and "development" such as the proposed flooding of huge areas of the virgin home forest of the Punan in Sarawak for a hydroelectric scheme (Clammer, 1987). Although the technology of hunter-gatherers is simple, their non-material culture can be rich. This illustrates very well our earlier assertion about the linking of society and economy, and a good example of

this is the body of rules determining the sharing of game amongst the whole group. An animal is never eaten privately or individually, but becomes a resource fo the whole community.

Swidden or Shifting Agriculturalists

Swidden or shifting agriculturalists are people who, in addition to gathering, trapping and hunting, also cultivate crops (usually dry or hill rice, vegetables and in some cases opium) and usually keep domestic animals and fowl (typically pigs and chickens), and inhabit substantial villages or long-houses. Examples are the "hill-tribes" of northern Southeast Asia and Southwestern China such as the Hmong (Geddes, 1976; Cooper, 1984), the Akha and the Karen (Hinton, 1967; Lewis, 1984), the Iban of east Malaysia (Freeman, 1980) and the Mnong Gar of Vietnam (Condominas, 1957). One of the best documented of these groups, the Hmong, grow dry, i.e. rain-irrigated hill rice, in small fields on steep mountainsides, and inter-crop it with opium poppy, the main source of their meager cash income. Many of these groups supplement their subsistence activities by trade with lowland peasants, with each other, or with Chinese merchants, with whom they exchange opium, in the case of the Thai hill-tribes, for cloth, medicine, guns and luxury goods (watches and radios are not uncommon), or in the case of the Malaysian groups, forest products (rattan, game, animal skins). In both instances and to a

Yao hill-tribe people in Northern Thailand survey the swidden fields.

lesser extent in southwestern China, those groups on the periphery of the mountains or jungle, or who are accessible by road or river have begun to exploit, or be exploited by, tourism, producing handicrafts for sale to visitors or for "export" to the regional market towns and even abroad. Thus swidden farmers are rarely isolated from outside influence – technology (firearms, axes), fashion, disease and religion have all been introduced in varying degrees from the surrounding world. Shifting agriculturalists often have complex social structures, sometimes with lineages and clans, ancestor cults and elaborate ritual systems, pottery working abilities. The more settled groups often have distinctive domestic architecture. Although swidden agriculturalists are concentrated in the mountainous areas of northern Southeast Asia, and the relatively untouched jungle zones elsewhere, it is important to note that swiddening is not exclusively a "tribal" adaptation, but is and has been practised by a wide range of groups, including not only hill-tribe people, but also peasants living in or near forests and groups that have much in common with, and are indeed sometimes thought to be, hunter-gatherers, such as the Semai of west Malaysia (Dentan, 1986).

The mode of life of these groups has sparked off an intense ecological debate. One school of thought argues that shifting agriculturalists are ecologically responsible. They say that farmers allow adequate time for regeneration of the land used, usually by cutting the large trees and burning off the cover and planting among the stumps and, given their small numbers, do not overexploit animal and plant resources. The other school argues that, on the contrary, shifting agriculture is ecologically disastrous. It destroys primary forest, uses agricultural methods which are inefficient and exhausts the land which is then abandoned to erosion and secondary growth when these people move on only to repeat the process in the next place of settlement. Whichever view we take, it is certainly the case that land is not unlimited, and that different groups find themselves in competition with one another, or with lowland peasants who move up into the hills as they too face land scarcity and overpopulation in the valleys – a process happening in Thailand, China, India, Nepal and Bhutan. The differences in ethnicity and culture between the upland and lowland peoples exacerbates the problems of economic/ ecological competition. In an attempt to solve this kind of problem many governments have attempted, usually with limited success, to get shifting agriculturalists to settle down and grow alternative crops – such as irrigated rice, fruit and cash crops (Cooper, 1984; Tapp, 1989 for northern Thai examples). Many, however, constantly revert to their former lifestyles and abandon the wet-fields and orchards, a clear example of the fact that when "development" and culture collide, it is often culture that wins.

Many swiddeners have of course been engaged in these agricultural practices for generations, if not for centuries, and are very aware of the cycles of fallow-time and planting necessary to sustain this lifestyle. Because of the need for long fallow periods and the regeneration of the vegetation that, once burnt off, provides the ash that fertilizes the soil, large tracts of spare land are absolutely necessary. In present political conditions, in which swiddeners are not citizens of nation-states which tend to have very definite conceptions of land ownership and use, farmers who utilize these techniques, whether they are "tribal" or peasant cultivators, come under severe restraints. An effect of this is to cause them to make the very mistakes, especially that of leaving inadequate fallow periods, that they would not make in the absence of external pressures. Swiddening has been practised for a

very long time by a wide variety of cultural communities, and historically should be seen not as a crude and underdeveloped form of agriculture, but as a sophisticated and highly evolved response to the problem of maintaining sustainable cropping on poor forest soils.

Peasants

Peasants, empirically a large and heterogeneous group, raise some important and difficult theoretical and definitional problems. The common-sense definition of a peasant as a small independent farmer producing mainly for subsistence, but with some surplus for market is all right so far as it goes. But initially, given our common-sense definition, it is possible to see represented in Asia several major types of peasants, beginning with relatively self-sufficient ones who market only a small proportion of their produce and need little in the way of inputs from the outside, either in terms of consumer goods or of agricultural technology, including items like chemical fertilizers. Examples of self-sufficiency still exist, in India, Laos, Burma and many remote parts of Indonesia. Then, as the level of technology rises, accompanied by the necessary inputs of fuel, parts, tools and so on, efficiency and productivity tend to rise, but self-sufficiency decreases. Technological dependency not only creates more direct needs, but also indirect ones – consumer goods and desires for information, for example. Furthermore, increased productivity generates a need for markets, which in turn require transportation to reach, and unless they are purely barter arrangements, these promote monetization. Examples of this type abound, ranging from the relatively mechanized peasants of the northern rice-bowl area of Malaysia to highly mechanized Japanese rice farmers with their access to large urban markets and a sophisticated "information society". Yet a third, and statistically very significant category, is that of peasants in socialist regimes – throughout Indochina for instance, and most conspicuously in China. The relationship between peasants and their political context is an important one.

Attempts to define "peasant" prompt fundamental questions: Is there just one such category that embraces all of Asia? Do peasants necessarily till the soil, or can groups engaged in other activities, such as fishing or in mixed economies also be considered peasants (a problem considered in Raymond Firth's classic work *Malay Fishermen* (1946))? Are peasants to be considered an autonomous social group, or are they always defined by their place in a set of "feudal" relationships in which they are always the subordinate and dependent partner? Do peasants cease to be peasants when they move to cities, as they have done all over Asia (see Chapter 12) or is there such a thing as "peasanthood" – a mindset as well as some economic characteristics, which continues to define peasants outside of their normal rural setting?

Normally we think of peasants as small farmers operating family-owned or landlord-owned small-holdings, utilizing only family labour or a minimum of outside paid labour at peak seasons, and able to maintain a subsistence economy or one with a relatively small surplus which is sold or exchanged in the market place. We also often think of peasants as being exploited by landowners, middle-men, providers of credit, seed, fertilizer and consumer goods, or as being landless and providing obligatory labour to feudal overlords. Many of these images are indeed, in some places and at some times, correct. But the reality is complex and as James Scott for example has brilliantly shown (Scott, 1985) peasant societies are

Peasant rice farmers in the Philippines.
Courtesy of Shosuke Takeuchi.

both internally stratified (into rich and poor, landed and landless) and maintain very complex links with the world beyond the farm and the hamlet through marketing networks, knowledge about the differential access to credit, agricultural extension services, the media, kin-networks, personal travel, political patronage, education, religion, and other means. In the terms used by more radical anthropologists, this represents both the "penetration" of a formerly non-monetized economy by the capitalist sector and the "co-existence of modes of production" – the living side by side of a non- or semi-capitalist mode of production and a capitalist one.

Like all our other categories, the peasantry are not a fixed entity, but a historical one, evolving through time as the technological and political context changes and as the world economy as a whole alters its structural qualities. So it is important to remember that peasants are not only a form of economy – small family farmers – but are also underdogs in the total agrarian social structure, despite their large numbers, and possess their own traditional cultures very different from those of both urbanites and other country-dwellers such as hunters and gatherers (Shanin,

1988: 11). The notion of the peasantry can also be a highly ideological and emotive one – some regarding them as the repository of all virtues once "correctly" politicized, as with Chinese revolutionary leader Mao Zedong, while others see peasants as the epitome of underdevelopment, ignorance and brutishness. Whichever view, or hopefully a more balanced one, we think it is important to remember that the isolated peasant living in an autonomous albeit "feudal" context is largely a thing of the past in contemporary Asia. The reality is a dynamic one: a peasantry increasingly "incorporated" into the national economies of Asia, through marketing networks, political mechanisms, media, the integration of the national economies into the world economy and the spread of a consumer economy. It is useful here to distinguish between peasants in basically capitalist societies and those in centrally-planned socialist ones where sometimes radical forms of collectivization have been attempted and where peasants have worked out complex accommodations between their traditional cultures and the demands of the new order.

But what happens to peasants when their traditional social structure breaks up? Most become landless labourers providing seasonal help for richer peasants, or work as agricultural labourers on commercial farms and market gardens or on plantations; yet others abandon the countryside and move to cities where they swell the urban population in cities like Jakarta and Bangkok, and many end up in the "informal sector", the often huge unregulated or "underground" economy typical of Asian cities. From the point of view of the economic anthropologist these are fascinating forms of economic activity with their own sociological and cultural life-forms, but to policy makers they are a major headache, not only because from the bureaucrats' point of view they represent a big sector of the total economy which is uncontrolled, untaxed and full of health hazards, straining the infrastructure (roads, sewage, education, health facilities) to breaking point – a fact that will not be lost on anyone who has visited, say, Manila or Calcutta, or almost any other major city in the tropical zone.

Amongst the attempts to solve these problems at source, rather than within the cities themselves and to offset this cityward migration, have been schemes to provide satisfactory employment in or near the countryside. Some of these schemes involve creating industrial centres in small towns and cities, away from the metropolis in an attempt to promote decentralization and the modest growth of regional cities. Malaysia has followed this pattern with "free-trade zones" in smaller cities like Penang and Malacca. Others promote rural-rural migration rather than rural-urban migration, the best known being the massive Indonesian "transmigration" scheme, involving the resettlement of hundreds of thousands of Javanese peasants in the outer and underpopulated islands of Kalimantan (Borneo), Sumatra and Irian Jaya. In a third category are those schemes which attempt to improve productivity and the rural infrastructure and make life on the land more attractive. Such schemes exist in northeastern Thailand (an impoverished area which is the main source of migration into Bangkok) with road building, village development schemes, irrigation improvements and the like, and in northwestern Malaysia where the best known one is the famous "FELDA" scheme, a massive government funded plan to promote the rice-bowl area of the country to maximum productivity (Hashim, 1979). Elsewhere land reform has been attempted, especially through the redistribution of the estate land to poor or landless peasants. This is being tried, although not yet very successfully, in the Philippines.

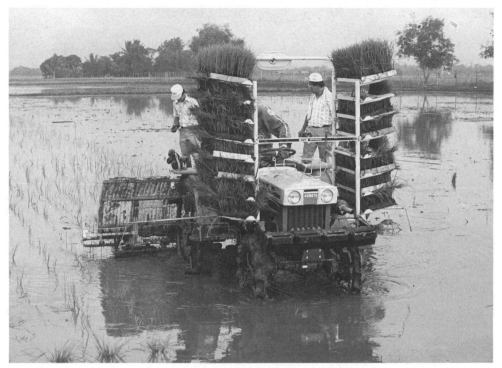

*Malaysian rice farmers using an automatic rice transplanter in the fields. This is one
example of technological change in peasant farming.*
Courtesy of Pernas Sime Darby Holdings Sdn Bhd.

Fishermen

Fishermen have long attracted anthropological attention because of their widespread
geographical distribution. Much of Southeast Asia is a maritime region, along
with Japan, and is oriented towards the sea. And China and India both have long
coastlines. The socio-economic organization of fishermen, like peasants, varies
with their ecological location, technology and their relationship to the wider
economy. Some kinds of fishing, especially inshore fishing, is supplementary to
on-shore agriculture, for others it constitutes an autonomous economy with an
associated culture and social structure of its own. Levels of mechanization range
from almost none at all to the sophisticated technology used by Thai, Korean,
Taiwanese and Japanese fishermen. Some fishing peoples, like the Bugis of
Indonesia, combine fishing with maritime trade or boat-building. Others are
essentially shore dwellers who launch their boats from coastal beaches, as with
most Malay fishermen (Firth, 1946). Some live on or over the sea in villages of
stilt houses, as with the formerly nomadic Bajau Laut of Sabah (Sather, 1985)
while others are still boat dwellers who maintain a mobile life style (Sopher,
1977). Not all fishermen use the sea as their primary resource – river and lake
fishing also takes place in inland areas, for example on the huge Tonle Sap Lake
in Cambodia, and fish farming is on the increase not only in natural waters, but
in artificial ponds. Not far from Bangkok large areas of swampy land have been

Dusun woman harvesting shellfish.
Courtesy of Sebastian Lee.

converted into prawn farms, producing a product of high value both for local and overseas markets.

Hydraulic Societies

The term "hydraulic societies" was coined by the German scholar Karl Wittfogel in a controversial book *Oriental Despotism* (1973) where he argued that typical Asiatic States, and China in particular, were based on the construction and management of large scale irrigation systems that necessitated strong central control. Although much of Wittfogel's thesis is hotly contested (see Chapter 7), he did draw attention to the profound significance of irrigation in the economic and social organization of many Asian societies. Therefore I would like to rehabilitate his term to refer to those settings where the creation and management of complex water systems is a crucial element of local culture and ecology. Many societies in Asia have historically developed elaborate irrigation systems – China, India, Sri Lanka, Thailand and Java being examples of societies where water management for agricultural purposes, fishing and inland transportation is, or was, widely developed. An outstanding contemporary example of this however is Bali, where over centuries a complex water management system evolved, linking networks of farmers who shared the same watershed and tying them into ritual relationships centred on "water temples" that both managed the water flow and provided a symbolic framework that unite "economics" and "religion" into a single holistic entity (Lansing, 1991). In rice economies the flow of water continues to be a vital ecological, economic and social factor (Bray, 1986).

In Bali, Indonesia,
"watertemples" play a vital
role in the island's complex
irrigation system.
Courtesy of Ashley Wright.

Pastoralists

Pastoralists are people whose livelihood is based on the management of domesticated herds or flocks of animals. Traditional pastoralists are often nomadic and are frequently transhumant herders – they migrate with their flocks or herds seasonally up and down, and given the grazing demands of their animals require large open spaces. Large stretches of land are surprisingly hard to find in Asia, where much of it is either under forest cover, subject to intensive crop cultivation, or is mountainous. So while the keeping of domestic animals as an adjunct to peasant farming is common, and while controlled commercial pastoralism does occur in a few places (in the form of dairy farming), large scale traditional pastoralism is almost uniquely confined to Mongolia and other parts of central Asia. Only here is space abundant, population densities low and the grazing land suitable for horses, sheep and goats available. There is an important cultural dimension to be considered as well. Many central Asian peoples, from Chinese Turkestan right across to Persia, are Muslims and so do not raise pigs, the

Hazak pastoralists in Northern China.
Courtesy of Irene Bain.

traditional Chinese domestic animal, but are mutton eaters. The Mongolians, however, are Buddhists.

Pastoralism is not just an economy, but really is "a way of life", often emphasizing mobility, independence, a martial spirit and contempt for settled peasants and townsmen. Pastoralists have an almost mystic identification with the animals they herd, who are the source of almost all nutrients and physical possessions (skin tents, for example), except those obtained through barter or trade. Restricted under Mongolian socialism (Jagchid and Hyer, 1979), and even more so in Tibet and China, large scale nomadic pastoralism was thought to be a thing of the past, that would inevitably be replaced by commercial farming. However there are now reports of the resurgence of pastoralism as communism retreats in central Asia, including parts of the former Soviet Union where until recently pastoral – transhumant herding was collectivised as part of the Soviet economy.

Plantations

An extremely important part of the economy of Asia since the introduction of colonialism has been plantation agriculture. This is a feature that Asia shares with much of the rest of the former colonized world – the West Indies for example. The particular forms that plantation agriculture took were rooted in the different colonial experiences of the region, and expressed themselves subsequently in different sociological ways that often had profound long term effects on the whole social structure of the whole national economy. Thus in the Philippines under Spanish colonialism large scale semi-feudal estates were created. Today much of

the rural social structure of the Philippines still revolves around these estates, which are now in the hands of big Filipino landowners and run as "agribusiness". In Indonesia the Dutch created the "Culture System" in which plantations were inter-laced with the peasant economy (Geertz, 1963). In Indochina the French established rubber plantations to feed the needs of their own empire (Murray, 1981). And the British Raj created a massive plantation sector in India and Sri Lanka (tea) and in Malaya (rubber). Under this British umbrella local, usually Chinese, entrepreneurs established their own plantations for sugar, rubber and later oil palm.

The Malayan case is especially interesting for what it reveals about the relationships of economy, society and politics. First of all, extensive plantation agriculture had a profound ecological impact. Huge tracts of forest land were cleared, to be replaced by uniform rows of rubber trees. While much of this land was unsettled or underutilized jungle, in many cases the natural economy was destroyed and the local Malayan population moved. The whole process also had major sociological effects. The Malays for the most part did not want to work in these aptly named "rural factories", which required workers to keep strict hours and fill quotas, all under the watchful supervision of European planters. To solve

A Chinese rubber tapper collects latex and scrapes rubber trees at a Puchong plantation owned by a Chinese millionaire.
Courtesy of Marlane Guelden.

the labour problem, therefore large numbers of south Indian Tamils were brought in, and while some returned to India at the end of their contracts, many remained. The long term result was the introduction of a whole new ethnic group into Malayan society which, when coupled with the parallel introduction of huge numbers of southern Chinese, completely and irrevocably altered the social landscape of Malaya and created all of the problems and issues of ethnic pluralism that plague that country.

Many Chinese also worked on plantations, but most soon moved out into independent vegetable farming (a Chinese specialty throughout Southeast Asia and southern China), into tin-mining, trade and urban occupations. Chinese vegetable farming is reputed to be one of the most efficient forms of agriculture in the world, with almost total recycling of waste products, intensive land-use, multiple cropping, sophisticated irrigation and fertilizing systems and very clever integration of crops, pigs, ducks, chickens, water plants and fish, all in very small spaces. Examples of this can be seen amongst the Cantonese farmers of the New Territories of Hong Kong and the Hakka gardeners of Malaysia. (Anderson and Anderson, 1973) Most Tamils, however, remain to this day in virtually mono-ethnic rural ghettoes with sub-standard schools and social facilities, far from the towns, badly paid and with little opportunity for social mobility.

The plantation sector also had long term economic consequences. Mono-crop primary commodities destined for export, are especially vulnerable to fluctuations in world demand, low prices and the challenge of alternative products (e.g. artificial rubber). Many plantations have, of necessity, up-dated themselves into modern agribusinesses, but they still all have one major side-effect. They create or require a labour force of landless workers (either ex-peasants or descendants of the original contract workers) and so create a rural proletariat, which is often badly paid and paternalistically managed, a fact exploited by insurgent movements such as the Communist Party of the Philippines.

Petty Commodity Production

Any rural economy requires more than landlords and labourers: it also requires artisans who can produce the technology and goods required by the local economy. In a rural setting small producers are to be found running, or employed in, small-scale workshops, factories or cottage industries, perhaps engaged in weaving, pottery or metal working as their primary activity, although they may well supplement this with gardening, farming or fishing to help make ends meet. A good example are blacksmiths, shoeing horses, fixing cart-wheels and producing tools and agricultural implements, well documented in the case of the Minangkabau people of Sumatra. Kahn shows not only how the economy of these producers is structured, and how they relate to the agricultural society of which they are a part, but how they are under threat from the bigger capitalist commodity producers in the cities who have *economies of scale* and threaten the small producers by flooding markets with mass-produced and often cheaper products (Kahn, 1980).

Traders

While most people in rural economies engage in occasional trade, some are full-time traders. Trade may take the modern and familiar form of shops and stores

with their associated paraphernalia of banks, taxation and bureaucratic licensing and regulation. But there are some equally important forms that fall outside this framework and are widespread in Asia. Two of the most significant are barter and hawking. Barter involves the direct exchange of one commodity for another without the use of money. From time immemorial this has been a normal way of conducting exchange all over the world and it continues all over Asia, such as in the informal barter between Thai hill peoples and lowlanders. Sometimes it is very organized. In the waters south of Singapore it is a daily sight to see inbound Indonesian sailing *prahu* laden with forest products on their way to the official barter dock in Singapore's Pasir Panjang district. They leave again loaded with cassette recorders, textiles and any number of manufactured commodities. Hawking is a more familiar form of petty trade, as it is very visible in almost every Asian town. Street vendors selling fruit, clothing, trinkets, in market places crowded with tiny stalls or with their produce simply set out on the ground. Little booths or carts are strung out along sidewalks or clustered around bus or train stations selling every variety of local cooked foods and drinks. Sometimes these activities are the sole livelihood of the individuals or families that run these stalls; sometimes they are a supplement to other economic activities, including wage labour. Sometimes they are highly organized and regulated, as in the custom-built "hawker centres" of Singapore; or they are part of the "informal sector", the "underground" and unregulated part of the economy which flourishes in almost every major Asian city.

An interesting feature of trading communities is that they are often ethnically homogenous. Much of the spice trade in Southeast Asia is in Indian Muslim hands, the coffee shops are monopolized by Mainland Chinese, while the diamond trade throughout Asia is largely Jewish-controlled, and so on. Indeed some ethnic groups – the Chinese in Malaysia or Indonesia, the Arabs throughout the region, the Parsis in India, are automatically associated with trade, even though in practice many of their members may be in other professions or activities. Archaeologists are aware that for centuries there has been trade both within the sub-regions of Asia and across the region as a whole. These linkages are attested to not only by material artifacts – Ming jars found in up-river Borneo communities for example – but by continuing networks of trade which are often organized on very traditional lines, such as the now declining plywood timber trade between Indonesia and Singapore, or the enormous networks created by prominent overseas Chinese such as Oei Tiong Ham, with relatives and representative offices in practically every important trading centre in East and Southeast Asia.

Services, Artisanal and Industrial

With the "modernization" of Asia, or at least with the industrialization that has engulfed so much of the world, large numbers of people have been drawn out of traditional rural activities into urban life and factory labour. These are of course not synonymous: urban centres create employment of a whole range of types, including of course hawking, but especially *services, artisanal* and *industrial* employment. Any large city requires a host of services to make it work – transportation, sanitation, banking, bureaucracy, vending of everything needed for the urban lifestyle of that particular place. It also requires people who make and fix things. And if it is at all industrial it requires a proletariat to man its factories. With the increasing urbanization of modern Asia employment in industry is

Ice-cream seller in Bali.
Courtesy of Hilary Andrews.

becoming normal. It has however a range of sociological effects, including disruption of traditional crafts, displacement of rural labour, slums and squatting. We also see a wide incidence of child labour (Weiner, 1991) and the extensive employment of women in industries involving repetitive and often low paid work, such as electronic appliance assembling, and prostitution. Also, country-specific variations in terms of different cultural responses to industrialization can be observed (UNCRD, 1989). For example, in Singapore labour has adjusted fairly well to industrialization, which has certainly brought about objective increases in the standard of living. In the Philippines, however, the impact of industrialization has often been negative with the destruction of local crafts and social structures, extensive unregulated pollution and unplanned urbanization, without at the same time doing much to alleviate the country's extensive poverty.

Of course we must recognize that in practice many of these types are mixed. Tribal people in India or Thailand often have complex economic and socio-cultural interactions with other groups in society. Pastoralists engage in trade, craftsmen keep a market garden. Indeed traditional craftspeople such as Balinese painters,

northern Thai jewelry makers, or Japanese teachers of flower arrangement are good examples of socio-economic groups still active in Asia, that are hard to categorize neatly. This is also true for logging which partakes of some of the features of plantation agriculture, swiddening, and modern agribusiness. Many small Japanese and Taiwanese farmers now spend more time in off-farm economic activities than they spend on them (Smith, 1978).

This overlapping of economic action begins to make more sense when we put it in a yet wider context.

Economy and Society in Asian Context

There are four major elements that we have used to contextualize the empirical economies we have identified: ecological, political, developmental and theoretical.

We have already stressed that every economic system is also an *ecological* one. Each derives from a particular ecological base (forest, sea, climate, mountain, etc.) and in turn modifies that base, often profoundly. The spectacular rice terraces of Luzon, that are the product of generations of labour by an upland people are an example of a natural environment being enhanced by this interaction rather than destroyed, with formerly forested mountain sides being transformed into a granary. Another is the landscape of Java which today looks like a continuous garden, densely populated and with red-tiled roofed hamlets scattered everywhere amongst the plots, each of which is utilized to its maximum extent. It is hard to imagine that within living memory much of Java was forest and that the primal landscape has been transformed by burgeoning population and intensive land use. Ecology and social structures are likewise closely tied together: forest gathering, while doing little to disturb the environment, does not permit high population densities which in turn tends to keep the size of domestic and social units small and simple in structure. Indeed there is evidence that many of these groups deliberately keep their population low precisely so that they can remain as nomads, their preferred lifestyle. Settled peasant agriculture however, especially on productive land, creates the conditions for elaborated kinship groups of the kind associated with the southern provinces of China (see Chapter 5), with their extensive lineages. The links between ecology, economy, social structure and culture are many, varied and complex, and beyond our scope to detail here. But it is important at the very least to stress that economic activity is always contextualized in an ecological setting, and is ultimately dependent on that setting for its viability (Godelier, 1986).

The *political* dimension of the economy is so important and varied that some anthropologists have suggested reviving the concept of "political economy" to help understand the relationships between the economic and the political (Clammer, 1985). Economic decisions are often also political ones and vice versa. Individuals or groups often ask themselves: With whom should I enter into an economic alliance? Whose daughter will bring the biggest dowry? Should I enhance my political status by sponsoring a feast? And so on. Social power in other words is multi-dimensional and it is often necessary to conduct politics by way of economics. But in a more formal sense the political context modifies the possibilities of economic activity. The slowing down, if not the total cessation of shifting cultivation amongst the northern Thai hill peoples, is not because they have

suddenly lost their wanderlust, but because the Thai government, for reasons to do with ecology, security, the opium business and the dangers of ethnic conflict with other hill groups or lowland Thais, is trying to stop their perpetual motion both by direct policy means and by the indirect means of linking them ever more closely with the lowland economy, something that is also happening progressively to, for example, the Lahu peoples (Hoare, 1985). This government intervention is even more apparent in the socialist countries of China and Indochina (Evans, 1990) where the role of the state in influencing economic and social possibilities is very pronounced.

The *development* dimension is closely linked to the political, and is often an expression of it. Development activities – road-building, well-digging, agricultural-extension work and so forth, whether directly intended to promote social well-being, or for other motives (security) – can profoundly effect the natural economy by introducing factors such as access to the outside world, its markets and its tastes, by changing the ecology, by bringing in outsiders (tourists, loggers, missionaries), and by creating new economic opportunities which the more entrepreneurial will be eager to seize. Development, for all its rhetoric, has until recently paid little attention to culture, and as a result has more often than not undermined local value systems, promoted industrialization and monetization at the expense of the natural economy, created subsequent distortions in kinship and social relationships, damaged the ecology and has even created the impoverishment it was supposed to eradicate. Fortunately there has been a recent movement back towards assessing the role of culture in development, and this in turn affects the way indigenous economic systems are understood and perhaps incorporated into a more sensitive and balanced understanding of what development means (e.g. Dove, 1988). Carl L. Hoffman (1988) for example shows that the Punan people of Borneo have a complex economy involving not only hunting, but also the collection for barter of a whole range of jungle products, including edible birds nests, aloes wood, rattan, camphor and *damar* (resin). Nobody else can collect these products that are greatly valued in the outside society, especially by Chinese traders. The Punan are thus actually specialized operators in a complex trading network, and Hoffman shows very clearly how inroads into their territory by loggers, farmers and government agencies upsets their ecological setting, which in turn changes social as well as economic relationships both within the Punan and between them and the wider society. "Development", while it may or may not improve standards of material life, often does so at the expense of cultural identity. (Brokensha *et al.*, 1990.)

Theory does not (or should not) mean abstraction and systems building; rather it means how to think accurately about the data in the real world that confronts us – in this case real people trying to make a living in various ways, and investing what they are doing with symbolic significance, and tying their relationships with material things into a meaningful bond with their social networks and values. In general terms then, anthropological theories are about how to think about our subject matter, and since economic anthropologists have taken rather different points of view on the interpretation of their subject matter, we need to address this problem as it bears directly on the issue of understanding the economic systems of contemporary, or even historical, Asian societies. This raises a further interesting question: most anthropological theories are the product of the West not of Asia, of the colonizers rather than the colonized, of intellectuals rather than

the practitioners of the economic arts that the anthropologists describe. So how relevant is all of this to the illumination of our empirical subject matter?

The Comparative Perspective: Rationality and Ecology

One of the themes implicit in all that has been said up to this point is the necessity of a comparative perspective. Anthropology has long prided itself on being a comparative social science, and in a discussion of Asian economic systems we can see that many of the most interesting points not only illuminate classic themes in economic anthropology, but shed new light on them. One example of this is the old theme of the gift, with which we began. Well documented as it is in many so-called "simple" societies, few anthropologists have thought to extend the idea to "complex" societies. But in Japan we find a gift economy on a huge scale, where not only are gifts given at mid-year and end of year to bosses, school-teachers, as well as those who have done one favours (or who might do them!), but on numerous other occasions throughout the year, when visiting someone's house and for countless other reasons. A large industry exists to provide, wrap and deliver these gifts, the basic purpose of which, as with many other exchanges, is to create, constitute, or deepen social relationships (Befu, 1974). Likewise feasting, a widespread institution with many forms exists in many contexts in Asia: the Chinese wedding feast and the Javanese *slamatan* to mark a birth, marriage or other life-cycle event, to name but two. But we do not always think to relate feasting to markets, to the ways in which commodities are circulated or to the gradual penetration of capitalism into "tribal" societies, but in practice the Asian economic material points to significant links here (Voss, 1987). The mystique of rice as something that has a "soul" is widespread throughout both the Malay/Indonesian and Thai speaking areas of Southeast Asia, but who would at first sight think to link it with Japanese resistance to opening their rice market to foreign imports? But there is a close connection, for not only do the Japanese eat a different variety of rice from that grown in south and Southeast Asia, but rice for them is deeply tied up with ideas of cultural identity, purity and even their biological make-up.

Two key factors actually tie all these diverse themes together. The first is a theme that has been a central element in a lot of recent discussion in economic anthropology, that of *rationality* (e.g. Godelier, 1972). What our material suggests is that rationality, while no doubt universal in some of its aspects, is deeply cultural and that different economic activities are embodiments and expressions of these rationalities. Second we must stress again the intimate connections between economy, culture and ecology. This is not only analytically the case, but also helps us to develop a unified field theory that links economy, rationality and development. For economic decisions are not only or necessarily *maximizing* ones; they are also, as we have seen, sociological and cultural *and* also ecological, often reflecting a deep understanding of climate, animal and plant life, husbandry and man's relationship to natural forces. The recent "culture and development" debate to which we referred earlier reveals this very clearly with its emphasis on

indigenous knowledge or what is sometimes called "ethno-science": the intimate knowledge of a native people of their natural environment, and the expression of this, often in ritual or religious forms. Obviously "development" which disturbs these carefully worked out cultural/ecological relationships is actually anti-development: destruction in the guise of progress of long-evolved systems of human/natural environment patterns. A small but perhaps significant footnote to this is that in the past economic anthropology had close connections with its cousin, *material culture* studies, so vital to archaeology (Chapter 2), which for various reasons have now been largely severed. This is a pity, because the links are real and close, and the indigenous tools, utensils, boats, architecture and dress of a people are a sign of the inner workings of their economic/cultural/ecological sensibility.

Finally we can see that even a modest survey of forms of economic activity points beyond itself into areas that we have only touched on, but have had no space to develop. These include the analysis of gender relationships in economic practices and questions of social power which is often embodied in economic forms, and the manifestation of this in patterns of social hierarchy and inequality. Not only is Marxist class analysis a useful tool here, but non-Marxist anthropologists have been led into discussions of such topics as the role of elites and of the connections between factors such as lineages and economic activity. How, for example, do the very different Malay and Chinese social structures, one cognatic, the other [patri]-unilineal profoundly influence patterns of saving, capital accumulation, entrepreneurship and commercial success. Other questions which have arisen out of debates about monetization and the penetration of capitalism are now at the cutting edge of social theory – including, for example, issues of the consumer society, commoditization and the semiotics of objects (the way in which things have many levels of symbolic importance quite apart from their purely functional utility). Yet other questions have arisen out of advances in ecology, in the political sociology of the State, in feminist studies, in economics itself, and in newer fields that have grown up around the edge of economics and business studies – organizational theory for example. Economic anthropology itself will have to move to take account of these developments, and as it does so its capacity for theorizing its empirical material – in this case the indigenous economic systems of contemporary Asia – will expand, and as it does so our grasp of the links between economy, ecology, society and culture will deepen, to the lasting benefit of us all.

7 ORDER UNDER HEAVEN

Anthropology and the State

Paul T. Cohen

Anthropology is usually associated with the study of "primitive" tribes or, at least, with village communities in more complex societies. What relevance, then, has anthropology to the study of the state? Actually, anthropological interest in the state dates back to the founding fathers of the discipline in the nineteenth century and their evolutionary theories. Thus, Lewis Henry Morgan's evolutionary scheme of Savagery, Barbarism and Civilization was concerned with the transition from kinship-based relations to stratified, state-organized societies based on territory.

In British anthropology interest in evolutionism, including the evolution of the state, lapsed under the influence of the **functionalism** of Bronislaw Malinowski and A.R. Radcliffe-Brown and their rejection of the armchair, speculative theories of the evolutionists and emphasis on empiricism and field research on extant "primitive" societies.

In America interest in the state was revived in the 1950s through the neo-evolutionary theories of Julian Steward, Marshall Sahlins, Morton Fried, Elman Service and Marvin Harris – the so-called **cultural materialist** stream of anthropology (Harris, 1969: Ch. 23). For example, Steward posited parallel evolutionary sequences in five regions of the world (northern Peru, central Mexico, Mesopotamia, Egypt and north China): Hunting and Gathering, Incipient Agriculture, Formative, Regional Florescence, and Cyclical Conquests. Later, Service proposed evolutionary stages of band, tribe, chiefdom, and state.

The study of the state in British anthropology emerged from anthropological research in Africa. It is true that the early, pioneering work by Edward Evans-Pritchard on the Nuer (of Sudan) and by Meyer Fortes on the Tallensi (Gold Coast) were on tribal, stateless societies. But as anthropological field work continued in Africa it became difficult to ignore the existence of the pre-colonial states of West Africa, and of the Interlacustrine area of East Africa. The first systematic, anthropological analysis of the state in Africa was Fortes and Evans-Pritchard's *African Political Systems* (1940), a collection of papers by anthropologists on two types of political system: Group A ("primitive states") and Group B ("stateless societies"). This pioneering publication was followed up later by a number of detailed monographs on pre-colonial African states, such as Siegried Nadel's *Black Byzantium* (1942), Aidan Southall's *Alur Society* (1956), Michael Smith's

Government in Zazzau (1960) and Jacques Maquet's *The Premise of Inequality in Ruanda* (1961). It is noteworthy that the anthropological research on which these monographs were based required a significant shift in methodology, away from single-village studies towards greater reliance on ethnohistorical methods using historical records and oral histories.

A key issue raised in these African studies of the state is that of African "feudalism" in comparison with that of Europe, in particular the institution of clientship (Goody, 1961). Of special relevance to an analysis of the state in Asia is the anthropological study by Southall of the feudal-like Alur state of East Africa. He examines the process of evolution of an embryonic state from chiefless societies. Then he outlines the geo-political characteristics of what he calls the "segmentary state" – a decentralized type of polity comparable with the Anglo-Saxon state in England (1956: 254), "feudal" France of the eleventh century (*ibid*: 256) and the "traditional states" of India, China and Inner Asia (*ibid*: 253). Southall's "segmentary state" has served as a model for some influential analyses of the state in Asia such as Stein's on the Chola Kingdoms of South India (1977) and Tambiah's on the "galactic polities" of Southeast Asia (1976). Finally Southall is concerned with the *process* of political centralization within segmentary states (from embryonic forms such as the Alur to more advanced forms) and the transition from segmentary states to more bureaucratic "unitary states".

This process has also interested the neo-evolutionary "cultural materialists" who have concentrated in particular on the relationship between the development of irrigation in Asia and the emergence of "despotic" pre-modern states (Steward, 1949; Harris, 1978). However, it can be argued that the theoretical framework of cultural materialism is too narrow and limited for an explanation of state development in that it envisages social forms as mere epiphenomena of technologies and environments. Others, such as the structural marxist school of anthropology of Maurice Godelier and Jonathan Friedman, attempt to steer a middle course between the extremes of cultural materialism and cultural idealism and encourage examination of the role of both material and mental factors in the analysis of state formation and evolution.

One of the most important and influential studies of incipient state formation carried out in Asia is that by Edmund Leach in *The Political Systems of Highland Burma* (1970), to be discussed further below. While the main aim of this study is to examine ideologies associated with hierarchies, chieftainships and the emulation of state forms of organization, it is also interested in why tendencies toward state formation collapse or succeed.

"Oriental Despotism"

As mentioned in the opening chapter, the "Orientalist" idea that Asia in the past had a static form of political organization has been summed-up most notoriously in the concept "Oriental Despotism". This idea has a long and complex history in Western thought (Anderson, 1974), but it also had a political function; it rationalized "enlightened" European colonial intervention in Asian societies in order to free them from "despotic" rulers. A despotic colonialism was often the outcome.

But there have also been solid intellectual attempts to construct a concept of "Oriental Despotism", most notably Karl Wittfogel's *Oriental Despotism: A Comparative Study of Total Power* (1973). Empirically China played an important role in this book, whose key idea was that despotic state systems arise as a necessity of large scale irrigation under certain social and ecological conditions. "It is only above the level of an extractive subsistence economy, beyond the influence of strong centres of rainfall agriculture and below the level of property-based industrial civilization that man, reacting specifically to the water-deficient landscape, moves toward a specific hydraulic order of life" (1973:12). Once established, these hydraulic state systems become increasingly centralized and despotic, of necessity. Dynasties may rise and fall, but each must re-create anew the despotic state system because of the imperatives of water control and its importance for food and surplus production. Marvin Harris is a more recent defender of this argument. The mere scale of the activities involved in water control, he argues, and the manpower co-ordination required them "being carried out by cadres obedient to a few powerful leaders pursuing a single master plan. Hence the larger the hydraulic networks and facilities, the greater the overall productivity of the system, the greater the tendency of the agro-managerial hierarchy to become subordinate to one immensely powerful person at the top" (Harris, 1978:175). The logic of the argument is persuasive, but in fact its assertions are too sweeping.

Ironically, the claims made by theorists of "Oriental Despotism" in some ways resemble the self-perceptions (and deceptions) of the rulers of the traditional Chinese state. The emperor and those at the centre of the kingdom acted as if they were all powerful under heaven. Tribute flowed in barges along that major feat of the hydraulic society, the Grand Canal to Beijing, but what it disguised was the fact that this tribute and this hydraulic system which served the emperor himself – the "one immensely powerful person" – covered only a small part of China, in the plains of the Yellow River and the lower Yangtze (Stover, 1974). Much of the hydraulic work carried out in the Chinese countryside was a result of the independent initiatives of the local gentry and had nothing to do with the emperor in any direct sense, and the further one moved from Beijing the less this local gentry was directed by the centre, especially with respect to hydraulic activities. The distant border provinces were led by men who were more like warlords than bureaucratic officials (Esherick and Rankin, 1990). The idea of total control was a fantasy of power rather than a reality, and it is only surprising how many observers have taken at face value the claims of Chinese dynasties that they held all power under heaven.

Outside of China Wittfogel's grand theory had some supporters; for example, Sedov (1968) and Coèdes for the Cambodian state of Angkor, Elliott (1978) for Central Thailand, Potter (1976) for Northern Thailand, and Tichelman (1980) for Java. However, supporters are outnumbered by critics, including several anthropologists. The main factual basis for their critiques can be summarized as follows:

1. In monsoonal Asia irrigation is normally a precondition of viable agriculture. It follows, too, that if large-scale irrigation systems fall into disrepair village-based agriculture still survives (Leach, 1959:23; Stargardt, 1986:32).
2. These small-scale irrigation systems can function in an autonomous way without the technological and managerial intervention of state authorities (Cohen, 1991; Geertz, 1980:69).

Angkor Wat: The Angkorian empire has been considered by some to be an example of "Oriental Despotism".
Courtesy of Grant Evans.

3. The size of state hydraulic works was sometimes exaggerated for political reasons, e.g. in Buddhist polities to enhance the prestige of the monarch as a "righteous ruler" concerned with the welfare of his subjects (Leach, 1959: 10; Stargardt, 1986: 31).

4. Major hydraulic works in or near the capital were sometimes built for aesthetic (Leach, 1959: 23) or magico-religious purposes. Van Liere (1980: 273–4) describes the temple ponds, moats and canals near Angkor as "theocratic hydraulic works" designed and oriented as a microcosm of the heavens.

5. In cases in which irrigation works were really large in dimensions, this fact *in itself* does not imply massive control over labour because they were often built over a very long period of time and in a discontinuous and often haphazard way (Leach, 1959: 14).

6. When large-scale hydraulic works *did* require the mobilization of mass labour by the state this was often only for initial construction. Thereafter the maintenance of the system was in the hands of local village institutions. Consequently, large-scale systems could survive *after* the collapse of the state (Stargardt, 1986: 32).

7. Villagers were also capable of co-ordinating irrigation on a large scale (in the sense of the cooperation of many villagers over an extensive area) without dependence on central state authorities. (Cohen, 1991; Geertz, 1980: 72; Stargardt, 1986: 32). In flow-of-the-river irrigation systems social segmentation is isomorphic with the physical segmentation of the canal system. Unification of entire, extensive irrigation systems is achieved by the same principle of complementary opposition as found in the segmentary kinship systems of

stateless ("acephalous") tribal societies, i.e. "although any group tends to split into opposed parts, these parts tend to fuse in relation to other groups" (Evans-Pritchard, 1940: 248).

Ecological Constraints on State Formation

Theoretically, Wittfogel's theory of hydraulic despotism has been subjected to a systematic and cogent critique by Jonathan Friedman who describes Wittfogel's thesis as a form of "technological determinism and vulgar materialism" (1974). Irrigation agriculture (as a productive force), he argues, can only set the *limits* in which a social system *can* develop but not directly determine its actual form; in other words, the **forces of production** (technology, land, etc.) only provide a set of *potentials* with regard to the way production is organized by social groups, the **social relations of production**. However, "the manner in which a given social system uses its techno-environment profoundly alters its own conditions of reproduction", and furthermore, "it is the relations of production themselves which determine the way a population will behave toward its own limit conditions" (1975: 165–6). Thus, regarding the Wittfogel thesis, Friedman concludes: "Of course the full scale state is associated with large scale irrigation, but the causality goes the other way around. Expansion of power (in the already formed state) entails expansion of social surplus which entails expansion of the agricultural system and the development of maximally intensive farming" (1974).

From Friedman's theoretical perspective let us now look at agriculture (as a productive force) in terms of its potentials and limitations in relation to political development in pre-colonial Southeast Asia. Pertinent to this issue are the following characteristics of dry (swidden) rice cultivation (see Friedman, 1975: 165–6). Swidden agriculture is ideal in conditions of abundant rainfall and rich soils. High yields are obtainable for minimum labour input. However, high productivity requires the maintenance of soil fertility which, in turn, requires suitably long fallow periods. If the fallow is reduced below twelve years the optimal conditions for reafforestation are forfeited; fertility and labour productivity progressively decline. Dry rice cannot support high population densities (a maximum of about fifty persons per sq. km) because the minimum cultivation cycle of one area every twelve years requires that a working population has at its disposal thirteen times more arable land than it uses in one season. Low population densities entail low levels of absolute surplus – a crucial material constraint on political development.

These constraints are exemplified in Friedman's (1975) theoretical reinterpretation of Edmund Leach's classic anthropological study of the Kachin of upper Burma, *Political Systems of Highland Burma* (1970). The accumulation of prestige by the chief through communal feasts is the driving force of the Kachin political system. This creates an accelerating demand for surplus by the chief which, in turn, creates a demand for more labour (in the form of wives, children and slaves) with a consequent rapid growth in population. However, the constraints of agricultural technology require that territorial expansion compensates for demographic growth so as to preserve the rate of productivity. These constraints have both *external* and *internal* political implications. The territorial (horizontal) expansion of a domain at a rate necessary to maintain productivity would result

Some people argue that swidden agriculture places ecological constraints on state formation.
Courtesy of Dennis Lau.

in a highly dispersed population in which vassal chiefs could easily break away. The simultaneous fissioning of groups leads to conflicts, warfare and the blocking or slowing down of territorial expansion. In such a situation the continuing demand for surplus *inside* the incipient state puts increasing pressure on the swidden agricultural system resulting in shorter fallows, ecological degradation, and lower productivity per unit of land and labour. There thus emerges a contradiction between the forces and social relations of production in the way which the chiefs demand for surplus outstrips the capacity of his dependents to pay. This culminates in increased discontent and finally revolts which establish egalitarian, stateless communities. In short, a state based on dry rice cultivation is inherently unstable and prone to disintegration.

Wet-rice (rainfed, deepwater and irrigated) has, according to Geertz, "extraordinary stability and durability" (1970: 29) in terms of its capacity to maintain yields per unit area of land under considerable population pressure (though per capita returns may diminish). This is made possible through intensification such as: improved irrigation techniques; transplanting from seedling nurseries rather than broadcasting; planting in precisely spaced rows; more frequent and thorough weeding; more thorough ploughing and raking, and levelling of muddy soil before planting; different harvesting techniques; multiple cropping; etc. (*ibid.*: 35). The high population densities made possible by wet-rice technology (up to two thousand persons per sq. km) means that there is considerable scope to increase absolute surplus.

Increased surplus provides the basis for the construction of large public works, the support of non-cultivator classes, and the concentration of labour (e.g. of artisans) in production for foreign trade (Friedman, 1974: 463; Friedman and Rowlands, 1977: 220).

Another political characteristic commonly attributed to wet-rice cultivation is that it contributes to sedentary, immobile populations which are amenable to state political control for the purpose of extracting agricultural surplus. This is due to what Geertz describes as the "introversive tendency" in wet-rice cultivation (1970: 32), that is, a tendency to work old plots more intensively rather than establishing new ones due to "overhead labour investment" (*ibid.*: 32). This contrasts with the tendency toward horizontal expansion of dry rice cultivation. However, we must be wary of exaggerating the differences. Geertz himself acknowledges that horizontal expansion is possible for wet-rice cultivation as well, "though more slowly and hesitantly than is sometimes imagined" (*ibid.*: 32). And we should bear in mind Dove's point concerning peasant mobility in pre-colonial Java: that while swidden agriculture was not attractive to the state (in terms of political control and extractable surplus) it was often attractive to the individual cultivator because of the high yields per capita it offered (in the absence of population pressure) and, practiced as it usually was in wilderness areas, as a refuge from an exploitative state. For this reason "agricultural desertions" were not uncommon (1985: 7, 12, 13). While wet rice has the *potential* to support a large, dense, population (and therefore a high level of absolute surplus) this potential was probably rarely realized in pre-colonial Southeast Asia, although it was in South and East Asia.

The State and Demographic Constraints

Rapid population growth (1 percent to 3 percent per annum) in Southeast Asia began only after colonial intervention in the region (eighteenth century and later). Prior to this the population density was overall very low. Reid estimates that the population of Southeast Asia in 1600 was only 22,425,000 (1987: 36), that is, 5.5 persons per square kilometre, which was very sparse compared to the neighbouring region of South Asia (thirty-two persons per square kilometre) and China (thirty-seven persons per square kilometre). China's population increased from approximately 65 million in 1400 to 430 million in 1850, a much higher rate of growth than Europe for the same period. This enormous demographic growth, according to Anderson (1974: 538–9), was matched by a great absolute increase in grain production attributable to expansion of acreage and higher yields (due to better seed strains, double cropping and new plant varieties, and increased water control and fertilizer use). So, China in this period, unlike Southeast Asia, *was* able to realize the full potential of wet-rice cultivation to support high population densities, large surpluses and a strong state.

Warfare was the most important limitation on population growth in pre-colonial Southeast Asia (Reid, 1987: 42–3). For example, the Siam-Burma wars between the sixteenth and eighteenth centuries led to the loss of a large proportion of Siam's population. Battle casualties were normally minimal because the primary objective was to obtain captives to increase manpower. However, warfare caused considerable loss of population due to crop destruction and famine as well as the

death of war captives during transportation. Also warfare caused great disruption and uncertainty, creating a constant need for readiness for flight in periods of disorder. This "probably meant avoiding further births at least until older children were able to run for themselves" (*ibid.*: 42). Internal wars of succession were equally disruptive and destructive of population. For example, almost continuous warfare between rival claimants to the throne of Mataram over a period of eighty years until the Gianti peace of 1755, led to a drastic decline in population in Central and East Java (*ibid.*: 35, 42).

Stability and Change in State Systems

The causes of wars of succession and dynastic instability (limiting population growth) are to be found in the peculiarities of Southeast Asian social structure, in particular political conceptions and kinship systems. This is consistent with Friedman's theory of "reciprocal causality" (1974: 447) in which the productive forces (technological, environmental, demographic) create limits to the development of the social system which, in turn, can alter significantly those limiting conditions.

Leach argues that both the Roman and Chinese empires were essentially "bureaucratic" with delimited frontiers and with administrations in the hands of office-holders (1960/61: 54). These political systems possessed "an extraordinary degree of stability" because "the structure of authority was almost impervious to the effects of palace revolutions and dynastic change" (*ibid.*: 55). While this underestimates the extent of disruption caused by dynastic change in China, for example, there is an important contrast to be drawn with the Indian political model that prevailed in Southeast Asia. In this model the ideal ruler does not sit at the pinnacle of a bureaucracy but is a charismatic individual. This is consistent with Wolter's claim that leadership in the Indianized states of Southeast Asia was based on the attribution of personal spiritual prowess (1982: 103).

Interestingly Vietnam was no exception, despite the profound influence of the Chinese model on Vietnamese society. Thus, according to Taylor (1986: 140), the Ly kings of eleventh century Vietnam "did not accept the Chinese style of dynastic institution with a bureaucratic administration." Chinese forms were utilized for diplomatic purposes but the legitimacy of the rulers within the country depended on what Taylor refers to as "Ly dynastic religion" in which the Ly king's "superior moral qualities...stimulated and aroused the supernatural powers dwelling in the terrain of the Viet realm..." (*ibid.*: 143). The same indigenous, charismatic conception of sovereignty was still important at the time of the Nguyen emperors in the nineteenth century (Woodside, 1988: 12).

The bureaucratic nature of the Chinese polity influenced succession. Usurpation was quite rare because succession was governed by law. Each emperor had a single legitimate heir specified by rules of descent. Thus, bureaucratic legitimacy was, so Winzeler argues, a product of the Chinese system of kinship and descent (1976: 628). The corollary is that in Southeast Asia the predominant bilateral (cognatic) kinship system (and absence of unilineal descent groups) helps explain the cultural emphasis on charismatic rule as well as the unpredictability of succession. "Every monarch has a successor, but every succession is an issue of dispute" (Leach, 1960/61: 56). For example, in Java founders of new dynasties were

very often parvenus of humble origin who attempted to establish links with their predecessors through complicated and often falsified lines of descent (bilateral, ambilateral and affinal). However, this falsification was not for the purpose of demonstrating legal, inherited legitimacy but to provide ancestral links with the most illustrious representatives of those dynasties so as to tap their ancestral charismatic power (Winzeler, 1976: 628; Anderson, 1972: 26). Again, with regards to Cambodia, Kirsch argues against theories that royal succession was based on unilineal descent (either matrilineal or patrilineal as certain scholars have variously argued). Rather, Khmer royalty reckoned kinship bilaterally as did commoners. Due to royal polygamy there were numerous rival contenders to the throne (that is, half siblings with different mothers of queenly rank) who would emphasize both male and female links to mobilize political support for powerful kinsmen (1976: 198).

Lieberman has placed royal succession and internal political disorder in the context of the cyclical trends within pre-colonial polities of Southeast Asia. His description of the periods of Burmese political history from the late sixteenth century to the mid-eigteenth century (1984: 271–4) can be summarized as follows:

1. A period of powerful dynastic founders in which (administrative) elites were bound to the king "by desire to identify with conquerors of manifest charisma".
2. The charismatic attraction of later kings diminishes and is accompanied by endemic competition among elites (regional and central) for control of manpower. Factional and inter-regional conflicts were focused on royal succession.
3. Simultaneously there were "endemic aspects of peasant behaviour" which led to voluntary movement from royal to private service and provided the material basis for elite autonomy.
4. Elite autonomy hastened popular disorganization by creating more scope for service evasion and by increasing the labour and tax burdens on peasant clients who remained in royal service.
5. A period of prolonged disorder and dissolution of royal administration ensued, which undermined agriculture and inter-regional trade and caused a decline in population.
6. The final period of the cycle is that of recentralization in which a new king emerges from a peripheral area (undisturbed demographically by political disorder) and with the support of elites (who needed a monarchy to validate their status and prerogatives) and the peasantry (who were in search of a charismatic saviour to put an end to deteriorating conditions).

According to Lieberman (ibid.: 278–92), similar cyclical trends are found in earlier eras of Burmese history as much as in other Southeast Asian polities, for example, the Javanese kingdom of Mataram (from the seventeenth to eighteenth centuries) and the Siamese kingdom of Ayutthaya (from the fourteenth to eighteenth centuries). In his analysis of the history of the Northern Thai kingdom of Lanna, Anan Ganjanapan also describes alternating cycles of "loose" and "tight" state control over peasant labour during the period from the fifteenth to eighteenth centuries (1984: 32–4).

This evidence of political decentralization and recentralization would appear to confirm the assertions made by theorists of Oriental Despotism about the static and unchanging nature of "Asiatic" societies. However, Lieberman, in his analysis

of Burmese history, is adamant that cyclic change did not exclude *linear* trends (1984: 271). Elsewhere he criticizes the "Orientalist cliché of the unchanging East" and also the assumptions of historians of Burma (e.g. Harvey, Furnivall) that "these oscillations occurred within a static framework" and that British colonialism "revolutionalized an exceptionally insular society that had shown itself incapable of creative growth" (1987: 162–3). On the contrary Lieberman concludes that "the evidence suggests that between the nineth and late nineteenth centuries, Burma experienced a number of administrative, military and economic transformations" (*ibid.*: 164) – a progression, though discontinuous and interrupted, towards increasing political centralization (that is, both horizontal and vertical extensions of state authority) (*ibid.*: 192–3). Similar linear trends can be discerned in Southeast Asia as a whole.

Trade and State Development

While previous sections have concentrated on the organization of production, and the ecological, technological and demographic influences on state development, the following section will look at the vital question of trade (as social relations which determine the social form of the circulation and distribution of the products of human labour). Trade consists of both internal and external exchanges of products. Production for external trade is a particularly important factor in political evolution. "As production for exchange seems to be a constant factor in evolution we must deal with a system larger than the local political unit...if we are to understand its conditions of existence and transformation" (Friedman and Rowlands, 1977: 204).

The earliest states did not begin to form in Southeast Asia until very late in the prehistoric era, that is, from between 500 to 1 B.C. (Higham, 1989: 307). The critical factor, some argue, was not the growth of trade *per se* but of a particular kind of trade, namely in prestige goods. According to Friedman and Rowlands, the emergence of an economy based on prestige goods is related to the expanded use of such goods by the central authority to create political alliances with peripheral aristocrats – alliances which were possibly also reinforced by marriage ties (1977: 219, 224). This is supported by the archaeological evidence from mainland Southeast Asia in which the increased circulation of prestige goods (such as shells, ceramic vessels, silk, cloth and bronze goods) was found to be coincident with the emergence of proto-states (Higham, 1989: 187). Higham emphasizes, too, the importance of strategic location as a factor contributing to inequality of access to prestige goods and the centralization of political power (*ibid.*: 187, 233; Welch, 1989: 22). The formation of the proto-state of Phimai has been attributed to its strategic location on regional trade routes between the Khorat Plateau and the Chao Phraya delta in Siam (Bronson, 1979: 327). The emergence of proto-states in prehistoric mainland Southeast Asia is also related by some authors to the contemporaneous intensification of agriculture through the introduction of irrigation, the plough, and the water-buffalo (Higham, 1989: 236).

So, in the late prehistoric period trade flourished. But it was regionally confined: "...regional centres were inwardly focused, engaging in extensive contact with one another but in minimal exchange with other regions" (Welch, 1989: 19). This was

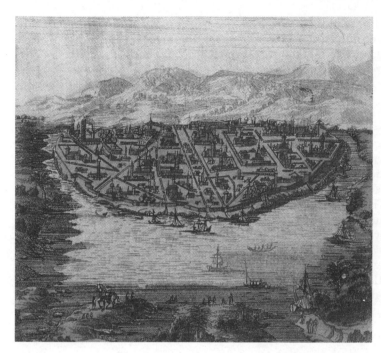

In Ayuthaya, the fourteenth century Siamese capital of the kingdom, royal monopolies controlled riverine trade on the Chao Phraya River and controlled sea ports in the Malay peninsula and on the eastern coast of the Bay of Bengal.
Courtesy of Revista de Cultura, 1991.

to change in the early centuries A.D. when Southeast Asia came to increasingly participate in the international trade between East and West. By the second century A.D., as the Central Asian caravan routes were disrupted by political turmoil, trade routes linking China, India and the Roman Empire were redirected through Southeast Asia, first via the coastal waters of mainland Southeast Asia and overland via the Kra Isthmus in the Malay Peninsula and later in the fifth century A.D. through the Straits of Malacca (Hall, 1985: 20–1). The expansion of the Roman Empire stimulated demand for luxury goods from the East (such as spices, aromatic woods, resins and cloth) and technological innovations in ship construction facilitated trans-oceanic voyages to India (*ibid.*: 28). There was also trade between Southeast Asia and India in response to India's need for a new source of gold (the medium of Asian trade) and inspired by Southeast Asia's reputation as the "Islands of Gold" (*Suvarndvipa*) (*ibid.*: 36; Coede's, 1968: 20).

The growth of inter-regional trade in the 1st millennium A.D. provided the impetus for further state development and political centralization. In particular, the expansion of trade with India in this period not only increased the volume of trade but also created new sources of coveted prestige goods such as glass, agate and carnelian (Higham, 1989: 312). Those rulers who occupied trans-peninsular and coastal estuarine locations (for example, from Funan and Champa in the mainland and Srivijaya in the Malay/Indonesian Archipelago) were in a strategic position to monopolize (through control of the river mouth and riverine communications) the burgeoning international commerce and bolster their political power vis-à-vis up-river chiefs (*ibid.*: 312; Hall, 1985: 3). Furthermore, foreign traders were more easily controlled and these cosmopolitan ports more easily taxed (due to their high profit margins), thereby increasing the potential wealth that could be tapped by coastal rulers (Bronson, 1979: 333).

A major threat to the wealth and power of a coastal ruler was competition from rulers of adjacent river-mouths. Success in naval warfare appears to have been crucial in eliminating the commercial threat of rival neighbours. The power of the early states of Champa and Srivijaya was due to supremacy in naval warfare as a means of ensuring strategic control over international maritime trade routes (Hall, 1985: 13–15).

There was a later trade boom in Southeast Asia between the fifteenth and seventeenth centuries, a period Reid refers to as "the age of commerce" (1990). The boom was a consequence of a surge in trade between China and the Mediterranean via Southeast Asia, caused by the collapse of the re-established Central Asian overland routes in the fourteenth century and by a huge increase in demand for Southeast Asian products, particularly spices, from Europe, China and Japan (*ibid.*: 5). The upturn in demand from China from the end of the fourteenth century coincided with two centuries of economic and demographic growth in China. This flourishing trade was facilitated by the use of Southeast Asian trading ships ("junks") of 200 to 500 tons which allowed transportation for the first time of bulk cargoes (Evers, 1987a: 755). China was the dominant market for Southeast Asia until the sixteenth century; thereafter, while remaining substantial, it was superseded by demand from the West due to Portuguese, Dutch and British competition for spices.

Impact of European Traders on Regional States

The Europeans competed to achieve a monopoly over the spice trade. It was for this purpose that the Portuguese conquered Malacca in 1511. But they did not have the shipping or manpower to impose a monopoly on the trade or to control production (McKay, 1976: 102). Rather, the Portuguese presence in the region served to stimulate the growth of new Southeast Asian trading centres (Aceh, Johor, Banten, Makassar) and, consequently, all ethnic groups prospered (*ibid.*: 103, 108). This prosperity saw the development in Southeast Asia of large, wealthy, bustling, cosmopolitan, port cities, which were open to new ideas and technologies (e.g. writing, arithmetic, firearms) and in which there was considerable scope for social mobility (Reid, 1979: 38).

The Dutch (through the Dutch East Indies Company) were successful in establishing control, sometimes by very ruthless methods, over the Spice Islands (Molucca, Ambon, Banda) and in monopolizing the spice trade in the Malay/Indonesian archipelago. Contacts between Dutch merchants and Indonesian princes provided for the exclusion of all other Indies and European powers (McKay, 1976: 118). Dutch political domination of this region was achieved by the end of the seventeenth century. Only Johor in the Malay Peninsula remained independent (*ibid.*: 113–15). Malacca fell to the Dutch in 1641. Banten (in West Java) lost its independence in 1684. The Central Javanese kingdom of Mataram progressively succumbed to Dutch political control in the second half of the seventeenth century (*ibid.*: 112–14; Lieberman, 1990: 77).

In the Malay/Indonesian archipelago Dutch victories "irrevocably fragmented indigenous political authority" and, in particular, the once powerful kingdom

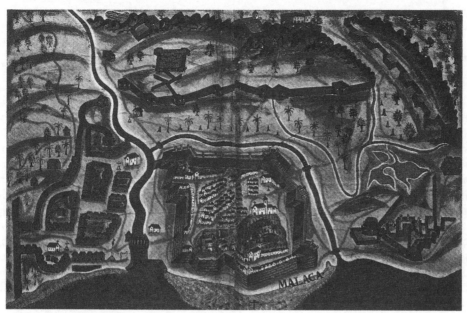

Malacca under Portuguese rule in 1634.
Courtesy of Revista de Cultura, 1991.

of Mataram "lost commercial revenues indispensable to political centralization" (*ibid.*: 77). However, the situation was different in mainland Southeast Asia. European intervention here was limited, at least until the nineteenth century, and trade with Europe, India and China expanded unabated. For example, in Siam the volume of maritime trade apparently doubled between 1500 and 1560 (*ibid.*: 81). At the end of the seventeenth century there was another surge in foreign demand – now more for bulk exports from the mainland, including rice, timber, and raw cotton (*ibid.*: 81). The revenues from maritime trade enhanced the tax base of the mainland states. "Burmese, Thai and Vietnamese authorities milked international trade through a combination of customs duties, pre-emptive purchase and resale of imports, and overseas trading ventures" (*ibid.*: 82). The wealth generated was not only derived from *entrepôt* trade but also from production for export of goods such as rice, sugar, pepper, cotton, timber, ships and ceramics (*ibid.*: 83).

Another important development in the mainland was the large-scale importation of foreign bullion (gold, silver) to service the expanding economies. This led to the gradual monetization of local economies. Cash taxes are easier than taxes in kind to collect from domestic traders and peasants and this strengthens the state's capacity to extract revenue from internal commerce (Lieberman, 1987: 177; 1990: 83–4).

Trade and State Transformation

The burgeoning trade-based wealth of the mainland had far-reaching political implications: first it was used to gain the allegiance of local officials through

patronage and, second, to finance military campaigns. Military campaigns were often directly linked to the control of trade routes, particularly in the case of the frequent wars between Siam and Burma (Evers, 1987a: 756). And the success of these campaigns came to depend heavily on European firearms and mercenaries (Reid, 1979: 42; Lieberman, 1990: 81). For example, Portuguese arms and mercenaries (who could only be hired for cash) played a significant part in the territorial expansion of Burma in the sixteenth and seventeenth centuries (Lieberman, 1980: 207).

The end result of these economic and political changes in mainland Southeast Asia was increased political centralization in terms of both external expansion and internal consolidation (Lieberman, 1990: 85). Thus, whereas in the mid-fifteenth century there were fifteen independent kingdoms in the mainland, there were only four major powers by the mid-eighteenth century, with others being converted into provinces or vassals (ibid.: 79). Internal consolidation, beginning variously from the late sixteenth century to the early seventeenth century, took the form of the appointment of royal officials to replace the hereditary princes to govern outlying regions (Tambiah, 1976: 136; Akin, 1969: 75; Lieberman, 1987: 176) and the use of various methods of asserting greater control over non-royal officials: increased personal dependence on the king by the hiring of foreigners to act as bodyguards and conduct foreign trade, and the use of personally dependent eunuchs (Wyatt, 1982: 108; Woodside, 1988: 63, 66); the appointment of spies, censors, military commissioners, etc., for the surveillance of provincial officials and to transmit local information to the king (Tambiah, 1976: 111; Akin, 1969: 75; Lieberman, 1987: 176; Woodside, 1988: 63); the abrogation of the right of provincial governors to appoint important subordinate officials (Akin, 1969: 75), as well as the periodic circulation of officials to prevent them from developing local power bases (Woodside, 1988: 63).

Magico-religious Ideas and State Development

In his book, *The Mental and the Material* (1986), Maurice Godelier provides some fruitful theoretical ideas for examining the role of magical and religious ideas in state formation and political centralization. He is critical of arguments which say that the relationship between infrastructure (forces and social relations of production) and superstructure is one between material and non-material institutions (e.g. kinship, religions, political), and views them as merely distorted, "imaginary" reflections of underlying material reality (ibid.: 9). Godelier argues that one cannot separate the material and non-material in this way. There is "a mental component at the core of our material relations with nature" (ibid.: 11). Thus, the origins of the state may lie in the realm of the sacred (ibid.: 16). In the early state certain magical and religious ideas not only had an "ideological" function of legitimizing domination and exploitation but, simultaneously, also functioned as social relations of production; that is, religion was "not a reflection but a component in the internal frame-work of the production relations" (ibid.: 160).

Paul Mus' (1975) analysis of the "cults of the soil" contains ideas similar to those of Godelier. These cults are a religious system which emerged in prehistoric India, China, and Southeast Asia with the development of sedentary agriculture and proto-states. In the religious rituals of these cults the chief is seen as the intermediary between the earth deity and ancestors, on the one hand, and the community, on the other (ibid.: 17) and in the chief "resides the power which assures the fertility of animals and plants, and in general the good fortune of the group" (ibid.: 15). The linga cult of Champa and the phii muang cult of the Tai people (Davis, 1984: 273–5) are examples from mainland Southeast Asia of "cults of the soil" (or territorial cults as they are sometimes called). A slightly different variant is that of the Spirit-Ancestor cult of the Kachin of Burma. According to Friedman, the Kachin community feasts, mentioned above, have the dual function of legitimizing the chief (through the distribution of surplus) and the propitiation of higher earth and celestial spirits (through the intercession of the ancestors of local lineages) in order to increase the wealth and prosperity of the entire group because surplus is not seen as a product of human labour but as "the work of the gods" (1975: 172). Thus, "economic activity in this system can only be understood as a relation between producers and the supernatural" (Friedman and Rowlands, 1977: 207).

A similar line of thought leads Godelier to conclude that the early state probably emerged less from the exercise of violence but from the consent of the dominated – a consent based on shared beliefs in which relations of domination and exploitation are perceived as an exchange of services (the invisible supernatural services of the ruler for the visible material services of the ruled) (1986: 12, 13, 160). Nor can the services performed by the ruler be defined as imaginary for: "The monarch's powers over the invisible world were...supposed to prove their worth in the visible world of the people's daily existence" (ibid.: 17). Magico-religious ideas on which consent was based often changed under the influence of creative rulers, and played a crucial role in the process of political centralization. We can see this process at work in the influence of Indian magico-religious ideas on state formation in Southeast Asia.

Indian magico-religious ideas were affected by two processes which were not mutually exclusive: localization and universalization. Regarding localization Mus argues, for example, that the stone phallus (linga) of the cult of the Indian god Siva in the early "Indianized" state of Champa was equivalent to the post, trees and stones in which the earth deity and ancestors were believed to materialize (1975: 31–2). "The Hindu guise was assumed in Champa: beneath it the local gods were preserved, but repainted in much more intriguing colours" (ibid.: 39). Again, Nidhi claims that in later Khmer cults Siva was transformed, in part, into a local territorial deity and closely identified with the indigenous Khmer tradition of ancestor worship (1976: 114, 116).

Wolters, however, alerts us to another, universalist dimension to Indian ideas which were crucial for political centralization. In the early historical period the dominant impulse in Hindu religious belief in Southeast Asia was a "devotional" and personalized one centred on Siva and other Hindu gods, with an emphasis on creating a close relationship with the god through asceticism and on the ascetic ideal of "heroic prowess" (1982: 10). Hindu devotionalism contributed in two ways to the development of Southeast Asian conceptions of political authority. First, the ruler's ascetic virtuosity was evidence that he had a closer relationship to Siva

(the patron of asceticism) than anyone else. This made possible "a heightened perception of the overlord's superior prowess...." (Wolters, 1982: 10). Second, Siva was also the sovereign deity who created the universe, the "absolute Siva" (*ibid.*: 11; Nidhi, 1976: 113). Thus, "the chief's prowess was now coterminous with the divine authority pervading the universe" (Wolters, 1982: 11). With reference to these "heightened self-perceptions" Wolters notes that in seventh century Cambodia Jayavarman I "seems to have recognized the obligation of bringing northwestern Cambodia under his influence in order to make good his claim to overlord status" (*ibid.*: 11). This statement has important theoretical implications for it implies that religious *ideas* constitute a primary impetus for political expansion.

It is probable that similar heroic ideas influenced the expansionist, centralizing policies of Tai chiefs between the thirteenth and fifteenth centuries. The French anthropologist Georges Condominas claims that the first phase in the evolution of Tai political systems was one in which loose "confederations" of Tai principalities (*muang*) were formed as the Tai "war chiefs" pushed westward from what is now northern Vietnam and northeastern Laos. The second phase was a consequence of one of the chiefs imposing his authority on a group of *muang*, thereby creating a larger, more centralized state (for example, Lan Na centred on Chiang Mai, Lan Sang on Luang Prabang, Siam on Ayutthaya) (1990: 37–8). Chroniclers portray those successful expansionist chiefs as "hero creators" of new states (*ibid.*: 40). These new, more centralized states comprised "a kingdom of kingdoms" (Lehman, 1984: 243) and fit Tambiah's definition of a "galactic polity" (1976: Ch. 7) and Southall's "segmentary state" (1956).

Cults and Political Centralization

Let us return to Cambodia and the Devaraja cult initiated by Jayavarman II. Jayavarman's Devaraja cult incorporated local deities, in particular ancestor worship, into a state-wide cult whose political function was an internally integrative one that promoted centralization. Jayavarman II and the Khmer monarchs who succeeded him fused the worship of Hindu deities such as Siva with the local deities and ancestor spirits. They even installed the local deities in the King's "Hindu" temples to symbolize his control and supremacy over the autochthonous protective forces of the realm (Hall, 1985: 141; Nidhi, 1976: 133).

The subordination of local gods and ancestral spirits to the centre, also discussed by Nicholas Tapp in Chapter 11, entailed the subordination of local temples which were the sacred physical focus of the local ancestral cults led by local landholding elites. These local or regional elites patronized local temples by means of a variety of merit-making gifts (e.g. land). Local temples were thus repositories of economic resources, such as land, its produce and the labour to work it (Hall, 1985: 149). Through the *Devaraja* cult local temples were subordinated to central temples strategically located throughout the Khmer Kingdom and part of the wealth collected from the local temples was directed to the state temples. Thus, these temples, says Hall, "were not just religious centers but were important links in the state's economic and political network. Religion supplied an ideology and a structure that could organize the populace, tap this production, and secure a region's political subordination, without the aid of separate, secular, economic or

At Angkor Thom the Khmer King Jayavarman VII built images of Bodhisattvas after his own likeness. Khmer monarchs were god kings. Courtesy of Kelvin Rowley.

political institutions" (*ibid.*: 153). Here we have cogent support from historian Hall for anthropologist Godelier's claim that in early states magical and religious ideas may function as social relations of production, as well as "dominate" the social life of a society (1986: 20).

Buddhist conceptions also had "universalist" characteristics with centralizing implications for state development. Strong, ambitious rulers commonly identified themselves as *Dharmaraja* ("Righteous Ruler") and *Cakkravarti* ("Universal Monarch" or, literally, "He Who Sets Rolling the Wheel of the Buddhist Law"). The emphasis in both is on rulers as protectors and exemplars of the Buddhist

dharma as a universal moral law and therefore on the supreme moral qualities of the ruler by contrast with the more military, war-like virtues of the "men of prowess" associated with Sivaism. However, these apparently contradictory qualities were not, in practice, mutually exclusive. For example, Jayavarman II identified himself both with Siva and with the Cakkravarti (Nidhi, 1976: 107, 109).

The political centralizing consequences of Buddhist "universalist" conceptions of Kingship are highlighted in Taylor's analysis of a national cult of royal authority in eleventh century Vietnam which he calls "Ly dynastic religion". It was the role of the Buddhist Ly Kings to create personal relationships of trust and loyalty with the numerous local deities (which protected powerful local clans) in order to incorporate them into the centre. This was made possible through the development of Buddhism as a national "civilized" culture in which local spirits were declared supporters of royal authority and as protectors of Buddhist religion because of the superior "moral and spiritual qualities" of the Ly Kings (1986: 143). Thus, the process of domesticating local spirits also served to enhance the political authority of the centre and its control over regional powers. Central authority, however, was fragile. The powerful regional clans were loyal because they "believed" in the Ly Kings. But local autonomy was never extinguished and indeed reasserted itself when the charismatic hold of the Ly Kings eventually waned. Thus, Taylor concludes that "the Ly dynasty was essentially the growth and decay of a religious idea" (*ibid.*: 170), thereby implicitly affirming the primacy of ideas in the process of political centralization.

The Burmese national cult of the thirty-seven *nat* (spirits/deities), initiated by King Anawratha of Pagan in the eleventh century, provides an interesting comparison with the Khmer and Vietnamese cults discussed above. The cult reflected Hindu/Buddhist cosmology with the Indian god Indra (identified with the Burmese King) in his abode on the top of Mt. Meru ruling over the thirty-two gods of the Tavatimsa heaven. Melford Spiro surmises that the *lokapala* (guardians of the four quadrants and protectors of Buddhism) were added to make up the thirty-seven *nat* (1967: 52). He also concludes that the political order was thereby created as a microcosm of the supernatural order. However, he adds that: "There are some grounds for believing that the *nat* structure not only reflects, but was instituted by, the political structure and more specifically, by the throne". Thus, each of the thirty-seven *nat* acquired an extensive fief through royal edict (*ibid.*: 133). These spirits ("lords") appointed by the King replaced local guardian spirits and, consequently, the monarchy ceased to be dependent upon local cult leaders descended from the cult founders. According to Lehman: "This, symbolically, goes a long way towards making it possible to do without a nobility, whose claim to recognition is more often than not based at least in part on the ideology of the founder's cult" (1984: 273). Here, therefore, we have a case of local cults (and their political loyalties) being eliminated altogether not just incorporated into state cults as in Cambodia and Vietnam.

Pre-modern Centralized States

Among the most centralized of the pre-modern states in Southeast Asia were Vietnam and Siam (Thailand) in the nineteenth century. In these states Neo-

Confucianist and Theravada Buddhist orthodoxies were critical to the process of internal consolidation.

Reference has already been made to the coexistence in Vietnam of the Chinese "bureaucratic" model and an indigenous charismatic tradition – what Woodside calls the Vietnamese "dual theory of sovereignty" (1988: 10). In the early 1800s the Nguyen emperors were committed to the goal of strengthening central government control and, for this purpose, they emulated the Chinese model more closely than the emperors of any other dynasty (ibid.: 27). The Chinese model, derived from Chinese classical political theories, embodied the following political attributes (ibid.: 62–5): first, an intricately graded hierarchy of officials headed by the Emperor (as "Son of Heaven"); second, obedience of officials to the emperor based on filial loyalty, that is, on personal father-son type relationship (an essential aspect of Confucian idealism); third, Chinese bureaucratic devices to control officials (such as personal interviews); fourth, the Confucian ideal of the "generalist" scholar-official (mandarin) who was dispensable due to lack of specialized administrative skills.

The Nguyen emperors exhibited a corresponding hostility towards aspects of indigenous village culture. For example, Emperor Gia Long prohibited the consumption of wine and meat at communal discussions of village business, and indulgence in the "hundred amusements" (such as cock-fighting), and restricted the frequency of village singing and musical demonstrations (ibid.: 27–8). His successor, Minh-mang also attempted to ban village operas (ibid.: 27). There were several reasons for these attitudes and policies. As in China there was Confucianist contempt at court for the vulgar "Little Tradition" of village life. Also, it was felt that local folk customs, if allowed to flourish, would undermine the diffusion of Confucian values by local mandarins as well as threaten Confucian education at the local level on which bureaucratic recruitment and the process of administrative centralization depended (ibid.: 28). Finally, local folk customs sometimes expressed political disloyalty, as in the case of the village operas which "often mocked court ritual" (ibid.: 26).

Theravada Buddhist orthodoxy served a similar function in nineteenth century Siam. The chaos that followed the capture and sacking of Ayuthaya by the Burmese in 1767 was ended by a charismatic military leader (a phumibun or "man of merit") called Taksin who established himself as King at the new Siamese capital at Thonburi (near present-day Bangkok). However, Taksin was soon deposed by Rama I, founder of the present Cakkri dynasty. As part of his programme of restoring the Siamese Kingdom Rama I moved quickly to expand the rule of the central government over the provinces by, amongst other things, establishing central control over the Buddhist monkhood (sangha) (Tambiah, 1976: 181). This was not entirely new – strong Buddhist rulers had taken similar measures in the past. What was creatively new was Rama I's "subtle revolution" in ideas (Wyatt, 1982). Unlike Taksin, Rama I "predicated his restoration not only on charismatic inspiration but on the methodological work of systematizing the religions, legal and literary heritage of Ayutthaya" (Keyes, 1989b). "All of Rama I's innovations... involved a change in focus that brought rational man clearly to the center of the stage of history..." (Wyatt, 1982: 40).

The fertile seeds planted by Rama I bore fruit several decades later with King Mongkut (1851–68). Mongkut was a monk from 1824 until 1851, when he became king. He founded the reformist Thammayut sect in the late 1830s. This sect,

*Students pay homage to the statue of King Chulalongkorn at the Royal Plaza in Bangkok,
Thailand, on 24 October morning, marking the seventieth anniversary of the death of the
king who reigned for forty-three years. He died at the age of fifty-eight.*
Courtesy of Associated Press.

under his inspiration and guidance, espoused a radically new nationalist Buddhist
philosophy which rejected the traditional view of the world as a reflection of the
cosmos in favour of a world comprehended in natural, scientific terms. The sect
also had a pronounced scripturalist orientation with an orthodox obsession with
separating the pure pristine practices of the Buddhist (Pali) canon from impure
accretions (e.g. myths, cosmologies, magical practices) and with an emphasis on
textual learning (Tambiah, 1976:211–14; Keyes, 1989b).

The political aspect of the Thammayut reformist movement was that it became
closely linked, under Mongkut its founder, to a powerful and privileged royalty
(Tambiah, 1976:215). Some of the highest ranking monks in the sect were princes.
With elite support, missionary zeal and tightness of organization the sect became
an important agent in the extension of central government control over outlying
regions. For example, in the Northeast region, which had hitherto been relatively
autonomous, government administration and the Thammayut sect expanded
synergistically. Educational and administrative reforms in the regions involved
both Thammayut (particularly the *pariyat* or "book-learning" monks) and civil
administrators. For this reason civil administrators offered considerable support
to Thammayut monks, especially in the setting up of monasteries in the Northeast
(Taylor, 1989:171). Thammayut also incorporated forest-monks who were inspired
by the same purist orthodoxy, though emphasizing meditation "practice" rather
than "learning" and who, through their wanderings, played a key pioneering role
in the expansion of the state. The growth and ramification of forest *samnak*

(branch monasteries) "frequently paralleled the establishment of localized bases of state expansionism" (*ibid.*: 482).

Coercion and Consent

Godelier has emphasized the importance of the consent of the dominated in the early state. However, he does not exclude the use of violence. Violence and consent are indissolubly linked in the process of domination, though consent is the strongest component (1986: 156). The presence of violence implies that "consent, even when passive, is never shared by all individuals and groups in society and, when it is active, it is rarely free from reservations or contradictions" (*ibid.*: 157). The issue of the limits to consent has been highlighted by James Scott whose pioneering work has analyzed various forms of "symbolic opposition" to elite values which may be expressed in the peasant "Little Tradition" through folksongs, proverbs, humour, popular theatre, and folk tales (1980: 69) as, for example, in the above-mentioned case of the Vietnamese village operas which "mocked court ritual", etc. The most radical form of this type of opposition are millenarian movements, discussed further in Chapter 11, which envisage, in times of extreme coercion and exploitation by elites, a complete reversal of the world as it is, into a utopia of equality, justice and material abundance (Scott, 1977).

The army is the coercive arm of the state. The Thai military have played a key role in the maintenance of the state in Thailand.
Courtesy of Shosuke Takeuchi.

The Modern State

Modern nation-states in Asia emerged either as creations of European powers or in response to Western penetration of the region. As already noted, Europeans first came in search of trade. They gained a political foothold in the region with the Portuguese conquest of Malacca in 1511. The Dutch, following the establishment of the United East India Company in 1602, from their base in Batavia (now Jakarta), gradually extended their influence over the Indonesian archipelago, through their powerful navy. The assertion of Spanish control over the Philippines was slow, from the end of the sixteenth century to the middle of the eighteenth century, though the southern Muslim areas were never really brought under effective control. The first British settlement in the territory of modern Malaysia was established on the island of Penang in 1786; yet it was not until the beginning of World War I (1914–18) that British paramountcy was extended to the whole of Peninsular Malaysia and the Straits Settlements (including Singapore). British and French colonization of Burma and Indochina was over a much shorter time span – in Burma from the 1820s (following the First Anglo-Burma War) and the annexation of Arakan and Tenasserim to the 1880s with the extension of control over Upper Burma. France's colonial domination of Vietnam, Cambodia and Laos took only twenty-five years, initiated by a French invasion of Vietnam in the late 1850s.

Thailand is the only Southeast Asian nation never to be colonized by a European power, though the British did gain significant economic and political influence in the country from the Bowring Treaty of 1855 (e.g. free trade, extraterritorial rights, etc.). Japan and China also resisted European colonial control, but China was subjected to ongoing intervention and the devastating Opium Wars of the mid-nineteenth century.

There are two principal components of the modern state: sovereignty and government. The sovereignty of the modern state has both internal and external aspects. Internally the state exercises supreme coercive authority (i.e. it monopolizes the use of force) through which it ensures obedience to laws. Externally, it claims supreme autonomy in international relations. The corollary is that every piece of the earth's surface must be the rightful legal possession of one and only one state. There can be no overlap between the territories of two adjacent states, which thus require clearly demarcated boundaries. This has caused endless troubles for ethnic groups which overlap these borders (Wijeyewardene, 1990). The present-day national borders in Asia, with minor modifications, are the same as those either drawn or enforced by the colonial powers.

Modern government also has a "pastoral" concern with the welfare of the population, adopting measures to improve health and increase wealth (Foucault, 1979: 5). This requires the accumulation of knowledge proper to government – a knowledge of all the processes of population (mortality and morbidity rates, cycles of scarcity, etc.), that is, the science of political economy (*ibid.*: 18). Moreover, the population emerges as a field of intervention and an object of government surveillance (*ibid.*: 19).

Both with respect to geo-political organization and economic organization the modern state differs fundamentally from the pre-modern "segmentary", "galactic" or even "bureaucratic" state in Asia. In these the power of the ruler wanes as one moves further away from the centre; consequently, there are no clear-cut boundaries

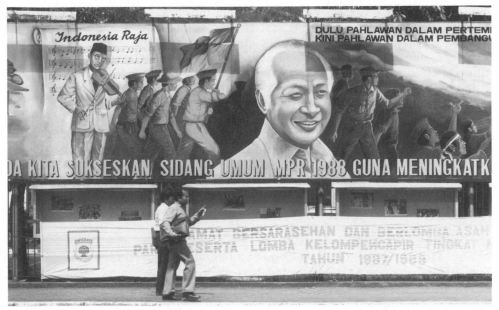

This poster from Indonesia illustrates how governments integrate their destiny with the destiny of their nations.
Courtesy of Marlane Guelden.

and neighbouring states have "interpenetrating political systems" with "zones of mutual interest" between them (Leach, 1960/61:50). Furthermore, in the pre-modern state the economy is organized as if it is a family or household. This aspect of the pre-modern state is highlighted by Max Weber in his analysis of "patrimonialism" (1968). For Weber there is a close link between patrimonialism and patriarchalism. Patriarchal domination is based on the authority of the master over his household. Under patrimonial rule the authority of the ruler over his personal dependants and political subjects is analogous to the authority of the patriarch over his household. The patrimonial state is the patriarchal household writ large. State offices originate in the household administration of the ruler, that is, state administration is an extension of household administration. By contrast, with the development of the modern state and the science of political economy the economy is disengaged from the family and recentred on the problem of population on the assumption that the population has its own regularities which statistics demonstrate are not reducible to the family (Foucault, 1979:17).

It is "government" and the science of political economy which provide the foundation of the modern bureaucracy, with its formal rules, professionally-trained salaried officials and specialized government institutions – all concerned with the rational servicing of the needs of the population. In the colonial states the "pastoral" concern for the welfare of the natives – imbued with a strong sense of paternalism and cultural superiority – was expressed in terms of "white man's burden" in the British colonies, "mission civilisatrice" in French Indochina and the "ethical policy" in Dutch Indonesia. However, the costs of financing a growing number of professionally trained, salaried colonial bureaucrats became increasingly "burdensome", especially during the lean depression years of the 1920s and 1930s.

One solution was to replace many of the European officials with natives. Recruitment, however, required education, sometimes abroad, and this education brought the native intelligentsia into contact with Western ideas of nationalism, socialism, and democracy. These ideas inspired the anti-colonial struggles which culminated in the gaining of Independence after World War II (1939–45).

In non-colonial Siam (Thailand) this process began in the 1890s. Here, following wide ranging modernizing reforms initiated by King Chulalongkorn (Wyatt, 1982: 208–11), the new breed of bureaucrats "consciously followed European administrative organization and behaviour, kept regular office hours, dressed in modified European fashion, and began to conduct business in a pattern of paper-work quite unlike the personal administration of their elders" (Steinberg, 1987: 205). In Japan the process began somewhat earlier after the Meiji Restoration of 1868, whereupon the Japanese began to learn from and emulate European administrative methods, especially German ones. China, by contrast, fell into increasing chaos, and a modern rational bureaucratic state only came fully into existence following the communist revolution in 1949.

The darker side of the development of modern "government" is that the bureaucratic management of a population creates a "disciplinary society" with increased surveillance and control (Foucault, 1979: 10, 19). Evers has called this process "Orwellization", that is, increased state control over the lives of citizens in ways that limit human rights and individual freedom (1987b: 667–8). Evers asserts that Orwellization has increased in post-independence Asia with its massive increase in the number of bureaucratic personnel which he describes as "runaway bureaucratization" (*ibid.*: 673). In this Orwellian sense, he adds, the modern state is much more despotic than even the most centralized pre-modern state in which "bureaucratic-Orwellian control was almost non-existent" (*ibid.*: 669).

The "Developmental" State

In the post-independence period state intervention for the welfare of its citizenry (still predominantly rural) has been expressed in terms of ideas such as "modernization", "development", "progress", and "democracy". This incremental intervention has had far-reaching structural implications for state-village relations comprising "two contradictory but co-existing political processes of citizen participation (by which the village becomes part of the state) and extended domination (by which the state becomes part of the village)" (Hirsch, 1989: 54). In Thailand and Indonesia, for example, parallel and closely related processes are those of the gradual erosion of village autonomy and the emergence of village headmen and other members of the village elite as agents of state interests rather than, as formerly, protectors of village interests against the state (*ibid.*: 53; Moerman, 1969; Hart, 1989).

These structural contradictions have linguistic analogues in state discourses. In Thailand, for example, keywords in this discourse are "development" (*patthana*), "progress" (*caroen*), "participation" (*kaan mii suan ruam*) and, during the rule of Field Marshall Sarit in the 1960s, the "Thai way to democracy" (*prachatipati baeb Thai*). In Indonesia the keywords in the discourse of the post-1965 New Order government have been *Pancasila* (the five principles of Belief in One God,

National day celebrations are used by all states to gain legitimacy. Here young Malaysians participate in national day celebrations.
Courtesy of Star Publication.

Humanitarianism, National Unity, Democracy, Social Justice), "mutual assistance" (*gotong royong*), "modernization" (*modernisasi*) and "development" (*pembangunan*) (van Langenberg, 1986).

Yet, the ostensibly benevolent and democratic significance of these terms cloaks contradictory authoritarian interpretations by the state. Thus, Sarit's "Thai way to democracy" was to be achieved within the framework of a highly conservative, hierarchical political order (Thak, 1974:211). Again, in the post-Sarit era in Thailand the state's view of popular participation means mobilizing villagers in state-controlled institutions rather than articulation of villagers' interests. Moreover, villagers' efforts to set up autonomous associations (to serve their own perceived economic and political interests) have usually been met with distrust by state officials and with accusations of illegality or of being Communist inspired, and even disbandment (Cohen, 1981). Also, popular participation in village meetings is superficial, for these meetings have now been coopted by the State for the dissemination of official policy by district officials, local headmen, and police and army officers (Hirsch, 1989:46).

Socialist States

What about the socialist states of Asia? Has Orwellization progressed further there, as one might expect? As already indicated the modern state only took root

The Lao socialist state celebrates its tenth anniversary.
Courtesy of Grant Evans.

in China after the communist revolution, and an "Orwellian" system is now
fully entrenched there. In Vietnam and Laos modernizing and developmentalist
discourses take the form of the "three revolutions" (in relations of production, in
science and technology, and in ideology and culture, with the aim of producing a
"new socialist man"). Grant Evans' recent study of Laos (1990) argues that co-
operatives were to play a key role in the socialist transformation of Laos, not just
as economic institutions but also as political ones used for mobilizing and educating
peasants and raising their political consciousness. Cooperatives were also seen as
the socialist answer to promoting citizen participation in the political system
(*ibid.*: 182). Administrative changes were introduced to enhance state control of
villages. Administrative committees were established at the provincial, district
and sub-district level. Paralleling and often overlapping this civil administration
is the party organization which has the aim of ensuring "the party's all-round
absolute and direct leadership over all links, from the mapping out of lines and
policies, to the organization of execution and control" (*ibid.*: 184). However, in spite
of these totalitarian pretensions, the influence of the party in practice wanes the
further down the bureaucratic hierarchy one gets and is often non-existent at the
village level (*ibid.*: 184), and mass organizations are hardly operative in many rural
areas (*ibid.*: 188). Paradoxically some state policies have discouraged supra-local
organization and identification. For example, restrictions on the movement of
people tended to reinforce local allegiances and village corporateness, leading
increasingly to dissociation between village and state (*ibid.*: 188). This state-village
hiatus is also exemplified in the difficulty the state has had in commandeering
rice from the peasantry and the eventual collapse of the cooperative movement in

the late 1970s. The corollary of village autonomy and corporateness is that village leaders are reluctant to assume official positions or, if they do, tend to side with village interests by refusing to enforce state decisions (*ibid.*: 190). A similar situation prevailed in many lowland rural areas in Thailand as late as the 1950s and 1960s (Moerman, 1969) but has given way, as pointed out above, to a situation in which the loyalties of village officials are much more biased towards the state and its interests.

Dissent

In non-socialist states religious reformist movements presently provide a powerful voice of dissent against the secular values – Western, capitalist, materialist – that underpin state developmental discourses. In Malaysia and Indonesia this religious form of dissent has been expressed most stridently through *dakwah*, a term which refers to a broad movement to spread and purify Islam and to organizations created specifically for that purpose. The *dakwah* movement is particularly influential among students (Anwar, 1987; Muzaffar, 1988). The *dakwah* reformists regard Islam holistically as a "way of life" and call for the creation of Islamic economic, legal, and educational systems and, in Malaysia at least, the formation of an Islamic state.

In Malaysia the government party UMNO (United Malays National Organization) initially tried to keep religion and politics separate, but has recently attempted to co-opt its *dakwah* critics by appealing to Islam for legitimacy and beginning a process of Islamization for Malaysia (e.g. Islamic Banking, International Islamic University), though without any commitment to an Islamic state. By contrast, under the New Order government of Indonesia military power has been consolidated and there has been a corresponding elimination of meaningful Islamic influence in the state through close bureaucratic control of Islamic institutions and through the promotion of *Pancasila* as the only permissible state ideology (McVey, 1983; Hassan, 1987).

In Thailand Buddhist reformism also has a holistic perspective which rejects the separation of religion and politics (Jackson, 1989). While this has not led to a demand for a Buddhist State it has spawned a political party, *Phalang Tham* ("Power of the Dhamma" [Buddhist Moral Law]), which achieved a landslide victory in Bangkok in the recent (1992) national election. A holistic view is also evident in the writings and speeches of prominent Thai intellectuals who have espoused a "Buddhist Road to Development" as an independent, indigenous model which relates development to religious goals. They express a particular concern for the negative effects of capitalist development in rural areas and advocate a more self-reliant agricultural economy, appropriate technology, and even the revival of the cooperative institutions of "communal culture" (Sulak, 1989); TDN [14]: 1987).

The State of State Studies

In this chapter I have highlighted the contribution of anthropology to the understanding of state formation and the evolution of the pre-modern state in

Asia. Anthropology has had less to say, to date, about the modern state, conventionally considered the domain of the philosopher, historian and political scientist. But this need not be so. What future direction of research might lead to a higher profile for anthropology in this field? Anthropology – the "Science of Man" – has always been catholic and eclectic in orientation, with a proclivity to reach out to other disciplines for inspiration and new ideas. In this regard I believe the philosopher Michel Foucault's analysis of power offers important possibilities for future anthropological research on the state.

I return to Foucault's distinction between "sovereignty" and "government" used in previous sections. Sovereignty, I reiterate, is concerned with the exercise of supreme coercive authority through which obedience to laws is ensured. Most conventional analyses of power have focused on the sovereighty of the state as a monolithic, hierarchical entity and on the state apparatuses of power (army, police, courts) through which the coercive authority of the state is exercised. However, the analysis of power from the perspective of "government" leads in another direction. Government is concerned with the tactics and techniques of power over bodies – social and individual. For an understanding of government, therefore, analysis must proceed from a micro-level because power operates in a "capillary" or net-like fashion from below, rather than being imposed from the apex of a social hierarchy, and the tactics and techniques of power are embodied in a multiplicity of local and regional institutions.

The work of anthropologist Andrew Turton on Thailand provides us with a paradigm, worthy of emulation for future anthropological research. Based on what Foucault calls the "microphysics of power", and using largely anthropological field work – for such localized forms of power are amenable to the traditional anthropological research method of participant observation – Turton examines a wide range of "ideological" or "discursive" forms of domination and "forms of social discipline" (e.g. regulations, registrations, supervision, surveillance) in Thai society. For example, accusations of being a "communist" may be used to stifle legitimate grievances against state policies or its officials:

> There is a range from relatively weak forms of innuendo, insinuation, rumour and smearing, to stronger forms of vilification and defamation (sai rai pai si). Anonymous leaflets may be circulated. Private warnings may be given about a specific person or group, by peoples with authority or who claim connection with such persons. Warnings or accusations may be made in public meetings: periodic official meetings, meetings of Village Scouts, defence volunteers, even in temple ceremonies, and in meetings organized by local agents of national and international agribusiness companies. (Turton, 1984: 52)

He also analyzes the more physically coercive forms of domination as well as the relations between coercive and discursive forms – here taking his cue from Godelier, to develop a theory of the relation between violence and consent, in which *fear* is a crucial factor (1984: 60; 1986: 40). So, both formal and informal institutions may combine to create "a climate of ideas and attitudes about dangers to society... and which serve to objectify and dehumanize the victims of such labelling..." He quotes the militant right-wing monk Kittivutho saying: "...it is necessary to kill communists. Communists are not people, however; they are the devil, and impurities and ideology personified, abstractions" (*ibid.*). Faced with such sloganizing

May 1992.
Thai soldiers stand
guard over arrested
pro-democracy
demonstrators in
Bangkok.
Courtesy of Dominic
Faulder/Bureau Bangkok.

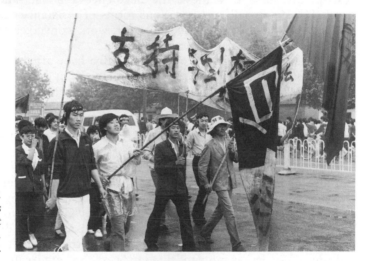

May–June 1989.
Beijing students
demonstrate against
the state.
Courtesy of Robert Delfs.

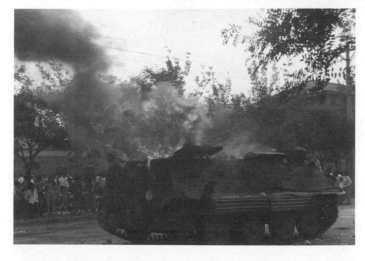

4 June 1989.
A personnel carrier on
fire in Beijing.
Courtesy of Pat Moore.

it is a brave person who speaks out against the *status quo*. Witch-hunts, containing a similar logic of fear, have also been common in communist countries, where Turton's methodology applies with equal force.

What is worthy of emphasis, in terms of relevance to anthropological analyses of the state, is the way in which Turton links discursive and coercive forms of domination to his theory of "local power structures" which are "local manifestations of power and the state" (1984: 22), such as local officials, politicians, businessmen, landowners, and members of a village elite or communist party cadres. Such local realities of power, according to Turton, "deserve greater theoretical prominence and conceptualization; they tend to be largely "invisible" in much academic writing, perhaps because they defy formal analysis in existing paradigms." These realities "are close to the experience and consciousness of the rural poor". Moreover, they "are crucial elements in the pattern of domination which...are articulated within the state itself" (*ibid.*: 33). Thus, Turton examines a variety of "restrictive ideological practices by which local officials in Thailand restrict discourse to achieve the obedience and obeisance of the rural poor" (*ibid.*: 46). He also discusses various forms of resistance (tactical and ideological) to local power structures, and here his work converges theoretically with, not only Foucault, but also Scott and others.

Several anthropologists working on China have attempted to employ modes of analysis similar to Turton. Mayfair Mei-Hui Yang artfully combines the classical work of Marcel Mauss on gift exchanges with the work of Foucalt to document resistance to total state control. By focusing on informal relations of *guanxi*, often represented as corruption by commentators on modern China, Yang sees gift-exchanges as attempts to personalize impersonal, universalistic relations promoted by the state. The redistributive socialist state tries to control all flows of key resources in the society, but "the art of guanxi *redistributes* what the state economy has already distributed, according to the people's own interpretations of need and the advantages of horizontal social relationships." (Yang, 1989: 50) Corruption implies no on-going reciprocity, whereas the "gift-economy" represents a sphere of opposition to state "techniques of normalization and discipline" (*ibid.*).

Helen Siu's examination of the communist transformation of southern Chinese culture and society is more indebted to Scott. She argues in her *Agents and Victims in South China* that the communist state since 1949 has profoundly re-shaped the way Chinese view the world. She asks: "If subordination is so total that it shapes even the spheres of resistance and strategies for negotiation, how can one meaningfully interpret the aspirations of either the upwardly mobile or the powerless? For anthropologists...the task then is to see how state goals and popular morality interpenetrate each other through human agents." (1989: 293). She argues that recent liberalization by the state in China has not seen the re-emergence of "traditional" China but only the resurgence of cultural fragments of the past. Rituals express a lack of faith in anything and a pervasive alienation, which shows how much popular beliefs have been affected by the state.

8 HIERARCHY AND DOMINANCE

Class, Status and Caste

Grant Evans

Bertolucci's film *The Last Emperor* re-created the opulence and ritual splendour of China's imperial social order. In it the Forbidden City hovered like an earthly heaven over the Chinese masses who practically lived in another world. The "Son of Heaven", the emperor Pu Yi, sat at the centre of this social cosmos, and those who came before the throne were to tremble in awe. For many the film dramatised the historical distance between traditional China and a modern world which assumes social equality; a world into which emperor Pu Yi was to be rudely propelled. But even after his abdication in 1912 and the collapse of the Qing Dynasty officials insisted on his special status, and in his autobiography Pu Yi, aware of the irony, relates the resistance he encountered to a request for a telephone: "If outsiders can make phone calls whenever they like will they not offend the Celestial Countenance? Will this not damage imperial dignity?" his officials argued. But Pu Yi got his telephone and opened contact with the world of commoners, thus enacting the momentous transition from emperor to citizen. During the twentieth century the attainment of formal, legal social equality has been a major achievement for the peoples of Asia, and for most of them it has meant a rise in their status rather than a fall, as with Pu Yi.

Formal, legal equality means that all citizens of a state have the same *rights* no matter how much wealth, for example, a person may have. It does not mean that all people are equally talented, nor does it imply an erasing of all differences between human beings – although some people appear to think that it does. This principle of social organization is, historically, a new one (Turner, 1986). Nevertheless people brought up in societies where this principle has reigned are often shocked to find out that for a large part of human history quite different principles have applied, and social *inequality* has been the prevailing assumption.

Symbolic demonstrations of subordination and social inferiority abound in Asian cultures. The Chinese word *kowtow* has entered English somewhat inaccurately to signify obsequiousness rather than deference and respect. It arises out of the the act of bowing and striking ones forehead on the ground before the emperor, but is repeated down the ritual hierarchy, including before household ancestors. As a sign of obedience and subordination it can hardly be bettered. Among the Thai the placing of the palms of ones hands together in a prayerful motion, the *wai*, is an act of respect and deference. In the presence of Thai royalty commoners will clasp

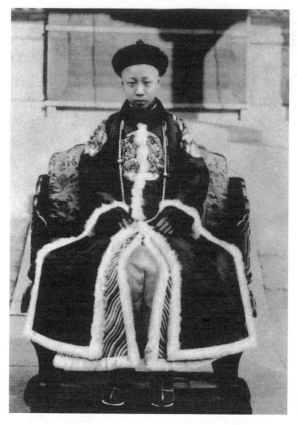

China's last emperor, Pu Yi.
Courtesy of Foreign Languages Press,
Beijing, China.

their palms above their heads while the royals will keep their *wai* at modest chest height. The height of the *wai* is a subtle sign of hierarchy and status. But this can also be turned into an act of defiance; the independently minded hilltribes of northern Thailand ignore these rules for *wai-ing* and assert their equality. As Amara Prasithrathsint points out in Chapter 3, most Asian speakers remain acutely aware of the status of the person being addressed, although language reforms in communist countries, and natural attrition in non-communist ones is beginning to "level" linguistic status consciousness.

Anthropologists study social hierarchy and dominance for several reasons. First, the anthropological tradition has spent a lot of time documenting the lives of people in "egalitarian", tribal communities and therefore they have been interested in the contrasts between egalitarian social systems and stratified ones. Second, they have been interested in how stratified societies emerged out of egalitarian ones, in particular with the emergence of the state, as explored by Paul Cohen in the previous chapter. Third, because social stratification deeply affects an individual's style of life, often determining what they can and cannot do as human beings, anthropologists must try to understand its nature and causes.

In Asia we find ourselves dealing with some of the most continuous **civilizations** in the world. Therefore some of the oldest systems of social dominance and hierarchy are to be found here, some of which are still operating in a modified

A young Thai man respectfully clasps his hands in a "wai" as his grand-mother cuts the first lock of his hair during an ordination ceremony for Buddhist monks.
Courtesy of Associated Press.

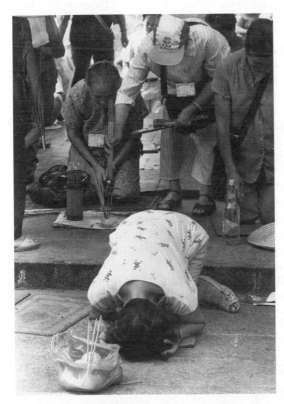

A Chinese woman "kowtows" before the gods in a Chinese temple.
Courtesy of South China Morning Post.

form, such as the caste system of India. While pre-state societies have social hierarchies and patterns of dominance, they usually lack the power to fundamentally differentiate individuals along a social axis. This is not true of traditional state-based social orders which can use force to protect an established system of social hierarchy and dominance. Because these patterns have been long established in Asian societies this chapter will begin with a discussion of state-based systems of stratification, and only then move onto a discussion of more egalitarian systems at the periphery of these civilizations. A discussion of modern societies will follow.

Concepts

Class, status and caste have been among the most common concepts used by social scientists to analyze social stratification. Caste has a number of unique and highly specific features which we shall discuss further on. Class is fundamentally a concept of political economy. It is primarily concerned with who has control over key economic resources in a society. This control may be exercised primarily through a system of direct ownership of capital, as in capitalist societies; indirect ownership of productive property, for example where a king is owner of all the land and peasants till their plots at his leisure and render up surpluses; or political control of state-owned property, as in communist systems. Class is a concept of *political economy* because class privileges or rights are usually protected by the state, and therefore the traits of a state will infuse class structures with their peculiarities. Similarly class structures are intertwined with systems of status ranking. Such status may be mandated by the state, as we shall see for traditional and contemporary China, or structured by the impersonal market and consumption as it tends to be in modern capitalist societies. The unique intertwining of class and status systems, and their mutual interaction in different societies is a question of great interest to anthropologists and sociologists.

It is important to understand, however, that although we are primarily interested in hierarchy and dominance not all classes stand in either a dominant or subordinate relation to other classes, and social stratification is not a set of social layers, but is a system. So, for example, a small shopkeeper in Hong Kong may be in a different class from the worker who comes to his shop to buy food or cigarettes, yet neither stands in a relation of dominance or subordination to the other, although both are socially less powerful than say, the Chair of the Hong Kong Bank. Furthermore, while hierarchy and domination require legitimation, all systems of social class and status and caste, are contested, and this may extend to social scientific categories that are not recognised by the people to whom they are applied. The opening chapter introduced Barbara Ward's observations on how the Chinese have various conscious or emic models of their society's make up. Lévi-Strauss who stimulated Ward's work, remarks that these "conscious models...are by definition very poor ones, since they are not intended to explain the phenomena but to perpetuate them" (1968:281). But, he goes on, "even if the models are biased or erroneous, the very bias and type of error are a part of the facts under study and probably rank among the significant ones" (1968:282). Thus social scientists may use the etic concept class in ways considered not emically relevant by particular individuals or groups.

The distinction between emic and etic concepts of stratification is important to bear in mind throughout this chapter. Conscious, emic models are open to interpretation, and not surprisingly, it is usually people placed at a disadvantage or oppressed by a particular system of stratification who wish to re-define it in ways advantageous to them, by manipulating either the status system or even the supposedly "rigid" caste system, for instance. More recently, a great deal of research has gone into how subordinate groups interpret, or re-interpret, systems of hierarchy and domination (Scott, 1990).

Class and Status in Traditional China

By traditional China is meant the period since the Tang dynasty which collapsed in the nineth century A.D. The ensuing Song, Yuan, Ming and Qing dynasties are taken as typical because it was under them that the imperial bureaucracy flourished. Earlier periods were dominated by a form of feudalism with hereditary aristocracies, followed by the gradual emergence of a more centralized powerful state served by non-hereditary officials. The latter was a unique feature of stratification in traditional China.

The hereditary transmission of social position is common in pre-modern societies and therefore the apparent deviation from this in China has caught the eye of social scientists. Like all societies the Chinese had their "conscious model" of the social structure, and it distinguished four classes of people:

Elite (*kwei*)	1. Scholars (*shih*)	
	2. Farmers (*nong*)	} The fundamental occupation
Commoners (*liang*)	3. Merchants (*shang*)	} Accessory occupations
	4. Artisans (*kung*)	

In an agrarian state like China it is not surprising to find that in ideology farmers (which it should be noted included large landowners and landlords) are ranked above merchants and artisans, although in reality merchants in particular often acquired much more power and prestige than peasants and sometimes even landlords. In theory everyone was entitled to compete in the imperial examination system and thereby join the elite, although at various times in Chinese history merchants were debarred. Thus, upward social mobility was possible. At the centre of the structure, however, the emperor maintained the hereditary social position of the royal house, and the very bottom of the structure was occupied by a quasi-hereditary pariah group such as actors, prostitutes and boatmen. The family of an official acquired his status and could inherit it and maintain it over at least one generation through the principle of *yin*, even if no one in that generation was an official.

This hierarchy was openly acknowledged and articulated in the Chinese conception of social order. As one sage remarked: "When social statuses are equal, there will not be enough for everybody...When people's power and position are equal and their likes and dislikes are the same, things will not be sufficient to satisfy everyone, and hence there cannot but be strife. Strife will lead to disorder and disorder will lead to poverty" (Chu, 1957:237). The classical Confucian scholar

Mencius explicitly justified inequality: "Inequalities are in the nature of things. There is the business of superior men and there is the business of little men. Hence the saying, 'Some work with their head; they govern others. Those who are governed feed the others; those who govern are the fed.' This is a just arrangement" (quoted in Stover, 1976:167). The uniqueness of the Chinese system, however, was not its acceptance of social inequality but the way it arranged it and justified it.

As can be seen from the model above, a key social divide was between the elite and commoners, yet this does not mean that Chinese society fell into only two classes. In fact the class structure is more accurately represented as an elite composed of two closely related classes, the state officials and the gentry landowners, then the peasantry, the merchants and artisans. The elite/commoner divide, however, was a crucial status marker in Chinese society, and status was allocated by the Imperial State as a result of achievement in the Imperial examination system through which individuals were allocated positions as officials. Thus, within the elite there existed a system of civil and military ranks attached to the bureaucratic hierarchy. This system of ranks and the elite/commoner divide was regulated by an intricate system of sumptuary laws relating to food, clothing, housing, domestic animals, attendants, boats, carriages, utensils, coffins and graves, which advertised a person's station in the social hierarchy. Thus, "by looking at a man's dress it can be seen whether he is noble or humble, and by looking at a man's flag, his power can be ascertained" (cited by Chu, 1965:133). The design of garments and their colour varied according to an official's rank, and retired officials retained the right to wear such garments. While the details of these laws varied from dynasty to dynasty they all established distinctions between ranks and between the elite and commoners. "During Sui, T'ang and Sung purple, scarlet, green, and blue were reserved for officials with rank...In Ming times the male commoners were permitted to wear garments of various colors but not yellow. Women of this class might wear purple, green, peach, and other light colors, but not scarlet, blue, black or yellow" (Chu, 1965:137). Hat styles were similarly regulated, and in no dynasty could common people wear ornaments of jade, gold, or silver. Inequality, consequently, paraded itself constantly as a reminder to inferiors of their lowly status.

Naturally, there was no equality before the law and generally superior groups were treated more leniently for crimes than inferior ones – by law. An important exception was the violation of sumptuary laws for which officials were punished more severely as they were expected to be more familiar with these laws than non-officials (Chu, 1965:151). This apparent anomaly coincides, however, with the system of domination in China described by Leon Stover as "Culturalism". That is, hierarchy and domination in China was legitimized by the claims that those in superior positions were in possession of a high, empire-wide culture.

In the Great Society, power persons from all over the realm belong to a common hierarchical order capped by the emperor. When the Local Snakes [i.e. regional officials and gentry] don their imperial robes, indicating rank in office or academic degree, they illuminate a ceremonial status system headed up by the Mighty Dragon. The pageantry of office and dignity of scholarship work to awe the Neolithic peasantry into yielding up its quota of tax and arms to the Local Snakes... (Stover, 1974:190)

A young Chinese mandarin of the first rank.
Courtesy of Hong Kong Museum of History.

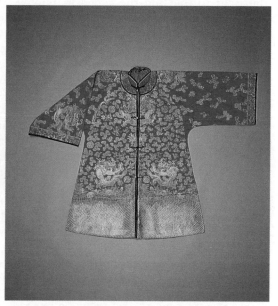

A lady's red dragon robe embroidered with golden threads, Qing dynasty.
Courtesy of Sam Tung Uk Museum.

Black gauze ceremonial overcoat with mandarin square of the crane insignia of the first rank, Qing dynasty.
Courtesy of Sam Tung Uk Museum.

In fact, one of the chief preoccupations of the state was the regulation and up-holding of *li*, of good manners and customs, and ceremony and formality. In this "culturalist" universe *li* only applied to the elite; commoners were subject to penal law codes. Thus the commitment to gentility and refinement legitimized the right to rule and the social hierarchy. This was especially true for the local gentry of China whose connections with official high culture ensured their local power (Esherick and Rankin, 1990).

While traditional ideology emphasized that each person had their assigned place in society, the Imperial examination system which was unique to China, assigned that place in a way that maintained social order while allowing some upward social mobility. Some authors see this mobility as more-or-less dissolving the class structure. Studies, however, have shown mobility to be infrequent and largely confined within the ambit of a very small Chinese ruling class (Ho, 1962; Eberhard, 1962). Just how small can be seen from the fact that in "the 1880s, the number of men legally entitled to privileged status, or *kwei*, was 1.5 million, of which 1.6 per cent held office. The de facto elite, some 6 million kinsmen closely related to the elite de jure, brought the gentry minority to 7.5 million, or close to 2 per cent of the total population" (Stover, 1976: 167). The key link between political office and landholding in China was the patrilineal lineage which supported examinees whose success brought status and wealth to their lineages. "While official rank was in theory open to the meanest peasant with talent and ambition, the absence of any widespread system of popular education usually required that the student have the support of a wealthy family for the long years of arduous study. Sometimes a wealthy family whose children lacked academic promise would provide for a bright boy from a poor background [within the lineage]. Hence the link between office and wealth through the lineage was one of the most important features of Chinese society" (Moore, 1966: 165; Eberhard, 1962: 210). Income from clan-held lands would be used to provide education and financial aid to selected kin who took examinations.

The importance of the "culturalist" order for status and power can be seen in the fact that many merchants who became wealthy and powerful in the Qing period attempted to legitimate that wealth and gain status by buying academic degrees. In the late nineteenth century some 36 per cent of degrees were purchased – an exercise of merchant class power that began to devalue the claims of "culturalism" and set the stage for its demise in the face of the expansion of capitalism along with a new set of values and a different system of stratification based on the market.

Caste

The caste system of India is usually seen as the epitome of a pre-modern system of stratification because of its "rigid" application of the principle of inequality, while its persistence into the late twentieth century is often considered a symptom of "religious irrationality". The caste system is made up of hereditary, hierarchically ordered, and culturally discrete groups, often associated with occupations, who consequently receive differential rewards and social evaluation. Castes, however, are not classes. The word caste is of Portuguese origin and is more accurately

rendered as *jati*, of which there are said to be several thousand in all of India. This is confusing to outsiders because of the association of *jati* with the traditional Hindu ranked hierarchy of four *varnas* ("colours" or estates): the highest being the *Brahmins* or priests, below them the *Kshatriyas* or warriors, then the *Vaishyas*, merchants, and then *Shudras*, or servants. Untouchables who form a fifth broad category do not register in this native model. In fact this simple model only relates tangentially to the actual workings of caste which is regionally diverse across the Indian sub-continent, although it provides a language for the expression of caste relations. As Louis Dumont writes: "the varnas have the advantage of providing a model which is both universal throughout India, and very simple compared with the proliferation of castes, subcastes, etc. Consequently it is a model which can among other things facilitate the comparison between different regions..." (Dumont, 1980: 73). Because there are different castes from one end of India to another, partly because of regional economic and ethnic diversity, this native model allows people travelling from one region to another to roughly evaluate the caste standing of themselves and others.

It is impossible for us here to enter the complex debate over the causes for the emergence of this unique system of stratification. But Berreman, for instance, suggests "that caste (*jati*) originated as an intermediate stage of stratification between the pre-state, kin-based inequality of bands, tribes, chiefdoms, and the non-kin (or supra-kin) class stratification characteristic of state societies." (Berreman, 1983: 237). This was a result of conquest by Indo-Aryan peoples of an ethnically/tribally and occupationally diverse Indian sub-continent and the ranked absorption of these peoples into a state system under the aegis of Hinduism. The latter has been described as a religion permeated by ritual elaboration rather than doctrinal cohesion and mobilization (see Chapter 11), and its very decentralization and local manifestations made it and the caste system highly resistant to change under successive conquests by Muslims or British Christians.

The broad features of caste which consolidated, however, are reasonably clear. First, it is important to understand caste as a total *system* of ranked relationships between distinct groups. Within the system everyone has a caste, even the *outcastes*. Caste has a segmentary character; that is castes and sub-castes are part of larger groups, which are then part of a whole system. For example, the area studied by André Béteille in the south of India contained three (note, not four) broad caste designations, Brahmin, Non-Brahmin (loosely designated *Shudras* by Brahmins in order to slot them into the native model), and Untouchables, called *Adi-Dravidas*. Each of these broader categories segment into castes, with the Non-Brahmins, for example, including "landowning castes, such as the *Muldaliyars*; landowning and cultivating castes, such as the *Vellalas*, *Gaundas*, and *Padayachis*; trading castes, such as the *Chettiyars*; artisan castes, such as the *Kusuvans* (Potters), *Tachchans* (Carpenters), and *Tattans* (Goldsmiths); servicing castes, such as *Ambattans* (Barbers) and *Vannans* (Washermen), as well as a large number of other specialist castes." (Béteille, 1965: 16). And even some of these castes segment into sub-castes at the village level. But being part of a segmentary system they are united as a group vis-à-vis Brahmins or Untouchables. Thus whatever social restrictions or distance there may be between two Non-Brahmin castes, they are temporarily suspended when the two are placed in relation to Untouchables, and so on. "Structurally," writes Dumont, "the caste appears in certain situations and disappears in others in favour of larger or smaller entities" (Dumont, 1980: 42).

Untouchables in India.
Courtesy of Maria Fialho.

Unlike class, caste is a lifelong, unalterable attribute acquired by birth. Therefore one's caste is a group status and individuals are not socially mobile, as in class systems, although the caste as a whole may become mobile. The group nature of the caste is commonly (though not universally) ensured by prescribing endogamous marriages. The size of caste groupings varies widely throughout India as does their corporate consciousness, or sense of themselves as a caste. Yet, by and large caste self-consciousness is enforced by the system itself which entails avoiding other castes and intense interaction within one's own caste. Caste membership is expressed physically, symbolically and ritually. Thus in village India different castes live in discrete sections of a village, and their caste position is advertised for example by styles of dress.

> *Among Brahmins, men are required by tradition to wear the eight-cubit piece of cloth or veshti after initiation. The traditional style of wearing the veshti by having the ends tucked at five places (panchakachcham) carries a ritual sanction among all Tamil Brahmins. Non-Brahmins or Adi-Dravidas, at least in Sripuram, do not wear the veshti in this way....Among Non-Brahmins also one finds in certain cases peculiarities of dress expressing the distinctive style of life of a particular caste. Thus, according to traditional usage, the Kalla women in Sripuram avoid wearing garments of dark blue or similar colours as this is thought to give offence to Karuppan, a deity who is worshipped particularly by members of this caste." (Béteille, 1965: 50–1)*

Despite the apparent similarity with the sumptuary laws in the Chinese system it is important to realise that these modes of self-presentation are neither prescribed nor enforced by a central state but by the castes themselves in the process of differentiation, or segmentation, and are usually policed by local caste councils, panchayat.

This self-disciplining of the castes as corporate groups is a key explanation of both the persistence and the effectiveness of this form of social hierarchy and domination over the centuries. But why did castes, in particular lower castes, police themselves and thereby reproduce their lower status? There is, of course, a Hindu religious explanation. Caste members hold their status because of *karma*, or merit acquired in earlier incarnations, and they can only hope to improve their status in their next life if they obey the *dharma*, law, of their caste in this life. Transgression of caste rules, therefore, breaks religious law. But there are other forces at work as well, namely the *jajmani* system. It will already be apparent from the listing of Non-Brahmin castes in the area where Béteille did his fieldwork that castes are often associated with specific occupations – something that was much less fluid in the past than today. In other words caste tends to correspond to the division of labour, which in turn means castes are economically interdependent. In the *jajmani* system this has entailed hereditary personal relationships between families of different castes, between a landlord caste and a labouring caste, for example. The *jajmani* regulates village-wide systems of prestations and counter-prestations between castes, on a daily, monthly or annual harvest basis or at festivals. A breaking of caste rules, which means disrupting inter-caste relations, can threaten the rewards, however minor, that pass through the *jajmani* system. Therefore, individual castes had every reason to keep their members in line. Conversely, individual caste members can only really rely on fellow caste members for support in daily life and this is a strong reason for not upsetting them by, for example, presuming to wear apparel associated with a higher caste. Thus the castes themselves upheld the established system of hierarchy and power.

While in theory Brahmins are at the top of the caste hierarchy, empirical studies in villages have tended to show that this is not always so, and the castes who wield most economic leverage, usually landowners, are the dominant caste. Whichever group is the dominant caste, however, a key principle by which hierarchy and dominance is established is by attributing degrees of ritual purity to each caste: pure = high, impure = low. The pure can always be polluted by the impure which explains why elaborate rules are observed to keep them separate or regulate their interaction, for contact with impure castes implies a fall in social status for the purer caste. Thus it is the castes above who protect themselves from the castes below, and in turn are excluded by those above them. Yet, given the division of labour in society, total separation is impossible and therefore purification rites abound and are especially associated with ritual bathing after contact with impure castes or with substances deemed impure such as bodily excretions, and so on. The preparation and eating of food is especially fraught with danger of pollution and higher caste Brahmins eat their food in complete isolation. But it is obvious that to establish caste ranking certain criteria are required, but these have a tendency to proliferate. Thus one caste may claim superiority to several other castes by virtue of the fact that they are vegetarians, while the other castes may claim superiority to this caste because they do not allow widow remarriage, and

so on. As Dumont (1980: 57) remarks, "it can well be imagined that it is difficult to grade all the castes of a given area in a fixed hierarchical order even though the fundamental principle is beyond question and universal in its operation. The complication springs from the multiplicity of concrete criteria and from the necessity of evaluating them in relation to each other. Each group will try to manipulate this situation to its advantage but other groups may be of a different opinion." It is through such "flaws" in the fabric of caste that caste social mobility is attempted and made possible.

Caste and Class

These two concepts are distinct, however they are not unrelated in social practice. Caste is not simply a more "rigid" form of class. While it is articulated through the division of labour and hence partly economic, this is not its exclusive domain. The principles on which it is based allow it to proliferate regardless of economic criteria. Thus landowners as a class, for example, may contain several castes or sub-castes. On the other hand a person may change their class position but not their caste.

In the pre-modern system of India there was a strong correlation between caste status and class, especially at the top of the hierarchy. Thus, in the area where Béteille worked landowners tended to be Brahmins and by virtue of landownership they also were the most powerful figures in the village. This is not surprising given that caste status was always potentially contestable by those below, and maintenance of the caste hierarchy in the long-run depended on the exercise of real social power.

Political and economic changes first introduced by British colonialism and after Independence, have also served to shift the relationship between class and caste. The British period not only saw an initial consolidation of the position of the Brahmins but also attempts by other castes to use the new political structure to further their status. Thus in the early nineteenth century the *Nadars* in South India attempted to upgrade themselves by adopting a number of higher caste attributes, including a breast cloth used by upper-caste women. For this *Nadar* women were attacked and beaten, but as Christian converts they appealed to British Missionaries for support as the prudery of the latter led them to approve of this covering up of naked breasts. But despite Missionary support the *Nadars* were ultimately unable to overcome upper-caste opposition which manifested itself in a series of violent outbreaks up until the end of the century (Hardgrave, 1969). Béteille's research reveals that economic change this century has loosened the relationship between caste and class in India, and political changes have loosened Brahmin control of the village. The development of capitalism in India and the growth of new occupations and new economic opportunities has made inroads on the old division of labour and allowed wealthier members of the village to move out of landholding and into urban-based occupations which are both more lucrative and more powerful in the new context. This combined with legal changes which accorded formal equality to Indian citizens has meant that an increasing number of Non-Brahmins and even the occasional Untouchable have become land owners. In other words they have changed their class position though not their caste. Furthermore, the introduction of democratic ideals has seen the mobilization of factions of castes at the village level, and more broadly in Indian society, and this has also disrupted

the straight-forward nexus of caste-class-power in the old structure. It must, however, be conceptualized as a re-alignment rather than a total dissolution of that older structure. The increased spatial mobility of the population has also given rise to regional and national caste identification – something that tended to be confined to Brahmins in the past, who like Chinese officials, traversed a wider social space and therefore tended to have a translocal corporate consciousness. Politics in India continues to express itself primarily in caste rather than class terms because it is through the caste and its symbolic organization that people emically recognize broader interests.

One consequence of these changing relations between castes has been an escalation of inter-caste violence. The following tale is common:

> Mr Ranguni Ram's family was shot and hacked to death because they were poor, low caste and born in Bihar, reputedly India's most backward, repressive and corrupt state. Mr Ram was in the fields on July 8 when his upper caste landlord's henchmen descended on the row of mud huts known as Kansara village, killed ten people including six women and two children and dumped their bodies in a river. The family had committed no crime...'These people never raised their voices for cash wages or anything', said villager Mr Krishna Ram. 'They were killed out of vengeance and to teach us a lesson.' Just two hours before the massacre unidentified gunmen had shot dead landowner Mr Vijay Singh in a nearby town. (South China Morning Post, 7 August 1986)

This was an area of intense landlord-tenant tension. In the same year riots broke out in Rajastan state after four Untouchables tried to assert their legal rights to worship in a temple there. In mid-1990 upper-caste students erupted in violent protests across India against government attempts to implement a long-standing policy of reserving civil service jobs for lower caste people. Symptomatic of the inequalities embodied in caste is the "sexual use and abuse...of women of the lowest rank by men of the highest...There is in return unremitting concern with the purity of women at the top..." (Béteille, 1991:491). Changing relations appear to have begun to restrict upper caste access to lower caste women, but bloody retribution has also been taken on lower caste men who have presumed to "soil" the purity of higher caste women:

> In a village 100 miles from Delhi, villagers hanged and then threw on to a fire a girl and two boys; the boys had first been tortured while their fathers had been made to watch, and one of them and the girl had still been alive when put in the fire. They had managed to crawl out but had been thrown back. The girl, from the powerful Jat caste, has tried to elope with one of the boys, assisted by his friend; both were untouchables... (The Economist, 8 June 1991)

This is violence in defence of hierarchy and dominance.

Caste Elsewhere and Outcastes

Does caste only exist in India? Dumont (1980) has put forward a powerful argument to say that the caste *system* is only found in India. He emphasizes "system" because outcastes or pariah castes who are considered to be intrinsically polluted and are

stigmatized can be found in other Asian societies, for example, the *Eta* or *burakumin* of Japan who were associated with defiling occupations, such as burying the dead or tanning animal hides. Yet in these other societies caste is not all-encompassing as in Hindu India, and therefore an elevation of the status of outcastes does not radically upset the hierarchy. In India legal equality has been enacted and even positive legislation passed concerning Untouchables but serious discrimination remains for, as Dumont observes (1980: 54): "untouchability will not truly disappear until the purity of the Brahmin is itself radically devalued; this is not always noticed." It therefore presents a fundamental challenge to Hindu practice.

Bali is the main bastion of Hinduism outside India and it has a caste system of sorts. But as Howe (1987) remarks, whether one decides a caste system exists or not in Bali depends on whether one is interested in religion or social stratification or some other aspect of Balinese culture. From the point of view of religious ritual, he would suggest, there clearly is. But this has few ramifications in other social institutions or in inter-personal interaction as it does in India. Furthermore, the Balinese bilateral kinship system does not lend itself to endogamy and self-contained corporate groups, and caste is largely articulated through membership in caste temples. But one can decide not to belong to such temples, or to belong to several of them which, as Lansing points out, "simply translates into supporting more temple festivals and rituals and having more 'kinsmen'" (1983: 110), or to change ones "caste" several times in a lifetime. Such fluidity is unknown in the Indian system where it would imply dramatic hierarchical social shifts for an individual, and generate intolerable inter-caste tension. Thus, at least from the point of view of the study of social stratification, the caste system in India would seem to be unique.

Slavery

Slavery is considered one of the most extreme expressions of hierarchy and dominance, and it was widespread in Asia up until at least the middle of this century. Before 1949 China, for example, "had one of the largest and most comprehensive markets for the exchange of human beings in the world" (Watson, 1980b: 223). Given the universal condemnation of "slave labour" in the modern world it is perhaps surprising to find that there is confusion and controversy over the exact nature of Asian slavery. The confusion partly arises from instances where slaves who have been captured in war or bought or given as a gift are found living in their "master's" household as one of the family, and are ultimately to be absorbed by it.

In an attempt to clarify the situation Watson offers the following definition: "'Slaves' are acquired by purchase or capture, their labour is extracted through coercion and, as long as they remain slaves, they are never accepted into the kinship group of the master. "Slavery" is thus the institutionalisation of these relationships between slave and owner" (1980a: 8). He also makes a very useful distinction between "open" and "closed" systems of slavery. An open system is one where the slave is absorbed into his master's kinship group, household and village, whereas in a closed system they remain hereditary outsiders. Watson

claims that closed systems are more prevalent in Asia because of the premium placed on access to land and this therefore affects attitudes to inclusion of outsiders (1980a: 12). Open systems, on the other hand, are more concerned with gaining control over people. While Watson's judgement is most certainly true for his field of East Asia, it seems to be less accurate in the Southeast Asian context where open systems are often encountered (Reid, 1983).

The Iban of Borneo practised just such an open system. We have already encountered the Iban as an example of cognatic lineages living in long houses, and without any sharp hierarchical distinctions (see Chapter 5). Temporary war leaders, however, were recognized and the Iban were feared as headhunters. The appearance of captured slaves in this society would appear to contradict claims that this was an unstratified society. But slavery among the Iban was only a temporary status as they were soon "enfranchised" in the community and adopted. Freeman (1981: 46) reports accounts of adopted captives being so well treated that when relatives tried to repatriate them they decided to stay on with their adoptive Iban *bilek*-family. He observes "that the captive, once he (or she) had been ritually enfranchised, had the same rights as all other Iban, including full parcenary rights in the *bilek* into which he (or she) had been adopted" (1981: 47). Similar situations were encountered among other peoples of Southeast Asia.

China, however, provides an example of a closed system of slavery. Slaves here were mostly bought rather than captured, or inherited. While it was mainly women rather than men who were traded, the burden of the closed system fell on men because, given the Chinese kinship pattern, women posed no threat to land

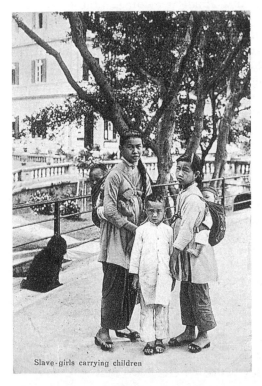

Slave-girls carrying children

"Mui jai", young slave girls in early twentieth century Hong Kong.
Courtesy of Dr Tong Cheuk Man.

inheritance; i.e. being already closed out of the system of inheritance it was not so important for them to be locked into a closed system of slavery. Female slaves could escape their condition through marriage, as could their daughters who may also escape slave status through becoming domestic servants. As Watson has indicated, pre-1949 China had an enormous market in people, but not all were sold into slavery: there were many varieties of bondage with women being acquired as domestic servants, prostitutes, or perhaps as concubines (Jaschok, 1988). These positions were not hereditary.

Given their insecure position in the Chinese lineage women were expendable, but the sale of a male heir was a great offence and likely to be done only by the poorest person. Thus an important source of bondservants and slaves was kidnappers. The purchase of males was usually done by families lacking male heirs and these males (usually children) were never slaves. The keeping of male slaves, or *sai man*, could only be done by the richest households and they were acquired as a mark of prestige rather than for their labour. Not surprisingly, therefore, the Imperial court maintained one of the largest systems of household slavery, with hundreds of eunuchs serving the dynastic line. "*Sai man*," writes Watson, "were owned as chattels by specific masters and their labour power was extracted by coercion (i.e. unlike clients they were not paid for their services). They were definitely of a lower hereditary status than ordinary 'free' peasants, both socially and politically. In addition, *sai man* marriages were never given legal recognition and their owners would never grant their slaves the status of kinsmen, even in a symbolic sense" (1980b:240). Thus he argues that this system of slavery was one of the most rigid systems of slavery in Asia. Yet, in its most extreme form, slavery only affected a small percentage of the Chinese population.

Slavery is no longer common (or legal) in Asia, but various forms of bondage are: thousands of children work as bonded labourers in India, and young girls in Thailand become "debt slaves" in brothels, while in China following economic liberalization in the 1980s kidnapping and the traffic in women has emerged once again. All of these manifestations of human bondage require further ethnographic research.

Peasants

Peasants remain one of the largest classes in Asia today and in many ways are a living link with Asia's pre-industrial and pre-capitalist past. A number of the economic features of the peasantry have already been discussed in Chapter 6, but we can say that the main features of peasants economically is that they rely primarily on household labour and that the aim of production is for self-sufficiency and the market. When production for the market eclipses production for use we can more accurately call peasants farmers and when wage labour overtakes family labour we can speak of capitalist farming. In fact one of the main trends in peasant farming in Asia this century has been the shift from self-sufficiency towards commercial farming.

Peasants are found in various social structures, usually as a subordinate class. Wolf (1966) has provided a still useful taxonomy of the socio-political domains

in which the peasantry is found: Patrimonial, Prebendal, Mercantile, and Administrative.

Patrimonial

The main example of this type of domain in Asia is Japan, although it also characterized early China, and some other early periods of state formation in Asia. This type of social structure, which is similar to European feudalism, is characterised by a dispersal of power among a confederation of hereditary lords. The Tokugawa period in Japan (1603–1867) saw a degree of centralisation of this kind of organization. At the pinnacle of the structure the emperor played a unifying, largely ceremonial, role. The real power at the centre lay with the *Shōgun*. Below him in rank were the great lords or *daimyō* who held hereditary title over large fiefs. Below them were the *samurai*, or warriors. These aristocrats lived in castle towns supported by surpluses extracted from surrounding peasant villages. The villages experienced a high degree of regimentation through policies of religious and status registration carried out by village headmen (*Shōya*) which restricted peasant movement from an area. The peasant's relationship to his overlord was not an individual one but as a member of a village which paid taxes jointly. Thus did Japanese feudalism encourage a group solidarity at the local level which has been much remarked on in studies of the Japanese peasantry (Beardsley *et al.*, 1959).

Prebendal

Prebendal domains found, for example, in Mogul India, Vietnam and China were ones where state-sanctioned officials were in a position to collect tribute from the peasantry, or landowners, out of which they took payment and passed the rest on to the treasury of the central sovereign. Peasants either paid tax as freehold farmers, or, if they were tenants who often rendered up to 40 percent or more of their harvest to the landlord, then the latter was liable for the tax. In traditional China many peasants were bondservants of landlords. They were legally considered "mean or base people" (*jianmin*), were forbidden from marrying commoners, from taking the Imperial examinations and were subject to harsh punishments for offences (Wiens, 1980). Landless peasants employed on a long-term basis by landlords were treated little differently than bondservants. Short-term labourers, on the other hand, were considered as commoners. Thus serf-like peasants co-existed alongside free peasants.

"A common feature of both patrimonial and prebendal domain," writes Wolf, "was the degree to which their exercise was surrounded by what we have called ceremonial. This was especially marked in the case of patrimonial domain, where the lord often stood in an immediate personal – or at least personalized – relation to his dependent peasants. Many services rendered such a lord had ceremonial aspects, and on occasion the lord reciprocated in kind" (1966: 51–2).

Mercantile

A mercantile domain is one where land is bought and sold as a commodity in a market. In traditional China this kind of domain co-existed with the prebendal domain. In the nineteenth century and into the twentieth century this kind of

commercial domain expanded, the use of bonded labour declined and labour relations and contracts began to proceed on an impersonal market basis. As Fei Hsiao-Tung noted in his classic study of the Chinese peasantry in the 1930s, "tenants do not know and do not care who is their landlord, and know only to which [rent collecting] bureau they belong" (1939:188).

With the collapse of traditional structures throughout Asia in the nineteenth and twentieth centuries and the expansion of capitalism we have seen the emergence of a generalized commercial peasantry tilling the soil as tenants, but more often as a free smallholders, and in recent decades even as a kind of contract farmer for large agribusiness where, as one Thai farmer remarked, it is "like being hired for wages on your own land" (Turton, 1984:34). Landlord abuses of their class power over the poor and landless or land-short still abound, as we saw above in the super-charged atmosphere of India, and it fuels peasant discontent among the rural poor throughout the Philippines. On the other hand, a successful class of technologically sophisticated small commercial farmers has emerged out of the peasantry in Taiwan and Japan. Thus, not only is the large class of peasants spread across rural Asia internally differentiated, but a significant section of this class is ceasing to be peasants.

Administrative

Peasants in the communist countries of Asia, however, find themselves in what Wolf refers to as an *administrative domain*. In all communist systems attempts have been made to collectivize the peasantry. This has often been preceded by violent land reform campaigns directed at "the landlord class", followed by state/collective assertions of ownership over the land, with peasants being organized into communes (China) or cooperatives (Vietnam). These collective organizations were then required to pay taxes or tribute to the state. During the 1970s de-collectivization began, and peasant families have been given rights over land, still in return for taxes. But there has only been a very partial re-commodification of land and labour, though this is likely to come (Potter and Potter, 1990; Vickerman, 1986; Evans, 1990).

Peasants have always been a subordinate class of surplus givers to a class of surplus takers. For much of history they have carried an inferior legal status as well as an inferior socio-economic one. Today peasants in Asia have formal equality – except perhaps in China where restrictions on peasant movements to the city, for example, makes them second class citizens – but the continuing power of landlords in some countries restrains them from exercising those rights. Developments among the peasantry remain one of the most important areas of social change in Asia today.

Classless Societies

The anthropological tradition has paid a great deal of attention to "egalitarian" societies. This derives from two sources: first, an interest in human evolution caused anthropologists to investigate the thousands of years in which human societies were hunter-gatherers; second, and following on, this saw anthropologists

begin to investigate the supposed "survivals" of this earlier period in human history, contemporary hunter-gatherers and "tribal" societies. Although anthropology has moved away from the assumption that hunter-gatherers are somehow survivals of an earlier age, the study of pre-state or classless societies makes up a large part of the anthropological tradition. This is perhaps less true for Asia than elsewhere because of the long established nature of the civilizations we have discussed so far in this chapter. All of these have been class societies, so what is meant by classless, perhaps "egalitarian", societies?

Classless societies have no social groups within them that monopolize access to key economic resources either through outright ownership or through political mechanisms. On the other hand classless societies are not uniformly egalitarian in either ideology or practice; the internal dynamics of some strain towards hierarchy and dominance through the assertions of aristocratic lineages, while others ferociously police their egalitarian constitution.

The Kachin in Burma, already referred to in Chapters 5 and 7 are not egalitarian. As Clark Sorensen points out marriage exchanges are part of a system of ranked lineages, and Paul Cohen has shown how this system of exchanges presses toward state formation and what would effectively be a society with classes. Edmund Leach's book on the Kachin, the classic source on their society, refers to it as class stratified, however he makes it clear that the Kachin conscious model of "class differences is almost totally inconsistent with Kachin practice...In theory rank depends strictly upon birth status; all legal rules are framed as if the hierarchy of aristocrats, commoners and slaves had a caste-like rigidity and exclusiveness. In Kachin theory rank is an attribute of lineage and every individual acquires his rank once and for all through the lineage into which he happens to be born. It is easy to see that this theory is a fiction..." (Leach, 1970: 159–60). For a start, an "open" (see above) system of slavery is practised and as Leach remarks (1970: 160), being a slave in Kachin society was "not necessarily one of disadvantage", and master and slave lived in the same house under the same conditions.

Heads of aristocratic lineages claimed chiefly status, yet this brought with it no economic power or recognizable differences in life-style. Powerful chiefs were at the centre of what anthropologists refer to as redistributive systems. That is higher status people were entitled to gifts from lower status ones. However, in this system, the receiver of gifts is thereby placed in debt by the giver. "Paradoxically therefore," writes Leach, "although an individual of high-class status is defined as one who receives gifts (i.e. 'thigh-eating chief') he is all the time under a social compulsion to give away more than he receives. Otherwise he would be reckoned mean and a mean man runs the danger of losing status" (1970: 163). A chief who attempted to accumulate this flow of gifts at the top and emulate a feudal lord would be quickly deserted and lose his power and status through a commoner revolt. Thus not only is downward mobility a feature of this theoretically rigid system, but upward mobility as well, and Leach shows how genealogies are easily manipulated and garbled in order to establish an aspiring commoner's claim to chiefly lineage status.

While Kachin theory insists on the importance of lineage solidarity under an hereditary chief, in practice ones finds continuous fissioning into small settlements led by aspiring chiefs. It is a further paradox of Kachin society that it is both the temptations of powerful chiefs to mimic neighbouring Shan lords that leads to a break up of their domain through commoner revolts, just as the competition for

aristocratic prestige leads to a proliferation of aspiring chiefs in smaller domains. In both cases a desire for hierarchy and dominance produces an egalitarian effect. The ability of Kachin chiefs to transform themselves into lords in fact depends on influences from outside Kachin society – their insertion into a regional opium economy for example (Nugent, 1982; Friedman, 1986), and political pressures from the Burmese state which has seen the emergence of warlord armies among the Kachin and other ethnic minorities.

In other contexts, however, the absorption of tribal societies into broader regional economies has in fact strengthened egalitarian tendencies within them. Many tribal societies in Asia have survived absorption into larger polities by living in remote mountainous regions which only the modern state has shown a determination to penetrate. Yet even prior to the development of capitalism and the modern state trading relations were established with many of these remote groups by lowlanders wanting forest products, and the latter would occasionally organize raids to capture slaves from among the mountain people. (It should also be noted, however, that some mountain groups were not averse to preying on their neighbours and selling them as slaves to lowlanders.) Among Philippine highlanders these lowland predations, if anything, strengthened the mechanisms which facilitated spatial mobility by these groups as a form of protection. The Buid, for example, have a very highly developed sense of individual autonomy and an ideology of ascribed equality which denies political power to any individual or office. They have a strong ethic of sharing food, for example, which enables individuals to move easily from group to group. Similar attitudes and practices are found among the Ilongot (Rosaldo, 1980). In both cases it allows them to evade control by lowland neighbours who cannot be resisted militarily. Thomas Gibson, who studied the Buid, suggests that their stress on sharing and their refusal to recognize indebtedness is partly a product of their interaction with lowlanders who refer to them as "*mangyan*" or slaves. "Since the lowlanders already regard the members of these groups as debt slaves, it would be fatal for those people themselves to acknowledge the principle of debt. These societies thus reject, often explicitly, the most fundamental principle of lowland state societies: dyadic dependency phrased in an idiom of moral and material indebtedness" (Gibson, 1990: 142). Thus the principle and practice of egalitarianism in this instance is a form of resistance to being absorbed into a class-stratified Philippine society.

Modern Egalitarian Societies

All societies in the modern world proclaim that their citizens have equal rights and most states claim to be democratic – even if they are dictatorships! That is, they justify their rule in the name of the majority. The two most notable exceptions to this have been Nazi Germany and the Republic of South Africa, both of which allocated rights according to racist criteria. While ethnic issues influence modern societies in the Asian region in fundamental ways (see Chapter 9) nowhere is one group proclaimed officially superior to another, whatever may be said privately and done in practice, although in some countries some ethnic restrictions remain. Sex-based inequalities have also proven intractable (see Chapter 10). A broad commitment to "equality", and democracy as an expression of it, is universal

today. Yet this flies in the face of continuing, and sometimes extreme, social inequalities throughout the world. Furthermore, these social inequalities have been held to contradict the aims of legal and political equality, and this provides the stuff of most modern politics.

The two dominant forms of social organization in Asia today are capitalism and communism. It should be said, however, that rarely do we find *pure* models of these societies. Capitalist societies have admixtures of socialism, and socialist societies elements of capitalism, and in Asia both may co-exist with various "pre-modern" forms of social and economic organization.

Capitalism

Class as a principle of stratification predominates in capitalist societies. The number of fully fledged capitalist industrial societies in Asia are few – Japan, South Korea, Hong Kong, Taiwan, and Singapore – while the rest are in various stages of capitalist development. People in capitalist societies acquire their class and status primarily through the workings of the market rather than having it assigned by political or religious means. It is a cultural bias of modern capitalism to consider these latter mechanisms to be inferior to, or less "fair" than the "impersonal" market. This might be called the conscious model of stratification under capitalism: individuals are distributed throughout the social hierarchy by the invisible hand of the market according to their individual talent and enterprise. (One might remark that this invisible hand has replaced invisible gods as the justification for the status quo.) Research in Hong Kong has confirmed the popular salience of this conscious model (Wong, 1991).

Some modern sociologists, building on the classic works of Max Weber, have begun to develop some powerful ways of conceptualizing class and stratification in modern societies, which are in principle applicable to pre-modern ones. Using the concept "social closure" they draw attention to the mechanisms by which some groups are able to monopolize particular resources – land, arms, means of production, or knowledge. Thus "market competition in the context of laws guaranteeing private property is the principal basis of monopolization in capitalist society whereas status group monopolies [e.g. lawyers], including those founded on educational credentials, are important but only secondary bases of monopolization" (Murphy, 1984:554). Thus large corporations and their owners and managers wield much greater social power than the most highly educated academic or skilfull lawyer, and tend to structure the rules of the game in capitalist societies. The fundamental overall structure of classes in capitalist societies therefore consists of capitalists and workers because legal title to private property is the principal form of exclusion. But there are also many other "derivative and contingent forms of exclusion which fragment the two principal classes and result in intermediate classes..." (Murphy, 1984:563). It is this which makes the class structure of capitalism seemingly so complex because the composition and relative positions of these intermediate classes are always on the move as the economy changes and old occupations fade out or are eclipsed by new ones. This also produces high rates of horizontal social mobility giving the illusion of high rates of upward mobility. Capitalism's economic dynamism, accordingly, is its strength in more ways than one.

Many of these intermediate groups "politicize" the "impersonal market" and

secure their position in it through closure strategies guaranteed by laws which place restrictions and conditions on who and how many people can become lawyers, doctors, teachers, and so on. Other groups like nurses campaign for "professionalism" in order to gain similar status. Few of these criteria bear a proven relationship to on-the-job performance, and often are reflections of cultural criteria, such as knowledge of class specific speech codes. Attempts to "naturalise" inequalities through the use of "intelligence tests" have largely failed, however, no doubt because they too closely resemble older ascriptive rather than modern achievement oriented criteria (leaving aside the culturally bound nature of these tests). But strategies of closure are also common among the working class, whereby trade unions restrict access to jobs by other workers – especially when they are ethnically different.

Thus it is not surprising that the dominant consciousness of people in capitalist societies tends to be a form of occupation consciousness rather than a broader class consciousness, as it is usually occupational groups who mobilize closure manoeuvres. In some cases, as in Japan, cradle-to-the-grave positions in some large companies forge identification at the company level. Furthermore, the culture of capitalism and the conscious model of stratification tends to individualize social awareness. Thus one of the most sensitive ethnographic explorations of class in the US, *The Hidden Injuries of Class* by Sennett and Cobb, discovered that people at the lower end of the scale attributed their position to their own individual failures rather seeing it as an outcome of a system. This also seems to be true in Asian capitalist societies, although we await a study of the calibre of Sennet and Cobb's, which will be sensitive to the nuances of dominance and subordination in various capitalist cultures in this part of the world.

Despite enormous inequalities of wealth and power in capitalist societies, with differentials that would make former emperors and *Shōguns* envious, and despite still large pools of poverty and neglect, the ability of industrial capitalism in Asia to deliver rising standards of living has ensured the broad legitimacy of its particular structure of hierarchy and domination. In the developing capitalist states of Asia this legitimacy is still being won.

Communism

While the aim of communism is a "classless" society, China, or North Korea, or Vietnam contain an array of classes and status groups. A peculiar feature of stratification under Asian communism is that it retains many features we associate with the old dynastic states.

Similar to the traditional state the Chinese communist state has tried to monopolize access to privilege through its ability to regulate the class and status of individuals. In many respects it inverted the old status hierarchy by placing those who could claim "poor peasant" status at the top of its conscious model which, subject to variations as a result of political campaigns, looks roughly as presented below.

Elite	1. Poor peasants
Commoners {	2. Middle peasants and industrial workers
	3. Rich peasants
Outcastes	4. Landlords, capitalists (including merchants) and intellectuals

Mao Zedong and Lin Biao during the "Cultural Revolution". Egalitarian dress under modern communism is an attempt to assert the classlessness of the society.

Not unlike the traditional model those at the top were deemed superior by virtue of having "purer" motives for social action, while those at the bottom were deemed venal, self-seeking and exploitative. Furthermore the position of those at the bottom, like the "mean" people of the past, was quasi-hereditary inasmuch as the offspring of these people were considered to be tainted with the values of their parents. One consequence of this was a degree of class endogamy. Jonathan Unger recorded one marriage strategy among "bad-class" households in a southern Chinese village he studied. "'Just about the only way a landlord son can get married', noted a Chen villager, 'is through a swap with another household...Both families sacrifice their daughters to keep the incense burning [i.e. to sustain the male line].' Normally such exchanges were arranged with other bad-class families" (Unger, 1984:134). Chinese culture gave a further twist to this "revolutionary" system by designating that class labels only passed through the patriline which made it much easier for women from "bad-class" families to marry up, especially where there was a shortage of women.

The monopolization of resources by the state, which in turn is controlled by the communist party, means that membership of the party is the key to power and influence, rather than economic ownership of productive property. As distinct from the above conscious model, communist party members are the real elite. Membership of the party can erase a "bad-class" background (true for a significant portion of the top leadership), while a poor peasant member of the party has greater power and status than a mere poor peasant. Furthermore, the party itself is hierarchically ranked and this determines an individual's location in the power structure, their life-style and their physical location in the country.

One significant consequence of this is that competition for scarce resources is concentrated on access to the state. This has had a fundamental effect on ordinary

people's attitude to class designations. The latter were often manipulated in the competition for resources and used to exclude those with "bad-class" or theoretically less pure class backgrounds when a particular resource was scarce, such as middle school places; or including them if, for example, such a person was educated and a teacher was needed for a local school. Thus "the class line was brought to bear precisely where local shortages in goods and services were most pronounced" (Unger, 1984: 132). In other words, strategies of closure found widely in capitalist societies are also in operation in Asian communist societies. With the market reforms in China in the 1980s, however, alternative routes for mobility have opened up outside the state through private business activities. Therefore, strategies of closure related to the state and manipulation of class designations are now accompanied by market based closure strategies more typical of capitalism.

In their field-study of another southern Chinese village, Zengbu, Sulamith Heins Potter and Jack Potter remark on a further aspect of social stratification that does not feature in the model sketched above, that is the birth-ascribed lower status of people in the country compared with the city. This, they write, "remains the most important social distinction in modern China" (1990: 297). Urbanites have access to a much greater range of goods and services than peasants in the countryside of China, therefore many people wish to move there. Partly motivated by a desire to not have swollen cities with slums and beggars, and partly by questions of political control, the government restricts access to the cities through a strict household registration system. One can easily move from the city to the country, but not vice-versa. This, says the Potters, makes the peasants very aware of being second-class citizens. Even marriage is not a sure route out of the countryside. For example, if a man in the city marries a peasant woman she cannot change her household registration or live with him. This is further compounded by a peculiar reversal of custom in the state regulations which say that a child inherits the mother's status. "The purpose of this departure from customary assumptions about the inheritance of status (traditionally, a child belongs to the father and his family, and shares his status) may be to restrict mobility as effectively as possible. Since men are much more likely to shift status than women, having the child take the mother's status means that far fewer children will shift status" (Potter and Potter, 1990: 304). Men change their status because they are more likely to join the army, or the party, or to get an education. Even so, mobility is rare, and the Potters refer to a single case of a young peasant boy in Zengbu who became a navigator. This case, they said, "has the quality of folklore, invoking the traditional tales of studious boys who rose in the ranks of the scholar gentry on the basis of ability alone" (1990: 309). But folklore is often enough to sustain the dream that a better lot in life is possible.

Emics and Etics of Hierarchy and Dominance

Edmund Leach (1967) and Louis Dumont (1980) have both warned anthropologists to discard assumptions about equality when investigating systems of stratification in other cultures lest researchers misconstrue the attitudes of other peoples towards hierarchy and domination. "Freedom and classlessness are political ideas;" writes

Leach, "they have no place in sociological analysis, which must necessarily be concerned with social constraints and status differences.... We assume that men are born equal. We must remember that this is a judgement and not a fact. Social systems different from our own rest on different assumptions" (1967: 14–15). This call for a culturally relative methodology, however, also has to be wary of too readily accepting the ideal or conscious models other systems have of themselves – which is a criticism levelled at Dumont's work on caste. There can be a disturbingly fine line between objective understanding and apologia for a brutal status quo. Historically, and still today, dominant groups claim that subordinate ones are content with their lot and adhere to the prevailing model of the social structure. Yet there is an accumulating body of evidence which suggests that the compliance of subordinate groups, although (or perhaps because) conducted in power-laden contexts, is contingent and contested.

The "everyday forms of resistance" to assertions of dominance take many forms. Thus there were continual violations of sumptuary laws in traditional China. "In the T'ang dynasty artisans and merchants were not permitted to ride on horses, yet to judge from the edict of 832 many of them had decorated saddles and silver stirrups and were followed by slaves on horseback. During Sung, common people were prohibited from using sedan chairs, yet officials frequently complained that many rich people [merchants], as well as prostitutes and actors rode in such chairs...In short, the orders issued from time to time to enforce these prohibitions indicate that...the population frequently ignored them" (Chu, 1965: 154). And we have already seen how lower castes attempt to usurp dress styles and other sumptuary laws of higher castes in order to become mobile, rather than docilely accepting their fate.

In what has already become a classic in this genre of research, *Weapons of the Weak* (1985), James Scott reports on two years of fieldwork among Malay peasants, investigating their pilfering of crops, their sabotage and arson, and their footdragging in response to subordination – all the "small arms fire in the class war". It was also a response to the changes in the village moral climate as values based on the capitalist market displaced older, more personalized ones. Scott writes: "In Sedaka, as in any peasant society, there is a large variety of ritual ties that lie beyond immediate relations of production and serve both to create and to signify the existence of a community – one that is more than just an aggregation of producers. The particular ritual ties that involves gifts and exchanges between rich and poor are sensitive barometers of the vicissitudes of class relations" (1985: 169). As impersonal market exchanges grew the traditional exchanges, often expressed in terms of Muslim morality, began to break down as richer villagers used excuses drawn from the newly emerging value system to refuse their obligations, thereby triggering off waves of resentment among poorer peasants. In an earlier study, *The Moral Economy of the Peasant* (1976), Scott argues that it was precisely this shift in values with the development of capitalism that caused peasant rebellions across Asia in the nineteenth and twentieth centuries. But outbreaks of peasant protest have a history that predates capitalism by centuries, in Japan, India and China, and hence are symptomatic of a more general reaction by peasants to their subordination.

But everyday forms of resistance are not only confined to peasants. Spirit possession among young Malay women workers in sanitized high-tech factories is, according to Aihwa Ong, a protest which springs from the encounter between a non-capitalist morality and factory discipline. In outbreaks of "mass hysteria" or

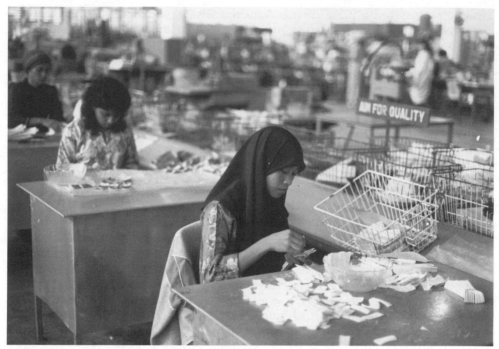

Women assemble shoes at the Bata factory in Seremban, Malaysia.
Courtesy of Marlane Guelden.

in individual reactions women are possessed by spirits of an archaic Malay world, such as *hantu*. Ong reports the following incident:

> It was the afternoon shift, at about nine o'clock. All was quiet. Suddenly, [the victim] started sobbing, laughed and then shrieked. She flailed at the machine...she saw a hantu, a were-tiger...People say that the workplace is haunted by the hantu who dwells below...well, this used to be all jungle, it was a burial ground before the factory was built. (Ong, 1987:207)

Spirit-healers (*bomoh*) rather than union officials were called in to deal with the outbreaks; and an American manager of one factory wondered how he was going to explain the loss of 8000 hours of work "because someone saw a ghost" (1987:204).

Thus, while a society may give the appearance of calm and consensus, exhibiting no, or few, dramatic demonstrations against current hierarchical arrangements, an often enigmatic hidden discourse can be found weaving its way through the lives of ordinary people. It speaks of discontent with hieararchy and domination and anthropologists must keep their ear close to the ground in order to hear it.

Exploitation?

These complex reactions to social change and to subordination draws attention to the equally complex idea of exploitation. This question, debated extensively by

anthropologists (Evans, 1988), also has an emic and etic dimension. "To the extent that [exploitation] can have some objective meaning," Barrington Moore writes, "it designates nonreciprocal social relationships. Some people get more out of the relationship than their contribution warrants and others get less" (Moore, 1978:455). But, he goes on:

> Any claim that exploitation exists has to take into account all relevant exchanges. It is not enough to demonstrate that a dominant class or caste consumes more material goods than it produces. It is also necessary to show that the other services it provides, such as coordinating the various economic and noneconomic activities of the society, rendering justice, providing defence against common enemies, are services that it fails to provide adequately, or that the social functions themselves have for some reason become less valuable than they were. (1978:455–6)

In a book concerned with popular perceptions of justice and toleration of injustice Moore stresses the historical contingency of subjective reactions to exploitation, while at the same time demonstrating it is a "recurring historical discovery" (1978:457).

Scott in *The Moral Economy of the Peasant* also establishes a conceptual link between objective conditions and the subjective feelings of the "exploited", and he explores how inequalities and stratification are legitimated. By examining peasant values, he argues, it is possible to construct the standards they use to judge whether a particular situation is just or not – their moral economy. There are, he claims, two enduring values or yardsticks used in this moral economy: a conception of reciprocal rights and duties between different groups, strata and classes in rural society, and a belief in a person's right to subsistence. He writes:

> In any particular agrarian order there is likely to be a similar moral consensus among tenants. Some balance between what tenants provide in goods and services to landlords and what they receive in return will be seen as reasonable and any substantial departure from that norm in the landlord's favour will appear exploitative. Naturally such norms will vary from place to place and from one period to the next. (1976:165)

Seen in this context stratification and inequalities are not automatically illegitimate, and indeed the fulfillment of obligations by the contracting social partners reinforces the salience of current arrangements. A crucial research problem, of course, is discerning whether compliance with current arrangements is made under duress or not. And if the former, peasants, or anyone else in a power-laden situation, are unlikely to say so freely.

Anthropologists and the Study of Stratification

Sociologists have paid much greater attention to questions of social class, especially in modern societies, than have anthropologists. But the macro studies conducted by them often suffer from a hiatus between large concepts like class and the

perceptions and practices of people in the streets, factories or fields. Furthermore, it could be argued that the actual practice of class power is enacted in micro-situations – where ethnography comes into its own.

Rubie Watson's study of class differences and affinal relations in a Chinese lineage is a perfect example of the insights anthropology can bring to bear on questions of hierarchy and dominance. Ideas of lineage solidarity in southern China deny the existence of class differences within the lineage, and obscure horizontal bonds stretching outside the lineage. Watson notes that it is the poorer peasant men who most strictly adhere to this ideology. This she relates to the differences between marriage transactions by landlord-merchant families and those of ordinary peasants. The former used a system of indirect dowry while poor peasants paid what amounted to brideprice (see Chapter 5). These different transactions have both different status implications, and peasant brideprice is a one-shot exchange requiring no further exchanges, whereas both families contribute to a dowry among the elite thereby allowing for ongoing future exchanges between affines. The elite also married over a wider area appropriate to their social horizons, whereas poor peasant men had few transactions beyond the lineage village, and the elite married with an eye to consolidating regional contacts and therefore influence. These different class patterns in marriage were obscured by the fact that marriage rituals were identical for landlords and peasants thus serving to confirm the symbolic unity of the lineage vis-à-vis outsiders. Thus, writes Watson, "the lack of affinal contacts between peasant men was part of a wider system of domination. While the peasant had little to do with men outside his lineage, he remained an economic and political dependent of his wealthy agnates. In striking

Members of the board of the Hong Kong Stock Exchange are sworn in, 1981.
Courtesy of South China Morning Post.

contrast extra-lineage contacts, including contacts with affines, helped maintain the landlord's dominant position" (1981:594). Such careful analysis of the role of kinship in stratification is one of the important contributions anthropologists can make to an understanding of Asian societies.

Nowhere would this seem to be more appropriate than in the study of ruling classes and elites in contemporary Asia. Yet it is remarkable how few studies there are of dominant groups compared with subordinate ones. James Watson, however, has found himself in an unusual situation. In the early 1960s he began detailed fieldwork on the Man lineage in Hong Kong's New Territories. From rural beginnings the new generation leaders of this lineage are now international businessmen in America and Europe. "If I want to see them I have to put on a suit and tie and make appointments", Watson commented at a 1991 University of Hong Kong seminar. These new men of power have the power and social confidence to control or reject the probes of anthropologists. As we noted earlier, closure strategies operate downwards, and in this case may lock out the anthropologist. Research on elites does, therefore, place unusual obstacles in the way of anthropologists compared to those typically encountered in the field. But assuming that the anthropologist can break through into this "charmed circle", other problems await them, as George Marcus has indicated: "Normally anthropologists are empathetic with their subjects and become increasingly so the longer they are involved with them... Working empathy with one's subjects can be misconstrued as ideological empathy; ideological distancing from one's subjects to the point of disapproval, is a difficult condition of work in an ethnographic style of research (and may be one reason why there are so few ethnographies of elites); and ambivalence or silence in judgements on subjects makes the ethnographer's research equally vulnerable to a charge of elitism..." (1983:23). One can imagine the dilemmas which lie in wait for the ethnographer of the Philippine or Indonesian oligarchy, or the ruling elite hidden behind high walls in China.

Attention to elites will not only expand our knowledge of Asian societies, but will produce a refreshing change in anthropological reports from the field: no longer horror stories of poor diet and disease, but ones of tables filled with *haute cuisine* and fatigue from endless social rounds in which marriage alliances are hatched, and reports of high political or economic intrigue planned in the back of stretched Mercedes Benz as they whiz along the freeways of Asia's now concrete jungles.

9 THE ETHNIC MOSAIC

Lian Kwen Fee and Ananda Rajah

The anthropological and sociological study of ethnicity is essentially concerned with understanding the considerable diversity of human populations as well as their commonalities as members of the same human species. It is also concerned with the social, cultural, economic, and political implications of this diversity. In everyday life, people are more often struck by the differences between groups of people than by what is common to them as *Homo sapiens*; and they behave accordingly, i.e. on the basis of the *perception* of difference. The study of ethnicity, on the other hand, attempts to explain – among other things – why it is that people view others differently and why it is that such views exert such a powerful influence on their behaviour which sometimes expresses itself in violent ways, acts of discrimination, or acts of symbolic violence such as the labelling of "others" in terms of negative, demeaning stereotypes.

Race and Ethnicity

A major distinction in the anthropological and sociological study of ethnicity is that between **race** and **ethnicity** as concepts. The former exists in popular usage and is often integral to the ways in which "other" people are seen to be different. The latter, is a much broader, more complex one and we discuss the concept more fully in a later section. An understanding of how these terms are used is important because it represents the first step in coming to grips with the issues which are posed by the diversity and commonalities *shared* by human populations.

The term "race", as it is often used today, is derived from much earlier uses of the term. Accordingly it has undergone many changes in meaning and connotations. The term comes from the Italian *razza* and when used in English (as in German, mentioned by Sandra Bowdler in her chapter) was taken to refer to groups of people, animals, or plants which were thought to share a common descent. The term, thus, was associated in some respects with biology as it emerged as a discipline (as we now know it) in Europe in the last century. As the term continued to be used in the human sciences and popular discourse, it came to carry certain associations deriving from its past usages and its uses in biology. As Evans points out in the introductory chapter, the biological idea of race was largely absent from most of Asia. It was an idea Europe gave to Asia and, later in this chapter, we explain the processes by which this took place. This does not mean, however,

that in Asia people did not view other Asian (or non-Asian) people as being different; the perceptions of difference would have been based on cultural criteria rather than the biological idea of "race".

As a result of its historical background popular use of the term "race" assumes two things whether or not people who use the term recognize these two assumptions. First, "race" assumes that people in general have certain physical, mental, and other characteristics which are determined by their genetic make-up. In biology proper, we may in fact only speak of "genotypes" which are genetically determined and "phenotypes" which include physical characteristics, and physiological as well as behavioural features. Hair colour, hair form, blood groups, and eye colour, for example, are genetically determined. In popular, biologically uninformed discourse, however, people often talk of behavioural characteristics such as intelligence, industriousness, business acumen, honesty and their opposites, i.e. stupidity, laziness, propensity to waste money, guile and so on, *as if* they are genetically determined, which they are not. Second, popular use of the term "race" assumes that the members of a particular group of people or "race" all share the same physical and non-physical attributes. It assumes, in other words, that no variation or diversity is possible within a so-called race because the genetic constitutions of its members are the same, if not identical.

Some of the problems, contradictions, and absurdities involved in popular use of the term "race" have been highlighted by Robin Fox:

> *Many anthropologists have stopped using the term [race] as a scientific concept, because they feel that it is meaningless for any useful analysis of human differences. Those broad categories of white, black, yellow, red, and various other bands of the spectrum are so full of internal diversity that they cannot be used as units of analysis at all. Between the two ends of the black band, for example, there may be nothing in common other than dark pigmentation, and in some cases even this may be less dark than the pigmentation of some Caucasoids – Hindus, for instance. And here again there are problems, for Hindus are not a race, but a religion; the British are not a race, but a nation; the word "Aryan" does not signify a race, but at best a language family. All these varying categories, however, have at one time or another been dubbed "races". The catalogue of races varies from a list of three to several hundreds, and there are no settled criteria of discrimination.*
>
> *Perhaps the broadest and least controversial of all definitions is the one proposed by M.F. Ashley Montagu and Loring Brace. They define a race simply as "a group of mankind, members of which can be identified by the possession of distinctive physical characteristics". But even this is a cultural rather than a biological definition. It depends on the perception of differences that are distinctive, rather than on actual genetic differences between the groups. Groups that look alike may have radically different genetic make-ups, in, for example, blood chemistry. And in "race relations" it is, of course, the perceived differences that matter. (1975b: 58)*

We should also be aware that in popular usage, the term "race" has sometimes been used in association with notions of "racial purity", "racial superiority", "racial inferiority" and so forth, to describe people *other than ourselves*, for which there is no scientific basis. Such ideas attaching to the term "race" and the term

Indians, Chinese and Malays pass a Muslim shop in Kelang, Malaysia.

itself have been used, and frequently continue to be used, in ways which justify acts of discrimination by one group vis-à-vis another ranging from the imposition of minor inconveniences and disadvantages to genocide (the extermination of a "race"). Beliefs of this kind sometimes can be held systematically or ideologically, i.e. in an apparently coherent way, by individuals or groups. Such beliefs and practices are correctly described by the terms "racism" and "racist" which are, of course, derived from "race". It is important to recognize that these various uses of the term "race" (which have sometimes led to horrifying consequences) contain implicit or explicit value judgements and that such *uses* have no place in social science analysis.

In studying how the term has been and continues to be popularly used, it is apparent that uses of the term "race" reflect attempts to "naturalize" what are in fact social and cultural differences. We should also be aware that even when the term "race" is not used, social and cultural differences between groups of people may be talked about *as if* they are somehow biologically inherited, are intrinsic to different groups of people, or are in some way expressions of an identifiable group psychology. This is sometimes more difficult to discern and is related to what is called ascriptive ethnicity, by which we mean the *attribution* of *fixed* identities, associated with supposedly distinctive characteristics, to culturally different peoples without taking into account cultural relativism as discussed by Evans in the Introduction. While some genetic differences, for example hair colour and eye colour, clearly *are* visible, for all practical purposes, when people perceive differences between groups of people they mostly do so on the basis of, for example, social organization, or behaviour which is guided by different social norms and codes, cultural practices, language, religion, and so forth. However, in trying to "explain" these differences, "race" and the ascription of ethnicity are often drawn upon because they provide a ready, but by no means true, explanation of such differences. It is convenient to "explain" differences in this way because

it simply says that all perceived differences are "in the nature" of people, i.e. that they are inherent and inherited. It is in this sense that "race" and certain expressions of ascriptive ethnicity naturalize differences. What is required, in fact, is a careful accounting for genetic differences so that we are then free to think more clearly about all the other differences that matter in anthropological and sociological analysis.

In the view of some anthropologists, the proper biological usage of the term "race" is relevant to the anthropological study of human diversity. The relevance lies in the study of long-term human population history. In biological usage, the term "race" is similar to the notion of "sub-species" as Sandra Bowdler points out in her chapter. The human species is a species by virtue of the biological criterion of *inter-fertility*, i.e. all males and females of the species can mate and produce fertile offspring. A sub-species, which naturally shares this criterion, is however distinguished on the basis of other, additional broad, classificatory criteria. Some anthropologists use the idea of race, in the sense of sub-species, to distinguish for example "Mongoloids" (comprising, for example, Chinese and Malays), "Caucasoids" (comprising Indians and Europeans), and "Negroids". But, there are many more than three *ethnicities* here. Here it is worth noting that La Barre has argued that human races are to a large extent both deliberately cultivated (by selective breeding) and essential for the survival of the species as a whole – so long as a sufficiently large number of individuals continue to interbreed across racial (i.e. sub-species) boundaries. Bowdler has pointed out that generally it is recognised that it is too simplistic to draw really firm distinctions where races are concerned. Notwithstanding this, some anthropologists have found that it is a useful concept when employed with other forms of evidence (for example, the archaeological, linguistic, and serological, among others) in the study of certain aspects of human population biology and human diversity in the long term (which we discuss later). We should note, however, that when it is used in this way the biological notion of "race" has nothing in common with "ethnicity" as used in social, cultural, or political analysis – or popular discourse.

The concept of ethnicity, as anthropologists and sociologists use the term, on the other hand is a very different concept. Ethnicity has very specific meanings for anthropologists and sociologists and reflects the importance accorded to cultural relativism. The term "ethnicity" however, is now generally accepted and exists in popular use though not always in the sense that anthropologists and sociologists understand the term. Indeed, it is sometimes used (along with other more oblique ways of referring to what are essentially cultural differences between groups of people) in much the same way as "race" in popular usage. Thus, we need to demonstrate a critical awareness of how terms such as race and ethnicity are used, as well as how differences between groups of people are talked about.

If Human Unity, Whence Human Diversity?

A major puzzle confronting those of us seeking to understand the nature of diversity in the midst of human unity is the process by which such diversity has come

about. Sandra Bowdler has explored several important issues in this puzzle, and her discussion of the arguments by archaeologists and physical anthropologists should be kept in mind when we consider diversity and unity in the context of the study of ethnicity. The lessons from Bowdler's chapter are relevant here. There is, at present, no single theory or argument which can explain *all* the archaeological and physical anthropological data now available. Likewise, there is no single theory which can explain how the considerable cultural diversity of present-day human populations has occurred and, we would stress, continues to occur – in some cases with startling rapidity. A number of theories have, in fact, been advanced and the theories have developed over time with greater understanding of how *complex* are the issues involved. There are some resemblances between the models of human evolution discussed by Bowdler and the models of cultural diversity which we discuss below, partly because the theories of cultural diversity have drawn upon some interpretations of human evolution. It is important to note, however, that there is no *fully coherent* theoretical connection between these models, for example, the "replacement model" discussed by Bowdler and the model of "migratory waves" below, although the latter is in some respects a derivative of the former. The absence of a full theoretical connection is discussed more fully later when we draw attention to the distinction between prehistory and history.

The first comprehensive attempt to explain diversity in Asia was embodied in a model of waves of migration. According to this model, the diversity was brought about by successive waves of migration by "culturally more advanced" people, displacing less advanced people who were forced to move to more isolated places (mountains and forests) where their pristine or primitive cultures were maintained (Rambo, Hutterer, and Gillogly, 1988: 2). The diversity of the populations of, for example, Peninsular Malaysia were explained by Cole (1945) in terms of this model. The Semang (or Negritos) were the earliest, most primitive inhabitants, who were displaced by the Senoi, who were in turn displaced by the Malays. As Rambo, Hutterer and Gillogly (*ibid.*) point out, this model was based on a culture history approach formulated at the beginning of this century in Germany by Graebner (1905, 1911) and Father Wilhelm Schmidt (1906a, 1906b, 1911) and others schooled in the tradition of European ethnology. Schmidt himself actually talked of "culture circles" being himself interested in the movement of culture rather than peoples and his work is often associated with the theory of cultural diffusion. Robert Heine-Geldern, a student of Schmidt, attempted to set out a comprehensive account of Southeast Asian ethnography in terms of "cultural complexes". In his view, the existence of similar complexes in different cultures was to be explained by diffusion associated with different waves of influence or migration (Keyes, 1977b: 4).

The unsatisfactory nature of this model had already become apparent to anthropologists such as Franz Boas working in North America in the 1920s but it continued to be used in Asia. Although the assumptions of the model were questionable on the basis of a growing body of ethnographic data, it is surprising (as Rambo, Hutterer, and Gillogly have observed) that it continued to be accepted for a long time. There are two obvious shortcomings of this version of the culture history approach. First, the assumption of culturally advanced people displacing others who were less culturally advanced fails to recognize that the *cultures* of peoples living in isolated mountain or forest habitats are as complex and

An interesting case of cultural diffusion in Northern Burma: A member of the Kachin Independence Army plays a bagpipe which had its origin among Scottish highlanders and was "diffused" to the Burmese highlands during British colonialism.
Courtesy of Hseng Noung Lintner.

sophisticated as that of their alleged usurpers inhabiting, for example, riverine, lacustrine and plains areas. Semang kinship systems, economic systems, and social organization are certainly not "primitive" when compared with that of their Senoi and Malay neighbours. Second, the hypothesis of waves of migrations – in the final analysis – simply pushes back further the questions of where migrant populations did come from, how they originated, and why are they different.

Dissatisfaction with the model of waves of migration and fresh evidence from Southeast Asian archaeological sites resulted, in the late 1960s and early 1970s, in the development of a new conceptual framework for understanding human diversity in the region. This framework, which Rambo, Hutterer, and Gillogly (1988:3) call a model of evolutionary adaptation – in the sense that differentiation evolved out of adaptation to environmental conditions broadly defined – is generally associated with Wilhelm Solheim (1969, 1970, 1975, 1979), Chester Gorman (1969, 1977), and Donn Bayard (1970, 1979, 1980). Although the archaeological evidence was not substantial, it was argued that there were long established human populations in Southeast Asia and that evolution occurred *in situ* contrary to earlier ideas that the region was inhabited by people who came in migratory waves from the north, i.e. China. Since then, however, a number of models, within this framework, have been advanced.

More recently, the *in situ* model of differentiation has been used to explain *physical* differences in a small part of Southeast Asia, for example the recent and

rapid evolution of "Negritoid" phenotypes from Mongoloid matrices, separately in the Philippines, Malaysia, and the Andamans. Work of this kind combined with the use of archaeological and historical evidence as well as ecological and linguistic studies, within a sophisticated and complex theoretical framework has also been undertaken to explain physical and cultural differentiation in peninsular Malaysia (Benjamin, 1985, 1986, 1987). This latter, synoptic approach merits consideration in its own right and we discuss it later in the section on Current Theoretical Trends and the Understanding of Ethnographies.

The second model of *in situ* differentiation explains the emergence of diversity in terms of ecological adaptation drawing upon perspectives provided by the study of cultural ecology (Rambo, Hutterer, and Gillogly, 1988: 4). Following arguments made in physical anthropology, for example that the occurrence of certain physical characteristics (such as size, skin colour, abnormal blood proteins) could be the result of natural selection pressure, the cultural ecologists put forward a similar kind of argument. In this model, it is argued that cultural traits and differences are the outcome of adaptation to different kinds of environmental selection pressures. It is important to realize that the argument attempts to explain *cultural* differences and not physical differences among people. It is also important to note that in this model, adaptation is seen not only as adaptation to the natural environment but to other social groups which form part of the social and cultural ecology of the group in question. There are now various versions of this basic model which show considerable anthropological and sociological sophistication in handling the issue of cultural diversity. Some of these versions include not only other groups of people or societies which form part of the "environment" which a group adapts to, but also the *state* and supralocal political forces. We discuss these issues more fully, later in this chapter, in relation to some examples from Southeast Asia.

The third model, which also has several versions, may be described as a model of intergroup interactions (Rambo, Hutterer, and Gillogly, 1988: 5). One exposition of diversity in these terms was put forward by Frederik Barth and it is an approach which has been extremely influential in the anthropological and sociological study of ethnicity. Barth (1969) propounded the view that the identity of an ethnic group (a term which we discuss in more detail below in relation to "ethnicity") and its members depends on the nature of interaction between groups. In Barth's view, "ethnicity" is an important principle of social organization and the boundaries of the group are not necessarily fixed and immutable. Furthermore, he argued that it is the boundary of the group which defines the group rather than the "cultural stuff" within it. While some anthropologists and sociologists might not necessarily agree entirely with this formulation, all would undoubtedly agree that Barth has convincingly argued that the identity of a group depends on the maintenance of its boundaries but that even these boundaries can be "crossed" under certain conditions. In Barth's example, these conditions concern the nature of the interactions between neighbouring groups in a situation of limited resources.

An earlier example of the intergroup interaction approach is provided by Edmund Leach's classic study (1970) of the Kachin in Burma. Leach's seminal study, as with Barth's essay, is an example of how the anthropological and sociological study of ethnicity in Asia can be an enormously challenging, exciting, and rewarding intellectual enterprise. Leach argues, in essence, that the Kachin (who are speakers of a Sino-Tibetan language) have a social structure and system which "oscillates"

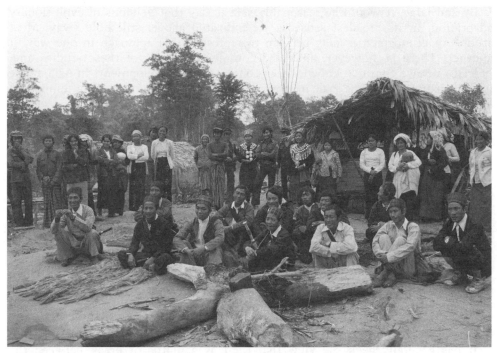

Variable ethnic identity. Among this group of Kachin several of the women are dressed as Shan and the men wear lowland Shan trousers and shirts, but a Kachin turban.
Courtesy of Hseng Noung Lintner.

between a democratic or egalitarian form and an autocratic form, the latter emerging when marriage alliances result in the accumulation of wealth. The social structure of Kachin groups becomes more complex and autocratic. At the same time, they express their wealth in various rituals and other symbolic forms which are modelled on those of the neighbouring Shan (a Tai-speaking group) who also happen to have a more complex political system. Leach argues that Kachin who emulate the Shan in this way may in fact call themselves Shan, which in effect is a change of identity. Lehman (1963), who studied the Chin in Burma, advances a very similar argument to that of Leach but adds yet another complexity. Lehman argues that the Chin are not only adapted to the natural environment and neighbouring groups but to *lowland Burman civilization* and the *state*. This, as we shall see below, is a recurrent theme in the study of ethnicity in modern times but it is a theme which manifests itself in highly varied and complex ways.

Current Theoretical Trends and the Understanding of Ethnographies

What are we to make of these various theories and what are the current theoretical trends in the understanding of human and cultural diversity, especially in the light of the vast array of ethnographies available to us now?

By and large, it would be reasonably safe to say that versions of evolutionary adaptation, in its broadest sense as we indicated above, still hold sway. Most studies or ethnographies may be seen to represent this approach in one way or another. There is, however, an added complexity. Many of these studies and, indeed, our own common knowledge of contemporary developments in Asia, make it clear that small or large scale migrations or movements, permanent or temporary, of people across national boundaries (as they have been drawn and accepted internationally today) are fairly common for many reasons. The reasons include movements motivated by the search for new lands to farm, the attractions of new economic opportunities and possible wealth, trading relations, escape from persecution in one form or another, and so forth. It requires very little imagination to realize that such migrations and movements, whether temporary or permanent result in *contact* between different groups of people and, accordingly, individual or intergroup adaptation in one form or another. We should bear in mind also that, in some cases, what was intended to be temporary migration ended up being permanent when the option of returning to the place of origin was closed, for whatever reasons. Thus, as Rambo, Hutterer, and Gillogly (1988: 7–11) point out, where theoretical trends and current conceptual frameworks are concerned, there can be and is in many instances a *complementarity* between theories of evolutionary adaptation and migration, at least in a generic sense. Nevertheless, it is essential to recognize that migration in this context is not to be understood in the sense of migratory waves as described above.

It has generally been the view that there is a hiatus or break between the theories of human evolution and theories of cultural diversity and differentiation between human groups. The hiatus is in some ways indicated by the categories we use: prehistory and history. The essential distinction lies in the existence of *unwritten* (i.e. archaeological) and *written* (i.e the historical and ethnographic) records. Given the present state of our knowledge, the uneven array of archaeological data, and the considerable ethnographic data now available, it has not been possible to offer a unified theory which can satisfactorily place the prehistorical, historical, and contemporary ethnographic and sociological data available to us (in all its variability) in clear-cut terms of a unified flow of *human evolution up to the present*, a process which as we have seen also demonstrates a remarkable *ability* for social and cultural differentiation despite the unquestionable, biologically defined commonality of the human species. Until only recently, the gap was marked by the absence of a conceptual framework that could link together our knowledge of the archaeological and prehistorical evidence and our knowledge of contemporary ethnographic and comparative sociological data as a seamless, uninterrupted flow of developments and processes, explaining how diversity can also be expressed within the unity of the species *Homo sapiens*. It is possible that for the time being at least, we may have to accept that the hiatus cannot be bridged if only because the necessary evidence to do so may well be irrecoverable.

It is worth noting, however, that more recent work by Benjamin (1985, 1986, 1987) has attempted to bridge this hiatus by drawing on a considerable amount of diverse data within a single theoretical framework, although the framework has not yet been applied to more than a small part of Southeast Asia because of the paucity of good genetic, archaeological, and historical data. Benjamin's main thesis is that most of the cultural variation in Peninsular Malaysia has arisen *in situ* and that

demographic and population-genetic variation in the Peninsula was essentially indigenous in character. In treating prehistoric archaeology as paleo-anthropology, Benjamin utilizes archaeological evidence, linguistic evidence, historical studies, craniometric studies by Bulbeck (1981) and population-genetic studies by Fix (1977, 1982), data from contemporary ethnographies, and ethnological and cultural ecological approaches. While conjectural in parts, Benjamin's theoretical framework is perhaps the most comprehensive of its kind applied to a part of Southeast Asia and is instructive in showing how cultural variation and population and demographic variation can be explained as a continuous, on-going process from prehistory, through history, into the present.

More generally however, the study of ethnicity, on the basis of historical evidence and contemporary data has made enormous progress. And, as we come to be more aware that groups of people or communities claiming a certain identity have continued to show a remarkable ability to maintain their identity or transmute it, we are made to realize that there is a constant need to refine the theories, further develop our conceptual frameworks, or rework existing hypotheses. It is for this reason that we claim that the study of ethnicity presents exciting intellectual challenges. And, if like Leach or Barth, we can develop original and thought-provoking hypotheses, theories, or conceptual frameworks to explain something as dynamic as ethnicity, it can also be tremendously rewarding intellectually.

We must, nonetheless, realize that the theories and models which we have reviewed above (from the cutural history approach onwards) concern the historical and contemporary much more than the archaeological and prehistorical. There is an enormous amount of study and research to be done even in this relatively smaller area in anthropology and comparative sociology. Thus, even if it may not always be possible to bridge the gap between the prehistorical and the contemporary (as Benjamin has done), we should recognize all the same that anthropological and sociological investigations of diversity in historical and contemporary times, nonetheless, represent tremendous challenges and opportunities for intellectual and scholarly endeavour. The opportunities and endeavours rest on a clear understanding of concepts such as "ethnicity" and their applications in academic and scholarly terms today.

In what follows, we set out some of the more important issues entailed in the study of human diversity through a number of examples drawn from South Asia and Southeast Asia, guided by the concept of "ethnicity".

Ethnicity, Ethnic Group and Ethnic Relations

Although a term of the social sciences, ethnicity is more difficult to grasp mainly because compared to "race" it is an open-ended concept. Such conceptual open-endedness is, however, essential because the phenomenon it seeks to describe and place in context is varied and dynamic in the sense that complex, on-going processes are involved. A full understanding of what "ethnicity" means in anthropology and sociology is, nevertheless, well worth the intellectual effort. For, through

this, we come to appreciate better the richness and diversity of human groups, and the ways in which they express their identities. We are also better placed to understand how, under certain conditions, the various assertions of such group identities can take place at the expense of other groups.

While it may be tenable to refer to "race" in many parts of Asia when examining the history of relations between, for example, colonizers who were usually Europeans and colonized, relations between non-European communities in Southeast Asia are more accurately viewed as ethnic relations. It is useful thus to begin by bearing in mind the distinction between race and ethnicity.

Race is a label imposed by a dominant group on a subordinate community. In societies with a colonial history, racism was used by colonial rulers as the ideological justification for subjugating indigenous populations. Hence one can speak of racism as an ideology if by the latter we mean a coherent set of beliefs with which we make sense of the world we live in. On the other hand, the concept of ethnicity is usually a self-imposed distinction. One can claim ethnic distinctiveness on the basis of "cultural" criteria such as religion, language and nation. The critical element of self-identification in ethnicity is best encapsulated by Anthony Smith (1986:32) who identifies an ethnic community or ethnic group as having the following characteristics—a collective name, a common myth of descent, a shared history, a distinctive shared culture, an association with a specific territory and a sense of solidarity.

Ethnicity and the State

An ethnic community does not exist by itself. It is meaningful to speak of an ethnic group only in relation to other groups. Ethnic relations are usually also relations of power and therefore should be viewed in terms of majority-minority relations or as dominant and subordinate groups. The organization in which a majority has been able to impose its will over minorities in the past as today is the state. In defining the state as originally formulated by Max Weber, Mann (1984:187–8) highlights several notions important to any conception of the state. These are centrality, control and territory. The task of maintaining general social order stands at the heart of the development of the state. To maintain order, there must be centralization in the sense that political relations (and therefore relations of power) radiate outwards from a centre, to establish control over territory. The perpetual problem of control involves the question of authority. When power is exercised by the state or state elite, how acceptable is this to its subjects? Here we refer to legitimacy. The notion of territory, while it may be clear cut today and mostly unambiguous in the modern sense because it is recognized by international law, is a great deal more contentious in the premodern or precolonial state. The main reason is that indigenous peoples do not have a conception of territory, as in "border", as we understand it today. The existence of border patrols or border police in Southeast Asian states is a creation of the modern state. Finally, while the bureaucracy and specialized institutions were rudimentary in the early state, the modern state has been able to exercise effective control partly as a result of the development of such institutions, which among other things, have facilitated surveillance.

We earlier alluded to the possibility that ethnic identity may develop on the basis of nation. It is difficult to refer to the nation without including the modern state. The nation is a modern product and emerged within the unfolding of the modern state. The relationship between the nation and the state has been adumbrated by Smith (1988: 8–10). He argues that there are two overlapping concepts of the nation. The civic or territorial conception treats nations as units of population which inhabit a demarcated territory, possess a common economy and laws and a public mass education system. The civic conception of the nation emerged first in Europe and in our view, it refers to the modern state. The no less fundamental ethnic conception of the nation embraces genealogy, demography, traditional culture and history. For example, we can speak of the Thai, Burman or Javanese conception of the nation. The ethnic conception is a premodern creation, it precedes modernity and often opposes the civic conception. Herein lies the problem of nation-building in Southeast Asian societies. When the civic conception largely coincides with the ethnic conception, we have literally the "nation-state" as an uncontroversial development, as for instance the Thai or Japanese nation-state. Where they do not overlap, as in Burma, Malaysia and Indonesia, the creation of nationhood becomes a challenge.

Strauch (1981a: 230–7) distinguishes between ethnic identity, ethnic categories and ethnic groups. Ethnic identities and categories, she states, may exist without ethnic groups, but ethnic groups, if they do come into being, must be built on categories and identities. Ethnic groups, like Smith's ethnic communities, imply a sense of shared interest or purpose but ethnic categories imply a common identity that offers a measure of comfort and relaxation but little concrete benefit beyond that. Strauch conflates ethnic categories and identity. These concepts need unpacking. Ethnic categories especially in colonial and post colonial Southeast Asia were useful instruments of control by the administrative state. For example, categorization became a conceptual shorthand to group the diverse peoples in Burma under broad ethnic labels during the colonial period (Taylor, 1982: 8). The European idea of ascriptive ethnicity subsequently was taken over by Burmans who now controlled the state. The same may be said of countries like Malaysia and Singapore. The institutionalization of ethnicity was given impetus by the rise of the modern state, as we shall see later.

While ethnic classification by the administrative state constitutes a definition of ethnic identity, it is an identity which is imposed. Ethnic identity, however, may also be seen as a process of self-identification. As such ethnic identity should be viewed in its own right. It has been argued elsewhere (Lian, 1982: 42–52) that ethnic identity be treated as a social process in a context of unequal relationships between groups. One common response of minority groups is to develop adaptive strategies in the society they live in. Thus ethnic identity must be examined in terms of such adaptive processes at both the interethnic and intraethnic levels.

Ethnic Boundaries

Having attempted to clarify some conceptual problems in the study of ethnicity in Asia, it is appropriate to now examine two schools of thought which attribute polar roles to ethnicity as explanation; these are the circumstantialists and

primordialists (Glazer and Moynihan, 1975; cf. Nagata, 1981: 89–90). The circum-stantialists, as Nagata describes them, regard ethnicity as a dependent variable, created and controlled by external interests and strategies, such as European colonial expansion and the economic and political changes which come with modernisation. Such influences invest ethnicity with a potential for mobilization. The primordialists take the opposite position, they see ethnicity as basic and elemental with a power and determinism of its own. If either argument is pushed to extremes it would lay the primordialists open to the charge of being reductionist and inflexible, and the circumstantialists susceptible to the criticism that everything is contingent and therefore relative.

Amongst the circumstantialists, Barth (1969) has been influential in the work of anthropologists and ethnographers who have, until recently, dominated the study of ethnic relations in Asia. Barth has been concerned mainly with the generation, maintenance and negotiation of ethnic boundaries and he focuses attention on the extent to which individuals can cross ethnic boundaries without nullifying their continued efficacy within the society. As Barth (1969: 10) states:

> *Ethnic distinctions do not depend on an absence of social interaction and acceptance but are quite to the contrary often the very foundations on which embracing social systems are built. Interaction in such a social system does not lead to its liquidation through change and acculturation; cultural differences can persist despite inter-ethnic contact and inter-dependence.*

In her discussion of Malay ethnic identity, Nagata (1974) describes how within the Muslim population in Malaysia there are significant intraethnic differences such as between Malays, Indonesians, Arabs, and some Indians. Because the Malays (*Melayu*) are the political majority in the country and are culturally defined in the constitution as Muslims who habitually speak the Malay language and follow Malay custom, Indonesian, Arab and Indian Muslims identify themselves as "*Melayu*" in some situations, for example in relation to the Chinese who are viewed as political and economic rivals, but fall back on their ancestral origins in other circumstances. Nagata (1974: 340) relates a situation in which a lady had repeatedly identified herself with her Malay neighbours who lived in the same *kampung* (village). When the author commented on her industry as she was busy cleaning her house, she remarked proudly that she is an Arab, and that "Arabs are not lazy like Malays".

This account of Malay ethnic identity is significant for three reasons. First, oscillation of ethnic identity can occur without assimilation, hence the persistence of cultural distinctions despite inter-ethnic contact. Second, few Chinese Muslims are included in the interchangeability of ethnic statuses within the Muslim community (Nagata, 1974: 345). In the study of ethnicity, we can speak of the malleability of ethnic identity between indigenous groups and its non-permeability between indigenous and immigrant minorities introduced into the society by colonial powers. Thirdly, as a consequence of the colonial creation of "plural society", the role of the postcolonial state in ethnic relations is to institutionalize ethnicity. The exclusion of Chinese Muslims from equal status within the larger Muslim community in Malaysia is attributed to two reasons (Nagata, 1981: 107–8). One is that the Chinese are perceived as being economically dominant in the country and viewed as a real threat to the political dominance of the

Malays. The other is that the Chinese are regarded as a different *bangsa*. Like Smith's "ethnic community", the term *bangsa* refers to a people sharing both a common origin and a common culture (*ibid.*: 98). More pertinently, it is an emic conception which implies that the common cultural traits are inalienably bound to a particular people who can claim descent from a single origin. When the notion of *bangsa* is perceived within the power configuration in Malaysia in which the Chinese are not only a substantial numerical minority (they constituted 33.8 percent and the Malays 55.3 percent of the total population of Malaysia in 1980) but also a significant economic influence, the imperviousness of relations between indigenes (*bumiputra*) and immigrants (*kaum mendatang*) is understandable.

The permeability of inter-ethnic contact amongst indigenous communities may be seen in the ways in which the Semai, an aboriginal people of West Malaysia (who are among the Senoi mentioned earlier), interact with their neighbours. The Semai speak an Austroasiatic language which is a branch of Mon-Khmer. However, they use local Malay dialect (which belong to the Austronesian group of languages) when talking to local Malays (Dentan, 1976: 77). They speak Malay with a thick Chinese accent in dealing with the local Chinese. With Malays from out of state, some Semai use formal Malay as in the national language. And in religious rituals when a spirit seems unresponsive to requests made in Semai, the Semai try out various Malay dialects until they find the desired one.

The ease with which Southeast Asians have been able to change identities is hardly surprising in the light of Benda's comments on the structure of Southeast Asian history (1962: 109). While Southeast Asian societies were recipients of external influences from Indian and Chinese civilizations in the past, they were not passive but far enough developed to force the intruding elements to become domesticated. The ability of Southeast Asian societies to absorb such exogenous forces is only paralleled by the symbiotic character of its interethnic relations. We must be careful not to overstate this. As Hinton (1967: 4–5) remarks, researchers who have been preoccupied with changing cultural identity have been students of the Thai, Karen, Lua' and Shan peoples. High altitude swidden cultivators like the Lahu, Hmong, Yao, Lisu and Akha are more homogeneous and relatively isolated. The identity of such groups is more rigidly defined and movements across cultural barriers are infrequent. The basic reason is economic. The Karen, Lua' and Shan are sedentary and find it necessary to come to terms with neighbouring communities who may be more powerful. Hence their interests are best served by political alliances, intermarriages and developing trade relationships.

The study of ethnic relations in Southeast Asia has been preoccupied with contemporary society. King (1982: 3) remarks on the lack of emphasis on historical background by both anthropologists and sociologists. There have been some recent attempts at examining ethnicity in relation to the state (Brown, 1989; Clammer, 1982; Benjamin, 1976) but most studies have been limited to the contemporary state. We suggest that these need to be complemented by more historical research.

Ethnic Relations in Burma

One early and important attempt at understanding ethnic relations in the context of the state was Lieberman's study of ethnic politics in eighteenth century Burma

(1978). Lieberman argues that the precolonial political organization of Burma had a number of powerful traditions which discouraged ethnic homogenisation (1978:458–62). First, there was a deeply-ingrained tradition of patron-client relations. The ties which bound clients to patrons, whether these be of headmen, local princes or military officials, were based on separate personal bonds. Since the influence of patrons depended on their individual power and charisma, their following was a personal one, not one based on a common identity such as ethnic affiliation. Secondly the legitimacy of Theravada kingship was not ethnic-bound but was based on the king's ability to advance the spiritual welfare of his followers. The king was *dhammaraja*, the upholder of Buddhist law; *cakkavatti*, a universal monarch and *bodhissattva*, a potential Buddha. Thirdly, the persistence of regional loyalties as a consequence of the absence of a "strong state" inhibited the development of either a pan-Mon or pan-Burman consciousness.

It was the organization of the precolonial state in Burma which had a direct impact on ethnic relations. Lieberman (1978:458) refers to Tambiah's description of traditional Southeast Asian kingdoms as "galactic polities" – each comprising "a central planet surrounded by an attenuated field of satellite communities whose number fluctuated according to the military strength of the centre". The implication of such a pattern, he continues, is that the more powerful the northern kingdom of Ava, the greater the number of people who identified themselves as Burmese, the stronger Pegu became, the bigger the "Mon population".

The territorial structure of the restored Toungoo and Konbaung state was organized on the basis of three administrative zones (Taylor, 1987:22–5) – the nuclear zone or the central plains where the king ruled directly, the zone of dependent provinces controlled by court-appointed officials and the peripheral zone of tributaries where authority was exercised by hereditary rulers from various ethnic backgrounds such as Shan, Kachin, Karen and Chin. The power of the state and its identity with kings who were ethnically Burman led groups and individuals who resided in the nuclear zone to accept the state's definition of their cultural orientation. The zone of tributaries was of marginal economic value to the centre and their security was the king's only concern. Here the homogenization of ethnic identities was negligible. As long as the minor rulers of the tributaries posed no challenge to the king, he had no reason to eliminate or incorporate their subjects. Taylor (1987:57) suggests there was therefore an ideological justification for the maintenance of political if not ethnic pluralism, under a single monarch.

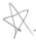

The state structures ethnic relations by its sheer ability to control and maintain its surveillance function. The further we move away from the centre of power, the less likely the state is able to incorporate groups on the periphery and consequently, the more distinctive the ethnic identities of such groups. In the precolonial Burmese polity, the limits of the state were the limits of the dominant ethnic community.

The implication of Tambiah's notion of the galactic polity is more complicated than has been inferred by Lieberman. Michael Adas has described precolonial Burma as a "contest state" (Taylor, 1987:15–16) in which the effective control of the king was restricted by rival elites, by weaknesses in administrative organization and commitment of state officials, by poor communications, and by a low population-to-land ratio, that placed a premium on manpower retention and regulation. With the exception of brief periods in the Toungoo and Konbaung dynasty which saw a coherent state in most of Burma, pre-British Burma was

rarely one centre of political power. It was a case of competing state civilizations which made interethnic relations extremely fluid. Hinton (1967:3), in quoting Lehman's work on Chin society, commented that minority groups in Burma had to "come to terms with more than one state civilization and a variety of other minorities themselves differently treated by different states". For instance, relations between Shans and Kachins for centuries were symbiotic, in terms of food and protection against marauders (La Raw, 1973:348–9). The Shan population in the past has come in between Kachin contacts with other lowlanders such as the Burmans. Kachin awareness of the Burmans was filtered through the Shans. Thus Kachin ethnicity can only be understood in relation to the Shans. Similarly, the Shans defined themselves in relation to the Kachins and the Burmans.

Renard's summary of the role of minorities in Burmese history (1988:88) is particularly relevant. Lowland wet-rice agriculturalists in early modern Burma (seventeenth, eighteenth and nineteenth centuries) lived in states; upland swidden cultivators were considered stateless. Differences between peoples at the periphery and those in the state centres were most pronounced; the former were minorities and the latter the majority. Not surprisingly, relations between Shans and Mons and other marginals were generally smoother. Where the states were smaller and majority-minority distinctions less sharp, relations were more amicable. Where the states were bigger, distinctions and animosities were heightened.

The colonial state began with the arrival of British officials to govern Arakan and Tennaserim in 1825 and ended when the British withdrew in 1942 in the face of an advancing Japanese army. The colonial state was no different from the traditional state in Burma in so far as it sought to maintain order to ensure that society ran smoothly to provide much needed resources for the state (Taylor, 1987:67–8). However, where it differed was the British administration having to produce wealth more efficiently and quickly. To this end, there was a greater degree of formal centralization. "The colonial state", Taylor says (1987:68), "was able to intervene in and direct more effectively the institutions of local government and the lives of the people than the early modern state was able to do" Taylor (ibid.:75) distinguishes three periods of British rule in Burma. Between 1825 and 1879, the state made little effort to direct economic forces in the south, content only to establish law and collect taxes in semi-frontier conditions. From 1880 to 1923, the state extended its power by developing communications, schools, health and agricultural services to facilitate economic activities. After 1923, government policy encouraged liberal democratic political institutions through which the state could achieve legitimacy. Burmese nationalism grew rapidly at this time in opposition to colonial rule.

During the colonial period, a modern state structure was imposed by the British only upon the more culturally uniform valley populations such as the Burmans, Mons and Arakanese (Taylor, 1982:8, 13). The colonial state remained as distant from the hill peoples – the Kachins, Chins and Shans – as the precolonial state. As in the precolonial era, the hill peoples were not considered a serious threat; neither did they live in a rich economic region. The British made no attempt to impose the full force of the modern state on them. Consequently, modern nationalism in Burma was very much a prerogative of the valley peoples. When the central state came to be identified with the majority Burmans in the post-independence phase, the Burmans like the British before them practised a policy of ascriptive ethnicity. The Burmans began seeing other ethnic groups in "them-

us" terms. It was possible to institutionalize ethnicity when you had the administrative apparatus to do so. Moreover, the modern state and its conception of fixed territory made it more urgent for those in power to establish effective control, and this included "administering ethnicity" by establishing neat ethnic boundaries, if the sovereignty of the nation-state was to mean anything.

Ethnic Relations in Thailand

In contrast to the ethnic complexity of Burma, ethnic relations within Siam (renamed Thailand in 1939) were much less turbulent. Following the sacking of Ayudhya by Burmese forces in 1767, the Siamese state was re-established near Bangkok in 1776 by Taksin, a half-Chinese general under the last king of Ayudhya. The beginning of the Chakri dynasty in 1782 saw the development of a central state. Its first king, Rama I, extended Bangkok's influence and reduced the military and political power of the Burmese (Steinberg, 1987: 113). The job of unifying the kingdom was made easier by the fact that the majority of its inhabitants spoke a common language which is now known as Thai. In Kammerer's words (1988: 274), "whereas in Burma the Burman majority resides in a minority of the land and in Laos the Lao majority is the numerical minority, in Thailand the highland region is a bare one-fifth of the national territory, and the highland population is perhaps, 1 percent of the national total".

At the turn of the nineteenth century, Rama I's empire consisted of several power centres (Steinberg, 1987: 158–60). At the centre of the kingdom were the provinces ruled by officials appointed from the capital and subjected to central regulation. The next layer consisted of large regional centres, ruled by *chaophraya* (generals) and were quasi-independent provinces. This was followed by principalities which were required to pay tribute to the capital and to provide manpower for warfare or public works. At the outermost layer were semi-independent rulers, including the northern Malay states, Luang Prabang and Cambodia, who paid regular tributes to Bangkok. In the second half of the nineteenth century a majority of Tai-speaking peoples were living within the bounds of the Siamese empire (Steinberg, 1987: 181). By the early twentieth century a number had come under Western colonial rule – the Shans under the British in Burma and the Lao and upland Tai-speakers under the French in Indochina.

By 1910, Siam had clearly defined borders on all sides, distinguishing it from the British colonies in Burma on the west and Malaya to the south and the French colonies in Indochina to the east (Steinberg, 1987: 212). The "galactic polity" of the early Bangkok empire had, beginning with Chulalongkorn's reign, given way to a single centralized control exercised by the Bangkok court and bureaucracy. Chulalongkorn found himself forced to abandon the older notion of the state as having an exemplary centre (Keyes, 1977). The relative unity and homogeneity of Siam was a distinct contrast to a fractious Burma at a comparable period.

The idea of nationhood was first popularised by King Vajiravudh (1910–25) although its roots are found in Chulalongkorn's reign. Vajiravudh referred to the "Thai nation" as a trinitarian concept of nation-religion-king, in which all three elements were inextricably bound together (Wyatt, 1984: 229). Allegiance to one meant commitment to all. The idea of a nation may be traced to the Sanskrit-

derived word *chat* (Murashima, 1988: 82–3). The original meaning of *chat* refers to a group of people born into the same caste. This was later extended to include people who by birth share a common language and culture. In the 1880s, *chat* increasingly came to mean a national political community and Western-educated Thai intellectuals began using the word as an equivalent for the "nation-state".

Murashima suggests that *chat* in the sense of nation-state gained greater acceptance partly because of the international pressures exerted on Siam and partly because of the influence of western political thought on Thai intellectuals. *Chat* was interwoven into a sort of official state ideology and nurtured by the aristocracy as a bulwark against Western colonialism. As the external threat to the Thai monarchy receded at the end of Chulalongkorn's reign, it was replaced by an internal threat coming from the increasing urban population (of whom the economically successful Chinese constituted a significant proportion) who were impatient with the absolute powers of the king (Murashima, 1988: 89). The 1912 plot against the king, inspired by the urban population of ethnic Chinese and government officials, precipitated Vajiravudh's campaign of economic nationalism which singled out the Chinese as "The Jews of the Orient" (Murashima, 1988: 94).

Vajiravudh's campaign against the Chinese can only be appreciated by looking at events in the years preceding 1912. In 1899 an annual head tax was imposed on every resident in Siam but the Chinese were exempted and continued to pay

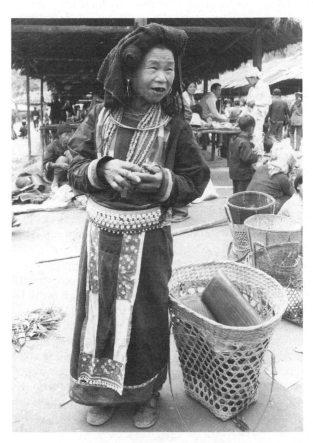

This Lisu minority woman in Northern Thailand is not considered a Thai citizen.
Courtesy of Hseng Noung Lintner.

only a triennial tax because of the urgent demand for labour (Skinner, 1962: 162–3). When the Chinese were required to pay the annual tax in 1910, they responded by calling a general strike which closed all Chinese businesses and shops. The strike was disastrous for the Chinese community in Siam. It brought home to the Thai people how dependent they had become on Chinese trade. It also called into question the loyalty of the Chinese to the Thai nation. When Vajiravudh came to the throne in 1911, he never forgot nor forgave the Chinese strike (Skinner, 1962: 164). The forces to encourage the Chinese to assimilate began to gather, and were intensified by the unprecedented magnitude of Chinese immigration between 1918 and 1931 (Skinner, 1962: 247).

Vajiravudh promulgated the concept of the "Thai nation" to single out the nation as the primary focus of personal and group identity (Wyatt, 1984: 229). The basis of Thai ethnic identity revolved around loyalty to Nation, Religion and King. What Vajiravudh and his predecessors attempted to do was to collapse territoriality and ethnicity in the notion of the nation, as in Smith's overlapping territorial and ethnic conceptions of the nation. A sense of territoriality was self-consciously incorporated into Thai ethnic identity as a consequence of the British and French establishing the territorial limits of Thailand. It was also a response to the growing Chinese population in Thailand, whom they feared could become a state within a state. As Kammerer (1988: 259) puts it, "the territorially bounded states in the western mode that emerged through the colonial encounter replaced the centre-oriented 'galactic polity'". In the process, modern Thai ethnic identity was constructed.

The Contemporary State and Ethnic Revolts

We earlier noted that any conception of the state must deal with the problem of control over territory and the problem of legitimacy. Rajah (1990: 123–4) draws attention to the important distinction Buzan makes between "weak" and "strong" states. Quoting from Buzan, he says when the "idea" and institutions of a state are weak, the efficacy of the state is correspondingly undermined. Buzan is unclear about what is meant by the the "idea" of the state; presumably he may be referring to the notion of a nation state. When the state is strong on both counts, its effectiveness is assured. Weak states are those that have failed to create a political and social consensus sufficiently to eliminate the large-scale use of force in domestic political life. In terms of this distinction, Rajah continues, Burma may well be considered a weak state while Thailand may be a strong state.

One important reason why Burma has a weak state may be attributed to what Leach (1960/61) described as significant contrasts in Burmese history between the Hill People like the Shans, Karens, Chins and Kachins and the valley people who are Burmans. There are deep differences in the ecology and social organization of both groups, which are reflected in centuries of conflict arising from the Burmans attempting to exercise control over the Hill Peoples. With the exception of the British administration of Burma between 1825 and 1942, the state has usually been identified with the Burmans.

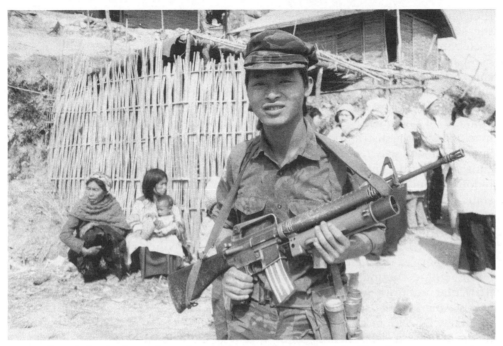

A member of the Kachin Independence Army in Kachin state, Northern Burma.
Courtesy of Fumio Arimura.

It is because Burma is a weak state that the dominant ethnic group, the Burmans, has pursued an uncompromising mono-ethnic policy at the level of ideology and at that of recruitment and resource allocation (Brown, 1989: 49–50). Prior to independence, the British were committed to protecting ethnic minorities like the Shans, Karens, Chins and Kachins from Burman domination. Pro-Burman policies after independence eroded the power of minority leaders and engendered feelings of betrayal. The result was to undermine the support of its allies in the outlying region, thereby weakening the control of the central state. The mono-ethnic drive of the Burmese state has only served to generate demands for increased autonomy by ethnic minorities and has resulted in numerous rebellions from such groups (Brown, 1989: 61).

Notwithstanding sporadic separatist responses from Muslims on its southern borders, Thailand's "problem" with its ethnic minorities show the presence of a strong state. For example, all hill-tribes in Thailand, unless there is strong documentary evidence to prove otherwise, are considered "aliens" and illegal settlers within the borders of Thailand (Keyes, 1979: 17). The classification of Karen as hill-tribes by Thai officials has resulted in the exclusion of Karen from the Thai political system beyond the village level. The role of the state in ethnic classi-fication reduces the permeability of ethnic interchanges and enhances its surveillance of hill-tribes, who because of their physical location, are difficult to control. This has to be appreciated in terms of the Thai conception of the nation as a coincidence of territoriality and ethnicity we discussed earlier.

Malaysia and Singapore are illustrative of strong states at the level of institutions. However, there is a fundamental difference in both societies which is reflected in

the state management of ethnic relations. Brown (1989: 47–62), in his typology of the state's responses to ethnic minorities, identifies three models – the plural society model which produces the mono-ethnic state, as in the case of Burma, the neo-patrimonial state or the clientelist model, and the bureaucratic state or the corporatist model.

Clientelism promotes the politics of comparative ethnicity, in which inter-ethnic rivalry is pursued through the activities of entrepreneurs, patrons and brokers (*ibid.*: 52). Consequently, state institutions and political parties function as political machines for the distribution of resources in return for the support of the masses. Such a model spawns a patrimonial elite, who as long as they can maintain consensus, will continue to mobilize political support on communal grounds. Indonesia and, it may be added Malaysia, are examples of the neo-patrimonial state. The corporatist policies of the state have emerged in the newly industrializing countries such as Singapore in response to the need to subordinate political and populist participation to an overall effective economic strategy (*ibid.*: 57–9). The state then makes a distinction between ethnicity as a politically subversive loyalty and ethnicity as the legitimate interest of the various ethnic communities. In the latter, ethnic communities function as corporatist interest groups, articulating particular interests and needs through institutionalized channels – such as the Malay Affairs Bureau, the Muslim Religious Council (MUIS), Mendaki (The Council for Malay Education) and Malay MPs representing the Malay minority in Singapore. In the process it depoliticizes ethnic loyalties and celebrates cultural ethnicity.

All three models, it may be concluded, have the effect of creating a heightened sense of ethnic consciousness and identity. We have drawn attention to Brown's typology because it is a useful conceptualization of the contemporary state and its ramifications for ethnic relations and vice versa.

The Dialectic and Modalities of Ethnicity and the Contemporary State

A dialectical relation between the nation-state and ethnicity means that ideas about the nation-state, such as the place that citizens of various ethnicities have within it and the policies which are designed to ensure this, have an *impact* on how people belonging to these ethnic groups define their identities and perceive their relations with the state. At the same time, depending on how the members of an ethnic group define their ethnic identity, and whether they feel that their legitimate interests are served by the states in which they are found, they may act through appointed or self-appointed leaders to either accept the legitimacy of the state or reject it, *and thus have in turn* an impact on the state. Much of our discussion in the sections above has been concerned with the various *principles* and *issues* of this dialectical relationship, taking a broad comparative and historical perspective on several states in Asia.

It is important to realize, however, that the mutually defining conditions of the contemporary state and ethnicity express themselves through various modalities, i.e. specific ways. Furthermore, it is extremely important to bear in mind that when we refer to the contemporary state we must also recognize that the state

does not exist in isolation from other states. Modern states are linked to one another by, for example, an international system of economic and political relations, the functioning of which has a direct impact on their citizens. Similarly, ethnic groups cannot be viewed as being found in one state and not in others. Indeed, ethnic groups in Asia are often found straddling national boundaries and are thus represented in neighbouring and even distant states. Both these considerations have implications for the understanding of the specific ways in which the dialectical relation between the contemporary state and ethnicity manifest themselves. The study of these different modalities today thus constitutes some of the most challenging tasks in ethnic studies.

Ethnic Conflict and Violence: Sri Lanka

One of the most striking aspects of ethnicity, ethnic relations, and the contemporary state in post-independence times is the remarkable increase in frequency of the occurrence of ethnic conflict and violence. This is true not only in Asia but in other parts of the world. The tasks entailed in the study of ethnic conflict and violence, from anthropological and sociological perspectives, have been well set out by Stanley Tambiah (1989, 1990a). In newly independent states, politics was conducted in terms of nation-state ideologies and policies. As a consequence of the internal dynamics and differences among their constituent groups however, politics has become dominated by the competitions and conflicts of ethnic collectivities which question or reject the legitimacy of the state and the nationalism and ideologies of the nation state which led to the establishment of the post-colonial state (Tambiah, 1989: 341). This process, which may be termed the "politicization of ethnicity", involves large numbers of people who are made conscious of an ethnic identity and the manipulation of collective ethnic identity for political action (ibid.: 343). The large-scale mobilization of the members of ethnic groups for political ends may, in fact, be seen as a modern phenomenon. The reason is that the formal and informal institutions and structures of contemporary society (for example, the media, theatres, public arenas, political rallies, strikes, schools, universities, factories, and so on) which are used to mobilize ethnic collectivities are characteristically modern.

Tambiah (ibid.) also posits that the welfare state in more advanced economies and socialist states committed to welfare policies in the Third World provides one of the stages for the politicization of ethnicity. He argues that such states, including democratic systems of governments, seem to be highly responsive to political and economic demands on the basis of ethnicity.

Such issues and considerations, among others, underlie the ethnic conflict and violence in, for example, Sri Lanka where many (though not all) Sinhalese and Tamils are today pitted against each other in a deadly confrontation. Given a long history of relatively peaceful accommodation between Tamils, Sinhalese and indeed Malay, Eurasian, and other minorities in Sri Lanka before independence, the conflict and violence in the present demands explanation. The value of a broad anthropological and sociological approach in understanding and explaining these developments is clearly demonstrated by Tambiah (1986).

The case of Sri Lanka illustrates how ethnic conflict can arise out of the

incompatibilities and contradictions between systems of government based on modern concepts of universal franchise, democratic electoral principles and political representation based on demographic and territorial criteria and traditional Asian systems of leadership and power, in former colonies of western imperial powers (*ibid.*: 67–8). The incompatibilities and contradictions also involve, however, colonial and post-colonial economic systems and the inequalities which they produce. But we should not interpret these historical and contemporary developments simplistically to mean that "West is bad" and "East is good" or vice versa. To do so contradicts the very notion of cultural relativism.

Where ethnic relations and the contemporary state are concerned, the experience of Sri Lanka shows that nationalism can be associated with the following: a rejection of colonial domination and western "values" and "culture" and indigenous elites associated with the colonial power; and in opposition to this, attempts to base independent nation-statehood on "indigenous" (i.e. majority Sinhalese) "culture" and "values". "Culture" and "values", in these circumstances, were translated to mean that Sinhalese would be the national language and the language of education and administration, and that national identity was defined in terms of a constructed identity, i.e. that of the majority of Sinhalese who were (and are) Buddhist, among other things. In the face of these developments, the predominantly Hindu Tamil community thus felt that their legitimate interests and opportunities were threatened. Some of the more extreme responses on the part of the Tamil community have been the emergence of armed groups such as the Tamil United Liberation Front and the Liberation Tigers of Tamil Eelam drawing on support from sympathizers in the state of Tamil Nadu in neighbouring India, and attempts to establish a separate state of Tamil Eelam.

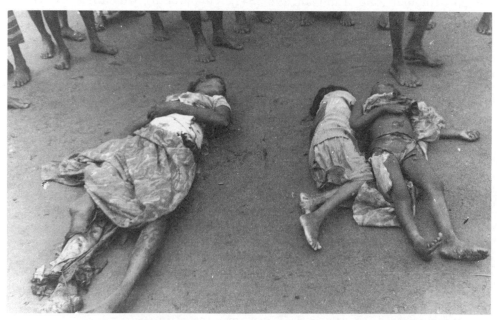

Sri Lanka. Sinhala civilians massacred at Dollar and Kent farms by Tamil separatist terrorists.
Courtesy of Lalana Nanayakkara.

From an anthropological and sociological perspective, one major point of analytical interest is that the concrete manifestations of the politicization of ethnicity involves, in the Sinhalese case, recourse to the *Mahavamsa*, a Buddhist text composed in fifth century A.D. The text glorifies Buddhism and the role of the Sinhalese in uniting Sri Lanka and expelling Tamil invaders from South India (*ibid.*: 70). In this way, a mythical history was constructed to justify Sinhalese rights. Such mythohistorical constructions combined with the definition or the construction of ethnic identity, the identity of the nation-state, and demands for political rights (which may extend to attempts to create separatist states) are by no means uncommon.

These developments in Sri Lanka, in the 1960s, were exacerbated by poor rates of economic growth especially in the agricultural sector and adverse international terms of trade, resulting in increasing unemployment and income disparities. Dissatisfaction was experienced not only by the rural and urban poor. The rich were also affected by the redistributive policies (entailing the nationalization of plantations and the imposition of limits on the private ownership of land) of a left-leaning government which implemented such policies more vigorously in an attempt to reduce the inequalities between rich and poor.

These conditions resulted in a downward spiral of national stability and security marked by occurrences of riots and communal violence perpetrated by both Sinhalese and Tamils in which the politicization of ethnicity was (and continues to be) an integral part. The downward spiral has also resulted in a "weak" state and the weakness of the state is indicated not only by armed conflict where the institutions of the state are contested to the point of violence but also by the intervention of the armed forces of neighbouring India from 1987 to 1988 albeit in a "peace-keeping" role.

Tambiah (1990a: 756–7) identifies a number of typical features (which are by no means confined to Sri Lanka) which may be discerned in such outbreaks of violence: the "ritualization of collective violence" in which emotive religious and other symbols are manipulated to mobilize crowds; "demonization of the enemy" in public rallies in large open spaces where crowds are made to feel omnipotent and righteous vis-à-vis opposing groups or persons through orations and propaganda drawing on mythohistorical claims, boasts and insults; intimidation through thuggery, the throwing of bombs in public places, and assassinations; bribes and the distribution of liquor to fuel the emotions of crowds; "triggering actions" which are calculated to insult and inflame passions often by violating religious symbols associated with the "enemy"; and rumours which attribute inhuman behaviour or "diabolical acts" to the "other" and which contribute to their demonization. The study of such conflict and violence may well be described as the "anthropology of collective violence". But because of the consequences of such acts of violence, Tambiah also draws attention to the importance of the study of two other areas: the "anthropology of displacement and dislocation", i.e. of displaced persons and refugees escaping from such violence; and the "anthropology of collective suffering", i.e. of those who are victims and survivors of violence.

It is too early as yet to say if these "anthropologies" identified by Tambiah have gained general acceptance or not. However, the value of Tambiah's insights into the "anthropology of collective violence" remains and calls for further exploration. The insights lie in pointing out how parts of the process of generating and

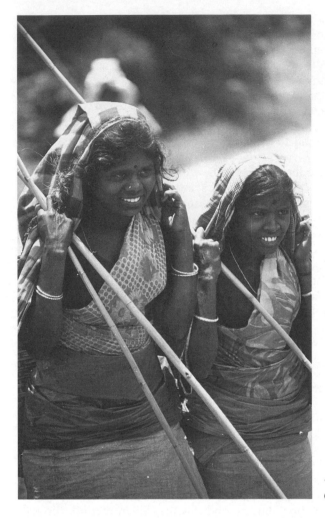

Tamil teapickers.
Courtesy of Rodney Tasker.

participating in collective violence bear resemblances to certain types of religious behaviour, and in showing how the anthropological and sociological study of religion can provide us with potentially useful ways of conceptualizing something seemingly so different as collective, ethnic violence. They also lie in drawing our attention to the question of how, in collective violence, people who would be considered normal – and who under ordinary circumstances would readily admit the humanity of their alleged adversaries – can perceive their adversaries to be non-human ("demons"), subject them to horrific forms of violence and death, and then return to apparently every semblance of normalcy and everyday life. These issues and considerations emerge as subjects for investigation because they are firmly located as part of one of the identifiable modalities, i.e. ethnic conflict and violence, within the dialectic of the contemporary state and ethnicity and ethnic relations.

Yet another important issue which becomes evident from our discussion above is that in the relation between the state and ethnicity, *culture* emerges as a crucial

feature in ethnicity and in the ways by which ethnic identities are defined, presented, or constructed. Furthermore, as contemporary developments in the world today demonstrate only too well, the modern state can sometimes be extremely fragile. Its "weakness" or even disintegration (for example in the Soviet Union and Eastern Europe) may well be brought about by ethnically based nationalisms. When the relation between the state and ethnicity as culture is viewed as a dialectical or mutually conditioning one, it becomes clear that a host of questions and issues arise requiring investigation and study. We have seen, taking Sri Lanka as one example, that in Asia there are instances of extreme ethnic conflict, violence, and secessionist movements which are, of course, attempts to break up the state. However, we also find that despite the very mixed ethnic composition of so many Asian states, for example Indonesia, the break up of the state has not occurred in many cases. Why is this so?

Conclusion

The model which posited waves of migration simply assumed that an "inferior" culture was replaced by a "superior" culture. Its successor, ecological adaptation, argued that social differentiation could be viewed as a process of adaptation to environmental selection pressures. Since both models emerged in a period when anthropologists were mainly occupied with documenting, classifying and describing variations within human society using incomplete records, their theories were attempts to explain cultural differences and diversity rather than ethnic relations. Barth tried to span the divide by focusing on the notion of boundary, within which social interaction and culture could be articulated. Since then the concepts of ethnic community, ethnic groups and ethnic identity have been developed to explain the process of ethnicization as a consequence of migration, colonization and the emergence of the modern state in a world made smaller by economic imperatives. As ethnic communities use every means available including the power of the state to protect and assert their ethnic identities, their strategies have ranged from becoming incorporated into the larger society to secession and outright suppression. In doing so, the relations of conflict and violence which have characterized inter-ethnic relations in the past are now even more acute within the modern state. In summary, we have come a long way from the biological conception of race, to the notion of "ethnicity" as inherent cultural forms and finally to ethnic relations as the relations of power. All three notions carry with them sets of assumptions which are not always easy to disentangle.

10 WOMEN IN ASIA

Anthropology and the Study of Women

Christine Helliwell

The Category "Woman"

All cultures of the world distinguish between "categories" or "types" of person. These categories are constructed on the basis of differences that are seen to exist between people. There are, of course, an infinite number of such differences: some people have brown eyes, some green, some black, some blue; some people live in single-storied houses, some in multi-storied; some people live by the sea, some inland; some people were born in the place where they live, some elsewhere; some people have brown skin, some black, some pink. But in any culture only a few of these differences are singled out as "differences which make a difference" to the identity of the person, that is, as differences that are believed to influence or even determine people's moral and social statuses, the kinds of activities deemed appropriate for them, the ways in which they behave, and so on. All of the differences listed above are, or have been, differences of this type at some time in some part of the world.

In most, if not all, societies the bodily differences that exist between women and men are also "differences which make a difference"; persons with "female" bodies are seen as a different category or kind of person from those with "male" bodies. But this does not mean that their difference is treated everywhere with the same importance; nor that it is always understood and elaborated in the same ways.

There is a tendency in many cultures, and especially in the West, to believe that the differences between these two kinds of person are most essentially biological ones. In fact, in all societies people most usually identify someone as a "woman" or a "man" on the basis of cultural data – including their dress, the cut of their hair, the way they walk – rather than on the basis of the strictly biological. I well remember a conversation that I had several days before I was about to leave the Dayak village of Gerai, in the interior of Indonesian Borneo, where I had been conducting fieldwork for over eighteen months. In reminiscing back over my time in the community, several women friends remarked on the feverish debate concerning whether I was a man or a woman that had accompanied my first few weeks in the village. There were, they told me, many in the village at that time who were strongly inclined to dispute my self-identification as a woman, in spite of the fact that my body shape, as outlined by a sarong while bathing in the river, was clearly consistent with such an identity. I did not, they

Sex - physical structure
gender - the set of cultural constructions
'what different cultures make of sex'

WOMEN IN ASIA 261

told me, walk like a woman, with arms held out from the body and hips slightly swaying; I was "brave", trekking from village to village through the jungle on my own; I had bony kneecaps; I did not know how to tie a sarong in the appropriate way for women; I could not distinguish different varieties of rice from one another; I did not wear earrings; I had short hair; I was tall. Clearly, what it means to be a "woman" as opposed to a "man" in this society extends to take in far more than simple differences in biology and bodily form.

For this reason, many anthropologists distinguish between two interrelated concepts: sex and gender. The sex of a person is seen as having to do with the physical structure of his or her body, and includes such features as the "type" of genitalia, height, distribution of body weight, amount of body hair, presence or absence of breasts, physiognomy and so on. Gender, on the other hand, is seen as having to do with the set of cultural constructions associated with those bodily differences in any particular setting: with the ways in which they are understood, explained, symbolized and valued. Put simply, gender is, in the words of Shelly Errington, "what different cultures make of sex" (1990:27).

What different cultures make of sex – that is, their sets of gender constructions – vary enormously. In some cultures for instance (and especially in the West), bodily difference between "women" and "men" is understood primarily in terms of differential sexual and procreative functions: notions of gender, in these settings, are rooted in the belief that women and men contribute fundamentally different things to the reproductive process. Unfortunately, use of the term sex to refer to the bodily differences between men and women makes it easy to infer that in *all* societies these differences are explained in such terms. Yet the belief that women

♀ ♀
∨
reproduction
(different
contributions)

Two Dayak women from the village of Gerai taking a rest from planting rice to chew betel.
Courtesy of Christine Helliwell.

and men perform essentially different functions in reproduction is by no means a universal one, so this inference should not, in fact, be drawn. Jane Atkinson tells us, for instance, that among the Wana of the island of Sulawesi in Indonesia, women and men are seen to have not different, but identical, reproductive functions: "both sexes menstruate, both become pregnant, and both are the 'source' of humanity" (Atkinson, 1990: 77). This does not mean that the Wana women and men perform identical *roles* within reproduction. But the difference between their roles is predicated not upon the essential functions that each performs (since these are the same), but rather upon *when* each performs these functions relative to the other. Thus, although it is a woman who actually gives birth, it is a man who is pregnant first; he carries the child in his own body for a period of time before passing it on to the woman (*ibid.*: 75–6). While the Wana recognize bodily differences between women and men then, and link these to what they see as the different characters and behaviours of each (for example, those with male genitalia are seen to be braver and more violent than those with female genitalia (*ibid.*: 82–6)), these differences are not related to differential reproductive function as they are in the West and elsewhere. Starting with the same set of bodily differences, we have here two very different sets of gender constructions.

Sex, then, constitutes a "difference which makes a difference" between persons everywhere in the world: whether a person is identifiably female or male plays a central role in defining his or her social and cultural identity. But the members of separate cultures understand and explain that difference in very different ways;

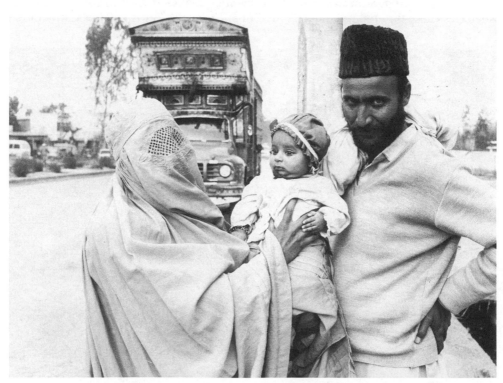

A family in Pakistan. The woman has her face covered – purdah – according to Islamic law.
Courtesy of Maria Fialho.

thus what it is to be a "woman" and what it is to be a "man" vary greatly from culture to culture. It is in this sense that anthropologists talk of the categories "woman" and "man" as being gender categories: they are at least as much to do with cultural elaboration and meanings as they are to do with the nature of one's body. In many cultural contexts, the fact that a person is classified as a "woman" says more about the ways in which she might be expected to behave, and about the value placed on her activities, than it does about her bodily form. Yet, this does not mean that we can afford to ignore either the fact that some bodily difference is always understood to exist between women and men, or that this difference must be, in some way, significant (otherwise the two separate categories as defined here would not exist). Because bodily differences are always involved in the construction of gender categories, bodies themselves frequently constitute the loci at which the meanings of gender are worked out and expressed. A Muslim Pakistani woman's careful concealment from the public eye of almost all parts of her body, the bound feet of a Chinese woman, the extensive tattooing on the body of an Iban woman from Borneo: these are all central expressions of "womanhood" in the culture in question. It was no accident that so many of the "feminine" characteristics that my Gerai friends saw as lacking in me were to do with the body: the way I walked, the form of my kneecaps, my lack of earrings, the length of my hair, my height.

Sex, then, is necessarily a part of gender construction; but it is not the only – or even necessarily the most important – part. While some cultures place great stress on the difference between men and women as grounded in bodily difference, others give such differences very little emphasis. Michelle Rosaldo, for instance, notes that the Ilongot people of Northern Luzon in the Philippines "speak not of physical 'nature', but of work – which turns forest to garden, garden to rice bowl, and game in the wild to meat that accompanies meals – to explain differences between men and women" (1980:103). Here, as in the West, men and women are viewed as complementary, but their complementarity is based not on conceptions of reproduction, but on understandings of *production*: men's expertise in hunting being matched by women's skill in rice-farming. Rosaldo argues that the Ilongot view of men as more "angry" and more "knowing" than (and as therefore morally superior to) women, is linked to differences that the Ilongot perceive between the types of work that each perform. We need to be wary then, of automatically ascribing a central role to sex with respect to the particular *ways* in which gender is understood and elaborated in any cultural context.

We must also take care to avoid assuming the existence of a one-way causal relationship between sex and gender, in which the former influences the latter, but is untouched by any reciprocal influence. Sherry Ortner and Harriet Whitehead's example from Imperial China of aspiring palace eunuch staff arriving at court with their genitals in jars in an effort to demonstrate their suitability for such employment, demonstrates the mutability of sex difference itself, and its vulnerability to other social considerations (Ortner and Whitehead, 1981:24), including that of gender. Increasingly in the West, people who feel themselves to be "women" but who have male genitals, and people who feel themselves to be "men" but who have female genitals, are seeking sex change operations: here, gender is shaping sex.

As we have seen, bodily difference in fact provides only a starting point for gender elaboration, that is, for the construction of particular cultural images of

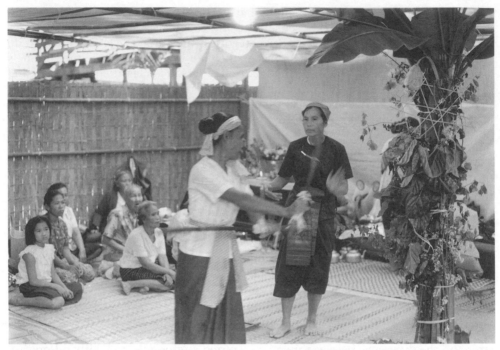

In Laos, Nang Tiam, or female shamans, dress as males, brandish swords and are possessed by male spirits.
Courtesy of Grant Evans.

what it is to be a "woman" or a "man". As my experience in Gerai revealed, there are a number of different factors which, taken together, add up to define a person's gender identity: including the nature of the body, activities and behaviours. This means that there is no reason to suppose that cultures will be divided into two mutually exclusive gender categories: if gender identity is dependent on a number of different factors, then it may be (and often is) ambiguous. Many societies of Southeast Asia contain "transsexuals" – individuals with the sex of a female but the behaviours of a man, or with the sex of a male and the behaviours of a woman. Their ambiguous identity is often seen as imbuing them with increased supernatural powers. Thus, for instance, among the Bugis of the island of Sulawesi in Indonesia, the Iban of Borneo, and various Philippine groups, the male transvestite frequently operates as a shaman. In other societies children may be regarded as "ungendered", or as of uncertain gender – often because they have not yet been culturally marked as "women" or "men". Thus among the Huaulu of the island of Seram in Indonesia, boys are of somewhat ambiguous gender until they undergo circumcision. It is this act that socially marks them for the first time as distinctly "men" rather than "women" (Valeri, 1990:259).

In fact, it makes sense to think about gender not in terms of discrete exclusive categories, but rather in terms of one or more dimensions along which differing degrees of "maleness" or "femaleness" may be plotted. Ann Anagnost, for instance, writing on Chinese gender constructions, cautions against identifying *yin* (the female principle) and *yang* (the male principle) exclusively with men and women.

In Chinese cosmology, she argues, everything necessarily contains at least some germ of its opposite, without which it would fail to exist (1989:320). "Both men and women as physical beings contain a measure of both *yin* and *yang*, and, indeed, the correct balance between them define well-being and good health" (*ibid.*). This is not to deny that women are associated with *yin* in ways that men are not, and vice-versa, but rather to point out that the gender categories involved here are fluid and relational, rather than absolute (*ibid.*).

While some category which might be translated as "woman" seems to exist almost everywhere then, its precise content – its meaning and value – is open to variation. It is not enough, in other words, to speak simply of the identity of a person as a "woman", as if use of that category is itself sufficient to delineate for us the person's experiences. Different cultures place quite different constructions on what it is to be a woman. In addition, even within the one culture, the category "woman" is rarely consistent or unambiguous in the meanings and values attached to it. Frédérique Marglin, for instance, through an analysis of Hindu women temple dancers (*devadasi*) of Orissa in East India, demonstrates the ambiguity of the images attached to women and their activities within Orissan Hindu culture. Here women are at the same time both "impure", a state which renders them inferior to men, and "auspicious", a state which speaks of "all that creates, promotes, and maintains life" (Marglin, 1985:19), including that of men.

To complicate matters further, within any one society the category "woman" can (and frequently does) change markedly in accordance with larger historical and political changes. In a study of the Ilonggo of the Visayas in the Philippines, for instance, Cristina Blanc-Szanton demonstrates that modern Ilonggo gender imagery has been strongly coloured both by contact with the Spanish colonizers who first arrived in the sixteenth century, and by the American occupiers of the first half of the twentieth century. Yet it has at the same time retained much of the original set of gender constructions which existed before Europeans reached the islands. She concludes that "the end result has been a modern composite gender symbolism and imagery, with aspects of pre-Hispanic egalitarianism, Spanish Catholicism, and some American individualism" (Blanc-Szanton, 1990:381).

In fact, as should already be clear from other chapters in this book, gender provides but one axis in terms of which members of a society may be categorized vis-à-vis one another: race, ethnicity, age, class, caste and nationhood are all examples of others. The social and cultural identity of any particular person at any moment in time is shaped not by any one of these, but rather by the ways in which they come together. No person is *simply* a woman: she is an old or a young woman, an urban or a rural woman, a woman of a particular clan or lineage, a Hokkien, Minangkabau or Karen woman, a woman of the *brahmin* or of the *harijan* caste, a woman of a wealthy merchant or of a poor peasant class. All of these different axes contribute to her particular identity, and help to shape the cultural meanings attributed to her actions and experiences. The ways in which gender itself is elaborated – the cultural images used to describe and differentiate men and women – are themselves crucially dependent on these other categories. Kalpana Ram, for instance, demonstrates that among the Christian Mukkuvars, a fisherpeople of South India, notions to do with women as "dangerous" are inextricably connected to the position of Mukkuvars as "polluted untouchables" in the eyes of caste Hindus (Ram, 1991). She argues that Mukkuvar women's complete exclusion from the activity of fishing must be seen not simply as the

outcome of indigenous beliefs about the dangerous character of women's bodies, but also "as a response to the threat of hostile outsider evaluation" (*ibid.*: 11), in the context of the Mukkuvar struggle to demonstrate to caste Hindus the essential dignity of Mukkuvar lives.

The inevitable conclusion to be drawn from all of this is that there is no single universal set of understandings concerning what it means to be a woman. While the category "woman" is everywhere linked in some (even insignificant) way to what is often termed "biology" or "nature", the content of that category varies from context to context. The result is, as Henrietta Moore points out, that "what the category "woman", or for that matter the category "man" means in a given context has to be investigated and not assumed" (Moore, 1988: 7). The simple fact that "women" have different bodies from "men" obviously "makes a difference" throughout the world, but the meaning and value attributed to that difference (including the importance ascribed to biology itself in creating it) is not a cross-cultural – or even an intra-cultural – constant.

Women and Work

A number of the meanings associated with gender difference in most, if not all, societies of the world, are concerned with a distinction between work deemed more appropriate for women, and that deemed more appropriate for men. Such a distinction is referred to by anthropologists (among others) as a sexual division of labour. It is significant that it is termed a "sexual" division of labour, for it is, in fact, a *gendered* division of labour: it is generally (as we shall see) a person's social identity as a "woman" or a "man", rather than his or her sex, that influences the kinds of work deemed appropriate for him or her.

In some societies the sexual division of labour appears to parallel a distinction between a "domestic" sphere of life (focused on household and family) and a "public" sphere of life (focused on the wider society). This second distinction is normally referred to by anthropologists as a domestic/public distinction. In societies where these two distinctions parallel one another, "women" are seen to be associated primarily with the private ("domestic") realm, and "men" with the public ("social") realm. Thus in these societies women are seen as more appropriately engaged in work inside and around the home, while men are seen as more appropriately engaged in work outside and away from the home. In societies which operate according to a domestic/public distinction, the former type of work is generally valued less than the latter. This domestic/public distinction constitutes the central principle according to which gender roles and the sexual division of labour are organized in countries like Britain, the United States, and Western Europe. This has had the unfortunate effect that anthropologists from these countries have often been inclined to see this same distinction as operating everywhere in the world, and as constituting the "traditional" sexual division of labour.

A major outcome of the tendency to view the domestic/public distinction as universal, has been that within anthropology the work performed by women often appears as much more homogenous throughout the world than the work performed by men. This is because "domestic" work – the work associated with women –

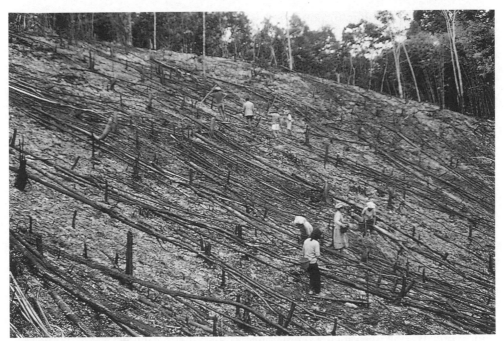

Sexual division of labour: during rice planting men walk in front making holes for the seed with sharpened sticks, women follow behind putting the seed into the holes.
Courtesy of Christine Helliwell.

is generally identified in the West with functions believed to be "natural" (Harris, 1981: 62): eating, sleeping, the fulfilling of sexual and emotional needs, and most particularly childbearing and raising. Because these functions are seen to be based in biology, they are believed to be invariant throughout the world, and so to be performed everywhere through the same kinds of work. Unfortunately, the ethnographic evidence necessary to refute this prejudice has rarely been forthcoming. For a number of reasons – including the belief that since domesticity is everywhere the same it is already known about, and therefore not worthy of in-depth study or analysis – there has existed until very recently among ethnographers a proclivity for focusing on the "public" at the expense of the "domestic". As a result, anthropology in fact knows very little about the character throughout the world of the types of activities typically classified as "domestic", and of the meanings and values attached to those activities. The outcome of this is that any variations that exist in the ways in which "domestic" tasks are classified and performed, and in who performs them, have routinely been overlooked. And as Sorensen observes at the end of Chapter 5 this has had important implications for the study of kinship.

While the process of acquiring and cooking household food, for instance, might superficially appear to be everywhere the same in that it fulfills the same biological needs, in fact there is a world of difference between the activity of buying rice in an urban market and cooking it on an electric stove as a middle-class Singaporean housewife might do, and raising the riceplants as ones "children", bringing the grain "home" to ones village house, threshing it, winnowing it, pounding it and

storing it – all according to notions of where the rice "belongs" at each stage of this process – and finally, cooking it on a wood fire over a hearthstone consecrated in recognition of the vital role that rice plays in the maintenance of the household, as women and men of Gerai might do. It is not simply that the meanings attached to such activities are in fact very different; so too is the time taken up by each and thus the labour power released for other activities, and so too are the amounts of cash required for each and thus the necessity to engage in paid employment. To treat the two activities as "essentially" the same can thus result in crucial questions about the differential workings of the two societies in question remaining unexplored.

Furthermore, ethnographic research into the ways in which "work" is classified cross-culturally, indicates that a distinction between "domestic" and "public" simply does not exist in some societies. In Gerai, for instance, the single concept "work" applies as equally to cooking and washing clothes as it does to tapping rubber or working in the ricefields. There is a distinction made here between what we might call "essential" work – work deemed central to the daily subsistence of the household, within which all the activities listed above would be included – and "peripheral" or "secondary" work – work which can be put aside in favour of "essential" work, without affecting the ongoing capacity of the household to survive. This "secondary" work includes weaving baskets and mats, cooking snacks and delicacies, fashioning knife handles, repairing longhouse apartments, and so on. To read onto such a set of conceptions a distinction between "domestic" and "public" activities, would be to completely misunderstand the cultural bases on which certain kinds of work in Gerai are in fact seen as more appropriately

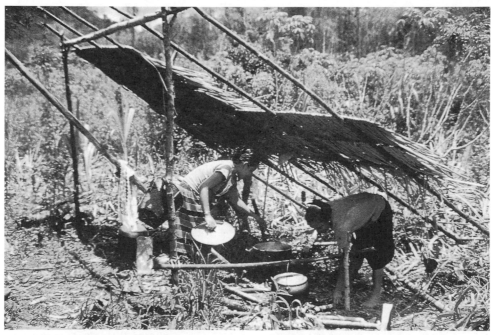

Gerai women cooking at an outdoor hut for a rice field feast.
Courtesy of Christine Helliwell.

performed by women, and certain kinds more appropriately performed by men. It would also be to assume that women's labour (as opposed to men's) in Gerai bears a similarity with "housework" which it does not in fact possess.

Even in those societies where there does seem to occur a fairly strict conceptual distinction between "women's" activities and work as associated with the home and "men's" activities and work as associated with the broader society, this distinction may be much less clear-cut than it seems when it comes to the ways in which labour is in fact organized. There are two reasons for this. Firstly, even in societies which operate according to such a conceptual scheme, it is often women's (unpaid) labour in the home which underlies the entire system of male "social" labour: without women to undertake, free of charge, the work of cooking, fetching water, cleaning, washing, raising children, and so on, the labour force – and so the entire system of productive relations – could not reproduce itself (a point often made by both Marxists and feminists). Secondly, in such societies women are themselves often engaged in paid labour. Since such labour is performed in the home it falls within the realm of "domestic" work, yet it is in most respects an integral part of the system of "social" labour relations. For instance, Maria Mies' account of the women of Narsapur in the Indian state of Andhra Pradesh, who crochet lace on a "putting-out" basis in their own homes, shows that this work is linked into the regional, national and international economy no less than any work performed by men in the "workplace" (Mies, 1982). To overlook these differences between ideology and practice in the organization of women's and men's labour, is to overlook the many and varied functions that women's "domestic" labour may in fact perform within the "public" economy.

Furthermore, it does not follow that in those societies where a distinction is made between what we might characterize as "domestic" and "public" spheres, and in which this distinction seems to overlap with one between "women" and "men", firstly that the kinds of work included in the former are the same as those covered by the term "housework" and secondly, that such work is seen as appropriate for women for the same kinds of reasons as in, for example, Japan or the United States. Thus Ursula Sharma's account of "household work" in a city of North India indicates that while such a distinction holds there, the "household work" that women are expected to perform includes a great deal more than what is conventionally meant by "housework" in the West:

> There are many other kinds of work which must be done if the household is to maintain itself and prosper, activities which do not relate so immediately to the physical needs of its members. For instance, expenditure must be organized; bills need to be paid, cash banked or withdrawn, credit arranged. Social relationships must be kept going; contact with 'family' friends or common kin must be maintained, presents given on festivals or ritual occasions, invitations extended and hospitality provided. (Sharma, 1986: 1)

In addition, Sharma points out that the cultural understandings concerning what it is to be a woman that underlie notions of the appropriateness of "domestic" work for women are rather different in North India from what they are in the West. While in the West such appropriateness is understood in terms of the needs of young children for maternal care, in India it is understood in terms of ideas about *purdah*, family honour and pollution, and how these relate to women (*ibid.*: 129). Thus although there is a clear association in Indian culture of women

with "domestic" work and men with "public" work, one should not assume that these divisions carry the same meanings and implications as they do in Japan, China or Australia.

In most societies women do, in fact, tend to perform the majority of chores termed "domestic" more often than men. But it does not follow from this that they are not also engaged in work that falls squarely within the "public" sphere, nor that this latter type of work is imbued with any less importance for them than the former. Jennifer Alexander notes that among the Javanese, "housework" is seen as primarily women's responsibility, but she also points out that only eight women over the age of twelve in the rural village that she studied (containing a population of 3000 people) were not engaged in work outside their own homes (Alexander, 1987: 29–33). "Women", she tells us "are expected to make economic contributions to the household income" (*ibid.*: 20). In a paper that has become a classic, Ann Stoler in fact claims that increasing landlessness in Java is likely to create more problems for rural men than for rural women, since, unlike their men-folk, Javanese rural women have always been engaged in alternative forms of income-generation (Stoler, 1977: 88–9). Java is by no means exceptional in this respect: throughout much of Asia women are employed in the "public" workplace in enormous numbers. Gavin Jones, for instance, points out that single women comprise over half of the workforce in most cities of East and Southeast Asia (Jones, 1984: 10). The notion of a gendered distinction between "domestic" and "public" spheres of work becomes extremely problematic in the face of these kinds of statistics.

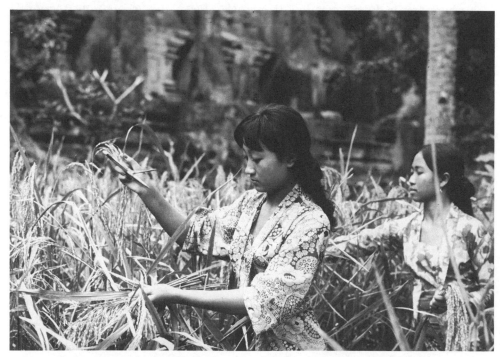

Balinese women play a major role in harvesting rice.
Courtesy of Paul Spencer Wachtel.

Just as for many parts of Asia it makes more sense to think about "women" and "men" in terms of potentially overlapping areas on an axis rather than in terms of exclusive categories, so "women's work" and "men's work" should also often be understood in this way. Throughout much of Southeast Asia in particular, the gendered character of work is explained less in terms of hard-and-fast rules that exclude women from some areas of work and men from others, and much more in terms of "the way things are usually done". A study of the literature pertaining to this region, for instance, indicates that while women perform what we conventionally call "domestic" work more often than men, it is by no means unusual to find men routinely engaged in such "core" domestic tasks as cooking and child-minding. Even in a country such as China, where there tends to be a much more marked sexual division of labour, some men assume a degree of responsibility for domestic work: in Elisabeth Croll's sample, taken from both urban and rural areas, the shopping in 38 percent of households was done by a man, and the cooking in 6 percent by a man (Croll, 1983: 314).

Perhaps the most obvious problem with the universalization of the association between "women" and "domestic" work, is that by no means all women in the world engage in domestic labour. In addition, whether or not any particular woman does so, the degree to which she does, and the importance that such work plays within her activities, are all determined by a great deal more than her classification as a "woman". Throughout much of Asia, for instance, wealthier women carry out only a restricted range of domestic tasks (while very wealthy women carry out none at all), because they perceive such work as demeaning, and can afford to pay others to do it for them. This means that for some poor urban women, such as those of Indonesia described by Kathy Robinson, "domestic" work may itself constitute a major form of paid employment (Robinson, 1991). Elisabeth Croll points out that in a large number of Chinese households an older retired woman takes on much of the responsibility for domestic work, leaving other women of the household much freer to engage in the collective labour force, and so to earn the family labour points and wages (Croll, 1983: 313). And Janet Salaff reports, similarly, that within Hong Kong households, "working daughters" are frequently exempted from domestic work on the grounds that they are making sufficient contribution to the upkeep of the household through the wages that they bring in (Salaff, 1981: 269). Joanna Liddle and Rama Joshi note similar treatment of "working daughters" in some Indian households (Liddle and Joshi, 1986: 145).

In other words, just as a range of factors come together to shape the meanings and values attributed to any individual woman's experience, so too a range of factors – including the cultural meanings associated with being a "woman", class, age, marital status and access to income – come together to determine the particular activities deemed appropriate for her. As a result, the kinds of work that women engage in, and the ways in which that work is classified and understood, are each open to considerable variation. So it is that many Javanese women engage in trading, that many Malaysian factories employ predominantly women workers, that many poor rural Thai households are dependent on the wages of a prostitute daughter, that women of the island of Borneo share with men the work of dry-rice cultivation, and women of Bali and China the work of wet-rice cultivation, that many Singaporean government workers and university teachers are women, that many Hindu Indian women are "housewives", that Christian Mukkuvar women

sell the fish that their husbands catch, and that the women of Narsupur crochet lace in their homes for export. To acknowledge this diversity is in no sense to deny that certain tasks – such as cooking and childrearing – are in most parts of the world more strongly associated with women than with men. It is instead to make a genuine start towards formulating an explanation as to why this might be. An unfortunate result of the tendency to overlook the diversity of women's work, and to emphasize instead their responsibilities within the "domestic" arena, has been that much anthropology has failed to even begin to understand the very complex relationships that exist between the ways in which gender is constructed in any society and the ways in which labour is organized.

Some of the more powerful explanations concerning the widespread relationship between women and "domestic" work have come from thinkers operating within a broadly marxist framework, many of whom have been concerned to trace the links between women's confinement to the domestic realm and processes such as capitalism, colonialism and industrialization. The work of Ester Boserup has been particularly influential in this respect. Boserup argues that the contribution of women to the economic upkeep of the household in pre-colonial Third-World societies has routinely been overlooked by western commentators. She points out that the penetration of both capitalism and of misogynist colonial ideology into such societies has very often had deleterious effects on women: dispossessing them of land and depriving them of the right to work at anything other than "domestic" tasks, and so increasing their level of dependence on men (Boserup, 1970). Following on in this vein, Barbara Rogers has argued that most development projects in Third-World societies are saturated with western notions of what is appropriate work for women, and so discriminate strongly against women in the allocation of resources. Again this creates or reinforces what she refers to as "the domestication of women" (Rogers, 1980).

There is no doubt that the penetration of capitalism has had precisely these effects on many Third-World women. Kathy Robinson, for instance, points out that in the Indonesian mining town of Soroako, men and women were "co-partners in agricultural production" before the arrival of the nickel-mining and processing facility (Robinson, 1988:65). But with the establishment of the mine, local people were forced out of farming and into dependence on employment with the mining company. Since such employment was reserved for men, women became strongly identified with the domestic sphere – an identification that had not existed in pre-mine times (Robinson 1983, 1988).

However, two caveats must be attached to any statement which posits an association of women with domesticity under capitalism. The first is that in recognizing the ways in which capitalism operates to "push women into the home" and so to confine their lives in important respects, the ways in which it functions similarly to constrain and circumscribe the lives of *men* should not be overlooked. Robinson's work, for instance, makes it clear that while the outcome of the establishment of the mine in Soroako has been to restrict women's activities much more severely to "domestic" work, it has also been to restrict men's activities much more severely to the "public" workplace. She notes that most men now have to leave the village very early in the morning in order to catch the transport to work, and do not return until very late in the evening. For many this involves a sixty-hour working week (Robinson, 1983:125). The second caveat is that it would be a serious mistake to assume, that because capitalism has led to the

"domestication" of women in some societies, that it has done so in all. In many parts of Asia the effect of industrialization and increased incorporation into a world capitalist economy has been to raise the numbers of women employed in the "public" workforce. Thus, in writing on the cities of East and Southeast Asia, Gavin Jones notes that:

> The rise in the proportion of urban women who are in the workforce suggests that migrants from rural areas continue to play the important economic role they did before moving, and that urban-born women, whose rates of economic activity were always lower, are being released from a confined role in reproducing and nurturing the workforce to a much more active participation in the processes of economic development. Further evidence of this quiet revolution is the sharp decline in fertility rates in urban populations throughout the region. (Jones, 1984:1)

The important point here, of course, is that (as we have seen) women do not constitute a homogenous unitary category, and therefore the effects on women's work of processes like capitalist penetration, industrialization and so on are very uneven. Again, this is something that is greatly influenced by other factors such as class, age, and education. Boserup herself makes this point in a very recent paper, pointing out that industrialization often favours women who are young and educated in obtaining employment, but may disadvantage older uneducated women in that the smaller family enterprises in which many work may suffer through the competition with a more highly industrialized sector (Boserup, 1990: 24). Stoler, similarly, points out that the effect of capitalist penetration into rural Java has not been to transform the sexual division of labour within *the* household, but rather to transform that between *different* households: members of wealthy households, whether men or women, now have different employment options available to them from those available to members of poorer households (Stoler, 1977). In rural Java, then, the penetration of capitalism has enhanced the capacity of wealthier women to establish themselves as successful traders (*ibid.*). In Soroako, on the other hand, the effects of capitalism have been increasingly to limit women to "domestic" work within the home (Robinson, 1983, 1988). Vina Mazumdar and Kumud Sharma point out that one of the effects of the industrialization of the Indian textile industry has been to displace women from what was once a largely female form of employment (Mazumdar and Sharma, 1990: 193–4). However, Jones' figures demonstrate that the effects of industrialization throughout the cities of East and Southeast Asia has been to increase the numbers of women in paid employment (Jones, 1984). We have here a series of apparent contradictions, yet there is no reason why these should strike us as problematic. Instead they provide further evidence of the fact that processes such as capitalism and industrialization affect different women in very different ways.

Janet Salaff's study of the "working daughters" of Hong Kong demonstrates very well the wide range of factors that contribute to the specific ways in which capitalist penetration and industrialization impact on the working life of any individual Hong Kong woman (Salaff, 1981). She shows how such cultural institutions as the nature of kinship and property relations within the household and the organization of the household, conspire with the characteristics of a woman's individual identity such as gender, age, marital status, class, and education to influence her eventual employment opportunities. The pooling of resources by

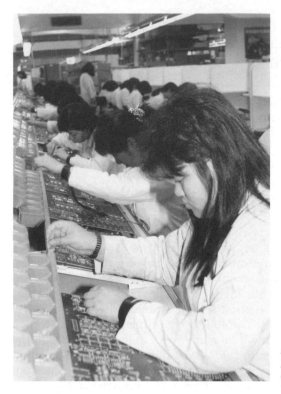

"Working daughters" in Hong Kong make substantial economic contributions to the household.
Courtesy of David Hayes.

and among members is a key strategy for the maintenance of the Hong Kong household, and women are socialized to contribute all that they can, first to their natal households, and later to their conjugal households. Because of the patrilineal system and the fact that women rather than men marry out of the household (both of which depend on cultural constructions of what it is to be a "woman" or a "man"), household members see it as important for the future of the household to advance the careers of sons over those of daughters. As a result, sons are likely to receive more education than daughters, and to join the workforce at a later age; daughters often go out to work at a relatively young age in order to help support their brothers through school. Salaff also shows that working-class women enter the workforce at a younger age than do middle-class women, and that they do so with less education. As a result they tend to obtain less prestigious and lower-paid jobs (*ibid.*: 259–61). In addition, a younger daughter will often receive more education than an older one – this is because the household is usually in a sounder position to support a younger daughter through school, because of the financial contribution made to her upkeep by older siblings. This results in her having better employment opportunities (*ibid.*: 265–6). Salaff's work demonstrates that even with respect to the same generation within the one household, it can be problematic to describe industrialization and capitalism as having unitary effects on women. At the same time it suggests that an adequate description of the organization of the system of labour in Hong Kong – and of the entry of so many young women into the workforce there – must take account of the gender constructions found within Hong Kong culture.

The Status of Women

One of the principal areas of research and debate for those anthropologists interested in issues of women and gender, has concerned the status of women vis-à-vis that of men. The notion of status used here is, as we shall see, profoundly problematic, but it generally refers both to the value ascribed to women and their activities, and to the degree of control that women are able to exercise over their own lives, as well as over the lives of others. The growth in popularity of this research area within anthropology dates back to the late 1960s and early 1970s, at which time feminist anthropologists began to search for ways to explain the widespread pattern throughout the world of women being accorded a lower status than men.

A crucial research question formulated at this time concerned whether or not women are everywhere subordinate to men: in other words, whether inferior female status could be said to be a human universal. However, providing an adequate answer to this question is more difficult than might at first sight appear to be the case. How, for instance, do we measure "status", and thus tell who has more of it and who less? The answer to this question is one on which anthropologists (along with the members of other disciplines) have never been able to reach agreement. As a result there is also a marked difference of opinion over whether women are in fact subordinate to men in many societies. Consider, for example, those societies in which men and women are each seen to have high status and to exercise considerable power, but within quite different spheres of social life. Is it legitimate in such cases to interpret in terms of superiority and inferiority what the members of the society themselves might understand simply as *difference*? In other words, does it make sense to reduce what may in fact be very different forms of status to the one equation, such that we can talk about men's status as appropriate to one domain being greater than woman's as appropriate to another?

Peggy Sanday notes that among the Minangkabau of the Indonesian island of Sumatra, women have higher status in the domestic realm, while men have higher status in the realm of village and wider political affairs: "women hold more power with respect to the disbursement and use of ancestral property...men hold more power in 'government'" (Sanday, 1990: 145). Sanday stresses that what we see among the Minangkabau is a *complementarity* of women's and men's social roles, which means that while they may have separate rights and enjoy different forms of authority, overall the two are ranked equally "high" (*ibid.*). Here, women's inferiority in certain social contexts is matched by men's in others, such that it becomes very difficult indeed to describe either as having a higher status in absolute terms.

Anthropologists have typically attempted to get around the problem of how to compare statuses appropriate to different realms of life by posing certain types of power as more important than other types. Thus the wielders of economic power are very often treated by anthropologists as having the highest status and the most power of any members in a society. Yet this raises the question of the validity of assessing status/power in these particular terms rather than in any other. We know, for instance, from Benedict Anderson's classic paper on Javanese notions of power, that in Java, control of economic matters is identified with *lower* rather than higher social status (Anderson, 1972). This explains the apparent paradox in the position of Javanese women vis-à-vis men: as Ward Keeler points out, it is in

part *because* Javanese women manage economic resources and play a dominant role in decision-making within the household, that they are seen as being less "potent", and are thus accorded a lower social status than men (Keeler, 1990).

The Javanese case in fact provides an excellent example of the kinds of ethnographic work that must be done before we can pass judgement on the "subordination" of women in any particular society. It is possible to make such judgments, but they must be made with great care, and only after we have posed the question of what it means to be powerful and to have a higher cultural value in the cultural context under study. These are difficult questions for the ethnographer to pursue, involving as they do research on a series of highly esoteric matters including notions of agency, intentionality and the self, but they are nevertheless ones which must be taken up if any genuine attempt is to be made at comparing the statuses of women and men.

The Minangkabau example, and a number of others from throughout the world, in fact suggest that the notion of women as universally subordinated to men requires considerable revision. However, the ethnographic evidence does seem to indicate that in *most* societies of the world women have a lower status than men. Yet, even among these societies there is great diversity in the degree of women's inferiority. Among Asianists, for instance, a distinction has often been drawn between the societies of Southeast Asia where women are accorded a relatively high status (under Gerai customary law, for instance, a woman is valued at seventenths of a man), and the societies of India and China where the status of women vis-à-vis that of men is seen to be much lower.

Among those anthropologists of the late 1960s and early 1970s who were concerned with questions about women's status, there were many who argued that women's subordination to men could be accounted for, ultimately, in terms of "biological" differences between women and men. It must be made very clear here that while those who advanced this kind of argument tended to claim that women are in the known world universally subordinate to men, they were not suggesting that women always *will* be subordinate to men, or that they *ought* to be. Rather they were suggesting that the bodily or sex differences between women and men are in all cultures understood and elaborated in the same terms, with the category "woman" everywhere being ascribed a lower cultural value than the category "man", and with women thus being everywhere accorded a lower social status.

Among those who subscribed to this position, two separate – although closely related – models became the focus of much research and debate. Each of these models has been extremely influential within the anthropology of women and gender. The first, advanced by Sherry Ortner in 1974, argues that the distinction between women and men is universally equated with the distinction between nature and culture: women are everywhere seen to be closer to nature while men are everywhere seen as closer to culture. Ortner argues that it is women's capacity to give birth – a "natural" form of creativity – that makes them appear closer to nature than men. Lacking an equivalent "natural" creativity, men are forced instead to seek cultural forms. But since the essence of culture is the transcendence of nature, the result is that women are seen to be transcended by men (Ortner, 1974).

While the woman = nature / man = culture model comprises an ingenious and elegant attempt to explain the apparent universal – or even the widespread –

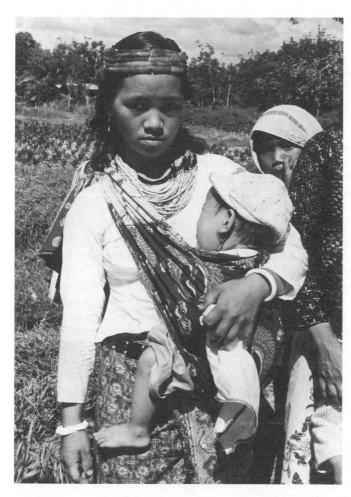

Some argue that it is women's capacity to give birth that makes them appear closer to nature than men. Here a Dayak woman from Sabah, Malaysia, holds her baby.
Courtesy of Paul Avery – Empire.

subordination of women, it suffers from a number of problems. Firstly, many cultures of the world – including many in which women *do* have a lower status than men – simply do not make a distinction between "nature" and "culture". Thus I myself have argued with respect to the Gerai Dayaks that there is no Gerai concept that can be translated as "nature", and that the notion that might very loosely be translated as "culture" in fact largely encompasses what English speakers might call "nature" (Helliwell, in press). In addition, even if such a distinction does appear to be made in a number of very different societies, it does not follow (as Marilyn Strathern cogently points out) that in all of them it means the same kinds of things – in terms of gender or anything else (Strathern, 1980). For instance, the Sinhalese of Sri Lanka, as described by Bruce Kapferer, do seem to see an opposition between nature and culture, but this does not accord in a straightforward way with a parallel opposition between women and men. Thus Kapferer points out that Sinhalese women are more prone to spirit possession than men because they are understood to *mediate* between culture and nature – a position which renders them especially vulnerable to spirits (Kapferer, 1983). This is not to deny that there *are* societies in which a conceptual distinction is made between nature

and culture, and in which such a distinction appears to equate with a second one between women and men: Valeri, for instance, argues that among the Huaulu of the Indonesian island of Seram, just such an equation is made (Valeri, 1990). But this conceptual scheme is by no means universal, and any attempt to treat it as if it were is doomed to misunderstand the meanings – and statuses – attached to gender difference in many societies.

The second model, advanced by Michelle Rosaldo also in 1974, argues that the distinction between women and men is universally equated with the distinction between domestic and public spheres of life: women are everywhere seen as associated with the domestic realm, while men are everywhere seen as associated with the public realm. Women are linked to the domestic realm through their childbearing and childrearing functions: the "core" of this realm consists of the mother-child relationship. Men, on the other hand, lacking childbearing functions, are associated with the public realm – that realm that operates to link together different domestic realms. The domestic realm is thus subsumed within the public realm, and as a result the position of women is subsumed within – and denigrated with respect to – that of men (Rosaldo, 1974).

Again, this argument appears, on first sight, to be extremely persuasive. But it in fact suffers from similar problems to those associated with the nature/culture model. As we saw in the preceding section of this chapter, a conceptual equation of women/men with domestic/public is by no means universal. Many societies of the world – including many in which women have a lower status than men – simply do not distinguish between "domestic" and "public" spheres of life; for those that do, there may be no clear-cut equation of such spheres with "women" and "men" respectively. In addition, Marilyn Strathern has argued persuasively that even if the members of a society *do* make a distinction between domestic = woman and public = man, this by no means implies that the domestic realm is *denigrated* with respect to the public (Strathern, 1984). Sanday makes it clear, for instance, that among the Minangkabau of the Indonesian island of Sumatra, women and men are associated respectively with domestic and public realms of life, but she argues that here the domestic realm is neither unimportant, nor peripheral to the centre of power (Sanday, 1990: 145).

The shortcomings of both these models illustrate the limitations of any attempt to formulate a single unitary theory of "the subordination of women", that is, of any model that postulates an identical status imbalance between women and men in all parts of the world, and proposes to account for such an imbalance everywhere in the same terms. Even if it were to be the case that women are universally accorded a lower status than men, we cannot assume from this – especially given what we have already seen about the diversity that exists in what it means to be a woman – that everywhere the status difference is *identical*, nor that it is always the result of the same social and cultural processes.

One of the main problems with single unitary models which propose to account for "the" subordination of women, is that they invariably reduce the very complex motivations and behaviours of men vis-à-vis women, and of women vis-à-vis men to a single dualistic set: that of oppressor on the one hand (men), and victim on the other (women). Each of these stereotypes is not only simplistic; it also contradicts the evidence in many cases. Thus there are many examples in the ethnographic literature of men who, both individually and collectively, operate in ways that positively *advantage* rather then disadvantage women. For instance,

Maila Stivens, in a discussion of the effects of colonial and capitalist penetration on the Malays of the state of Negeri Sembilan in Peninsular Malaysia, points out that in recent times women's landholdings have increased, and that much of their newly acquired land has in fact been given to them by husbands and fathers. When Stivens enquired among her informants as to why men should be giving land to women, most of them pointed to the greater vulnerability of women within the changing rural economy, and their resultant need for land as a form of security (Stivens, 1985). Here, then, we find men acting not as "oppressors" of women, but in such a way as to protect the women's interests.

Similarly, the "woman as victim" stereotype that tends to be implicit in unitary accounts of "the" subordination of women is problematic, for a number of reasons. Firstly, such a model fails to take account of the extent to which women themselves oppress other women, or collude in the oppression of other women by men. Those practices typically seen by outsiders as confining of women and demeaning of their social status are frequently perpetrated against women most directly not by men, but by other women. The practice of footbinding which operated until very recently in China, provides an obvious example here. Along with the clitoridectomy carried out in parts of northern Africa, footbinding raises a series of very real problems concerning how we think and talk about "women's oppression".

Foot-binding involved the folding under of all toes on the foot except the large one. These were held back towards the heel as tightly as possible through being

Two young Hong Kong women with bound feet, accompanied on an outing by an amah (the early part of the twentieth century).
Courtesy of Hong Kong Museum of History.

bound with a long bandage; this was, as Anagnost notes, a "terrible painful process, especially in its initial stages" (1989:331). In making it difficult for women to walk, foot-binding very effectively confined them to the home and so placed a severe constraint on their extra-domestic activities. Yet, while there seems to be no doubt that foot-binding was carried out in the context of a set of social and familial relations which ascribed men a higher value than women, and allowed them a considerable degree of control over women's activities, what is problematic here is that it was perpetrated not by a *man*, but by a woman on her own daughters. Furthermore, as Anagnost makes clear, while the physical confinement of women to the home that foot-binding so graphically underlined was an integral part of the exercise of male authority over women, it was equally an integral part of the authority which women of higher generations within the household were able to exercise over those of lower generations. Anagnost notes that in the ethnographic film "Small Happiness" (made in 1984) elderly rural Chinese women reminisce about the constraints placed on their movements as young women by their mothers-in-law: "to leave the house, a daughter-in-law required the permission of her mother-in-law who would pull a long face and give grudging consent only if the younger woman promised not to be long" (*ibid*.). The binding of women's feet thus served to reinforce not simply male authority, but *female* authority as well. It is ironic that many of those who worked to eradicate foot-binding in China were in fact "elite males influenced by Western education and missionary horror at the practice" (*ibid*.:329).

Secondly, the view of women as "victims of male oppression" ignores the degree to which women are active agents within social life, and are able, as such, to manipulate and subvert the very institutions which are apparently "oppressing" them. Liddle and Joshi, for instance, point out that in urban middle-class households in North India, it is sometimes the case that a young working wife chooses to become part of a traditional "extended" family with her in-laws after marriage, rather than establishing (with her husband) an independent nuclear family unit of her own (Liddle and Joshi, 1986:145–6). Since the extended family form has often been depicted as a source of women's oppression in India, such a choice is intriguing. In fact, rather than being the helpless victims of their mothers-in-laws' authority within such an institution, these middle-class working wives have discovered that the extended family setup provides them with more freedom to pursue activities outside the home, since their mothers-in-law are able to undertake most of the domestic work. Liddle and Joshi note that rather than joining the households of older couples, in the traditional style, some young couples set up their own independent households, and then invite the older couple to join *them*. This creates a subtlety different power dynamic from that found in the "traditional" extended household (Liddle and Joshi, 1986:145–6). What we see here are women *choosing* to create the very extended household structures which have been so often described as oppressive for them, because they are able actively to subvert such structures to their own ends.

It is not merely that many women seek to subvert their oppression by men. Many also seek actively to resist it, a response which is all too often overlooked in the depiction of women as universally oppressed. In this sense, the "woman as victim" stereotype is, ironically, itself denigratory towards women: it tends to depict them as passive, unresisting objects, those who "have oppression done to them". Third-world women, in particular, have argued that this is a major problem

with the view that many western feminists have of non-western women. Thus Valerie Amos and Pratibha Parmar point to the patronizing Euro-American feminist image of "the passive Asian woman subject to oppressive practices within the Asian family" (Amos and Parmar, 1984:9) – a depiction which often seems to suggest that Asian women lack the more enlightened feminist "consciousness" of their western "sisters". In similar vein, Chandra Mohanty notes that:

> An analysis of 'sexual difference' in the form of a cross-culturally singular, monolithic notion of patriarchy or male dominance leads to the construction of a similarly reductive and homogeneous notion of what I shall call the 'third-world difference' – that stable, ahistorical something that apparently oppresses most if not all the women in these countries. (Mohanty, 1988:63)

In this respect, she argues, western feminism in fact perpetuates colonialist ideology concerning the backward "Third World", and so serves to strengthen the oppression that occurs within the colonialist enterprise.

It is clear that throughout the world women resist control by others (men or women) over their activities. But because they often do so through an appropriation or subversion of institutions normally defined as oppressive to them, this resistance is often overlooked or misunderstood. Thus Aihwa Ong describes the differing forms that resistance to exploitation by male factory management may take among Malay women workers: these include crying, verbal abuse, adopting an uncaring attitude towards orders, spending periods of time in the locker room under the guise of attending to "female problems", adjournment to the prayer room and surreptitious wrecking of factory machinery and products (Ong, 1987:203–11). Furthermore, Ong argues that the recurrent outbreaks of spirit possession among Malay factory women that cost Malaysian factories many workhours each year, also constitute in part "a mode of unconscious retaliation against male authority" (ibid.:207) as women attempt to constitute for themselves "a new identity rooted in human dignity" (ibid.:196). Linda Lim argues that the stereotype of the grossly exploited third-world woman worker in multinational factories is in fact often not in accordance with the reality: she points out, for instance, that in South Korea women textile workers are considered to be among the most militant of the labour unions (Lim, 1990:112). It also needs to be noted that many Third-World countries – including many in Asia – have long contained feminist movements. Thus Kumari Jayawardena points out that:

> Debates on women's rights and education were held in 18th-century China and there were movements for women's social emancipation in early 19th-century India...feminist struggles originated between 60 and 80 years ago in many countries of Asia. (Jayawardena, 1986:2–3)

The set of problems associated with speaking of women as a universally subordinated group then, revolve around the absurdity of any attempt to capture the diversity of women's and men's experiences within a single dualistic set of roles and statuses. Not only does the notion that women are universally oppressed by men tend to oversimplify the relationships operating between men and women in any society, so it may also lead to a failure to take account of the many other forms of subordination that different women may be required to contend with. Amos and Parmar, for instance, argue that Black women

> cannot simply prioritize one aspect of our oppression to the exclusion of

Benazir Bhuto of Pakistan, one of Asia's most well-known woman politicians, speaks to supporters after being released from prison in 1986.
Courtesy of Ahmed Rashid.

others, as the realities of our day to day lives make it imperative for us to consider the simultaneous nature of our oppression and exploitation. Only a synthesis of class, race, gender and sexuality can lead us forward, as these form the matrix of Black women's lives. (Amos and Parmar, 1984:18)

As a result of these kinds of problems with any model of "the" universal subordination of women, most feminist anthropologists now stress the need to look at questions of status and the exercise of power in the context of particular cultural and social settings. In fact, just as there is no single meaning universally attached to the category "woman", so anthropologists have increasingly discovered that there is also no single cross-cultural value that can be attached to it: not simply meaning, but status too, varies from context to context. We have already seen that intersections between gender and class, caste, age, kinship and so on make it impossible to devise a unitary meaning for the category "woman". Similarly, these same intersections rule out any attempt to attribute a single value or status to "women" vis-à-vis "men". In other words, any individual woman's power relative to that of the men with whom she interacts is dependent not simply on her gender identity as a "woman" (although that is obviously a crucial component of it), but also on her identity as an old woman or a young one, on her specific caste, class, and so on. This is in part because a woman's life opportunities, and thus her capacity to achieve higher social status, are dependent on a range of such factors. We have already seen, for instance, how a number of factors, including class and age, contribute to the ability of any individual Hong Kong woman to acquire a better education and so obtain a higher status job (Salaff, 1981).

Certain "kinds" of women may, in fact, be accorded a higher social ranking than certain "kinds" of men. Thus Anagnost points out that in Chinese society in the past, gender as a ranking device was cross-cut by other hierarchical principles including age, generation, birth order and ascribed rank. It was thus possible "for a woman to occupy a superior position to men by virtue of rank, age or generation" (Anagnost, 1989:321). This is by no means to deny that "female" was in many respects valued lower than "male" in this culture; Anagnost in fact notes that because of her perceived inferior moral and intellectual capacities a woman's higher social rank was always vulnerable (ibid.). But it is to stress that her "womanhood" is only one among a range of different factors whose intersections determine her particular social status. While it is certainly the case that throughout Asia – as throughout the world – the category "woman" is usually accorded a lower cultural ranking than the category "man", the fact that so many Asian nations have been, or currently are, led by women, indicates that a great deal more than the single fact of her "womanhood" contributes to any individual woman's social status and to the degree of authority available to her.

In addition, just as the meaning attached to the womanhood of any particular woman may vary from context to context, so too may her status. Thus Anna Tsing argues that among the Meratus people of Indonesian Borneo, gender most of the time remains relatively unmarked, and the status of women vis-a-vis men is relatively equal. However, she shows that in the context of dispute-settlement proceedings, women are very explicitly accorded a lower value than men, and are thus effectively silenced: relegated to the role of an "audience for male 'stars'" (Tsing, 1990:98).

Those with an interest in the anthropology of women have long given thought to the possibility of relationships existing between the status of women within any society, and their engagement in certain types of work or activity. Is it the case, for instance, that the status of women who are engaged in work outside the home is generally higher than that of those women who are engaged solely in "domestic" work? There does seem to be some evidence to suggest a link between women's confinement to activity normally defined as "domestic" and their lower status vis-à-vis men. A very common argument made with respect to such evidence is that in these situations women become more dependent on men for subsistence, and hence their status is diminished relative to that of men. Yet there are problems with this explanation. Objectively, in this kind of arrangement men are dependent on women for the most basic things of life: food to eat, water to drink, a clean bed to sleep in and so on. To describe women as dependent on men in such situations, with no account of men's reciprocal dependence, simply buys into the denigration of domesticity so common in many parts of the world. Many thinkers have also claimed that women's access to paid work outside the home raises women's status because it provides them with increased autonomy. Again, there are problems here. Increased autonomy does not necessarily mean increased status, a point which Strathern has argued at length (Strathern, 1987). Thus Salaff points out that although engagement in the paid labour force increases the autonomy and degree of control over their own lives available to Hong Kong women, it does little to improve women's status vis-à-vis that of men (Salaff, 1981:13). In fact, there is evidence to indicate that engagement in paid work may increase social and cultural pressure to control women and their sexuality: this is certainly the case, for instance, for the Malay factory women described by Ong (1987). In a

similar vein, Croll's research on the position of women in post-revolutionary China indicates that as the economic value of daughters' labour has increased in rural areas under the system of collectivization, so the determination of the rural household to maintain control over marriage transactions has strengthened (Croll, 1984).

As ethnographic research on the status of women in different societies has proliferated, anthropologists have increasingly come to recognize the inadequacy of any model which attempts to explain the widespread inferiority of women's status vis-à-vis that of men in terms of a single underlying cause such as women's role in production or women's access to property. Not only do a large number of factors intersect to determine the actual status of any individual woman, but also it is simply not enough to postulate a one-way causality *from* one or other of these factors *to* women's status: the status of women is itself a crucial determinant of the sexual division of labour, the organization of inheritance and control over property and so on, in any society. For instance, if women's status is demeaned through the work that they typically perform, this diminution occurs not because of the inherent nature of that work, but because of the way in which it has been culturally defined (as demeaning). This definition is itself likely to be linked to the fact that it is women who are identified with such work; in many cultures the kinds of work deemed appropriate for women are accorded a lower value than those deemed appropriate for men. Thus, while in such contexts it is certainly true that women's lower status is related to the type of work that they engage in, there is no sense in which the latter can be seen as the ultimate cause of women's subordination. Women's work is demeaning, in part, because it is *women's* work.

Women, Resemblance and Diversity

Within anthropology (and related disciplines) women from traditions as diverse as those found in Bali, Iceland, Sierra Leone and Arizona, have commonly been treated as a homogeneous group, that is, as if they share some mysterious substance "womanhood", which bonds them together to a much greater degree than any parallel substance ("manhood") unites the men of those regions. Thus it is seen to be perfectly sensible for a textbook of this type to contain a contribution about "women", but no corresponding one about "men". Any notion that the diverse meanings and activities associated with men in different parts of the world could adequately be accounted for within a single chapter of a book such as this, strikes us as absurd.

A central aim of this chapter has been to suggest that there is as little homogeneity among the women of the world as there is among the men. Thus we have canvassed the immense diversity found throughout the world in what it means to be a woman, in the kinds of work in which women engage, in the value placed on women and their activities, and in the degree of control which women are able to exercise over social events. Yet we are left, finally, with a conundrum. For in stressing the *differences* between women, and the vulnerability of the category "woman" to other forms of social identification including those of class, caste, ethnicity and age, we run the risk of robbing that category of any meaning

or explanatory power. If different women may have little in common with one another, does that mean that their gender identity as "women" is meaningless, or irrelevant?

In fact, although great diversity is found within the category "woman", a striking degree of consistency also occurs there. While it would be foolish, for instance, to invent any such person as "the Asian woman", it is certainly helpful for certain purposes to speak of "women in South Asia", "women in Southeast Asia", or even "women in Asia", in order to allude to certain broad similarities in historical, political and cultural experience. Furthermore, within Asia or elsewhere, similarities inevitably occur between women of the same caste, class or nationality, in spite of the diversity which otherwise obtains between them. Thus the Indian writer Gayatri Spivak evokes very movingly both the differences that separate her from two Indian women of a different age and caste, and the similarities of colonial history and experience that draw them together as women of India.

> To begin with, an obstinate childhood memory.
> I am walking alone in my grandfather's estate on the Bihar-Bengal border one winter afternoon in 1949. Two ancient washerwomen are washing clothes in the river, beating the clothes on the stones. One accuses the other of poaching on her part of the river. I can still hear the cracked derisive voice of the one accused: "You fool! Is this your river! The river belongs to the Company!" – the East India Company, from whom India passed to England by the Act for the Better Government of India (1858); England had transferred its charge to an Indian Governor-General in 1947. India would become an independent republic in 1950. For these withered women, the land as soil and water to be used rather than a map to be learned still belonged, as it did one hundred and nineteen years before that date, to the East India Company.
> I was precocious enough to know that the remark was incorrect. It has taken me thirty-one years and the experience of confronting a nearly inarticulable question to apprehend that their facts were wrong but the fact was right. The Company does still own the land. (Spivak, 1987:135)

Of perhaps greater significance is that while there are many components that go to define the experiences of an individual woman, one of those is necessarily the fact of her being identified as "a woman". That fact she shares with all other "women". On the basis of such shared identity, different women are likely to have certain experiences in common. We have seen, for instance, that throughout the world women most usually have a lower social status than men. We have also noted that in most societies "domestic" work is identified more strongly with women than it is with men. It is not necessary that these similarities between women be universal in order to be deemed significant; nor need their remarking involve a denial of the obvious diversity of women's lives. Rather, it is helpful to think about such similarities in terms of what the philosopher Ludwig Wittgenstein calls a "family resemblance". All members of a family share a resemblance; this does not necessarily mean that a single characteristic is common to all. In other words, what one woman shares with another may be different from what she shares with yet another; but among the members of the overall category "women", the sense of something shared, as well as the sense of difference from men, will each be high enough for the category itself to be a meaningful one.

A person's gender identity as a "woman" (or as a "man") then, is neither meaningless nor insignificant. On the contrary, it marks her as belonging to a category of persons within which certain characteristics are widely shared, regardless of other factors such as culture, class and age. This means that not only is a person's experience as a woman moulded by these other aspects of her identity (as we have seen), but that a person's experience as a member of a particular culture, class or age group is in turn shaped by the fact of her "womanhood". It is impossible, for instance, to describe in any meaningful terms the life of a Japanese, Indian, or Thai person, without specifying that person's identity as a "woman" or a "man". Nor can one adequately outline the details of a middle-class or a working-class life, without first taking into account its gender. In other words, the kinds of work which women engage in, the meanings and values associated with women and their activities and the degree of control which women are able to exercise over their own and other people's lives, are all affected in some way by their status as "women". Notions of what it is to be a "woman" as distinct from a "man" are as much a part of the workings of any society as are its understandings of, for instance, age, class and ethnicity.

We have seen, in this chapter, that there are serious problems involved in any attempt to delineate or account for "the" nature or position of women. Partly as a result of such problems, and partly because of a wish to refute the view of women's lives as essentially uniform, the last decade or so has seen a tendency among anthropologists with an interest in issues of women and gender, to avoid questions about broad cross-cultural similarities between women, and to focus instead on the particularistic details of women's lives in many different societies. The emphasis in this chapter on the diversity of women's experience reflects these concerns. The rich store of ethnographic detail which has been the result has now made it possible to frame anew the kinds of comparative questions which were so important within the anthropology of gender fifteen or twenty years ago. Such questions should no longer be avoided, the more so since they can now be posed from within a perspective which allows for the fact that while the experiences of any woman resonate with those of other women, they do not replicate them.

11 KARMA AND COSMOLOGY

Anthropology and Religion

Nicholas Tapp

Modern studies of religion in Asia well illustrate the way in which the anthropology of religion has developed out of early debates on the nature of religion at the turn of the century. Sir Edward Tylor (1871), for example, who emphasized the importance of the widespread belief in souls as a primitive explanation for experiences of dreaming, trance, illness and death, argued for a "minimalist" definition of religion as based upon "the belief in Spiritual Beings". Émile Durkheim (1954), however, rejected the belief in supernatural beings as a criterion of religion since this would deny religion to those people who did not distinguish clearly between the natural and the supernatural, and also rejected a belief in gods as a defining feature of religion since it appeared that Buddhism (as it was understood at the time) involved no such beliefs in gods or deities. Durkheim's approach, questioning the likelihood of the whole of religion having been founded on an intellectual error, as Tylor's theory seemed to suggest, and drawing attention to the deep social significance of religion, led to several generations of functionalist studies focusing on the role of religion in society. Yet Mclford Spiro (1966), as part of what has been seen as a general shift in the social sciences from function to meaning, has defended Tylor's definition on the ethnographic grounds that in Theravada Buddhist countries like Burma and Thailand, villagers in fact do take part in a number of magical rituals aimed at propitiating the gods, ensuring health, longevity and prosperity.[1] Georges Condominas (1975) similarly described in Buddhist Laos the belief in a hierarchy of *phi* spirits encompassing household, village and state, as a system which had become fused with the official cycle of Buddhist rites and festivals.

Theravada Buddhism

Technically beliefs in spirits and rituals to propitiate them need form no part of Buddhism, which teaches the accumulation of merit through one's own good

[1] The Theravada Buddhism, or "Teaching of the Elders", of Sri Lanka and Burma, Thailand, Laos and Cambodia is distinguished from the Mahayana Buddhism of Nepal, Tibet, China, Korea and Japan.

deeds as the way to ensure good fortune, and Nirvana as the elimination of the suffering inherent in existence outside the endless round of death and rebirth. Yet fieldwork has shown that Buddhist villagers do believe in a variety of good and malicious spirits and the magical efficacy of rituals. Nirvana remains a distant goal for most ordinary Buddhist villagers, who aim to accumulate merit for this life or a better rebirth through meritorious deeds which include offerings to monks and donations to temples. These rituals blend with other protective rituals of a magical type aimed at ensuring health, longevity, prosperity and fertility, which are often associated with the *phi* or spirits (J. Bunnag, 1973; Tambiah, 1968; Terwiel, 1975).

An evolutionist approach would see this animism as the survival of earlier, more primitive forms of nature worship, involving the worship of the sacred *nagas* or serpents associated with water and fertility, which was once widespread in India and Southeast Asia (Kirsch, 1973). Yet for the villager these two systems of Buddhism and beliefs in spirits are not separate, but form part of a single system by which the world is understood. For both the Buddhologist and the historian, then, there is a case for saying that these kinds of beliefs in spirits are not properly speaking an essential part of Buddhism. Yet the anthropologist is struck by their deep importance in the lives of Buddhist villagers, and the impossibility of distinguishing between them.

Gannath Obeyesekere (1968) goes further, arguing that the recourse to astrology, a non-Buddhist system, found in every Buddhist country, must be explained in structural functionalist terms as the result of the psychological indeterminacy of

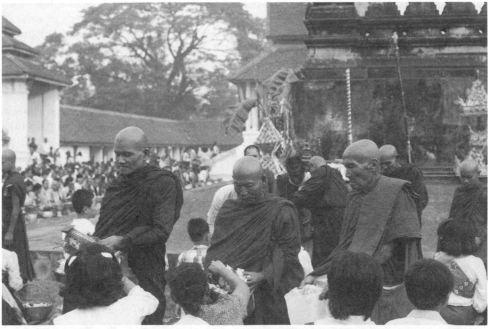

Theravada Buddhist monks in Laos receive offerings from lay followers at the festival of That Luang.
Courtesy of Grant Evans.

the Hindu-Buddhist doctrine of karma. Karma teaches that wholesome deeds bring about wholesome results while unwholesome deeds bring about unwholesome results. Thus it is possible to explain everything which happens to us, whether good or bad, in terms of some deed which was performed previously whether in this life or in a previous one. The doctrine is logically unarguable, and completely determinate in that it can explain any fortune or misfortune. Yet it does not tell us *when* our fortunes will change. As Obeyesekere puts it, "I may be a pauper today, tomorrow a prince. Today I am in perfect health, but tomorrow I may be suddenly struck down by a fatal disease" (*ibid.*: 21). In order to solve this psychological indeterminacy – this anxiety a Buddhist must feel at not knowing when the results of past actions will begin to take fruit – Buddhists need to consult another system, astrology, which is psychologically determinate since it can tell us when fortune or misfortune is likely to occur. Then steps can be taken to minimize or avert future misfortune which are based on quite non-canonical beliefs, such as the belief that it is possible to cancel out the fruits of unwholesome deeds by wholesome deeds (which explains the phenomenon of asceticism in old age found in Theravada Buddhist societies), the belief that special rituals can transfer one's own store of merit to one's parents or ancestors (often given in Thailand as the reason for a young man becoming a monk), or the belief that the last moment of thought of a dying person can influence the form of his next rebirth (which is why sacred texts are chanted around a death-bed). In a similar way, Obeyesekere argues, Mahayana Buddhism altered the emphasis on individual salvation which was crucial to the Buddha's original teachings, in order to introduce the personal cult of the Boddhisattva saviour, the Buddha (Enlightened One) who returns to this world, delaying his own liberation, in order to help those who still suffer, who may pray to him for guidance and protection.

Whether one sees the other system of belief in which Buddhist villagers partake as fulfilling a psychological need not satisfied by official doctrine, or as the survival of a form of "primitive animism" which has become incorporated into Buddhism in the same way as other "world religions" have incorporated elements of previous faiths, it is clear that different interpretations of Buddhism may be held by different kinds of people. In Thailand *reformist monks* such as Phra Buddhadasa and liberal intellectuals such as Sulak Sivaraksa argue strongly for the revival of a "pure" form of Buddhism, devoid of superstition and magical practices. Beliefs associated with the *phi* (spirits) and *khwan* (soul), although widely held by Buddhist villagers, are firmly excluded from the Buddhist framework of beliefs by such thinkers. In many towns in Burma, Thailand, Sri Lanka and even Malaysia, there are small groups of generally middle-class office workers who take part in private meditation classes. It is such people who tend to argue that the animistic Buddhism of the peasants is corrupt and mistaken and who claim access to a purer form of Buddhism through the texts they can read and the meditation they have the leisure to study. This sort of lay middle-class Buddhism, however, is a radically new phenomenon. In the past meditation was the prerogative of a very few long-standing monks, mainly those belonging to the "forest" or *arannavasin* tradition of wandering monks (Mendelson, 1975; Tambiah, 1984). Monks tended to specialize in either practice (*patipatti*) or in theory (*pariyatti*). Theory was mainly equated with book-learning (*ganthadura*), and meditation was but a minor aspect of practice, which also included teaching and moral deeds.

The urban elite Buddhism which is particularly likely to appeal to Westerners on account of its apparent rationality and absence of "cultural" trappings, should be seen as reflecting the rise of a new middle-class elite in Asian countries after the end of the colonial era, and the emergence of modern nation-states in the region (Anderson, 1983). Many of the Buddhist texts which became available to this new elite were those which had been previously translated into European languages by early scholars of the Buddhist and Pali Text Societies and were then translated back into the vernacular. Traditionally these texts were only available to commoners through the few monks who had spent sufficient time in the monasteries in scholarship to be able to read them themselves, since chants and rituals continue to be in the sacred and dead Pali language of ancient India which is not generally understood, and illiteracy was moreover widespread in the past.

While interesting as a social phenomenon in their own right, these claims of urban lay Buddhists to represent a valid, pure form of Buddhism contrast with the

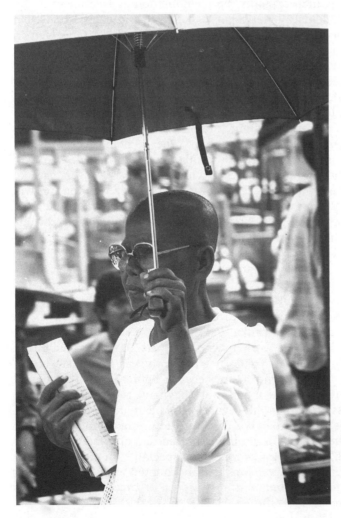

A Thai Buddhist nun.
In orthodox Theravada
Buddhism women are deemed
to have less merit than men
and occupy subordinate roles
in the "sangha".
Courtesy of David M. Hayes.

practices of villagers who freely blend Buddhist and non-Buddhist traditions as they have done for centuries. Periodic reform movements, such as that of King Mongkut in the nineteenth century which led to the founding of a new Order of monks in Thailand, strengthen state control over religion and remove official interpretations, doctrine and ritual further from popular practice. Yet the power of popular religion to express popular aspirations continues, as can be seen in the various messianic and millenarian type movements associated with peasants' rebellions and local holy men throughout the region (see below). Often associated with the idea of Maitreya Buddha, the future Buddha who will bring about a new spiritual and temporal order, these movements can be seen as an expression of popular religious feeling against the domination of the state. Today in Thailand there are estimated to be as many as three thousand unregistered temples and many unorthodox ones, such as Wat Tam Kraboke, where the monks are allowed to work in the fields, and those of the Santi Asoke movement, where women are ordained as nuns. The conflict may be seen as one between culture or society, and official interpretations of religion which seek to control its popular expressions. Village Buddhism is deeply embedded in and inseparable from cultural traditions. Official Buddhism represents the power of the state, in what Keyes (1989a: 59) has called a "Buddhist nationalism".

Modern Buddhists who argue for a closer involvement of Buddhism in solving social problems such as poverty and prostitution, appeal to the historic inseparability of religion and society. And it is true that the monastic tradition of Theravada Buddhism, where monks are forbidden to work for a living in case they accidentally take life, so that they depend on the local village community for their support through daily alms rounds and monthly offerings at the temple (Bunnag, 1973), has historically been much more closely integrated with society than the monastic traditions of other world religions such as Christianity. Monks in Thailand are usually only ordained for one monsoon period of three months, and monasticism is not usually a permanent way of life. Before the advent of modern systems of medicine and education, the local monks were often the only doctors and teachers in the village community, and also took on local legislative and administrative tasks. *Reformist Buddhists*, on the other hand, who wish to detach religion from an involvement in social issues, argue for a view of Buddhism which emphasizes the wisdom of detachment, non-involvement and withdrawal from the world. But this view itself largely derives from text-oriented views of Buddhism of the type advocated by the urban elite, and does not correspond to the historical realities of religious involvement in society.

Millenarianism

The most well-known millenarian movements in Thailand have been the 1900–1902 movement in northeast Thailand and the movement led by Khruba Siwicai in north Thailand in the 1920s against the standardization of ritual and ordination ceremonies (Bunnag, 1967; Keyes, 1977a; Murdoch, 1974; Ishii, 1977; Chatthip, 1984; Tanabe, 1984). Usually such movements have involved the members of deprived social groups and ethnic minorities.

The 1900–1902 movement was preceded by the circulation of palm-leaf manuscripts prophesying an imminent catastrophe and urging people to prepare themselves. According to one manuscript, wax gourds and pumpkins would become elephants and horses, while short-horned water buffalo and swine would turn into cannibal ogres. Then the King of Righteousness would appear as the master of the world. Spinsters should quickly marry lest the ogres devour them, water buffalo and swine should be killed before they became ogres. The guilty should quickly purify themselves (Ishii, 1977).

Syncretic millenarian movements have also been common in the Christian Philippines (Pertierra, 1983), and throughout Chinese history, where they were important in both the Taiping and Boxer Rebellions (Wakeman, 1977). Although syncretic, uniting Buddhist, Taoist and Christian elements, these Chinese movements were also "nativistic" in that they represented attempts to revive or revitalize elements of the original culture (Linton, 1943; Wallace, 1956). Even in 1982 a man was arrested in Hunan province of China who claimed to be the next Emperor of China. Earthquakes, floods and plague would accompany the establishment of his new dynasty. All the evil people would die, and so would half the good. Zhou Yongyi interpreted ancient prophecies to refer to himself, practised faith-healing and said he had a step-father in Hong Kong who had persecuted him unsuccessfully for trying to have sexual relations with his wife. He tried to obtain cheap watches and tape-recorders from Guangzhou to distribute to his followers, who believed that the character *wang* for "king" was written on his forehead and allowed him to take their daughters as concubines. The case was taken by the Chinese authorities as an example of "feudal superstition" (Anagnost, 1985), which we discuss more fully below. In fact, although rarely reported, millenarian movements have periodically occurred in socialist China, often linked with ethnic minorities in extreme conditions of economic hardship. Here we can see how millenarian movements like cargo cults typically involve an attempt to reformulate assumptions of power (Burridge, 1969). Keyes (1977a) notes that where millenarian movements survive long enough, they become new religions. A case in point is the Cao Dai in Vietnam. Like Chinese movements it was a syncretic religion based on Taoism, Buddhism and Christianity, but considered itself to be a higher synthesis of these world religions. In its formative stages in the early twentieth century Cao Dai relied heavily on séances for revelation of truth and guidance for action (Oliver, 1976). It was through these séances that various figures from the Buddhist and Confucian pantheon were contacted, as well as some from the West, such as the French novelist Victor Hugo and Saint Joan of Arc, all of whom became "patron saints" of Cao Dai. The disturbed social conditions of the Mekong Delta of Vietnam favoured the formation of nativistic movements like Cao Dai, and a more directly Buddhist movement, the Hoa Hao (Hue-Tam, 1983; Popkin, 1979), both of which expressed strong anti-French sentiments. The Cao Dai borrowed its organizational structure from the Catholic Church and established a "Pope" in the Great Divine Temple in Tay Ninh. These organizational borrowings were probably the secret of its long-term success. Occasionally outlawed, this movement finally made its peace with the French, and with subsequent Vietnamese governments, including an uneasy truce with the communists after 1975. They are, however, unlike other millenarian movements which have come and gone, now a permanent part of the official southern Vietnamese religious landscape.

Cao Dai priests at Tay Ninh.
Courtesy of David Jenkins.

Chinese Religion

The distinction between folk and official religion is reflected in different ways in other parts of Asia. In China, as Yang (1961) shows, organized institutional religion remained weak since the Song Dynasty (960–1279). The Taoist and Buddhist priesthoods were uncentralized and materially poor; there was no organized lay community as there is in all Theravada Buddhist countries, and they did not sponsor extensive charitable or educational works. This was partly owing to the suppressions of organized religion in China by the Confucian elite and also to the polytheistic tradition of Chinese religion and what Yang (1961:328) calls the dominance of "magical ideas" (which for him means the individualistic, material ends sought by the worshippers). There were no membership requirements to worship at a particular temple; anybody could pray worship or make a vow, at any temple of any faith. The worshipper went to the temple of the divinity he or she believed to be the most efficacious for a particular purpose. There were thus no stable, binding ties between the worshippers and the priests or temples. But the strength and power of Chinese religion has lain in the fact that it was *diffused* and embedded closely in other social institutions such as the family. This is why Chinese folk religion, or the "diffused religion" of China as Yang calls it, has freely blended Taoist, Buddhist and Confucian elements in such a way that it is practically impossible to separate them.

So Wolf (1978), in his analysis of popular Chinese folk religion, prefers to adopt a synchronic viewpoint and distinguish between the worship of gods, ghosts and ancestors. In Taiwan it is customary for traditional families to light three sticks of incense in the morning and evening – one outside the back door for wandering ghosts, one for the Stove God in the kitchen, and one for the ancestors before their tablets in the main hall. Wolf argues that the essential categories of Chinese religion are, therefore, gods, ghosts and ancestors, and that these categories reflect the social landscape of the Chinese.

The relationship of the Stove God to the stove reflects the relationship of the god to the family. When families divide, they separate their kitchens and stoves, and so the Stove God is able to represent the family. The relationship of god to family is a bureaucratic type of relationship, since as the family is seen as the lowest corporate unit in society, so the Stove God is seen as the lowest in the supernatural hierarchy. Each New Year sticky rice is offered to the Stove God so that he will not make a bad report on the family to his superiors; he is something like a policeman reporting on the family to other gods. The prototype of gods is the *Tu Te Kung*, the locality god who has two functions; first, to guard against the *kuei* or wandering ghosts, who are like bandits and strangers; and second, to watch over the local community, so that all births, marriages, deaths and misfortunes in the region should be reported to him. *Ch'eng Huang*, the City God, the immediate superior of *Tu Te Kung* in the heavenly bureaucracy, is like the other gods also depicted as a scholar-official, who makes tours of inspection of the city boundaries three times a year. For most people all gods are seen as bureaucrats, which is why they have limited areas of jurisdiction and tend to be consulted for particular purposes.

The Jade Emperor sits at the pinnacle of the Chinese pantheon.

While everyone is in the same relation to the gods, people are in different relations to the other two main supernatural categories: ancestors and ghosts. Ancestors and ghosts are *relative* categories: "One man's ancestor is another man's ghost" (Wolf, 1978: 146). In the ideal world of the patrilineal Chinese kinship system, everyone would have male descendants, and there would be only two categories of the dead; one's own ancestors, and the ancestors of others. But of course there are people with no descendants. So in fact there is a host of ambiguous souls, and a kind of continuum from ancestors to whom one owes respect to ancestors to whom one owes nothing. Hence the vague category of *kuei* or "ghosts", and the mechanisms of "ghost marriage" which attempt to provide living descendants to these souls. From the normal point of view, then, *shen* (including gods and ancestors) are opposed to *kuei* (ghosts). *Kuei* are like beggars or bullies, feared and despised. They are other peoples' ancestors or the souls of those with no descendants to worship them, the supernatural equivalents of feared strangers. So that there is a three-part division between the gods, reflecting the public realm of the state and the citizen, the ancestors, reflecting the world of the family, and the ghosts reflecting the world of the stranger, who is likely to be a bandit, beggar, or outlaw. Wolf suggests that we can relate this to the fate of the three souls at death in Chinese belief: the soul that stays by the grave is like a stranger; the soul which travels to the Otherworld to be judged is like the citizen of a state; and the soul which stays with the ancestral tablet is like a family relative. As Feuchtwang puts it, the relationship of the god to the worshipper is based on loyalty, like that between the ruler and subject, while the relationship of the ancestor to his descendant is based on respect, like that between father and son; the *kuei* or ghosts are the antithesis of these two structures of political loyalty and filial respect, and peasant grievances were identified in a great elaboration of different kinds of *kuei* and ambivalent figures at the borders between gods and demons, who could become the patrons of secret cults and societies and rebellions (Feuchtwang, 1975).

Feng-shui

To these main structures of Chinese religion should be added the system of *feng-shui* or geomancy practised by the Chinese and some Chinese minorities; a system of divination for the siting of homes and graves, the residences of the living and those of the dead. *Feng-shui* is based on a complicated system of correspondences between time and space, the seasons and years, animal categories, colours and directions first examined by Émile Durkheim and Marcel Mauss (1970) as an example of "primitive classification". Both Feuchtwang (1974) and Freedman (1979) argue for *feng-shui* as a kind of counter to ancestor worship in the Chinese tradition. While ancestor worship provides a focus of ritual unity for the lineage, for example in communal sacrifices performed at ancestral halls or at the graves of ancestors when they are ritually swept at the Qing Ming festival, *feng-shui* mirrors the process of lineage fission by which brothers divide sub-lineages. Since the different siting of an ancestor's grave will benefit different lines of his descendants unequally, *feng-shui* is often the occasion for arguments and conflicts between brothers and different sub-lineages. Indeed, social conflicts between different villages are often expressed in terms of *feng-shui* symbols, as Aijmer (1969) shows for rival villages in Hong Kong.

Freedman argues that *feng-shui* has survived in urban Hong Kong and Singapore, where modern buildings are often sited in accordance with *feng-shui* principles, owing to its essentially non-religious character; that is, that it does not include a belief in spiritual beings who must be propitiated or appeased, but is rather "based on self-evident propositions". Joseph Needham (1954) similarly dismisses *feng-shui* as a "pseudo-science". Here we see how Tylor's definition of religion has continued to be important in modern studies.

But in fact it may be practically impossible to separate beliefs in *feng-shui* from beliefs in supernatural agencies. The placing of a mirror in front of a door may be seen as an attempt to harmonize the "breaths" of the landscape in accordance with the theoretical principles of *feng shui* or it may be seen as an attempt to ward off evil spirits who will be frightened by the sight of their own faces. Again, then as in the case of Theravada Buddhism, a belief in spirits and natural forces and powers can be seen as interpenetrating and interfusing a highly abstract, extremely complex theoretical system.

As we saw above, Yang talks about the dominance of "magical" ideas in Chinese religion. Burckhardt (1982:142) similarly refers to the view that "The Chinese are not religious, only superstitious". What is really being discussed here? Heberer (1989) notes that an "anti-religious attitude" had been common in China since the fourth century, which equated "religion" with "superstition". "Religion" in China was seen as merely one doctrine (*jiao*) among many and the practical realism of the Chinese was antithetical to the kind of "spiritual" concerns supposed to define proper religion. Is not this dismissal of popular religious practice as

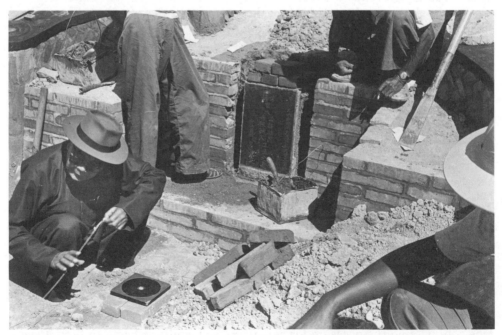

A Chinese geomancer in Hong Kong's New Territories sites a frame for the cleared bones of an ancestor to take advantage of the natural benefits of the site for his descendants – long life, success, wealth and fertility.
Courtesy of Hugh Baker.

"superstition" similar to the attitudes adopted by purist, reformist Theravadin Buddhists towards what they see as the "corrupt" forms of Buddhism practised by rural peasants? Pertierra (1988) shows how indigenous religious practices persist in the Christian Philippines at the domestic level, largely concerned with illness and death. A religious syncretism has emerged, characterized by for example personal ties between Catholic saints and their devotees of a magical nature. Institutionalized religion is associated with the urban areas and high social status. In the countryside, however, Sodusta (1983) documents the inter-mingling of Christian and animistic beliefs in offerings to local spirits and the ancestors.

Magic

Magic in anthropology has generally been seen as an attempt to control or influence action or nature through supernatural means. Its "this-worldly", pragmatic orientation has been contrasted to the "other-worldly", spiritual concerns of true religion. The "pure manipulation relationship" of worshippers and gods in magic, has been opposed to the "pure communion relationship" found in religion (Horton, 1960). Émile Durkheim and Max Weber concurred in seeing magic as a more individual than collective activity, supported by a clientele rather than a "church". Bronislaw Malinowski (1954) stressed the practical nature of magic and its utility in practical action, while Sir James Frazer had seen magic as essentially a fallacious attempt to control the forces of nature, as science was eventually able to do. Thus the Chinese believer visiting the temple of the Four-Faced Buddha for a personal, particular purpose, such as curing barrenness, or the Thai believer wearing an amulet of Acharn Mun, a famous holy forest monk, to protect himself against harm (Tambiah, 1984), are both seen to be performing essentially "magical" kinds of acts, and difficulties have arisen for observers trying to reconcile these types of ritual with types of religion felt somehow to be more truly "religious" in nature, such as a belief in the Law of Karma leading to moral action, or a "pure communion relationship" with the gods.

But approaches to magic have changed in anthropology. While the tendency in the past was to see magic as a failed attempt at scientific thought and practice, and religion as the speculations of a primitive philosopher meditating on the mysteries of dreams and death, as Tylor did, the trend more recently has been to see magic and ritual activity in general as a form of expressive, symbolic activity, more akin to dance or art than to pseudo-scientific logic. It should noted, however, that the Tylorean intellectualist approach has been resurrected in the work of Claude Lévi-Strauss, especially in *The Savage Mind* (1966). Basic principles of symbolism can be seen at work in Frazer's notions of homeopathic and contagious magic (the principle that objects can influence other objects if they resemble each other or have been in contact) and Sir Edward Evans-Pritchard's (1937) now famous example of the Zande who, hurrying home late from work, hangs up a stone in a tree to delay the setting of the sun yet does not stop hurrying for that reason. (Tambiah, 1985). One of Frazer's (1922) examples well illustrates this. Is the Chinese descendant who embroiders the character for longevity on the gown of an aged ancestor really doing so because he believes that by doing so he will ensure a long life for his ancestor (as Frazer thought), or as a symbolic expression of his wish that the ancestor should enjoy a long life? If magic can be seen as an essentially

symbolic, expressive type of social action, as the latter view would suggest, then it cannot be dismissed as irrational, pre-logical or superstitious.

Yet these distinctions between "magic" and "religion" persist, not only in anthropology but also in the religious thought of many of the societies which anthropologists study, as we have seen in the views of the reformist Buddhists in Thailand and the Chinese literati who adopted Confucianism as an ethical creed. Moreover, the distinction between "religion" and "superstition" persists in present-day China, where it is politically most important, as Feuchtwang (1988) observes. While the freedom of religious belief is officially guaranteed under the Constitution, superstition is prohibited. Interpretations of "superstition" can be extremely arbitrarily made by local officials, so that the shamanism of minority people is illegal, while the practices of the world religions receive some official sanction. This distinction between the magical cults of the peasantry and the world religions, although difficult to support theoretically, empirically exists in every society where state formations have co-opted a form of religion in order to legitimate themselves.

In the Chinese case, it may be more important *not* to examine the differences between diffused folk religion and organized institutional religion as Yang does, since as he shows the latter has in recent history never been particularly important, but rather the differences within popular religion between officially sanctioned varieties of religion and those not so sanctioned. James L. Watson, for example, recently (1988) argues that in China orthodoxy was achieved through standardization of *practices* rather than beliefs, so that while marriage and funeral rites and the symbols of different gods were widely standardized and had to be officially approved, interpretations of the symbols and the meanings of rituals varied widely at the local level. Ideas about Ma Tsu, titled Tien Hau, the "Empress of Heaven" varied widely from locality to locality, and between men and women. Women in the New Territories of Hong Kong maintained that she had killed herself in order to avoid marriage and consulted her for fertility and gynaecological problems – quite different from the official versions of the goddess' life, which emphasize her worthy social origins and gloss over the facts of her death. Thus the way in which religion may be integrated with political institutions supporting the state may be quite different from the way it is integrated with other social institutions such as the family, although Yang considers both as examples of "diffused" religion.

Hinduism

While in Theravada Buddhist countries religion was directly co-opted in support of the state, leading to sharp distinctions between national and local forms of religion, and later to the emergence of distinctions between the elite religion of the towns and the folk religion of the countryside, in China attempts were made to standardize and control the power of religion and assert the authority of the state, founded on the cult of Heaven and the Emperor, above it. While in Thailand the power of folk religion must be seen in the context of its relationship with state-sanctioned institutions, in China the power of folk religion flourished largely unchecked by the elite, who dismissed it as the magical superstition of the countryside, and themselves adhered to a Confucian moral ethic. In the Hindu religion of India, however, folk religion dominated state institutions and was

characterized by extreme complexity and diversity. A plethora of divinities, goddesses, and holy men or saints (*saddhu*) has accounted for a diversity of local cults which are largely unchecked by official structures. However, as in the Theravada Buddhist countries, it is necessary to consider the close relation of the religion with the lay community in the village, and in China religion must be seen as embedded in the structures of ancestor worship and the political structures of state-sanctioned deities, so in India the Hindu religion cannot be considered outside the context of the caste system, which is "essentially religious" as Dumont (1980: 270) observed. Here it should be noted that the actual caste system is far more complex than the ideal division into four *varnas* (colours or caste categories) enshrined in classical literature, i.e. *Brahmin* priests, *Kshatriya* warriors and rulers, *Vaisya* farmers (and later merchants), and *Sudra* labourers and craftsmen, and the Untouchables such as barbers, washermen or sweepers. An example of a *jati* might be to be the member of a Lahore Arora, a regional sub-group within the *Khatri jati* of the *Kshatriya varna*. While relatively inflexible in an occupational sense, to some extent the location of sub-castes in relation to each other is relative. Some non-*Khatri* would assign the Arora to the lower, *Vaisya* category, rather than the *Kshatriya*, for example (Berreman, 1972).

Complex rules of purity and pollution on a scale of commensality mark minute distinctions between *jati*. Who you may not eat with and who you may not touch identify those who are considered as members of *jati* superior or inferior to your own. These taboos are very particularly observed, and ideals of purification can be seen as a defining feature of Hindu religion as they also are in Javanese religion. The three "higher" castes are considered to be "twice-born" through a special initiation ritual. The belief in *karma* and retribution, which we have already examined in a Buddhist context, legitimates the whole structure of caste through the notion of *dharma* or "moral duty", and ties it together in what Dumont (1980: 273) has called a "religious organization of society". Orthodox Hinduism is adhered to through daily rites of purification and the sacraments of the life-cycle, the reading of sacred scriptures and visits to temples where *puja* (worship) is performed, through participation in annual festivals and pilgrimages to holy sites. And the local cults of particular deities, which often take the form of the followers of a holy man or *guru* known for his exemplary sanctity or supernatural powers, may provide the sort of psychological consolation which Obeyesekere argues the doctrine of *karma* logically could not provide (although Brahmin priests also act as astrologers). Devotional and ascetic cults in Hinduism may act as a "safety valve" for egalitarian sentiments which cannot be expressed in the caste system, as Ishwaran (1980) and others suggest, but they may also be seen as representing a groundswell of popular religious feeling which becomes routinized in orthodox Hinduism.

Recent anthropological work has shown clearly that not all people share this orthodox thought-structure – that indeed the whole model is largely a Brahmin model of social organization which the lower castes may not accept. Not only may there be disagreement about the relative status of sub-castes, supposedly fixed by karmic law and custom, and a certain amount of upward (as well as downward) mobility within the caste structure itself through the process of Sanskritisation, as deities and customs associated with the higher castes such as vegetarianism and avoidance of alcohol are adopted, but also there may be a refusal to recognize the relative status of the castes at all. Some consider all the

Indian women in front of a Hindu temple.
Courtesy of R. Peter Rorlach.

Sudra jati as Untouchable, and for no one does "Untouchable" include their own caste (Berreman, 1972). Thus Sudra informants may deny that they are at the base of a hierarchical structure, although this is clearly written in the sacred texts of India, and maintain that the model is a kind of ideal fiction, invented by the Brahmins to legitimate their own traditional role at the apex of the structure. The process of Sanskritisation has played on an undercurrent of local religious activity and resulted in a widespread opposition between "Sanskrit" and "village" deities, *gramadevata* (Fuller, 1988). And opposed yet complementary to the Brahmin priest is the figure of the curer-exorcist, who is often drawn from the lower castes (Babb, 1975; Srinivas, 1952) like the *dukun* religious specialist in Java.

It seems that anthropologists had again accepted a largely literate, text-oriented, elite version of philosophical Hindu religion and social organization, and had failed to recognize the power of popular religion and popular conceptions of the world. Dube (1967:88) has described this as "a living faith in spirits, ghosts, demons, witches and magic". As Dumont himself admits, "The Brahmins have been heard, the Untouchables have not". In a very similar way to the attitudes of purist, reformist Buddhists in Theravada Buddhist countries, or the average urban Chinese, the urban Indian may often look down on these popular Hindu practices and dismiss them as ignorance or superstition. Yet the whole modern city of New

Delhi came to a standstill when the holy man, Sai Baba, who reputedly produces jewels and flowers from the air, visited for a few days in 1971. The followers of Nimkroli Baba, in Nainital, North India, will explain to any visitors how their *guru* gained his name from a railway station where a train refused to move without him. The strength of popular religion, which expresses the popular aspiration for deliverance from suffering, contrasts strikingly with the elite conceptions of religion so ironically dubbed the "Great Tradition" by Robert Redfield (1955). While elite versions of religion are important for what they may tell us about the attempts of political authorities to control and harness the power of popular feeling, anthropologists have had to learn to emphasize more popular understandings of religion over and against this. Islam demands a fusion and identity of state with religion of a far more extreme kind than in other Asian religions. Where Islam has not become the national religion, as in Malaysia and Indonesia, it has led to the emergence of politically restive minorities such as the Moro of the Philippines, the Rohingya of Northwest Burma, the Muslims of South Thailand, the Chinese Muslims known as Hui and other powerful Islamic minorities in China such as the Uighur and Kazak (Israeli, 1980). In Java and Malaysia, however, where Islam replaced earlier Hindu-Buddhist states in the fourteenth century, divisions between purist and more liberal, syncretic forms of religion incorporating elements of magic and animism similar to those of the Theravada Buddhist countries have emerged, largely as a result of the nineteenth century Wahhabiya Islamic reform movement which also affected Islam in China. Geertz (1960) has documented how the *slametan*, or religious feast, provides the core of peasant ritual practice in Java, to which Koentjaraningrat (1985) adds the importance of ancestor worship and visiting ancestral graves (cf. Bachtiar, 1985). Endicott (1970) showed how Malaysian magical practices are based on the idea of *semangat* or an all-pervading vital force (cf. Golomb, 1985).

Popular Religion

Popular religion in Asia does conform closely to Tylor's original model of animism, involving a belief in souls and their rebirth, and spirits of the dead, of ancestors, or of natural objects, revealed in dreams, trances and prophecies.

Long ago Paul Mus (1975) had argued that there was an ancient agricultural cult of Asia which gave a special role to the spirit of the soil, a localized spirit manifested in a sacred rock or tree. On ritual occasions the dependence of the community on its territory and the fertility of the soil would be celebrated by rituals identifying this spirit with a temporal authority such as a chief. While Gehan Wijeyewardene (1986) believes such speculations untenable because they are not historically confirmable, they can be seen to exist today at the most essential sub-strata of popular Asian religion. The *phi muang* cults of the Thai and Tai peoples which linked the spirits of the home, the village and the state in a hierarchical structure, emphasize the ritual importance of place in a similar way to the cults of the God and Goddess of the Earth (*Tu Te Kung Tu Te Po*) of China and the worship of sacred rocks and trees survives in the complex associations of the Chinese system of *feng-shui* (Graham, 1967: 117), as "the worship of trees, rivers and mountains" is included with ancestor cults within Hinduism (Srinavas, 1952: 178). The *khwan*

which the Tai believe humans, animals, rice and houses to possess may even derive from the Chinese notion of the *hun* or soul (Anumon Rajadhon, 1962). In Burma, Laos and Cambodia, spirit cults comparable to those of Thailand can be found.

In many places, the spirits of aboriginal people conquered by the majority have been assimilated to the worship of territorial spirits. Thus in North Thailand and Laos the possession cults of *Phu Se Ya Se* (Kraisri, 1967; Archaimbault, 1973), cannibal aboriginal spirits converted by Buddhism, derive from the ancient Mon-Khmer people of the region who were slowly assimilated by the Tai (Condominas, 1990).

It is these spirits which are often the source of cults of spirit possession curing rituals, as also are ancestral spirits. The Northern Thai have preserved or developed a system of matrilineal descent groups (*kok phi*) supported by the worship of ancestral spirits (*phi phunyaa*). Sacrificial offerings are made to them annually and triennially by members of the group at shrines of founding ancestresses after illness, before marriage, and before and after long journeys. They may possess a medium within the lineage in order to communicate their instructions and guidance. The spirits are angered if sexual relations occur in the main sleeping place between a man and a woman who do not live there, and patrilocal marriage is disapproved since it is felt that the matrilineal spirits of an in-marrying daughter-in-law would disagree with those of her husband. The spirits may make their anger felt by causing a member of the lineage to fall ill, and if not properly worshipped will become evil ghosts known as *phi ka* which are transmitted through all members of the lineage, their spouses and descendants. *Phi ka* attack females outside the lineage by possessing them, and must be banished by an exorcist. Today in the urban centres of North Thailand professional groups of predominantly female mediums have emerged, divorced from the structures of the kinship system and often possessed by heroes of the remote past, who cure illness and mental disturbance for their clients through contacting their possessing spirits in trance (Davis, 1973; Turton, 1972; Wijeyewardene, 1977).

Calling the Soul

In its most essential form, popular religion can be found in the animism, shamanism and ancestor worship of many of the ethnic minority people of Asia, largely untouched by the structures of the state.

The Hmong shaman is the physician of the community, whose business is with life rather than death. Only he (or she) can cross without danger the border between this world and the Otherworld, to rescue the souls of those afflicted by disease or misfortune. For evil spirits of the forest (*dab qus*) are believed to have captured their souls, causing disease or persistent misfortune, and if they are not brought back, death will result as the soul will seek to be reborn in another form. The shaman's business is to exchange the souls of sacrificed animals for the souls of the sick which have been captured by spirits. He is himself the master of a special category of helping spirits (*neeb*) which possess him in trance, and ride with him into the Otherworld to help him perform his task.

After the preliminary consultation, which takes place at the shaman's house, the shaman will visit the house of the sick or troubled person. He brings with him his own equipment, which he has inherited from the Master Shaman who initiated

Hmong female Shaman rides off to the other world.
Courtesy of Robert Cooper.

him; a hood to cover his eyes, symbolizing inner vision; a gong which his apprentice will beat loudly as he goes into trance to summon the helping spirits; a sword with which to threaten the demons; bell-rings placed upon his left index finger, an iron rattle which is shaken by the right hand, and a long wooden bench which serves as his "horse" on which he will ride into the Otherworld. His body begins to shake and tremble violently as he goes into trance, calling loudly on all his helping spirits, the Green Woodpecker, the Dragon, Thunder and Lightning, the Heavenly Cavalry and many others The session of chanting may last several hours, and according to his instructions a chicken or pig is sacrificed for the spirits during the session.

The session is a kind of psychodrama involving the whole family during which the patient, who is seated behind the shaman throughout the proceedings, becomes the focus of attention and concern. As Lemoine (1986) observed, the shaman acts like a modern psychotherapist in first identifying, then retrieving, the absent or lost parts of the self, divided by shamans into five entities; the chicken soul, the bamboo soul, the bull, the reindeer and the shadow souls. The division of the self into animal, vegetable and images of the human, parallels the division of the Hmong natural world.

The souls of the living like to wander and play, and if they wander too far they may get lost or be unable to return or be trapped by an evil spirit. This is particularly true of the weak souls of children. Souls leave the body during dreams or after a shock as well as in sickness. This is why the most common ritual in any Hmong village for ordinary sickness is the *hu plig* or soul-calling ritual which can be performed by any head of household for a sick member of his family. In

Theravada Buddhist Thailand, the *suukhwan* or soul-calling rituals performed at pregnancy and marriage, before entering the monastery or going into retreat, and after a long journey or illness, as well as for the newly harvested rice, performs the same role.

At the Thai wedding ceremony a *suukhwan* ritual may be performed to call the souls of the bride and bridegroom. The ritual officiant is a village elder who may be addressed by the title of a Hindu Brahmin priest. During the ritual a long cord is stretched from the ritual offering through the hands of all those present, including the bride and bridegroom. A candle is lit, and the officiant summons the *thewadaa* (angels) to help call the souls of the couple. The elder sprinkles lustral water on the couple, and all those present join in binding the wrists of the bride and bridegroom with pieces of white thread. It is this thread which symbolizes the binding of the *khwan* to the body (Tambiah, 1968). The ritual officiant is often himself an ex-monk who may also take part in *phi* or spirit rituals. Cantonese mothers similarly attribute most children's illnesses to the loss of their souls, which can be retrieved by a medium (Potter, 1978).

From such brief examples it can be seen how an earlier generation of anthropologists, influenced by Tylor and others, came to believe in the widespread nature of "primitive animism". A century of sophisticated theory has grappled with the distinctions between magic and religion and definitions of religion with no real success. In the attempt historical explanations have been ignored and sophisticated and detailed studies made of the function of religion in different societies in Asia. Yet the emphasis on institutional religion, and its differences from "folk" religion, has tended to downplay the importance and power of popular religions and popular religiosity. It is this dynamic power which is expressed in the continuing emergence of local saints, millennial-type rebellions, secret societies and cults. And they appeal to the basic sub-stratum of popular religious belief; that is, that there is an essence in things which can be controlled and manipulated to help or harm the affairs of men and women. Indeed, it may be in magic that religion finds its fullest and most clear expression.

Future Studies

Durkheim's clear-cut opposition between the sacred and the profane has been argued against by many anthropologists but notions of the sacred continue to be important in religious anthropology. Stirrat (1984) has recently argued that there are two models of the sacred effectively used in anthropology; a socially derived sacred, closely reflecting the structure of society as the Chinese otherworld can be seen to do, which is a Durkheimian or time-bound model; and a model of the sacred which is outside time and eternal and in no way reflects social reality, the model of the sacred used by Mircea Eliade (1954). The Buddhist conception of Nirvana, or the Hindu notion of *Moksha* or Liberation from the cycle of birth and rebirth (*samsara*), provide examples of what Stirrat calls the "Eliadean sacred". He adds that there may be a third model of the sacred as liminal and marginal, a model deriving from Arnold Van Gennep's analysis of rites of passage (1960) and the work of Mary Douglas (1966) and Victor Turner (1969). The importance of renunciation of the world and society found in the Sivaite Hindu ascetics

(*sannyasin*) who follow the path of *jnana* or knowledge as opposed to the paths of either *bhakti* (devotion) or *karma*, (moral) action in the world, and found in an attenuated form in the forest traditions of monastic Buddhism in Thailand and Burma, may be seen as illustrating a notion of the sacred which is believed to be beyond time and unconditioned by society or the world. Yet too sharp distinctions between the sacred and profane may obscure the extent to which religion is involved in social action. As Stirrat notes, these distinctions between a timeless and a timebound sacred tend to be elided in "supershrines", the great pilgrimage centres of the world religions. Moreover, there have been serious debates about the extent to which it is heuristically possible to distinguish ritual from practical types of action, as a rigid distinction between sacred and profane would seem to require.

Maurice Bloch (1977), however, deals with the problem of time rather differently from Stirrat. Taking Clifford Geertz's (1973) description of the Balinese as having a static, non-durational notion of time based on their use of a permutational calendar according to which ritual dates are fixed by a combination of their places in a five-day, a six-day and a seven-day week, Bloch argues that the Balinese also have a practical conception of time which they use for practical affairs, which is much like our own pragmatic notions of time. The reason Geertz believed the Balinese had a distinctive idea of time, Bloch suggests, is that Geertz concentrated on their ritual activities rather than their *practical* activities and the reason that anthro-pologists have so often come up with models of knowledge which are socially determined (as Durkheim did) is because of their over-emphasis on highly formalized, ritual types of behavior which reflect and support the social structure.

In any society, Bloch argues, there may be *two* systems of knowledge; one dealing with ritual action, which is socially determined and reflects the nature of that society, and one which has to do with practical affairs, which is constrained by nature rather than by the structure of the social system, and where a real knowledge of the world, of a scientific rather than an ideological type, becomes possible. So Bloch too utilizes the distinction between ritual and practical affairs to deny the relativity of knowledge, affirming that there are distinctions still to be made between "science" and "ideology". Yet one may ask whether this theory of 'dual consciousness' does not mirror old-fashioned distinctions between the sacred and profane which have been found to be untenable in many studies of religion in the Asian region?

Belief systems can hardly be seen as uniform or homogenous any longer. Varying interpretations of the Chinese Goddess of Heaven, arguments between reformist and modern Buddhists in Thailand, and dissensions from the orthodox Brahmin model of Hindu society, all illustrate the extent to which it is no longer possible to depict "belief systems" as monolithic or cohesive. It was Edmund Leach (1970) who first described ritual beliefs as a "language of argument" rather than a "chorus of harmony". Future work has therefore to concentrate on the extent to which dissensus can be maintained within a single system, the struggle between variant discourses and how the domination of certain ideas is achieved and maintained (Gates and Weller, 1987; Bell, 1989). Here issues of gender, as well as those of class and other variables, are likely to prove particularly important. Current preoccupations with textuality should not lead us to overlook the need to specify the precise nature of the relationship between text-oriented traditions of knowledge and popular practices and beliefs in particular situations.

For the Buddhist villager, Buddhic and non-Buddhic rites are part of a single system. To stress the discrepancies between Sanskritic and non-Sanskritic elements in Hindu religion may also lead one to overlook their structural continuities (Das, 1977; Pocock, 1973; Dumont, 1980; Babb, 1975). What is needed, therefore, is to understand how textual and non-textual elements combine in popular practice; what is actually done and believed, rather than what should be done or believed.

12 PEOPLE IN CITIES

Anthropology in Urban Asia

Patrick Guinness

The twentieth century has witnessed a remarkable shift of population from rural to urban centres. In 1920, 20 percent of the world's population resided in cities. By 2000 that figure will reach over 50 percent. Anthropologists have followed this development with interest, although their long accepted area of interest has been small scale rural societies. In the 1950s anthropologists in Africa traced the movement of rural migrants in search of industrial employment into the towns of southern Africa, and there analysed the persistence of kin and ethnic loyalties. Later anthropological research broadened its sights to almost every facet of urban life and culture. The questions to be asked of urban anthropology are how it extends our knowledge of urban life and culture, and what contributions it makes to anthropological theory and practice.

A major debate in urban anthropology has centred on what should constitute the focus of its enquiry. On the one hand scholars such as Richard Fox (1977) emphasize the holistic approach in relation to studies of urban society, focusing on the roles that cities as wholes play in the wider state society. On the other hand many anthropologists who have worked in the cities have regarded the city as not much more than a locale for their studies, and have concentrated rather on the diversity of behaviour and social groups found there, the way of life of marginalised people such as the poor, squatters, or ethnic communities, or the adaptations that rural migrants make when they settle in the cities. This chapter will reflect on both these approaches.

Cities and towns are defined both by demographic features and economic and political functions. They are concentrations of population that stand out among the surrounding rural hinterlands, distinguished both by larger number and greater densities of people. They are also the nodes of economic and political activity and organization within the surrounding region, and as such contain the offices, the religious centres, or the market places necessary for those roles. What differentiates a town, city, or megalopolis may depend on the whim of demographers or national statisticians, but there is a hierarchy of urban settlements in regard to their function in the economic, political and even ritual life of the state. I will not attempt to make a precise distinction here, but will indicate at various points where towns and cities perform different roles and are marked by different social and cultural patterns. The most extreme example is that of the primate cities of Southeast Asia, which in terms of administrative function, infrastructural sophistication, industrial concentration and sheer population tower over all other urban centres in the respective nations.

Anthropology is a discipline that concentrates on cross-cultural comparison, and that is no less true of urban anthropology. This paper will examine the urban societies of the region somewhat arbitrarily called Asia. Urbanization in Asia in the twentieth century has not reached the same levels as elsewhere in the world, though Asia contains some of the world's largest cities (Tokyo, Shanghai, Calcutta, Bombay). By 2000 a projected 27 percent of Asian population (31 percent in East Asia, 24 percent in South Asia) will reside in cities of over 100,000 population. In 1920 that figure was a bare 3 percent (Armstrong and McGee, 1985: 7). However in the year 2000 that urban population will total 970 million people or 43 percent of the world's projected urban population. The challenge for the urban anthropologist is to chart the commonalities and diversities of these urban concentrations, and to understand the complexity of urban social organization and culture.

Pre-capitalist Urban Society in Asia

Although figures from 1920 suggest that Asia's urban population was historically small, many of its cities have a long history. Excavations have revealed the existence of two highly developed cities along the Indus river in present-day India and Pakistan that were centres of a regional civilization beginning about 2500 B.C. (Spates and Macionis, 1982: 171). Each had a population as high as 40,000, and in Moehnjo-Daro housing was organized in a grid-pattern with a remarkable system of brick-lined open sewers. In China perhaps the earliest city was Po, the capital of the Shang Dynasty about 2000 B.C. Later Shang capitals such as Cheng-chou and An-yang were cities enclosed by rectangular walls some miles in length and ten metres high. The administrative and ceremonial centres were contained within the walls, while artisans lived in unwalled quarters outside (Spates and Macionis, 1982: 172). In Southeast Asia urban settlements existed as far back as the records allow us to trace (Reid, 1980: 235). Early trade centres were already established in the first century A.D. (McGee, 1967: 29). In the early centuries A.D. Vyadhapura and Oc-Eo were cities of the powerful kingdom of Funan on the Mekong river, Hmawza (Prome) capital of the Pyu kingdom in the Irrawaddy valley, and Indrapura and Vijaya cities of the Kingdom of Champa on the central coast of present day Vietnam (Kirk, 1990: 18–20). In Japan a series of provincial capitals were established by ruling elites, protected by warrior castes, in the eighth century A.D. These capitals were weakly linked to an emperor living in the capital city of Kyoto (Yazaki, 1973: 141–2).

The cities of Asia in the centuries before contact with the western world were not of a single type, but differed as to the nature of the state in which they were located. Fox (1977) suggests that they can be broadly classified into three types according to the role which these urban settlements performed, as ritual, administrative, or mercantile centres. The ritual centres were particularly characteristic of Indianized kingdoms in South Asia and Southeast Asia. Fox (1977: 50) reports the presence of Rajput forts in many parts of north India before British conquest. These "regal-ritual cities of the Rajput chiefs were physically overgrown villages with the addition of important functions relating to the maintenance of the chief's prestige and power. They were usually small (from several hundred

to ten thousand people) and functionally simple....Rajput chiefly settlements were the ideological and physical centers of lineage independence." In Southeast Asia these regal-ritual centres were of complex design, constructed to symbolize a sacred cosmography, focused on Mount Meru, the centre of the cosmos. Such were the temple cities of Vijaya, Pagan and Angkor. Their construction made huge demands on the labour and wealth of the state, in agricultural surplus, skilled and unskilled labour and administration. They symbolized the ritual pre-eminence of the ruler, often conceived as a God-King, and hosted the sacred ceremonials thought to guarantee the welfare and security of the whole state. The influence of these sacred centres and their rulers was strongest in the region immediately surrounding the sacred city. In more remote areas minor chiefs replicated the rituals and settlement pattern of the sacred centre, and could in time attain sacred pre-eminence for themselves and their capitals. Geertz (1980) likened these ritual centres in Bali to theatre states. The pomp and ceremony gave form and purpose to the state, for the status of the ruler and the unity of his realm was expressed in ritual. *Negara / negeri* meant both state and city, palace and realm (Geertz, 1980: 4; Reid, 1980: 240).

In China, Beijing under Emperor Yung Lo was designed as a symbol of everything vital to Chinese life. Between 1404 and 1420 the city was rebuilt as cities within cities, arranged on a perfect north-south axis. The "Forbidden City" of the Emperor was the centre of this construction, enclosed within the Imperial city, itself centrally located in the Tartar or Inner City, each "city" surrounded by defensive walls and/ or moats. Most of the city's population lived without the wall in the Outer City or Chinese city. In its depiction of elaborate Chinese cosmology Beijing was a

Temple of Heaven, Forbidden City, Beijing.
Courtesy of Jennifer Nason Davis.

symbolic world, a whole city built upon the cultural themes of harmony with nature, security and power, and centred on the omnipotent emperor. Surrounding the city were the Altar to the Sun on the east, the Altar to the Moon on the west, and the Temple of Agriculture and the Temple of Heaven in the south (Spates and Macionis, 1982: 134–9).

These regal-ritual cities also carried out administrative functions, but these were of secondary importance. However there was another type of Asian urban settlement characterized as the administrative centre, such as the Chinese garrison towns and the castle towns of Tokugawa Japan. Tokugawa Japan (1600–1858) witnessed one of the most rapid and large-scale periods of urban growth known in the pre-industrial world. Large castle towns in Japan evolved through a general political centralization and pacification under the *Shogun*, who stood atop the power pyramid and directly administered one-quarter of the country from his capital Edo. By 1700 Edo numbered nearly one million inhabitants and ten per cent of the Japanese population lived in cities of over ten thousand people (Yazaki, 1968: 134). The castle towns of the Tokugawa military elite dominated the countryside and acted as centres of power, commerce and administration. The town's prosperity was promoted through the impoverishment of the rural countryside. Inside the town the *samurai* military elite lived in comfort within the central area, while artisans, merchants and the mass of the urban poor lived in the remainder of the city. Social distinctions were rigidly enforced.

The third type of pre-industrial urban settlement was the port-town or mercantile centre. These sprang up throughout Asia from earliest times, predominantly along the coasts, or the deltas of strategic rivers. Their orientation was to the sea, and in some areas of the Malay Peninsula they had virtually no population in their hinterland. This however did not impede their growth into major trading centres of the region. Reid (1980: 238) points out that with populations numbering between 50,000 and 100,000 Southeast Asian cities such as Melaka, Ayutthaya and Demak in the early sixteenth century and Aceh, Makasar, Surabaya and Banten in the seventeenth were larger than most of the European cities of the same periods. Because so much of the hinterland was unoccupied jungle "Southeast Asia in this period must have been one of the most urbanized areas in the world" (Reid, 1980: 239). The trading towns were dominated by the merchants, who were frequently alien to the area. Thus these towns, more than the others, were characterized by ethnic diversity, and residential segregation into ethnic quarters. They were also marked by wealth differentiation and occupational specialization.

The Impact of Colonialism and Capitalism

From the fifteenth century the sudden interest of the European world in the wealth of the "East" spelled radical changes to the structure and independence of the Asian states, and consequently their urban settlements. At first European interest was in mercantile activities. Dutch control of Indonesia was through a trading company, the Dutch East India Company (VOC), which monopolized the export of nutmeg and other spices from the "East Indies". In China the British purchase of silk was made through trafficking in opium, enforced by military power. Trading activities were conducted and controlled from the towns. Hong

Kong was founded as a base from which British traders exchanged opium for Chinese silk and tea. Elsewhere existing trading ports such as Melaka in the Malay Peninsula were taken over. Control of established port cities and the founding of new ones to channel this trade were essential. Calcutta and Bombay and Madras in India, Batavia (Jakarta) in the Netherlands East Indies, Manila in the Philippines, Singapore, and Hong Kong on the Chinese mainland were all the creation of European mercantile interests. Those interests were inseparable from political control, such that the port towns frequently became the colonial capitals, replacing inland regal-ritual and administrative centres. Political control was centralized to a degree rarely experienced before, backed up by the military and naval might of the colonial powers. A colonial bureaucracy, dominated by Europeans but often employing alien and indigenous Asians as well, joined the merchants in the expanding port capitals. These colonial trading outposts represented the first wave of colonialism in Asia. A second and stronger wave came with the industrial revolution in Europe in the nineteenth century, which drove European manufacturers to guarantee supplies of raw materials from Asia through the establishment of mines and plantations. These emerging industrial concerns required sophisticated financial, transportation and administrative networks centred on the major colonial cities.

A second major impact of the European mercantile and colonial expansion in Southeast Asia was the increased migration of Chinese and Indians. Although Chinese were already present in the pre-colonial towns of Southeast Asia, and in fact had dominated the Annam region of present-day Vietnam for centuries, the European colonial powers encouraged the migration of Indians and Chinese as both merchants and labour force. In the Malay Peninsula the tin mines were worked by Chinese, while the rubber plantations that were developed by British interests early in the twentieth century were worked by both Indian and Chinese migrant labour. This introduced concentrations of alien Asians into the hinterland of Malaya who formed the nuclei of new towns. Ipoh and Kuala Lumpur developed from Chinese settlements of tin miners and shopkeepers. During the Emergency in Malaya from 1948 to 1957 the British administration accentuated the identification of Chinese (and Indians) with urban settlements by resettling hundreds of thousands of these "alien" Asians in rural towns called "new villages" (Sandhu, 1964). Colonial policies thus confirmed ethnic segregation within the urban settlements of Asia. The Europeans themselves inhabited prestigious and well-serviced suburbs in prime locations in the various capitals, and encouraged Chinese, Arabs and various other ethnic groups to live in distinct neighbourhoods of the major cities or smaller towns. This promoted a "plural society" (Furnivall, 1944) in which different ethnic groups lived within the same city without sharing a common lifestyle or set of cultural priorities.

On the other hand the colonial powers did not encourage manufacturing activities in their Asian territories. Apart from mining and the initial processing of primary products ready for export, manufacturing activities were developed instead in the European "home" countries. Indigenous craft manufacture continued, but even this was threatened by the import of European manufactured goods. In India home production of textiles was decimated by the import of British cloth and the excessive duties on Indian cloth imported to Britain. In the cities of Asia the colonial regimes encouraged the alien Asian population to specialize in commerce and the indigenous inhabitants to restrict themselves to providing services.

Provincial and small towns were largely ignored under the colonial expansion. In Java, where colonial governments developed highly efficient plantation crops, such as tobacco and sugar, with processing mills to service them, adjacent small towns were bypassed by these industrial developments (Elson, 1984). The major colonial urban expansion took place in the metropolises of the colonies, where merchant offices and banks, and government headquarters were established. These metropolitan towns became the hub of road and rail transport networks, and the focus for the development of other urban infrastructure.

Post-colonial Society of Contemporary Asian Cities and Towns

Most of the anthropological studies of Asian urban society have focused on contemporary cities. But the depiction of the structure and roles of such cities must take account of the historical context in which these urban societies developed. The colonial period saw the growth of rigidly stratified, ethnically segmented populations in the major cities, with a major division between capitalist and non-capitalist sectors of the economy. Similarly there were major differences between the large capital cities and the provincial small towns. In some countries this became so marked that these capital cities were called primate cities. In Thailand, itself never a colony but still strongly influenced in its economic development by Western capitalist interests, Bangkok was ten times larger than the next largest town. Manila similarly dominated the urban population of the Philippines.

The massive capital expenditure in the major cities that had characterized the colonial period was continued after Independence. Political independence was not accompanied immediately by economic independence, as the new nations continued to invite the investment of foreign, mainly Western, capital. Much of this capital was attracted into manufacturing activities situated in and around the major centres where the infrastructure of housing, transport and energy was already available. Desperate to retain and increase foreign investment governments guaranteed not only cheap land and facilities, but also a cheap labour force to work for foreign investors. These major centres became the employment centres for an industrial workforce increasingly attracted from the rural hinterland. Factory work was attractive because it offered regular, if not high, wages, often in air-conditioned premises, with opportunities for leisure activities and socialising. The major cities were seen as the locale of other lucrative employment, as public servants, or providers of services to the public or capitalist sectors. The attraction of the major cities was heightened by the educational institutes located there. With population pressures in the countryside reducing farming opportunities for many, villagers were attracted into the cities. Whereas the population increase in colonial cities was marked by migrations of alien Asians, the Independence period was marked by the rural-urban migration of an indigenous population. Migration made an increasingly important contribution to urban growth. Between 1960 and 1980 Asia's urban population increased from 183 million to 435 million, more than doubling in the period. Much of this was due to migration. In Indonesia between

1961 and 1971, 32 percent of the 6.8 million increase in the urban population was due to net migration, while between 1971 and 1980 net migration's contribution to a much larger increase of 9.6 million had risen to 52 percent (Hugo, 1987).

The exceptions to this trend were the socialist countries in Asia, where urban-rural economic differences were a source of major concern to governments. China under Mao Zedong emphasized rural development and encouraged the movement of urban youth back to rural areas. A 1954 government policy prevented large-scale urban movement by insisting on official approval for any move away from an established residence and workplace unit. Even after the economic reforms of 1978 and 1984, with their focus on urban industrial development, the Chinese government "retained restrictions on labour migration [into the cities] and an intention to contain large-city growth" (Forbes and Thrift, 1987: 15). The de-urbanization process was most extreme in Cambodia where most of Phnom Penh's population of 2.5 million was driven, partly for reasons of political control, out of the city to work on rehabilitating rural infrastructure and rejuvenating the rural economy. Both Chinese and the post-1975 Vietnamese governments adopted deurbanization policies aimed at converting large "consumer" cities to "producer" cities, but with limited success. After an initial drop, the population of Ho Chi Minh City in 1984 had returned to its 1975 proportion of the total population (Forbes and Thrift, 1987: 10–15). On the other hand Hanoi gained in population as reconstruction was implemented (McTaggart, 1988: 55–7).

The Anthropology of Urban Asia

Anthropological studies of urban Asia can be distinguished on the basis of whether they present a holistic account of the city or town, including its relation to the wider state, or portray segments of those urban societies and cultures. Among the former Clifford Geertz (1963, 1965) analysed the social structures of Javanese and Balinese towns, and the roles of Javanese Islamic merchants and Hindu nobility in promoting economic development. He described the pre-1930s Javanese town as hollow, "a composite of self contained status communities was regional and interurban, not local and intra urban" (1965: 4). He identified three sectors in the town, the bureaucracy characterized by aristocratic Javanese court culture and Dutch colonial practices, the market sector in which women, pious Muslims and Chinese were particularly active, and the *kampung* sector focused on wage labour and a culture reminiscent of village Java. Following Indonesian independence the town, according to Geertz, became more responsive to its agricultural hinterland and to religio-political currents sweeping the nation, becoming in the process more "solid". Geertz thus presented an analysis of a whole town set within the context of national history and politics.

Other more recent studies have also attempted to portray the whole town or urban area. Robinson (1986) focused on the development of a nickel mining town in Sulawesi, Indonesia, in which a highly stratified and ethnically divided society was created by company and government policies. While expatriates and Indonesians from the national capital occupied the higher echelons of the company hierarchy and the most prestigious of company housing, the indigenous residents became mere "stepchildren" of the developments, accorded few opportunities or privileges.

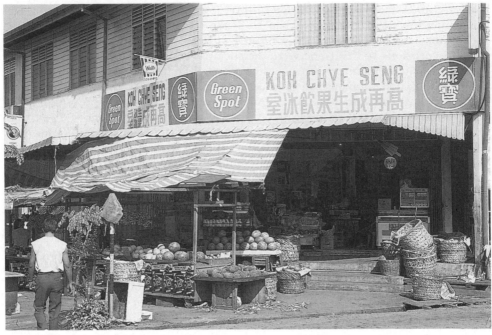

A Chinese shophouse with fruitstalls outside in Johor, Malaysia.
Courtesy of Patrick Guinness.

Along these lines, Strauch (1981b) focused on a small town in Malaysia and noted the impact of national policies on a population of ethnically diverse Chinese. A study in Mukim Plentong, Malaysia (Guinness, 1991) focused on a subdistrict, rapidly urbanizing as a result of the development of an industrial estate and international port on the diverse ethnic groups in the area. Government discrimination in favour of the Malays and capitalist emphasis on status discrimination in both workplace and residential estates contributed to a starker division of the subdistrict into categories based on race and class.

An emphasis on city culture is reflected in Hildred Geertz's (1963) succinct account of the Indonesian metropolitan superculture that permeated from the national capital to provincial cities through a national middle class of public servants. It was characterized by the use of the Indonesian national language, interest in national literature, popular music, films and political writings, and its proponents enjoyed higher education, travel abroad, and Western luxury goods. Siegel (1986) reflected on the interface of national and regional cultures in the city of Surakarta in central Java. Keyes (1977b: 282) also focused on the national ideology that is disseminated through television and education from the capital cities of Asian nations. Fox (1977), following Redfield and Singer (1954), characterized these as the orthogenetic and heterogenetic cultural functions of cities, whereby an urban elite crystallises and disseminates to the nation a national culture. Koentjaraningrat (1985) chose in his depiction of Javanese urban culture to concentrate almost entirely on the *priyayi* class of nobility and bureaucrats. The *priyayi* culture, he states, dominates the urban sector of Javanese life.

Such analyses of towns or cities as a whole have stimulated anthropologists to think in terms of the nation state and to place urban society as a meeting point of national and subnational cultures and organization. Their weakness, however, has been in their skimming over of so much of the complexity of city life, a neglect that results in superficial analyses of the groups or communities that comprise the city.

People Within Cities

In juxtaposition to this approach, the ethnographies of people within cities are in danger of losing sight of the wider city or nation, and the impact of this wider economy, polity and culture on the lives of specific communities. The study of the whole city, sometimes comprising several million people, is itself a daunting proposition for anthropological methods. The study of smaller sections of the city population and their relationships to the wider city can therefore present at least one side of the multifaceted urban reality. Hannerz (1980) suggested various domains by which anthropologists can document city life – kinship and household, neighbouring, provisioning (or production), leisure (including voluntary associations) and traffic (ephemeral or street contact). These provide a useful format for examining the anthropological accounts of life in Asian cities.

Kinship and Household

The migration of rural villagers to the city has been a major focus of anthropological studies. While sociological insights from Western societies suggested kinship links would decline once migrants settled in the city, anthropologists have demonstrated the continuing vitality of urban people's links with rural communities. Eames (1967) and Rowe (1973) showed how migrants to Indian cities continued to support, and remain integral members of, joint families based in the village, principally through remittances from the city worker and support for his nuclear family still resident in the village. Phongpaichit (1982) described how young women from large poor rural families in the north of Thailand migrated to Bangkok to become masseuses and prostitutes. They remitted their earnings, far in excess of rural incomes, back to their families who used them to construct or renovate homes, or install electricity or wells, or assist in the education of their siblings. Some villages became well-known in the city as the providers of the most beautiful "girls", and as a result benefited enormously from their city earnings.

In Yogyakarta labourers in a small-scale brick-crushing enterprise were all recruited from a single village in the barren Gunung Kidul area. Labourers returned at intervals to their families in the village, carrying their own and their friends' earnings as much-needed supplement to village earnings. While they saw to harvesting or house-construction at home, they sent a replacement to the Yogyakarta enterprise, thus strengthening the village link with that enterprise. Remittances from the city were sent with any of their fellow-workers who happened to return to the village.

Not only do migrants retain ties with home villages and kin, but they also form groups within the city that are based on ties of origin, kinship or ethnicity.

Migrants frequently move to cities where they have kin or village-mates, who supply an introduction to city ways. Pinches (1987) described the residential concentration of Visayan people in a Manila slum. Many of these were kinsmen. Incoming migrants from the Visayas were frequently found employment by fellow migrants who had preceded them to the city. Jellinek (1978, 1991) describes how street ice-cream vendors acquired skills and equipment from a former village-mate, who acted as host and patron to them on first arrival in Jakarta, accomodating them in *pondok* "barracks".

Kin ties with other migrants in the city may be maintained despite their being forced to live long distances apart in the hurly-burly of the city. Bruner (1961) demonstrated the strength of Batak ethnic associations within Indonesian cities. As a distinct minority in the cities of Medan, Jakarta or Bandung they continued with cultural practices based on homeland clan and village identity. Similarly Persoon (1987) points out how important ethnic identity and ethnic relations are to Minangkabau survival in Jakarta. In my research among residents in off-street neighbourhoods (*kampung*) extensive kinship ties persisted, often cemented by joint ownership of city land. Urban neighbourhoods were bound together not just by neighbourhood associations but by real and fictive kinship ties (Guinness, 1986). However, contrary to these accounts, Basham (1978: 116) noted the decline of the significance of extended kin in urban Japan and the assumption of many extended family functions by employers. He concluded that changes in Asian families with the spread of urban life styles are intimately connected with the peculiarities of each cultural tradition.

In a perceptive study Tania Li (1989) described the contrasting cultural practices of Chinese and Malay households in Singapore. She noted how relations between family members within Malay households are characterized by voluntary gifts of affection, care or material resources, while in Chinese households and families they are marked more by obligations. This leads to more successful corporate ventures among the Chinese and provides a basis for entrepreneurial success. However Li is equally adamant that ethnic differences among Malays and Chinese in Singapore are structured by education and work opportunities, government policy and an ideology promoted by both Malay and Chinese elites.

After research in Penang, Singapore and Hong Kong, Anderson (1972) explained how traditional Chinese households coped with crowding within the home. Large numbers of persons per household are desired by traditional Chinese, as a small household is a sign of poverty and misfortune. He suggested that specific social codes make such crowding bearable, even pleasant. Space is allocated so that different rooms serve very different functions. Bedrooms, for example, are inviolate and outsiders are not even supposed to look into them. Time management is loose and flexible. Noise is a sign of life and action, rather than a problem; status and respect management is straightforward, with women giving way to men, and young people to the old; and discipline of children is a shared expectation. A Chinese household, Anderson claims, is a relaxed place.

The Overseas (or *Nanyang*) Chinese constitute a large and important ethnic "community" in Southeast Asian urban society. Chinatowns as segregated areas were the creation of colonial administration, although Jackson (1975: 47) notes the "persistent desire of the Chinese overseas to live among members of their own kind". Although generally viewed as a homogeneous group by the wider society, the Chinese were distinguished by regional and cultural loyalties. These formed

the basis of the myriad secret societies and voluntary associations for which overseas Chinese are renowned (Siaw, 1981). Jackson (1975) also draws attention to the contrast between the poor localized Chinatown residents and the more secularized middle and upper class Chinese spread through the suburbs. Chinatown residents, most of them in shophouse trade or service businesses, frequently are only tenants in property owned by the more wealthy suburban Chinese. Business relationships are always personal relationships among Chinatown entrepreneurs, and workers generally belong to the proprietor's family. In larger businesses, such as the truck transport industry, co-proprietors are frequently linked by kinship ties, while their workers are non-kin, and strong class divisions pertain (Nonini, 1983). However the fact that the minority Chinese were treated as a distinct group, privileged under colonial regimes, contained under independent governments, led them to consolidate business and community links exclusive to Chinese and to concentrate on commerce when other avenues of employment, such as the public service, were denied them.

The Chinese "community" is seen as a problem in some of the Southeast Asian countries, because of their exclusivity and their apparent economic success. In Malaysia and Indonesia those Chinese who assimilated to some degree (in marriage, language or religion) to the dominant culture were distinguished by separate terms, *baba* and *peranakan*, although not regarded as part of the cultural majority. Only in Thailand, where King Chulalongkorn insisted on the "Thaification" of the Chinese, have they become accepted as members of the dominant Thai society. Most Thai-Chinese have given up even such traditional Chinese customs as the keeping of an ancestral altar (Basham, 1978:249; Skinner, 1958).

Neighbouring

A debate similar to that over the informal sector has raged over the place of indigenous housing, slums and squatments, that is informal sector housing, in Asian cities. During the 1960s government policy was antagonisic towards the spreading mass of dense, low-cost, unregulated and unserviced housing within the city. It was seen as a health-risk, as a den of criminals, as unsightly, particularly to the desired overseas tourists and business people, and as a potential political threat to established governments. Anthropologists and other social scientists took up the challenge of addressing these prejudices of government and city elites. One of their conclusions was again in terms of the inter-dependence of formal and informal sectors in urban housing. Slum and squatter settlements provided much of the housing for the city's low wage-earners, and at a price and in a location that made it possible for them to survive at the level of wages paid in formal sector employment. It was simply impossible for city governments to construct public housing for such large numbers, particularly without imposing substantial extra transportation costs on wage earners. In addition it was questionable whether such settlements could be viewed as breeding grounds for city criminals, or national revolutionaries. Although some criminal elements were based in these low-cost settlements, and there were occasional vehement protests from their residents directed at national and city authorities the slum and squatter areas were not centres of political dissent (Laquian, 1979, 1980; Basham, 1978: 184; Cohen, 1985). Strong community traditions and neighbourhood alliances provided a sense of

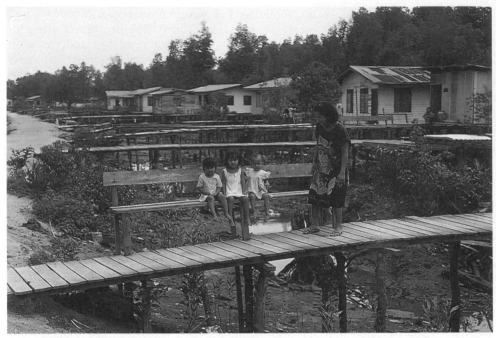

Squatter houses over tidal swamps, Johor, Malaysia.
Courtesy of Patrick Guinness.

identity and security to residents at minimal cost to government (Sullivan, 1990; Guinness, 1986; Pinches, 1987). There were various avenues for communal support, such as on ritual occasions, or during periods of unemployment or financial distress, or even for investment capital, such as the Indonesian institution of *arisan*, that neighbourhood residents could not enjoy outside the settlements.

Other reseachers have called attention to the ties of patronage that frequently link these poor neighbourhoods with the city elite. Turner described how patronage provided a "subsistence crisis insurance" for poor families in the town of San Fernando, in the northern Philippines. With the help of patrons, clients were able to mount the proper ceremonies at births, marriages and deaths, to cover educational expenses of other children, to deal with bureaucracies and obtain employment. Rabibadhana described how patrons among Bangkok's city elite provided protection for members of a squatter community.

Social scientists such as Laquian (1979) pointed to the higher health risks and lack of basic infrastructure in these communities. They pointed out that poverty of material resources did not imply a rejection of the dominant culture or political system, or a poverty of culture, but represented a challenge for effective government programmes. Realizing their inability to remove such settlements, various governments began programmes of slum rehabilitation, *kampung* improvement and the like, and began to recognize community institutions and even land claims. However urban authorities continue to employ quite contradictory policies in regards to these settlements, at times issuing orders for their clearance by bulldozers, and at others making promises of land title, and electricity and water supplies.

Production

The massive population growth in the major Asian industrial centres was not matched by growth either in formal employment or housing. This led to the channelling of more and more immigrants into the bazaar-centred economy, or informal sector of the economy, and into informal housing, such as slums, squatter settlements and various forms of indigenous housing. Much of the anthropological attention focused on Asian cities has concentrated on these poor and marginalised sections of the urban population. They are easily identified, and often socially bounded, populations, to which the anthropologists' methods of participant observation and qualitative, holistic research are well suited.

Geertz (1963) defined the urban (small town) economy of Java in terms of firm-centred and bazaar-centred activities. The firm was characterised by corporate organization, rational economic decision-making, impersonal business relations, that is a profit seeking capitalist foundation defined on the Western model. On the other hand the bazaar was characterized by myriad small-scale, ad hoc arrangements. Movement from one to the other was rare. This bazaar sector was later defined as the informal sector by Hart (1973) in a paper on urban unemployment in Ghana. The informal sector was distinguished from the regulated economy of the city as a set of activities, or businesses, that were marked by relative ease of entry, family ownership, indigenous resources, labour intensive and adapted technology, informally acquired skills and unregulated and competitive markets. The aim of such a formulation was to include in the analysis of the urban economy all those activities not recognized under government license or regular financing arrangements; the street stalls, pedicabs, hawkers, petty manufacturers, domestic servants, criminal activities, black market, prostitutes, and others. The concept has proved very useful to students of the urban economy over the last two decades, despite several important criticisms of it.

One of the main problems with the concept has been the difficulty of operationalising it. Many urban enterprises that appear less than formal do not satisfy the many distinguishing features of Hart's informal sector model. Rather than a dual economy of rigidly separated sectors, such as defined by Geertz (1963) or even earlier by Boeke (1953) in Indonesia, there appears rather to be a continuum between the two extremes of formal and informal economic activities.

A second problem with the model is that there are many linkages between formal and informal sector activities. More recently writers have pointed out that the informal sector both services and depends on the formal sector, there is an interdependence between the two. Armstrong and McGee (1985) suggest that the urban economy should be represented as a circuit, in which informal and formal sector activities can be distinguished as separate loops, but nevertheless connected. Thus the wage-earners of the formal sector may depend on the cheap services, such as food provision and accommodation and transportation, of the informal sector to survive on their poor earnings. Large-scale manufacturers may farm out certain operations to the informal sector, or may depend for the supply of certain materials on the informal sector. In Yogyakarta building contractors constructing low and medium cost housing estates on government licence extract supplies of cheap brick dust mortar from informal sector producers. In Johor, Malaysia, tailors operating from formal sector shops send out much of the cutting and sewing work to women working from their own homes on a casual basis. These informal sector

operators frequently depend on the business of those in the formal sector. Many anthropologists who have written about informal sector acttivies have delineated such links between the two sectors, emphasizing not only the survival mechanisms of the urban poor, but the marginal position, economically, politically, socially and culturally, into which they are forced by the urban elites. Jellinek (1991) describes the "wheel of fortune" by which informal sector livelihoods in Jakarta are sustained, even flourish, only to collapse at the whim of city authorities and national economic changes. These anthropologists are concerned with the wider political relations with which the poor have to accomodate.

The findings of these writers had implications for public policy. Particularly in the national capitals and those cities with international appeal governments were intent on cleaning up the streets, restricting population growth and regularising economic activity. Jakarta, for example, was declared a "closed city" in 1970 after which the metropolitan government repeatedly led campaigns against street stalls and pedicabs (becak) (Jellinek, 1991). These campaigns on the whole were conducted without any firm plan for redeploying those denied their former sources of income. In the most extreme cases street stall operators were simply dumped outside the city limits. These harsh measures incurred strong criticisms from students of urban society, who pointed to the loss of income and security suffered by the victims of these measures, and the impoverisation of urban life as a result of the disappearance of informal sector activities.

Pinches (1987) criticises the emphasis put on the informal sector in analyses of Asia's poor. He finds that wage labour provides the most secure and important income for most slum households, and suggests that much informal sector activity could as easily be defined as formal sector, such as those tailors who produce garments at home on a piece rate. Another interest of anthropologists writing about production activities has been in the manufacturing developments of urban Asia. Ong's study looked at the employment of rural Malay women in manufacturing firms near Kuala Lumpur. She described a partnership between village leaders and factory management that produced a compliant, exploited labour force. Ong identifies the occasional outbursts of mass hysteria by these women in the factories as a language of protest against labour discipline and male control in the modern industrial situation.

In Hong Kong, Salaff (1981) described how the labour of unmarried Chinese daughters was a resource monopolized by their families. These girls were expected to give at least three quarters of their pay to their families to meet household expenses and to provide an education for young siblings. They were encouraged to delay marriage to prolong the period during which they contributed to the family economy. Both these studies thus pointed to the increasing burdens on young women as a result of changing employment structures.

Less anthropological work has been done on other sectors of urban production, such as the bureaucracy, management, and business. Writers such as Howe (1990) call for urban anthropology to move into such areas, becoming an anthropology of complex, rather than urban, society. In Japan, Apter and Sawa (1984) described the organization of leftist sects, farmer resistance and bureaucratic response in the protracted struggle over Tokyo's Narita airport, while Abegglen and Stark (1985) detailed the strategies and interorganizational environment of Japanese corporations, in comparison with Western ones (Sanjek, 1990: 170).

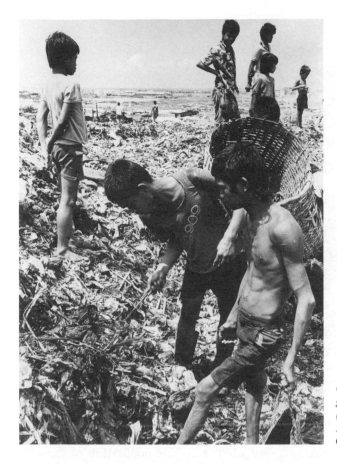

*Children working on the
garbage mountain of Tondo
(Smoky Mountain), Manila,
Philippines.*
Courtesy of Veronica Garbutt.

Leisure

The attention paid to slum and squatter settlements indicated the links of
neighbouring that developed among the city poor. Among the city elite these were
not as strong, but were more likely to be replaced by ties through voluntary
associations (Guinness, 1986). Sairin (1980) described the *trah*, descendants of a
Javanese ancestor, who gathered annually at his/her gravesite and comprised a
meaningful social network within the city. Sparks (1985) described religious
associations among Teochiu resettled in the New Territories of Hong Kong. These
were focused on holding specific festivals in order to support and expand local
temples. Rather than being outmoded social and cultural organizations Sparks
suggested that these were dynamic organizations expressing ethnic unity and
interethnic rivalry in the new settlements.

Traffic

Hannerz (1980: 105) described traffic relationships as those involved in situations
of minimal interaction, where the time period is brief. They may involve people
passing along the pavement, waiting in a queue, or the avoidance of eye contact

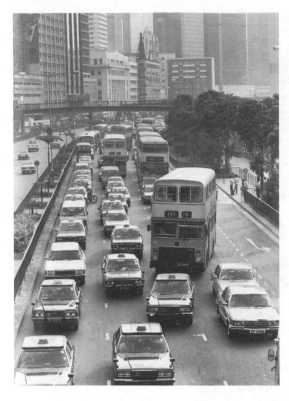

Traffic snarl-ups have become a common feature of Asian cities, as shown here in Hong Kong.

or causing offence through odour or noise. They may be seen, he suggested, as being on the borderline of being relationships at all. However traffic relationships are often very significant in making a city what it is. The population of the city is so large and dense that many relationships in the city are of this category.

Traffic relationships frequently take the form of categorical relationships, the stereotyping of other people according to their uniform, behaviour, or, frequently, ethnicity. Bruner (1974) asserted that relationships between members of different ethnic groups in Indonesia tended to be tense, lacking in trust and based on ethnic stereotypes. An elaborate set of stereotypes or labels defined the characteristics of the various ethnic groups vis-à-vis each other. So the Javanese and Sundanese were known to be very polite and refined and to control their emotions while the Batak were considered as more expressive and volatile and less refined.

These studies of groups or categories of people within cities are open to the criticism of not coming to terms with the urban context within which these groups survive. Some anthropologists faced with the daunting task of reducing the diversity and complexity of urban lives and cultures to precise ethnographies have chosen to confine their attention to small, easily identifiable segments of the city. There at least they can make use of the established methodologies of anthropology, participant observation and holistic analysis. The issue facing urban anthropology is how to construct an analysis of the whole city from these segments. One means of building up an ethnography of the city is through piecing together a number of such studies. It is therefore essential that each of these ethnographies locate the subject group socially and culturally within the structures of the wider city and

nation. All such groups are subject to the economic and political, social and cultural complexities of the wider society. For this reason the study of those wielding political and economic power in the cities is long overdue.

A second means open to urban anthropologists which has been widely used is integrating the findings of a wide range of social sciences within their accounts of the city. Sociologists, historians, human geographers, political scientists, economists and demographers all produce analyses of urban processes that can be grist to the anthropologist's mill. Urban anthropology, perhaps more and earlier than other fields of anthropology, has sought the contributions from other social sciences.

Conclusions

Anthropologists have recognized the role of the city within the nation state and the world economy and analysed the articulation of capitalist and non-capitalist forms of production, and the inter-relation of urban and rural, elite and working classes. Anthropologists' special contribution to this study is in the portrayal of the people and relationships behind the processes, the family members who run the street stall, the relations of patrons and clients in small town politics or slum organizations. By testing the more general hypotheses in the light of a more intimate knowledge of households, kin groups, neighbourhoods or town communities anthropologists can challenge or modify the conclusions drawn by other social scientists and in turn generate new hypotheses. From the minutiae of daily life, and the diverse groups and communities that compose urban society anthropologists can help to build a picture of the city. It is a role vital to our understanding of the society and culture of Asian cities.

Urban anthropology's further contribution is in cross cultural analysis. Are there aspects of culture and social organization specific to the megalopolises, or in contrast the small towns? Are there peculiar cultural, political or economic factors that lead to a strong sense of community or support for voluntary associations in some urban settlements and not in others? Is there anything distinctive about Asian, or Southeast Asian, or predominantly Chinese cities? The comparison must take as its starting point or reference point the wider society in which such urban settlements are found. There is a need for clearer demarcation of the range of urban settings in which anthropology is practised, based on historical, demographic and economic criteria.

A third contribution of urban anthropologists has been in the realm of government policy and urban planning. Anthropological research conclusions applied to specific areas of government concern have helped to shape policy, as the discussion on urban slums or the urban informal sector demonstrated. The task ahead for anthropologists of urban Asia is in these three areas: to further refine and question the characterization of urban society and institutions developed in other social sciences and to contribute towards a total picture of the urban by analysing all aspects of urban life, including the role of the city elite; secondly, to develop cross-cultural analyses of cities, initially within Asia and then within other regions of the world; and thirdly to continue to articulate concerns relevant to government policy and practice in the region.

13 INTO THE FIELD

Applied Anthropology and the Dilemmas of Development

Jesucita Sodusta

What anthropologists do with research and theory, and how they pursue their practical benefits, are subjects that concern applied anthropology. However, in the process of finding its practical applicability, anthropologists take diverse approaches and are not neutral practitioners, or passive implementors. The way in which anthropologists interpret cultural experiences and respond to development problems varies. This is because applied anthropologists are not only influenced by intellectual history and cultural traditions but also by social and political processes. The outcome is actively shaped by both individual anthropologists and the society.

One problem that has challenged anthropologists is how to develop models or theories that can regulate changes so that their consequences are least harmful to the individual or to society. Some argue that development and modernization have often produced inequality and dependency and have not improved the quality of life of the people concerned. Stanley Tambiah (1985), therefore, has urged anthropologists to re-think the opportunities and hazards of an action-oriented approach when they attempt to solve problems facing contemporary societies. In other words, applied anthropologists should take a proactive position – taking action before a harmful event takes place. As Roger Bastide (1971) argues, one should foresee problems and then devise the best strategy for action. In some cases, concern with change may involve taking sides and political commitment. Instead of maintaining the ideal scholar's "value-free" position with an entirely unbiased and impartial posture, this "radical" approach advocates a political or ideological involvement in the problems of the people studied. This position also suggests that applied anthropology should assume social responsibility.

Another problem is how to undertake useful research that may provide greater comparative insight and better interpretive skills. Roger Keesing (1976), for example, has suggested the need for broader and more powerful anthropological models of sociocultural processes, particularly, of politics and economics, to provide answers to problems of emerging nationhood and transforming economies. We urgently need refined and rigorous models or theories that are useful in analyzing immediate problems facing the governments and peoples of Asia. What applied anthropology hopes to provide is a scientific theoretical anthropology that can provide a guidance for change and development.

Applied Anthropology and Colonialism

The notion that applied anthropology is a child of Western imperialism has been quite common among anthropologists and others. That it was a product of the expansion of the Western world into Asia, Africa and Latin America has been a recurrent theme in debates concerning applied anthropology. However, applied anthropology is not simply a reflection of Western imperialism; it also developed according to a set of internally generated theoretical and practical problems related to field research. As was pointed out in the opening chapter the general concerns of anthropology have fluctuated over time in response to both the preoccupations of society at large and in reaction to general debates within anthropology. Anthropology cannot be totally independent from the pressures which can be exerted on it either subtly or directly by society and more specifically its institutional and political structures. Applied anthropology is particularly vulnerable to these broader pressures because more than any other area of anthropology it finds itself often having to deal directly with these institutions and engage in social and political debates of contemporary significance – sometimes to the detriment of anthropology. This was true for the Western anthropologists who carried out their work in Asia during the colonial period (Asad, 1973), and is true for many Asian anthropologists or anthropologists of Asia who are subject to varying degrees of political pressure today. It is, nevertheless, intriguing how anthropological advice has been sought in some situations and ignored in others.

When the United States acquired the Philippines from Spain before the turn of the twentieth century and the Pacific territories after the war, or when Burma, India and Malaysia, among other countries, became colonies of the British empire, the usefulness of anthropology for understanding remote cultures and "exotic" populations was officially acknowledged. The colonial governments, for example, sought the assistance of anthropologists to develop a census which included social and cultural data, and to provide training for colonial officers. The United States government in particular relied on anthropologists to help planners and technicians in public policy. Yet, in the British Empire there was little demand for the services of anthropologists in Asia. Except for the development of a census in India, sociological services and research were hardly ever encouraged. As Adam Kuper pointed out:

> ...the demand for anthropological instruction was never widespread and it never became established outside the African empire. Nor were the anthropologists to succeed in getting money and recognition for many years. (1973: 126)

Thus the relationship between anthropology and colonialism is a complex one, and there is little ground for believing that all or even most anthropologists kowtowed to the demands of colonial administrations. Nevertheless, as Kuper shows (1973: 147–8), they were inhibited by the colonial milieu from asking questions about the impact of colonialism on native populations, for instance, that later anthropologists were less shy about asking.

But during this period anthropology had begun to pioneer fieldwork practice and it was this method of research which made applied anthropologists attractive to governments and administrators. Bronislaw Malinowski (1884–1942) was the

first to use the new technique while observing social and cultural behaviour in the Trobriand Islands, thereby making Asia-Pacific its first field laboratory, and providing anthropology with a significant tool for empirical research. For applied anthropology this development was fundamental. To be able to introduce innovations into a community and to demonstrate the applicability of anthropological knowledge, it is important for anthropologists to have an ethnographic analysis of that community. A description of the existing culture and society is needed not only to understand how it works, but also for developing programmes which will not erode ethnic or cultural integrity. It is also necessary to try to predict the outcome of a programme, without creating new problems, or to find adequate remedies before they become manifest. This naturally led anthropologists to depend on fieldwork and case studies.

Fieldwork and Its Uses

By means of fieldwork, anthropologists are able to study social and cultural behaviour directly. Prior to its development, anthropologists had to rely on piecemeal secondary materials, many of questionable validity. This is not to say, however, that anthropologists did not benefit in important ways from early ethnographers including missionaries, colonial administrators and travellers.

Ideally fieldwork should be intensive, but as a rule the length of stay in the field should be determined by the goals of the project. Most anthropologists spend

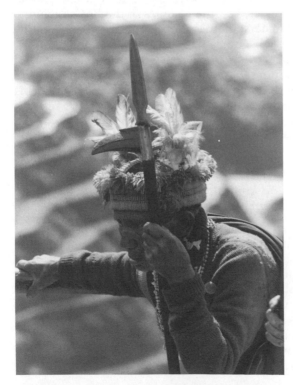

An Ifugao elder.
Courtesy of Shosuke Takeuchi.

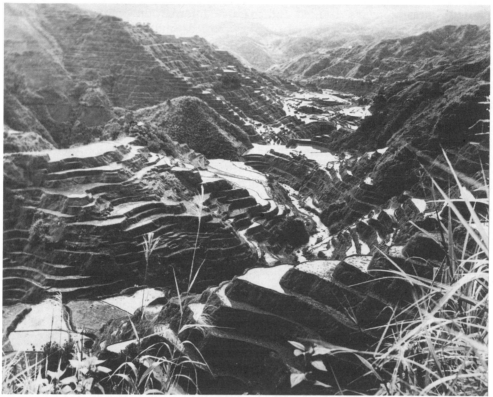

Like stairways leading to the sky, these rice fields were built by the Ifugao. They make use of a very ingenious means of irrigation.
Courtesy of The Philippine Tourist and Travel Association.

around twelve months, yet others may spend three years or so in the field, usually involving several visits and combining several techniques to collect data. The work of Harold Conklin, which covered thirty-eight months of fieldwork among Ifugao highland peasants in the northern Philippines, is exemplary. By using the technique called "participant-observation", he observed not only the actualities of social life but also systematically collected data concerning the thought processes of the Ifugao. Conklin combined studying every detail of the people's life and culture through learning the vernacular language, knowing the members of the community personally, and participating in their social and economic activities, with techniques employed in ethnoscience or cognitive anthropology. By documenting the people's concept-forming abilities he obtained information about their own system for perceiving and organising material phenomena. The latter, it should be noted, are not only things. They include events, behaviour and emotions which in the end reflect the way the people organize and use their cultures.

What makes the fieldwork of Conklin especially noteworthy is that he employed a wide range of observational and recording techniques, combining a full use of key informants with "high-tech" aerial photography. Such a mix produced one of anthropology's great ethnographies. His research on Ifugao terrace agriculture and geography, which included archival research in the Philippines, Spain and the

United States, conveys detailed and massive information on the relationships between villages, the distribution of rice terraces and their intricate drainage systems, and the pattern of trade routes.

One important means of obtaining data in the field is through the use of key informants. As the name suggests, one or a few indigenous members of a community are chosen to assist the fieldworker. Such choices are often determined by considerations of rapport with the fieldworker and fellow members of the community, communication skills and accessibility. The key informant provides an "inside view" of the culture and participates in the investigation of cultural facts by assisting in the collection and analysis of data. In addition, he or she is a link between the anthropologist and the community, thus often facilitating acceptance of the researcher and mutual cooperation. In some cases, the key informant may have a distinctive technique for presenting the realities of his culture.

One of the more colourful examples of the interaction between the anthropologist and a key-informant is that given by anthropologist William Geddes in his *Nine Dayak Nights* which revolves around the story of a Dayak folk hero which was told to him by a key-informant over nine nights. But all was not plain sailing. His key informant "Raseh, the medicine man, was a recalcitrant subject for an anthropologist – quite the worst in the village. He refused to play the game, being secretive" (Geddes, 1987: xvi). Not only that, Raseh insisted on payment for telling the story. Geddes, writes:

> *This was the first time I had ever been asked for money in return for information. Most of it had come in the give-and-take of talk on topics of interest, and the rest had been given out of good will. Raseh's suggestion seemed alien in this atmosphere of informality, as though I were a stranger... Furthermore, if I paid him, why should I not pay all the others...? As usually happened in my differences of opinion with the villagers, Raseh was right and I was wrong. (1987: xx)*

Raseh valued his story and asked for cash because Geddes did not have rice. Cash was what Geddes valued. Finally, the story was told in great detail over the nine nights, and in the end Raseh refused the cash. "He simply said, 'No', wishing, now that I had heard the story and realized its worth, not to obscure the fact that he had never valued his performance simply in terms of cash. I did realize this fact very well" (1987: xxxi). Geddes highlights nicely the complex relationships that can develop between anthropologists and key informants, with the latter actively helping to construct the anthropological discourse. In a sense, it is a dialogue. And Geddes book is a lovely example of its results.

Recently, however, the fieldwork tradition, which many believe to be the bedrock of anthropology, has come under critical scrutiny. Clifford Geertz, for example, refers to "The mystique of field work that Malinowski founded" (1988: 37), and critically examines what he sees as the illusions of scientific objectivity produced by some of the classic figures of the discipline in the writing up of their field research. Others have added their voice to this critique of fieldwork objectivity, stressing the interactive nature of the knowledge acquired in the field, or even suggesting that anthropological writing is semi-fictional (Rosaldo, 1986; Clifford, 1990). While these critiques have raised awareness among anthropologists about their methodological assumptions, and perhaps led to a sort of theoretical house-

cleaning, the fact remains, as a recent guide to ethnographic research puts it, that "Fieldwork holds a position of crucial importance in modern anthropology" (Ellen, 1984:35).

The Fieldwork Paradox

What has divided applied anthropologists in recent years, however, is not the mastering of fieldwork techniques but the search for an ethics of fieldwork. In the collection and interpretation of data fieldworkers sometimes have divergent views about the uses to which their knowledge can be put. Furthermore, anthropologists can find themselves caught between the demands of their funding agencies and the people they study. Some Asian anthropologists have wondered how they should define their sense of patriotism when they know their government has no hesitation in using their knowledge for military and political ends. On the other hand, to what extent should anthropologists tie themselves to a particular community at the possible expense of, for example, neighbouring communities, local governments, or even the demands of anthropological associations? Can we expect anthropologists to maintain their disciplinary integrity while promoting particular policies, say, the integration of a tribal group into the larger nation?

The quest for answers to these questions obviously requires long philosophical debates and empirical researches. But during the Vietnam War they received dramatic attention when a spotlight was thrown on the research activities of a number of anthropologists working not only in Vietnam, but also in northern Thailand. This debate deeply divided the anthropological world. In the sixties, a number of American social scientists including anthropologists took part in research on counter-insurgency in Thailand. Reports concerning tribal communities of Northern Thailand and contiguous areas provided ethnographic data not only for scientific purpose but also produced information for the military and the government. Thus, "up-to-date information as to the location of tribal villages, the number and ethnic identity of the inhabitants, their migratory history" was collected (Wolf and Jorgensen, 1970:31). Obtaining information of this kind had considerable implications for political and military leaders, who aimed to stifle the spread of communism in the region. It also created bitter divisions among the members of the social science community.

Anthropologists took contrasting views about the war. Many launched strong protests against it, and the American Anthropological Association condemned the war. The basic reasons included the defence of the social and cultural rights of the minority peoples, and the belief that Western countries, particularly the United States, should not intervene in what was considered an "internal conflict" between north and south Vietnam. Others showed no overt dissent against the war, as indicated in their willingness to participate in counter-insurgency research in Thailand and neighbouring areas.

This case, and a Himalayan Border Project which was quickly withdrawn when the Indian government saw its interventionist implications, have been interpreted as proof of the existence of anthropologists' interference in the affairs of others. It has been argued by some that anthropologists engaged in these activities because

of the trade-offs or benefits derived from participation, such as increased salaries, professional opportunities, prestige, and so on. At that time many people felt that anthropologists who become involved in such activities violated the morality of anthropology, hurt the interests of the people among whom they worked, and sullied the reputation of the profession.

In the absence of a formal "ethics of fieldwork", any practical participation poses special problems for anthropologists called upon to help promote social or political change. The formulation of an "ethics of fieldwork" by the American Anthropological Association in the seventies is one solution, and US anthropologists are bound by this code. Another option is to abstain from practical developmental anthropology and remain a neutral academic researcher. Then there are those who believe that anthropologists should act as intermediaries whose main task is to raise the consciousness of the people they work amongst so that they will be in a better position to represent themselves (Hastrup and Elsass, 1990).

Whatever the arguments between the value-free position and advocacy there is no doubt that it is very hard to draw up abstract rules for practical action. The fact is that many research projects in anthropology are conducted in a situation where the goals are stipulated, whether broadly or in detail, by institutions and agencies outside the discipline, funding agencies or state bodies. Often anthropologists are unable to finance their own research and therefore they become subject to the imperatives of donor agencies and organizations. Indeed, these agencies can use anthropologists to enhance their power and serve their interests. One example was the Advanced Research Projects Agency (ARPA) of the United States Defense Department, which provided funds for the Himalayan Border Project of the Institute of International Studies at the University of California, Berkeley, in the late sixties. ARPA, which fronted for a counter-insurgency adventure, utilized anthropologists to centralize power and control resources on a global scale (Wolf and Jorgensen, 1970: 33). The Asia Foundation, an American organization, is another example of an institution involved in linking the social sciences community to the purposes of the US government.

The possibility of disengaged anthropology is not even recognized in communist systems where anthropologists, by and large, have had to conceive of their work in an applied perspective. The work of Vietnamese anthropologists, for example, has been tied from the very beginning to the communist movement's need to unite the minorities into their nationalist struggle and later to try to incorporate them into the Vietnamese state. At all times anthropologists have been constrained both by the imperatives of state policy and by state control over theoretical views, which have had to conform to a particular Marxist-Leninist orthodoxy. For example, in some of their recent work they had to downplay Chinese influences among various ethnic minorities because of the political tension which existed between the two countries in the late 1970s and 1980s. Yet, compared with Western or Western-trained anthropologists Vietnamese anthropologists, appear to be in agreement with the state's developmental objectives vis-à-vis the minorities there. And although their work brings them into close contact with Vietnam's minorities, and may therefore at times cause them to express some disagreements with the state's more heavy-handed policies, there is little open dissension. But as Grant Evans has observed, even if there was, "the logic of state power will tend to prevail over their counsel wherever the two come into conflict, which they inevitably must" (Evans, 1985: 143).

The same can be said of the first generation of the communist anthropologists in China. Marxist ideology has served as the only available model for study of the culture and history of the minorities. As in Vietnam, the central Chinese state's policy towards the fifty-five minority groups found inside China was based on the premise that the minorities are inseparably linked with the body of the Chinese people and anthropologists were instructed to seek ways of facilitating their integration into the Chinese nation. This is not the place to discuss the results of Chinese policies or the role of Chinese anthropologists in either formulating them or implementing them. But, like the Vietnamese anthropologists, Chinese anthropologists see an applied dimension as central to their work. As China's most famous anthropologist, Fei Hsiao Tung, expressed it in his address to the American Society for Applied Anthropology in 1980: "under our social system, theory is linked with practice; in a society where science is made to serve politics, it is necessary for a scientific worker to estimate the effects of his work on society. This is not just a question of personal morality but also a question of what is good or bad for the majority of people" (Fei, 1981: 17). Thus research work

China's most famous anthropologist Fei Hsiao Tung with Canadian sociologist Janet Salaff.

among the minorities in the country has been meant to help the social changes initiated by the government. In the work of both Vietnamese and Chinese anthropologists one finds few expressions of anxiety about the correctness of their view of "progress" and few doubts that they are bringing positive social changes to the minorities. But in such a strictly controlled intellectual and political environment one can only wonder about the possible reservations held by at least some anthropologists about the nature of their work.

Competing, if not conflicting, perspectives to development also create tensions in fieldwork which can cause formidable obstacles to project implementation. Janice Sacherer (1986) has provided a harrowing account of her experiences on a Swiss funded integrated hill development project in Nepal where tensions between herself and technical experts on the project reached breaking point. She shows quite clearly how there were conflicting expectations of the role of the anthropologist on the part of the agency based in Switzerland who wanted an overview of the direction of the project whereas the technicians on the project wanted her to address short term problems. In many ways these technicians had a fixed plan and in their opinion the role of the anthropologist was to "sell" it to the locals and help smooth over any conflicts with them, not to suggest that the project design was wrong, based on incorrect information, or whatever, which is what Sacherer began to suggest after being there for a short time. This quickly brought to the surface "the frequent hostility toward social science and social scientists held by many (but certainly not all) technical personnel such as engineers, agronomists, foresters, and livestock breeders...it is a phenomenon for which the anthropologist should be prepared" (Sacherer, 1986: 253). As she points out, the frustrations that many of these technicians felt with the project were directed at her rather than the agency in Switzerland: "one lone anthropologist was a much easier and safer target for all of the latent hostilities toward the organization hierarchy than forthright criticism of those who held the financial and contractual power" (1986: 253).

One of the real dilemmas for the development anthropologist, Sacherer points out, is that they are usually employed by a development project because of the expertise they have developed about a particular culture over years of study. In a professional sense, they have made a heavy investment in learning about one place, and this includes strong emotional attachments. This is not true for most technicians who move from one project to another in different countries. The consequences of conflicts which inevitably arise with locals at various levels during the project implementation are unlikely to have serious repercussions for them, but they may for the anthropologist who wishes to have future access to the country. This is one of the real dilemmas of project involvement. No doubt it was one of the reasons that Sacherer described development anthropology as "a quantum leap beyond the demands of academic research in terms of theoretical complexity, methodological difficulty, physical hardship, and personal frustration. In addition it tends to foster philosophic questions and doubts not encountered in academic research, ranging from the value of development to the nature and future of the human race as well as raising questions about one's personal worth and sanity" (1986: 247).

But Sacherer also offers some stiff criticisms of anthropological training that causes anthropologists to be part of a project's problems and not part of the solution. She points out that an ability for team-work is absolutely essential for

a project's success, but that much anthropological training and research tends to be very individualistic. Furthermore she argues that too few anthropologists have a good understanding of the broader issues related to economic and social change, or have a poor understanding of technical subjects which would allow them to establish a better rapport with other people on a project. They too often assume that technicians should learn from them, and not vice versa. Furthermore, she argues that applied anthropologists need to develop skills for collecting highly specific rather than generalised data, and to be able to gather and process data in shorter time-frames than is assumed by academic fieldwork. Finally, anthropologists need a better understanding of how bureaucratic organizations work, something they have tended to disdain, given their focus on the "grass roots".

These practical concerns over development are sometimes aggravated by discomforting historical legacies. Edward Robins, for example, points out that the legacy of colonialism in developing countries can create resentment of expatriate advisers:

> In Indonesia there was considerable resentment of the advice proffered by advisers. "Indonesians listen politely, and then do what they want." I heard that refrain repeatedly. Inevitably, the expatriates responded in kind and spoke of the unreliability, the incompetence, the insincerity of Indonesians. This is classic ethnocentrism, and its identification falls to the anthropologist. He/she must attempt to promote communication among the antagonists for pragmatic reasons. It is not merely that ethnocentrism is "wrong", but rather that particular differences of opinion must be resolved in particular ways to the benefit of goals held in common. (Robins, 1986:71)

Applied anthropologists will always be vulnerable to outside influences. Almost all applied anthropologists are dependent on various government institutions, usually foreign aid organizations, to finance their research. Some, however, also work with non-government organizations (NGO). All of these organizations which employ the services of applied anthropologists have their own agenda. This does not mean that anthropologists will not use their own value judgements and will derive no benefits from their liaison with such agencies. But one consequence is that there is an ambiguity not only in the ethics of participation but also in the type of work considered acceptable. And, in some cases, there are strong financial attractions that can override ethical considerations.

The Development Challenge in Applied Anthropology

On the whole, development-oriented agencies are involved in the development of peoples, institutions and infrastructures. The charters of agencies such as the International Development Research Centre, Asian Development Bank, Australian International Development Assistance Bureau, and so on are concerned with the alleviation of poverty and the improvement of the quality of life. Although some of these goals are attained through direct intervention, by enhancing agricultural productivity or environment and nutrition programmes, others are routed through

Applied anthropologists help out with irrigation in Northeast Thailand.

education, population and information research activities, among other things. In Asia, where many of the world's poor are found, applied anthropologists are challenged by the immensity of the region's problems. Not only do parts of Asia present a dismal picture of poverty and poor living standards; it has problems in the areas of high population growth, nutrition and community health, let alone environmental degradation, which threatens the region's development. This is a paradox because Asia also has one of the strongest rates of economic growth in the world over the past two decades and is rich in natural resources. But here is the challenge for applied anthropology. Can applied anthropologists respond to regional development problems and demonstrate the usefulness of their research? In fact applied anthropology has already succeeded to some extent in this endeavour, though the disciplinary response may not be defined and integrated as one would have wished. The following case studies illustrate how applied anthropology has tackled some of the problems.

Irrigation and Culture

Because anthropological village studies have usually included detailed discussion of agriculture, this gives anthropologists a competitive advantage in demonstrating

Grassroots rural development workers with Thai farmers.

how culture plays an important role in economic development. In order to increase agricultural productivity, especially of rice, development experts stress the importance of irrigation. While it has been demonstrated that irrigation or the systematic utilisation of water has an impact on productivity, the extent to which it promotes social change is not entirely clear. Does irrigation development really promote modernization? Or does it create a situation which leads to "traditionalization", or even to instability?

David Groenfeldt (1986) investigated the degree of cultural change attributable to a large scale irrigation project in northwest India. Using a grant from the United States Agency for International Development, he chose two villages with similar characteristics in terms of size, caste structure and infrastructures. They were only five kilometres apart, but one village was irrigated while in the other only a small percentage of the fields (22 percent) received irrigation. The irrigated village had electrification. Before the introduction of irrigation, the village of Bagarpur had only twenty-seven households, with a large number of elderly bachelors who were too poor to marry. As a result of the promulgation of the Surplus Land Act and the construction of the irrigation canal both in 1952, the villagers were able to intensify their agricultural production. New crops such as cotton, wheat and cowpeas were introduced in addition to increased yields of the traditional crops of chickpeas and millets. These crops provided food and cash as well as security of livelihood to nearly all, including the landless. During dry years irrigation guaranteed subsistence and a surplus of produce during wet years.

A woman threshing grain in Northern India. Courtesy of Jagdish Agarwal.

The productivity of the land brought about by irrigation attracted migrants from the neighbouring villages, thus increasing the population size from 27 to 101 households. Meanwhile, the village without irrigation experienced a slow but steady migration out of the village. With no dependable water supply for farming, productivity was low. As it was not possible for the economy to intensify production due to lack of irrigation, the economy diversified. Villagers had to make a living as agricultural workers on nearby farms, as bus conductors, or as truck drivers. There is no doubt that, by and large, Chhotapur lacked the opportunities for agricultural development because of the absence of irrigation. But it is important to note that, as Groenfeldt pointed out, replacing subsistence farming with irrigated, relatively high technology, cash-based agriculture constitutes only one aspect of social change. While the economic changes without doubt are important, there are

cultural changes which also need to be considered. Applied anthropology is concerned with both explicit and implicit forms of change. There are usually few difficulties in tracing explicit changes, such as increased productivity or change in family composition. But it is often difficult to identify implicit changes which have a detrimental or constraining impact on development. Groenfeldt illustrates this problem in his study of the impact of irrigation.

His analysis of the relationship between irrigation and modern technologies led him not only to an understanding of the effect of development on behaviour, it also showed how cultural values and behaviour affect development. This can be seen in his study of credit behaviour. Rural credit is considered an important feature of development, yet it has been difficult for experts to explain the patterns of success or failure of rural credit schemes. The surprising thing that Groenfeldt discovered was that the relatively more affluent villagers in the irrigated village of Bagarpur had, on average, much higher levels of debt than in the "dry" village of Chhotapur. Why? First, because of government policies they found it easier to secure loans. But were they using these loans for productive activities, as expected by the credit scheme? In fact only half was being used for agricultural purposes. The rest was being channelled through "traditional" cultural routes, such as increasing dowry payments, and competitive drinking and gambling. In fact what had occurred in this village was that as it became richer through agricultural intensification, prestige competition – whereby people (especially the poorer ones) would spend beyond their means and go into considerable debt – intensified. Of course, dowry payments may be part of a long-term economic and social strategy on the part of a family, as argued by Sorensen in Chapter 5, but such marriage strategies usually do not fall within the narrow economic calculus of credit schemes. Groenfeldt also points out how such credit schemes can be manipulated by the higher castes in a village in such a way that it increases their power over lower castes, quite the opposite effect to what was intended. But this too is a consequence of the cultural background of those who administer the credit schemes. As Groenfeldt writes:

> The civil servants responsible for government development schemes are usually of the same caste as the Bagarpur landowners Jat, and share a similar caste prejudice against the Harijan (Untouchable) community. When officials from the IRDP office roared into Bagarpur late one evening to announce a loan subsidy scheme for the landless poor, the values of urban prestige and caste prejudice was very much in the air...They were treated to typical hospitality (tea) at the sarpanch's (head of the village council) house. Meanwhile anyone who wanted a loan was supposed to come and see them immediately...Harijans are not going to visit the house of a wealthy landowner, especially not at night. Not surprisingly, no Harijans came... (Groenfeldt, 1986: 102)

This is not an argument against rural credit, but it demonstates how rural credit is subject to cultural forces. Such forces influenced the Bagarpur farmers in ways unanticipated by government planners. Unless the whole range of forces which bear down on the farmers – political, economic, social and cultural – are taken in to account then credit schemes are likely to have unintended, and possibly retrograde consequences. It is good argument for a holistic approach to developmental problems.

Sustainable Environment

Many anthropologists have studied people-land relations as well as the native principles of environmental utilization and conservation. They have produced fascinating insights into how traditional rituals, for example, are used to maintain a balanced ecosystem. But while anthropology has made substantial progress on its own in this regard, inter-disciplinary approaches to development have not been sufficiently emphasized. For example, research on the practice of swidden cultivation often is not linked to forest conservation, nor research on traditional systems of subsistence related to land tenure policies.

But there have been some promising attempts to do just this in projects associated with upland development or social forestry. In cooperation with an economist, a botanist, a forest ecologist and a tropical forester, anthropologist Sam Fujisaka (1986) developed a social forestry project for the Bureau of Forest Development in southern Luzon, Philippines. The purpose was to improve local systems of resource use and management among a group of settlers and to assist them to adopt an "improved" method of swidden cultivation. Fujisaka used anthropological methods to obtain information about the project community. The Calaminoe community which straddles the Mt. Banahaw and the Sierra Madre mountains faces the same serious ecological degradation problems as upland communities elsewhere in the Philippines. The settlers, described as the "poorest of the poor", are part of 7 million Filipinos inhabiting upland areas and competing for scarce resources.

The anthropological contribution here was to provide an overview of existing agricultural land-use and cropping patterns, and management practices as well as of the social organization, technical knowledge and perceptions of the villagers. Therefore a mix of methodologies was required. Fujisaka and his team employed survey instruments that were pretested and modified prior to the interview being conducted in Tagalog, the language of the settlers. But some locally sensitive topics and events required the use of more intensive and informal key-informant interviews. The so-called "single-shot" or "rapid rural appraisal" approach, while useful to obtain exploratory data, was found to be inadequate in obtaining an effective understanding of the farmer's knowledge and practices. Fujisaka's design incorporated the iterative informal interview, which involved continuous dialogue between the farmer and the interviewer. One could call this the stimulus-response interview in which follow-up questions and indigenous information is continuously revised and improved. As Fujisaka observed, results can go beyond "just talking to farmers" and involve the re-orientation of the project's direction. The iterative approach elicits in-depth data which often show potential not only for planning and implementation, but for stimulating downstream community linkages as well.

The above research resulted in a comprehensive body of information needed for the formulation of strategies for upland development. Farming practices reflected a mixture of adaptation techniques: slash-and-burn cultivation, crop shifting from annual to perennial, and land-use cycles. The team endorsed some practices, focusing in particular on those with resource regeneration and sustainable potential. As competition for resources intensifies between different ethnic groups who have resettled in villages in the project area the problem of cooperation in resource management will become more important and therefore the team considers its findings as vital for strategic planning.

The findings also underscore the need for investigations into the social aspects of development: Long-term research also revealed important institutional constraints to any upland development. Local, provincial, and national level land and resource jurisdiction was confused. The nearby Laguna-Quezon provincial boundary location has not been settled and two different nearby municipalities claimed local jurisdiction. Each local faction allied with a different municipality. Nationally, the forest bureau and the Bureau of Lands (BL) did not know who had area jurisdiction. Some settlers hoped that the BL had jurisdiction since such lands could be made alienable and disposable – i.e., could be individually titled and sold. Confusion, claims, and counterclaims at the different levels added to local polarization. (Fujisaka, 1986:165)

Skill Training and Human Resource Development

With the slow pace of social and economic change in developing societies change-agents are increasingly taking into account the importance of human development. For example, the United Nations Development Programme (UNDP) has noted the need to examine strategies for realistic, practical and afforable human development.

In a 1990 report, the UNDP emphasizes the importance of human development by arguing for investment in education and skill training. This line of thinking so far has not been popular among anthropologists. But F. Landa Jocano has used his anthropological knowledge successfully to construct a model for "values formation" among workers in corporate business in the Philippines. His approach is to conduct regular seminars to help improve workers' productivity, innovativeness and leadership. The main idea is how to make use of indigenous values of *pakikisama* (getting along with others), *utang na loob* (debt of gratitude) and the like, to integrate workers into corporate values and culture.

Jocano identifies different levels of participation. One level of participation involves leadership development. Seminars and workshops are held to develop leaders and sensitize them to indigenous values and corporate goals. The training also aims to promote interaction among workers in the corporate environment. The second level of participation involves the training of rank and file workers. Here, the workers are given lectures on the dynamics and characteristics of Filipino values. The value of *pakiramdam* (sensitivity), for example, is significant for shaping the attitudes of workers toward teamworking.

Jocano makes the interesting suggestion that cultural values provide experiential grounding for the construction of corporate perceptions of performance and productivity. But Jocano has been criticized for moving away from typical anthropological concerns to a line of thinking that is utilitarian and "non anthropological". Most anthropologists in the Philippines, for example, are engaged in development studies in areas such as agriculture and education. Some focus on how social factors might affect the implementation of irrigation projects and land reform; others examine the role of culture in administering schools. A few examine

the aspects of leadership and rank differentiation, while some study ritual and ecology.

Jocano brings out the potential in culture by merging it with management concepts and then devising a programme that enables him to train corporate members. Some Filipino anthropologists disagree with his programme and consider it simply a form of corporate brainwashing with no real anthropological standing. But, these differences no doubt reflect different political views of the role of anthropology, and while the tension between these positions continues, it must be said that Jocano has expanded the applicability of anthropological knowledge. Many multinational and local companies have appreciated the practical benefits derived from Jocano's programme, which is evident by the increasing number of firms – for example, San Miguel Corporation, Phillips, E.R. Squibb, and Mutual Benefit Assurance – interested in placing their workers in Jocano's skill training enterprise.

Health Care and Anthropology

Health care is another area where anthropologists can make a key contribution. Anthropological research has focused on the description and analysis of indigenous medical systems, beliefs and practices. Anthropologists, by identifying the aetiology of an illness and describing people's perceptions of it, their healing practices and preventive mechanisms, can provide a pool of knowledge for planners and technicians involved in health care.

Today it is common for anthropologists to become directly involved in health care, instead of merely supplying knowledge base for others to use, and this has added a new dimension to their work. In the area of primary mental health care, Nick Higgenbotham and Linda Connor for example, have produced a model which transforms existing Balinese mental health programmes. The model called "culture accommodation" consists of a framework that examines how Balinese interpret, conceptualize and respond to illnesses in social and therapeutic terms (1989: 70). According to this model, those attending to the patient, such as the healers and the government health agencies, both have an important role in providing health care. Thus, their social background, their experiences and their styles of communication with the patient and his family members must be assessed. Each of them has a function in providing health care, and how they are accommodated into the programme becomes a crucial component of the model.

> For example, if specific government policies in the health and economic sectors are undercutting opportunities of the healers to learn and effectively practise their craft, then the government should review these policies in light of their adverse health consequences. At a minimum, government agencies could acknowledge and support the operation of healers as primary health care provides for their recognized spheres of expertise. While doing so, health ministries must cautiously avoid measures to license, or monitor folk specialists (balian) or co-op their allegiance by providing monetary incentives. Such measures invariably undercut the ritual base of sacred practitioner and distance them from the influence of local residents. However,

when discussing the problem of balian failure, we cannot discount the possibility that one factor may be incompetent and irresponsible healers. But in these cases controls do exist: in rural areas, such practitioners usually experience declining clientele or great pressure to conform to local ethical and procedural standards. (Higginbotham and Connor, 1989:71)

Higgenbotham and Connor's model cannot be subjected to clear-cut scientific examination, but it should be considered as an organizing framework that leads to the genuine demonstration of an alternative mental health care programme. The model transformed existing programmes in Bali, Indonesia. It proposes to obtain the support of folk healers as primary health care agents. Their integration into the health care services provided by polyclinics not only expands the efficacy of the system of indigenous healing but also enhances acceptability to the patients and their families. The programme is capable of such integrated functions as treating illness, sharing management, or developing effective policies.

But the programme does not merely attempt to solve these problems. Rather, it requires greater sensitivity on the part of the polyclinic medical personnel. Thus, an important part of this programme is the selection and training of personnel who will serve in the community in primary health care. Such training has already begun at the Udayana University. The public health faculty has introduced a socio-cultural curriculum in community medicine for undergraduate medical education. The importance of the programme lies in the way it handles training. Instruction is carried out in the community by a medical anthropologist. Here, the students are taught how to comprehend health issues, traditional healing practices and perceptions of health, and so on. Once the training is completed, the would-be psychiatrist can serve as participant-facilitator in community care-giving transactions.

Thus the model can be seen as an attempt to integrate indigenous health practices and a modern psychiatric model of service development in Bali, and in other villages in Indonesia. And, in the process, it helps resolve the contradiction between the principles of primary health care and the organization of psychiatric services. While the ultimate impact of the model is not yet known as it requires a political solution to re-formulate health policies, the model can be regarded as one attempt to utilize and manipulate ethnographic knowledge for the development of health care in the region.

The Challenge of Land Reform

Land distribution to the needy poor is a vexed strategy. Although many policy makers and development experts have endorsed land reform as a means to alleviate poverty among farmers and the landless, reservations have been raised about it by some anthropologists. Land reform is implemented on the assumption that land ownership improves productivity, promotes development and brings about political stability. But, it can be argued that the model is essentially culture blind: the assumption is that land reform programmes all work in the same manner. These programmes seem to reflect the belief that the agricultural sector of society reacts uniformly to land reform initiatives. This is a serious error, because it fails to

Landless peasant farmer from
Tarlac, Philippines.
Courtesy of Jose T. Reinares, Jr.

take into account the individual skills and capabilities and cultural variations. The fact that some farmers are able to produce more than others, apply fertiliser to their fields more appropriately, or use better farming practices than their neighbours, must be taken into consideration before assuming that land reform will automatically improve productivity.

Land reform programmes in Asia were developed following the success of land reform programmes in Japan, South Korea and Taiwan in the 1950s. The principle features of these programmes included land ownership, package of inputs, irrigation and credit facilities (Latz, 1989; Yager, 1988; Wang, 1986). These were adopted as the organizing principles for land reform programmes in the Philippines, for example. Recently, however, these assumptions have been called into question. For example, I have been studying the implementation of a programme in southern Luzon, Philippines, for over a decade. I have also studied the abilities of the farmers to utilize agencies newly established by the government, and to meet expectations of increased productivity and performance. In random and case studies, farmers are asked about their participation in farmers' associations, application of inputs according to desired timing and quantity, and so on. I have discovered that different farmers respond differently to problems concerning irrigation, certificates of ownership, and with respect to credit (see Table 13.1).

Table 13.1
Distribution of Respondents in Response to:
What are your Farm Problems?

		(N = 113)
Responses	n	%
Irrigation	33	29.20
*CLT not returned	24	21.24
No problems	23	20.35
Land payment	12	10.62
Capital	5	4.43

No responses: 16 or 14.16%
*Certificate of Land Transfer
(Source: Sodusta, 1977)

The most common problem for farmers is the unreliability of water, which is a result of the defective installation of the irrigation canals, some of which are built too low. Poor management techniques have also affected the distribution of water. Problems have been aggravated by bribery and inefficiency:

Another thing wrong with this irrigation system...the people who manage it. Like Mr. Esguerra, the water-master. Because...he was given something, he irrigated the fields (in Dampol) and neglected Pungo. Why can't water-master be rotated to other places...to avoid favouritism?

People like him don't do their jobs...The farmers here...use water pumpers...Emilio Cuanderno had to spend for the gasoline and the water-pump operator.

And also we want this complaint to reach the authorities and President Marcos. (Sodusta, 1977:40)

Hence, it is difficult for them to meet the goals set by the government to produce ninety-nine sacks of rice per hectare. But one needs to look beyond this context if the aim is to enhance productivity. The institutional conditions that improve productivity and make land reform a success should also be taken into account.

In credit resources, for example, farmers can no longer borrow from the landowner "patrons" because the ties between them have been severed as a result of the farmer's acceptance of land redistribution. The farmer now has the option of obtaining credit from the rural bank, or from the existing moneylenders at high interest. Whether the farmer is allowed credit by the bank or the moneylender depends on how effectively he is able to repay loans. This in turn depends on the yield of the farm, the time allotted for repayment and the farmer's own motivation, networking competency and community standing. As it happens, the twin enemies of the farmer, drought and flood, often erode his ability to repay. In addition, bureaucratic wrangles, corruption and mismanagement on the side of the government agencies sometimes stymied expectation of repayment. Ultimately, the government tried to recoup losses by charging the farmers in court for failing to pay their debts. This, naturally, created discontent among the farmers and hostility towards the government and its schemes. It is my belief that land reformers have erred in positing ownership as the simple answer to development problems

in agrarian-based economies. The fact that Japan or Taiwan could successfully implement land reform is no reason to assume that the Philippines could do the same. I see success in land reform as dependent not merely on the availability of land ownership and on a package of inputs. Rather, I see it as heavily dependent on institutional capacities reflecting competence, efficiency and enterprise to enable the farmer to deal with the changing environment. Japan's tightly knit work group, sustainable use of traditional institutions along with efficient modern organizations provided the social infrastructure for the land reform programme that triggered the country's development (Sodusta, forthcoming).

Conclusion

The examples cited above confirm that anthropologists have devised methods to make their theory and research applicable in development projects. Their work has created closer ties with agriculture, economics, business management and health services. Anthropology adds knowledge crucial to these sciences in terms of cultural perception, recognition of indigenous values, fieldwork approaches and so on. But the importance of applied anthropology lies not merely in its cooperation with other science, its investigative techniques can be used to understand specific features of culture change.

The potential contribution of applied anthropology to the study of social change in Asia is enormous. Evaluation research, strategic planning and policy making covering the aspects of sustainable environment, education or health, and controversial topics in politics, ethnic relations and religious movements require the incorporation of cultural variables. Another potential contribution will be to study the donor agencies themselves in the light of their relationship with the people they aim to help. But unless anthropology is able to develop more precise techniques for the understanding, investigation and prediction of cultural processes, its role in the mainstream of development will remain ambiguous.

14 JAPAN: THE ANTHROPOLOGY OF MODERNITY

Joy Hendry

There can be little doubt that Japan has entered fully the age of modernity. Indeed, talk there is more likely to be couched in post-modern terms, although these labels are increasingly liable to draw a sigh since Japan has become confident enough to stop seeing itself in terms of Western systems of measurement. Japan has all the technology she could want, and the wealth to develop more. She leads the world in many fields, and in microchip technology has done so for some time. Her transport and communication systems are so efficient they leave members of countries which provided the initial models for them quite embarrassed at how much they have fallen behind.

Nevertheless, behind the cosmopolitan, concrete frontage, Japan has retained a great deal of her Japaneseness, and this is not always as visible as the trappings of technological success. In their immaculate Western suits, and fashion-leading Western dresses, Japanese men and women look to Westerners deceptively similar to themselves. To other Asians, they may look alarmingly foreign in their apparent Westernization, although some of the assumptions behind their thoughts might be surprisingly familiar if this layer of superficial appearance should be penetrated, for underneath remain layers of previous influence introduced from her Asian neighbours.

A visit to a Japanese home, for example, will usually reveal the persistence of time-tested customs such as the removal of shoes before entering the house, sitting and sleeping on springy *tatami* matting, long and therapeutic soaking in a deep, soap-free bathtub, and the wearing of loose, comfortable *yukata* for relaxing in the home. At festivals and formal ceremonies, which have flourished in recent years with Japan's increased prosperity, the continuing popularity of splendid indigenous garments is evident to the outside world as well. Visits to shrines and temples will also witness a persisting abundance of religious activity rather than the secularization at one time widely predicted to accompany modernization.

Just as Japanese gifts are supremely appropriate for establishing and maintaining harmonious relationships, Japan's success in impressing the outside, at present very often Western, world is partly due to her efforts to fit in, again appropriately, to the "modern" trappings she found there. It is important not to be misled by the superficially Western veneer with which Japan has coated many of the external

features of life, however. The distinction between this "modern" wrapping and ways of doing things which lie beneath it actually forms an important aspect of Japanese social classification, as will be shown in the course of this chapter.

The application of anthropology to this kind of society is actually very appropriate. In the sections which follow, various subjects will be covered. There will first be some consideration of the methodology used by anthropologists in such a complex society, and the way this differs from the approaches of other social scientists. Western scholars often found Japan difficult to accommodate to their theories about industrialised societies, and several Japanese writers responded by trying to explain Japan's apparent uniqueness. A second section will demonstrate how the work of anthropologists has been able both to undermine Western theories about modernization, and put Japan in a wider global context.

Subsequent sections will demonstrate different types of anthropological approach in more detail, sometimes taking up the examples of the second section again. First, a section will discuss the importance of learning the language of a particular society, including the system of *classification*, and demonstrate the way this approach to Japan, despite its complex and varied forms of life, will draw out important concepts and values. The following section will show how a *structural* approach may be used to describe the features of persistent principles underlying rapid social change, and a third will go on to glance at the *models* offered as the reaction of another anthropologist to what he saw as an oversimplification of Japanese life. This will introduce some of the dynamic which arises in a society which has become very self-conscious about its own *identity*. The final section will turn to look at the subject of *syncretism*, an excellent way to illustrate the layers of indigenous and outside influence which Japan has incorporated into the social and symbolic vocabulary which makes up her modern world.

Methodology

Japan provides an excellent example of a country where anthropologists are working successfully in an environment quite the opposite of those chosen by the pioneers in our field. Unlike the small-scale, pre-literate, technologically relatively simple communities of early fieldwork, it is a complex society, with almost universal literacy and the most highly developed technology the world has to offer. Some of the anthropologists there do choose relatively isolated communities, to be sure (see, for example, Hendry, 1981; Kalland, 1981; Moeran, 1984; Moon, 1989) but no part of Japan is cut off from the media, and all are linked effectively into the highly efficient transport and other communications networks. There are also anthropologists working in the heart of the largest cities.

Here, then, it is possible to look at the contribution anthropologists may make in the traditional preserve of sociologists and economists, and I will argue that they do have a distinct role despite the Asian convergence of interests which was pointed out in the introduction to this book. As Guinness notes in Chapter 12, they aim to use a holistic approach, looking at social behaviour in as wide a context as possible. They also use the usual social anthropological research methods, characterized by *participant observation* over a relatively long period of fieldwork,

Participant observer Joy Hendry.
Courtesy of Joy Hendry.

although the unit of study is much more variable than it is in small-scale communities where the inhabitants generally all know each other.

In a city, for example, the anthropologist may be immersed in a neighbourhood, examining social relations just as they would in a village in the country, although in a completely different context (see, for example, Ben-Ari, 1991; Bestor, 1989; and the pioneering work of Dore, 1958); or they may take up employment and observe a section of society by working in it. There are examples of ethnography carried out in a bank (Rohlen, 1974) a large company (Clark, 1979), a cake-making factory (Kondo, 1990), a school (Goodman, 1990), a wedding hall (Edwards, 1989) and as a practising member of a religious sect (Davis, 1980). There is also a fascinating ethnography which was carried out by an anthropologist who shared the lives of a house of *geisha* entertainers (Dalby, 1983).

Anthropologists may also choose a smallish number of institutions to visit on a regular basis, perhaps attaching themselves to one of them, which gives a long-

term base for comparison, but including others to get a range of experience and cover a larger sample of the genre. Of this approach there are examples of studies of high schools (Rohlen, 1983), kindergartens and day nurseries (Hendry, 1986), factories (Dore, 1973), practitioners of East Asian medicine (Lock, 1980), and a range of healing practitioners, including religious ones (Ohnuki-Tierney, 1984a). Sometimes anthropologists choose a specific subject and spread their net more widely, as was the case with ancestor worship in Smith (1974). This last course of action becomes especially effective when the anthropologist has already gained experience doing more intensive work.

Ultimately, whatever the specific approach, the aim of *participant observation* over a long period is to allow a depth of understanding which goes beyond the sampling techniques and statistical analyses of other fields. This depth of understanding should, at least ideally, approach that of the indigenous researcher, and some anthropologists working in Japan are indeed Japanese, although they often choose shorter term research methods than outsiders do. They also tend to choose areas of Japan which are quite different to those of their own background so that they are to some extent outsiders too.

The outsider does of course have special advantages, which were discussed in the introduction to this book. In this chapter these advantages in the particular case of Japan will be demonstrated as we go along, but it should be emphasized straight away that anthropologists from outside of Japan usually receive excellent cooperation from local colleagues. Collaboration of this sort makes for the best possible results in a modern, complex society such as Japan, as was summed up by the Japanese anthropologist, Professor Yoshida Teigo, in a report he wrote of a conference of the Japan Anthropology Workshop,

> *It seems to me that even when they study the same phenomena, Western and Japanese anthropologists are somehow interested in different aspects, emphasizing different points. Therefore, Western and Japanese anthropologists have the opportunity to play complementary roles, helping each other out. (Japan Foundation Newsletter, 1987:Vol. XV, No. 1, p. 23)*

It is perhaps worth reiterating here the point made in the introduction to this book that there is of course much variety within Japan, itself, and while depth is a strength of the anthropological approach, it hardly allows its practitioners easily to make generalizations about whole nations. This provides another way in which we can make use of the studies of our Japanese counterparts, particularly the meticulous work of the folklorists who visited all the outlying regions of their country. Thus, where what follows is written in rather a general style, the reader should always bear in mind that there will of course be considerable leeway for variety in practice.

Anthropology and Modernization Theory

The success of Japan's surface adaptation to the "modern" world it has in the last century been emulating may well have fuelled Western-inspired theories, now largely discredited, about the convergence of industrial societies. This is one area where detailed anthropological studies have made it possible to put common

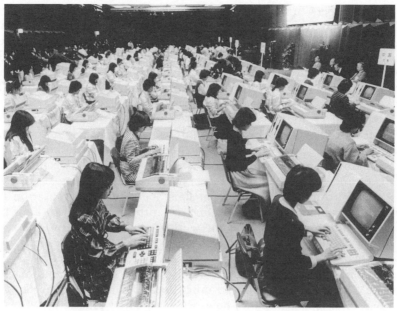

Concentrating on their keyboards and displays are eighty-one selected office workers from all over Japan as they compete for the word processing technique and speed during the 1984 All Japan Word Processor contest held at Nissekei Kaikan Hall in Tokyo on 23 November.
Courtesy of Japan Information Service.

industrial features into a local cultural context, and sometimes to refute ideas about how Japan (and indeed other industrialised societies) would change in the face of "modernization". Three good examples were provided in a collection of papers by anthropologists who have studied in Japan, entitled *Interpreting Japanese Society: Anthropological Approaches*, and these also introduce themes which will reappear in more detail in subsequent sections.

The first, by a Korean anthropologist, Okpyo Moon, addresses directly assumptions of Western modernization theory about social change expected to accompany economic development, used also by Japanese social scientists to make predictions about their own society. In particular, the indigenous Japanese household (*ie*), described in detail below, was for many years expected to disappear. Based on fieldwork carried out in a mountain village which had recently diversified its economy from the production of rice and silk to include a wider range of agricultural goods as well as the servicing of a ski slope, she was able to provide a lively account of the changes which have taken place, and to conclude:

> *...the development of a tourist industry in Hanasaku has provided those of its residents who are faced with a potential crisis in household continuity with a positive adaptive strategy with which they can manipulate the changing economic situation to their advantage. The household still remains the basic unit of social, political and religious life in Hanasaku, and...its relative stability accounts for many of the persistent features of village life. (Hendry and Webber, 1986: 185)*

Two further papers in the same book addressed the question of *secularization* which had been predicted as another feature of modernization, and again used their research to conclude that there was little evidence of this. In each case, the authors showed that there had been change and adaptation to the new situation but they both argued that religious activities were still very much in evidence. (See below for a more detailed discussion of contemporary Japanese religion.)

One of the papers, by Mary Picone, discusses Buddhist popular manuals and what the author calls "contemporary commercialization of religion in Japan", and while she acknowledges the debt the phenomenon owes to marketing techniques made possible by the mass media, she also points out that the genre of Buddhist manuals is not new. An interesting aspect of her approach as an anthropologist is that she is able to make direct comparisons about ideas of causation found in these modern manuals with the findings of anthropologists working in a pre-literate society on the other side of the world. This is interesting and refreshing, in view of an almost obsessive interest taken by the Japanese public in unique features of their society.

The other article, by David Lewis, is also about local notions of causation. Based on fieldwork carried out in an urban location in one of the most densely populated areas of Japan, it shows how explanations of practices concerned with "years of calamity" have been "modernized" without dislodging the fundamental ideas behind them. These ideas are based on the notion of non-homogeneous time, which was discussed by Durkheim and Mauss (1970) at the turn of the century as characteristic of a Chinese system of *classification*. It is held that at certain ages people are particularly vulnerable to illness and misfortune, therefore various precautions and protective measures should be taken, many of them involving recourse to religious activity.

Explanations of the existence of these years of misfortune are, however, often couched in "scientific" terms, according to the author, who writes:

> It is almost as if 'science' has taken the place once occupied by religious literati – technical scientific language being here like the use of Latin by medieval monks – so that the mystification of science in relation to ordinary people allows the possibility of 'science' being used to validate or provide a veneer of acceptability to folk concepts. (Hendry and Webber, 1986:172)

The existence of such notions does of course offer an explanation of misfortune when it occurs around these times, and the comparison with Latin is not inappropriate in the Japanese case because much of the language of Buddhist and Shinto prayer is almost entirely incomprehensible to lay participants.

A much more detailed and complex approach to the subject of modernization and Japan is to be found in the monograph by Emiko Ohnuki-Tierney, entitled *Illness and Culture in Contemporary Japan*. This Japanese woman, who lived and worked for many years in the United States, returned to Japan to carry out fieldwork among her own people. Her subject matter was "the contemporary health care system in urban Japan", but she focuses on "the culturally defined concepts of hygiene, urban magic, deities and buddhas as medical doctors, and family involvement in the care of the sick, as well as clinics and hospitals". She shows that although Japan is a country as modern as any other industrialized one, it is

necessary to look much further than the imported Western biomedical practises to understand the Japanese response to them. In this case, the book claims to challenge "the view held by some social scientists that modernization produces a 'rational' individual whose behaviour loses symbolic dimensions". Ohnuki-Tierney sets out to demonstrate that, on the contrary, the contemporary Japanese "among whom both industrialization and the development of science have reached a high degree" have "thought patterns and behaviors" that are "deeply symbolic". She argues further that this whole aspect of modernization theory is based on notions of "scientific" and "intellectual" developments deriving from the comparison of "nonmodern Third World cultures and the cultures of Western intellectuals" so that an examination of "the structure and meaning of thought through time" and "a systematic study of the cultures of ordinary people in contemporary Western societies" would reveal the theory to be unfounded.

Socialization and Classification

The Anthropological Interest in Classification

Anthropologists in any society must start out by learning the language of the people they have chosen to study, and this includes the broad systems of *classification* which underly social behaviour. Classification is concerned with the culturally variable way in which people divide up the environment in which they live, as well as the people who form part of that environment, and the way they express these divisions in a mutually comprehensible manner. An understanding of a system of classification goes a long way towards a deeper understanding of the people concerned, especially when examined together with the way value is attached to categories of the system.

In a complex society there will always be some variation, especially when it comes to attaching value, but in the case of Japan there is an initial advantage because the vast majority of its population share the same language. The Japanese language divides up the world in a way which has become increasingly standardized in the years since the introduction of nationwide education, first, then television and other media, and this makes the task of understanding local systems of classification much easier. Local differences can be seen as variations on a broader common theme, as can the diverse value systems which exist alongside one another, this time probably more commonly within urban areas. Social change can be accommodated in a similar way.

There are many different avenues to approach the study of classification in a particular society, but the results of one investigator should ultimately dovetail with those of others conducting research in the same society, since the system of classification underlies all aspects of social life. In this section I will talk a little bit about my own research as a means of understanding aspects of the system of classification and then give some examples of predominant Japanese categories. An understanding of these will help us to interpret Japan's particular form of modernization.

Child Rearing: A Case Study

In my book *Becoming Japanese* I present some distinctive features of the Japanese system of classification gleaned from a detailed examination of the methods used by mothers and teachers in the socialization of pre-school children in Japan. Any child is born a biological being who gradually becomes a social being by learning how to communicate with other human beings, inevitably in a way which is peculiar to the society in which it is born. As it learns to speak, and to behave appropriately in other ways, it is all the time learning how the world is classified by the human beings around it. The study of this period of life thus provides a good opportunity for an outsider to a society to see what categories are being presented to the child as particularly significant and important in the ordering of its world.

Research for this project was again based on participant observation, in this case often with my own small children in tow. Part of the time was spent with mothers, comparing notes about methods of rearing and generally observing the approach of my Japanese counterparts. Another part of the time was spent visiting kindergartens and day nurseries to observe the methods employed by teachers and carers in those institutions. Some time was also spent reading the materials which are issued free or sold to those involved in the rearing of children, watching television programmes aimed at children and their mothers, and also occasionally attending lectures for young parents, in practice usually mothers.

During all this time, certain concepts would keep recurring, as would certain ideas about the ordering of the world which were being stressed in dealings with the children. In the book these are mentioned as part of the descriptions of the different arenas where children are being socialized, but they are brought together in the final chapter, first as summaries of each of these arenas – the home, the neighbourhood and the kindergarten – and then as a series of principles which I felt were the basis of the system of classification being passed on.

The most important distinction made during the early period seemed to be that between the home (*uchi*) and the outside world (*soto*). This was not only stressed by the need to remove and don shoes, and utter fixed phrases of greeting, every time a child entered or left the house, but also reinforced in other aspects of the world being presented. The inside (*uchi*) of the house and its members were always associated with cleanliness, security, safety and trust; the outside (*soto*) was where dirt, danger and fear were left behind. Cooperation and compliance with those on the inside, including later the nursery carers and kindergarten teachers, ensured fun, harmony and general good cheer; a reluctance or an aversion to joining in with the expectations of adults and other children became associated with tears, isolation and ostracism.

Gradually also the child begins to build up another distinction, namely that between the *inside* and the *outside* of its own self. In order to comply with the expectations of adults and other children in a variety of circumstances, it learns to adopt a suitable face to show to the world, and it learns to suppress its own personal (selfish) wants and needs in the interest of the wider group to which it belongs. Through more complex classificatory principles of *hierarchy* and *equality*, *reciprocity* and *obligation*, it learns to *cooperate* with social expectations and adopt a front (*tatemae*) for the world which it can gradually distinguish from the real, personal feelings (*honne*) which lie beneath.

Socialization: Mother teaches two-year-old to fold his clothes.
Courtesy of Joy Hendry.

Wider Applications of the System of Classification

The distinction between *uchi* (inside) and *soto* (outside) is found throughout Japanese society. It is used to distinguish members of any organization from those who do not belong, from the home in the first instance, through the kindergarten, school and university, to the workplace and even common interest groups for hobbies, sports and so forth. An individual is also usually surrounded by a series of ever greater *uchi* groups, at least at an ideological level, with the home at the centre, followed by the neighbourhood or village, the wider town, city or district, the prefecture, and ultimately, Japan as a whole, each being invoked only at the appropriate level, perhaps, for example, to generate support for some venture.

The relationship between the *uchi/soto* distinction and that between *tatemae* and *honne*, mentioned above, is not necessarily one to one, since there may be several different types and layers of *tatemae* depending on the occasion and the specific group involved. However, the idea of distinguishing between the front presented to the world and the differing opinions held beneath may clearly be seen as parallel to the inside/outside dichotomy, and it is also a distinction found, and explicitly recognized, throughout Japanese society. In any situation, then, one should always behave in a way which is appropriate to that situation, rather than worrying too much about being consistent between situations.

This distinction, and its importance in social relations, fits in very well with the assertions made above about the way Japan's modern, often Western-seeming veneer should not be taken entirely at face value. In fact, this impressive front may be described as a very skilful piece of cooperative *tatemae* designed to fit the

international world which Japan for long wanted so desperately to join. In fact Japan has recently become more confident in her own social configurations, so that her front for the world now also includes much Japanese culture, but the principle of needing to look behind the veneer still remains of the utmost importance in understanding Japan and her people.

Family and Marriage in Japan: A Structural Approach

The "Family System"

One way in which anthropologists make sense of a modern, complex society like Japan is to seek structural principles which underly various manifestations of social behaviour in different arenas. Within the bounded areas of their research, anthropologists make observations which apply only to that particular local group, but they may also be able to identify principles of social order which are more widely applicable, albeit in forms modified to suit different conditions. This section will introduce some basic units of social organization, and then demonstrate how a structural principle may be argued to be more widely applicable.

The idea of the Japanese "family system" is an emic construct, created out of actual *samurai* practice and codified at the beginning of the Meiji period (1868–1913), partly in response to the abundance of Western influence which seemed to some to be getting out of hand. The issue of the family provoked controversy in the government of the time since feelings were divided about whether it should be abolished to make way for "progress", or whether it should be retained as essential for an orderly social life along the Confucian lines which were held to support it. The latter view prevailed and elements of the system were included in an imperial rescript which schoolchildren were to learn by heart.

The chief characteristic of the pre-modern Japanese family, which has been described in many reports, anthropological and otherwise, was the house or household, known in Japanese as the *ie*. This was a continuing unit which was perpetuated through time by a single married couple remaining in the house in each generation. This couple would live with their children and any remaining senior generations, together with their unmarried siblings. The unit as a whole held property, status, and usually also a household occupation, and each member of the house would be expected to work for the house and uphold its reputation.

The headship would be passed down, usually in the male line, although there were some regional variations about whether it should pass to the eldest son, the youngest son, or even the eldest child regardless of sex. The most important aspect of the system of inheritance was that there be continuity of the *ie*, so the specific relationships could be quite varied, although *primogeniture* was the system codified in the Meiji period. If there were no sons, a daughter's husband was regarded as a good substitute; if there were no children at all, a more distant relative, or even a stranger, could be adopted to play this role.

Other siblings would be expected to move out of the house, usually on marriage. Daughters, and sons who were to be adopted into houses with no sons, would very

Members of a family clean their ancestor's tomb before offering incense and new flowers at a cemetery in Tokyo's Tosima ward during "Hugan" (the equinoctial week). Almost all Japanese Buddhist families visit their ancestors' tombs to pay their respects to the spirits of their ancestors during the week, particularly on 23 September, the Autumnal Equinox National Holiday.
Courtesy of Japan Information Service.

often marry into other established houses, setting up affinal links which would persist for three or more generations. Where economically viable, a few non-inheriting sons would set up branches of their house of birth, and these main house/branch house links would in certain regions persist for much longer, in the north of Japan often playing an important part in local politics.

Within the household, each member was expected to put the needs of the *ie* before their own personal interests, and all were regarded as temporary incumbents charged with the care of a continuing unit. This unit included the ancestors who went before them, remembered daily with offerings of the first rice, and less frequently with flowers and other gifts, at the Buddhist altar which held their memorial tablets. It also included a notion of descendants who would follow, and the living members were expected to do their best to provide and rear children to this end. A wife or adopted husband who seemed unable to fulfil this role would be returned to their original house, as they would if they failed to fit in for some other reason.

Personal relationships within the house were somewhat variable from one region to another, and indeed, from one house to another, but they were generally expected to follow the broadly Confucian-backed lines of deference from female to male and from younger to older members, with birth in the house and the expectation of permanancy also giving some priority. The head had overall legal responsibility for the whole house, and he would very often receive preferential treatment by,

for example, being served first at meals, his heir usually taking second place. A daughter-in-law would come under the tutelage of her mother-in-law, and for some time retain the lowest status, although the birth of a son usually improved her position. An adopted son-in-law was typically regarded as having rather low status too.

Generally, each generation was expected to give loyalty and devotion to those members of the senior generations which preceded them, obeying them during their youth and caring for them when they retired and grew old and perhaps helpless. In return the senior generations were expected to care for the junior ones, and offer them support and benevolence as long as they were able. Members of the *ie* were thus forever bound into relations of dependence and obligation to one other, either as members of the same house, or, for those who moved out, in relations between houses.

Industrialization

With industrialization, the manufacturing and trading houses themselves grew according to the old main house/branch house principles, forming the powerful *zaibatsu* which preceded Japan's successful modern enterprises. New opportunities arose for non-inheriting siblings to go off to work in cities, and the concerns they joined tried to look after their employees in the way that the *ie* they had left in the country had done. They even created a system whereby personal links at different levels of the organization were modeled on the parent/child relations of benevolence and loyalty described above. Again, employees were tied into relations of obligation, as were the employers who adopted the system, both to their employees, and often also to other branches of the enterprise.

These urban employees formed nuclear families, sometimes accommodated by the husband's company, and this unit of parents and children proliferated as time went by. In the Civil Code which was drawn up during the Allied Occupation after World War II, the *ie* was abolished as a legal entity, and couples are now required to register themselves as a new unit on marriage. All children are supposed to have equal rights to inheritance and to share responsibility for the care of their parents. According to the Constitution of 1947, laws pertaining to the family, marriage, inheritance and so forth "shall be enacted from the standpoint of individual dignity and the essential equality of the sexes" (Article 24).

These values were imported directly from the West, and are at some variance with the system which was operating before that. Nevertheless, in the post-war efforts to catch up, Japan tried, at least superficially, to bend over backwards to accommodate Western ideals, where these were thought to be beneficial. As she began to "modernize", by Western standards, those who advocated the convergence of social organization along with technological advance, expected Japan's family arrangements to grow more and more like those of Western "modern" countries, and they would cite the proliferating numbers of nuclear families, and the results of attitude questionnaires to prove that it had.

This is a superficial interpretation of post-war change in Japan, however, and the detailed work of anthropologists has made a much deeper and more satisfactory contribution. The article by Okpyo Moon has already been mentioned, and her book, *From Paddy Fields to Ski Slope*, is a further development of the argument. It examines just how economic change, in the form of a new and thriving tourist

industry, has affected the *ie* and the community. Not only has this influx of wealth and employment helped to maintain many of the long-held principles of social organisation, it has actually reinforced and revitalised them in adapting to the new situation. Her study also provides a detailed account of social change within this new economic situation.

Anthropologists working in the country have generally reported the persistence of the *ie* system, albeit in a modified form. Jane Bachnik's article in a 1983 edition of *Man* is a good example of the value of long-term research for providing a really insightful account of the conceptualization and workings of the *ie* as she observed it. She discusses the relationship between notions of kinship and the *ie*, and considers the whole question of inheritance in terms of recruitment strategies, of which kinship is merely one possible option. This approach not only illuminates the post-occupation version of a long-standing Japanese institution, but develops theoretical perspectives about "domestic groups" which could be used in a comparative context.

It is not only in the countryside that the *ie* is still found, however, and Bachnik suggests an approach which aids an understanding of its persistence elsewhere:

> ...the continuing existence of small and medium-sized enterprises, their connexion to larger enterprises and the related questions of subcontracting links and non-permanent employment in the Japanese system can all be better approached if the ie is primarily viewed, not as a kinship organisation, but as an enterprise one. (1983:177)

Indeed, in urban areas, the *ie* has certainly very often persisted, even in residential form, where there has been a business concern, preferably with premises, to pass down through the generations.

Application of Family Ideology

There are more elusive ways in which Japanese family ideology has persisted through some forty-five years of legal non-existence, however. An anthropological argument of a structural nature can identify the principles of the *ie* in many other areas of modern Japanese life. The argument of Nakane Chie, put forward in her book *Japanese Society*, has been criticised for being too all embracing and for ignoring many cases which fail to fit her model. However, it is clear to anthropologists, if not to some other social scientists, that she has identified a structural principle which is very pervasive, whereby the reciprocal relations of loyalty and benevolence, outlined above, are serving as a model for relations in many other spheres.

Nakane argues that these relations may also be observed between teachers and pupils, landlords and tenants, politicians, adherents to religious sects, and, perhaps more strongly than anywhere else, between gangsters and their accomplices. A Japanese expression for the type of relationship, discussed by many writers besides Nakane, is *oyabun/kobun*, literally, "parent-part/child-part". Other aspects of the *ie* ideology are invoked by Nakane to explain other features of the more complex urban society Japan has become, for example:

> A company is conceived as an ie, all of its employees qualifying as members of the household, with the employer at its head...this 'family' envelops the

employee's personal family; it 'engages' him 'totally' (marugakae in Japanese).
The employer readily takes responsibility for his employee's family, for which,
in turn, the primary concern is the company, rather than relatives who
reside elsewhere. (1973:8)

She, too, uses this evidence to argue against stereotyped views of modernization
or urbanization, and asserts that "the basic social structure continues in spite of
great changes in social organization" (*ibid.*).

There is of course great variety in family life in modern Japan, and indeed, in
the extent to which companies adopt a familial attitude towards their employees.
This does not destroy the classificatory principles, however, still called upon for
various purposes throughout Japanese society. An anthropological study of Japanese
National Railways before they were fragmented and privatized looks at this very
subject in examining what the much quoted notion of the One Railroad Family
meant for different people at different levels of the huge organization (Noguchi,
1990).

Weddings: A Case Study

The presence of an underlying structure is revealed in various ways, not least
through the system of classification, but both may be discerned through symbolic
communication. A book by Walter Edwards, entitled *Modern Japan through its*
Weddings, illustrates both the interpretation of symbols to reveal various ideas
which lie behind them, and also demonstrates in some personal detail how an
anthropological study may proceed in a complex society.

A bridal couple in Japanese wedding kimonos makes a contrast with
another couple in western clothes at the scenic garden of a famous
wedding hall in Tokyo.
Courtesy of Japan Information Service.

The anthropologist carried out his research while working as a casual helper at White Crane Palace, a commercial wedding hall in urban Japan. The symbols chosen for the gorgeous "performance" arranged for couples being joined in this way are predominantly Western, with the "cutting" of a huge empty cardboard wedding cake providing one of the climaxes, but Edwards argues that they actually represent rather conservative underlying Japanese values.

In contrast to Western expectations of individualism, and individual autonomy as a measure of maturity, Edwards argues that this wedding clearly portrays that the Japanese individual is alone "incomplete" and incapable of reaching maturity without recognizing the need to admit this incompleteness. Marriage offers an occasion for accepting the perceived complementary incompetences of men and women, and also allows them to gather and acknowledge a number of other groups of people with whom their lives, as a couple, will be necessarily inter-dependent.

Edwards describes in some detail how he works to identify meaning in this ritual event, and relates it to wider social relations. He also describes the circumstances surrounding his research. He is himself half-Japanese, but born and brought up in America, married to a Japanese wife. Much of the exercise is personalised, but this is quite insightful to a reader trying to identify the nature of anthropological endeavour. The book is also a good illustration of Japanese skills of incorporating and adapting foreign elements in their rituals.

Alternatives to the Structural Model

Nakane's work, together with that of some of the other early observers of Japanese society, has been criticized for emphasizing a too harmonious view of the workings of Japanese groups, indeed for emphasizing the importance of the group as a feature of Japanese society apparently over and above all other considerations. This so-called "group model" has been delineated by the anthropologist Harumi Befu. Befu suggested various respects in which this model is wanting, back in the late seventies (see Befu, 1980), and has since been offering alternative models for interpreting and understanding Japanese social behaviour.

Befu characterizes the group model as one in which cooperation and conformity are regarded as prime virtues, whereas open conflict and competition are seen as being taboo, subject to social sanctions such as ostracism and ridicule. It depicts members of the group as selflessly working towards the goals of the group, the leader with benevolence and magnanimity helping and supporting his followers, who in turn express uncalculating loyalty and devotion. Such qualities of Japanese society he argues are put forward, amongst others, to explain Japan's economic success.

In practice, as Befu points out, Japan is, like any other society, "riddled with all kinds of conflict and competition". The group model is an ideological statement rather than a proposition about actual behaviour, and Befu turns to the emic Japanese terms *tatemae* and *honne* to help explain this distinction, although he points out that neither refers to actual behaviour. The former is a front, an official view, whereas the latter is what any one individual will actually have in his or her mind. The notion of the company as one big harmonious family is evidently

an example of a *tatemae* description, which is never expected to represent reality, although it might be held up to inspire it.

Befu's suggestions for new models include the application of social exchange theory to Japanese social interaction, or at any rate an approach which would look at the individual in Japanese society, and examine indigenous notions of personhood. He points out that observers from societies which emphasize individualism as an ideal tend to oppose this feature with the so-called "groupism" of Japanese society, thus ignoring both the individual in Japan and the collective in their own societies. (Edwards' study, cited above, examines some of the more complex reasons why this has happened.)

Befu points out also that this tendency to emphasize the behaviour of groups in Japan is likely to remain firmly in male worlds. The "large-scale organizations with several hierarchical tiers" are for the most part the preserve of men, at least on a long term basis, and focusing on this area of Japanese society tends to leave women and their lives out of the analysis almost altogether. At best, they appear as temporary employees for a few years before they marry, but their own lives are usually much more complex than this, rarely involving long-term commitment to highly structured groups.

A study which gets around both these problems starts from the point of view of individual women and examines the way in which their lives are "crafted". In *Crafting Selves: Power, Gender, and Discourses of Identity in a Japanese Workplace*, Dorinne Kondo describes her own experiences working with Japanese women (and men) creating cakes and confectionary. This book is interesting on several levels.

Carrying banners and demanding shorter working hours, members of labour unions affiliated with "Rengo" (The Japanese Trade Union Confederation) march through the streets after attending a Central May day rally at Yoyogi Park in Tokyo.
Courtesy of Japan Information Service.

It is a detailed description of fieldwork, and some of the problems it brings; it is an interesting example of the reflective approach to the subject, recently sought among some anthropologists; and it is a charming insight into the lives of real Japanese individuals. It has an introduction which places the succeeding text within the anthropological theory of the period, but this may be skipped by a novice to the field without hindering an appreciation of the rest of the book.

Befu's objections to the so-called group model are based on a knowledge and understanding of anthropological theory, and aim to push further our understanding of Japanese society beyond what he sees as a limiting approach. Other objections to the approach of Nakane lump her together with a number of other Japanese academics who have written theories purporting to explain Japanese uniqueness, and which form a numerous collection of sometimes rather far-fetched and totally unscientific work. The problem here is that notions such as harmony, consensus and cooperation have become buzz words which characterize these theories, and there is a corresponding set of work which aims to counteract it by emphasizing conflict in Japanese society.

The advantage of an anthropological approach is that it labours under no illusions about the *ideological* nature of the notion of harmony in Japanese society. Anthropologists expect to find conflict in any society, but they know that there will also be methods of resolving it, and this is what they are interested in finding out about. A book edited by S.N. Eisenstadt and Eyal Ben-Ari, entitled *Japanese models of conflict resolution*, is a collection of papers which address the subject in a comparative perspective, including contributions from an economic, historical, sociological and political standpoint, as well as the anthropological one. The final paper in this book is another contribution by Harumi Befu, who summarizes four approaches to understanding aspects of the complex society Japan has become.

Befu has also tackled the interesting question of why Japanese writers have been so keen and so popular when offering explanations of their own society, very often emphasizing elements which they present as unique to Japan. In a period of great influence from the outside world, particularly the West, he argues that Japanese people have been suffering from a need to reestablish their own identity. These writings make overly stark comparisons between Japan and a mythical monolithic "West", partly to confirm characteristics of Japanese culture which looked in danger of being swallowed up during the waves of industrialization and modernization which swept through the country (Befu, 1983: 232–66).

For an outsider to the field it may be difficult to distinguish these theories of Japaneseness (*Nihonjinron*) from the approach of the anthropologist, who needs to make careful descriptions of a particular society, Japan included, before proceeding to make comparisons informed by knowledge of a wide range of forms of life. Nakane, for example, was inspired by fieldwork in India. Many of the anthropologists who have worked in Japan have been Western, however. Even the Korean anthropologist, Okpyo Moon, was trained in the UK. The theoretical bias is therefore often Western, which may help to cloud the distinction.

The introduction to *Interpreting Japanese Society*, and the first article, on the post-1945 anthropology of Japan by Jan van Bremen, address precisely these questions, and attempt to extricate anthropological work from being classed together with the often overly simple theories about Japaneseness. An attempt is also made there to clarify the value of an anthropological approach in the case of Japan. A more recent collection of papers, *National Traditions in Japanese Studies* (Befu

and Kreiner, 1991) addresses the question of national bias in the study of Japan. Here scholars from a variety of different countries examine the work of their compatriots for signs of local bias, aided by Japanese scholars conversant with each of the countries included.

Religious Practices, Cosmology and Syncretism

This last section will set out to demonstrate one of the ways in which the variety found in a modern society may be examined and interpreted from an anthropological point of view. The choice of religious practices as a focus also provides a way of illustrating the persistence, but also modification, of several layers of outside influence which have swept through Japan during the period of recorded history, and even beyond. This long-term approach also makes it possible to put into perspective the current emphasis on Western models for the front which Japan presents to the outside world.

What follows will necessarily be a cursory view of each of the elements discussed, and may, from an Asian perspective, appear to be an oversimplification of the bodies of religious tradition considered. The aim, however, is to demonstrate, through an examination of the rich mix of *syncretism* now available to members of Japanese society, the way one people may adopt and adapt elements of cultural tradition from outside and still retain their own specific characteristic features.

Over the centuries, various religious movements have been influential in Japan, along with the introduction of other features of culture from her neighbours and further afield. Many of these were originally introduced during the huge influx of Chinese civilization between the sixth and eleventh centuries which also included the adoption, almost wholesale, of political and bureaucratic organization, as well as architectural style and forms of everyday and artistic activity. The religious elements include various manifestations of Buddhism, Confucianism and Taoism, all of which have, over the years, taken on a variety of Japanised forms, some even eventually being exported again.

Even much of the so-called indigenous Shinto (a name introduced first to distinguish Japanese practices when these other religious elements were introduced), which forms the basis of Japanese mythology, accounting for the alleged source of the imperial line, and resorted to extensively to support more recent military incursions, was originally largely imported from Korea, along with stone tools and rice cultivation. Current practises are now distinctively Japanese, of course, and over the centuries, there have been conscious attempts to amalgamate different strands of religious tradition, for example conflating boddhisattvas with Shinto deities, and encouraging joint ritual practice at a single sacred site. Nowadays, Shinto shrines and Buddhist temples are usually separate, but Japanese people turn fairly indiscriminately to either, as well as to a range of other sources of support, for a variety of needs.

Illness, for example, will probably be taken to a regular hospital for treatment, but the same patient may also visit a herbal specialist, an acupuncturist, a diviner and a variety of shrines and temples, if the symptoms persist for long enough (see,

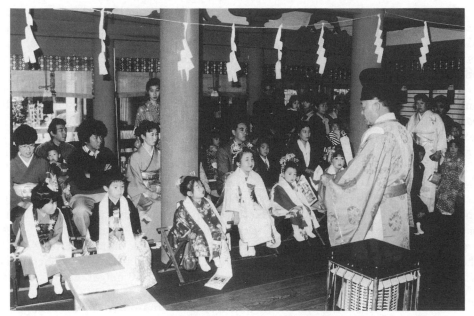

Children in their best kimonos are purified by a Shinto priest before praying for continued growth and good health at a shrine in Kofu city on Sunday, four days before the 15 November "Shichi-Go-San" (Seven-Five-Three) festival for children aged three, five and seven. Since this festival is not an official holiday, some parents now take their children of these ages to shrines on the preceding Sunday should 15 November fall on a weekday.
Courtesy of Japan Information Service.

for example, Ohnuki-Tierney, 1984a). Here is a good example of the Japanese version of syncretism, for different belief systems are being invoked in each individual case – Western science, Chinese science, Taoism, Shinto and Buddhism. Japan is very tolerant of and pragmatic about the ideas they import from abroad. If they might work why not give them a try?

This is quite a different view from that of the Christians who have come to Japan to try and spread their faith, first in the sixteenth century, and later in the nineteenth and twentieth. Their limited success may be related to their exclusiveness. In my own experience, followers of Christianity tend to cut themselves off from their neighbours and other associates by adhering to this one faith. The work of Christians has not been ignored, however, and Japan has many fine hospitals and educational establishments founded and run by Christian organizations. Again, if they have something to offer, they are accepted.

During the life of a single Japanese person, who may well claim no religious faith if asked directly, activities will very likely include most, if not all of the following elements: visits to Shinto shrines during a series of childhood ceremonies, first as a baby, then at various stages of development; a Christian or Shinto wedding ceremony; discussions invoking Confucian, neo-Confucian (and possibly Christian) morality, appeals to a Taoist/Buddhist/Shinto healing practitioner, and attendance at a number of Buddhist funerals and memorial services.

Trips and travel in Japan very often also include apparently fairly casual visits to shrines and temples, invariably placed at the most scenic sites the country has to offer, and more directed visits may be made at times of particular stress, such as before examinations or childbirth, during illness or inauspicious years, and to offer prayers after the decease of a loved one.

Large numbers of Japanese people have in recent years attached themselves to one or more organizations collectively described as New Religions. Often originally based on more ancient traditions, these movements have usually developed out of a variety of transcendental experiences which their charismatic leaders claim to have had, and on the basis of which they devote their lives to attracting followers. Some are more successful in terms of numbers than others; some, like Soka Gakkai and the M.O.A. Foundation, have made considerable impact abroad.

Elements of millenarianism are common in the ideology of these movements, and they display many of the characteristics of cults which have arisen in other parts of the world during times of social upheaval. In the case of Japan, these organizations very often provide for city dwellers very pragmatic benefits, such as the security and companionship they have lost by moving away from the country, where they were surrounded from childhood by friends and neighbours. They also often offer help with very specific ailments.

Winston Davis's book *Dojo: Magic and Exorcism in Modern Japan* (1980) is an excellent ethnography of such a movement. Although his background is in religious studies, rather than anthropology, Davis carried out his research through participant observation in the *Sukyo Mahikari* (True-Light Supra-Religious Organization), becoming initiated as a practising member. He also refers to anthropological and sociological theory in his analysis, making several comparisons between his Japanese findings and those of Malinowski (1954) among the Trobriand Islanders.

This sect attributes misfortunes of all kinds, from illness to the breakdown of a motor car, to the activities of evil spirits. The "treatment" for these misfortunes is to cast out the spirits, and members of the organization are given the power to do this exorcism themselves. Davis examines the teachings and practices of this sect in their historical and social context, and details a number of case studies to illustrate the reasons why its members have come to join it.

He discusses his findings in the light of prior theories of religion, and the relationship between religion and magic, although interestingly enough he argues that his material does not run counter to general theories of modernization, largely influenced by the work of Weber. Rather, he sees a place for the democratic version of magic which *Mahikari*, and other New Religions offer, in the "rational" world of industrialized Japan: "There is room...for churches of magic in modern industrialised societies, especially in those where, since earliest times, religion has been geared to the satisfaction of immediate needs and wishes" (Davis, 1980: 302).

From a different angle, then, Davis comes to a conclusion not that different from the one formulated by Emiko Ohnuki-Tierney, cited above, although they have adopted contrasting approaches to the subject of modernization theory. In the end, both are telling us that we must understand Japanese behaviour, religious and otherwise, within the Japanese system of classification, on the one hand, but both are also able quite happily to apply much broader theories (of cosmology, causation and symbolic meaning) to their Japanese material.

There is plenty of evidence, then, to refute theories of secularization in Japan, but, interestingly enough, a superficial examination may give a misleading impression. Asking a Japanese person if they are religious, or if they believe in a religious faith, is as likely as not to elicit a negative or highly qualified answer – e.g. "not unless I want something" – but the abundance of activity which is (or could be) classed as "religious" is quite at variance with this, and it seems likely that this response again reflects a view prevalent in the modern (usually Western) world. Some commentators have noted instead that the current Japanese interest in Japaneseness has elements of religious faith about it.

It is evident that a very broad definition of "religion" is needed to accommodate such an idea, but it is amenable to anthropological analysis. Notions of purity and pollution are among the characteristic features of Shinto thought, and these are rather pervasive in other ways, sometimes linking rather neatly with the *uchi/soto* distinction mentioned above. Ohnuki-Tierney (1984a: Ch. 2), for example, discusses these ideas in the context of germ theory, eventually concluding that both the "cultural germs" held responsible for illness (the pollutants) and the religious practitioners, Buddhist, Shinto or Taoist, credited with healing powers (the purifiers) are generally in marginal positions which fall at the boundaries of these important categories.

This is the same ambigious position in which "strangers" are placed, as the Japanese anthropologist, Yoshida Teigo, has pointed out, and these ideas can explain why, time and again, Japan, as a huge *uchi* group, has adopted and adapted the powerful (but possibly dangerous) ideas of their *soto* neighbours and other foreign associates. They are impressed with their power, which they want also to share, but they Japanize them to try and make them safe, at the same time representing what they are doing at a *tatemae* level, as in keeping with outside expectations. In the process, they manage to maintain the rather strict boundary between Japan and the outside world.

Fortunately, most Japanese people operate in everyday life in much smaller *uchi* groups than this. Indeed, their everyday interaction is very often within small-scale face-to-face groups rather similar to those studied by anthropologists all over the world. They live and work where they are well known, and they regulate their lives according to the expectations of their associates and colleagues. They need to adopt *tatemae* positions for dealing with outsiders to this world, sometimes even within the world. These are the groups which can be penetrated by social anthropologists and in which their deeper investigations can successfully be carried out.

Where to Next?

The most recent studies on Japanese society have been rather interactive, typically involving investigators with Japanese parentage, though perhaps born abroad, seeking their own roots through ethnographic study. This has been in keeping with a self-reflective mood in anthropology, known as *reflexivity*, where anthropologists are examining their own biases and assumptions as they work.

In something of the same spirit, anthropologists of Japan have been seeking anthropological theory which grows out of the Japanese material rather than being

imposed, sometimes rather awkwardly, from outside, usually Western, sources. Two recent collections of papers (Ben-Ari *et al.*, 1990; Goodman and Refsing, 1991), have pursued these aims. The first aims to "unwrap" Japan from the layers in which social science has enveloped it, following a metaphor suggested by Hendry in the same volume, that layers of "wrapping" can be found throughout Japan – in language, clothes, space and ordering of gatherings, as well as in the wrapping of gifts. Goodman and Refsing are interested in the relationship between ideology and practice in Japanese society.

An interesting line of inquiry for the future would be comparative study between Japan and her modernized Asian neighbours. Although Japan has led the field economically, several of her neighbours are now hot on her heels, and it would be fascinating to see how the relatively similar characteristics of modernization develop within these related, but now very different cultures.

15 A GLOBAL VILLAGE?

Anthropology in the Future

Grant Evans

A popular image of the anthropologist is of someone who goes off to live in an isolated village among "primitive" peoples. At one time this was a reasonably accurate presentation of the anthropologist's vocation, and perhaps many people still think that they should do something similar if they are to become *real* anthropologists. But in the late twentieth century it is hard to find a secluded village, while many contemporary anthropologists are realizing that previous images of totally isolated villages were more often than not an artifact of pioneering anthropological imaginings. Earlier anthropologists went in search of "traditional" societies, and they provided detailed ethnographic descriptions of kinship patterns and religious practices in them. They often ignored the trucks which rumbled through "their" village on the way to log the forest or to extract minerals and precious metals; and they usually discounted the effects of these activities on "their" people when they sat down to write their monographs. Many earlier anthropologists overlooked the fact that apparently remote peoples were, both in the past and in the present, connected to wider political and economic networks that structure the internal patterns of the societies under investigation. In a critique of the anthropologists of his own and more senior generations the late Edmund Leach writes:

> We went to the field to study 'traditional' society, not to look at what was there in front of our eyes. And, by definition, 'traditional' society was free from contamination by European traders, missionaries, administrators. It was not so much that the consequences of colonial history were invisible; they had to be deleted from the record in order to arrive at the pure essence of what had been there before. (Leach, 1989–90: 48–9)

Eric Wolf comments in his celebrated *Europe and the People Without History*:

> The concept of the autonomous, self-regulating and self-justifying society and culture has trapped anthropology inside the bounds of its own definitions. Within the halls of science, the compass of observation and thought has narrowed, while outside the inhabitants of the world are increasingly caught up in continent-wide and global change. Indeed, has there ever been a time when human populations have existed in independence of larger encompassing relationships, unaffected by larger fields of force? (1982: 16)

Wolf's book is a key statement of a new mood in anthropology, one which sets out a more complex agenda for anthropological research.

Macro-anthropology

One of the main theoretical challenges for modern anthropology is the construction of a dynamic concept of culture to replace the more reified and static idea of it which has prevailed in the past among anthropologists, and in the wider society. The idea of spatially fixed unified cultures was, as indicated in Chapter 1, a direct outgrowth of modern nationalism. Separate states legitimised themselves by making claims to integrated cultures. The idea of discrete cultures struck a deep chord among the populace of modernising societies, and in that peculiarly modern specialism, anthropology. It continues to do so, as can be seen in the myriad nationalist and micro-nationalist movements in the world today. But now when all nations on earth are becoming increasingly integrated economically, politically, and culturally, the idea of a Global Village (Marshall McCluhan's term) with a Global Culture has also emerged. Thus cultural integrity and cultural universalism vie with one another for the hearts and minds of the peoples of the world.

The reality of this accelerating interaction has provided the sociological backdrop for anthropological discussions of cultural interchange both in the past and in the present, and to a realization that cultures have always been changing. Wolf notes:

> Once we locate the reality of society in historically changing, imperfectly bounded, multiple and branching social alignments, however, the concept of a fixed, unitary, and bounded culture must give way to a sense of the fluidity and permeability of cultural sets...."A culture" is thus better seen as a series of processes that construct, reconstruct, and dismantle cultural materials, in response to identifiable determinants. (1982:387)

Moreover, he argues, these changes do not occur simply as part of the working out of an "internal cultural logic", but also in response to larger political and economic forces.

However, "macro-anthropology" presents certain dilemmas for an anthropological tradition which prides itself on documenting micro-worlds and on the "cult of fieldwork", as Gellner calls it. Yet, micro-analysis must remain a pillar of the anthropological enterprise; but how do anthropologists move "up from ethnography" to wider questions?

One response has been to turn to political economy and various strands of neo-Marxist thought which sought to place localized studies in the context of socio-economic development, more often conceptualised as "underdevelopment", and "world systems theory" as elaborated by Immanuel Wallerstein (Ortner, 1984). The basic argument of these authors is that capitalism has cast an economic, political and cultural net over the societies of the world, and that each day, each month, each year, this net is drawing tighter, irreversibly transforming all non-capitalist societies – including, in the late twentieth century, former communist societies – and creating "a world after its own image", in Marx's evocative phrasing.

The strength of this new orientation was that it upgraded discussions of power and the state into anthropological discourse. It drew attention to how capitalist

expansion out of Europe profoundly changed the societies of Asia, Africa, Latin America and the Pacific Ocean. Initially these global asymmetries were primarily economic and political, but in an era of mass communications they have also been cultural, in the form of ubiquitous American TV dramas, pop music, English language use, books, and commodities which have come to represent "cultural imperialism", such as Coca-Cola or McDonald's fast food. Combined with growing international economic interdependence and flows of millions of people as migrants, labourers, refugees or tourists, these cultural flows have led to speculations about "global culture" (Smith, 1990).

While it is clear that there are many elements of culture which are coming to be shared worldwide, the image of an asymmetrical cultural flow from centre to periphery cannot be sustained. Anthropologists influenced by political economy, and others, have also built up an impressive list of studies which document cultural resistance to change imposed by the larger world, and they have documented localized responses which become new cultural elaborations. The articles contained in *Everyday Forms of Peasant Resistance in Southeast Asia* edited by James C. Scott and Benedict Tria Kerkvliet (1986) and *History and Peasant Consciousness in Southeast Asia* edited by Andrew Turton and Shigeharu Tanabe (1984) are notable examples. While Aihwa Ong's study, *Spirits of Resistance and Capitalist Discipline: Factory Women in Malaysia* (1987) is a powerful illustration of this style of analysis in an urban setting.

Other anthropologists have become interested in understanding "the translocal, transnational organization of meaning". Ulf Hannerz argues: "The macro-anthropological project entails a strategic selection of research sites which would take ethnographers to those interfaces where the confrontations, the interpenetrations and the flowthrough are occurring, between clusters of meaning and ways of managing meaning; in short, the places where diversity gets, in some way and to some degree, organized" (Hannerz, 1989:211). Thus rather than studying allegedly "pure" cultural forms the anthropologist begins to document "hybrid" or "creole" forms of culture which draw on a wide cultural inventory. In a sense, they appear to be arguing, "we are all creoles now!"

There are many sites at which this type of anthropological research can take place, but one which most readers of this book will have already visited and participated in is *tourism*.

Tourism and the Search for Cultural Authenticity

Internationally famous French ethnographer Claude Lévi-Strauss's *Tristes Tropiques*, an account of his trip to South America and his fieldwork there, has been described somewhat irreverently as "one of the greatest travel books of the postwar period" (Cockburn, 1987). But there is undeniably an uncanny and perhaps uncomfortable resemblance between the tourist and the anthropologist. I recall, several years ago when I attempted to take the photo of two Hmong women in a market in the remote highlands of Laos, being almost offended when their husband intervened to ask for money. In his eyes I was a tourist. (I was also stunned by the fact

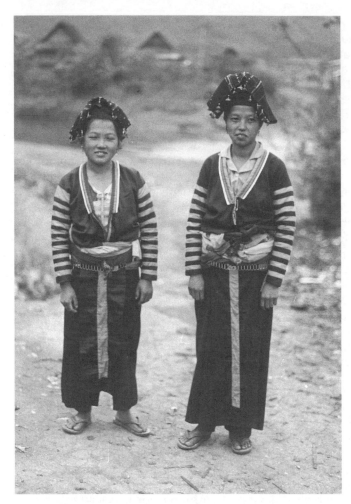

"I recall several years ago when I attempted to take a photo of two Hmong women in a market in the remote highlands of Laos, being almost offended when their husbands intervened to ask for money."
Courtesy of Grant Evans.

that a practice which is common in neighbouring Thailand had made its way to an area where there are no tourists.) In *Tristes Tropiques* Claude Lévi-Strauss writes:

> *Journeys, those magic caskets full of dreamlike promises, will never again yield up their treasures untarnished. A proliferating and over-excited civilization has broken the silence of the seas once and for all. The perfumes of the tropics and the pristine freshness of human beings have been corrupted...The first thing we see as we travel round the world is our own filth, thrown into the face of mankind. So I can understand the mad passion for travel books and their deceptiveness. They create the illusion of something which no longer exists but still should exist...There is nothing to be done about it now...Mankind has opted for monoculture; it is in the process of creating a mass civilization... (1975:37–8)*

The mood of nostalgia which pervades this passage of Lévi-Strauss is common not only to much anthropology, but also to travel brochures.

Tourists are invited to visit peoples "untouched by civilization", to witness "timeless rituals", and photograph villagers who still practise "ancient traditions", and produce "authentic artifacts". But exposure to tourism soon "spoils" these destinations, and hence to cater for those in search of the "exotic" yet another village or culture is discovered by an insatiable tourist industry. Anthropologists, too, once went in search of "pristine", "untouched" cultures and not surprisingly their work has often blazed the trail for later tourism, or become a kind of respectable prop for the large and glossy tourist guidebooks that proliferate in Asia and elsewhere.

But, appropriately, anthropologists have begun to study tourism in earnest rather than disdain it, and the results so far have been fascinating, not only because of what has been documented but also because of the way it has challenged more static definitions of culture. Nevertheless old ideas die hard, and some of the main concepts that anthropologists have used to try to understand tourism, such as commodification of culture and that of staged authenticity, still reflect earlier pre-occupations. The idea of the commodification of culture is easy enough to understand. It refers to a situation where artifacts which previously circulated among a group because of their usefulness or because they had some ritual or religious significance, become objects which are produced for exchange in a tourist market. Carvings, paintings, miniature houses, and so on are produced by the thousands for consumption by tourists. Also, traditional dances and ceremonies, once performed at festivals or on religious occasions, become part of the tourist industry's repertoire. In this way tourism is said to strip these activities of meaning by reducing each of them to the status of a commodity which can be bought and sold like any other. This latter idea overlaps with the concept of staged authenticity. That is, where a cultural performance which has been designed especially for the tourist market is presented as if it is an authentic traditional performance. Or places are created, such as the Sung Dynasty Village in modern Hong Kong, as examples of authentic China.

An excellent arena for testing some of these ideas is Bali, whose name is almost synonymous with "Tourist paradise". The results are illuminating. Michel Picard's detailed study of cultural performances and tourism in Bali shows how various individuals and agencies have laboured to construct an idea of "authentic" Balinese culture – Dutch colonial officials, Balinese intellectuals, and Western anthropologists, most notably Margaret Mead (Pollman, 1990) who also popularised the "Pacific paradise" of Samoa. As he remarks, from the beginning all of them were sure that they were "witnessing the swan song of a traditional culture miraculously preserved right up until then from the corrupting influences of modernity" (Picard, 1990: 40). They saw tourism as a source of cultural pollution and disintegration.

Picard focuses on dramatic performances because this is the main cultural interface between the Balinese and tourists. The dilemma for the Balinese, some anthropologists have argued (McKean, 1977), arises from the fact that they believe a divine audience is present at their performances and that it would be sacrilegious to present these to tourists. The problem is overcome by distinguishing between performances for locals and for tourists, for whom they add "inauthentic" performances. What Picard discovered was more problematic.

In contrast to "art" in the modern world, dance and painting in Bali had been an integrated social activity. With the tourist industry, however, the Balinese

faced the peculiar situation of having to provide a foreign audience with an interpretation of their culture. From the arrival of the first tourists in 1920 onwards the Balinese have tried to convert performances into entertainment, usually by de-contextualising them. "Some [dances] were removed from their original theatrical context to be transformed into solo dance (*Baris, Topeng, Jauk*), some were originally designed for the tourists (*Panyembrama, Oleg Tamulilingun*) while others are abridged or simplified versions of court dances (*Legong Keraton*)...These performances, nowadays rigorously standardized, were readily dubbed 'Legong Dance', even if they did not conserve anything of the original *Legong* except its name" (Picard, 1990: 50). But most interesting was the outcome of a furore which erupted in the 1960s when the Bali Beach Hotel decided to open its "Legong Dance" with an authentic temple dance, the *Pendet*. Tourists, it was said, were being treated in the same way as the gods! The controversy was resolved by the composition of a new dance by the Conservatory of Music. "Entitled *Panyembrama* (literally 'that which is offered to the guests') or else *Tari Selamat Datang* ('welcome dance'), this new creation from then on replaced the *Pendet* as a curtain-raiser to the tourist performances. Later on, this tourist version of a temple dance was brought back to the temple, as dancers who had learned the *Panyembrama* at the Conservatory began to perform it instead of the *Pendet* during temple festivals" (1990: 52). For the actors themselves the *Panyembrama* has become Balinese "tradition".

This feedback of tourist entertainment into Balinese ritual activity is both fascinating and simultaneously disturbing for static intellectual conceptions of "traditional" culture, because culture *in process* will always slip through their fingers. Picard, for example, carefully documents how the Balinese authorities

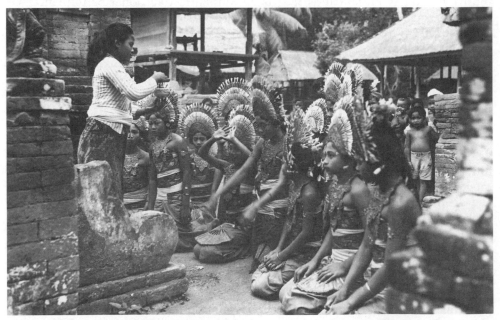

Young Balinese dancers having holy water sprinkled on them before a performance.
Courtesy of Roeder.

tried in the early 1970s to arbitrate cultural matters and separate the "sacred" from the "profane". They claimed there were *wali* or sacred dances exclusive to the temple, *bebali* or ceremonial dances not necessarily confined to temples, and *balih-balihan* secular dances. The problem is, Picard discovered, few Balinese performers or other informants could easily make these distinctions. A further discrimination was added by the authorities: *wali* required the consecration of the dancers and their equipment – such as headdresses, masks and *kris*. Without consecration *wali* performances were not sacred. However, the performers insisted on consecrating their masks and other paraphernalia. Why? Because consecration brought them "alive" and thus ensured success with the audience, including tourists. But, "through the use of consecrated masks of *Rangda* and *Barong*, a tourist performance of 'Barong and Kris Dance' may become magically efficient, and therefore dangerous. Hence, ritual precautions are required, such as the use of so-called 'redeeming offerings'..." (1990: 69–70) This leads Picard to conclude that ordinary Balinese are not worried about "confusing" the sacred and the profane, or about separating entertainment from ritual. "In short, while the regional authorities endeavour to 'disenchant' parts of the world, the dancers continue to move in a totally 'enchanted' world" (1990: 70).

Yet, what looks like the persistence of "tradition" in the face of a massive tourist onslaught is in reality a transformed culture. Tourist performances are

Sex tourism in Thailand.
Courtesy of Shosuke Takeuchi.

now Balinese "tradition", and this is a direct outcome of the promotion of "cultural tourism" which has instructed the Balinese about their own "cultural heritage". Thus, in the words of Adrian Vickers, Balinese culture, as "expressed in art and religion, is what is promoted in tourist literature, what tourists come to see, and what is eventually accepted by the Balinese themselves as a definition of what is important in their own society" (quoted by Picard, 1990: 74).

Where does this leave concepts like staged authenticity or commodification of culture? Obviously, their critical implications must be seriously qualified. Historically human cultures have always been in a process of change, more or less rapidly, sometimes induced by outside forces, sometimes by internal ones. Tourism is merely one of the latest episodes in this long history of change. "Tradition" and its evocation of timeless cultures is an illusion. There are no "cold" societies or "peoples without history", there are only "hot", changing ones. Nevertheless, the above concepts do retain some critical efficacy in that they draw attention to power asymmetries and make anthropologists ask questions about how, in a situation of choice, cultural changes have been forced on a people and previous cultural meanings spirited away from them and not replaced. Tourism, in some situations, has been culturally destructive and degrading. Sex tourism in Asia is one example among many (Phongpaichit, 1982; Thanh-dam, 1990). The ambiguous results of tourism can be seen clearly in relation to ethnicity.

Tourism and Ethnicity

As Ananda Rajah and Lian Kwen Fee show in Chapter 9 ethnicity, like culture, is something which many people believe to be fixed. But as they demonstrate people either construct, reconstruct, or lose their ethnicity in response to a range of influences, to which we can add, tourism. Generally, ethnic tourism is where the people from minorities are "on show". The difference with the case of Bali given above is only one of degree. The Balinese are a Hindu religious minority in Indonesia, but within Bali there are the Aga people living in the mountains, who are sometimes presented as the original Balinese. Hilltribe Tourism in northern Thailand and its flourishing handicraft industry is one highly visible instance of ethnic tourism.

While tourist brochures often present the hilltribes of northern Thailand as remote exotic people, relations between these various groups and lowland states go back centuries, as the ritual and trade relations referred to by Paul Cohen in Chapter 7 reveals. In recent years these contacts have intensified along with state education and tourism. The most spectacular and well-publicized aspect of this relationship is the production and trade in opium conducted by some highland groups. But while opium growing is a key exotic motif in Thai tourist promotions, it is also the target of state action and suppression.

Penetration of the mountains by tourists is now highly organized, and some villages have become completely oriented towards the tourist market. One-day excursion tours to these villages are organized from Chiang Mai. Others go on "Jungle Tour" treks through the highlands, normally taken by younger tourists in search of "authentic tribal life" and a counterpoint to modern urban life. They often shudder when they find these people using, for example, plastic cups because

it shatters their stereotypical image of hilltribes. While there is, according to Eric Cohen, some genuine cultural interchange, the process can cause profound changes among the highlanders. He writes: "Hill tribe tourism has not been initiated by the villagers themselves, nor do the villagers have a say in its organization and the direction or regulation of its development. Tourism amongst highlanders is not conducted primarily with a view to furthering the economic or other interests of the villagers. Rather...hill tribes are an attraction, and tourists are brought to view them as they would view any other natural or historical sight" (Cohen, 1983: 314). The impact of tourism can be seen in the growing commercialization of relations between hosts and guests, the creation of tourist spaces within villages as headmen (most typically) construct special houses for visitors, and in conjunction with tour guides begin to make money out of the tourists. Some of these even become sensitive to the tourists' search for authenticity and during visits hide from their eyes any signs of modernity. The cornering of the tourist market by some village groups can lead to tensions between those able to gain from the visitors and those who cannot (Seewuthiwong, 1989: 417). Excluded villagers, or those from villages which are off the beaten track, are reduced to begging and are disdained by tourists for it. But begging, according to Cohen, entails an insistence by hill people on a minimal form of reciprocity from tourists who come to look at them and photograph them. (Cohen, 1983: 319) Economically some villagers can make reasonable money by engaging in porterage for tour groups (Seewuthiwong, 1989: 417). But the flourishing of hilltribe handicrafts has probably been one of the most lucrative activities. But here too the results have been ambiguous. It has led to a certain pride in these ethnic products and a parading of them as ethnic markers, and has assisted "in the preservation, and occasionally the revival of old skills" (Cohen, 1983: 322). On the other hand, as Cohen shows most clearly in a discussion of the handicraft industry among Hmong refugees from Laos, growing commercialization has also led to motif standardization and transformation of handicraft styles (Cohen, 1989).

The full import of tourism for the hill-tribes of Thailand remains to be studied. But some of its uglier spin-offs are evident. In the context of the broader drug trade in the "Golden Triangle" addiction among hill-tribes has grown, and a significant number of tourists are attracted to the north by drugs. Accompanying this is AIDS and prostitution, the latter's ranks swelled by hill peoples as the uplands come under demographic and ecological pressure. "Evidence shows a rapid spread of HIV through the barely educated hilltribes, whose women fill many of the cheapest brothels while men travel around the region as labourers and petty traders" (Handley, 1990: 28).

Another ethnic minority, however, has taken control of tourism to re-create their ethnic identity in the context of modern Japan. They are the Ainu of the northern island of Hokkaido, usually described in anthropological literature as hunter-gatherers. The peculiarities of Japanese national ideology has denied this group ethnic status, while at the same time treating the Ainu as outcasts. They have lost their lands and been marginalized in Japanese society, working as agricultural or industrial labourers and many are on welfare. Some tried to escape by adopting a full Japanese identity. Only a few were successful.

In the 1970s some Ainu began a movement to re-establish their cultural identity. They re-built traditional villages, established Ainu schools, began producing traditional handicrafts and invited tourists to witness their revival. Ritual activities

are advertised in order to get tourists to attend, whereupon they are instructed on Ainu history and culture. "Tourist production," writes Friedman, "has become a central process in the conscious reconstruction of Ainu identity. It emphasizes the distinctive content of Ainu ethnicity for Japanese tourists in a context where such specificity is officially interpreted as a mere variation of Japanese culture and not a separate identity. The presentation of Ainu selfhood is a political instrument in the constitution of that self-hood....It is in defining themselves for the Japanese, their significant Other, that they establish their specificity" (Friedman, 1990: 321). In contrast to many of the Thai hill-tribes, the Ainu are in control of the presentation of their culture to other people. Interestingly, in Thailand where the larger society emphasizes the "exotic" ethnicity of the hill-tribes the latter have lost some control of who they are in the context of tourism, whereas in Japan denial of Ainu identity by the national ideology has allowed them a space in which to reconstruct who they are. Something similar appears to be happening among the long neglected Taiwanese aborigines (Chiu, 1989). Thus, Friedman would argue that cultural identity is not something that is given, but is constructed in a "global" context.

To date mass tourism has primarily been a Western phenomenon, but as Asian societies become more affluent so tourism within the region is growing. Japanese now travel to see the Ainu while Javanese, for example, travel to the highlands of Tana Toraja in Sulawesi, previously viewed with a measure of contempt, to buy miniature traditional Toraja houses and other tourist artifacts. There is still little anthropological research on Asian tourism, but Toby Alice Volkman, who has produced penetrating analyses of the transformations of Toraja culture, writes: "It is tempting to speculate about why middle-class (usually Muslim) Javanese, for

Taiwan aborigines of the Amis tribe at Hualien tourist village.

example, now bring their children on holiday to Toraja to watch funerals. Is it to affirm their differences from the strange, primitive peoples who live within their nation? After all, it is the uniqueness of Toraja culture that is stressed, not say, its ancient roots in "high" Indonesian civilization, as in Hindu/Buddhist Java or Bali. Is it to glimpse at the ethnic diversity promoted in parks such as Taman Mini [in Jakarta], in schools, or on television? Is it to enhance their prestige, as travel to and souvenirs from remote places increasingly become urban status symbols? Is it to discover what Westerners find so compelling?" (Volkman, 1990: 107) Tourism by Asians in Asia is yet another site for anthropological research.

Anthropologists and Ecology

Few people today are unaware that the world faces an ecological crisis, the dimensions of which remain unclear. Each part of the globe has its own problems, but in Asia these are manifest in the rapid depletion of rainforests and the flora and fauna they contain, and the uncontrolled pollution which has accompanied industrialization and urbanization. To these can be added population pressure on the environment.

Anthropology has a unique contribution to make to the environmental debate, partly because here anthropology has often successfully combined macro and micro perspectives. On the one hand, anthropology studies the long time-sequences of social and human evolution and this has caused it to pay special attention to the interaction between human cultures and the natural environment. On the other hand, this focus has lent itself to micro-studies of the interaction of small-scale societies with their physical substratum. Attention to the environment has spawned a distinctive approach in anthropology, glossed as cultural ecology, which views human cultures as adaptive systems. All of the writers who adopt this approach stress that population pressure is a principal mechanism of change. There have been heated debates within anthropology concerning this approach, with some dissenting that it underplays the independent logic of purely cultural mechanisms in its understanding of social change and evolution, and that because societies are often divided into conflicting groups and individuals with diverse strategies the notion of the whole society as an adaptive unit is problematic (Orlove, 1980; Vayda, 1986). Some of the issues in this debate are epistemological, some are arguments or disagreements over the level of abstraction at which the debate should take place. As was pointed out in the introduction, such confusion is common to theorizing and it is unfortunate that many writers do not make clear the level of abstraction at which they wish their claims to be applied. On the other hand, anthropologists who pay special attention to environmental factors may not want to be identified as cultural ecologists.

Often the conclusions reached by some ecological anthropologists are not comfortable ones. They suggest that not all adaptations are for the better, and that many changes are made "blindly". Marvin Harris, a prominent figure in this debate, argues in his book *Cannibals and Kings: The Origins of Cultures* (1978) that population growth and changing energy demands of specific cultures has forced transformations upon them. "Surveying the past in anthropological perspective, I think it is clear that the major transformations of human social life

have hitherto never corresponded to the consciously held objectives of the historical participants. Consciousness had little to do with the processes by which infanticide and warfare became the means of regulating band and village populations: women became subordinate to men...labour saving devices became the instruments of drudgery; irrigation agriculture became the trap of hydraulic despotism" (1978:208). Escalating energy demands and population, he suggests, will soon force a radical transformation on industrial civilization, and it is arguable whether modern humans are likely to have any greater control over the outcome than peoples in the past. All cultures believe that they will survive forever. Few have.

The most dramatic ecological change which is taking place before our eyes in Asia today is rapid deforestation. This not only threatens wider ecological changes, but is destroying the habitat of forest peoples. Calling it "the new age of clearance", one writer has attempted to place deforestation in a long-term perspective. Not only have similar clearances occurred in Europe and America, but "a more continuous clearance, penetrating deep into the tropics, has created the agricultural landscapes of China and India. In the broad sweep of human history, what is now happening to the tropical rainforests is no more than the completion of this transformation" (Brookfield, 1988:210). Nor should we imagine that deforestation has come to a halt in China or India, for it is continuing and with serious ramifications (Smil, 1978). Brookfield does, however, say that what is happening today is "qualitatively" different in its ecological implications. The massive logging boom which has taken place in Southeast Asia since the 1960s has led to indiscriminate forest destruction with little concern for the productive potential of the land left behind. Often it has caused massive erosion. What Brookfield and others show, in contrast to notions of an untouched timeless nature, is that forests in Asia have been undergoing a continuous transformation in accordance with both natural and social calendars. The composition of many forests has been significantly effected by human activity in them – through the making of forest clearings or the harvesting and carrying of species from one area of the forest to another. The nature of such human/forest interaction in the past is not well understood.

But in a recent controversial study one anthropologist, Terry Rambo, tried to quantify this impact by investigating the Semang of Malaysia. The title of his monograph, *Primitive Polluters* (1985), suggests his conclusions. Rambo's study could be seen as a reaction to the claims by environmentalists and some anthropologists that pre-industrial cultures, and especially hunter-gatherers, are more "in tune" with nature because of their values. What modern human societies need, they argue, is an ethical reformation based on a return to earlier values. Rambo, on the other hand, argues that human interaction with nature is not based on values alone, but also on demography, technology and social structure. He argues: "change is the inevitable consequence of the functioning of human social systems rather than a reflection of any particular cultural values regarding human interactions with nature. People change the environment, not because they necessarily desire to do so, but because as participants in social systems they have no choice in the matter" (1985:1). Furthermore, social systems may adapt to survive but these adaptations need not "result in a better or happier way of life for individual human participants" (1985:10).

Rambo's study provides an interesting glimpse of the way a forest people "pollute" their environment. The Semang clear forests and cause some muddying

of streams; they burn wood, smoke tobacco and congest their dwellings and lungs; they trap animals; and in response to outside trade opportunities they scour the forest for its natural products, removing from it more than their individual social system needs. Rambo's most controversial claim is that the differences between industrial societies and societies like the Semang are "quantitative rather than qualitative"; the environmental impacts of the Semang "are qualitatively no different than those so loudly deplored when they result from the activities of civilized societies" (1985: 78). But pollution implies irreversible degradation of an environment, and this Rambo does not prove on the part of the Semang, whereas it can be established quite easily for industrial societies, as it can be for many pre-industrial societies. The Semang's quantitative impact on the environment has not caused a radical, qualitative change.

Deliberately controversial, Rambo's study raises some complex and crucial theoretical and practical issues for modern anthropology. Rambo's study is theoretically interesting for the way it demonstrates the anthropologist's penchant for detailed description combined with statements about the broad sweep of human history. But we can also see how this approach tends to delete the key element which mediates between on the ground action and long term evolution, namely, social structure. His conclusions are relatively indifferent to whether, for example, the economic logic of capitalism or the insatiable demands of state-socialism for surpluses, makes these societies more ecologically destructive than other forms of social organization. In his eyes, all social structures are ecologically equivalent.

Sarawak natives before the start of a forum on "Sarawak Natives Defend their Forests" at the University of Malaya, Kuala Lumpur, Malaysia.
Courtesy of Wan Fairuz Ismail.

One critic (Laderman, 1987) of Rambo has argued that in his crusade against "romanticism" of the pre-modern Rambo has overlooked the purposes to which his conclusions could be turned. The people who have power over the Semang in modern Malaysia, many of whom regard these forest people with contempt, can use such polemical conclusions to not only attack these people but as a way of deflecting criticism away from the companies to whom the government has given logging concessions. Anthropologists, of course, often have no way of controlling the political uses to which their conclusions may be put. And as Jesucita Sodusta has shown in Chapter 13, anthropologists are not always innocent. Moreover, anthropologists often find themselves having to act as advocates for forest peoples because the latter have no indigenous intellectuals who can speak for them in the language of the modern state.

Anthropologists like Rambo raise challenging questions for anthropology in general. He points out a need to get problems like those confronted by the people of the rainforest into a realistic perspective if anthropologists are going to help represent their interests adequately in the face of the imperatives of the "developmental state". As shown by John Clammer in Chapter 6, anthropologists have been able to counter self-serving claims that shifting cultivation is always destructive of forests. Brookfield concurs with this, but he also shows how the Kenyah people of Sarawak are adapting to the timber industry, by combining shifting cultivation with occasional employment as loggers. Occassional employment has caused a change in the sexual division of labour and a break-up of some longhouses. But the Kenyah are making "logical selections from the available choices, with sustained improvements in living standards the goal" (1988:219). In the future extensive systems of agriculture in the forest are likely to give way to a system of sustainable forestry management in which these peoples may play a part by drawing on their "indigenous knowledge" of the forest, sketched, for example, in Peter Brosius' study of the Penan Gang in Sarawak (Brosius, 1986). Brookfield concludes that our "definition of *people of the rainforest* will require a wider scope in the next century" (1988:223). Once again, anthropologists are faced with the question of cultural change, and the dilemmas of participating in it.

Anthropology in the Future

Anthropology is a *process* – an ongoing product of the societies and cultures in which it is practised, taught, talked about and written. Each generation of anthropologists, faced with new problems and different possibilities for fieldwork, re-construct anthropological knowledge inherited from the past in terms relevant to the present. One outcome is the emergence of new theoretical "fashions" in anthropology which take the discipline by storm and dominate its "pageants" (conferences) and publications for a few years. Ambitious students and academics are quick to be *à la mode*. So, we find that anthropologists are often driven by the same vanity and quests for power and prestige that one finds in the broader society. But stepping back from the academic cat-walk on which the latest theoretical fashions are strutted, one can see that such bold re-fashioning of past knowledge is a necessary part of intellectual development. It does not negate what

is already known, it re-shapes it; some parts are cut out (perhaps to return in the future), while other quite innovative additions are made. Of course, new fashions have a habit of proclaiming themselves to be the ultimate truth, and of declaring that all that has gone before is either mistaken or *passé*. Whatever a fashion's self-perceptions (i.e. the emic view of anthropologists upholding a "radically new" approach), etically it serves the function of disrupting the theoretical entropy that inevitably occurs in the institutionalized practice of anthropology. New ideas draw attention to new problems, or ones that have been overlooked, and thereby provide a source of theoretical regeneration. This was certainly true for feminist anthropology when it arrived on the scene in the early 1970s.

The most recent "fashion" in anthropology, especially influential in the United States, calls itself "post-modern ethnography". This type of ethnography according to one advocate of it, Stephen Tyler, "foregrounds dialogue as opposed to monologue, and emphasizes the cooperative and collaborative nature of the ethnographic situation in contrast to the ideology of the transcendental observer. In fact, it rejects the ideology of 'observer-observed', there being nothing observed and no one who is observer. There is instead the mutual, dialogical production of discourse, of a story of sorts" (Tyler, 1986:126). Previous ethnography is accused of being like a "transcendental observer" who claims to know all and who imposes extraneous categories on what is observed. A cursory look at the ethnographic record shows this is an exaggeration. For example, in Chapter 13 reference was made to Geddes's 1950s ethnography, *Nine Dayak Nights*, to show its "dialogical" nature. The "new ethnography" emphasizes "reflexivity", that is an awareness on the part of the anthropologist of his or her own cultural background, the context of ethnographic fieldwork, sensitivity to indigenous voices who should be heard in the ethnographic text as much as that of the ethnographer, an awareness of textual devices in the presentation of material, and so on. There is no question that reflexivity, or a heightened self-awareness of one's vocation, must be a crucial part of anthropological practice, especially in the discipline's attempts to surmount culture-bound knowledge, and this latest "fashion" has at least sparked off an intense debate on this problem. Furthermore, it could be seen as a reaction to the more abstract system-building engaged in by anthropologists influenced by political economy in the 1970s and 1980s. Yet, the way the "post-modernists" have pursued this debate could also be seen as being somewhat culture-bound. Steven Sangren has argued that this new fashion, instead of privileging the transcendental observer with a bag full of concepts privileges instead individual "experience", and this he says, is part of a "Western predisposition to 'think' reality in terms of individual experience" (Sangren, 1988:423). Such preoccupation with face-to-face, inter-personal interaction is undeniably an important part of North American culture. Preoccupation with face to face interaction is also important in Asia, but as Joy Hendry points out in the case of Japan, here one is concerned with appropriate form rather than "real", "genuine" experience. I can only place these words in inverted commas to emphasize their North American meaning, for a concern for appropriate form generates equally genuine and real experiences for Japanese.

The "new ethnography" would reject the argument outlined in Chapter 1 for scientific practice because science asserts that despite their dialectical interaction there is a distinction between observer and observed, and that analytic categories may be at variance with individual experiences and reactions, although the latter is part of its raw material. It can be argued, as Chapter 1 suggests, that fieldwork

will always throw up methodological problems concerning how best to adequately grasp the cultural processes of another society or social group, and this will inevitably always feedback into discussions of the epistemological status of the kind of knowledge generated by anthropology. Yet it would be a mistake to collapse methodological problems into epistemological ones, and vice versa. In their mutual interaction we will come to learn more about human cultures, although this (much to the consternation of some) will bring us no nearer to absolute truths. Science, after all, is open-ended.

The material gathered together in the chapters of *Asia's Cultural Mosaic* displays the immense amount of anthropological research which has been carried out on Asian societies, and yet we in these pages have covered only a fraction of the research on Asia. Even so, in the foregoing introductory survey we can see that there are still many areas awaiting anthropological enquiry. Sandra Bowdler has treated the complex problems of evidence in determining the origins of Asians and shown how models from Africa and Europe have obscured some key issues in the archaeology of Asia. Implicit in her argument, however, is the danger of repeating ethnocentric biases in Asian research. As indicated in Chapter 1 nationalism likes to project the existence of "the nation" into the distant past and is disturbed by any questioning of this antiquity. Archaeologists and anthropologists working on Asian pre-history, therefore, have found themselves caught up in contentious debates about the origins of their respective nations and under considerable cultural and political pressure to assert ancient roots for their respective peoples. This has included denials that the genus *Homo* originated in Africa, as well as assertions that the remains of peoples found thousands of years ago are the same as current populations, something which cannot be substantiated, as Bowdler points out. She also points out how these debates are couched in quasi-racial terms which are highly problematic. Thus the many questions surrounding archaeology which are seemingly distant and abstract in fact resonate throughout contemporary cultural/ nationalist discourse. Social and historical linguistics are also often called into discussions of the origins of particular Asian cultures, but as Amara Prasithrathsint shows a great deal of work remains to be done here. She also points out how there have been ongoing assertions about the relation between language, thought and culture in Asia and elsewhere, but that it remains an area of research which is open and unresolved.

Clark Sorensen in his survey of domestic groups and kinship systems in Asia lists several key areas which require future research: like Goody (1990) he calls for greater attention to the dynamics of domestic groups; for an examination of the interaction between kinship and marriage and social stratification; for greater attention as to how gender structures attitudes to kinship "rules"; and finally, he says we need to know more about how different family structures influence psychological development. There has been much loose speculation in Asia concerning all of these areas and hard empirical work must be done before they can be properly answered.

Economic change is intensifying throughout Asia but John Clammer emphasizes the fact that even in capitalism, the most purely "economic" of cultures, economic action is still steeped in social and cultural values and he argues that these need explicating if we are to really understand the nature of contemporary Asian societies. Sociologists and political scientists have given a great deal of attention to the formal and macro-structures of the state. Paul Cohen suggests that anthropology

of the contemporary state in Asia has a special contribution to make by focusing on micro-levels of power in villages and other "informal" systems of power. When one studies past societies it is often said that one studies the history of kings and queens, partly because they were the only ones to leave written records. In the present, however, we seem to know less about our own elites and Grant Evans suggests that anthropologists should also turn their attention to those who are at the top of social hierarchies in Asia and dominate others. The Sri Lankan anthropologist, Stanley Tambiah, is cited by Lian Kwen Fee and Ananda Raja as turning his considerable talents to analyzing the vexed issue of ethnic tension and violence in the world today. Anthropology has made fundamental contributions to debates on ethnicity and therefore it can hopefully throw further light on this explosive issue in Asia today.

Christine Helliwell has outlined the achievements of a feminist anthropology in Asia over the past two decades. Initially concerned with explaining the apparent universality of women's subordination the accumulation of empirical case studies on womens' lives has shown that these are not amenable to singular explanations. Yet there is a commonality in the cultural location of women in subordinate roles, but explaining this entails a difficult theoretical navigation between what is specific to some women and what is general among women. She also points out that there is no equivalent chapter on men in the book. This is partly a consequence of the fact that womens' studies has become something of an academic growth industry, but secondly of the fact that there are very few anthropological analyses of the cultural construction of males. An exception is Charles Keyes' study "Ambiguous Gender: Male Initiation in a Northern Thai Buddhist Society" (1986) which examines the role of temporary monkhood in the social preparation of "cool-hearted" (jai yen) males and its tension with another ideal of aggressive maleness (nakleng), which "may be related to the quite high incidence of and tolerance for male homosexuality found in Thai society" (1986:96). Clearly, there is a need for many more anthropological studies of male gender in Asia and this will allow future books to carry chapters on gender (male and female) rather than on women only.

Anthropology has developed an enormous body of literature on religious ideas and religious ritual, and contributed in particular to an understanding of popular religion as distinct from textual or 'high' religion. Nicholas Tapp says that future anthropological work needs to look at the limits of possible popular interpretations and syncretism in religion, and at the role of women in religion.

By the year 2000 probably half or more Asians will be living in cities, therefore the locus of much anthropological work in Asia must shift as well. Patrick Guinness calls for more comparative work on cities and asks, do different cultures produce different kinds of cities? who are the elites in Asian cities? Through their examination of the minutiae of daily life of people in cities anthropologists can add to the work of other social scientists and contribute to policy debates on urban living in the bloated cities of Asia. Jesucita Sodusta is also interested in questions of policy because anthropologists are often called upon to apply their knowledge in the field. She is critical of the individualistic nature of much anthropological training, however, and suggests that anthropologists are ill-prepared for teamwork on development projects. On the other hand, many aid officials and bureaucrats do not like to hear the disturbing questions anthropologists raise about the process of development, yet it is their special focus on cultural processes,

she argues, which makes them indispensable participants in the planning and enacting of change in Asia.

Japan is the most developed industrial nation in Asia today. However, as Joy Hendry shows, it has constructed unique cultural adaptations to industrialism. This she suggests must be true for other industrializing Asian countries and she recommends comparative studies of Japan with other industrial Asian nations. Finally, in this chapter the growing internationalization of culture has been highlighted alongside the ongoing adaptiveness of specific cultures to this process. Cultural analysis, therefore, has become more problematic and challenging. The earth also faces serious ecological problems and anthropologists have much work to do in analyzing the interaction between culture and nature, where once again they often find themselves posing uncomfortable questions to non-anthropologists.

Will the anthropology of Asia be qualitatively different in the future when its practice is dominated by Asians? On scientific grounds one is tempted to say no – although when it occurs there will no doubt be some people who will claim that the axis on which the anthropology of Asia turns has shifted fundamentally. But just who will be making such claims cannot be determined *a priori*. For instance, in contemporary debates we find a Frenchman, Louis Dumont, claiming against an Indian André Béteille that "he does not value past India or traditional India as I do..." (Dumont, 1987), and non-Japanese Japanologists are criticized by some Japanese for fetishising the "uniqueness" of Japanese culture. But unquestionably, as there are more contributions to the anthropology of Asia by people from diverse cultural backgrounds so a new, or a different light will be thrown on old problems, and new ones will be brought to our attention. Perhaps the most welcome aspect of this shift will be a decline in "The West" as a continual point of comparison in anthropological literature and therefore a greater engagement with the distinguishing features of Asian societies. A "decline of the West" in comparative thought, however, may make it more possible to think of the West in less stereotypical ways, just as we in this book have tried to break through stereotypes of "The East". Hopefully, one result of these changes will be that more anthropologists from Asia will go to study Australian, American and European cultures and help throw new light on them. But whatever the specific future direction of anthropology in Asia, generally it will continue to proceed on the basis of synthesizing and critically assessing what is already known in order to produce what we still need to know about this large and fascinating part of the world.

BIBLIOGRAPHY

Abegglen, James C. and G. Stark (1985) *Kaisha: The Japanese Corporation*, Basic Books: New York.

Acciaioli, Greg (1985) "Culture as art: From practice to spectacle in Indonesia", *Canberra Anthropology*, Vol. 8, Nos. 1 & 2, pp. 148–174.

Aigner, Jean S. (1981) *Archaeological Remains in Pleistocene China*, Verlag C.H. Beck: Munich.

Aigner, Jean S. (1988) "Dating the earliest Chinese Pleistocene localities: The newly proposed O18 correspondences", in P. Whyte, J.S. Aigner, N.G. Jablonski, G. Taylor, D. Walker, Wang Pinxian and So Chak-lam (eds.) *The Palaeo-environment of East Asia from the Mid-Tertiary, Vol. II: Oceanography, Palaeozoology and Palaeoanthropology*, Centre of Asian Studies, University of Hong Kong: Hong Kong.

Aigner, Jean S. and William S. Laughlin (1973) "The dating of Lantian man and his significance for analyzing trends in human evolution", *American Journal of Physical Anthropology*, Vol. 39, pp. 97–110.

Aijmer, Goran (1969) "Being caught by a fishnet: On fengshui in southwestern China", *Journal of the Hong Kong Branch of the Royal Asiatic Society*, Vol. 8, pp. 74–81.

Akin, Rabibhadana (1969) "The organization of Thai society in the early Bangkok period, 1782–1873", Southeast Asia Program, Data Papers, 74, Cornell University: Ithaca.

Alexander, J. (1987) *Trade, Traders and Trading in Rural Java*, Oxford University Press: Singapore.

Amos, Valerie and Pratibha Parmar (1984) "Challenging imperial feminism", *Feminist Review*, No. 17, pp. 3–19.

Anagnost, Ann S. (1985) "The beginning and end of an emperor: A counter-representation of the state", *Modern China*, Vol. 11, No. 2, pp. 147–176.

Anagnost, Ann (1989) "Transformations of gender in modern China", in Sandra Morgen (ed.) *Gender and Anthropology: Critical Reviews for Research and Teaching*, American Anthropological Association: Washington, DC.

Anan, Ganjanapan (1984) "The partial commercialization of rice production in northern Thailand (1900–1981)", PhD Thesis, Cornell University: Ithaca.

Anderson, Benedict (1972) "The idea of power in Javanese culture", in Claire Holt (ed.) *Culture and Politics in Indonesia*, Cornell University Press: Ithaca.

Anderson, Benedict (1983) *Imagined Communities: Reflections on the Origin and Spread of Nationalism*, Verso: London.

Anderson, Douglas D. (1990) *Lang Rongrien Rockshelter: A Pleistocene-Early Holocene Site from Krabi, Southwestern Thailand*, The University Museum, University of Pennsylvania: Philadelphia.

Anderson, Eugene N. (1972) "Some Chinese methods of dealing with crowding", *Urban Anthropology*, Vol. 1, No. 2, pp. 141–150.

Anderson, Eugene N. and Marja J. Anderson (1973) *Mountains and Water: Essays on the Cultural Ecology of South Coastal China*, Asian Folklore and Social Life Monographs No. 54, Orient Cultural Service: Taipei.

Anderson, J. Gunnar (1934) *Children of the Yellow Earth: Studies in Prehistoric China*, MIT Press: Cambridge, MA.

Anderson, P. (1974) *Lineages of the Absolutist State*, New Left Books: London.

Anumon Rajadhon, Phya (1962) "The Khwan and its ceremonies", *Journal of the Siam Society*, Vol. 50, Pt. 2, pp. 119–164.

Anwar, Z. (1987) *Islamic Revivalism in Malaysia: Dakwah Among the Students*, Pelanduk: Petaling Jaya, Malaysia.

Apter, D. and N. Sawa (1984) *Against the State: Politics and Social Protest in Japan*, Harvard University Press: Cambridge, MA.

Archaimbault, C. (1973) *Structures Religeuses Lao*, Editions Vithagna: Vientiane. "Religious structures in Laos", *Journal of the Siam Society* (1964), Vol. LII, No. 1, pp. 57–74.

Armstrong, W. and T. McGee (1985) *Theatres of Accumulation: Studies in Asian and Latin American Urbanization*, Methuen: London and New York.

Asad, Talal (ed.) (1973) *Anthropology and the Colonial Encounter*, Humanities Press: New York.

Atkinson, Jane M. (1990) "How gender makes a difference in Wana society", in Jane M. Atkinson and Shelly Errington (eds.) *Power and Difference: Gender in Island Southeast Asia*, Stanford University Press: Stanford.

Atlas of Primitive Man in China (1980) Science Press: Beijing.

Babb, L.A. (1975) *The Divine Hierarchy: Popular Hinduism in Central India*, Columbia University Press: New York and London.

Bachnik, J.M. (1983) "Recruitment strategies for household succession: rethinking Japanese household organisation", *Man* N.S., Vol. 18, No. 1, pp. 160–182.

Bachtiar, H. (1985) "The religion of Java: A commentary", in Ahmad Ibrahim, Sharon Siddique and Yasmin Hussain (eds.) *Readings on Islam in Southeast Asia*, Institute of Southeast Asian Studies: Singapore.

Barth, Frederik (1969) "Introduction", in Frederick Barth (ed.) *Ethnic Groups and Boundaries: The Social Organization of Cultural Difference*, Allen and Unwin: London.

Barth, Frederik (1970) "Economic spheres in Darfur", in Raymond Firth (ed.) *Themes in Economic Anthropology*, Tavistock Publications: London.

Bartstra, Gert-Jan (1982), "*Homo erectus erectus*: the search for his artefacts", *Current Anthropology*, Vol. 23, No. 3, pp. 318–320.

Bartstra, Gert-Jan (1988) "The age of Solo Man and Java Man", in John R. Prescott (ed.) *Early Man in the Southern Hemisphere*, Supplement to *Archaeolmetry: Australasian Studies (1988)*, Department of Physics and Mathematical Physics, University of Adelaide: Adelaide.

Bartstra, Gert-Jan and Basoeki (1989) "Recent work on the Pleistocene and the Palaeolithic of Java", *Current Anthropology*, Vol. 30, No. 2, pp. 241–243.

Bartstra, Gert-Jan, Santosa Soegondho and Albert van der Wijk (1988) "Ngandong man: age and artifacts", *Journal of Human Evolution*, Vol. 17, pp. 325–337.

Basham, R. (1978) *Urban Anthropology: The Cross-Cultural Study of Complex Societies*, Mayfield Publishing: Palo Alto, CA.

Bastide, Roger (1971) *Applied Anthropology*, Harper and Row: New York.

Basu (ed.) (1985) *The Rise and Growth of Colonial Port Cities in Asia*, University Press of America, Lanham.

Bayard, Donn T. (1970) "Excavations at Non Nok Tha, northeastern Thailand", *Asian Perspectives*, Vol. 13.

Bayard, Donn T. (1979) "The chronology of prehistoric metallurgy in north-east Thailand: Silabhumi or Samaddhabhumi?", in R.B. Smith and W. Watson (eds.) *Early South East Asia*, Oxford University Press: New York.

Bayard, Donn T. (1980) "An early indigenous bronze technology in northeast Thailand: Its implications for the prehistory of East Asia", in H.H.E. Loofs-Wissowa (ed.) *The Diffusion of Material Culture*, Social Science Research Institute, University of Hawaii: Honolulu.

Beals, Ralph L. and Harry Hoijer (1971) *An Introduction to Anthropology*, Macmillan: New York.

Beardsley, Richard K., John W. Hall and Robert E. Ward (1959) *Village Japan*, University of Chicago Press: Chicago.

Befu, Harumi (1963) "Patrilineal descent and personal kindred in Japan", *American Anthropologist*, Vol. 65, No. 6, pp. 1328–1341.

Befu, Harumi (1971) *Japan: An Anthropological Introduction*, Chandler Pub. Co.: San Francisco.

Befu, Harumi (1974) "Gift giving in a modernizing Japan", in T.S. and W.P. Lebra (eds.) *Japanese Culture and Behaviour: Selected Readings*, University of Hawaii Press: Honolulu.

Befu, Harumi (1980) "A critique of the group model of Japanese society", *Social Analysis*, No. 5/6, pp. 29–43.

Befu, Harumi (1983) "Internationalization of Japan and Nihon Bunkaron", in Mannari and Hiroshi Harumi Befu (eds.) *The Challenge of Japan's Internationalization: Organization and Culture*, Kodansha International: Tokyo.

Befu, Harumi and Josef Kreiner (eds.) (1991) *National Traditions in Japanese Studies*, Iudicium Verlag: Munchen.

Bell, Catherine (1989) "Religion and Chinese culture: Towards an assessment of 'popular religion'", *History of Religions*, Vol. 29, No. 1, pp. 35–57.

Bellwood, Peter (1985) *Prehistory of the Indo-Malaysian Archipelago*, Academic Press: Sydney.

Bellwood, Peter (1987) "A prehistory of island Southeast Asia: a multidisciplinary review of recent research", *Journal of World Prehistory*, Vol. 1, pp. 171–224.

Bellwood, Peter (ed.) (1988) *Archaeological Research in Southeastern Sabah*, Sabah Museum Monograph, Vol. 2, Sabah Museum and State Archives: Sabah.

Belshaw, C. (1965) *Traditional Exchange and Modern Markets*, Prentice Hall: Eaglewood Cliffs, NJ.

Ben-Ari, Eyal (1991) *Changing Japanese Suburbia*, Kegan Paul International: London.

Ben-Ari, Eyal, B. Moeran and J. Valentine (1990) *Unwrapping Japan*, Manchester University Press: Manchester.

Benda, Harry (1962) "The structure of Southeast Asian history: Some preliminary observations", *Journal of Southeast Asian History*, Vol. 3, No. 1, pp. 106–139.

Benedict, Paul (1942) "Thai, Kadai and Indonesian: a new alignment in Southeastern Asia", *American Anthropologist*, Vol. 44, pp. 576–601.

Benedict, Paul (1972) *Austro-Thai: Language and Culture, with a Glossary of Roots*, Human Relations Area Files, Yale University: New Haven, CT.

Benjamin, Geoffrey (1976) "The cultural logic of Singapore's multiracialism", in Riaz Hassan (ed.) *Singapore Society in Transition*, Oxford University Press: Kuala Lumpur.

Benjamin, Geoffrey (1985) "In the long term: Three themes in Malayan cultural ecology", in Karl L. Hutterer, A. Terry Rambo and George Lovelace (eds.) *Cultural Values and Human Ecology in Southeast Asia*, Center for South and Southeast Asia Studies, University of Michigan: Ann Arbor, MI.

Benjamin, Geoffrey (1986) *Between Isthmus and Islands: Reflections on Malayan*

Palaeo-Sociology, Working Paper No. 71, Department of Sociology, National University of Singapore: Singapore.

Benjamin, Geoffrey (1987) "Ethnohistorical perspectives on Kelantan's prehistory", in Nik Hassan Shuhaimi bin Nik Abd Rahman (ed.) *Kelantan Zaman Awal: Kajian Arkeologi dan Sejarah di Malaysia*, Perbadanan Muzium Negeri Kelantan: Kota Bharu.

Berreman, Gerald (1963) *Hindus of the Himalayas*, University of California Press: Berkeley.

Berreman, Gerald (1972) "Social categories and social interaction in urban India", *American Anthropologist*, Vol. 74, No. 3, pp. 567–586.

Berreman, Gerald D. (1983) "The evolutionary status of caste in peasant India", in Joan P. Mencher (ed.) *Social Anthropology of Peasantry*, Somaiya Publications: Bombay.

Bestor, T.C. (1989) *Neighbourhood Tokyo*, Stanford University Press: Stanford.

Béteille, André (1965) *Caste, Class, and Power: Changing Patterns of Stratification in a Tanjore Village*, University of California Press: Berkeley.

Béteille, André (1991) "Race, caste and gender", *Man*, Vol. 25, No. 3, pp. 489–504.

Binford, Lewis R. and Chuan Kun Ho (1985) "Taphonomy at a distance: Zhoukoudian, 'the cave home of Beijing Man'?", *Current Anthropology*, Vol. 26, No. 4, pp. 413–442.

Binford, Lewis R. and Nancy M. Stone (1986) "Zhoukoudian: a closer look", *Current Anthropology*, Vol. 27, No. 5, pp. 453–473.

Blanc-Szanton, Cristina (1990) "Collision of cultures: historical reformulations of gender in the lowland Visayas, Philippines", in Jane M. Atkinson and Shelly Errington (eds.) *Power and Difference*, Stanford University Press: Stanford.

Bloch, M. (1977) "The past and the present in the present", *Man*, Vol. 12, No. 2, pp. 278–292.

Boeke, J. (1953) *Economics and Economic Policy of Dual Society*, H.D. Tjeenk Willink: Haarlem.

Bond, M.H. (ed.) (1986) *The Psychology of the Chinese People*, Oxford University Press: Hong Kong.

Borgstrom, B.E. (1983) *Power, Technology and Culture in Nepal and Northern Sweden*, Lund University Research Policy Institute: Lund.

Boserup, Ester (1970) *Women's Role in Economic Development*, Allen and Unwin: London.

Boserup, Ester (1990) "Economic change and the roles of women", in Irene Tinker (ed.) *Persistent Inequalities*, Oxford University Press: New York.

Bourdieu, P. (1984) *Distinction: A Social Critique of the Judgement of Taste*, Harvard University Press: Cambridge, MA.

Bowdler, Sandra (1990) "Peopling Australasia: the 'coastal colonisation' hypothesis reconsidered", in P. Mellars (ed.) *The Emergence of Modern Humans: An Archaeological Perspective*, Vol. 2, University of Edinburgh Press: Edinburgh.

Bray, Francesca (1986) *The Rice Economies*, Basil Blackwell: London.

Brissenden, R. (1976) "Patterns of trade and maritime society before the coming of the Europeans", in E. McKay (ed.) *Studies in Indonesia History*, Pitman: Carlton, Australia.

Brokensha, D., Michael D. Warren and Oswald Werner (eds.) (1990) *Indigenous Knowledge Systems and Development*, Kegan Paul International: London.

Bronson, B. (1979) "The late prehistory and early history of central Thailand with

special reference to Chansen", in R.B. Smith and W. Watson (eds.) *Early South East Asia*, Oxford University Press: Oxford.

Brookfield, Harold (1988) "The new age of clearance and beyond", in Julie Sloan Denslow and Christine Padoch (eds.) *People of the Tropical Rainforest*, University of California Press: Berkeley.

Brooks, Alison S. and Bernard Wood (1990) "The Chinese side of the story", *Nature*, Vol. 344, No. 6264, pp. 288–289.

Brosius, Peter (1986) "River, forest and mountain: The Penan-gang landscape", *Sarawak Museum Journal*, Vol. 36, No. 57, pp. 173–184.

Brown, David (1989) "The state of ethnicity and the ethnicity of the state: Ethnic politics in Southeast Asia", *Ethnic and Racial Studies*, Vol. 12, No. 1, pp. 47–62.

Brown, Keith (1966) "Dozoku and the ideology of descent in rural Japan", *American Anthropologist*, Vol. 68, No. 5, pp. 1129–1151.

Bruner, E. (1961) "Urbanization and ethnic identity in North Sumatra", *American Anthropologist*, Vol. 63, No. 3, pp. 508–521.

Bruner, E. (1974) "The expression of ethnicity in Indonesia", in A. Cohen (ed.) *Urban Ethnicity*, Tavistock Publication: London.

Bulbeck, F. David (1981) "Continuities in Southeast Asian evolution since the late Pleistocene", unpublished MA dissertation, Australian National University: Canberra.

Bunnag, J. (1973) *Buddhist Monk, Buddhist Layman: A Study of Urban Monastic Organization in Central Thailand*, Cambridge Studies in Social Anthropology, No. 6, Cambridge University Press: Cambridge.

Bunnag, Tej (1967) "Khabot phumibun phak isan ro so 121", *Sangkomsat parithat*, Vol. 5, No. 1, pp. 78–87.

Burckhardt, V.R. (1982) *Chinese Creeds and Customs*, South China Morning Post: Hong Kong.

Burridge, K. (1969) *New Heaven, New Earth: A Study of Millenarian Activities*, Basil Blackwell: Oxford.

Buruma, Ian (1989) *God's Dust: A Modern Asian Journey*, Farrar, Straus, Girou: New York.

Caplan, Lionel (1984) "Bridegroom price in urban India: Class, caste and 'dowry evil' among Christians in Madras", *Man*, Vol. 19, No. 2, pp. 216–233.

Carlisle, Richard (Editor-in-chief) (1978) *The Illustrated Encyclopedia of Mankind*, Marshall Cavendish: London.

Carter, Anthony T. (1984) "Household histories", in Robert Netting, Richard Wilk and Eric Arnould (eds.) *Households: Comparative and Historical Studies of the Domestic Group*, University of California Press: Berkeley and Los Angeles.

Chang, Kwang-Chih (1986) *The Archaeology of Ancient China*, 4th Edition, Yale University Press: New Haven and London.

Charlesworth, M., L. Farrall, T. Stokes and D. Turnbull (1989) *Life Among the Scientists: An Anthropological Study of an Australian Scientific Community*, Oxford University Press: Melbourne.

Chatthip Nartsupha (1984) "The ideology of holy man's revolts in North East Thailand", in Andrew Turton and Shigeharu Tanabe (eds.) *History and Peasant Consciousness in Southeast Asia*, Senri Ethnological Studies No. 13, National Museum of Ethnology: Osaka.

Chiu, Yen Liang (1989) "Taiwan's aborigines and their struggle towards radical democracy", in Kumar David and Santasilan Kadirgamar (eds.) *Ethnicity: Identity, Conflict and Crisis*, Arena Press: Hong Kong.

Chu, Tung-Tsu (1957) "Chinese class structure and its ideology", in J.K. Fairbank (ed.) *Chinese Thought and Institutions*, University of Chicago Press: Chicago.

Chu, Tung-Tsu (1965) *Law and Society in Traditional China*, Rainbow Bridge Book: Moulton, Paris.

Clammer, John (ed.) (1978) *The New Economic Anthropology*, Macmillan Press: London.

Clammer, John (1982) "The institutionalization of ethnicity: The culture of ethnicity in Singapore", *Ethnic and Racial Studies*, Vol. 5, No. 2, pp. 127–139.

Clammer, John (1985) *Anthropology and Political Economy: Theoretical and Asian Perspectives*, Macmillan Press: London.

Clammer, John (1987) "Incorporation and assimilation: The aboriginal peoples of Malaysia and the forces of modernization", *Journal of Social and Economic Studies*, Vol. 4, No. 2.

Clark, R. (1979) *The Japanese Company*, Yale University Press: New Haven.

Clifford, James (1990) "Notes on fieldnotes", in Roger Sanjek (ed.) *Fieldnotes: The Makings of Anthropology*, Cornell University Press: Ithaca.

Clifford, James and G. E. Marcus (1986) *Writing Culture: The Poetics and Politics of Ethnography*, University of California Press: Berkeley.

Coale, Ansley J. (1965) *Aspects of the Analysis of Family Structure*, Princeton University Press: Princeton, NJ.

Cockburn, Alexander (1987) "Bwana vistas", in *Corruptions of Empire*, Verso: London.

Coèdes, G. (1968) *The Indianized States of Southeast Asia*, East-West Centre Press: Honolulu.

Cohen, D. (1985) "The people who get in the way: Poverty and development in Jakarta", in R. Bromley (ed.), *Planning for Small Enterprises in Third World Cities*, Pergamon: Oxford.

Cohen, Erik (1983) "Hill tribe tourism", in John MacKinnon and Wanat Bhruksasri (eds.) *Highlanders of Thailand*, Oxford University Press: Singapore.

Cohen, Eric (1989) "International politics and the transformation of folk crafts – The Hmong (Meo) of Thailand and Laos", *Journal of the Siam Society*, Vol. 77, No. 1, pp. 69–81.

Cohen, Myron (1976) *House United, House Divided: The Chinese Family in Taiwan*, Columbia University Press: New York.

Cohen, Myron (1990) "Lineage organization in north China", *Journal of Asian Studies*, Vol. 49, No. 3, pp. 509–534.

Cohen, Paul (1981) *The Politics of Economic Development in Northern Thailand, 1967–1978*, PhD Thesis, University of London: London.

Cohen, Paul (1987) "From moral regeneration to confrontation: Two paths to equality in the political rhetoric of a northern Thai peasant leader", *Mankind* (Special Issue 5), Vol. 17, No. 2, pp. 153–167.

Cohen, Paul (1991) "Irrigation and the northern Thai state in the nineteenth century", in E.C. Chapman and G.W. Wijeyewardene (eds.) *Patterns and Illusions: Papers on Thai Topics in Memory of Richard Davis*, White Lotus: Bangkok.

Cohen, Paul and Gehan Wijeyewardene (eds.) (1984) "Introduction", in *Spirit Cults*

and the Position of Women in Northern Thailand. Mankind (Special Focus Issue), Vol. 14, No. 4, pp. 249–262.

Cole, Fay-Cooper (1945) *The Peoples of Malaya*, Van Nostrand: Princeton, NJ.

Comrie, Bernard (ed.) (1990) *The Major Languages of East and Southeast Asia*, Routledge: London.

Condominas, Georges (1957) *Nous avons mangez le foret*, Mercure de France: Paris.

Condominas, Georges (1975) "Phībān cults in rural Laos", in G. William Skinner and A. Thomas Kirsch (eds.) *Change and Persistence in Thai Society*, Cornell University Press: Ithaca.

Condominas, Georges (1990) *From Lawa to Mon, From Saa' to Thai: Historical and Anthropological Aspects of Southeast Asian Social Spaces*, Australian National University: Canberra.

Conklin, Harold (1980) *Ethnographic Atlas of Ifugao: A Study of Environment, Culture and Society in Northern Luzon*, Yale University Press: New Haven, CT.

Cooper, Robert (1984) *Resource Scarcity and the Hmong Response: Patterns of Settlement and Economy in Transition*, Singapore University Press: Singapore.

Croll, Elisabeth (1983) *The Family Rice Bowl*, Zed Press: London.

Croll, Elisabeth (1984) "The exchange of women and property: marriage in post-revolutionary China", in René Hirschon (ed.) *Women and Property – Women as Property*, Croom Helm: London and Canberra.

Dalby, L.C. (1983) *Geisha*, University of California Press: Berkeley.

Dargyay, Eva K. (1982) *Tibetan Village Communities*, Aris and Phillips: Warminster.

Darwin, Charles (1889) *The Origin of Species by Means of Natural Selection*, John Murray: London (originally published 1859).

Das, Veena (1977) *Structure and Cognition: Aspects of Hindu Caste and Ritual*, Oxford University Press: Delhi.

Davis, Richard B. (1973) "Muang matrifocality", *Journal of the Siam Society*, Vol. 61, No. 2, pp. 53–62.

Davis, Richard B. (1984) *Muang Metaphysics*, Pandora Press: Bangkok.

Davis, W. (1980) *Dojo: Magic and Exorcism in Modern Japan*, Stanford University Press: Stanford.

Dentan, R.K. (1976) "Ethnics and ethics in Southeast Asia", in David Banks (ed.) *Changing Identities in Modern Southeast Asia*, Mouton Publishers: Paris.

Dentan, R.K. (1986) *The Semai: A Non-violent People of Malaya*, Holt, Rinehart and Winston: New York.

Dikotter, Frank (1990) "Group definition and the idea of 'race' in modern China (1793–1949)", *Ethnic and Racial Studies*, Vol. 13, No. 1, 420–431.

Donnan, Hastings (1988) *Marriage Among Muslims: Preference and Choice in Northern Pakistan*, Hindustan Publishing: Dehli.

Dore, Ronald (1958) *City Life in Japan: A Study of a Tokyo Ward*, University of California Press: Berkeley.

Dore, Ronald (1973) *British Factory, Japanese Factory*, University of California Press: Berkeley.

Douglas, Mary (1966) *Purity and Danger: An Analysis of the Concepts of Pollution and Taboo*, Routledge & Kegan Paul: London.

Dove, M.R. (1985) "The agroecological mythology of the Javanese and the political economy of Indonesia", *Indonesia*, No. 39, pp. 1–36.

Dove, M.R. (ed.) (1988) *The Real and Imagined Role of Culture in Development: Case Studies from Indonesia*, University of Hawaii Press: Honolulu.

Dube, S.C. (1967) *Indian Village*, Allied Village: Bombay.

Dumont, Louis (1980) *Homo Hierarchicus: The Caste System and Its Implications*, Complete Revised English Edition, University of Chicago Press: Chicago.

Dumont, Louis (1987) "On individualism and equality", *Current Anthropology*, Vol. 28, No. 5, pp. 669–677.

Durkheim, Emile (1954) *The Elementary Forms of the Religious Life*, Free Press: Glencoe, IL.

Durkheim, Emile and M. Mauss (1970) *Primitive Classification*, Cohen & West: London.

Eames, E. (1967) "Urban migration and the joint family in North Indian villages", *Journal of Developing Areas*, Vol. 1, No. 2, pp. 163–178.

Eberhard, Wolfram (1962) *Social Mobility in Traditional China*, E.J. Brill: Leiden.

Ebrey, Patricia (1986) "Concubines in Sung China", *Journal of Family History*, Vol. 11, No. 1, pp. 1–24.

Ebrey, Patricia (1991) "Introduction", in Rubie S. Watson and Patricia Ebrey (eds.) *Marriage and Inequality in Chinese Society*, University of California Press: Berkeley and Los Angeles.

Edwards, W. (1989) *Modern Japan Through Its Weddings: Gender, Person and Society in Ritual Perspective*, Stanford University Press: Stanford.

Eisenstadt, S.N. and Eyal Ben-Ari (eds.) (1990) *Japanese Models of Conflict Resolution*, Kegan Paul International: London.

Eliade, Mircea (1954) *The Myth of the Eternal Return*, Bollinger Series 56, Prineeton University Press: Princeton, NJ.

Ellen, R.F. (1984) *Ethnographic Research: A Guide to General Conduct*, Academic Press: London.

Elliott, D. (1978) *Thailand: Origins of Military Rule*, Zed Press: London.

Elson, R. (1984) *Javanese Peasants and the Colonial Sugar Industry: Impact and Change in an East Java Residency 1830–1940*, Oxford University Press: Singapore.

Emeneau, Murray B. (1954) "Linguistic prehistory of India", in *Language and Linguistic Area*, Essays by Murray B. Emeneau, Selected and Introduced by Anwar S. Dil (1980) Stanford University Press: Stanford.

Emeneau, Murray B. (1955) "Linguistic area: Introduction and continuation", in *Language and Linguistic Area*, Essays by Murray B. Emeneau, Selected and Introduced by Anwar S. Dil (1980) Stanford University Press: Stanford.

Emeneau, Murray B. (1956) "India as a linguistic area", in *Language and Linguistic Area*, Essays by Murray B. Emeneau, Selected and Introduced by Anwar S. Dil (1980) Stanford University Press: Stanford.

Emeneau, Murray B. (1965) "India and linguistic area", in *Language and Linguistic Area*, Essays by Murray B. Emeneau, Selected and Introduced by Anwar S. Dil (1980) Stanford University Press: Stanford.

Endicott, K.M. (1970) *An Analysis of Malay Magic*, Clarendon Press: Oxford.

Endicott, K.M. (1979) *Batek Negrito Religion: The Worldview and Rituals of a Hunting And Gathering People of Peninsular Malaysia*, Clarendon Press: Oxford.

Errington, Shelly (1990) "Recasting sex, gender and power: a theoretical and regional overview", in Jane M. Atkinson and Shelly Errington (eds.) *Power and Difference*, Stanford University Press: Stanford.

Esherick, Joseph W. and Mary Backus Rankin (eds.) (1990) *Chinese Elites and Patterns of Dominance*, University of California Press: Berkeley.

Evans, Grant (1985) "Vietnamese communist anthropology", *Canberra Anthropology*, Vol. 8, Nos. 1 & 2, pp. 116–147.

Evans, Grant (1988) " 'Rich peasants' and cooperatives in socialist Laos", *Journal of Anthropological Research*, Vol. 44, No. 9, pp. 229–250.

Evans, Grant (1990) *Lao Peasants Under Socialism*, Yale University Press: New Haven, CT.

Evans-Pritchard, E.E. (1937) *Witchcraft, Oracles and Magic Among the Azande*, Clarendon Press: Oxford.

Evans-Pritchard, E.E. (1940) "The Nuer of the southern Sudan" in M. Fortes and E.E. Evans-Pritchard (eds.) *African Political Systems*, International African Institute, Oxford University Press: London.

Evers, Hans-Dieter (1987a) "Trade and state formation: Siam in the early Bangkok period", *Modern Asian Studies*, Vol. 21, Pt. 4, pp. 751–771.

Evers, Hans-Dieter (1987b) "The bureaucratization of Southeast Asia", *Comparative Studies in Society and History*, Vol. 29, No. 4. pp. 666–685.

Fasold, R. (1984) *The Sociolinguistics of Society*, Blackwell: Oxford.

Fasold, R. (1990) *The Sociolinguistics of Language*, Blackwell: Oxford.

Featherstone, M. (1991) *Consumer Culture and Postmodernism*, Sage Publications: London.

Fei, Hsiao-Tung (1939) *Peasant Life in China*, Routledge and Kegan Paul: London and Henley.

Fei, Hsiao Tung (1981) *Toward a People's Anthropology*, New World Press: Beijing.

Feuchtwang, S. (1974) *An Anthropological Analysis of Chinese Geomancy*, Vithagna: Vientiane.

Feuchtwang, S. (1975) "Investigating religion", in Maurice Bloch (ed.) *Marxist Analyses and Social Anthropology*, Malaby Press: London.

Feuchtwang, S. (1988) "The problem of 'superstition' in the People's Republic of China", in G. Benavides (ed.) *Religion and Political Power*, Cambridge University Press: New York.

Firth, Raymond (1946) *Malay Fishermen: Their Peasant Economy*, Kegan Paul: London.

Firth, Rosemary (1943) *Housekeeping Among Malay Peasants*, London School of Economics Monographs in Social Anthropology No. 7, Athlone Press: London.

Firth, Rosemary (ed.) (1970) *Themes in Economic Anthropology*, Tavistock Publications: London.

Fix, Alan G. (1977) "The demography of the Semai Senoi", *Anthropological Papers* No. 62, Museum of Anthropology, University of Michigan: Ann Arbor, MI.

Fix, Alan G. (1982) "Genetic structure of the Semai", in Michael H. Crawford and James H. Mielke (eds.) *Current Developments in Anthropological Genetics*, Vol. 2, Plenum: New York.

Forbes, D. and N. Thrift (eds.) (1987) *The Socialist Third World: Urban Development and Territorial Planning*, Basil Blackwell: Oxford.

Fortes, Meyer (1958) "Introduction", in Jack R. Goody (ed.) *The Developmental Cycle in Domestic Groups*, Cambridge Papers in Social Anthropology No. 1, Cambridge University Press: Cambridge.

Fortes, Meyer (1961) "Pietas in ancestor worship", *Journal of the Royal Anthropological Institute*, London, Vol. 91, pp. 166–191.

Fortes, Meyer (1978) "An anthropologist's apprenticeship", *Annual Review of Anthropology*, Palo Alto, Vol. 7, pp. 1–30.

Fortes, Meyer and E.E. Evans-Pritchard (eds.) (1940) *African Political Systems*, International African Institute, Oxford University Press: London.

Foster, Brian (1977) *Social Organization of Four Mon and Thai Villages*, Human Relations Area Files Press: New Haven, CT.

Foucault, Michael (1979) "On governmentality", *Ideology and Consciousness*, Vol. 6, pp. 5–21.

Fox, Robert B. (1970) *The Tabon Caves*, Monograph 1, National Museum of the Philippines: Manila.

Fox, Robert B. (1978) "The Philippine Paleolithic", in F. Ikawa-Smith (ed.) *Early Paleolithic in South and East Asia*, Mouton: The Hague.

Fox, Robin (ed.) (1975a) *Biosocial Anthropology*, Malaby Press: London.

Fox, Robin (1975b) *Encounter with Anthropology*, Penguin Books: Harmondsworth.

Fox, Robin (1977) *Urban Anthropology: Cities in their Cultural Settings*, Prentice Hall: Englewood Cliffs, NJ.

Fox, Robin (1985) "Anthropology", in A. Kuper and J. Kuper (eds.) *The Social Science Encyclopedia*, Routledge and Kegan Paul: London.

Fraenkel, Gerd (1967) *Languages of the World*, New Aspect of Language 3, Ginn and Company: Boston.

Frazer, James (1922) *The Golden Bough: A Study in Magic and Religion*, Macmillan Press: London and Basingstoke.

Freedman, Maurice (1966) *Chinese Lineage and Society: Fukien and Kwangtung*, London School of Economics Monographs on Social Anthropology No. 33, Athlone Press: London.

Freedman, Maurice (1969) "Geomancy", *Proceedings of the Royal Anthropological Institute*, London, pp. 5–15.

Freedman, Maurice (1979) "Chinese geomancy: Some observations in Hong Kong", in G. William Skinner (ed.) *The Study of Chinese Society: Essays by Maurice Freedman*, Stanford University Press: Stanford.

Freeman, Derek (1970) *Report on the Iban*, London School of Economics Monographs on Social Anthropology No. 41, Athlone Press: London.

Freeman, Derek (1980) *Iban Agriculture: A Report on the Shifting Cultivation of Hill Rice by the Iban of Sarawak*, MS Press: New York.

Freeman, Derek (1981) *Some Reflections on the Nature of Iban Society*, An Occasional Paper of the Department of Anthropology, Research School of Pacific Studies, Australian National University: Canberra.

Fried, M.N. and M.H. Fried (1980) *Transitions: Four Rituals in Eight Cultures*, W.W. Norton: New York.

Friedman, Jonathan (1974) "Marxism, structuralism and vulgar materialism", *Man*, Vol. 9, No. 3, pp. 444–469.

Friedman, Jonathan (1975) "Tribes, states, and transformations", in M. Bloch (ed.) *Marxist Analyses and Social Anthropology*, Malaby Press: London.

Friedman, Jonathan (1986) "Generalized exchange, theocracy and the opium trade", *Critique of Anthropology*, Vol. 7, No. 1, pp. 15–31.

Friedman, Jonathan (1990) "Being in the world: Globalization and localization", *Theory, Culture and Society*, Vol. 7, Nos. 2–3, pp. 311–328.

Friedman, Jonathan and M.J. Rowlands (eds.) (1977) "Notes towards an epigenetic model of the evolution of 'civilization'", in *The Evolution of Social Systems*, Duckworth: London.

Fujisaka, Sam (1986) "Anthropology in upland and rainfed development in

Philippines", in Edward C. Green (ed.) *Practicing Development Anthropology*, Westview Special Studies in Applied Anthropology, Westview Press: Boulder and London.

Fuller, C.J. (1988) "The Hindu pantheon and the legitimation of hierarchy", *Man*, Vol. 23, No. 4, pp. 757–759.

Furnivall, John S. (1944) *Netherlands India: A Study of a Plural Economy*, Cambridge University Press: Cambridge.

Furnivall, John S. (1956) *Colonial Policy and Practice*, New York University Press: New York.

Gallin, Bernard and Rita Gallin (1982) "Socioeconomic life in rural Taiwan: Twenty years of development and change", *Modern China*, Vol. 8, No. 2, pp. 205–246.

Gardner, Allen and Beatrice Gardner (1969) "Teaching sign language to a chimpanzee", *Science*, Vol. 165, No. 3894, pp. 664–672.

Gates, H. and R. Weller (1987) "Hegemony and Chinese folk ideologies", *Modern China*, Vol. 131, pp. 3–16.

Gates H. and R. Weller (eds.) (1987) "Symposium on hegemony and Chinese folk ideologies", *Modern China*, Vol. 13, Nos. 1 & 3.

Geddes, W.R. (1976) *Migrants of the Mountains: The Cultural Ecology of the Blue Miao (Hmong Njua) of Thailand*, Clarendon Press: Oxford.

Geddes, W.R. (1987) *Nine Dayak Nights: The Story of a Dayak Folk Hero*, Oxford University Press: Singapore.

Geertz, Clifford (1960) *The Religion of Java*, Chicago University Press: Chicago and London.

Geertz, Clifford (1963) *Peddlers and Princes: Social Change and Economic Modernization in Two Indonesian Towns*, University of Chicago Press: Chicago.

Geertz, Clifford (1965) *The Social History of an Indonesian Town*, MIT Press: Cambridge, MA.

Geertz, Clifford (1970) *Agricultural Involution: The Processes of Ecological Change in Indonesia*, University of California Press: Berkeley and Los Angeles.

Geertz, Clifford (1973) "Person, time and conduct in Bali", in *The Interpretation of Culture*, Basic Books: New York.

Geertz, Clifford (1980) *Negara: The Theatre State in Nineteenth-Century Bali*, Princeton University Press: Princeton, NJ.

Geertz, Clifford (1984) "Anti anti-relativism", *American Anthropologist*, Vol. 86, No. 2, pp. 263–278.

Geertz, Clifford (1988) *Works and Lives: The Anthropologist as Author*, Stanford University Press: Stanford.

Geertz, Hildred (1961) *The Javanese Family: A Study of Kinship and Socialization*, Free Press: Glencoe, New York.

Geertz, Hildred (1963) "Indonesian cultures and communities", in Ruth McVey (ed.) *Indonesia*, Yale University: New Haven, CT.

Gellner, Ernest (1983) *Nations and Nationalism*, Basil Blackwell: London.

Gellner, Ernest (1985) *Relativism in the Social Sciences*, Cambridge University Press: London.

Gellner, Ernest (1987) *The Concept of Kinship and Other Essays*, Basil Blackwell: London.

Gibson, Thomas (1990) "Raiding, trading and tribal autonomy in insular Southeast Asia", in Jonathan Haas (ed.) *The Anthropology of War*, Cambridge University Press: Cambridge.

Girsdansky, Michael (1967) *The Adventure of Language*, Newly Revised, edited by Mario Pei, Fawcett Publications: Greenwich, CT.

Glazer, Nathan and Daniel P. Moynihan (eds.) (1975) *Ethnicity, Theory and Experience*, Harvard University Press: Cambridge, MA.

Glover, I.C. (1981) "Leang Burung 2: An upper Palaeolithic rock shelter in South Sulawesi, Indonesia", in G.J. Bartstra and W.A. Casparie (eds.) *Modern Quaternary Research in Southeast Asia*, Vol. 6, A.A. Balkema: Rotterdam.

Glover, Ian (1986) *Archaeology in Eastern Timor, 1966–67*, Terra Australis 11, Department of Prehistory, Research School of Pacific Studies, Australian National University: Canberra.

Godelier, M. (1972) *Rationality and Irrationality in Economics*, New Left Books: London.

Godelier, M. (1986) *The Mental and the Material*, Verso: London.

Golomb, L. (1985) *An Anthropology of Curing in Multiethnic Thailand*, University of Illinois Press: Urbana and Chicago.

Goode, William J. (1963) *World Revolution and Family Patterns*, Free Press: New York.

Goodenough, Ward H. (1981) *Culture, Language and Society*, Cummings Publishing: Menlo Park, CA.

Goodman, R. (1990) *Japan's 'International Youth': The Emergence of a New Class of Schoolchildren*, Clarendon Press: Oxford.

Goodman, R. and K. Refsing (1991) *Ideology and Practice*, Routledge: London.

Goody, Jack (ed.) (1958) *The Developmental Cycle in Domestic Groups*, Cambridge University Press: Cambridge.

Goody, Jack (1961) "Religion and ritual: The definitional problem", *British Journal of Sociology*, Vol. 12, No. 2, pp. 142–164.

Goody, Jack (1973) *Bridewealth and Dowry*, Cambridge University Press: Cambridge.

Goody, Jack (1990) *The Oriental, the Ancient and the Primitive: Systems of Marriage and the Family in the Pre-industrial Societies of Eurasia*, Cambridge University Press: Cambridge.

Gorman, Chester F. (1969) "Hoabinhian: A pebble-tool complex with early plant associations in Southeast Asia", *Science*, Vol. 163, pp. 671–673.

Gorman, Chester F. (1977) "A priori models and Thai prehistory: A reconsideration of the beginnings of agriculture in Southeast Asia", in C.A. Reed (ed.) *Origins of Agriculture*, Mouton: The Hague.

Gough, Kathleen (1961) "Nayar: Central Kerala", in David M. Schneider and Kathleen Gough (eds.) *Matrilineal Kinship*, University of California Press: Berkeley.

Grace, George W. (1981) *An Essay on Language*, Hornbeam Press: Columbia, SC.

Grace, George W. (1987) *The Linguistic Construction of Reality*, Croom Helm: London.

Graebner, Fritz (1905) "Kulturkreise und kulturschichten in Ozeanien", *Zeitschrift für Ethnologie*, Vol. 37, pp. 28–90.

Graebner, Fritz (1911) *Die Methode der Ethnologie*, Karl Winter's Universitätsbuchhandlung: Heidelberg.

Graham, D.C. (1967) *Folk Religion in Southwest China*, Smithsonian Press: Washington, DC.

Greenberg, Joseph H. (1971) "The science of linguistics", in Morton H. Fried (ed.)

Readings in Anthropology, 2nd Edition, Thomas Y. Cromwell: New York. Also in *Language, Culture and Communication* (1971), Essays by Joseph H. Greenberg, Selected and Introduced by Anwar S. Dil, Stanford University Press: Stanford.

Greenberg, Joseph H. (1977) *A New Invitation to Linguistics*, Anchor Books: Garden City, NY.

Greenhalgh, Susan (1985) "Is inequality demographically induced: The family cycle and the distribution of income in Taiwan", *American Anthropologist*, Vol. 87, No. 3, pp. 571–594.

Gregory, C.A. and J.C. Altman (1989) *Observing the Economy*, Routledge: London.

Groenfeldt, David J. (1986) "Analyzing irrigation's impact in Northwest India: An ethnographic approach", in Edward C. Green (ed.) *Practicing Development Anthropology*, Westview Special Studies in Applied Anthropology, Westview Press: Boulder and London.

Guinness, Patrick (1986) *Harmony and Hierarchy in a Javanese Kampung*, Oxford University Press: Singapore.

Guinness, Patrick (1992) *On the Margins of Capitalism: People and Development in Mukim Plentong, Johor, Malaysia*, Oxford University Press: Singapore.

Gumperz, John J. and Stephen C. Levinson (1991) "Rethinking linguistic relativity", *Current Anthropology*, Vol. 32, No. 5, pp. 613–622.

Gupta, K.A. (1979) "Travails of a woman fieldworker", in M.N. Srinivas, A.M. Shah and E.A. Ramaswamy (eds.) *The Fieldworker and the Field*, Oxford University Press: Bombay.

Ha Van Tan (1978) "The Hoabinhian in the context of Viet Nam", *Vietnamese Studies*, Vol. 46, pp. 127–196.

Ha Van Tan (1980) "Nouvelles recherches prehistoriques et protohistoriques au Vietnam", *Bulletin de l'Ecole Francaise d'Extreme-orient*, Vol. 68, pp. 113–154.

Hall, K.R. (1985) *Maritime Trade and State Development in Early Southeast Asia*, Allen & Unwin: Sydney and Wellington.

Handley, Paul (1990) "Dangerous liasons", *Far Eastern Economic Review*, 21 June.

Hannerz, Ulf (1980) *Exploring the City: Enquiries toward an Urban Anthropology*, Columbia University Press: New York.

Hannerz, Ulf (1989) "Culture between centre and periphery: Toward a macro-anthropology", *Ethnos*, Nos. 3 & 4, pp. 200–216.

Hardgrave, Robert L. (1969) *The Nadars of Tamilnad: The Political Culture of a Community in Change*, University of California Press: Berkeley.

Harrell, S. (1986) "Men, women and ghost in Taiwanese folk religion", in C.W. Bynum, S. Harrel and P. Richman (eds.) *Gender and Religion*, Beacon Press: Boston.

Harris, Marvin (1969) *The Rise of Anthropological Theory*, Routledge & Kegan Paul: London.

Harris, Marvin (1978) *Cannibals and Kings: The Origins of Cultures*, William Collins: Glasgow.

Harris, Olivia (1981) "Households as natural units", in Kate Young, Carol Wolkowitz and Roslyn McCullagh (eds.) *Of Marriage and the Market*, CSE Books: London.

Harris, Roy (1980) *The Language Makers*, Duckworth: London.

Hart, G. (1989) "Agrarian change in the context of state patronage", in G. Hart, A. Turton and B. White (eds.) *Agrarian Transformations: Local Processes and*

the State in Southeast Asia, University of California Press: Berkeley, Los Angeles and London.

Hart, K. (1973) "Informal income opportunities and urban employment in Ghana", *Journal of Modern African Studies*, Vol. 11, No. 1, pp. 61–89.

Hashim, A. (1979) "Land development under FELDA: Some socio-economic aspects", in B.A.R. Mokhzani (ed.) *Rural Development in Southeast Asia*, Vikas: New Delhi.

Hassan, M.K. (1987) "The response of Muslim youth organizations to political change: HMI in Indonesia and ABIM in Malaysia", in W.R. Roff (ed.) *Islam and the Political Economy of Meaning: Comparative Studies of Muslim Discourse*, Croom Helm: London.

Hastrup, Kirsten and Peter Elsass (1990) "Anthropological advocacy", *Current Anthropology*, Vol. 31, No. 3, pp. 301–308.

Haudricourt, André (1954) "De l'origine des tons en vietnamien", *Journal Asiatique*, Tome 242, pp. 69–82.

Haugen, Einar (1977) "Linguistic relativity: Myths and methods", in W.C. McCormack and S.A. Worm (eds.) *Language and Thought: Anthropological Issues*, Mouton: The Hague.

Heberer, T. (1989) *China and Its National Minorities: Autonomy or Assimilation?* M.E. Sharpe: New York and London.

Helliwell, Christine (in press) "'A just precedency': Hierarchy as equality in anthropological discourse", in Mark S. Mosko and Margaret Jolly (eds.) *Transformations of Hierarchy*, Oxford University Press: Sydney.

Hendry, Joy (1981) *Marriage in Changing Japan*, Croom-Helm: London.

Hendry, Joy (1986) *Becoming Japanese*, Manchester University Press: Manchester.

Hendry, Joy (1987) *Understanding Japanese Society*, Routledge: London.

Hendry, Joy and J. Webber (1986) *Interpreting Japanese Society*, Occasional Papers No. 5, Journal of the Anthropological Society of Oxford: Oxford.

Hickey, Gerald Cannon (1964) *Village in Vietnam*, Yale University Press: New Haven, CT.

Higginbotham, Nick and Linda Connor (1989) "Primary mental health care in Southeast Asia: Present contradictions, alternative features", in Paul Cohen and John Purcal (eds.) *The Political Economy of Primary Health Care in Southeast Asia*, Australian Development Studies Network: Canberra.

Higham, C. (1989) *The Archaeology of Mainland Southeast Asia: From 10,000 B.C. to the Fall of Angkor*, Cambridge University Press: Cambridge.

Hinton, Peter (1967) *Tribesmen and Peasants in North Thailand: Proceedings of the First Symposium of the Tribal Research Centre*, Chiang Mai, Thailand.

Hirsch, P. (1989) "The state in the village: Interpreting rural development in Thailand", *Development and Change*, Vol. 20, No. 1. pp. 35–56.

Ho, Ping-Ti (1962) *The Ladder of Success in Imperial China*, Columbia University Press: New York.

Hoare, P.W.C. (1985) "The movement of Lahu hill people towards a lowland lifestyle in North Thailand: A study of three villages", in Anthony R. Walker (ed.) *Studies in Resource Utilization, Contributions to Southeast Asian Ethnography*, No. 4, Singapore.

Hoben, Allan (1982) "Anthropologists and development", in B. Siegel (ed.) *Annual Review of Anthropology*, Palo Alto, Vol. 11, pp. 349–375.

Hockett, Charles F. (1960) "The origin of speech", *Scientific American*, September.

Reprinted in William S.Y. Yang (ed.) (1982) *Human Communication: Language and Its Psychobiological Bases*, W.H. Freeman and Company: San Francisco.

Hoffman, Carl L. (1988) "The 'wild Punan' of Borneo: A matter of economics", in M.R. Dove (ed.) *The Real and Imagined Role of Culture in Development*, University of Hawaii Press: Honolulu.

Horton, Robin (1960) "A definition of religion and its uses", *Journal of the Royal Anthropological Institute*, Vol. XC, 201–226.

Houtart, Francois and Geneve Houtart (1984) *Hai Van: Life in a Vietnamese Commune*, Zed Books: London.

Howe, Leo (1987) "Caste in Bali and India: Levels of comparison", in Ladislav Holy (ed.) *Comparative Anthropology*, Basil Blackwell: Oxford.

Howe, Leo (1990) "Urban anthropology: Trends in its development since 1920", *Cambridge Anthropology*, Vol. 14, No. 1, pp. 37–66.

Hue-Tam Ho Tai (1983) *Millenarianism and Peasant Politics in Vietnam*, Harvard University Press: Cambridge, MA.

Hugo, G. (1987) "Population movement, economic development and social change in Indonesia since 1971", paper presented to PAA Annual Meeting, Chicago, IL.

Hymes, Dell (1962) "The ethnography of speaking", in T. Gladwin and W.C. Sturtevant (eds.) *Anthropology and Human Behavior*, Anthropological Society of Washington: Washington, DC.

Inden, R. (1990) *Imagining India*, Blackwell: Oxford.

Ingold, Tim (1988) "The animal in the study of humanity", in Tim Ingold (ed.) *What Is an Animal?* Unwin Hyman: London.

Ishii, Yoneo (1977) "A note on Buddhistic millenarian revolts in northeastern Siam", in S. Ichimura (ed.) *Southeast Asia: Nature, Society, Development*, University Press of Hawaii: Honolulu.

Ishwaran, K. (1980) "Bhakti tradition and modernisation: The case of lingayatism", *Journal of Asian and African Studies*, Vol. 15, Nos. 1–2, pp. 72–82.

Israeli, Raphael (1980) *Muslims in China: A Study in Cultural Confrontation*, Curzon Press: London.

Jackson, J. (1975) "The Chinatowns of Southeast Asia", *Pacific Viewpoint*, Vol. 16, No. 1, pp. 45–86.

Jackson, P.A. (1989) *Buddhism, Legitimation and Conflict: The Political Functions of Urban Thai Buddhism*, Institute of Southeast Asian Studies: Singapore.

Jagchid, S. and P. Hyer (1979) *Mongolia's Culture and Society*, Westview Press: Boulder, CO.

Jarvie, I.C. (1984) *Rationality and Relativism*, Routledge and Kegan Paul: London.

Jaschok, Maria (1988) *Concubines and Bondservants: The Social History of a Chinese Custom*, Oxford University Press: Hong Kong.

Jayawardena, Kumari (1986) *Feminism and Nationalism in the Third World*, Zed Books: London.

Jellinek, L. (1978) "Circular migration and the pondok dwelling system: A case study of ice cream traders in Jakarta", in P. Rimmer, D.W. Drakakis-Smith and T.G. McGee (eds.) *Food, Shelter and Transport in Southeast Asia and the Pacific*, Australian National University: Canberra.

Jellinek, L. (1991) *The Wheel of Fortune: The History of a Poor Community in Jakarta*, Asian Studies Association of Australia and Allen & Unwin: Sydney.

Jia, Lanpo (1985) "China's earliest Palaeolithic assemblages", in Wu Rukang and

John W. Olsen (eds.) *Palaeoanthropology and Palaeolithic Archaeology in the People's Republic of China*, Academic Press: Orlando.

Jia, Lanpo (1989) "On problems of the Beijing-man site: a critique of new interpretations", *Current Anthropology*, Vol. 30, No. 2, pp. 200–204.

Jia, Lanpo and Huang Weiwen (1985a) "On the recognition of China's Palaeolithic cultural traditions", in Wu Rukang and John W. Olsen (eds.) *Palaeoanthropology and Palaeolithic Archaeology in the People's Republic of China*, Academic Press: Orlando.

Jia, Lanpo and Huang Weiwen (1985b) "The late Palaeolithic of China", in Wu Rukang and John W. Olsen (eds.) *Palaeoanthropology and Palaeolithic Archaeology in the People's Republic of China*, Academic Press: Orlando.

Jia, Lanpo and Huang Weiwen (1990) *The Story of Peking Man: From Archaeology to Mystery*, translated by Yin Zhiqi, Foreign Languages Press and Oxford University Press: Beijing and Hong Kong.

Jocano, F. Landa (1990) *Management by Culture*, University of the Philippines Press: Quezon City.

Jones, Gavin W. (1984) "Introduction", in Gavin W. Jones (ed.) *Women in the Urban and Industrial Workforce*, Development Studies Centre Monograph No. 33, Australian National University: Canberra.

Jones, Rhys (1989) "East of Wallace's Line: Issues and problems in the colonisation of the Australian continent", in Paul Mellars and Chris Stringer (eds.) *The Human Revolution: Behavioural and Biological Perspectives on the Origins of Modern Humans*, Edinburgh University Press: Edinburgh.

Josselin de Jong, P.E. (1952) *Minangkabau and Negri Sembilan: Sociopolitical Structure in Indonesia*, M. Nijhoff: The Hague.

Kahn, J.S. (1980) *Minangkabau Social Formations: Indonesian Peasants and the World Economy*, Cambridge University Press: Cambridge.

Kalland, A. (1981) *Shingu: A Study of a Japanese Fishing Community*, Scandinavian Institute of Asian Studies Monograph Series No. 4, Curzon Press: London.

Kammerer, C.A. (1988) "Territorial imperatives: Akha ethnic identity and Thailand's national integration", in R. Guidieri, Francesco Pellizzi, Stanley J. Tambiah with the assistance of Rose Wax Hauer (eds.) *Ethnicities and Nations*, University of Texas Press: Austin, TX.

Kapferer, Bruce (1983) *A Celebration of Demons*, Indiana University Press: Bloomington.

Karve, Irawati K. (1953) *Kinship Organization in India*, Deccan College Postgraduate and Research Institute: Poona.

Karve, Irawati K. (1968) *Kinship Organization in India*, 3rd Edition, Asia Publishing House: New York.

Kato, Tsuyoshi (1982) *Matriliny and Migration: Evolving Minangkabau Traditions in Indonesia*, Cornell University Press: Ithaca.

Keeler, Ward (1990) "Speaking of gender in Java", in Jane M. Atkinson and Shelly Errington (eds.) *Power and Difference*, Stanford University Press: Stanford.

Keesing, Roger M. (1976) *Cultural Anthropology, A Contemporary Perspective*, Holt, Rinehart and Winston: New York.

Kendall, Laurel (1985) "Ritual silks and kowtow money: The bride as daughter-in-law in Korean wedding rituals", *Ethnology*, Vol. 24, No. 4, pp. 253–267.

Kendall, Laurel (1989) "A noisy and bothersome new custom: Delivering a gift box to a Korean bride", *Journal of Ritual Studies*, Vol. 3, No. 2, pp. 185–202.

Kennedy, J. (1977) "From stage to development in prehistoric Thailand: An exploration of the origins of growth, exchange and variability in Southeast Asia", in K.L. Hutterer (ed.) *Economic Exchange and Social Interaction in Southeast Asia: Perspectives from Prehistory, History and Ethnography*, Michigan Papers on Southeast Asia, No. 13, University of Michigan: Ann Arbor, MI.

Keyes, Charles F. (1977a) "Millenialism, Theravada Buddhism, and Thai society", *Journal of Asian Studies*, Vol. 36, No. 2, pp. 283–302.

Keyes, Charles F. (1977b) *The Golden Peninsula: Culture and Adaptation in Mainland Southeast Asia*, Macmillan Publishing: New York.

Keyes, Charles F. (ed.) (1979) *Ethnic Adaptation and Identity*, Institute for the Study of Human Ideas: Philadelphia.

Keyes, Charles F. (1986) "Ambiguous gender: Male initiation in a northern Thai Buddhist society", in C.W. Bynum, S. Harrell and P. Richman (eds.) *Gender and Religion*, Beacon Press: Boston.

Keyes, Charles F. (1989a) *Thailand: Buddhist Kingdom as Modern Nation-State*, Westview Press: Boulder, CO.

Keyes, Charles F. (1989b) "Buddhist politics and their revolutionary origins in Thailand", *International Political Science Review*, Vol. 10, No. 2, pp. 121–142.

Kim, Choong Soon (1990) "The role of the non-Western anthropologist reconsidered: Illusion versus reality", *Current Anthropology*, Vol. 31, No. 2, pp. 196–200.

King, Victor and W.D. Wilder (1982) "Southeast Asia and the concept of ethnicity", *Southeast Asian Journal of Social Science*, Vol. 10, No. 1, pp. 1–6.

Kipp, Rita Smith and Susan Rodgers (1987) "Introduction: Indonesian religions in society", in Rita Smith Kipp and Susan Rodgers (eds.) *Indonesian Religions in Transition*, University of Arizona Press: Tucson.

Kirk, W. (1990) "Southeast Asia in the colonial period", in D. Dwyer (ed.) *Southeast Asian Development: Geographical Perspectives*, Longman Scientific and Technical: Harlow, Essex.

Kirsch, A. Thomas (1973) *Feasting and Oscillation*, Southeast Asia Program Data Paper, No. 92, Cornell University: Ithaca.

Kirsch, A. Thomas (1976) "Kinship, genealogical claims, and social integration in ancient Khmer society: An interpretation", in C.D. Cowan and O.W. Wolters (eds.) *Southeast Asian History and Historiography: Essays Presented to D.G.E. Hall*, Cornell University Press: Ithaca and London.

Koentjaraningrat (1982) "Anthropology in developing countries", in Hussein Fahim (ed.) *Indigenous Anthropology in Non-Western Countries*, Carolina Academic Press: North Carolina.

Koentjaraningrat (1985) *Javanese Culture*, Oxford University Press and Institute of Southeast Asian Studies: Oxford and New York.

Kondo, Doreen (1990) *Crafting Selves: Power, Gender, and Discourses of Identity in a Japanese Workplace*, University of Chicago Press: Chicago and London.

Kraisri, Nimmanhaeminda (1967) "The Lawa Guardian Spirits of Chiangmai", *Journal of the Siam Society*, Vol. 55, Pt. 2, pp. 185–226.

Kuper, Adam (1973) *Anthropologists and Anthropology*, Penguin: England.

Kuper, Adam (1980) "The man in the study and the man in the field", *European Journal of Sociology*, Vol. XXI, No. 1, pp. 14–39.

Kuper, Adam (1988) *The Invention of Primitive Society: Transformations of an Illusion*, Routledge and Kegan Paul: London.

La Raw, Maran (1973) "Toward a basis for understanding the minorities in Burma: The Kachin example", in John McAlister (ed.) *Southeast Asia: The Politics of National Integration*, Random House: New York.

Laderman, Carol (1987) Review of *Primitive Polluters, Journal of Asian Studies*, Vol. 46, No. 3, pp. 703–704.

Lafont, P. (1982) "Buddhism in contemporary Laos" in M. Stuart-Fox (ed.) *Contemporary Laos: Studies in the Politics and Society of the Lao People's Democratic Republic*, Queensland University Press: St. Lucia.

Lansing, Stephen J. (1983) *The Three Worlds of Bali*, Praeger Publishers: New York.

Lansing, Stephen J. (1991) *Priests and Programmers: Technologies of Power in the Engineered Landscape of Bali*, Princeton University Press: Princeton, NJ.

Laquian, A. (1979) "Squatters and slum dwellers", in S. Yeh and A. Laquian, *Housing Asia's Millions: Problems, Policies and Prospects for Low Cost Housing in Southeast Asia*, International Development Resource Center: Ottawa.

Laquian, A. (1980) "Improvement and development of low income settlements in Southeast Asian cities", *Prisma*, Vol. 17, pp. 10–26.

Laslett, Peter (ed.) (1972) "Introduction", in *Household and Family in Past Time*, Cambridge University Press: Cambridge.

Latz, Gil (1989) *Agricultural Development in Japan: The Land Improvement District in Concept and Practice*, Geography Research Paper No. 255, University of Chicago, Committee on Geographical Studies: Chicago.

Lavely, William (1991) "Marriage and mobility under rural collectism", in Rubie Watson and Patricia Ebrey (eds.) *Marriage and Inequality in Chinese Society*, University of California Press: Berkeley and Los Angeles.

Lawson, Thomas E. and R.N. McCauley (1990) *Rethinking Religion: Connecting Cognition and Culture*, Cambridge University Press: Cambridge.

Le Van Hao (1972) "Ethnological studies and researches in North Vietnam", *Vietnamese Studies*, No. 32, pp. 9–48.

Leach, Edmund (1959) "The hydraulic society in Ceylon", *Past and Present*, No. 15, pp. 2–26.

Leach, Edmund (1960/61) "The frontiers of Burma", *Comparative Studies in Society and History*, Vol. 3, pp. 49–68.

Leach, Edmund (1967) "Caste, class and slavery: The taxonomic problem", in Anthony de Reuck and Julie Knight (eds.) *Caste and Race: Comparative Approaches*, J & A Churchill: London.

Leach, Edmund (ed.) (1968) *Dialectic in Practical Religion*, Cambridge Papers in Social Anthropology, No. 5, Cambridge University Press: Cambridge.

Leach, Edmund (1970) *Political Systems of Highland Burma: A Study of Kachin Social Structure*, G. Bell: London (first published 1954).

Leach, Edmund (1971) "Language and anthropology", in Noel Minnis (ed.) *Linguistics at Large*, Victor Gollancz: London.

Leach, Edmund (1982) *Social Anthropology*, Fontana: London.

Leach, Edmund (1989/90) "Masquerade: The presentation of the self in holiday life", *Cambridge Anthropology*, Vol. 13, No. 3, pp. 47–69.

Lehiste, Ilse (1988) *Lectures on Language Contact*, MIT Press: Boston, MA.

Lehman, F.K. (1963) *The Structure of Chin Society: A Tribal People of Burma Adapted to a Non-Western Civilisation*, Illinois Studies in Anthropology No. 3, University of Illinois Press: Urbana, IL.

Lehman, F.K. (1984) "Freedom and bondage in traditional Burma and Thailand", *Journal of Southeast Asia Studies*, Vol. 15, No. 2, pp. 233–244.

Lemoine, J. (1986) "Shamanism in the context of Hmong resettlement", in Glenn L. Hendricks, Bruce T. Downing and Amos S. Deinard (eds.) *The Hmong in Transition*, Center for Migration Studies of New York: New York.

Lévi-Strauss, Claude (1966) *The Savage Mind*, Weidenfeld & Nicolson: London.

Lévi-Strauss, Claude (1968) *Structural Anthropology*, Penguin Allen Lane: London.

Lévi-Strauss, Claude (1975) *Tristes Tropiques*, Atheneum: New York.

Lévi-Strauss, Claude (1982) "The social organization of the Kwakiutl", in *The Way of the Masks*, translated by Sylvia Modelski, University of Washington Press: Seattle.

Lévy, Marion J. (1949) *The Family Revolution in Modern China*, Harvard University Press: Cambridge, MA.

Lewis, Paul W. (1984) *People of the Golden Triangle: Six Tribes of Thailand*, Thames and Hudson: London.

Li, Tania (1989) *Malays in Singapore: Culture, Economy and Ideology*, Oxford University Press: Singapore.

Lian, Kwen Fee (1982) "Identity in minority group relations", *Ethnic and Racial Studies*, Vol. 5, No. 1, pp. 42–52.

Liddle, Joanna and Rama Joshi (1986) *Daughters of Independence*, Zed Press: London.

Lieberman, J.B. (1980) "Europeans, trade, and the unification of Burma, c. 1540–1620", *Oriens Extremus*, Vol. 27, pp. 203–226.

Lieberman, J.B. (1984) *Burmese Administrative Cycles: Anarchy and Conquest c. 1580–1760*, Princeton University Press: Princeton, NJ.

Lieberman, J.B. (1987) "Reinterpreting Burmese history", *Comparative Studies in Society and History*, Vol. 29, No. 1, pp. 162–194.

Lieberman, J.B. (1990) "Wallerstein's systems and the international context of early modern Southeast Asian history", *Journal of Asian History*, Vol. 24, No. 1.

Lieberman, Victor (1978) "Ethnic politics in eighteenth-century Burma", in *Modern Asian Studies*, Vol. 12, No. 3, pp. 455–482.

Lim, Linda Y.C. (1990) "Women's work in export factories: The politics of a cause", in Irene Tinker (ed.) *Persistent Inequalities*, Oxford University Press: New York.

Ling, Trevor O. (ed.) (forthcoming) *Buddhist Trends in Contemporary Southeast Asia*, Institute of Southeast Asian Studies: Singapore.

Linton, R. (1943) "Nativistic movements", *American Anthropologist*, Vol. 45, No. 2, pp. 230–240.

Lock, M. (1980) *East Asian Medicine in Urban Japan*, University of California Press: Berkeley.

Malinowski, Bronislaw (1954) *Magic, Science and Religion*, Double Day Anchor Books: Garden City, NY.

Mann, Michael (1984) "The autonomous power of the state: Its origins, mechanisms and results", *European Journal of Sociology*, Vol. 25, No. 2, pp. 185–213.

Maquet, J.J. (1961) *The Premise of Inequality in Ruanda: A Study of Political Relations in Central African Kingdom*, Oxford University Press: London.

Marcus, George (ed.) (1983) "'Elite' as a concept, theory and research tradition", in *Elites: Ethnographic Issues*, University of New Mexico Press: Albuquerque.

Marglin, Frederique A. (1985) *Wives of the God-King: The Rituals of the Devadasis of Puri*, Oxford University Press: New Delhi.

Marr, D.G. and A.C. Milner (eds.) (1986) *Southeast Asia in the 9th–14th Centuries*, Institute of Southeast Asian Studies: Singapore.

Martin, Samuel E. (1966) "Lexical evidence relating Korean to Japanese", *Language*, Vol. 42, pp. 185–251.

Matisoff, James A. (1973) "Tonogenesis in Southeast Asia", in Larry M. Hyman (ed.) *Consonant Types and Tone*, Southern California Occasional Papers in Linguistics, No. 1, University of California: Los Angeles.

Matisoff, James A. (1983) "Linguistic diversity and language contact", in John Mckinnen and Wanat Bhruksasri (eds.) *Highlanders of Thailand*, Oxford University Press: Kuala Lumpur.

Matisoff, James A. (1991) "Sino-Tibetan linguistics: Present state and future prospects", *Annual Review of Anthropology*, Vol. 20, pp. 469–504.

Mauss, M. (1954) *The Gift*, Cohen and West: London.

Mayer, Adrian C. (1960) *Caste and Kinship in Central India: A Village and its Region*, University of California Press: Berkeley and Los Angeles.

Mazumdar, Vina and Kumud Sharma (1990) "Sexual division of labour and the subordination of women: A reappraisal from India", in Irene Tinker (ed.) *Persistent Inequalities*, Oxford University Press: New York.

McCloskey, D.N. (1985) *The Rhetoric of Economics*, University of Wisconsin Press: Madison.

McGee, T. (1967) *The Southeast Asian City: A Social Geography of the Primate Cities of Southeast Asia*, Frederick Praeger: New York.

McKay, E. (1976) "Sixteenth to nineteenth centuries: The significance of the coming of the Europeans" in E. McKay (ed.) *Studies in Indonesian History*, Pitman: Carlton, Australia.

McKean, Philip Frick (1977) "Towards a theoretical analysis of tourism: Economic dualism and cultural involution in Bali", in Valene Smith (ed.) *Hosts and Guests*, University of Pennsylvania Press: Philadelphia.

McTaggart, D. (1988) "Kings of the mountain: Dominance and urban growth in Southeast Asia", in G. Krausse (ed.) *Urban Society in Southeast Asia, Volume II: Political and Cultural Issues*, Asian Research Service: Hong Kong.

McVey, Ruth (1983) "Faith as the outsider: Islam in Indonesian politics", in J.P. Piscatori (ed.) *Islam in the Political Process*, Cambridge University Press: Cambridge.

Mellars, Paul (ed.) (1990) *The Human Revolution: Behavioural and Biological Perspectives on the Origins of Modern Humans*, Vol. 2, University of Edinburgh Press: Edinburgh.

Mellars, Paul and Chris Stringer (eds.) (1989) *The Human Revolution: Behavioural and Biological Perspectives on the Origins of Modern Humans*, Vol. 1, Edinburgh University Press: Edinburgh.

Mendelson, E. Michael (1961) "A messianic Buddhist association in Upper Burma", *Bulletin of the School of Oriental and African Studies, University of London*, Vol. 24, pp. 560–580.

Mendelson, E. Michael (1975) *Sangha and State in Burma: A Study of Monastic Sectarianism and Leadership*, Cornell University Press: Ithaca.

Merson, J. (1989) *Roads to Xanadu: East and West in the Making of the Modern World*, Child and Associates: Australia.

Mies, Maria (1982) *The Lace Makers of Narsapur*, Zed Press: London.

Miller, Roy A. (1967) *The Japanese Language*, Charles E. Tuttle: Tokyo.

Mischung, Roland (1984) *Religion und Wirklichkeitsvorstellungen in einem Karen-Dorf Nordwest-Thailands*, Franz Sterner Verlag: Wiesbaden.

Moeran, B. (1984) *Lost Innocence: Folk Craft Potters of Onta, Japan*, University of California Press: Berkeley.

Moerman, M. (1969) "A Thai village headman as a synaptic leader", *Journal of Asian Studies*, Vol. 28, No. 3, pp. 535–549.

Mohanty, Chandra (1988) "Under western eyes", *Feminist Review*, Vol. 30, pp. 61–88.

Moon, Okpyo (1989) *From Paddy Field to Ski Slope*, Manchester University Press: Manchester.

Moore, Barrington (1967) *The Social Origins of Dictatorship and Democracy*, Penguin Books: UK.

Moore, Barrington (1978) *Injustice: The Social Bases of Obedience and Revolt*, Penguin Allen Lane: London.

Moore, Henrietta L. (1988) *Feminism and Anthropology*, University of Minnesota Press: Minneapolis.

Mouer, R. and Y. Sugimoto (1986) *Images of Japanese Society*, KPI: London.

Murashima, Eiji (1988) "The origin of modern official state ideology in Thailand", *Journal of Southeast Asian Studies*, Vol. 19, No. 1, pp. 80–96.

Murdoch, John B. (1974) "The 1901–1902 holy man's rebellion", *Journal of the Siam Society*, Vol. 62, Pt. 1, pp. 47–66.

Murdock, George Peter (1949) *Social Structure*, Macmillan: New York.

Murphy, Raymond (1984) "The structure of closure: A critique and development of the theories of Weber, Collins, and Parkin", *The British Journal of Sociology*, Vol. XXXV, No. 4, pp. 545–567.

Murray, M. (1981) *The Development of Capitalism in Colonial Indochina, 1870–1940*, University of California Press: Berkeley.

Mus, Paul (1975) *India Seen from the East: Indian and Indigenous Cults in Champa*, translated by I.W. Mabbett, Monash Papers on Southeast Asia, No. 3, Monash University: Melbourne.

Muzaffar, Chandra (1988) "Islamic resurgence and the question of development in Malaysia", in Lim Teck Ghee (ed.) *Reflections on Development in Southeast Asia*, Institute of Southeast Asian Studies: Singapore.

Nadel, S. (1942) *A Black Byzantium: The Kingdom of Nupe in Nigeria*, International African Institute, Oxford University Press: London.

Nagata, Judith (1974) "What is a Malay? Situational selection of ethnic identity in a plural society", *American Ethnologist*, Vol. 7, No. 2, pp. 331–350.

Nagata, Judith (1981) "In defence of ethnic boundaries: The changing myths and charters of Malay identity", in Charles Keyes (ed.) *Ethnic Change*, University of Washington Press: Seattle.

Nakamura, Hajime (1964) *Ways of Thinking of Eastern Peoples: India, China, Tibet, Japan*, edited by Philip P. Wiener, University Press of Hawaii: Honolulu.

Nakane, Chie (1967) *Kinship and Economic Organization in Japan*, Athlone Press: London.

Nakane, Chie (1973) *Japanese Society*, Pelican: Harmondsworth.

Nakane, Chie (1975) "Fieldwork in India – A Japanese experience", in A. Beteille and T.N. Madan (eds.) *Encounter and Experience: Personal Accounts of Fieldwork*, University Press of Hawaii: Honolulu.

Needham, J. (1954) *Science and Civilization in China*, Vol. II, Sections 1–18, Cambridge University Press: Cambridge.

Netting, Robert McC., Richard R. Wilk and Eric J. Arnould (eds.) (1984) *Households: Comparative and Historical Studies of the Domestic Group*, University of California Press: Berkeley and Los Angeles.

Nidhi, Aeusriwongse (1976) "The Devaraja cult and Khmer kingship at Angkor", in K.R. Hall and J.K. Whitmore (eds.) *Explorations in Early Southeast Asian History: The Origins of Southeast Statecraft*, Michigan Papers on Southeast Asia, No. 11, University of Michigan: Ann Arbor, MI.

Noguchi, Paul H. (1990) *Delayed Departures, Overdue Arrivals: Industrial Familialism and the Japanese National Railways*, University of Hawaii Press: Honolulu.

Nonini, Donald (1983) "The Chinese truck transport 'industry' of a Peninsular Malaysian market town", in Linda Lim and Peter Gosling (eds.) *The Chinese in Southeast Asia*, Vol. 1, Maruzen Asia: Singapore.

Noss, Richard B. (ed.) (1984) *An Overview of Language Issues in Southeast Asia 1950–1980*, Oxford University Press: Singapore.

Nugent, David (1982) "Closed systems and contradiction: The Kachin in and out of history", *Man*, Vol. 17, No. 3, pp. 508–527.

Obeyesekere, G. (1968) "Theodicy, sin and salvation in a sociology of Buddhism", in Edmund Leach (ed.) *Dialectic in Practical Religion*, Cambridge Papers in Social Anthropology No. 5, Cambridge University Press: Cambridge.

Ohnuki-Tierney, Emiko (1984a) *Illness and Culture in Contemporary Japan*, Cambridge University Press: Cambridge.

Ohnuki-Tierney, Emiko (1984b) "'Native' anthropologists", *American Ethnologist*, Vol. 11, No. 3, pp. 584–585.

Oliver, Victor L. (1976) *Caodai Spiritism: A Study of Religion in Vietnamese Society*, E.J. Brill: Leiden.

Ong, Aihwa (1987) *Spirits of Resistance and Capitalist Discipline: Factory Women in Malaysia*, State University of New York Press: Albany.

Orlove, Benjamin S. (1980) "Ecological anthropology", *Annual Review of Anthropology*, Vol. 9, pp. 235–273.

Ortner, Sherry B. (1974) "Is female to male as nature is to culture?", in Michelle Z. Rosaldo and Louise Lamphere (eds.) *Woman, Culture and Society*, Stanford University Press: Stanford.

Ortner, Sherry B. (1984) "Theory in anthropology since the sixties", *Comparative Studies in Society and History* Vol. 26, No. 1, pp. 126–166.

Ortner, Sherry B. and Harriet Whitehead (1981) "Introduction: Accounting for sexual meanings", in Sherry B. Ortner and Harriet Whitehead (eds.) *Sexual Meanings*, Cambridge University Press: Cambridge.

Papanek, Hanna (1979) "Family status production: The 'work' and 'non-work' of women", *Signs*, Vol. 4, No. 4, pp. 775–781.

Parish, William L. and Martin King Whyte (1978) *Village and Family in Contemporary China*, University of Chicago Press: Chicago.

Persoon, G. (1987) "Congelation in the melting pot: The Minangkabau in Jakarta", in Peter Nas (ed.) *The Indonesian City*, Princeton University Press: Princeton, NJ.

Pertierra, Raul (1983) "Religion as the idiom of political discourse in the Philippines: A sociological view", *Philippine Social Sciences and Humanities Review*, Vol. XLVII, Nos. 1–14, pp. 219–242.

Pertierra, Raul (1988) *Religion, Politics and Rationality in a Philippine Community*, Ateneo de Manila University: Manila.

Phillips, H. (1965) *Thai Peasant Personality*, University of California Press: Berkeley.

Phongpaichit, P. (1982) *From Peasant Girls to Bangkok Masseuses*, ILO: Geneva.

Picard, Michel (1990) "'Cultural tourism' in Bali: Cultural performances as tourist attractions", *Indonesia*, No. 49, pp. 37–74.

Pinches, M. (1987) "'All that we have is muscle and sweat': The rise of wage labour in a Manila squatter community", in M. Pinches and Salim Lakha (eds.) *Wage Labour and Social Change: The Proletariat in Asia and the Pacific*, Monash University: Melbourne.

Pocock, D. (1973) *Mind, Body and Wealth : A Study of Belief and Practice in an Indian Village*, Basil Blackwell: Oxford.

Polanyi, K., C.M. Arensberg and H.W. Pearson (1957) *Trade and Market in the Early Empires*, Free Press: Glencoe, NY.

Pollmann, Tessel (1990) "Margaret Mead's Balinese: The fitting symbols of the American dream", *Indonesia*, No. 49, pp. 1–35.

Pope, Geoffrey G. (1988) "Recent advances in Far Eastern palaeoanthropology", *Annual Review of Anthropology*, Vol. 17, pp. 43–77.

Popkin, Samuel L. (1979) *The Rational Peasant: The Political Economy of Rural Society in Vietnam*, University of California Press: Berkeley.

Potter, Jack M. (1976) *Thai Peasant Social Structure*, University of Chicago Press: Chicago and London.

Potter, Jack M. (1978) "Cantonese shamanism", in A. Wolf (ed.) *Studies in Chinese Society*, Stanford University Press: Stanford.

Potter, Sulamith Heins and Jack M. Potter (1990) *China's Peasants: The Anthropology of a Revolution*, Cambridge University Press: Cambridge.

Prasithrathsint, Amara (1981) "Characteristics of foreign language and cultural borrowings in Thai", *Science of Language*, Department of Linguistics, Chulalongkorn University: Bangkok.

Prasithrathsint, Amara (1988) "Change in the passive constructions in standard Thai from 1802 to 1982", *Language Sciences*, Vol. 10, No. 2.

Premack, Ann James and David Premack (1972) "Teaching language to an ape", *Scientific American*, October, pp. 92–99. Reprinted in William S.Y. Wang (1982) *Human Communication: Language and Its Psychobiological Bases*, W.H. Freeman: San Francisco.

Qiu, Zhonglang (1985) "The middle Palaeolithic of China", in Wu Rukang and John W. Olsen (eds.) *Palaeoanthropology and Palaeolithic Archaeology in the People's Republic of China*, Academic Press: Orlando.

Rajah, Ananda (1990) "Ethnicity, nationalism, and the nation-state: The Karen in Burma and Thailand", in Gehan Wijeyewardene (ed.) *Ethnic Groups across National Boundaries in Mainland Southeast Asia*, Institute of Southeast Asian Studies: Singapore.

Ram, Kalpana (1991) "Moving in from the margins: Gender as the centre of cultural contestation of power relations in south India", in Gill Bottomley, Marie de Lepervance and Jeannie Martin (eds.) *Intersexions*, Allen and Unwin: Sydney.

Rambo, A. Terry (1985) *Primitive Polluters: Semang Impact on the Malaysian Tropical Rainforest Ecosystem*, Anthropological Papers No. 76, Museum of Anthropology, University of Michigan: Ann Arbor, MI.

Rambo, A. Terry and Neil L. Jamieson III (1970) *Cultural Change in Rural Vietnam: A Study of the Effects of Long-Term Communist Control on the Social Structure, Attitudes, and Values of the Peasants of the Mekong Delta*, Asia Society: New York.

Rambo, A. Terry, Karl L. Hutterer and Kathleen Gillogly (eds.) (1988) "Introduction", in *Ethnic Diversity and the Control of Natural Resources in Southeast Asia*, Michigan Papers on South and Southeast Asia No. 32. Center for South and Southeast Asian Studies, University of Michigan: Ann Arbor, MI.

Redfield, R. (1955) *The Little Community*, University of Chicago Press: Chicago.

Redfield, R. and M. Singer (1954) "The cultural role of cities", *Economic Development and Culture Change*, Vol. 3, No. 1, pp. 53–73.

Reid, Anthony (1979) "The origins of Southeast Asian poverty", in W.E. Willmott (ed.) *Scholarship and Society in Southeast Asia*, New Zealand Asian Studies Society: Christchurch.

Reid, Anthony (1980) "The structure of cities in Southeast Asia", *Journal of Southeast Asian Studies*, Vol. 11, No. 2, pp. 235–250.

Reid, Anthony (1983) *Slavery, Bondage and Dependency in Southeast Asia*, University of Queensland Press: St Lucia.

Reid, Anthony (1987) "Low population growth and its causes in pre-colonial Southeast Asia", in N.G. Owen (ed.) *Death and Disease in Southeast Asia: Explorations in Social, Medical and Demographic History*, Oxford University Press: Oxford and New York.

Reid, Anthony (1988) *Southeast Asia in the Age of Commerce, 1450–1680*, Yale University Press: New Haven, CT.

Reid, Anthony (1990) "An 'age of commerce' in Southeast Asian history", *Modern Asian Studies*, Vol. 24, No. 1, pp. 1–30.

Renard, Ronald (1988) "Minorities in Burmese history", in K.M. De Silva, Pensri Duke, Ellen S. Goldberg and Nathan Katz (eds.) *Ethnic Conflict in Buddhist Societies*, Pinter Publishers: London.

Rightmire, G. Philip (1988) "Homo erectus and later Middle Pleistocene humans", *Annual Review of Anthropology*, Vol. 17.

Robins, Edward (1986) "Problems and perspective in development anthropology: The short-term assignment", in Edward C. Green (ed.) *Practicing Development Anthropology*, Westview Special Studies in Applied Anthropology, Westview Press: Boulder and London.

Robinson, Kathy (1983) "Women and work in an Indonesian mining town", in Lenore Manderson (ed.) *Women's Work and Women's Roles*, Development Studies Centre Monograph No. 32, Australian National University: Canberra.

Robinson, Kathy (1986) *Stepchildren of Progress: The Political Economy of Development in an Indonesian Mining Town*, State University of New York Press: Albany.

Robinson, Kathy (1988) "What kind of freedom is cutting your hair?", in Glen Chandler, Norma Sullivan and Jan Branson (eds.) *Development and Dis-placement: Women in Southeast Asia*, Monash University Centre of Southeast Asian Studies: Clayton, Victoria.

Robinson, Kathy (1991) "Housemaids: The effects of gender and culture on the internal and international migration of Indonesian women", in Gill Bottomley, Marie de Lepervance and Jeannie Martin (eds.) *Intersexions*, Allen and Unwin: Sydney.

Rogers, Barbara (1980) *The Domestication of Women*, Tavistock: London.

Rogers, Susan Carol (1991) *Shaping Modern Times in Rural France: The Transformation and Reproduction of an Aveyronnais Community*, Princeton University Press: Princeton, NJ.

Rohlen, T.P. (1974) *For Harmony and Strength: Japanese White Collar Organisation in Anthropological Perspective*, University of California Press: Berkeley.

Rohlen, T.P. (1983) *Japan's High Schools*, University of California Press: Berkeley.

Rosaldo, Michelle Zimbalist (1974) "Woman, culture and society: A theoretical overview", in Michelle Z. Rosaldo and Louise Lamphere (eds.) *Woman, Culture and Society*, Stanford University Press: Stanford.

Rosaldo, Michelle Zimbalist (1980) *Knowledge and Passion: Ilongot Notions of Self and Social Life*, Cambridge University Press: Cambridge.

Rosaldo, Michelle Zimbalist (1986) "From the door of his tent: The fieldworker and the inquisitor", in James Clifford and George E. Marcus (eds.) *Writing Culture*, University of California Press: Berkeley.

Rowe, W.L. (1973) "Caste, kinship and association in urban India", in A. Southall (ed.) *Urban Anthropology: Cross Cultural Studies of Urbanisation*, Oxford University Press, New York.

Sacherer, Janice (1986) "Applied anthropology and the development bureaucracy: Lessons from Nepal", in Edward C. Green (ed.) *Practicing Development Anthropology*, Westview Special Studies in Applied Anthropology, Westview Press: Boulder and London.

Said, Edward (1985) *Orientalism*, Peregrine Books: London.

Sairin, S. (1980) "The Javanese Trah", MA Thesis, Department of Anthropology, Australian National University: Canberra.

Salaff, Janet (1981) *Working Class Daughters of Hong Kong: Filial Piety or Power in the Family?*, Cambridge University Press: New York.

Salaff, Janet (1988) *State and Family in Singapore: Restructuring a Developing Society*, Cornell University Press: Ithaca and London.

Sanday, Peggy Reeves (1990) "Androcentric and matrifocal gender representations in Minangkabau ideology", in Peggy R. Sanday and Ruth G. Goodenough (eds.) *Beyond the Second Sex*, University of Pennsylvania Press: Philadelphia.

Sandhu, K. (1964) "Emergency resettlement in Malaya", *Journal of Tropical Geography*, Vol. 18, pp. 157–183.

Sangren, P. Steven (1988) "Rhetoric and the authority of ethnography: 'Postmodernism' and the social reproduction of texts", *Current Anthropology*, Vol. 29, No. 3, pp. 405–436.

Sanjek, R. (1990) "Urban anthropology in the 1980s: A world view", *Annual Review of Anthropology*, Vol. 19, pp. 151–186.

Santa Luca, A.P. (1980) *The Ngandong Fossil Hominids*, Yale University Publications in Anthropology, 78, Yale University Press: New Haven, CT.

Sapir, Edward (1929) "The status of linguistics as a science", *Language*, Vol. 5, pp. 201–214.

Sather, C. (1985) "Boat crews and fishing fleets: The social organization of maritime labour amongst the Bajau Laut of southeastern Sabah", in Anthony R. Walker (ed.) *Studies in Resource Utilization, Contributions to Southeast Asian Ethnography*, No. 4, Singapore.

Scheffler, H.W. (1984) "Markedness and extensions: The Tamil case", *Man*, Vol. 19, No. 4, pp. 557–574.

Schmidt, Wilhelm (1906a) "Die moderne ethnologie", *Anthropos*, Vol. 1, pp. 134–163, 318–387, 593–643, 950–997.

Schmidt, Wilhelm (1906b) *Die Mon-Khmer Völker, ein Bindeglied zwischen den Völkern Zentralasiens und Austronesiens*, F. Viehweg: Braunschweig.

Schmidt, Wilhelm (1911) "Die kulturhistorische methode in der ethnologie", *Anthropos*, Vol. 6, pp. 1010–1036.

Schneider, David M. (1961) "The distinctive features of matrilineal descent groups", in David M. Schneider and Kathleen Gough (eds.) *Matrilineal Kinship*, University of California Press: Berkeley and Los Angeles.

Scott, James C. (1976) *The Moral Economy of the Peasant: Rebellion and Subsistence in Southeast Asia*, Yale University Press: New Haven and London.

Scott, James C. (1977) "Protest and profanation: Agrarian revolt and the little tradition", *Theory and Society*, Vol. 4, Pt. 1, pp. 1–38; Pt. 2, pp. 211–246.

Scott, James C. (1980) "Hegemony and the peasantry", in S. Matsumoto (ed.) *Southeast Asia in a Changing World*, Institute of Developing Economies: Tokyo.

Scott, James C. (1985) *Weapons of the Weak: Everyday Forms of Peasant Resistance*, Yale University Press: New Haven, CT.

Scott, James C. (1990) *Domination and the Arts of Resistance: Hidden Transcripts*, Yale University Press: New Haven, CT.

Scott, James C., J. Benedict and Tria Kerkvliet (ed.) (1986) "Everyday forms of peasant resistance in Southeast Asia", *Journal of Peasant Studies*, Special Issue, Vol. 13, No. 2.

Sedov, I. (1968) "La societe Angkorienne et le probleme du MPA", *La Pensee*, pp. 71–84.

Seewuthiwong, Duangta (1989) "Weddings, wealth, pigs and Coca Cola: *farang* tourists in an Ahka Village", in John McKinnon and Bernard Vienne (eds.) *Hill Tribes Today*, White Lotus-Orstrom: Bangkok.

Sémah, Francois, Anne-Marie Sémah and Tony Djubiantono (1990) *They Discovered Java*, Pusat Penelitian Arkeologi National and Museum National de l'Histoire Naturelle: Jakarta.

Sennett, Richard and Jonathan Cobb (1972) *The Hidden Injuries of Class*, Cambridge University Press: Cambridge.

Seshaiah, S. (1979) "Selecting a 'representative' village", in M.N. Srinivas, A.M. Shah and E.A. Ramaswamy (eds.) *The Fieldworker and the Field*, Oxford University Press: Bombay.

Shanin, T. (ed.) (1988) *Peasants and Peasant Societies*, 2nd Edition, Penguin Books: Harmondsworth.

Sharma, Ursula (1986) *Women's Work, Class and the Urban Household*, Tavistock: London.

Siaw, Lawrence (1981) "The legacy of Malaysian Chinese structure", *Journal of Southeast Asian Studies*, Vol. 12, No. 2, pp. 395–402.

Siegel, John (1986) *Solo in the New Order: Language and Hierarchy in an Indonesian City*, Princeton University Press: Princeton, NJ.

Siu, Helen F. (1989) *Agents and Victims in South China: Accomplices in Rural Revolution*, Yale University Press: New Haven, NJ.

Skinner, William (1958) *Leadership and Power in the Chinese Community of Thailand*, Cornell University Press: Ithaca.

Skinner, William (1962) *Chinese Society in Thailand: An Analytical History*, Cornell University Press: Ithaca.

Smalley, William A. (1988) "Thailand's hierarchy of multilingualism", *Language Sciences*, Vol. 10, No. 2.

Smil, Vaclav (1984) *The Bad Earth: Environmental Degradation in China*, Sharpe: Armonk, NY.

Smith, Anthony D. (1986) *The Ethnic Origins of Nations*, Basil Blackwell: Oxford.

Smith, Anthony D. (1988) "The myth of the modern national and the myths of nations", *Ethnic and Racial Studies*, Vol. 11, No. 1, pp. 1–26.

Smith, Anthony D. (1990) "Towards a global culture?", *Theory Culture and Society*, Vol. 7, Nos. 2–3, pp. 171–191.

Smith, M.G. (1960) *Government in Zazzau, 1800–1950*, Oxford University Press: London, New York and Toronto.

Smith, Robert J. (1974) *Ancestor Worship in Contemporary Japan*, Stanford University Press: Stanford.

Smith, Robert J. (1978) *Kurusu: The Price of Progress in a Japanese Village*, Stanford University Press: Stanford.

Sodusta, Jesucita L. (1977) *Assessment of the Effectivity of Land Reform Program Implementation*, Institute of Developing Economies: Tokyo.

Sodusta, Jesucita L. (1983) *Jamoyawan Ritual: A Territorial Concept*, University of the Philippines Press: Quezon City.

Sodusta, Jesucita L. (forthcoming) *The Underdevelopment of Agriculture in Southeast Asia*, University of Philippines: Quezon.

Solheim II, Wilhelm G. (1970) "Northern Thailand, Southeast Asia, and world prehistory", *Asian Perspectives*, Vol. 13, pp. 145–157.

Solheim II, Wilhelm G. (1975) "Reflections on the new data of Southeast Asian prehistory: Austronesian origin and consequence", *Asian Perspectives*, Vol. 18, pp. 146–160.

Solheim II, Wilhelm G. (1979) "A look at 'L'Art Prebouddhique de la Chine at de l'Asie du Sud-Est et son Influence en Oceanie' forty years after", *Asian Perspectives*, Vol. 22, No. 2, pp. 165–205.

Sopher, D. (1977) *The Sea Nomads: A Study of the Maritime Boat People of Southeast Asia*, National Museum: Singapore.

Sorensen, Clark W. (1988) *Over the Mountains are Mountains: Korean Peasant Households and their Adaptations to Rapid Industrialization*, University of Washington Press: Seattle.

Southall, A.W. (1956) *Alur Society A Study in Processes and Types of Domination*, Hepper: Cambridge.

Sparks, D. (1985) "Group dynamics of religious association in Hong Kong", in G. Krausse (ed.) *Urban Society in Southeast Asia, Volume II: Political and Cultural Issues*, Asian Research Service: Hong Kong.

Spates, J. and J. Macionis (1982) *The Sociology of Cities*, St. Martin's Press: New York.

Spiro, Melford (1966) "Religion: Problems of definition and explanation", in Michael Banton (ed.) *Anthropological Approaches to the Study of Religion*, Association of Social Anthropologists Monographs, Tavistock Publications: London.

Spiro, Melford (1967) *Burmese Supernaturalism: A Study in the Explanation and Reduction of Suffering*, Prentice-Hall: Englewood Cliffs, NJ.

Spivak, Gayatri Chakravorty (1987) *In Other Worlds*, Methuen: New York and London.

Srinivas, M.N. (1952) *Religion and Society Among the Coorgs of South India*, Asia Publishing House: Bombay.

Srinivas, M.N. (1979) "The fieldworker and the field", in M.N. Srinivas, A.M. Shah and E.A. Ramaswamy (eds.) *The Fieldworker and the Field*, Oxford University Press: Bombay.

Stargardt, J. (1986) "Hydraulic works and South East Asian polities", in D.G. Marr and A.C. Milner (eds.) *Southeast Asia in the 9th to 14th Centuries*, Institute of Southeast Asian Studies: Singapore.

Stein, Burton (1977) "The segmentary state in south Indian history", in Richard G. Fox (ed.) *Realm and Region in Traditional India*, Oxford University Press: Delhi.

Steinberg, D.J. (1987) *In Search of Southeast Asia: A Modern History*, Allen & Unwin: Sydney and Wellington.

Steward, J. (1949) "Cultural causality and law: A trial formulation of early civilization", *American Anthropologists*, Vol. 51, No. 1, pp. 1–27.

Stirrat, R.L. (1984) "Sacred models", *Man*, Vol. 19, No. 2, pp. 199–215.

Stivens, Maila (1985) "The fate of women's land rights: gender, matriliny, and capitalism in Rembau, Negeri Sembilan, Malaysia", in H. Afshar (ed.) *Women, Work and Ideology in the Third World*, Tavistock: London.

Stoler, Ann (1977) "Class structure and female autonomy in rural Java", *Signs*, Vol. 3, No. 1, pp. 74–89.

Stover, Leon (1974) *The Cultural Ecology of Chinese Civilization: Peasants and Elites in the Last of the Agrarian States*, Pica Press: New York.

Stover, Leon and Takeko K. Stover (1976) *China: An Anthropological Introduction*, Goodyear Publishing: California.

Strathern, Marilyn (1980) "No nature, no culture: The Hagen case", in Carol MacCormack and Marilyn Strathern (eds.) *Nature, Culture and Gender*, Cambridge University Press: Cambridge.

Strathern, Marilyn (1984) "Domesticity and the denigration of women", in Denise O'Brien and Sharon W. Tiffany (eds.) *Rethinking Women's Roles*, University of California Press: Berkeley.

Strathern, Marilyn (ed.) (1987) "Introduction", in *Dealing with Inequality*, Cambridge University Press: Cambridge.

Strauch, Judith (1981a) "Multiple ethnicities in Malaysia: The shifting relevance of alternative Chinese categories", *Modern Asian Studies*, Vol. 15, No. 2, pp. 235–260.

Strauch, Judith (1981b) *Chinese Village Politics in the Malaysian State*, Harvard University Press: Cambridge, MA.

Stross, Brian (1976) *The Origin and Evolution of Language*, W.M.C. Brown: Dubugue, IA.

Sulak, Sivaraksa (1989) *Religion and Development*, Thai Inter-Religious Commission for Development: Bangkok.

Sullivan, J (1990) *Community and Local Government in Java: Facts and Fictions*, Centre for Southeast Asian Studies, Monash University: Melbourne.

Tambiah, Stanley J. (1968) "The ideology of merit and the social correlates of Buddhism in a Thai village", in Edmund Leach (ed.) *Dialectic in Practical Religion*, Cambridge Papers in Social Anthropology, No. 5, Cambridge University Press: Cambridge.

Tambiah, Stanley J. (1973) "Dowry and bridewealth and the property rights of

women in South Asia", in Jack Goody and Stanley J. Tambiah (eds.) *Bridewealth and Dowry*, Cambridge University Press: Cambridge.

Tambiah, Stanley J. (1976) *World Conqueror and World Renouncer: A Study of Buddhism and Polity in Thailand against a Historical Background*, Cambridge University Press: Cambridge.

Tambiah, Stanley J. (1984) *The Buddhist Saints of the Forest and the Cult of Amulets: A Study in Charisma, Hagiography, Sectarianism, and Millenarian Buddhism*, Cambridge University Press: London.

Tambiah, Stanley J. (1985) *Culture, Thought and Social Action: An Anthropological Perspective*, Harvard University Press: Cambridge, MA.

Tambiah, Stanley J. (1986) *Sri Lanka: Ethnic Fratricide and the Dismantling of Democracy*, I.B. Tauris: London.

Tambiah, Stanley J. (1989) "Ethnic conflict in the world today", *American Ethnologist*, Vol. 16, No. 2, pp. 335–349.

Tambiah, Stanley J. (1990a) "Presidential address: Reflections on communal violence in South Asia", *Journal of Asian Studies*, Vol. 49, No. 4, pp. 741–760.

Tambiah, Stanley J. (1990b) *Magic, Science, Religion and the Scope of Rationality*, Henry Morgan Lectures (1984), Cambridge University Press: Cambridge.

Tanabe, Shigeharu (1984) "Ideological practice in peasant rebellions: Siam at the turn of the twentieth century", in Andrew Turton and Shigeharu Tanabe (eds.) *History and Peasant Consciousness in Southeast Asia*, Senri Ethnological Studies No. 13, National Museum of Ethnology: Osaka.

Tanabe, Shigeharu and Andrew Turton (1984) "Introduction", in Andrew Turton and Shigeharu Tanabe (eds.) *History and Peasant Consciousness in Southeast Asia*, Senri Ethnological Studies No. 13, National Museum of Ethnology: Osaka.

Tanner, Nancy (1985) "Rethinking matriliny: Decision-making and sex roles in Minangkabau", in Lynn L. Thomas and Franz von Benda-Beckmann (eds.) *Change and Continuity in Minangkabau: Local, Regional, and Historical Perspectives on West Sumatra*, Monographs in International Studies, Southeast Asia Series, No. 71, Ohio University: Athens, OH.

Tapp, Nicholas (1989) "Hmong religion", *Asian Folklore Studies*, Vol. XLVIII, No. 1, pp. 59–94.

Taylor, J. (1989) *From Wandering to Domestication: The Thai-Lao Forest Monastic Tradition*, PhD Thesis, Macquarie University: Sydney.

Taylor, K. (1986) "Authority and legitimacy in 11th century Vietnam", in D.G. Marr and A.C. Milner (eds.) *Southeast Asia in the 9th – 14th Centuries*, Institute of Southeast Asian Studies: Singapore.

Taylor, Robert (1982) "Perceptions of ethnicity in the politics of Burma", *Southeast Asian Journal of Social Science*, Vol. 10, No. 1, pp. 7–22.

Taylor, Robert (1987) *The State in Burma*, C. Hurst: London.

Terwiel, B.J. (1975) *Monks and Magic: An Analysis of Religious Ceremonies in Central Thailand*, Scandinavian Institute of Asian Studies, Monograph Series No. 24, Curzon Press: London.

Thai Development Support Committee (1987) *TDN (Thai Development Newsletter)*, Bangkok.

Thak, Chaloemtiarana (1974) "The Sarit Regime, 1963–1975: The formative years of modern Thai politics", PhD Thesis, Cornell University: Ithaca.

Thanh-dam Truong (1990) *Sex, Money and Morality: Prostitution and Tourism in Southeast Asia*, Zed Books: London.

Thurgood, Graham (1985) "Benedict's work: past and present", in *Linguistics of the Sino-Tibetan Area: The State of the Art*, Papers Presented to Paul K. Benedict for his 71th Birthday, Pacific Linguistics Series C, No. 87, edited by Graham Thurgood, James A. Matisoff and David Bradley.

Tichelman, F. (1980) *The Social Evolution of Indonesia: The Asiatic Mode of Production and its Legacy*, Martinus Nijhoff: Hague, Boston and London.

Trautman, T.R. (1981) *Dravidian Kinship*, Cambridge University Press: Cambridge.

Tsing, Anna L. (1990) "Gender and performance in Meratus dispute settlement", in Jane M. Atkinson and Shelly Errington (eds.) *Power and Difference*, Stanford University Press: Stanford.

Turner, Bryan S. (1986) *Equality*, Ellis Horwood and Tavistock Publications: London.

Turner, V. (1968) *The Drums of Affliction*, Oxford University Press.

Turner, V. (1969) *The Ritual Process*, Routledge Kegan Paul: London.

Turton, Andrew (1972) "Matrilineal descent groups and spirit cults of the Thai Yuan in northern Thailand", *Journal of the Siam Society*, Vol. 60, No. 2, pp. 217–256.

Turton, Andrew (1984) "Limits of ideological domination and the formation of social consciousness", in Andrew Turton and Shigeharu Tanabe (1984) *History and Peasant Consciousness in Southeast Asia*, Senri Ethnological Studies No. 13, National Museum of Ethnology: Osaka.

Turton, Andrew (1986) "Patrolling the middle-ground: Methodological perspectives on 'Everyday Peasant Resistance'", *Journal of Peasant Studies*, Vol. 13, No. 2, pp. 36–48.

Turton, Andrew and Shigeharu Tanabe (eds.) (1984) *History and Peasant Consciousness in Southeast Asia*, Senri Ethnological Studies No. 13, National Museum of Ethnology: Osaka.

Tyler, Stephen A. (1986) "Post-modern ethnography: From document of the occult to occult document", in James Clifford and George Marcus (eds.) *Writing Culture: The Poetics and Politics of Ethnography*, University of California Press: Berkeley.

Tylor, E.B. (1871) *Primitive Culture: Researches into the Development of Mythology, Philosophy, Religion, Language, Art and Custom*, Shigeharu John Murray: London.

Unger, Jonathan (1984) "The class system in rural China: A case study", in James L. Watson (ed.) *Class and Social Stratification in Post-revolutionary China*, Cambridge University Press: Cambridge.

United Nations Centre for Regional Development (UNCRD) (1989) *Industrialization and Development: Focus on ASEAN*, United Nations Centre for Regional Development: Nagoya.

United Nations Development Programme (UNDP) (1990) *Report on Human Resource Development*, Oxford University Press: New York.

Valeri, Valerio (1990) "Both nature and culture: Reflections on menstrual and parturitional taboos in Huaulu (Seram)", in Jane M. Atkinson and Shelly Errington (eds.) *Power and Difference*, Stanford University Press: Stanford.

van der Meer, Peter (1987) "Taming the ascetic: Devotionalism in a Hindu monastic order", *Man* N.S., Vol: 22, No. 4, pp. 680–695.

Van Gennep, Arnold (1960) *The Rites of Passage*, translated by Monika B. Vizedom and Gabrielle L. Caffee, Routledge & Kegan Paul: London and Henley.

van Langenberg, M. (1986) "Analysing Indonesia's New Order state: A keywords approach", *RIMA*, Vol. 20, No. 2.

van Liere, W. (1980) "Traditional water management in the lower Mekong basin", *World Archaeology*, Vol. 11, No. 3, pp. 265–280.

Vayda, Andrew P. (1986) "Holism and individualism in ecological anthropology", *Reviews in Anthropology*, Vol. 13, No. 4, pp. 295–313.

Vickerman, Andrew P. (1986) *The Fate of the Peasantry: Premature 'Transition to Socialism' in the Democratic Republic of Vietnam*, Monograph Series No. 8, Southeast Asia Studies Programme, Yale University: New Haven, CT.

Volkman, Toby Alice (1987) "Mortuary tourism in Tana Toraja", in Rita Smith Kipp and Susan Rodgers (eds.) *Indonesian Religions in Transition*, University of Arizona Press: Tucson.

Volkman, Toby Alice (1990) "Visions and revisions: Toraja culture and the tourist gaze", *American Ethnologist*, Vol. 17, pp. 92–110.

Voss, J. (1987) "The politics of pork and the rituals of rice: Distributive feasting and commodity circulation in northern Luzon, the Philippines", in John Clammer (ed.) *Beyond the New Economic Anthropology*, Macmillan Press: London.

Wakeman, F. (1977) "Rebellion and revolution : The study of popular movements in Chinese history", *Journal of Asian Studies*, Vol. XXXVI, No. 2, pp. 201–238.

Wallace, Alfred Russel (1869) *The Malay Archipelago, the Land of the Orang-utan and the Bird of Paradise; a Narrative of Travel with Studies of Man and Nature*, 2 vols., Macmillan: London.

Wallace, Alfred Russel (1956) "Revitalization movements", *American Anthropologist*, Vol. LVIII, No. 2, pp. 264–281.

Wang, In Keun (1986) *Rural Development Studies*, University of Hawaii Press: Honolulu.

Ward, B. (1985) *Through Other Eyes: An Anthropologist's View of Hong Kong*, Chinese University Press: Hong Kong.

Warren, C. (1989) "Balinese political culture and the rhetoric of national development", in P. Alexander (ed.) *Creating Indonesian Cultures*, Oceania Ethnographies: Sydney.

Watanabe, Naotune and Darwin Kadar (eds.) (1985) *Quaternary Geology of the Hominid Fossil Bearing Formations in Java: Report of the Indonesia-Japan Joint Research Project C TA–41, (1976–1979)*, Geological Research and Development Centre Special Publication No. 4, Directorate General of Geology and Mineral Resources, Ministry of Mines and Energy: Bandung.

Watson, James L. (1975) *Emigration and the Chinese Lineage: The Mans in Hong Kong and London*, University of California Press: Berkeley.

Watson, James L. (ed.) (1980a) "Slavery as an institution, open and closed systems", in *Asian and African Systems of Slavery*, University of California Press: Berkeley.

Watson, James L. (ed.) (1980b) "Transactions in people: The Chinese market in slaves, servants, and heirs", in *Asian and African Systems of Slavery*, University of California Press: Berkeley.

Watson, James L. (1985) "Standardizing the gods: The promotion of T'ien Hou ('Empress of Heaven') along the south China coast, 960–1960", in David Johnson, Andrew J. Nathan and Evelyn S. Rawski (eds.) *Popular Culture in Late Imperial China*, University of California Press: Berkeley.

Watson, James L. (1986) "Anthropological overview: The development of Chinese descent groups", in Patricia L. Ebrey and James L. Watson (eds.) *Kinship Organization in Late Imperial China, 1000–1940*, University of California Press: Berkeley and Los Angeles.

Watson, James L. (1988) "The structure of Chinese funerary rites: Elementary forms, ritual sequence, and the primacy of performance", in James L. Watson and Evelyn S. Rawski (eds.) *Death Ritual in Late Imperial and Modern China*, University of California Press: Berkeley.

Watson, Rubie S. (1981) "Class differences and affinal relations in south China", *Man*, Vol. 16, No. 3, pp. 593–615.

Watson, Rubie S. (1991) "Wives, concubines, and maids: Servitude and kinship in the Hong Kong region, 1900–1940", in Rubie Watson and Patricia Ebrey (eds.) *Marriage and Inequality in Chinese Society*, University of California Press: Berkeley and Los Angeles.

Watson, Rubie S. and Patricia Ebrey (eds.) (1991) *Marriage and Inequality in Chinese Society*, University of California Press: Berkeley and Los Angeles.

Weber, Max (1968) *Economy and Society*, Bedminster Press: New York (3 vols.).

Weidenreich, F. (1943) "The skull of Sinanthropus pekinensis", *Palaeontologica Sinica* (n.s. D), Vol. 10, pp. 1–298.

Weiner, M. (1991) *The Child and the State in India: Child Labour and Education Policy in Comparative Perspective*, Princeton University Press: Princeton, NJ.

Weinreich, Uriel (1953) *Languages in Contact*, Linguistic Circle and Mouton: New York.

Welch, D.J. (1989) "Late prehistoric and early historic exchange patterns in the Phimai Region, Thailand", *Journal of Southeast Asian Studies*, Vol. 20, No. 1, pp. 11–26.

Whorf, B. (1956) "An American Indian model of the universe", in J.B. Carroll (ed.) *Language, Thought and Reality*, MIT Press: Cambridge, MA.

Wiens, Mi Chu (1980) "Lord and peasant: The sixteenth to the eighteenth century", *Modern China*, Vol. 6, No. 1, pp. 3–39.

Wijeyewardene, Gehan (1977) "Matriclans or female cults: A problem in northern Thai ethnography", *Mankind*, Vol. 11, pp. 19–25.

Wijeyewardene, Gehan (1986) *Place and Emotion in Northern Thai Ritual Behaviour*, Pandora: Bangkok.

Wijeyewardene, Gehan (ed.) (1990) *Ethnic Groups across National Boundaries in Mainland Southeast Asia*, Institute of Southeast Asian Studies: Singapore.

Wilson, Bryan (ed.) (1979) *Rationality*, Basil Blackwell: Oxford.

Winzeler, R.L. (1976) "Ecology, culture, social organization, and state formation in Southeast Asia", *Current Anthropology*, Vol. 17, No. 4, pp. 623–640.

Wittfogel, K.A. (1973) *Oriental Despotism*, Yale University Press: New Haven, CT (first published 1957).

Wolf, Arthur P. (ed.) (1978) "Gods, ghosts and ancestors", in *Studies in Chinese Society*, Stanford University Press: Stanford.

Wolf, Arthur P. (1984) "Family life and the life cycle in rural China", in Robert Netting, Richard Wilk and Eric Arnould (eds.) *Households: Comparative and Historical Studies of the Domestic Group*, University of California Press: Berkeley and Los Angeles.

Wolf, Eric R. (1966) *Peasants*, Prentice Hall: Englewood Cliffs, NJ.

Wolf, Eric R. (1982) *Europe and the People Without History*, University of California Press: Berkeley.

Wolf, Eric R. and Joseph G. Jorgensen (1970) "Anthropology on the warpath in Thailand", *The New York Review*, November.

Wolf, M. (1978) "Child training and the Chinese family", in A.P. Wolf (ed.) *Studies in Chinese Society*, Stanford University Press: Stanford.

Wolpoff, M.H. (1989) "Multiregional evolution: The fossil alternative to Eden", in Paul Mellars and Chris Stringer (eds.) *The Human Revolution: Behavioural and Biological Perspectives on the Origins of Modern Humans*, Edinburgh University Press: Edinburgh.

Wolpoff, M.H., Wu Xinzhi and A.G.Thorne (1984) "Modern *Homo sapiens* origins: a general theory of hominid evolution involving the fossil evidence from East Asia", in F.H. Smith and F. Spencer (eds.) *The Origins of Modern Humans: A World Survey of the Fossil Evidence*, Alan R. Liss: New York.

Wolters, O.W. (1982) *History, Culture, and Region in Southeast Asian Perspectives*, Institute of Southeast Asian Studies: Singapore.

Wong, Thomas W.P. (1991) "Inequality, stratification and mobility", in Lau Siu Kai, Lee Ming-kuan, Wan Po-san and Wong Sui-lun (eds.) *Indicators of Social Development: Hong Kong (1988)*, Hong Kong Institute of Asia-Pacific Studies, Chinese University of Hong Kong: Hong Kong.

Woodside, A.B. (1988) *Vietnam and the Chinese Model: A Comparative Study of Vietnamese and Chinese Government in the First Half of the Nineteenth Century*, Harvard University Press: Cambridge, MA and London.

Worsley, P. (1957) "Introduction", in *The Trumpet Shall Sound: A Study of Cargo Cults in Melanesia*, MacGibbon & Kee: London.

Wu, Rukang and Dong Xingren (1985) "*Homo erectus* in China", in Wu Rukang and John W. Olsen (eds.) *Palaeoanthropology and Palaeolithic Archaeology in the People's Republic of China*, Academic Press: Orlando.

Wu, Rukang and Lin Shenglong (1985) "Chinese palaeoanthropology: Retrospect and prospect", in Wu Rukang and John W. Olsen (eds.) *Palaeoanthropology and Palaeolithic Archaeology in the People's Republic of China*, Academic Press: Orlando.

Wu, Rukang and John W. Olsen (eds.) (1985) *Palaeoanthropology and Palaeolithic Archaeology in the People's Republic of China*, Academic Press: Orlando.

Wu, Xinzhi and Wu Maolin (1985) "Early *Homo sapiens* in China", in Wu Rukang and John W. Olsen (eds.) *Palaeoanthropology and Palaeolithic Archaeology in the People's Republic of China*, Academic Press: Orlando.

Wu, Xinzhi and Zhang Zhebiao (1985) "*Homo sapiens* remains from late palaeolithic and neolithic China", in Wu Rukang and John W. Olsen (eds.) *Palaeoanthropology and Palaeolithic Archaeology in the People's Republic of China*, Academic Press: Orlando.

Wyatt, David (1982) "The 'subtle revolution' of King Rama I of Siam", in D.K. Wyatt and A. Woodside (eds.) *Moral Order and the Question of Change: Essays on Southeast Asian Thought*, Monograph Series, No. 24, Southeast Asian Studies Programme, Yale University: New Haven, CT.

Wyatt, David (1984) *Thailand: A Short History*, Yale University Press: New Haven, CT.

Yager, Joseph (1988) *Transforming Agriculture in Taiwan: The Experience of the Joint Commission on Rural Reconstruction*, Cornell University Press: Ithaca.

Yang, C.K. (1961) *Religion in Chinese Society*, University of California Press: Berkeley.

Yang, Martin C. (1945) *A Chinese Village: Taitou, Shantung Province*, Columbia University Press: New York.

Yang, Mayfair Mei-Hui (1989) "The gift economy and state power in China", *Comparative Studies in Society and History*, Vol. 31, No. 1, pp. 25–54.

Yazaki, Takeo (1968) *Social Change and the City in Japan*, Japan Publications: Tokyo.

Yazaki, Takeo (1973) "The history of urbanization in Japan", in A. Southall (ed.), *Urban Anthropology: Cross Cultural Studies of Urbanisation*, Oxford University Press.

Zhang, Senshui (1985) "The early Palaeolithic of China", in Wu Rukang and John W. Olsen (eds.) *Palaeoanthropology and Palaeolithic Archaeology in the People's Republic of China*, Academic Press: Orlando.

Zuraina, Majid (1982) "The West Mouth, Niah, in the prehistory of Southeast Asia", *Sarawak Museum Journal 31*, Special Monograph No. 3, Sarawak Museum: Kuching, Sarawak.

Zuraina, Majid (1990) "The Tampanian problem resolved: archaeological evidence of a late Pleistocene lithic workshop", *Modern Quaternary Research in Southeast Asia*, Vol. 11, pp. 71–96.

Zuraina, Majid and H.D. Tjia (1988) "Kota Tampan, Perak. The geological and archaeological evidence for a late Pleistocene site", *Journal of the Malaysian Branch of the Royal Asiatic Society*, Vol. 61, Pt. 2, pp. 123–134.

GLOSSARY

Adoption: a form of fictive kinship which may be regarded as a social mechanism through which imbalances or deficiencies in the natural (biological) process of reproduction may be adjusted to fit with the norms of kinship ideology. Adopted kinsmen thus fill the role of true kinsmen.

Affinity: relatives by marriage rather than descent; may include relationships between corporate groups linked by marriage among their members.

Archaeology: the study of human societies by their material remains.

Areal Classification: classification of languages according to their being close to one another in location and sharing common characteristics due to their borrowing of linguistic features from one another.

Areal Linguistics: study of languages which are not genetically related but classified into one group because they stay close and influence one another.

Assemblage: a group of things which recur together at particular times and places, such as types or artifacts, or the remains of species of animals (= faunal assemblage).

Bilateral Kinship: the type of kinship system in which individuals affiliate more or less equally with their mother's and father's relatives; descent groups are absent.

Birth Family: the family in which one is born and raised, or birth family, is commonly different from the new family created upon adulthood and marriage, or marital family. As an adult, one may call both one's birth and marital families simply as "family" even though one may no longer reside with, or even legally belong to, one's birth family.

Brideprice (Bridewealth): a substantial transfer of goods or money to the bride's kin by the groom or his kin at or before the marriage. Characteristically these payments establish rights over the wife's sexuality, work services, residence, fertility and the like.

Civilizations: urban societies with a state-type political organization, implying an increasingly complex division of labour, generally accompanied by literacy and the elaboration of artistic, religious or ceremonial life.

Clans: a unilineal descent groups that trace their ancestry to an apical ancestor or ancestress, but do not know their precise genealogical links to that ancestor.

Classification: systems of social and cultural classifications as areas of study in theory of anthropology and structural anthropology.

Collateral Relative: in kinship studies, consanguineal relatives – those of the same "side" not in a line of descent but related "horizontally" such as brothers or cousins. Relatives not directly related through descent.

Complementary Filiation: the rights, obligations and relationships channelled through the maternal line in patrilineal systems or the paternal line in matrilineal systems. It provides counterbalancing elements in the lineage system, complementing the formal, jural relationships of unilineal descent with the more informal affective ties of the non-descent relationships.

Complex Family: complex families include more than one marriage and can be further divided into three types: stem, joint, and polygamous. There are two types of polygamy: polygyny, in which an individual man marries more than one woman, and polyandry in which a woman marries more than one man.

Both types of marriage are found in Asia – sometimes even in the same family – but in Asian societies, polygyny and/or polyandry are usually options taken up by a small proportion of the wealthy or childless in complex family systems rather than separate systems in their own right. Each of these types of family may be further subdivided by the type of kinship reckoning, post marital residence, inheritance, and succession.

Conjugal: having to do with marriage relations.

Connotation: meaning of a word in addition to its fundamental or literal meaning (compare with denotation).

Consanguinity: kinship relations based on recognised biological ties. Applies to persons related through descent rather than marriage.

Corporate Group: a social group whose members act as a legal individual in terms of collective rights to property, a common group name, collective responsibility, etc. A kin group assigned the power to hold, or own, property of various types, including land, money, and ritual objects; a social group that owns and controls significant property or resources.

Cosmology: a theory of, or a set of beliefs concerning the nature of the universe or cosmos. These beliefs may include postulates of the structure, organization and functioning of the supernatural, natural and social worlds.

Cross-Cousin: the child of Ego's mother's brother or of Ego's father's sister.

Cultural Materialist: the position, argued most forcefully by Marvin Harris, that cultures represent primarily adaptive solutions to the material circumstances of life, and hence that peoples with similar technologies in similar environments will tend to evolve broadly similar modes of social grouping, similar belief systems, etc. Material constraints are viewed as directing human activity and life.

Cultural Relativism: a methodological approach adopted by most anthropologists concerning the need to understand cultural forms or acts in the context in which they occur. Some anthropologists elevate cultural relativism to an epistemological principle.

Culture: a set of learned behaviours, beliefs, attitudes, values, or ideals that are characteristic of a particular society or population. This forms patterned and interrelated traditions, which are transmitted over time and space by non-biological mechanisms based on man's uniquely developed linguistic and non-linguistic symbolizing capability; culture can also refer to a population unit defined by this commonality.

Culture Area: a geographic area where the population shares many common characteristics such as related languages, common artistic traditions, similar features of social organization, and so on. It is defined on the basis of the distribution of cultural traits, though these are sometimes difficult to specify clearly.

Denotation: the explicit meaning of a word, as opposed to its connotation.

Double Descent: a system whereby two systems of social groups or categories exist (for different purposes) in the same society, one based on patrilineal descent and the other on matrilineal descent.

Dowry: a substantial transfer of valuable goods or money from the bride's family and/or relatives to the bride (usually), the groom, or the groom's family in connection with her marriage. It can function as a kind of anticipated inheritance.

Duolocal Residence: a rule of residence whereby a couple, following their marriage, remain members of their respective primary nuclear family kin groups, living apart from one another, while any children reside with their mother.

Emic: the notes and formal statements made by the ethnographer about things and events the members of a culture regard as significant, meaningful, real or appropriate; the subjective meanings shared by a social group and their culturally specific model of experience.

Enculturation: the process of transmitting a specific culture, its norms and patterns, to the next generation. It may include the incorporation of migrants or persons in situations of contact and change into new cultural configurations at any moment in their lives.

Endogamy: the selection of marriage partner from within a kinship group as defined by custom or law.

Ethnocentrism: the learned conception or attitude that other societies customs and ideas can be judged in the context of one's own culture, often resulting in an assumption of superiority.

Etic: the development and application of models derived from the analyst's theoretical and formal categories.

Exogamy: a rule of marrying outside a kinship group as defined by custom or law, or sometimes applied to village exogamy.

Family: essence of a family is kinship relations; a social and economic unit consisting minimally of a parent and children.

Family Developmental Cycle: that variation in size of a domestic group structure as a result of the birth of children and then its dwindling as they marry. Only a small percentage of domestic groups would conform to the ideal type at any one moment.

Feminism: a variety of movements and ideologies appearing first in modern societies and concerned with the emancipation or liberation of women, and opposition to all forms of male dominance.

Filiation: the social recognition of relationships between parents and children.

Form: part of the form-substance dichotomy of language, meaning the arbitrary label signalling the meaningful units of a language, e.g. a word, utterance, etc.

Formalists: in economic anthropology argue that the models of (neoclassical) economic theory can be applied to all human societies. It asserts that certain abstract properties are common to all economic action.

Fosterage: custom of employing foster mothers to raise children not related to them by blood.

Functionalism: theories or models in the social sciences which explain and interpret social and cultural institutions, relations and behaviour in terms of the functions which they perform in sociocultural systems, rather than looking for causal explanations.

Gender: socially and culturally determined differences in the behaviour, role and status of men and women.

Genetic Classification: classification of languages according to their sharing a common ancestor.

Genetrix: following the distinction originally made between Genitor and Pater some anthropologists have similarly distinguished the "sociological mother" or mater, who is the woman through whom the child is linked to other kin, from

the biological mother or genetrix. In most cases, however, the biological and sociological mother are the same person.

Genitor: the biological father of a child, as opposed to the sociological father or pater.

Grammar: the level of language that deals with rules of putting words together to form meaningful sentences.

Holocene: a geological period, also known as the "Recent", which spans the last 10,000–12,000 years; follows the Pleistocene, and coincides with the melting of the extensive glaciers of the last Ice Age.

Household: a domestic group engaged in the acquisition, preparation and consumption of food and the procreation, rearing and socialization of children.

Hypergamy: the norm that a man should marry his daughter into a family of higher status than his own. In such a marriage system, a woman should preferably marry a superior but may marry an equal, and a man should not marry a woman of higher status than himself.

Hypogamy: a form of marriage norm in which a man should marry a woman of higher status than himself. Hypogamy is a structural phenomenon which represents the tension between paternal and maternal lines, while hypergamy represents the triumph of the paternal over the maternal lineage.

Identity: a sense of one's self as an individual (personal identity) or as a bearer of a particular cultural heritage (cultural identity).

Ideology: a cultural belief system, particularly one that entails systematic distortion or masking of the true nature of social, political and economic relations.

Impartible Inheritance: property which is undivided on the death of its owner. Normally it is inherited in toto by either an eldest or youngest child.

Incest Taboo (Tabu): prohibition of sexual relationship between immediate kin and other categories of kin, delineation of which varies from society to society.

Inheritance: the transmission of property following the death of its owner.

Isogamic (Isogamy): marriage between partners of equal status.

Joint Family: often as equivalent to extended family. A household comprising of several conjugal units and their offspring living under the same shelter, but may have specialized meaning with reference to specific societies.

Kindred: a local group made up of bilateral relatives. The social significance of the kindred varies according to the nature of the kinship system, because different kinship systems employ different principles of selection or closure which limit or channel a person's social relations with certain members of the kindred.

Legitimize (Legitimacy, Legitimation): ideas or beliefs that justify the exercise of power or the existence of superior statuses, privileges and so on.

Lineages: a unilineal descent group (patrilineage or matrilineage) whose members trace descent from an apical ancestor or ancestress through known genealogical links.

Lineal Relative: relatives directly descended from one named and known individual.

Linguistic Convergence: phenomenon resulting in a situation whereby two or more languages that are located close to one another become similar due to their borrowing linguistic features from one another.

Marital Family: the new family created upon adulthood and marriage.

Mater: the sociological mother as opposed to the biological mother.

Material Culture: includes the sum or inventory of the technology and material artifacts of a human group, including those elements related to subsistence

activities as well as those which are produced for ornamental, artistic or ritual purposes. The study of material culture is linked to archaeology and the anthropology of art, music, dance, symbolism and ritual.

Matrilateral: relationships on the mother's side.

Matrilineal Descent: "on the mother's side". Refers to those who are linked by descent through the mother and the mother's relatives.

Maximizing: the theoretical assumption that individuals (or groups or firms) will make decisions in such a way as to achieve maximum reward (whether in money, power, etc.) regardless of social or cultural context; an assumption underlying neoclassical economics and formalist economic anthropology.

Means of Production: the resources used in the process of production (tools, land, technological knowledge, raw materials etc.). In Marxist analyses social classes are defined with reference to their differential relationship to the means of production.

Mercantilism: a key phase of intensified commercial activity centred in Europe prior to the rise of capitalism as a fully established social system. It formed a world market and initiated European colonial conquest of Latin America, Africa and Asia.

Methodological: procedures for collecting and evaluating empirical evidence.

Models: a device employed in order to aid interpretation of reality and the building of theory. They occupy an intermediate status between the levels of empirical observation of specific cases and abstract general theory.

Morpheme: see morphological system.

Morphological System: the system in language that deals with morphemes – minimal meaningful units in a particular language.

Neo-classical Economics: the mainstream theoretical approach in capitalist economies. It argues that under conditions of free trade and minimal state intervention maximum efficiency in production and marketing will be achieved.

Neolocal: a rule of residence whereby a married couple establishes a residence apart from the relatives of both the wife and the husband. It may be associated with a fluid local group composition, with independent domestic groups based on a nuclear family, with bilateral kinship systems, or with societies where factors other than kinship are the principle determinants of residence.

Nuclear Family: a human social unit that is composed of a married couple and their dependent children. It is not universally present in all societies.

Orientalism: a term used to describe a stereotypical set of European perceptions and modes of analysis of "the East", which initially meant the Muslim "middle" East but was extended to include India, China, Japan and other Asian countries.

Palaeontology: a branch of Geology – the study of past plants and animals by their fossil remains.

Paradigm: the prevailing model, problems and solutions which dominate scientific, or more general intellectual activity at any moment in time.

Paradigmatic Relationship: relation between members of a class, e.g. nouns, verbs, adjectives, etc.

Parallel Cousins: children of the siblings of the same sex. One's parallel cousins are father's brothers' children and mother's sisters' children.

Parcenary Rights: joint rights of inheritance.

Partible Inheritance: property which is distributed to siblings usually on the death of the owner.

Participant Observation: a technique of anthropological research through extended periods of fieldwork, in which the anthropologist immerses him or herself in the daily life of the people studied, minimizing the effect of his or her presence and permitting a full appreciation of the culture.

Pater: sociological father as opposed to biological father.

Patrilateral: relationships on the father's side.

Patrilineal Descent: tracing descent through the father and his male ancestors.

Patrilocal: the pattern of residence in which a married couple establish their residence with or near the husband's family.

Patrimonialism: a form of highly personalised and centralized political rule in which nepotism is normal.

Phonological System: the system in language which deals with phonemes – significant speech sounds in a particular language.

Phonology: the level of language that deals with speech sounds.

Physical Anthropology: the study of biological characteristics of human beings, especially in fossil form.

Pleistocene: a geological period, also known as the "Ice Age", although in reality it includes several separate "Ice Ages"; covers the period 1.8 million years to 10,000–12,000 years ago.

Pliocene: a geological period which immediately precedes the Pleistocene, spanning the time period 0.7 million to 1.8 million years.

Polyandry: a form of plural marriage where a woman has more than one husband.

Polygamous (Polygamy): plural marriage; marriage to more than one spouse simultaneously; the practice of multiple marriages.

Polygyny: a form of plural marriage in which the husband is permitted more than one wife.

Prehistory: the period of human history before the invention of writing; usually but not only, studied by archaeologists.

Primitive Societies: a concept commonly used by earlier anthropologists primarily to describe hunter-gatherer societies. It was often couched in social evolutionary assumptions of progression from simple to complex societies. The concept has, however, fallen into disfavour because of its failure to acknowledge different levels of social and cultural complexity, and because of suggestions of social and cultural inferiority.

Primogeniture: the rule of inheritance or succession which favours the eldest child (e.g. the eldest son where inheritance or succession is solely or preferentially in the male line).

Quaternary: a geological period comprising the Pleistocene plus the Holocene.

Reflexivity: critical reflection on, or awareness of, one's own social and intellectual practices.

Reifying (Reification): a notion which refers to a general tendency to artificially isolate aspects of a social, cultural or theoretical totality. Through decontextualization these aspects are often presented as if they exist autonomously.

Relations of Production: derived from Marxist theory, the social relationships through which production (and distribution and consumption) are organized in a society. Relations of production and of production, in various combinations define a mode of production.

Rights in Genitricum: the role of brideprice in effecting the transfer of rights to filiate offspring to the groom's descent group.

Rights in Uxorem: rights to the domestic services of a woman as wife.

Secularization: decline in religious interpretations of the world.

Segmentary: lineage systems define descent groups in terms of identifications with more distant apical ancestors. The structure of society is thus conceived of as tree-like, in which there are different levels of unity and opposition.

Semantic System: the system of language that deals with meanings conveyed by words and sentences in a particular language.

Semiotics: the study of signs and sign-using behaviour and their meanings, including both the study of linguistic and non-linguistic communication.

Simple Family: sometimes known as nuclear families, or conjugal families, simple families may be extended by the addition of other unmarried kinsmen (grandparents, grandchildren, aunts, uncles), but they remain simple so long as only one currently active marriage is involved.

Social Evolutionism: current among earlier anthropologists and sociologists, it embodies the idea of societies' progression through fixed evolutionary stages, and usually assumed that modern societies were the "highest" stage of evolution. In some cases it made perverse use of Darwin's idea of "fitness" to suggest the inevitable dominance of certain countries or "races" over others.

Socialization: the process of transmitting human culture; a child's incorporation into his or her society through learning from parents and others, resulting in conformity to the standards deemed appropriate by the culture.

Stem Family: a family form usually predominating among prosperous strata of rural peoples. It consists of at least two generations of conjugal units. Rights to land or property are handed down from generation to generation and each inheritor becomes the focus for the family organization in that generation.

Structural Approach: the theoretical tradition that seeks to find beneath cultural phenomena, enduring basic structures. While the surface phenomena vary, the underlying ordering principles remain the same.

Substance: part of the "form-substance" dichotomy of language, meaning all the content except the "signifier" or the pronunciation of the language.

Substantivists: in economic anthropology take the stance that the models of neoclassical economics properly apply only to capitalist economies. In substantivist theory economics is properly concerned with socially and culturally specific ways in which humans produce and distribute the material goods that sustain them.

Succession: the pattern whereby successors are chosen.

Symbol: a word, colour, object or idea which refers to something else (its referent) in a conventional rather than a natural way. Symbols are, therefore, arbitrary and can have a wide range of cultural meanings.

Syncretism: synthesis of the elements of two or more cultures, particularly religious beliefs and ritual practices. This is a general feature of development of religious and cultural systems over time as they absorb and re-interpret elements drawn from other traditions with which they are in contact.

Syntactic System (or syntax): the system in language which deals with rules of ordering words into a large unit, as sentences.

Syntax: see Syntactic system.

Topological Classification: Classification of languages according to their "universal types": phonologically, e.g. tone, languages; morphologically, e.g. inflectional languages; or syntactically, e.g. SVO languages.

Unilineal Kinship: tracing descent and recognizing kinship through links of one sex only.

Utrolocal: a marriage is utrolocal (utro = either) when a child may choose virilocal or uxorilocal residence, but must choose one or the other. The person, either male or female, who marries out eventually becomes fully incorporated in his or her marital family.

Uxorilocal: a residence rule whereby on marriage the couple goes to live with or near the wife's kin. It has been associated with the solidarity of the female kin group and is also referred to as **Matrilocal**.

Word: the smallest meaningful unit that can stand in isolation.

INDEX

LIST OF CONTRIBUTORS

Sandra Bowdler is Professor of Archaeology at the University of Western Australia. She has done extensive research and published widely on aboriginal Australia. More recently she has been carrying out research in Asia.

John Clammer is Professor of Anthropology and Sociology and Graduate Professor of Asian Studies at Sophia University, Tokyo. His work has focused on Southeast Asia and Japan, and especially questions of economic life, religion and ethnicity, and on the interrelationships between these, mainly in urban settings. He has edited several books on economic anthropology and written others on Singapore, the most recent being *The Sociology of Singapore Religion* (Singapore, 1991).

Paul T. Cohen is a Senior Lecturer in Anthropology and Comparative Sociology in the School of Behavioural Sciences at Macquarie University. He is currently interested in comparative analysis of beliefs and practices relating to illness and healing. He has co-edited *The Political Economy of Primary Health Care in Southeast Asia* (Canberra, 1989). He has published extensively on the culture, politics and economy of northern Thailand and is co-editor of *Spirit Cults and the Position of Women in Northern Thailand* (Sydney, 1984).

Grant Evans is a Reader in Anthropology, Department of Sociology, University of Hong Kong. He has published widely on Indochina and his most recent book is *Lao Peasants Under Socialism* (Yale, 1990).

Patrick Guinness is a Senior Lecturer in the Department of Sociology and Anthropology, La Trobe University and former Research Fellow in the Department of Anthropology, Australian National University. His publications include *On the Margins of Capitalism: People and Development in Mukim Plentong, Johor, Malaysia* (OUP, 1992) and *Harmony and Hierarchy in a Javanese Kampung* (OUP, 1986). His main research interests are issues of development and the urban populations of Southeast Asia.

Christine Helliwell is a Lecturer in Anthropology and Comparative Sociology in the School of Behavioural Sciences, Macquarie University. She has carried out ethnographic research on understanding of person and community, with particular emphasis on the cultural construction of domesticity, among both New Zealanders and Dayak people of Indonesian Borneo. She is currently completing a book based on her research – *The Ricefield and the Hearth* – which looks at the character of social relations and the domestic group among Borneo Dayak people.

Joy Hendry is a Reader, Scottish Centre for Japanese Studies, University of Stirling, Scotland, and Principal Lecturer at Oxford Polytechnic, Oxford. She has lived in

and carried out research on Japan for the last twenty years and is the author of *Marriage in Changing Japan: Community and Society* (Croom Helm, 1981; Tuttle, 1986), *Becoming Japanese: The World of the Pre-school Child* (Manchester University Press, 1986), *Understanding Japanese Society* (Croom Helm, 1987), and *Packaged Politeness: Wrapping, Presentation and Power in Japan and Other Cultures* (in press).

Lian Kwee Fee is Lecturer in Sociology at the National University of Singapore. His current research interests are in ethnic relations, the nation-state, citizenship, and civil society in Southeast Asia. He has published on the ethnic identity of the Chinese in New Zealand and on Maori political development in *Plural Societies*.

Amara Prasithrathsint is Associate Professor and Chair of the Department of Linguistics, Faculty of Arts, Chulalongkorn University, Bangkok, Thailand. Her research has been on linguistic change among Thai and more recently she has been carrying out comparative research on Zhuang in southern China. She is editor of a forthcoming Thai language text, *Thai Language in its Social and Cultural Context* (Bangkok).

Ananda Rajah is a Fellow and Co-ordinator of the Social Issues in Southeast Asia Programme at the Institute of Southeast Asian Studies, Singapore. He has undertaken fieldwork on the Karen in Northern Thailand and his research interests are the anthropological study of ethnicity, religion, and the nation-state in mainland Southeast Asia. He has published widely on these issues, most recently in *Ethnic Groups Across National Boundaries in Mainland Southeast Asia* (Singapore, 1990).

Jesucita Sodusta is currently a development consultant working out of Macau. Previously she was a Research Fellow at the Institute of Southeast Asian Studies in Singapore and a Lecturer in the Department of Sociology, University of Hong Kong. She has published on land reform and problems of agrarian development in Asia, as well as on religion, *Jamoyawan Ritual: A Territorial Concept* (University of the Philippines Press, 1983).

Clark Sorensen is Associate Professor in Anthropology at The Henry Jackson School of International Studies, University of Washington, Seattle, USA. His research has been on South Korean society, part of which is reported in his book *Over the Mountains are Mountains: Korean Peasant Households and their Adaptations to Rapid Industrialization* (University of Washington Press, 1988).

Nicholas Tapp is a Lecturer in the Department of Anthropology, Chinese University of Hong Kong. He has carried out extensive work among the Hmong of northern Thailand and among minorities in China. He has co-edited *Ethnicity and Ethnic Groups in China* (Hong Kong, 1989), and written *Sovereignty and Rebellion: The White Hmong of Northern Thailand* (OUP, 1990).